LIGHT *of* ASIA

Buddha Sakyamuni
in Asian Art

This exhibition and its catalogue are funded in part by grants
from the National Endowment for the Humanities and the
National Endowment for the Arts and by an indemnity from the
Federal Council on the Arts and the Humanities.

Organized by Pratapaditya Pal

With essays by
Robert L. Brown
Robert E. Fisher
George Kuwayama
Amy G. Poster

LIGHT *of* ASIA

Buddha Sakyamuni
in Asian Art

Los Angeles County Museum of Art
Distributed by University of Washington Press, Seattle and London

Exhibition Itinerary:

Los Angeles County Museum of Art
March 4–May 20, 1984

The Art Institute of Chicago
June 30–August 26, 1984

The Brooklyn Museum
November 1, 1984–February 10, 1985

Published by the
Los Angeles County Museum of Art
5905 Wilshire Boulevard
Los Angeles, California 90036

Edited by Lynne Dean
Designed by Lilli Cristin

Typeset in Trump Medieval by
Continental Typographics Inc.,
Chatsworth, California

Printed in an edition of 3,000
softcover and 1,500 hardcover on
Quintessence Dull papers by
Lithographix, Inc., Los Angeles,
California

Hardcover distributed by University
of Washington Press, Seattle and
London

Front Cover:
Buddha Sakyamuni (Detail)
North India, 6th century
(no. 85)

Library of Congress Cataloging in Publication Data
Main entry under title:

Light of Asia:

 Bibliography: p.
 Includes index.
 1. Gautama Buddha—Art—Exhibitions. 2. Art, Asian—
Exhibitions. I. Pal, Pratapaditya. II. Los Angeles
County Museum of Art.
N8193.2.A3C44 1984 704.9'4894363 84-788
ISBN 0-87587-116-X

CONTENTS

6 Directors' Foreword

7 Preface

11 Acknowledgments

13 Lenders to the Exhibition

15 Contributors to the Catalogue

15 Notes to the Reader

17 Introduction

22 Color Plates

37 I: The Legendary Life of Buddha Sakyamuni
 Pratapaditya Pal

129 II: Symbols of Buddha Sakyamuni
 Pratapaditya Pal

143 III: Images of Buddha Sakyamuni
145 The Buddha Image in India *Pratapaditya Pal*
155 The Buddha Image in Sri Lanka and Southeast Asia *Robert L. Brown*
165 The Buddha Image in China *George Kuwayama*
175 The Buddha Image in Korea *Robert E. Fisher*
183 The Buddha Image in Japan *Amy G. Poster*

251 IV: Transcendental and Cosmic Buddhas
 Pratapaditya Pal

314 List of Sanskrit Terms That Employ Diacritical Marks

315 Bibliography

321 Index

330 Photo Credits

331 Trustees and Supervisors

DIRECTORS' FOREWORD

THIS EXHIBITION REPRESENTS the most comprehensive attempt to date to examine the image of Buddha Sakyamuni as interpreted in the various cultural and historical contexts where Buddhism has flourished. It contains over one hundred ninety sculptures and paintings drawn from Asian, European, and American collections and has involved over four years of preparation. Looking at the beautiful and highly varied works of art assembled here, one cannot help but be struck by the intense faith that Buddhism inspired in its adherents. The creators of the majority of these magnificent paintings and sculptures remain unknown to us, and this anonymity underscores the fact that these objects were not intended to produce a detached aesthetic experience or to reflect credit upon their artists. Instead, Buddhist artworks served to instruct, awe, and inspire the devotee.

We would like to express our gratitude to Dr. Pratapaditya Pal, Senior Curator of Indian and Southeast Asian Art, LACMA, and his staff for the tremendous effort they have exerted in conceptualizing and coordinating this amazingly comprehensive exhibition. Furthermore, we applaud Dr. Pal's concern with making the exhibition's subject matter accessible to a Western audience.

The continued assistance of a number of colleagues has also been highly important to the success of this exhibition. We would like to give special thanks to: Dr. Kapila Vatsyayan, Additional Secretary, Department of Culture, Government of India; Dr. Sunu Choi, Director General, Seoul National Museum, South Korea; Mrs. Chira Chongkol, Director, National Museum, Bangkok, Thailand; and Mr. Kiichiro Saito, Deputy Director General, Nara National Museum, Japan.

It has been extremely gratifying for the Los Angeles County Museum of Art to collaborate with The Art Institute of Chicago and The Brooklyn Museum. Knowing that audiences in three major American cities will have the rare opportunity to view this important group of works makes the lengthy and involved preparation of this exhibition seem especially worthwhile.

Light of Asia has received major funding from the National Endowment for the Humanities and the National Endowment for the Arts; many foreign loans have been indemnified by the Federal Council on the Arts and Humanities. Without such support, an exhibition of this scope and magnitude would have been impossible.

Earl A. Powell III	James N. Wood	Robert T. Buck
Director	Director	Director
Los Angeles County Museum of Art	The Art Institute of Chicago	The Brooklyn Museum

PREFACE

SEVERAL YEARS AGO, I happened to visit an exhibition highlighting important figures in black history and was surprised to see included portraits of Buddha Sakyamuni, an Indian religious leader who had lived over twenty-five hundred years ago. The presence of the Buddha among the representations of black leaders made me realize the nearly universal appeal of his teachings. Furthermore, it suggested to me the possibility of an exhibition of artistic representations of Buddha Sakyamuni drawn from diverse historical periods and created in a variety of Asian cultures.

The only previous exhibition devoted to an examination of the image of the Buddha was organized by the late Professor Benjamin Rowland, Jr., of Harvard University in 1964. That exhibition, however, was limited in both scale and scope and did not focus upon narrative representations of Sakyamuni's life. It also ignored the concept of the Buddha's transcendental nature, a subject that comprises a substantial portion of the present exhibition.

Buddhism has long held a fascination for European authors and artists, as evidenced by Sir Edwin Arnold's poem *The Light of Asia,* from which this exhibition takes its name, and by the exhibited representations of the Buddha by Odilon Redon and Paul Gauguin (see nos. 129 and 130). Buddhist thought has also influenced many noted American philosophers, as discussed in a recent study entitled *Buddhism and American Thinkers,* published by the State University of New York Press. Today, the Buddhist religion—especially the Zen Buddhism of Japan and various forms of Tibetan Buddhism—continues to steadily attract a following both in Europe and America. Nevertheless, the Western public often feels dismayed when confronted with exhibitions of Asian art and immediately imagines multi-limbed deities and arcane philosophies. The cultural diversity and religious complexity inherent in the art of Asia can indeed appear quite formidable to the uninitiated. An examination of representations of Buddha Sakyamuni—a historical personage who was later deified—however, provides an easily accessible introduction to Asian art, and the thematic unity of the exhibition should help even the most uninformed viewer to recognize and appreciate the cultural diversity of Asia without being overwhelmed by it.

Considered as a whole Buddhism is a highly complex religion that inspired art of incredible iconographic variety. Even in restricting ourselves to the theme of the historical Buddha, Sakyamuni, it has been necessary to carefully organize and limit the scope of the exhibition due to constraints of time and space. As a result, we were unable to treat the important concept of the bodhisattva in Buddhist art and thought.

Both the exhibition and its catalogue are divided into four principal sections. The first of these is devoted to narrative reliefs and paintings depicting major events in Buddha Sakyamuni's life. Although this section is by no means exhaustive, it is hoped that the objects and entries presented will give the audience some familiarity with the career and ideals of the founder of Buddhism. This introduction should in turn make the following sections more interesting and comprehensible.

Early symbolic representations of the Buddha are treated in section two of the exhibition, and the role that these symbols continued to play in later works of art is examined. The third section concentrates on images that may be identified with some certainty as Buddha Sakyamuni. An examination of the artworks included in this section will help the viewer form some idea of the tremendous national and aesthetic diversity manifested in images of the Buddha. At the same time, the consistency of certain fundamental iconographic traits and concepts should become readily apparent.

Section four introduces the cosmic and transcendental Buddhas, major figures in the art and rituals of later forms of Buddhism, such as Vajrayana. The relationship between these Buddhas and Buddha Sakyamuni is discussed, and reasons for the frequent difficulty in differentiating transcendental and cosmic images from those of Sakyamuni are explored.

All curators who have ever attempted to coordinate an exhibition of this sort, involving institutions and governments spread over three continents, are doubtlessly well aware of the enormous gulf that exists between dream and reality. Nearly four years ago, after beginning the selection of artworks for this exhibition, we came to the realization that it would be impossible to secure all the objects we wished to include. Governments and institutions alike are becoming more and more aware of the potential hazards of traveling exhibitions and are increasingly reluctant to part with major masterpieces. At the start of the project, I was not aware, for instance, how many Japanese representations of the Buddha Sakyamuni are still housed in the temples and collections of that country or how difficult it is to borrow works designated Important Cultural Property for a traveling exhibition. These and other difficulties made it necessary to trim our original wish list, but thanks to the ungrudging cooperation of collectors and colleagues around the world, we believe that we have assembled an interesting and truly informative exhibition.

The cooperation of numerous scholars and colleagues has been vital to the success of this project. I wish especially to thank the contributors to the catalogue: Robert L. Brown, Associate Curator of Indian and Southeast Asian Art, LACMA; Robert E. Fisher, Professor of Art History, Department of Art, University of Redlands; George Kuwayama, Senior Curator of Far Eastern Art, LACMA; Amy G. Poster, Associate Curator of Oriental Art, The Brooklyn Museum. Not only have they been diligent and dedicated in the preparation of essays and entries, their assistance has been invaluable in securing loans of artworks and in facilitating many aspects of the exhibition. Furthermore, I would like to gratefully acknowledge the contributions of Jane Burrell, Curatorial Assistant, Far Eastern Art Department, LACMA, who prepared a number of the Chinese entries, and Dr. Siri Gunasinghe, Professor of History in Art, University of Victoria, British Columbia, who translated the fascinating and lengthy inscriptions comprising the entry for the Sinhalese manuscript covers (no. 137). We are also indebted to Jung-hee Lee of the University of California, Los Angeles, for her assistance in translating numerous Chinese and Korean inscriptions. Because several authors were involved in writing the catalogue, the task of editing has been especially arduous. Museum editor Lynne Dean has been both thorough and cheerful and deserves much of the credit for the consistency and lucidity of the publication.

Almost every department in the Museum has been involved in one way or another in preparing for this exhibition, and unfortunately, I am only able to directly acknowledge a few of the many participants here. Dr. Earl A. Powell III, Director of the Museum, has been consistently supportive of this project, and his enthusiasm has been sincerely appreciated. Dr. Sheila R. Canby, former

Associate Curator of West Asian and Egyptian Art, who left the Museum in June 1983, provided invaluable assistance and cooperation during her two-year stay with us. She also wrote the entry for the two Persian manuscript illuminations included in the exhibition (no. 12). Stephen Markel, a University of Michigan graduate student and National Endowment for the Arts Intern in the Museum's Department of Indian and Southeast Asian Art, has been another willing and diligent coordinator of many facets of the exhibition.

An extraordinary number of friends and colleagues outside the Museum have helped generously and graciously during the exhibition's long period of gestation. All of them known to us are listed in the Acknowledgments that follow, and we thank them wholeheartedly. It should also be emphasized that this exhibition would not have been possible without the generous cooperation of the lenders who have so willingly agreed to part with their precious objects for well over a year. I have nothing but admiration for their selflessness, a virtue strongly advocated by the Buddha. May the merits derived from this collective effort accrue to them, as well as to the numerous others who have so generously contributed to this project.

Pratapaditya Pal
Senior Curator
Department of Indian and Southeast Asian Art

ACKNOWLEDGMENTS

The Museum and the authors would like to thank the following individuals and institutions who have contributed in many different ways to the organization of the exhibition and the preparation of its catalogue.

Canada
Toronto—Royal Ontario Museum: James R. Cruise, Director.

France
Paris—Musée Guimet: Vadime Elisseeff, Director; Gilles Beguin, Conservator; Robert Gera-Bezard, Conservator.

India
Government of India—Department of Culture: Kapila Vatsyayan, Additional Secretary. *Calcutta*—Indian Museum: S. C. Ray, Director. *New Delhi*—National Museum: I. D. Mathur, Assistant Director.

Japan
Kyoto—Takashi Yanagi. *Nara*—Nara National Museum: (late) Bunsaku Kurata, Director General; Takashi Hamada, Director General; Kiichiro Saito, Deputy Director General; Yoshio Kawahara, Curator Buddhist Archives. *Tokyo*—Agency for Cultural Affairs: Kyotaro Nishikawa, Councilor on Cultural Properties.

Korea
Kyongju—Kyongju National Museum: Han Byong-sam, Director. *Seoul*—Seoul National Museum: Sunu Choi, Director General. Dongkuk University Museum: Hwang Su-yong, Professor of Buddhist Art.

Switzerland
Zurich—Museum Rietberg: Eberhard Fischer, Director.

Thailand
Government of Thailand—Department of Fine Arts: Dejo Savanananda, past Director General; Aree Kulatan, Director General. *Bangkok*—National Museum: Chira Chongkol, Director; Kamthornthep Krataithong, Head of the Curatorial Staff; Somlak Charoenpot, Assistant Curator.

United Kingdom
London—Spink and Son Ltd.: A. G. M. Maynard, Deputy Chairman; Anthony Gardner, Associate Director. Victoria and Albert Museum: Roy Strong, Director; Robert Skelton, Keeper Indian Department.

United States

Baltimore—The Walters Art Gallery: Robert P. Bergman, Director; Lilian Randall, Curator of Manuscripts and Rare Books. Boston—Museum of Fine Arts: Jan Fontein, Director; James Watt, Curator of Asiatic Art. Brooklyn—The Brooklyn Museum: Robert T. Buck, Director; Robert Moes, Curator Oriental Art. Burlington—University of Vermont: Hiram W. Woodward, Jr., Associate Professor. Cambridge—Harvard University, Fogg Art Museum: John Rosenfeld, Acting Director. Chicago—The Art Institute of Chicago: James N. Wood, Director; Jack V. Sewell, Curator of Oriental Art; Suzanne McCullagh, Associate Curator of Prints and Drawings. Cincinnati—Cincinnati Art Museum: Millard F. Rogers, Jr., Director; Daniel Walker, Curator Ancient, Near and Far Eastern Art. Cleveland—Cleveland Museum of Art: Sherman E. Lee, Director Emeritus; Evan Turner, Director; Stanislaw Czuma, Curator of Indian and Southeast Asian Art; Michael J. Cunningham, Curator of Oriental Art. Denver—The Denver Art Museum: Lewis W. Story, Interim Director; Ron Otsuka, Curator Asian Art. Fort Worth—Kimbell Art Museum: Edmund P. Pillsbury, Director; Emily J. Sano, Assistant Director of Programs and Academic Services/Curator of Asian Art. Granville—Denison University: George Bogdanovitch, Department of Art. Denison University Gallery: Paul J. Cardile, Director; Janice Leoshko, Visiting Lecturer. Honolulu—Honolulu Academy of Arts: George R. Ellis, Director; Howard A. Link, Curator of Asian Art. Indianapolis—Indianapolis Museum of Art: Robert Yassin, Director. Kansas City—Nelson Gallery—Atkins Museum: Marc F. Wilson, Director. Lawrence—University of Kansas: Stephen Addiss. Los Angeles—Los Angeles County Museum of Art: Tamara Moats, former Curatorial Assistant of Far Eastern Art. University of Southern California: Richard E. Vinograd, Department of Art History. Korean Cultural Service: Ki Byung Yoon, Director; Moon Ik Chang, Deputy Director. Minneapolis—The Minneapolis Institute of Arts: Samuel Sachs II, Director. Newark—The Newark Museum: Samuel C. Miller, Director; Valrae Reynolds, Curator of Oriental Collections. New York—The Asia Society: Allen Wardwell, Director; Robert D. Mowry, Curator of the Mr. and Mrs. John D. Rockefeller 3rd Collection of Asian Art. Burke Collection: Andrew Pekarik, Curator. Columbia University: H. Paul Varley, Professor of History; P. Yampolsky, Professor, Eastern Asian Language and Culture Department. Japan House Gallery: Rand Castile, Director. The Metropolitan Museum of Art: Philippe de Montebello, Director; Martin Lerner, Curator of Indian and Southeast Asian Art; Barbara Ford, Curator of Japanese Art. The New York Public Library: Donald Anderle, Associate Director of Special Collections; Walter Zervas, Administrative Associate, Special Collections; Frederick Baekeland; Keita Itoh; Ichiro Shirato; Ann Thompson. Pittsburgh—Museum of Art, Carnegie Institute: John R. Lane, Director; Phillip M. Johnston, Curator, Section of Antiquities, Oriental and Decorative Arts. Oakland—Mills College: Mary-Ann Lutzker. San Francisco—Asian Art Museum of San Francisco, The Avery Brundage Collection: René-Yvon Lefebvre d'Argencé, Director; Terese Tse Bartholomew, Curator of Indian Art; Roger Keyes. Santa Barbara—The Santa Barbara Museum of Art: Richard V. West, Director; Susan S. Tai, Assistant Curator of Oriental Art. Seattle—Seattle Art Museum: Arnold H. Jolles, Director; Henry Trubner, Associate Director and Curator of Asian Art. Toledo—The Toledo Museum of Art: Roger Mandle, Director.

West Germany

Berlin—Staatliche Museen Preussischer Kulturbesitz, Museum für Indische Kunst: Herbert Hartel, Director; Marianne Yaldiz, Curator of Central Asian Collection. Cologne—Museum für Ostasiatische Kunst: Roger Goepper, Director.

LENDERS TO THE EXHIBITION

Mr. and Mrs. James W. Alsdorf, Chicago

Alsdorf Foundation, Chicago

The Art Institute of Chicago

The Asia Society, New York: Mr. and Mrs. John D. Rockefeller 3rd Collection

Asian Art Museum of San Francisco, The Avery Brundage Collection

Baekyang-sa, Cholla-namdo Province, and Dongkuk University Museum, Seoul

Jean-Michel Beurdeley Collection, Paris

George P. Bickford

The Brooklyn Museum

Bumper Collection

Mrs. Jackson Burke

Alston Callahan, M.D.

Chantharakhasem National Museum, Ayutthaya, Thailand

Cincinnati Art Museum

Mr. and Mrs. Willard G. Clark

The Cleveland Museum of Art

Denison University Gallery

The Denver Art Museum

Professor Samuel Eilenberg

R. H. Ellsworth Ltd.

Fogg Art Museum, Harvard University, Cambridge, Massachusetts

Mr. and Mrs. John Gilmore Ford

Mr. and Mrs. Mark Gordon

John W. Gruber

Marion Hammer

Mr. and Mrs. Chester Herwitz Family Collection

Collection of Philip Hofer

Honolulu Academy of Arts

Indian Museum, Calcutta

Indianapolis Museum of Art

Mr. T. Kaku, Taiyo Ltd., Tokyo

Kim Dong-hyun, Seoul

Kimbell Art Museum, Fort Worth

Navin Kumar Gallery

Ravi Kumar

Kwak Yong-dae, Seoul

Kyongju National Museum

Mr. and Mrs. Harry Lenart Collection

Los Angeles County Museum of Art

Claude de Marteau Collection, Brussels

M. Maruoka Collection, Tokyo

The Metropolitan Museum of Art

The Minneapolis Institute of Arts

Mr. and Mrs. Robert Wm. Moore Collection, Los Angeles

Musée Guimet, Paris

Museum für Ostasiatische Kunst, Cologne

Museum of Art, Carnegie Institute

Museum of Fine Arts, Boston

Museum Rietberg, Zurich, Von der Heydt Collection

Nara National Museum

National Museum, Bangkok

National Museum, New Delhi

Nelson Gallery—Atkins Museum, Kansas City, Missouri

The New York Public Library, Spencer Collection

The Newark Museum

M. Nitta Collection, Tokyo

Mr. and Mrs. Lawrence R. Phillips

Margot and Hans Ries

Royal Ontario Museum, Toronto

The Santa Barbara Museum of Art

Seattle Art Museum, Eugene Fuller Memorial Collection

Seoul National Museum

Julian Sherrier Collection, London

Shin'enKan Collection

Staatliche Museen Preussischer Kulturbesitz, Museum für Indische Kunst, Berlin

The Toledo Museum of Art

Henry and Ruth Trubner Collection

Vajra Arts

Victoria and Albert Museum

Paul F. Walter

The Walters Art Gallery, Baltimore

Doris Wiener Collection, New York City

Takashi Yanagi, Kyoto

Zimmerman Collection

Several anonymous lenders

Contributors to the Catalogue

RLB — Robert L. Brown
Associate Curator
Department of Indian and Southeast Asian Art
Los Angeles County Museum of Art

JB — Jane Burrell
Curatorial Assistant
Far Eastern Art Department
Los Angeles County Museum of Art

SRC — Sheila R. Canby
Research Consultant
Oriental Art Department
The Brooklyn Museum

REF — Robert E. Fisher
Professor of Art History
Department of Art
University of Redlands

SG — Siri Gunasinghe
Professor
Department of History in Art
University of Victoria

GK — George Kuwayama
Senior Curator
Far Eastern Art Department
Los Angeles County Museum of Art

PP — Pratapaditya Pal
Senior Curator
Department of Indian and Southeast Asian Art
Los Angeles County Museum of Art

AGP — Amy G. Poster
Associate Curator
Oriental Art Department
The Brooklyn Museum

Notes to the Reader

In an effort to simplify reading for the nonspecialist, diacritical marks have been omitted from the majority of foreign terms employed in the text itself. In the case of Chinese personal names, the Pinyin version is given first with the Wade-Giles romanization supplied in brackets. Diacritics have been used where appropriate in Wade-Giles spellings. A list of Sanskrit Terms That Employ Diacritical Marks precedes the Bibliography.

The ordering of the entries in the various sections of the catalogue is primarily chronological following dates of execution. Minor exceptions to this rule have been made on occasions when the proximity of two works would establish or emphasize a relationship more significant than that of date. Two major exceptions to this system of organization occur in sections one and four. In the first section of the catalogue, entries no. 18–66 are arranged by subject mat-

ter in an order approximating the chronology of events in the Buddha's life. Entries in the fourth section, Transcendental and Cosmic Buddhas, are arranged in groups paralleling the discussion of various topics in the essay for that section. These groups are as follows: no. 132–35, *Jataka* Tales; no. 136–39, Multiple Buddhas and Buddhas of the Past; no. 140–47, Buddha Sakyamuni's Transcendental Manifestations; no. 148–49, The Healing Buddha; no. 150–55, Idiosyncratic Representations; no. 156–74, The Transcendental and Cosmic Buddhas of Mahayana and Vajrayana Buddhism; no. 175–79, The Future Buddha, Maitreya.

For each of the exhibited objects, the following information is supplied where available or appropriate: artist, title, medium, dimensions in inches and centimeters, credit line, locations where the work will be exhibited, and a note indicating if a

work is also reproduced in color. In the case of most sculptures, the height is the only dimension given. Where multiple dimensions occur, the height precedes the width, precedes the depth, unless otherwise indicated. The abbreviations h = height and diam = diameter are used consistently throughout the text.

A system of in-text footnotes has been used which corresponds to the bibliographical form adopted. In cases where two or more works were written by a single author during the same year, a letter designation has been added after the date in both footnote references and the bibliography.

The name *Cambodia* has been employed throughout, instead of the more current appellation *Kampuchea*, based on the assumption that the latter name is still unfamiliar to the majority of readers.

Forty-five rains [after his Enlightenment] showed he [the Buddha] those
In many lands and many tongues and gave
Our Asia light, that still is beautiful,
Conquering the world with spirit of strong grace....
 (Sir Edwin Arnold, *The Light of Asia*)

INTRODUCTION

O

F ALL THE COUNTLESS SAINTS and gurus
that the Indian subcontinent has produced over the past three millennia, none has en-
joyed such widespread influence as the Buddha (the Awakened or Enlightened One).
Known also as Sakyamuni (Sage of the Sakya People), the Buddha lived in the sixth and
fifth centuries B.C., thus preceding Christ by some five centuries and antedating Muham-
mad, the founder of Islam, by over a thousand years. He would probably not have consid-
ered himself the founder of a new faith or religion in the sense that these terms are gen-
erally understood in the West, but the fact remains that his teachings, which were
systematized by his followers after his Death, have profoundly influenced the lives and
cultures of countless inhabitants of the vast Asian continent for over two thousand years.
As one modern authority has stated:

> To say that Gotama the Buddha founded a religion is to prejudice our under-
> standing of his far-reaching influence. For in modern usage the word religion
> denotes merely one department of human activity, now regarded as of less and
> less public importance, and belonging almost entirely to the realm of men's pri-
> vate affairs. But whatever else Buddhism is or is not, in Asia it is a great social
> and cultural tradition. *(Ling, p. 15)*

Although Buddhism ultimately evolved a pantheon of deities as varied and extensive as
that of the Hindus, and probably much more so than those of ancient Greece and Egypt,
throughout its course of development the concept of "the Buddha" remained centrally
important. In this exhibition, we will concentrate primarily on Buddha Sakyamuni—so

aptly described by Sir Edwin Arnold as The Light of Asia—and on the profound influence of his image in the visual arts. It is our hope that the examination of the over one hundred ninety exhibited images of the Buddha and his life, executed within a variety of periods and cultural contexts, will in turn provide some sense of the complexity and significance of the system of thought that engendered these remarkable works of art.

While the historical existence of the Buddha is generally accepted, our knowledge of the most rudimentary details of his life remains sketchy. At the time when his first biographies were being compiled, probably around the third century B.C., the facts of his life had already become interwoven with, and often overshadowed by, myths and legends. Thus, despite the fact that, unlike Christ, Sakyamuni had never asserted his own divinity, he was considered a divine and transcendental figure even before the beginning of the Christian Era. To the faithful, everything that was written concerning the Buddha, no matter how incredible it may appear to us, was accepted as true; and it is not possible at this point in time to separate the kernel of fact from the husk of legend. Rather, through an examination of the artworks assembled here, we will endeavor to present Buddha Sakyamuni, the man and the god, as interpreted by unknown and unsung Asian artists throughout the centuries.

In India, the country of its origin, Buddhism had become nearly extinct by about the twelfth century A.D. Before this date, however, it served as a major cultural force throughout East and Southeast Asia. Even after the twelfth century, it continued to be influential in most Asian countries, including Sri Lanka, Burma, Nepal, Tibet, Afghanistan, China, Mongolia, Korea, Laos, Vietnam, Cambodia, Thailand, and Indonesia, which together comprise nearly two-thirds of the world's population. Indeed, without Buddhism, the artistic traditions of most of these countries would have been much the poorer and in some instances almost nonexistent.

Although the basic ideas and forms of Buddhist art originated in India, each nation or ethnic group ultimately interpreted Indian models to suit its own religious and aesthetic requirements. Thus, notwithstanding the basically conservative nature of the religious tradition, iconographic and stylistic variations are often dramatic and frequently bewildering. Although it is not possible to represent all traditions and styles within a single exhibition, the selection presented here should make it abundantly clear to the viewer that Buddhist art objects not only demonstrate the diversity of ethnic and national artistic traditions, but also reveal the psychological and religious differences characteristic of various groups of practitioners. These idiosyncrasies are discussed at length in the essays in the third section of this catalogue and in the entries concerning the individual artworks, but one or two general observations made here will establish the point.

In China, Japan, and Korea, the cult of Sakyamuni was probably eclipsed, although not totally displaced, by that of Amida Buddha (one of the transcendental and cosmic Buddhas; see the essay in the fourth section of the catalogue for further discussion of this concept). As a result, a distinct sect known as the Pure Land school developed in these countries, although there is little evidence of the existence of such a school in India itself. Certain texts such as the *Avatamsaka* or the *Saddharmapundarika* (*The Lotus of the True Law*, commonly known as *The Lotus Sutra*) also enjoyed far greater popularity in China than they did in India. Chan, or Zen, Buddhism is another example of a school that was founded in China and spread to Korea and Japan, but was unknown in India. Its founder, ironically, was an Indian monk named Bodhidharma (active late 5th–early 6th century).

Such conceptual and doctrinal variations, as well as differences in emphasis, often resulted in the expression of significant national artistic differences. Chan and Zen Buddhists, for example, developed a distinctive image of a bearded and ascetic Sakyamuni (nos. 40–43). Even though a few divine traits are still recognizable in such portrayals, the emphasis is on depicting the essential humanity of Buddha Sakyamuni, in keeping with Zen attitudes. The purpose of such "realistic," as opposed to "idealized," portraits was to reestablish the eminence of the historical Buddha "after his eclipse by the vast pantheon of deities of Esoterism and by transhistorical Buddhas such as Amitabha" (Rosenfield and ten Grotenhuis, p. 168). The concept of the gaunt, ascetic Buddha was not unknown in India and ancient Gandhara (part of present-day Pakistan and Afghanistan) where artists invented a type of emaciated image that was at once graphic and majestically hieratic (see no. 39). The Chan and Zen painters, however, depicted the ascetic Sakyamuni descending from the mountains. No such landscape figures in Sakyamuni's biography, and the East Asian version was probably influenced by the practice of Daoist teachers who sought out mountainous retreats.

Similarly, only in China and Japan (and to a lesser extent Korea) do we frequently find small bronzes representing the infant Buddha (nos. 26–28). A special cult of the baby Buddha appears to have developed in these countries, and the ceremonies involving such images are still observed in Japan during the annual celebrations of Sakyamuni's birthday in April or May. These bronzes are ceremonially bathed to reenact the first lustration of Siddhartha (the Buddha's given name), a ritual to my knowledge not performed in any other country. Furthermore, although large images representing the Death of the Buddha are known in most Buddhist countries, only in China and Japan (and especially in the latter country) do we find a special importance given to this theme in paintings (nos. 64 and 66). While the Japanese were particularly fond of emphasizing the poignancy and grief of this occasion, the artists of Sri Lanka preferred to show the Master alive and awake, almost as if he were relaxing after a big meal, as Indians and Sinhalese are apt to do in the afternoon (no. 65).

Other countries also introduced novel iconographic deviations reflecting local or regional religious or mythological concepts; some of these were unknown in India and others were syncretic in origin. For instance, the Dvaravati artists of ancient Thailand preferred to show their standing Buddhas with both hands raised symmetrically at chest level and displaying the teaching gesture (no. 102a). No Indian precedent for this iconographic variation has been found. The same group of artists also originated an image curiously known as *Vanaspati* (Lord of the Forest), which portrays the Buddha and two attendants astride a mythical, birdlike creature (no. 150). This particular portrayal only remained popular in the region between the seventh and the tenth centuries and has no parallel elsewhere. A satisfactory interpretation of this intriguing theme still remains elusive. In later Thai Buddhist art, one of the most popular representations shows the Buddha in the act of walking and hence has come to be known as the "walking Buddha" (no. 120). Although suggestions are made in this catalogue of a possible Indian connection, this latter image remains a hallmark of the Buddhist art of Thailand.

In neighboring Cambodia, interesting conceptual innovations were introduced during the reign of the powerful Jayavarman VII (1181–1219?), the most pious Buddhist king Cambodia has ever known. Jayavarman VII took a particular fancy to the story of Buddha Sakyamuni being sheltered by the serpent Muchalinda (see no. 50), and he introduced a Buddha Muchalinda cult that remained popular in the region for some time. Continuing the general practice of Cambodian

monarchs and the prevailing cult of the *Devaraja* (Divine King), he even had statues made of himself in the likeness of the Buddha.

The island state of Java, which is now part of Indonesia, seems not to have created any new genre of Buddha image, although the Barabudur—an immense and structurally complex monument covered with striking bas-reliefs—remains, along with the Great Stupa at Sanchi in India, one of the most impressive Buddhist monuments ever raised. Furthermore, the Barabudur is an important example of the idiosyncratic development of Javanese Buddhism, and modern scholars continue to debate its exact significance. Rather peculiar syncretic attitudes existed in Java, especially between Buddhism and Sivaism (one of the Hindu religious systems introduced from India), but these did not affect the Buddha image in any significant way. The catholic attitude that prevailed during the rule of the famous Sailendra dynasty (8th–9th century) is best illustrated by epigraphical evidence. In an inscription written in 784, the three major Hindu deities—Brahma, Vishnu, and Siva—are identified with the Buddhist deity Manjusri, while in a ninth-century inscription a Buddhist image is said to be an "embodiment of all forms of religion" (Sarkar, vol. 1, pp. 45 and 48).

Apart from such interesting iconographic variations, there are obvious ethnic and aesthetic differences among Buddha images. The sanctity of the image of the Buddha notwithstanding, the artists of the different Asian regions created an astonishing variety of images that should appeal to virtually all tastes and proclivities. Western classicists should find the Gandhara Buddha with its naturalistic modeling especially appealing (nos. 74, 76, and 77), while those familiar with Romanesque art will easily appreciate the noble austerity and linear elegance of some of the early Chinese Buddha images (nos. 21 and 176). Others may be attracted by the sensuous charms of the Indian Gupta Buddhas (nos. 83–85) or those produced by the sculptors of the Dvaravati Kingdom in Thailand (nos. 102 and 103). Still others will doubtless be moved by the serene grandeur of the Buddhas of Sri Lanka (nos. 89 and 101), while some will find the lively folk qualities of the late Buddhas from Korea refreshing (nos. 123 and 126).

The exhibition further establishes that although the ultimate models for images of Buddha Sakyamuni were of Indian origin, there was considerable intermingling of ideas and stylistic influences. Thus, Chinese images exerted a notable influence upon those of Korea which, in turn, served as models for Japanese Buddhist icons. Similarly, figures from Sri Lanka played a key role in the development of Buddha images throughout much of Southeast Asia. And certainly the two Himalayan regions of Nepal and Tibet freely borrowed artistic ideas and forms from one another. There was a lively exchange of concepts and aesthetics among the various kingdoms that flourished in ancient Cambodia, Thailand, and the Malay Peninsula, which often makes the modern art historian's attempts to determine a precise point of origin extremely difficult. It is also probable that both iconographic and stylistic traits from China infiltrated into Southeast Asia and the northwestern regions of the Indian subcontinent, although these influences have not been fully explored. An unusual fifteenth-century Persian representation of the "resurrection" of Sakyamuni may represent just such an exchange (no. 12b). In the Indian textual tradition Sakyamuni was cremated after his Death and his ashes distributed among the various tribes and races who venerated him; there is no mention of his reappearance in any form. The story of Sakyamuni's "resurrection" and his final sermon before his mother, however, does occur in the Chinese tradition, as Alexander Soper has shown (1959b, pp. 159–69), and it is likely that the Islamic historian was familiar with the Chinese version of Sakyamuni's life. Clearly the world of the early Bud-

dhists was not as cluttered with passports and visas as ours is today, and both religious and artistic ideas moved about from one country to another with relative freedom and ease.

Regardless of their style and aesthetic intent and irrespective of where and when they were created, the Buddha images included in this exhibition share one common feature: they are the products of an intense faith that transcended political, cultural, and ethnic barriers. It is important to bear in mind that what we consider an "artwork" to be displayed in the necessarily artificial environment of a museum was once a vital source of hope and spiritual nourishment for the rich as well as the poor, for the conqueror as well as the conquered.

Buddhism may no longer be the powerful civilizing force that it once was in Asia, but the basic message of the Buddha is as valid today as it was during his lifetime. Life's uncertainties and sufferings, as well as the inevitability of death, are no less real for us than they were for the Buddha. Indeed, his teachings are so simple and universal that they should offend no one:
>Words do not matter; what matters is Dhamma [religion],
>What matters is action rightly performed,
>after lust, hate, and folly are abandoned,
>with true knowledge and serene mind,
>and complete detachment from the fruit of action.
>
>(Lal, p. 42)

Pratapaditya Pal

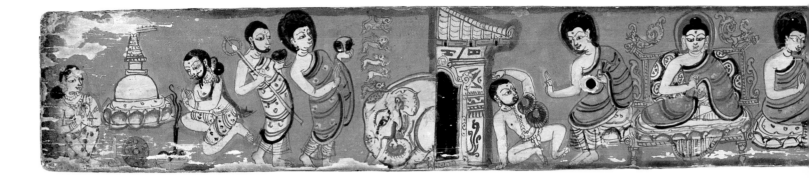

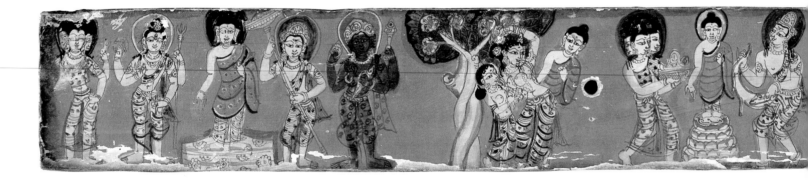

cat. no. 8

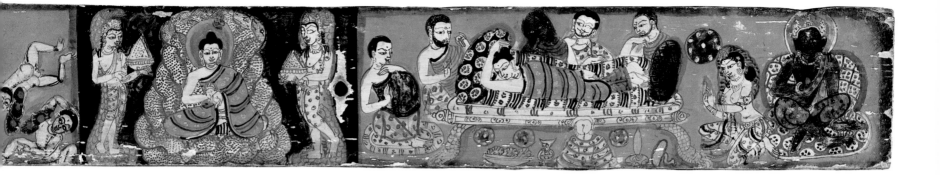

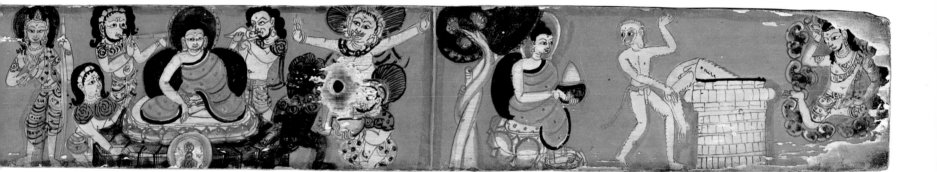

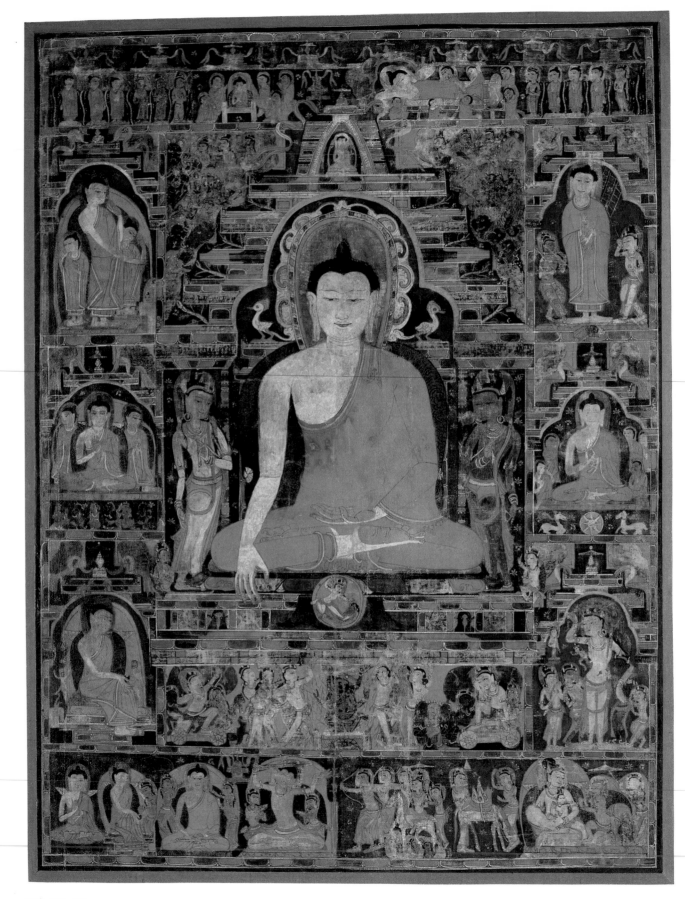

cat. no. 11

24

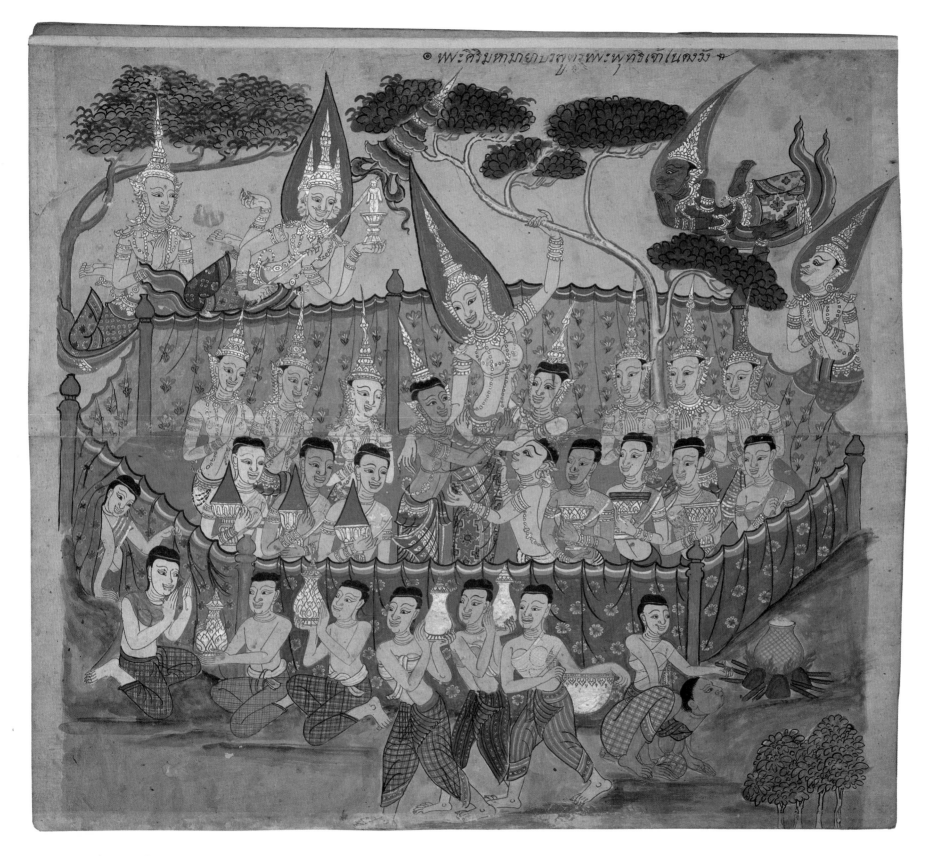

พะศรีมหามายาบรลุดรพะพุทธิเจ้าในดงวัง ๚

cat. no. 15 (scene a)

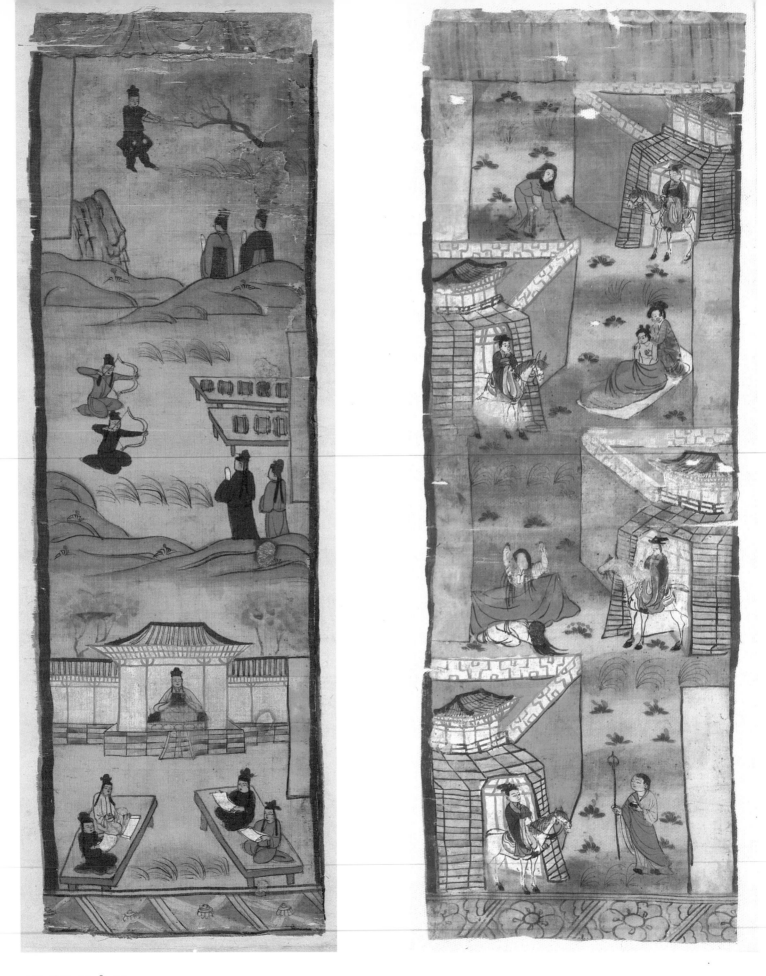

cat. nos. 32 & 34

26

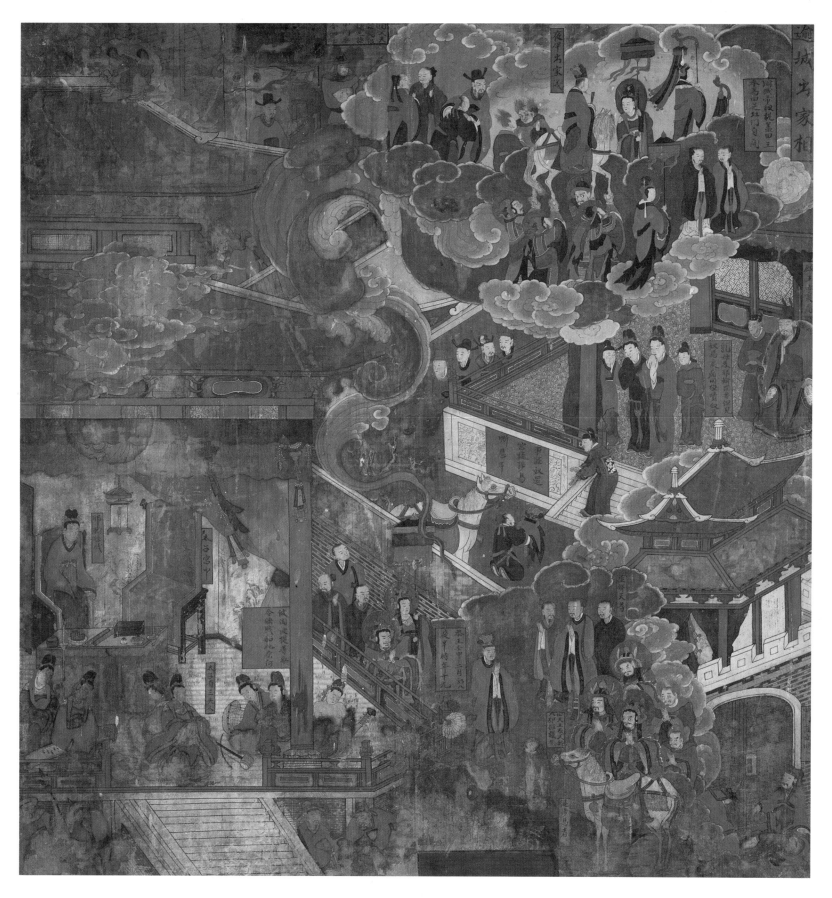

cat. no. 37

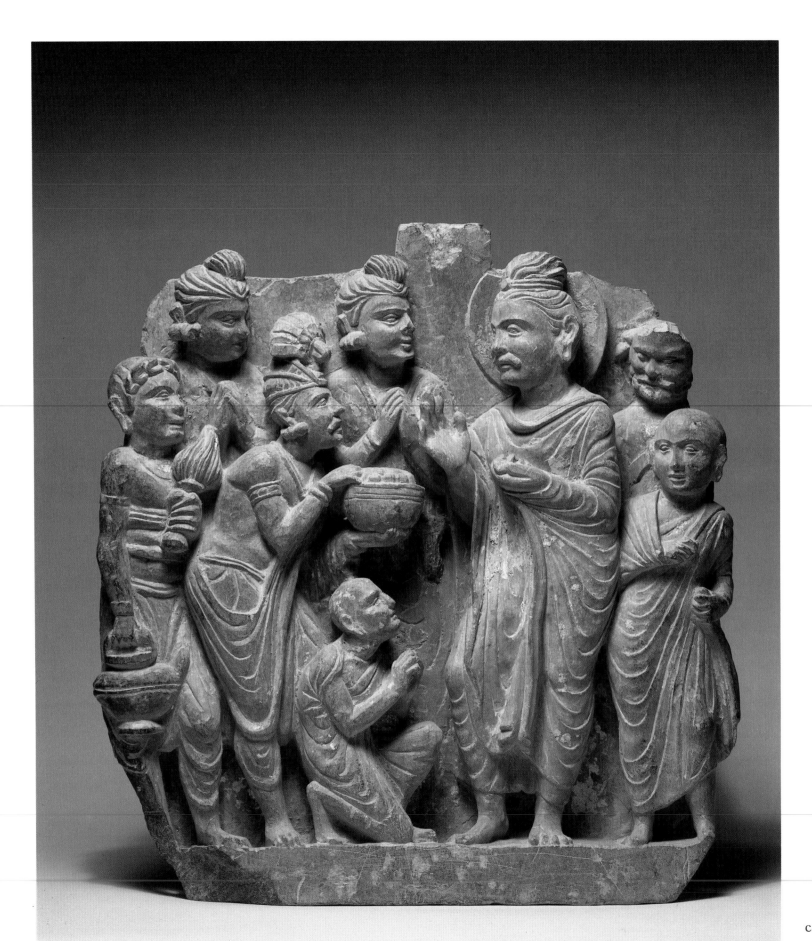

cat. no. 57

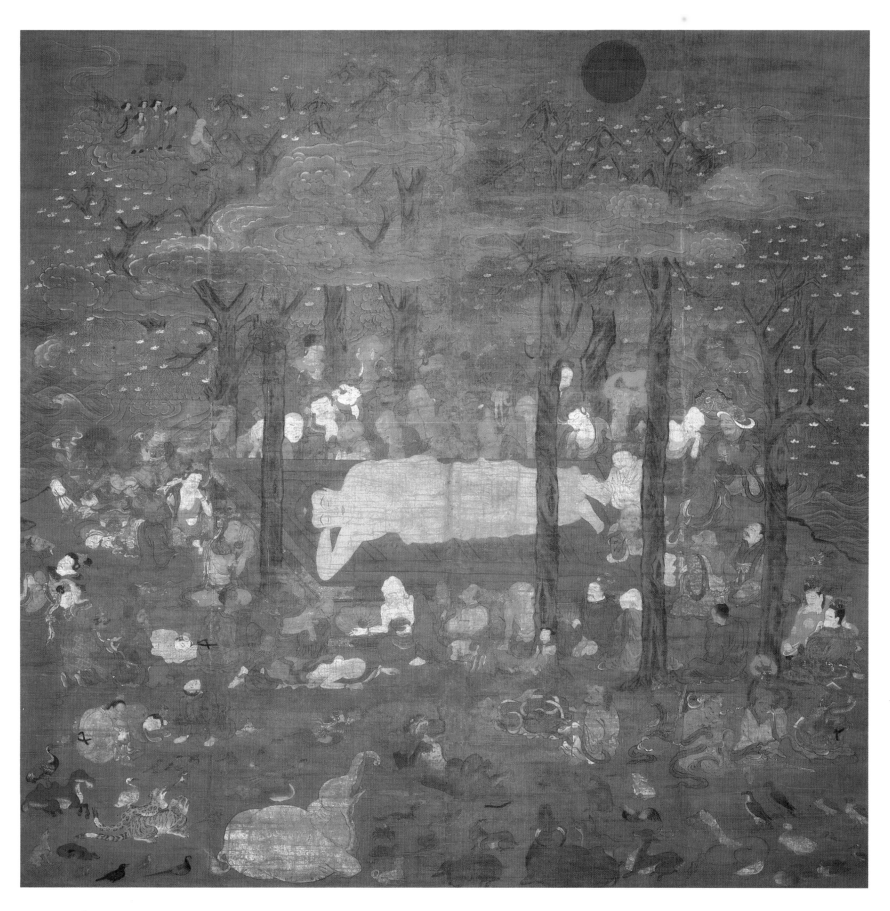

cat. no. 64b

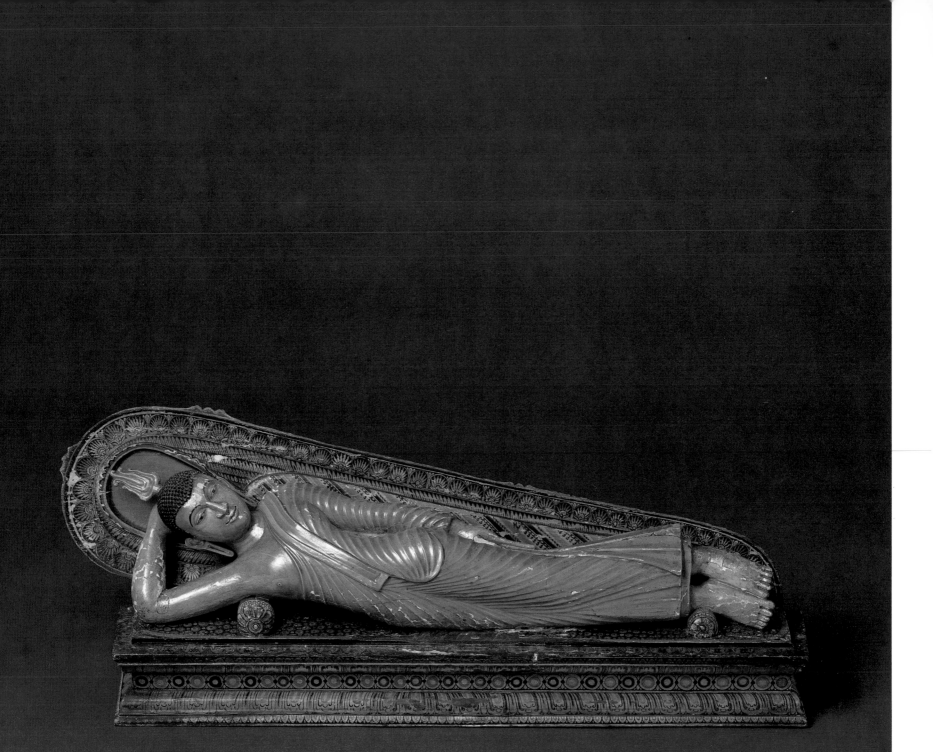

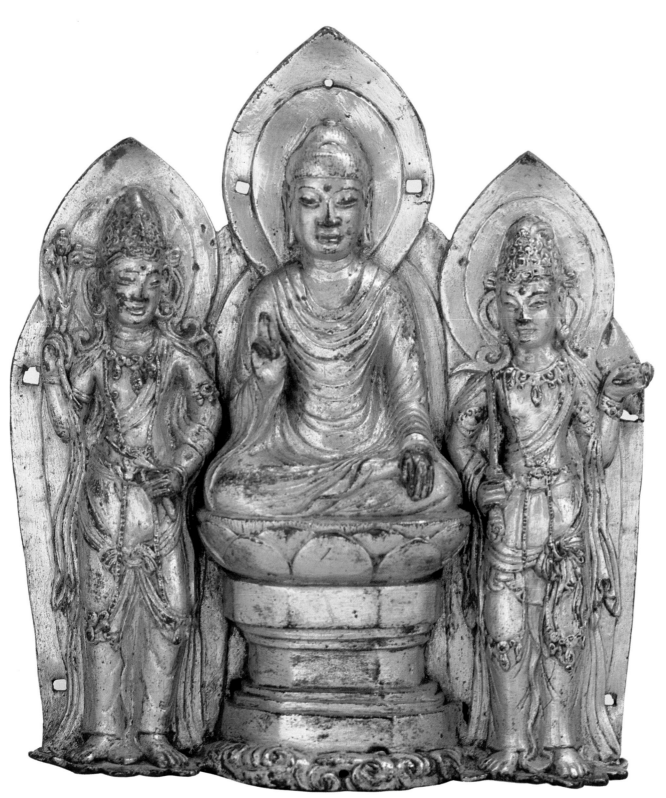

cat. no. 65

cat. no. 111

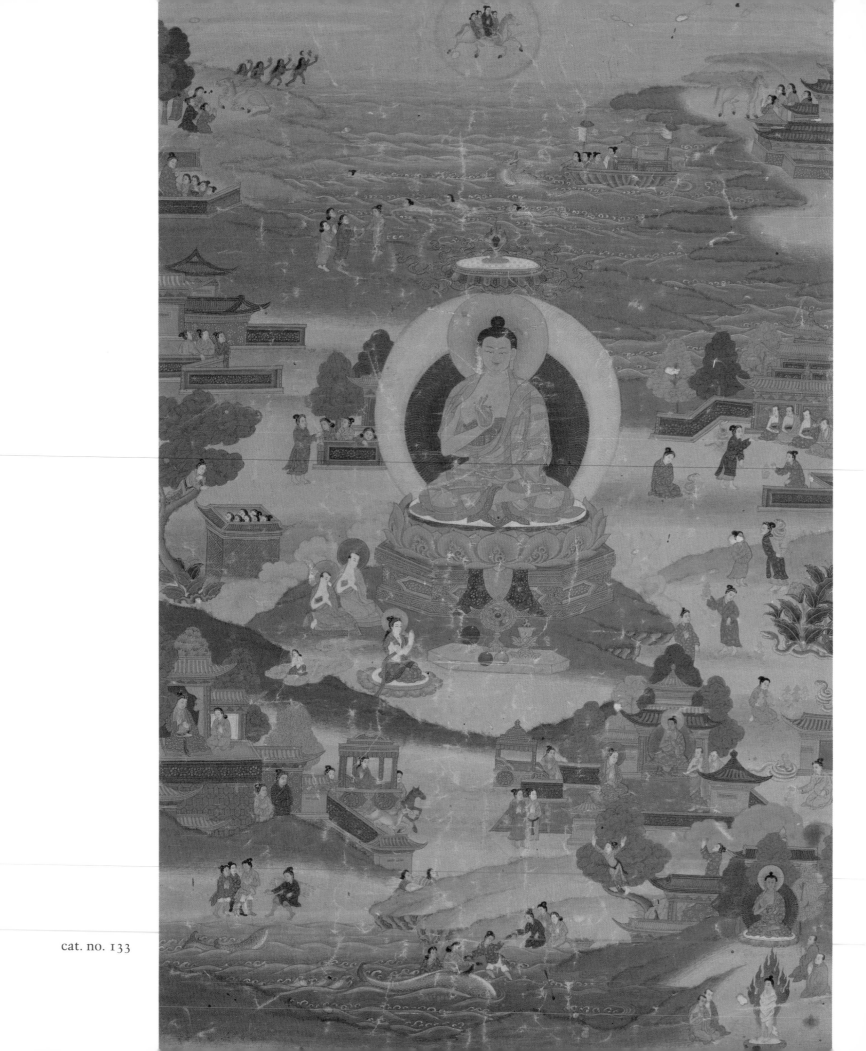

cat. no. 133

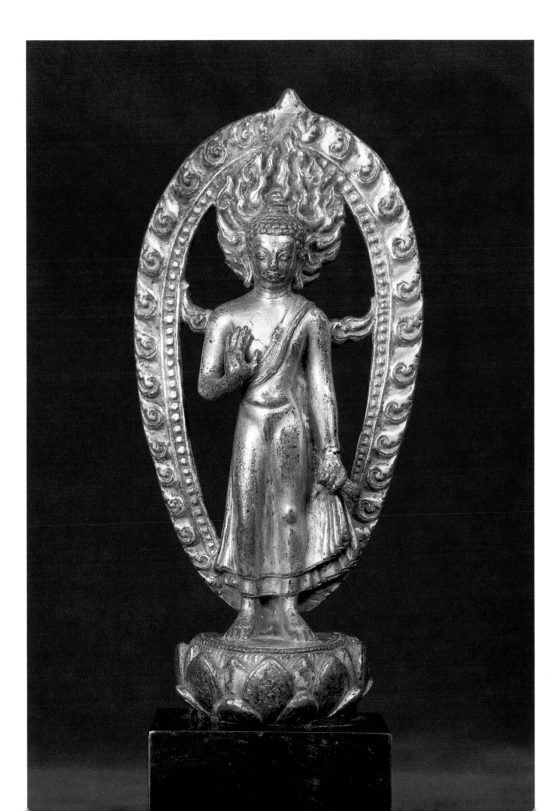

cat. no. 136

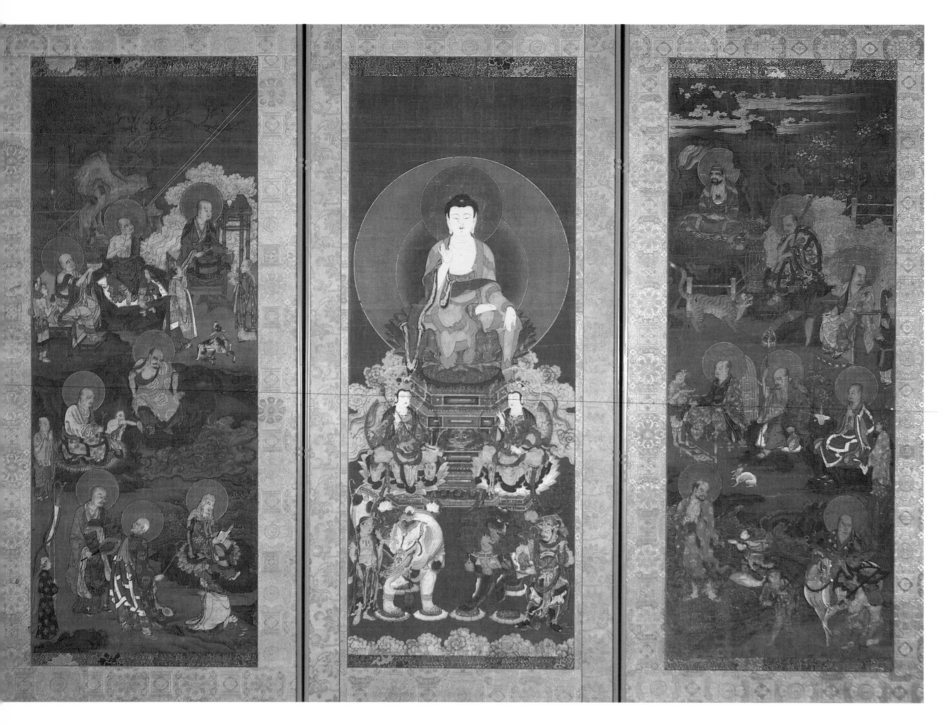

cat. no. 144

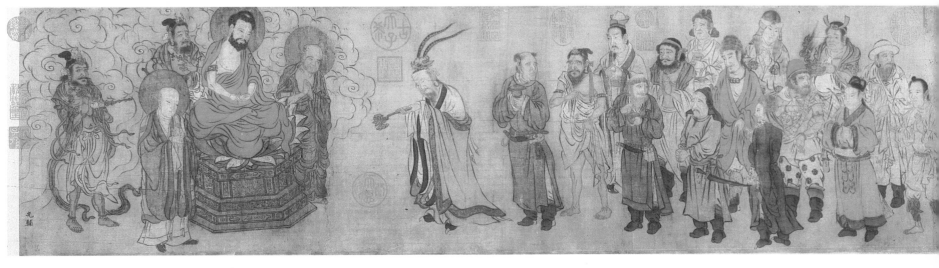

cat. no. 152

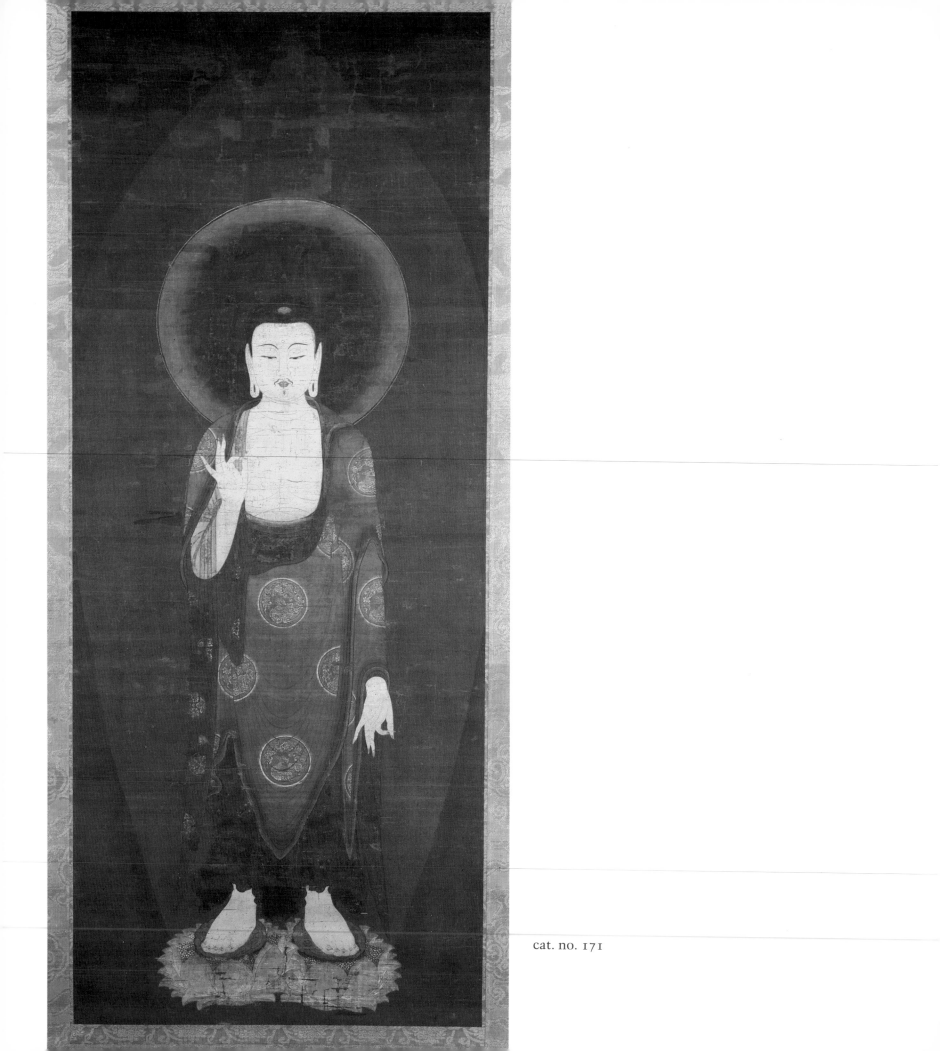

cat. no. 171

I THE LEGENDARY LIFE OF BUDDHA SAKYAMUNI

I am not a Brahmin, rajah's son or merchant; nor am I any what; I fare in the world a sage, of nothing, homeless, self completely gone out—it is inept to ask me of my lineage. (Conze et al., p. 105)

A BRIEF ACCOUNT OF THE BUDDHA'S LIFE

Despite the Buddha's assertion that it is "inept" to demand the details of his past, as well as a basic Buddhist tenet that denies the existence of the self, events both mundane and miraculous from the life of Sakyamuni are the frequent subjects of Buddhist literature and art. It is important to note, however, that no single authoritative version of Sakyamuni's life exists. His story has been related so frequently and in such a variety of historical and cultural contexts that differing accounts have naturally resulted.

Four of the numerous occurrences in the Buddha's long life—the Birth, Enlightenment, First Sermon, and Entry into *Mahaparinirvana*—are of primary importance, and they have been represented in a variety of media in nearly all Buddhist countries. According to tradition, the Buddha himself declared the preeminence of these four episodes in his last discourse to his disciples. As art historian A. K. Coomaraswamy has written:

> And the Master made mention of four places that should be visited by the clans-
> men with feelings of reverence—the place where the Tathagata [Predestined
> One] was born, the place where he attained Supreme Enlightenment, the place
> where the kingdom of righteousness was established, and the place where the
> Tathagata utterly passed away: "And they Ananda, who shall die while they,
> with believing heart, are journeying on such a pilgrimage, shall be reborn after
> death, when the body shall dissolve, in the happy realms of heaven."
> *(Coomaraswamy, 1964, p. 82)*

The idea of pilgrimage was undoubtedly a significant motivation for the choice of these particular occurrences, and the importance of this concept to Buddhism will be discussed later. At present, however, we will concern ourselves with an examination of the four principal events and the artworks they inspired.

The Birth and Early Life

BUDDHA SAKYAMUNI, a member of the Gautama clan and the ancient Sakya tribe, was born in the grove of Lumbini in the Himalayan foothills of present-day Nepal. His birthplace was not far from Kapilavastu, the capital of the Sakyas, and his father, Suddhodhana, was the tribal chief. The Sakyan state was rather small and thrived on both trade and agriculture. It was also one of the several tribes in the region with an oligarchic form of government; although it is possible that by the time of Sakyamuni's Birth, about 563 B.C., the chieftaincy had become hereditary, and Suddhodhana would therefore have been regarded as the *raja* (ruler). Two of the epithets commonly used in describing the Buddha—Sakyamuni (Sage of the Sakyas) and Sakyasimha (Lion of the Sakyas)—incorporate a reference to his tribal affiliation.

Both the conception and the Birth of Buddha Sakyamuni were miraculous. As was the case with the conception of Christ, that of Sakyamuni was not tainted by any conjugal relationship between his father and his mother, Maya. Rather, one day Maya dreamt that a divine elephant with six tusks had entered her womb, and following this dream, she discovered that she was pregnant. In this manner, the Buddha, who was then a bodhisattva (one striving toward enlightenment), descended from his heavenly abode to fulfill his destiny on earth.

As Maya's time to deliver her baby drew near, she went into a grove that housed an ancient shrine devoted to the mother goddess, Lumbini, or Rumminidevi. It was there, standing below a flowering *sala* tree, a branch of which she clung to for support, that Maya gave birth. (The motif of a woman and a tree is common in earlier Indian art and has remained an abiding symbol of fertility and abundance.) Miraculously, the Buddha emerged from his mother's right hip. In this context, the description of the Birth offered by the first-century Indian poet Asvaghosha in his *Buddhacharita (Life of the Buddha)* is interesting; he justifies the miraculous delivery by citing earlier instances in which universal monarchs were presumed to have been born in equally unusual fashions:

> Then as soon as [the constellation] Puṣya became propitious, from the side of the queen [Māyā], who was hallowed by her vows, a son was born for the weal of the world, without her suffering either pain or illness. As was the birth of Aurava from the thigh, of Prthu from the hand, of Mandhatṛ, the peer of Indra, from the head, of Kakṣivat from the armpit, on such wise was his birth. *(Johnston, p. 3)*

Maya's sister Mahaprajapati is often portrayed as present at this auspicious event (no. 23), as are several of the gods who were worshiped at the time. The various Buddhist texts provide differing accounts of just what gods were in attendance at the Buddha's Birth. Indra, the king of the gods, is often mentioned in this context (see nos. 1, 2, and 22), and some texts mention Brahma as well (see no. 23):

> [The Bodhisattva] appeared, at the end of ten full months, out of his mother's right side, in possession of memory and knowledge, unsullied by the impurity of the mother's

womb. At the same moment came Cakra [Indra], the king of the gods, and Brahmā Sahāpati and stood before him. With the greatest respect they received the Bodhisattva in a divine Kāshika-garment [silken garment], recognizing him in all his limbs and parts of his body, and knowing him. *(Krom, p. 31)*

The newborn baby was received and bathed by the attendant gods. Although accounts of this first bath differ in the various texts, it is generally believed that two streams of water flowed forth from the sky, refreshing both the infant and his mother. Immediately after this, the child took seven steps to proclaim his spiritual sovereignty and cosmic nature (nos. 25–29). The number seven is significant: in ancient Indian cosmology it was believed that the world was made up of seven continents.

Following his lustration, the child was taken to his father's palace, where, according to custom, he was presented to the royal guru and astrologers. The guru, a venerable sage named Asita, predicted that the boy would grow up to become a Buddha and lamented the fact that his own advanced age would prevent him from witnessing this event. It was also at this time that the child was given the name Siddhartha.

A week after the Birth of her son, Maya died from her excessive joy and went straight to heaven. Siddhartha was not left unattended, however, as Suddhodhana had other wives, one of whom was Maya's sister Mahaprajapati. The boy grew up among half brothers and cousins and was never lonely or in any way neglected. On the contrary, he was pampered and constantly surrounded by luxury (no. 30). Suddhodhana, however, was extremely disturbed by Asita's prediction and the thought of losing his son and heir. He therefore determined at all costs to protect Siddhartha from any contact with the unpleasantness of the real world, which might prompt him to pursue a course of renunciation leading to Buddhahood.

The boy was educated in the traditional manner befitting a nobleman's son, but special emphasis was given to the martial arts, in which he excelled (nos. 31 and 32). During his youth he was sheltered from any exposure to poverty, squalor, death, or disease, and every attention was given to his comfort. When he became a young man, he was married to his beautiful cousin Yasodhara, who later bore him a son named Rahula. For some years after his marriage Siddhartha led a fairly normal life with the exception of one experience that prefigured his unusual destiny. On a warm day, Siddhartha, saddened by the sight of farmers toiling in the midday sun, sat under a *jambu* (rose apple) tree near the fields. There he entered into a trance and became oblivious to his surroundings. Curiously, during the lengthy period while he sat meditating, the shadows of adjacent trees followed their normal courses of movement while that of the *jambu* remained stationary (no. 33). Everyone present marveled at this wonderful sight, and Siddhartha recognized in the trance a sign that he must renounce his life at the palace and go forth in search of the truth.

The news of this occurrence caused Suddhodhana to redouble his efforts to keep his son distracted but to no avail. Soon after this experience, Siddhartha made four successive trips outside the palace and on each encountered a different figure: an old man, a sick man, a corpse, and a wandering monk (no. 34). Greatly troubled by the first three meetings, he found comfort and inspiration in the calm presence of the monk. The latter's serenity suggested to him the correct path to take in order to escape the endless cycle of rebirth and the miseries of terrestrial existence. That night Siddhartha resolved to leave his home.

Soon after midnight, Siddhartha, who was then twenty-nine years old, summoned his favorite horse, Kanthaka, and along with his trusted groom, Chandaka, left Kapilavastu, resolving not to return until he had achieved his goal of enlightenment. The prince's escape was aided by the gods, who caused all the inhabitants of the city to sleep and appointed four *yakshas* (nature deities) to muffle the sound of Kanthaka's hooves. A safe distance away from the city, Siddhartha dismounted and gave all his ornaments to Chandaka. Then, taking his sword, he cut off most of his hair (no. 38). After a touching farewell, the faithful servant and horse were sent back to Kapilavastu, and Siddhartha was on his way to enlightenment.

The Enlightenment Cycle

SINCE THE NAME *Buddha* means "Enlightened One," it is not surprising that the events leading to Sakyamuni's Enlightenment *(Bodhi)* at Gaya—or Bodhgaya, as it came to be known after this momentous event—have remained of primary importance for both biographers and artists. It should be noted, however, that there are many accounts of Sakyamuni's trials during this period and that these narratives often vary significantly both in content and chronology.

Following his departure from home, Siddhartha, donning the yellow robes of a mendicant, roamed from village to town, along riverbanks and through forests, and from one master to another in his search for enlightenment. During his travels he acquired five ascetic companions. Several texts recount a six-year period of meditation that took place soon after Sakyamuni's disappointing encounter with Arada Kalama, a leading teacher of the time. In the *Buddhacharita*, Asvaghosha describes this lengthy period of meditation thus:

> Carrying out many kinds of fasting that were difficult for a man to perform, for six years
> in his desire for quietude he made his body emaciated.
> Yearning to reach the further shore of the cycle of transmigration whose further shore is
> unbounded, he lived by taking at mealtimes a single jujube fruit, sesamum seed and
> grain of rice.
> Whatever his body lost by reason of these austerities, just so much was made good again
> through his psychic power.
> Emaciated as he was, yet with his glory and majesty unimpaired, he was a source of joy
> to the eyes of others, as the moon in autumn at the beginning of the bright fortnight is
> to the night lotuses.

> *(Johnston, p. 183)*

The meditation and attendant austerities were particularly popular subjects with the sculptors of Gandhara (no. 39), but they were only occasionally represented in later Indian and Nepali art (nos. 7 and 9). The Buddha's subsequent renunciation of such extreme forms of penance as a means of attaining salvation perhaps explains the general lack of popularity that this theme had with Indian artists. The idea of the emaciated Sakyamuni had special appeal for the Chan and Zen Buddhists of China and Japan, however, because they emphasized the importance of solitary meditation. As a result, the Chinese and Japanese devised a type of painting depicting a lean and gaunt Sakyamuni with overgrown hair and beard coming down from the mountains after meditating and fasting (nos. 40 and 41). This type of painting is commonly known by its Japanese name,

Shussan Shaka (Sakyamuni Coming Down the Mountain), and the choice of a mountainous locale seems unique to Chan, or Zen, Buddhism.

Dissatisfied with his severe austerities, Sakyamuni ultimately broke his fast and accepted some rice cooked in milk, which was offered to him by a girl named Sujata. This annoyed his five ascetic companions, who regarded the termination of his fasting as a sign of weakness and therefore abandoned him. Undaunted, Siddhartha proceeded alone to the city of Gaya on the bank of the Nairanjana River. Somehow he perceived that his Enlightenment was near, and after bathing in the river he encountered a grasscutter from whom he procured some grass. He spread the cut grass on a rock below an *asvattha* (pipal) tree and then sat down to meditate once again.

Just as Christ was tempted by Satan, so was Sakyamuni tempted during this meditation by Mara, the Buddhist god of desire (nos. 44–49). Alarmed by the possibility of Siddhartha achieving enlightenment, Mara arrived with his seductive daughters and a host of demons. Relentlessly they tried to dissuade Sakyamuni from his intent, alternately attempting to seduce him with sensual pleasures and to physically assault him. Mara unleashed nine storms of wind, rain, rocks, weapons, live coals, hot ashes, sand, mud, and darkness. When these assaults proved unable to unseat the future Buddha, Mara commanded his army to destroy Sakyamuni, but to no avail. Through his determination, Sakyamuni rebuffed Mara and his army, and finding himself alone, he called upon the Earth to witness his victory by drawing his right arm from beneath his ascetic's robe and stretching it forth to touch the ground: "And the mighty earth thundered, 'I bear you witness!' with a hundred, a thousand, a hundred thousand roars, as if to overwhelm the army of Mara" (Stryk, p. 41).

After the Enlightenment, Siddhartha, who was now properly called the Buddha, continued to meditate in various postures for several weeks. During this time he was lashed by a severe storm, and it was on this occasion that the serpent king Muchalinda protected him. "Seven times he [Muchalinda] coiled himself around the Buddha, and he spread his hood above the Buddha's head to shelter him. And thus the Buddha suffered not at all during this period of bad weather" (Herold, p. 107). This charitable act was performed in return for a favor that Muchalinda had received from the Buddha in a former life, and in some regions it became the focus of an individual cult (see no. 50).

The First Sermon

IT APPEARS THAT AFTER the Enlightenment the Buddha was hesitant to spread his message. Once more, however, the gods intervened in his life, persuading him to undertake the task. Brahma in particular exhorted:

> Rise up! Beat the drums, sound the gong! Let the law blaze like a burning torch, or like refreshing rain, let it fall upon the parched earth. Deliver those who are tormented by evil; bring peace to those consumed by a vicious fire! You, who are like a star among men, you alone can destroy birth and death. *(Herold, pp. 112–13)*

For the site of his First Sermon, Sakyamuni selected the Deer Park at Sarnath near the ancient city of Banaras, or Kasi (no. 51). The choice of locale must have been deliberate, for this city was

the most important center of learning in the country. (It remained so until the British period of Indian history.) While at the Deer Park, the Buddha encountered the five ascetic companions who had abandoned him during the Enlightenment Cycle, and they constituted the audience of his First Sermon, becoming his first disciples as well. In the First Sermon, the Buddha expounded the doctrine of the Middle Way between the two extremes of self-mortification and self-indulgence. He taught that the cause of all human suffering was appetitive desire, which must be extinguished in order to gain liberation. One might achieve this goal by following the Eightfold Path: right views, right aspirations, right speech, conduct, and mode of livelihood, right effort, right mindfulness, and right rapture.

From the time of this initial sermon up until his Death at the age of eighty, the Buddha traveled, primarily in the Gangetic valley, converting monks and nuns and founding monasteries. He was especially active in large cities, notably Sravasti, Vaisali, and Rajagriha, all of which were centers of expanding capitalist states. Of these, Rajagriha—the capital of Magadha, an ancient kingdom located south of the Ganges that comprises present-day Bihar—was most important. Within two centuries of the Buddha's Death, Magadha was to become the first great empire on the Indian subcontinent. Bimbisara, the king of Magadha, was especially devoted to the Buddha, as were many other important monarchs in the region, among them Udayana of Kausambi (present-day Kosam) (see nos. 54 and 55). Indeed, in addition to his importance and success as a religious leader, the Buddha must have been politically very astute, as he befriended many of the important rulers and wealthy merchants of his time. The merchant Anathapindada became one of the Buddha's best-known supporters and built a lavish Buddhist monastery in the city of Sravasti, which he richly endowed (no. 57).

After gaining considerable renown, the Buddha returned to his birthplace near Kapilavastu and preached to the Sakyas, including his father, Suddhodhana. He admitted his son Rahula into his monastic order, and he also ordained Ananda, a childhood friend, who became one of his chief disciples. The Buddha's stepmother, Mahaprajapati, sought to join the order as well, but as a woman she was initially refused admission. The Buddha remained adamant on this point for some time, but he finally relented due to the persistence of both Mahaprajapati and Ananda. Nanda, one of the Buddha's cousins, also became his faithful follower; but another cousin, Devadatta, proved to be a continuous source of trouble. As a child, Devadatta had always been jealous of Siddhartha, and after the Master became famous, he made repeated attempts to destroy him. It was Devadatta who turned Ajatasatru, Bimbisara's successor to the throne of Magadha, against the Buddha. As a result, the followers of the Buddha in Magadha may have been harassed for a period of time. Ajatasatru was eventually able to shake off Devadatta's pernicious influence, however, whereupon he, too, became a devout follower of the Buddha.

The Entry into Mahaparinirvana

THE DEATH OF THE BUDDHA is known commonly as the *Mahaparinirvana* (that which follows the great nirvana). In a sense the Buddha had achieved nirvana (the extinction of all desires) at the moment of his Enlightenment at Bodhgaya. His physical Death, however, symbolizes his complete freedom from the cycle of rebirth.

The passing away of the Master was considered so significant that an entire text, the *Mahaparinirvanasutra,* was devoted to this event alone. Briefly, the Death came about in the following manner: At the age of eighty, the Buddha resolved to die at a place called Kusinagara (present-day Kusinara) in the state of the Malla tribe. The Mallas were a neighboring tribe of the Sakyas and were closely united with them by kinship ties. The Buddha proceeded, along with his disciples, from Rajagriha to this final destination. En route, at Pava, he ate a meal in the house of Chunda the smith, consuming some meat (or mushrooms, according to a recent theory), and he was subsequently taken ill. He then bathed in a river near Kusinagara and went into a grove and lay down on a couch that had been hastily prepared by his disciples under a pair of stately *sala* trees. There, surrounded by Ananda and those of his disciples who were closest to him, the Master went into four trances and ultimately passed into the final nirvana. Just as he had been born in a grove below a *sala* tree, so he died.

The Buddha's selection of the obscure Kusinagara, rather than one of the major cities in which he had comfortable monasteries, cannot have been accidental. The Buddha was doubtless a champion of democratic principles and yet, during his lifetime, the tribal way of existence he so admired was being eroded by the emergence of powerful and ambitious monarchies. His own Sakyas were devastated by the Kosala Kingdom, and the Magadha Empire was coveting the nearby Vajjian State. The tribal state of the Mallas, however, was still independent, and therefore the Buddha's selection of a village in the Malla territory can be seen as a final affirmation of his faith in a fast-disappearing way of life.

The Buddha's Death, like the moment of his Enlightenment, became the focal point of a cult in most countries where Buddhism came to be practiced. Similarly, the Crucifixion provided Christians with one of their most potent symbols. It became customary to enshrine enormous images of the recumbent Sakyamuni; these probably followed the model that was created at Kusinagara. Colossal images commemorating the *Mahaparinirvana* can be seen at Ajanta, India; Polonnaruwa, Sri Lanka; Nara, Japan; and Bangkok, Thailand. Some of these images measure as much as sixty feet in length. Apart from these large images, smaller sculptures and paintings were worshiped or used as ex-votos in temples. Examples from Sri Lanka and Japan are included here (nos. 64–66). Known as *Nehan* in Japan, the *Mahaparinirvana* theme remained especially popular in that country where, based on Chinese models, it was painted throughout centuries.

THE EIGHT GREAT MIRACLES

EIGHT EVENTS FROM BUDDHA Sakyamuni's life were traditionally isolated and regarded as "great" miracles. Greater significance was attributed to these miraculous events than to myriad others. The Eight Great Miracles were frequently represented as a distinct group in art, especially in Bihar in India and in Nepal (see nos. 5 and 69). Tibetan Buddhists disagreed with this list somewhat, believing in twelve, rather than eight, significant miracles. Despite variations of this sort, however, the four principal events—the Birth, Enlightenment, First Sermon, and Mahaparinirvana—figure in all such groupings.

The idea of pilgrimage was an important factor in the choice and emphasis of certain of the Buddha's miracles and hence the sites associated with them. An essential element of universal religions, pilgrimage has been successfully exploited as an affirmation of faith by Christianity and Islam, as well as Buddhism; certainly, Jerusalem has an appeal for the Christian and Mecca for the Muslim that is similar to that of Bodhgaya for the Buddhist.

Of the locales associated with the four principal events in the Buddha's life—Lumbini (the Birth), Gaya or Bodhgaya (the Enlightenment), Sarnath (the First Sermon), and Kusinagara or Kusinara (the Mahaparinirvana)—Gaya has remained the most important. Lumbini and Kusinagara never achieved the significance or popularity of Sarnath and Bodhgaya. This was no doubt due to the fact that the two former cities were situated considerably off the beaten track. On the other hand, Banaras, of which Sarnath is a suburb, and Gaya were celebrated as important pilgrimage and religious centers even before

their association with Buddhism, and they remain so today. Given the status conferred on these cities by their past associations, the selection of Gaya as the site of the Buddha's Enlightenment and of Sarnath as the site of his First Sermon was perhaps not altogether without design.

The cities of Sravasti, Sankisya, Rajagriha, and Vaisali are the sites of the remaining four miracles included in the most common list of eight. Of these, Sravasti, Rajagriha, and Vaisali would have had greater claims than some of the other likely candidates due to their political importance. Rajagriha and Sravasti were the capitals of Magadha and Kosala, two of the most powerful kingdoms of the Buddha's age. Moreover, the Jetavana monastery in Sravasti was the Buddha's favorite retreat (see no. 57). Vaisali, situated on the northern trade route, was the capital of the Licchavis and a wealthy commercial center. Like the Sakyas and the Mallas, the Licchavis were also a tribal people. Doubtless Vaisali's claims to a share of the Buddha's relics were as strong as any of the others, especially in view of the Buddha's own sympathies for the rapidly disappearing tribal form of government. The claim of Sankisya seems to have been the weakest of the four, both in political and economic terms. Although it was on the ancient highway leading from Taxila in the northwest to Banaras, Sankisya was certainly not as important as Mathura or Kanyakubja (present-day Kanauj).

Of the four secondary miracles within the group of eight, the miracle associated with Sravasti is by far the most complex. Not only are there diverse textual traditions describing this event, it appears that the Buddha actually performed several miracles on this one occasion. He is said to have instantly grown an enormous tree from a mango stone, to have walked in the air in various attitudes while alternately emitting flames and waves from the upper and lower parts of his body, and, finally, to have multiplied images of himself in all directions, thereby confounding the heretics and preaching the Law. It is generally the multiplication and the teaching that are emphasized in artistic representations (no. 53).

Soon after the performance of these wondrous acts at Sravasti, the Buddha ascended to the Trayastrimsa Heaven to preach the Law to his mother and to the gods. He stayed there several months and came back to earth down three ladders at Sankisya (no. 54). The Buddha's choice of Sankisya is not explained in any text, and this locale does not figure again in his life. Nevertheless, it was still an important pilgrimage site in the seventh century when the Chinese pilgrim Xuan Zang [Hsuan Tsang] (c. 596–664) visited it. This pious pilgrim has left us a description of the beautiful temple, which was skillfully decorated by artists and contained a magnificent image of the Buddha. Xuan Zang also saw the three ladders in the monastery, made of gold, crystal, and silver.

The remaining two miracles involve animals—a monkey and an elephant. Significantly, both creatures play an important role in the *jataka* (past-birth) stories of the Buddha (see nos. 132–135). (See the essay in section four of the catalogue for further discussion of *jataka* tales.) Curiously, the miracle of the Monkey Giving an Offering of Honey to the Buddha is not included in any of the known biographical texts; it is, however, briefly described in the *Dhammapada Commentary* and by Xuan Zang. Between these two sources, the story states that once a monkey offered honey to the Buddha and thereafter either danced with joy or in his ecstasy fell into a well and died. It is rather curious that such an incident should have taken place in an urban environment; this seems to reveal the rather contrived association of the episode with the important city of Vaisali. Fur-

thermore, one would have expected an incident of this nature to have occurred during the Enlightenment Cycle when the Buddha would have had need of nourishment.

The encounter with the mad elephant Nalagiri at Rajagriha has a more credible basis and epitomizes the Buddha's protracted rivalry with his cousin Devadatta. Ever since their childhood, Devadatta had been intensely jealous of the Buddha, and according to the Buddhist tradition, on various occasions he had tried to kill the Master. It was Devadatta who released the mad elephant, but his plans failed: Upon seeing the Buddha, the elephant suddenly became calm and, like a friendly puppy, rubbed his trunk against the Master's robes.

THE NARRATIVE OF THE BUDDHA'S LIFE IN ART

REPRESENTATIONS OF THE LIFE of the Buddha have remained a favorite theme with Indian artists since at least the second century B.C., if not before. The earliest surviving representations appear on the Great Stupa at Bharhut in central India. There seems to be little doubt, however, that prior to the construction of this monument monasteries had murals painted on their walls and were adorned with long, painted cloth scrolls depicting the principal events of the Buddha's life. The mural fragments from Central Asia (nos. 56 and 62) and the painted scroll from Tibet (no. 16) included in this exhibition continue a tradition that must have begun rather early in the history of Buddhist art. Apart from murals and scrolls, stories from the life were also frequently depicted in virtually every medium employed by the artists in the various countries where Buddhism flourished.

While there is considerable iconographic and formal conformity among the wide variety of Buddha images created in the various Buddhist countries, there is a far greater diversity in representations of the narrative themes. Even if the basic iconographic features and compositional schemes sometimes remain faithful to Indian prototypes, the manner of representation, the salient details, the modes of dress, and the behavioral patterns reflected in such depictions differ considerably from country to country. Generally, each country made Buddha Sakyamuni one of its own, and the legends of his life were enacted in a localized social context and cultural environment. Sometimes, however, differences are perceptible in even more significant features. For instance, both in China and Japan, in scenes of the Birth, the infant Buddha is shown emerging from his mother's long sleeve

rather than her hip (no. 21). Obviously, the Sino-Japanese sense of decorum did not permit Maya to stand in seminudity as she does in representations from the Indic tradition. Similarly, within the basic Indian iconographic framework, the Thais elaborated upon the Birth scene with remarkable inventiveness (see no. 15).

Prior to the first or second century, it was customary to represent incidents from the life in considerable detail without showing the Buddha himself in anthropomorphic form (see the essay in section two of the catalogue). Between the first and the fourth century, the artists of both ancient Gandhara and the Amaravati region in India were particularly enthusiastic about depicting the life in detailed relief sculptures. These reliefs were employed to embellish religious edifices, as well as for didactic purposes. The practice of representing the life in stone or stucco reliefs appears to have lost favor in India, starting in about the fifth century, and, with the exception of the great reliefs of the Barabudur stupa in Central Java, it did not find much currency in other Buddhist countries. Neither in Sri Lanka nor in China, where early structural monuments and excavated temples survive, do we encounter relief sculptures depicting scenes from the Buddha's life. These monuments may once have been decorated with murals, however, which have long since disappeared. Many surviving murals in Korea, Thailand, Sri Lanka, Tibet, and Nepal do not date much further back than the sixteenth century, but monuments in India, Central Asia, and Burma clearly indicate the antiquity of the tradition. It is interesting to note that murals depicting the Buddha's life are still being painted in the traditional manner on newly built temples in South Korea.

A substantial number of cloth paintings, most of which date from the Tang period (618–906), have been recovered from Buddhist sites in Central Asia (see nos. 32 and 34), and these confirm the continuance of the earlier Indian narrative tradition. Paintings on cloth were also created in other countries, as indicated by several examples included here from Nepal (no. 14), Tibet (nos. 11 and 16), and Thailand (no. 134).

By the fifth century, Indian Buddhists seem to have lost some of their earlier enthusiasm for representing the life of the Buddha in a narrative manner. Instead, the artists of the Sarnath school devised a type of stele (no. 3) in which four or eight principal events from the Buddha's life were grouped together and presented in a summary fashion. Their successors working for the important monasteries of Bihar further condensed these representations (nos. 5 and 6), and often the events could only be identified by the presence of certain symbols. Around the eleventh century, it also became popular both in Bihar and in Nepal to depict the Eight Great Miracles on the covers or pages of *Ashtasahasrika Prajnaparamita* manuscripts (nos. 7 and 8). This book, supposedly written by the great Buddhist philosopher Nagarjuna (active 2nd century), is primarily a philosophical work and has nothing to do with Sakyamuni's biography. It has never been made clear why *Prajnaparamita* manuscripts were illustrated with scenes from Sakyamuni's life.

A glance at the objects included in this section will make it abundantly clear that in most countries the primary emphasis was placed on the four principal events—the Birth, Enlightenment, First Sermon, and *Mahaparinirvana*. The Birth and the *Mahaparinirvana* were further singled out as the focus of more intense cults in certain countries. Although no statistical study has been made, it would hardly be an exaggeration to state that the representation of the Buddha stretching his right arm in the earth-touching gesture symbolizing his Enlightenment is the Buddhist cult image par excellence.

Pratapaditya Pal

52

Narrative Representations of the Life of Buddha Sakyamuni

Entries no. 1 through 17

Pediment with Scenes from the Buddha's Life
Pakistan (Ancient Gandhara),
2nd–3rd century
Gray schist
h: 7½ in. (19 cm.)
Alston Callahan, M.D.

This pediment once served as the base of a stupa similar to that illustrated in no. 68. A scene from the Buddha's life is carved on each side of the work within a shallow niche framed by two broad columns. Two of the scenes depicted ([c] and [d]) reveal some unusual iconographic features.

(a) Here the Birth is represented in a conventional manner. A god, presumably Indra, receives the infant Siddhartha as he emerges from Maya's right hip. On Maya's left stands her sister Mahaprajapati, who offers support. The figure holding what appears to be a bag (of riches?) in her right hand and a rhyton in her left represents Lumbini, the goddess of fertility and abundance.

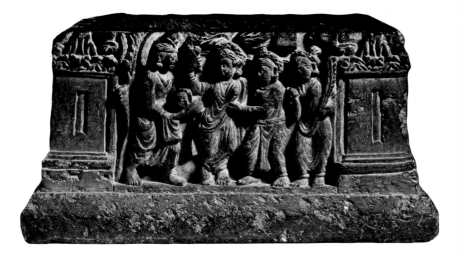

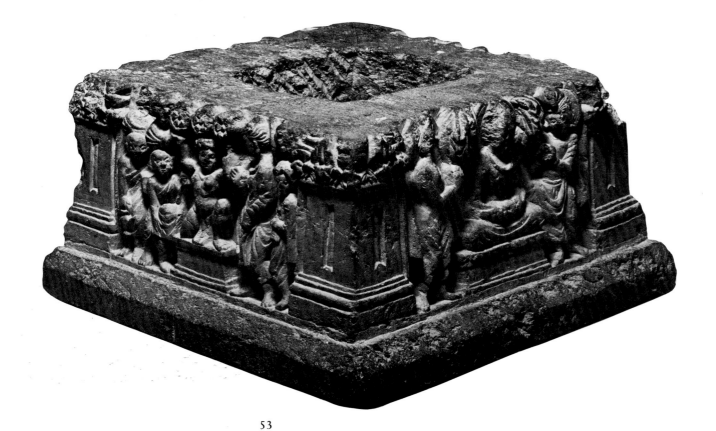

(b) In this scene, Siddhartha departs from Kapilavastu on his horse Kanthaka. *Yakshas* (nature deities) muffle the horse's hooves. Siddhartha's guardian angel, Vajrapani, stands behind him, just in front of the palace gate. The figure behind the horse's head is probably Siddhartha's groom. In front of the horse, a god indicates the way, and on the extreme left, the city goddess of Kapilavastu is shown adoring the future Buddha.

(c) In the third scene, the artist has represented the occasion immediately following the Enlightenment, when the gods exalt the reluctant Buddha and Brahma persuades him to spread his message. The Buddha sits impassively in meditation with his hands beneath his garment; Brahma stands on his right and Indra on his left. This incident was most frequently represented by the artists of Gandhara.

(d) The fourth scene represents the First Sermon at the Deer Park in Sarnath in a novel fashion. In Gandhara reliefs, the Buddha is usually shown seated on a platform, either simply teaching or literally turning a wheel with his right hand (see no. 52). Here, however, an Atlaslike *yaksha* kneels on the throne and supports three wheels (shown here as lotuses or rosettes), one in each hand and a third on his head. There can be little doubt that these three wheels symbolize the three parts of the Buddha's First Sermon. The Buddha in this relief is shown standing to the right of the throne with his hand raised; he is accompanied by Vajrapani. On the other side of the platform are the five ascetics who formed his first audience.

—*P. P.*

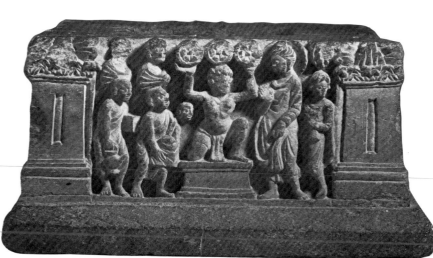

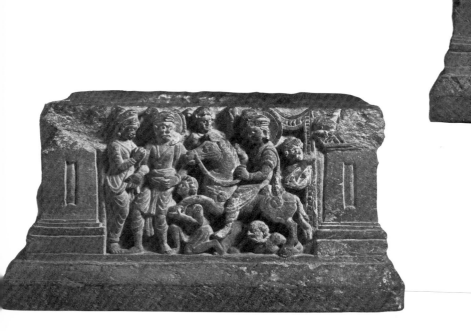

Part of a *Diptych with Scenes from the Buddha's Life*
Pakistan (Ancient Gandhara),
c. 5th century
Gray schist
h: 3⅜ in. (8.2 cm.)
Professor Samuel Eilenberg

Diptychs such as this and the one in no. 52 probably served as traveling shrines used by monks or merchants. Most examples found on the Indian subcontinent seem to have originated in the northwest. (A Chinese variant of such a shrine is discussed in no. 4). This particular example is especially intriguing because of the seated male depicted on its exterior. A bearded figure, his hair tied with a band, the man wears a long-sleeved jacket and boots. He probably represents a Central Asian, perhaps a Scythian, and he carries a type of basket on his back that one still sees in the Himalayas. The contents of the basket cannot be identified. A headless male, perhaps a child or a dwarf, is seated partly astride the larger figure's shoulders and partly on the basket. We are unable to suggest an exact identification for either figure. Both may represent *yakshas* (nature deities), or the Scythian may be intended as a trader, although why he should carry another figure on his shoulders is unclear.

On the inside of the diptych, the Birth and Death of the Buddha are represented in two separate panels. In the Birth scene, the infant emerges from his mother's right hip, while a divine being, probably Indra, stands by with a mantle to receive the baby. Siddhartha is also shown on the ground about to take his seven steps. Figures such as this naked baby must have served as models for the Chinese representations of the infant Buddha (see no. 28).

In the lower panel, the Buddha is stretched out on a couch below a tree, surrounded by mourners. The Buddha's last disciple, Subhadra, sits meditating in the center of this scene. It is very likely that the other half of this diptych depicted the remaining two principal events—the Enlightenment and the First Sermon.

—P. P.

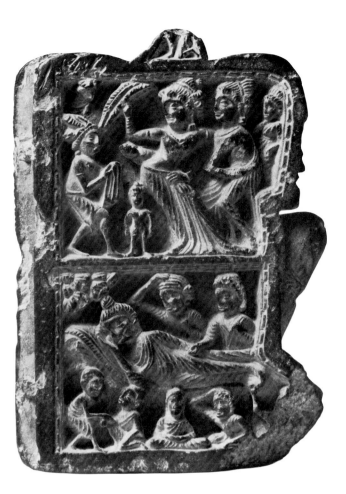

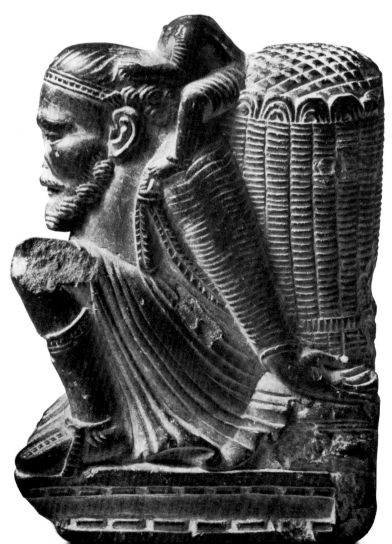

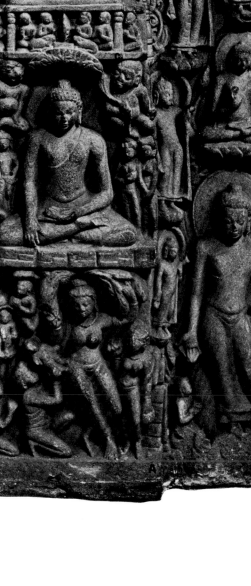

*Stele with Scenes from the
Buddha's Life*
India, Sarnath; c. 475
Sandstone
h: 30 in. (76.2 cm.)
Indian Museum, Calcutta

The four principal events of the Buddha's life are represented in the projecting middle section of this stele. The Birth and the lustration of the infant Siddhartha are illustrated in a panel at the bottom of the work. In the lustration scene, two serpent kings pour water from a jar over the baby Buddha's head while he stands upon a lotus. The panel immediately above portrays the Enlightenment at Bodhgaya, and the third panel depicts the Buddha, accompanied by two bodhisattvas, preaching at Sarnath. The Buddha's Death appears across the top of the stele.

Nine Buddha figures, two of which are seated, are carved along the two sides of the stele. These multiple figures are probably intended to represent the Multiplication Miracle at Sravasti, where the Buddha multiplied himself in order to confound the heretics (see no. 53). If they do indeed represent that occasion, then this is an unusual way of depicting the great miracle.

During the Gupta period (320–600), the sculptors of Sarnath seem to have originated this type of relief, which typically includes representations of four or eight principal scenes from the life of the Buddha. They are not found in any other school of art. Later the artists of Bihar took up the idea and depicted the Eight Great Miracles both in sculpture (nos. 5 and 69), where their representations were more cryptic and symbolic; and in manuscript illuminations (no. 7), where they continued the narrative manner preferred by the Sarnath artists.

—*P. P.*

*Shrine with Scenes from the
Buddha's Life*
China; Tang dynasty, 8th century
Gilt bronze
h: 3 in. (7.6 cm.)
Asian Art Museum of San Francisco,
The Avery Brundage Collection

This miniature shrine is a bronze replica of the small, portable wooden shrines used by traveling monks. It consists of a conically shaped panel with two hinged side-wings that fold inward. All three panels are carved.

The central image on the front panel is a standing Buddha with a halo. This Buddha's hands are placed on his knees in an unusual gesture. Above this figure is another image of the Buddha with no halo, this time shown seated in meditation with his legs crossed. Both figures are clothed in a highly stylized version of the linear drapery characteristic of Gandhara sculpture (cf. no. 1). This drapery style is similar to the parallel repetitive lines seen on sixth-century Northern Wei (386–535) sculptures, particularly those from Shaanxi (Siren, 1925, vol. 2, pls. 125–30). Beneath these Buddha figures are two demigods seated in relaxed poses on either side of a central post.

The hinged side-wings are carved with scenes from the life of the Buddha; the Birth and the *Mahaparinirvana* appear on one wing; the first

seven steps and one of the four encounters of Prince Siddhartha—probably with the sick man—on the other. The depictions of events from the life of Buddha equip the shrine as an instrument for transmitting the Buddhist faith (for Indian parallels, see nos. 2 and 52).

The *retardataire* drapery style used on the main images, the relaxed pose of the demigods, and Maya's portly figure and massive coiffure date this shrine to the eighth century. Sandalwood shrines were prized possessions of itinerant monks and were also vehicles for transmitting iconographic formulas and sculptural styles. In both the presence of the demigods and the drapery style used on the Buddha's robes, this miniature bronze shrine resembles the Tang dynasty (618–906) folding shrine believed to have been brought to Japan in 806 by the Japanese priest Kobo Daishi (Soper, 1969, p. 32).

<div align="right">—J. B.</div>

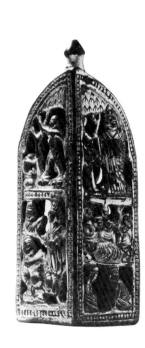

5

Stele with Eight Buddhas
India, Bihar; 10th century
Black chlorite
h: 29⅞ in. (75.8 cm.)
Alsdorf Foundation, Chicago

Continuing the tradition that originated in Sarnath during the Gupta period (320–600) (no. 3), the sculptors of Bihar created an image type in which the Eight Great Miracles are represented in a cryptic manner without many narrative details. This sharply carved and highly polished relief is one of the finest examples of such sculptures.

The Birth of the Buddha is made somewhat less significant by its placement along the base of the stele on the left of the lotus on which the central Buddha stands. An image of Tara, the saviour goddess of Vajrayana Buddhism, is added on the other side, as if to balance the composition.

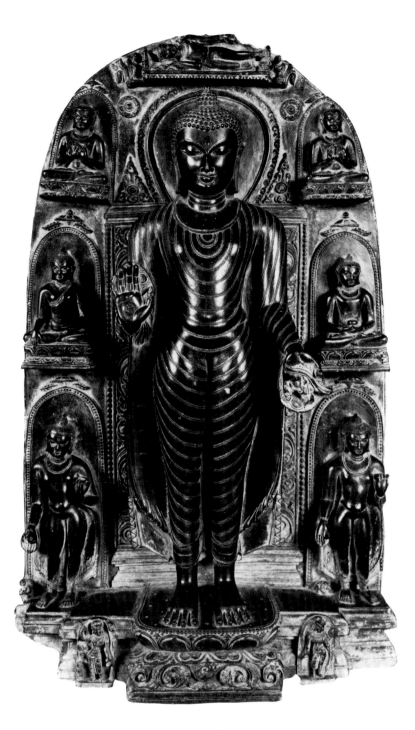

At the apex of the stele is the *Mahaparinirvana*, which invariably occupies this position in such reliefs. Then, continuing clockwise, are the Sravasti Miracles; the Monkey Giving an Offering of Honey; the Taming of the Mad Elephant Nalagiri; the Descent from the Trayastrimsa Heaven; the Enlightenment; and the First Sermon, which is distinguished from the Sravasti Miracles by the addition of a small wheel shown against the lotus seat.

The representation of the columnar central figure of the Buddha, with his right hand displaying the gesture of reassurance, indicates that he is a cosmic figure. On either side of the flaming nimbus behind his head are the solar and lunar symbols signifying the heavens, while the lotus on which he stands symbolizes the earth.

<div align="right">—P. P.</div>

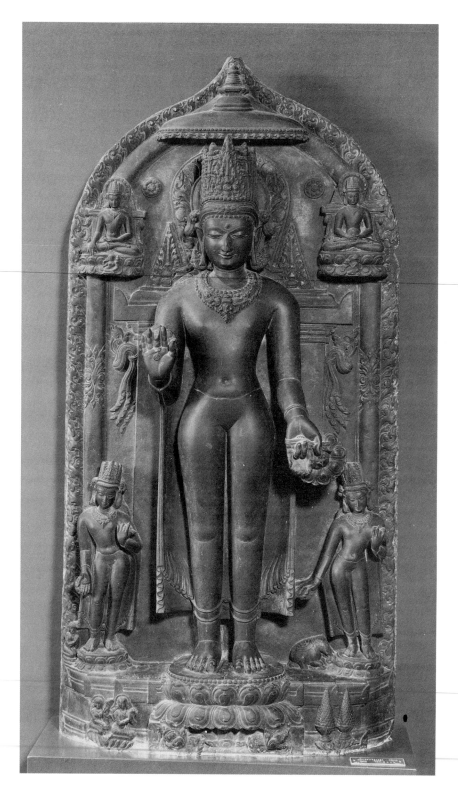

Stele with Five Buddhas
India, Bihar; 11th century
Black chlorite
h: 41½ in. (105.4 cm.)
Asian Art Museum of San Francisco,
The Avery Brundage Collection

All five Buddhas in this stele are similarly crowned and attired, and each wears an elaborate necklace. The large central figure stands pillarlike on a lotus below an umbrella that bears a finial in the shape of a stupa. Both of this central Buddha's hands are marked with a sign resembling either the Wheel of the Law or a lotus. His left hand holds the ends of his garment, and his right displays the gesture of reassurance. Along the base of the stele, on either side of the lotus, two small figures representing the donor couple and two bowls containing offerings of grain are carved.

Four smaller images of the Buddha are carved on either side of the central figure near the flame-embellished edges of the stele. The two figures at the base sway gracefully, and the inclusion of the kneeling elephant at the foot of the figure on the right leaves no doubt that this image depicts the Taming of the Mad Elephant Nalagiri. The corresponding figure on the left must then represent the Descent from the Trayastrimsa Heaven, where the Buddha had gone to preach to his mother; this incident is usually paired with the scene of the elephant. The seated image above the right shoulder of the central Buddha symbolizes the Enlightenment; this is evident both from the earth-touching gesture of the right hand and the inclusion of the kneeling Earth goddess next to the lotus. The fifth figure on the other side represents the Monkey Giving an Offering of Honey. The Buddha holds a bowl in his hands, and a monkey holding another bowl is carved against the lotus base.

This stele is unusual in that it includes five rather than the more common eight figures. Of these five events, four represent great miracles. The use of a group of five is reminiscent of the pentad of Vajrayana Buddhism. The crowning and ornamenting of the five Buddhas also suggest certain Vajrayana rituals involved with regal consecration ceremonies. This regal aspect of the Buddha is again emphasized by the parasol at the apex of the stele. The symbols of the sun and the moon, located on either side of the central Buddha's crown, emphasize his cosmic nature (cf. no. 5).

—P. P.

Book Covers with Scenes from the Buddha's Life and Multiple Buddhas
India, Bihar or Bengal; 11th century
Wood with polychromy
Each cover: 2⅛ × 22¼ in.
(5.3 × 56.5 cm.)
Los Angeles County Museum of Art, from the Nasli and Alice Heeramaneck Collection, Museum Associates Purchase

Like the Nepali book covers (no. 8), these two covers once protected a *Prajnaparamita* manuscript. This manuscript was completed c. 1054 in the eighteenth regnal year of King Ramapala of Bihar and Bengal, and the covers were probably painted at the same time.

(a) The scenes depicted on this cover are as follows (left to right):

1. Siddhartha cuts his hair, and the god Indra kneels to collect it in a bowl.

2. The meditating Siddhartha is sheltered by the serpent king Muchalinda during a storm.

3. The Buddha becomes emaciated during the Enlightenment Cycle.

4. The Buddha accepts rice cooked in milk from Sujata.

5. The Buddha is shown walking.

6. The Buddha confronts the serpent in Kasyapa's fire temple at Uruvilva (see no. 58).

7. The Buddha holds the tamed serpent in his hand.

8. The Buddha is shown meditating.

9. The Buddha receives homage from a couple.

The narrative panels of cover (a), hold our interest with their unusual themes and free and lively delineation. These incidents from the Buddha's life are not the usual Eight Great Miracles seen in most contemporary sculptures or manuscript illuminations; to my knowledge, this is the only instance of a representation of the emaciated Buddha from this period, although the theme is more common in Nepali art (nos. 9 and 14). The emphasis given to the conversion of the serpent and the fire worshipers of Uruvilva is also unusual. Certainly the representation of Sujata's hospitality is the most delightful on this cover. Not only is she shown milking the cow; she also appears cooking the victuals in a pot and offering them to Sakyamuni.

(b) The first eight seated figures on the second cover represent Buddhas, and they all display gestures associated with teaching. The first Buddha wears a crown and earrings that relate to the initiation ceremonies of Vajrayana Buddhism. The other seven may represent the Five Buddhas of the Past and the Buddhas of the Present and Future. (See section four of the catalogue for further discussion of past and future Buddhas.) The bodhisattva at the right end of this cover may be Avalokitesvara. These gracefully delineated Buddhas with their delicate coloring contribute to making this set of covers among the finest extant examples of Indian Buddhist manuscript illuminations.

—P. P.

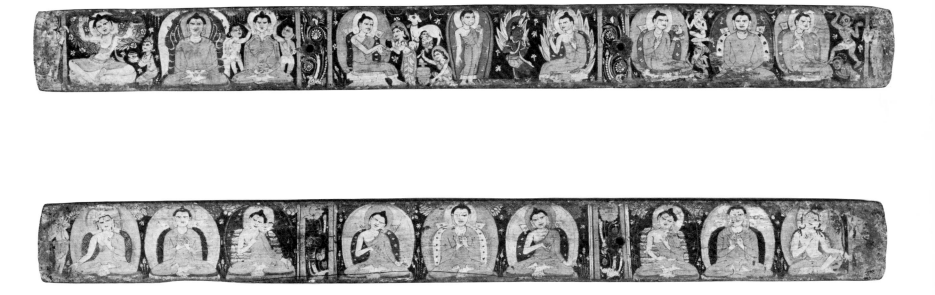

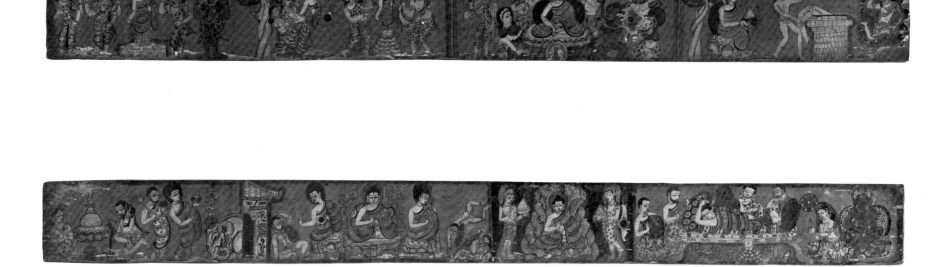

8

*Book Covers with Scenes from the
Buddha's Life*
Nepal, manuscript dated 1054
Wood with polychromy
Each cover: 2⅛ × 22⅛ in.
(5.3 × 56.2 cm.)
Los Angeles County Museum of Art,
from the Nasli and Alice
Heeramaneck Collection, Museum
Associates Purchase
(Reproduced in color)

The *Prajnaparamita* was one of the
most popular Buddhist texts in India
and Nepal, and it was often commis-
sioned and copied by pious Bud-
dhists. Both the pages and covers of
the *Prajnaparamita* were frequently
illustrated with hieratic images of
Vajrayana deities and with scenes of
the Eight Great Miracles. The Ne-
pali artist who created these covers
has displayed a greater narrative
intent than is usual in representa-
tions of the period and introduced
interesting variations in iconogra-
phy and chronology.

The top cover (a) is divided into three
distinct panels, with the Nativity

panel occupying nearly half the
entire surface. In the middle of the
Nativity scene, the Buddha emerges
from Maya's left hip, rather than the
traditional right. To the left of this
scene, four deities—Brahma, Siva,
Indra, and Vishnu—receive the in-
fant. On the right, the infant Buddha
takes his seven steps, which are sig-
nified by the pyramid of lotuses on
which he stands. Brahma and Indra
flank the baby Buddha and offer him
a bowl of rice and a fish respectively.
Although these gifts would not be
inappropriate for such an auspicious
occasion, offerings of this sort are
not described in any text. The mid-
dle panel on this cover illustrates the
Enlightenment and Mara's assault.
In the final panel, the Monkey Giv-
ing an Offering of Honey is depicted.
After presenting the honey, the mon-
key is seen falling into a well and
then ascending to heaven enveloped
in clouds.

In the first panel on the second cover
(b), we see a man adoring a stupa fol-
lowed by the scene of the Taming of
the Mad Elephant Nalagiri. Immedi-
ately above the elephant are tiny fig-

ures of lions, no doubt symbolizing
the power of Sakyamuni, who is of-
ten regarded as Sakyasimha (Lion of
the Sakyas). The following composi-
tion represents the Multiplication
Miracle at Sravasti, where the
heretics are thrown helter-skelter
upon beholding three identical im-
ages of the Buddha. In the next
panel, the Buddha is shown shel-
tered by the serpent king Mucha-
linda and attended by two other ser-
pent kings who have brought
offerings. This incident is part of the
Enlightenment Cycle, and as such it
should have been included before
the Monkey Giving an Offering of
Honey. Furthermore, in most repre-
sentations of the Muchalinda leg-
end, the Buddha is shown meditat-
ing, but here his gesture clearly
indicates that he is teaching. It is
also noteworthy that the occasion of
the First Sermon has been omitted
from these two covers. The final
scene depicts the Death of the Bud-
dha in the usual manner, with the
addition of a dark figure, perhaps a
deity, seated at the end.

—P. P.

Scenes from the Life of the Buddha
Nepal, 11th century
Copper alloy with vestiges of gilding
h: 10½ in. (26.7 cm.)
Los Angeles County Museum of Art,
Gift of Mr. and Mrs. Michael
Phillips

A superb example of metal casting—
for which the Newars of Nepal were
justly famous—this bronze's tech-
nical complexity is as admirable as
its aesthetic richness. Although the
iconographic formula and composi-
tional arrangement stem from the
Buddhist art of eighth- or ninth-cen-
tury Bihar (cf. no. 69), this Nepali
version is far more elaborate and
lively than its Indian precursors.

As is usual in most conventional
representations of the Eight Great
Miracles (see nos. 10 and 11), the
central event is the Enlightenment
at Bodhgaya. In this scene, the Bud-
dha's right hand is held in the earth-
touching gesture; a thunderbolt
below the lotus signifies *vajrasana*
(the thunderbolt seat—this term is
also used to refer to Bodhgaya and
the temple at Bodhgaya); and the
bodhi tree appears behind Sakya-
muni's head. The Buddha's Death is
represented in its customary place at
the apex of the icon. Here, grieving
monks stand behind their Master,
and the last disciple, Subhadra, sits
at his feet. The remaining scenes,
each of which is placed upon a lotus,
are (clockwise from the upper right-
hand corner): The Monkey Giving
an Offering of Honey, the First Ser-
mon, the Descent from the
Trayastrimsa Heaven, the Nativity,
the emaciation during meditation,
the Taming of the Mad Elephant
Nalagiri, the Sravasti Miracles, and
the Buddha's sermon to his mother.

The Nepali artist has emphasized
some of the conventional miracles
in greater detail than usually seen in
Bihar reliefs (cf. no. 5). He has also
added two incidents that are rarely

depicted in Indian Buddhist art. One
of these is the figure of the ema-
ciated Buddha from the Enlighten-
ment Cycle. With the exception of
Gandhara representations (no. 39),
artists on the Indian subcontinent
appear to have generally avoided this
theme. Thus, to my knowledge, this
is one of the rare instances of such a
representation by an Indian or Ne-
pali artist. We propose to identify the
other unusual event depicted on this
sculpture as the Buddha's sermon to
his mother in the Trayastrimsa
Heaven. Not only do we see the Bud-
dha preaching to a solitary female in
this scene, but the incident is placed

immediately above the Sravasti Mir-
acles. In the textual tradition, the
Buddha ascended to the heaven
immediately after performing the
Multiple Miracles at Sravasti, and
as Dr. Robert Brown informs me, the
two miracles are similarly paired in
Thai art. It must be noted, however,
that the various miracles do not
always follow a strict chronological
order in artistic representations but
are frequently arranged according to
aesthetic considerations.

—*P. P.*

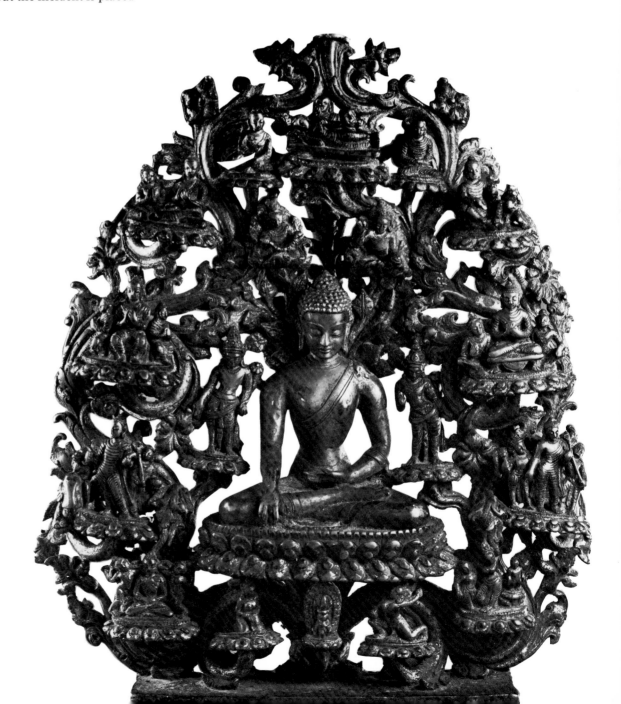

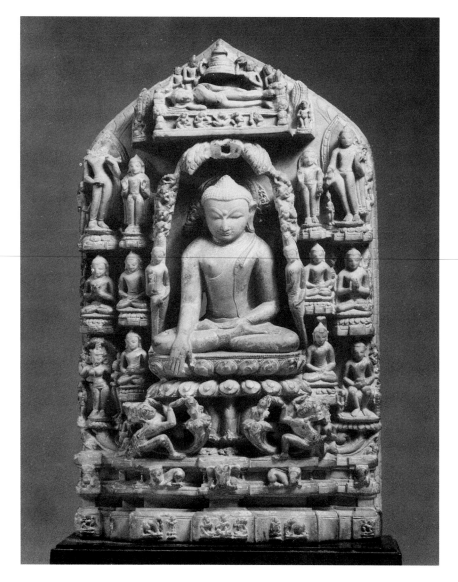

10

Plaque with Scenes from the Buddha's Life
Burma, 12th century
Sandstone with traces of gold leaf
h: 7¾ in. (19.6 cm.)
The Asia Society, New York:
Mr. and Mrs. John D. Rockefeller 3rd
Collection

This stone relief is one of a rather small group of similar plaques that depict the Eight Great Miracles. These carvings, all under eight inches in height, are called *andagu* (dolomite) plaques in Burmese. The central Buddha on the illustrated relief is seated on a lotus and extends his hand in the earth-touching gesture, which indicates the Enlightenment and the defeat of Mara. Mara's army is delicately carved into the foliage on either side of the Buddha's head.

Above this large central Buddha is the standard scene of the *Mahaparinirvana* with the recumbent figure of Sakyamuni. The other six scenes surround the central image, appearing along the outermost edge of the tablet. Reading down on the right side are: the Descent from the Trayastrimsa Heaven, the Sravasti Miracles, and the Monkey Giving an Offering of Honey; on the left side are the Taming of the Mad Elephant Nalagiri, the First Sermon, and the Nativity.

The inspiration for these tablets is clearly the Pala period (8th–11th century) representations of eastern India (cf. no. 5). Some scholars have suggested that the tablets were in fact made in India and brought to Burma. Similar plaques have been found in Sri Lanka and Tibet, suggesting that visitors from various Buddhist countries brought them back from pilgrimage sites, most likely Bodhgaya in India. The fact that the majority of these tablets have been found in Burma, however, while only a fragment of one has actually been excavated in India—in this case, from Sarnath—supports the theory that they are of Burmese workmanship. Furthermore, the Burmese appear to have added to the Eight Great Miracles (which are frequently seen in standard Pala reliefs) additional Buddha figures representing the seven weeks Sakyamuni spent at Bodhgaya following his Enlightenment.

These added Buddha figures are located in the space between the large central figure and the six life scenes already described. It is not possible to identify absolutely which week and which activity each of these added six Buddhas represents. As there are only six figures (necessitated by the symmetry of the composition), but seven weeks, one of the figures must represent two weeks. It is clear that the Buddha seated in meditation with a cobra's hood above his head, at the lower right, indicates the sixth week after Enlightenment, when the *naga* (serpent) Muchalinda protected the Buddha from the rain. The Buddha seated with a bowl in his lap at the lower left may represent the seventh week, when the Buddha was presented with a gift of honey cakes and peeled sugarcane by the merchants Tapussa and Bhallika. As this scene is not represented elsewhere in the exhibition, it should be expanded upon a little here. Tapussa and Bhallika, variously identified as merchants from Orissa or Burma, are said to have offered food to the Buddha as he sat in meditation, thus becoming his first lay disciples. It is significant that they are identified as rich merchants, since members of the mercantile class were some of the earliest supporters of Buddhism.

Of the remaining four Buddhas, the two seated in meditation immediately above the Buddha with a bowl and the Muchalinda Buddha may represent weeks one, four, and five, during which the Buddha meditated in a seated position. Finally, the two standing Buddhas at the top represent weeks two and three, when the Buddha was either standing or walking.

—R. L. B.

surround a central shrine containing the image of Buddha accompanied by two bodhisattvas. The temple is obviously the Vajrasana, or Mahabodhi, which was erected at Bodhgaya (see no. 73), the site of the Buddha's Enlightenment. The hordes of Mara are shown attacking Sakyamuni on either side of the temple's superstructure. In panel 16, Mara himself appears on the left in a chariot shooting an arrow of desire at the Buddha. Mara is shown leaving the scene in a dejected mood on the right side of the same panel. The other incidents depicted can be identified as follows:

1. The Buddha preaching in heaven before his last Birth.

2. The Death.

3. The Descent from the Trayastrimsa Heaven.

4. The First Sermon in the Deer Park.

5. The Birth.

6. The Presentation of Siddhartha to Asita.

7. The return of Kanthaka with Siddhartha's clothes and diadem.

8. The great departure.

9. The cutting of the hair.

10. The Enlightenment.

11

Life of the Buddha
Tibet, Kadampa style;
13th–14th century
Opaque watercolors on cotton
31½ × 23½ in. (80 × 59.7 cm.)
Zimmerman Collection
(Reproduced in color)

This *thanka*, or painting on cloth, is the earliest surviving example of a Tibetan painting depicting the life of Buddha Sakyamuni. The various scenes unfold in cartouches, which

11. Sujata offering rice cooked in milk to the Buddha.

12. The First Sermon.

13. The Monkey Giving an Offering of Honey.

14. The Sravasti Miracles.

15. The Taming of the Mad Elephant Nalagiri.

16. The attack of Mara.

The artist does not appear to have arranged the incidents in their chronological sequence.

—*P. P.*

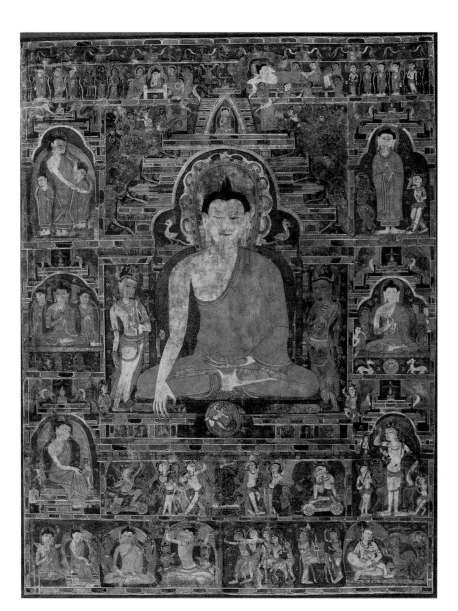

	1		2	
15				3
14				4
13		16		5
12	11	10 9	8 7	6

(Jami al-Tavarikh) of Rashid ad-Din, and *Book of Victory (Zafarnameh)* of Shami—for the compilation of his history. Hafiz-i Abru extended his chronicle in 1423, rearranging the book into four parts, the first of which dealt with the world before the Arab conquest. This extended work was entitled *Majma' al-Tavarikh (Collection of Chronicles)*. From an illustrated holograph copy of the *Majma' al-Tavarikh* in the Topkapu Saray Library in Istanbul, we know that the first section of the book was completed on November 18, 1425. Pages from an additional copy of this manuscript, including those illustrated here, were dispersed and have found their way into many Western collections. The verso of the Los Angeles folio contains the library stamps of Shah Rukh, from which one can conclude that the dispersed manuscript was produced between 1425 and 1430, the year of Shah Rukh's death.

Representations of Buddhist subjects in Islamic art are extremely rare and occur almost exclusively in the context of illustrated world histories. Although sections of the great fourteenth-century *Jami al-Tavarikh (World History)*, compiled by Rashid ad-Din for the Mongol emperor Uljaitu, were thought to be lost by the early fifteenth century, the illustrators of the 1425 copy of the *Majma' al-Tavarikh* apparently based some, if not all, of their paintings on those of the Mongol text. Three illustrations of Buddhist scenes are included in the section of the *Jami al-Tavarikh* that was produced in 1314; these were formerly in the collection of the Royal Asiatic Society (Gray, figs. 25–27). These illustrations do not correspond, however, to the three known representations of Buddha Sakyamuni from the dispersed Hafiz-i Abru manuscript. Presumably, the artists of the Hafiz-i Abru pages based their works on illustrations of the "His-

12

Two Pages from a Dispersed Majma' al-Tavarikh *of Hafiz-i Abru*

(a) *The Nativity*
Iran, Herat; c. 1425
Opaque watercolors on paper
17 × 13⅛ in. (43 × 33.5 cm.)
Courtesy of the Walters Art
Gallery, Baltimore

(b) *The Appearance of Sakyamuni to the People After His Death*
Iran, Herat; c. 1425
Opaque watercolors on paper
13 × 8¾ in. (33 × 22.3 cm.)
Los Angeles County Museum of
Art, the Nasli M. Heeramaneck
Collection, Gift of Joan Palevsky

In 1417 Shah Rukh, the son of the Iranian emperor Tamerlane, commissioned his court historian, Hafiz-i Abru, to write the history of the world from Adam to the present. Fortunately, Hafiz-i Abru could draw liberally on the works of his predecessors—notably the *Chronicle (Ta'rikh al-Rusul wa'l-Muluk)* of al-Tabari, *World History*

tory of Hind and Sind" (both terms denote the Indian subcontinent) from a copy of the *Jami al-Tavarikh* that is now lost.

That Rashid ad-Din should have included the life of the Buddha in his chronicle attests to the cosmopolitan and intellectual environment at the Il-Khanid (Mongol) capital of Tabriz. Although the Mongol rulers Ghazan Khan (r. 1295–1304) and Uljaitu (r. 1304–16) became Muslim, they tolerated Buddhism, Christianity, and even Manichaeism. Furthermore, they encouraged trade with Central Asia and China on the one hand and the West on the other. In short, Tabriz in the early fourteenth century was a magnet for traders and travelers and men of ideas from all over the world. Even though the biography of the Buddha had already been incorporated into Persian sources by the tenth century, its importance was appreciated anew in Il-Khanid times.

In the early fifteenth century, another bibliophile king, Shah Rukh, and his court historian, Hafiz-i Abru, demonstrated their joint desire to bring world history up to date by paying homage to the great historians of the past. Fortunately, the Hafiz-i Abru manuscripts were illustrated, providing us with a glimpse of how Iranians envisioned such exotic figures as the Buddha and his Indian followers.

According to Richard Ettinghausen, the illustrations of the Hafiz-i Abru manuscripts were executed in the "historical style of Shah Rukh," an archaistic manner with close connections to the Rashid ad-Din manuscripts (Ettinghausen, p. 42). The high horizon, simple draftsmanship, flat treatment of forms, and vivid palette of *The Nativity* and *The Appearance of Sakyamuni to the People After His Death* typify this historical style.

In *The Nativity*, the artist has followed the Persian text closely. Queen Maya is depicted in a grove holding a branch that has bent down for her just as she is about to give birth. From the sky, a cooling shower rains down upon the mother and the baby, who, unlike his Indian counterparts, is born in the normal manner. Such a deviation must be the result of a textual rather than an artistic tradition, since the artists of the Hafiz-i Abru manuscript would certainly have been familiar with the story of the Persian hero Rustam's cesarean birth.

The other scene (b) also introduces unconventional features. It is well known that the Buddha's body was cremated after his Death, although the artists of Gandhara did show it placed in a coffin before the incineration. Here, however, the Persian artist, following the Islamic tradition, has placed the dead Sakyamuni in a tomb. Furthermore, we are told in the text that the Buddha is about to appear before his followers after his Death. No Indian source is known for any such "resurrection," although, as mentioned in the Introduction to the catalogue, there is a Chinese text in which the Buddha returns from death.

Possibly in the early Islamic versions of the life of the Buddha, the story of his Death and of Christ's Resurrection were conflated, resulting in the peculiar confusion maintained by Hafiz-i Abru. In keeping with the date of the manuscript, Sakyamuni lies in a domed tomb tower comparable to those found in fourteenth- and fifteenth-century Iran. On either side of the structure, dark-skinned Indians observe the apparition. Only one of the onlookers lifts his fingers to his lips in a gesture of astonishment, while the rest of the men gaze impassively at the Buddha.

—*S. R. C.*

وسکیان راحاضر کرد وتعبیر مدتی ازین خواب رسید چون این خواب معدازتانی وتفکر ایشان باتفاق گفتند این خواب دلالت میکند
مزاک اوراسری شود که پادشاه جهان باشد تا ثابت بود که مدت این چنان کنند اوراتجسن کرد ازان مدت ازان چون مدت تا استیلاو
ازنه ماه کذشت وبس رسید ماها می تفرج میکرد وهمی رفت ودست راست ساخی ازی میکرد دین حال ازروی سری درآمد

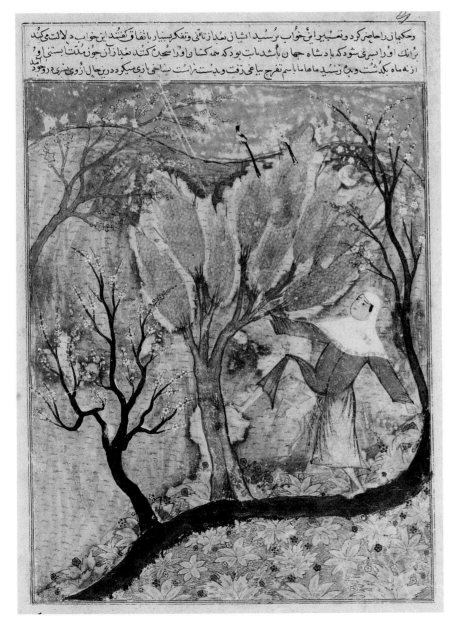

ناگاه دیدند که بودی نشانند اسلحه پوش ازشرکند بیرون رفت وهماز سه روز شخصی ازولایتی رسیده
تا ازمجن شاکمونی فائده گیر درخبر واقعه اوشنید وزار زار بگریست وخود رامیکشت وان واقعه از
مرد خود شرح صحبت بود دناگاه نگاه کرد وشاکمونی برآسمان دید وهمه مریدان اورا اصحبان درست
میدیدند وازآسمان بان تحص آواز کرد که عذرمجوز و زاری وفغان و دل کابی خرم وخوش دل شد و
سخنان وفوائد شاکمونی جمع کرد وازان دفتری ساخت ومجموعه و داخت وان مقصودی نهاد تمام شد
حالت شاکمونی از کداولادت تا کداولادت تا ک هلاکت اوبحسب معتقدان اهل مند وکشمیر تقدیر ورغم ایشان بعضی
ازین حرافات ومغوات در قلم آمد ازصح ونسخ ورنخ والله اعلم بالصواب والیه المرجع المآب ببنا اوالک شائر
اهل مند وبین وملت تناسخ اند ودین ها پیش یامت ادیان خصوصا دین سلطانی که رین ادیان وخلاصه
وقا وه وزبانست مندهنس وسطس وجون تاریخ شاکمونی وجون دین ووضع دین مقصن تناسخ است تمام شد خواستم
که رساله که پیش ازبرد راملتا تناسخ وضعف وکسر بی وملت وجلت ایشان این ضعف راانفاق بنیاد افتاد وآبا
اقتباس آثار راطماس واندراسه غادی باطل ایشان مقصود بود که آنکتاب رارونق راز ایشان ثبت
شود ودیل آن منقبل ومرتبط کرد تا مطالعان ازبرد ودرا ومادرین ملت راشفا واین مجروح را دوازبلد باشد وبعمد
رای واستغوا واستهوا ه اعتقاد ایشان واقف شوند ان رسالہ مندرج درکتاب وصحائف

13

Life of Buddha Sakyamuni
Tibet, 15th century
Opaque watercolors on cotton
20⅝ × 18¾ in. (52.4 × 47.6 cm.)
Mr. and Mrs. Mark Gordon

The central shrine in this *thanka* represents the Bodhgaya temple and includes the image of the crowned Buddha Sakyamuni accompanied by two bodhisattvas. Around the arch above the Buddha's head are seven smaller shrines enclosing seven more Buddha images. These are probably the Seven Buddhas of the Past, Present, and Future. On either side of the shrine's superstructure, four deities and sixteen monks are represented in four panels arranged in stepped spandrels. Around this central section, the life of the Buddha unfolds in considerable detail. The scenes are identified in the following chart and list:

1. A preaching bodhisattva

2. Buddha Sakyamuni gives his last instruction in heaven before descending to earth

3. Maya's dream

4. The Birth and the seven steps

5. The presentation of the baby to the sage Asita

6–8. Siddhartha learns the martial arts

9–10. Palace scenes

11. Riding a horse, Siddhartha sees a sick man and a corpse

12. Siddhartha's encounter with a monk

13. The great departure

14. The return of Chandaka and Kanthaka

15. Siddhartha cuts his hair

16–20. Events from the Enlightenment Cycle

21. The First Sermon

22. Unidentified

23. The Multiplication Miracle at Sravasti

24. Buddha preaching before a congregation of women

25. Buddha preaching to his mother

26. The Monkey Giving an Offering of Honey

27. The Taming of the Mad Elephant Nalagiri

28. Unidentified

29. The Descent from the Trayastrimsa Heaven

30. A preaching bodhisattva

31 & 33. Monks

32. The Death of the Buddha

—P. P.

30	31	32						33	1
29									2
28									3
27									4
26									5
25									6
24									7
23									8
22									9
21									10
20	19	18	17	16	15	14	13	12	11

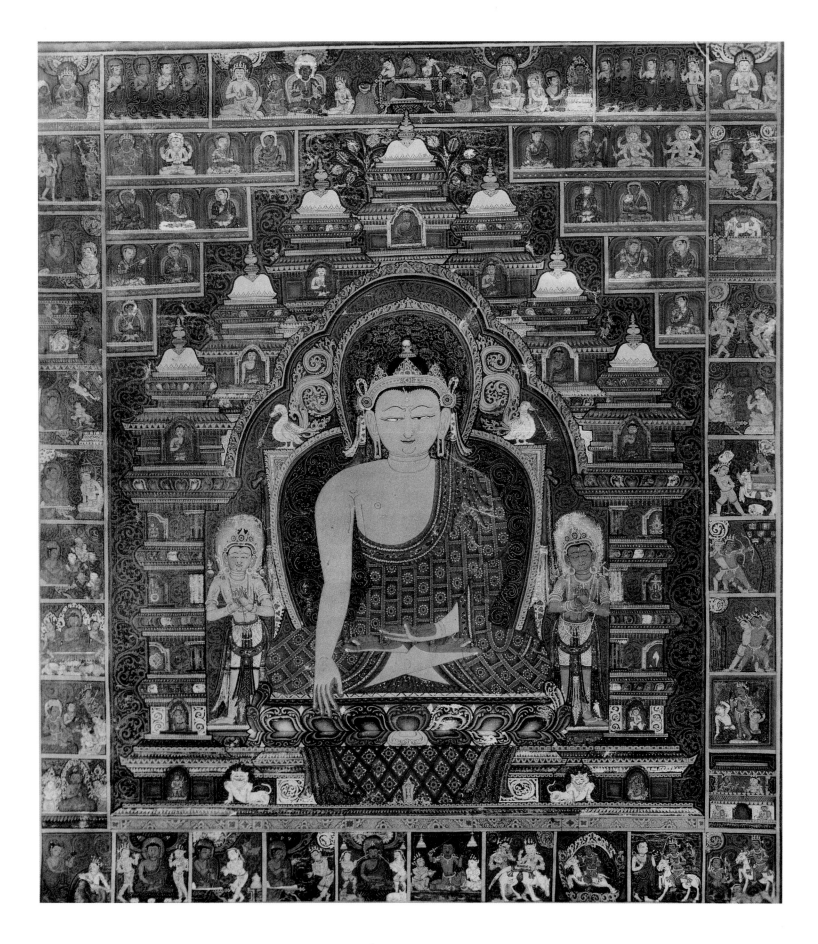

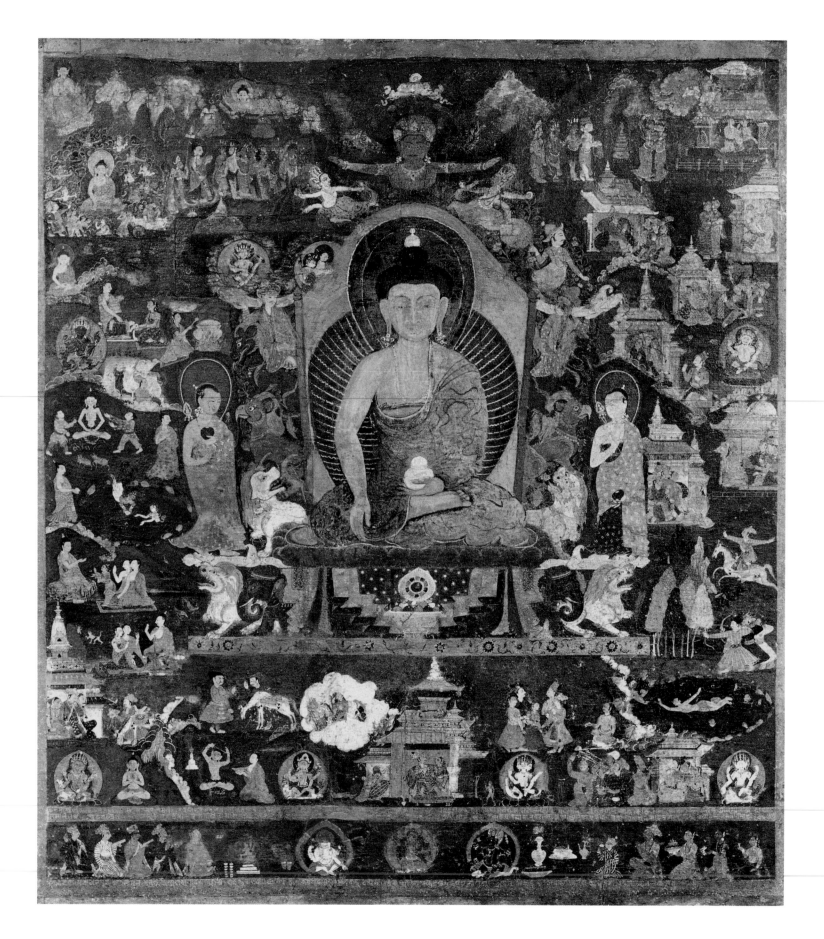

68

14

Life of the Buddha
Nepal, dated 1702
Opaque watercolors on cotton
32⅛ × 27¾ in. (81.6 × 70.5 cm.)
Navin Kumar Gallery

Buddha Sakyamuni appears in the middle of this painting seated on an elaborate throne and flanked by Sariputra and Maudgalyayana, two of his principal disciples. Both of these figures hold a staff and a bowl. Sakyamuni himself holds a bowl in his left hand and wears a necklace and earrings. The blue nimbus behind him is decorated with narrow golden lines, clearly intended to demonstrate the Buddha's luminosity. The principal events of Sakyamuni's life are represented around the throne, beginning at the upper right-hand corner and continuing clockwise. They may be identified as follows:

1. The Birth and the seven steps

2. Scenes in the royal palace and the presentation of the infant to the sage Asita

3. The education of Siddhartha, which consists of riding, archery, and swimming

4. The marriage of Siddhartha and Yasodhara

5. A night in the palace

6. The great departure; Siddhartha's farewell to his horse and groom prior to sending them back; and the future Buddha cutting his hair

7. The groom's return to the palace with Siddhartha's horse, and the subsequent report to the king

8. The search for enlightenment

9. The emaciation

10. Sakyamuni accepting food from Sujata, who is also shown cooking milk and rice

11. Mara's assault and the Enlightenment

12. The Death of the Buddha and, immediately below, Dipankara Buddha being led in procession (see the essay in section four of the catalogue for further discussion of Dipankara)

In this painting, the eighteenth-century Nepali artist has introduced several elements not usually included in representations of life scenes. These are the illustrations of Sakyamuni swimming, the marriage ceremony, the emaciation, and Sujata offering rice. The last two events appear to have had some appeal for the Nepali artists, as they are included in earlier life scenes as well (see no. 9). It is also interesting to note that the costumes worn by the figures in this painting have changed completely from earlier representations. By the seventeenth century, Nepali men had adopted the Mughal/Rajput mode of dress; the attire of the princes and courtiers in this painting reflects the prevalent fashion.

—*P. P.*

15

Scenes from the Buddha's Life
Thailand, dated 1776
Ink, gold, and opaque watercolors
on paper
Each folio: 9¼ × 20⅜ in.
(23.5 × 51.8 cm.)
Staatliche Museen Preussischer
Kulturbesitz, Museum für
Indische Kunst, Berlin
(15a reproduced in color)

There are few ancient manuscripts
from Southeast Asia that have sur-
vived the tropical climate, insects,
and wars. This manuscript, one of
the rare exceptions, is in remarkably
good condition and has the added
advantage of being dated. Most of
the manuscript's illustrations deal
with the Buddhist cosmology, a
popular subject in Thailand. There
are also, however, four scenes from
the Buddha's life—discussed
below—and representations of epi-
sodes from the *Vessantara Jataka.*
(Additional illustrations from this
manuscript depicting the *Vessan-
tara Jataka* are discussed in entry
no. 135.)

Life Scenes

(a) The first scene depicts the Bud-
dha's Birth. His mother, identified in
the Thai inscription as "Phra Shri
Maha Maya," stands in the center of
a circle formed by curtain walls. Her
body is extremely elongated, and she
is nearly twice as tall as her atten-
dants. She reaches up, as in the earli-
est depictions of the Birth from In-
dia, to hold the branch of a tree.
Above her, flying in the air, are four
deities, two of whom can be identi-
fied: The four-faced Hindu god
Brahma appears on the left, and the
green-skinned Hindu god Indra on
the right. As in the Khmer relief (no.
23), it is Brahma who receives the
baby Buddha, holding him in one of
his four hands. Interestingly, the art-
ist has represented the Buddha in the
form of a tiny gold statue standing
on a high base. The popular East
Asian cult of the baby Buddha, with
its focus on statues of the infant (see
nos. 26, 27, and 28), may also have
been known in Thailand.

The artist has shown considerable
interest in everyday surroundings,
carefully depicting the various cloth
patterns of the dress worn by the fig-
ures in the foreground. These atten-
dants bring gifts in golden vessels
that are in turn passed under the
curtain to the left. Of particular
interest are the two women tending
a pot of boiling water in the right
foreground. The artist may have
been familiar with the use of boiled
water during a delivery, but this
practice would hardly have been
necessary for the miraculous Birth
of the Buddha.

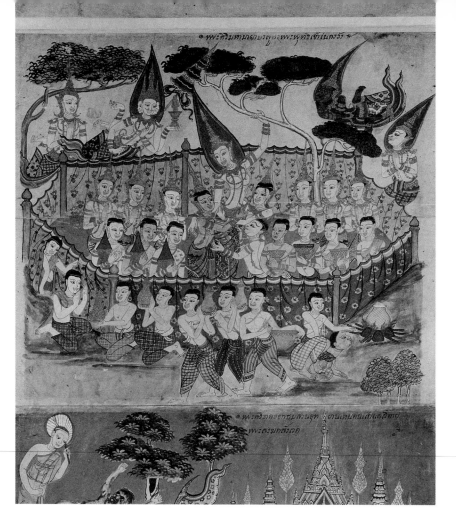

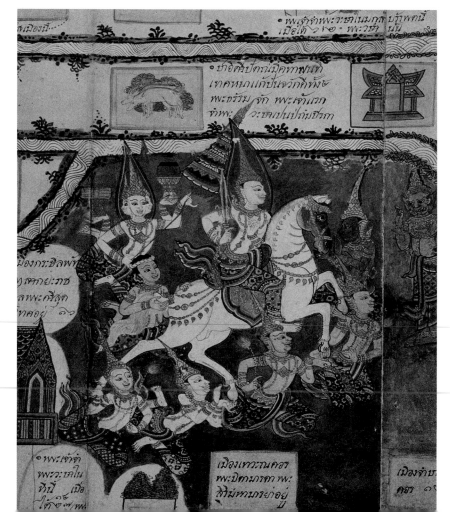

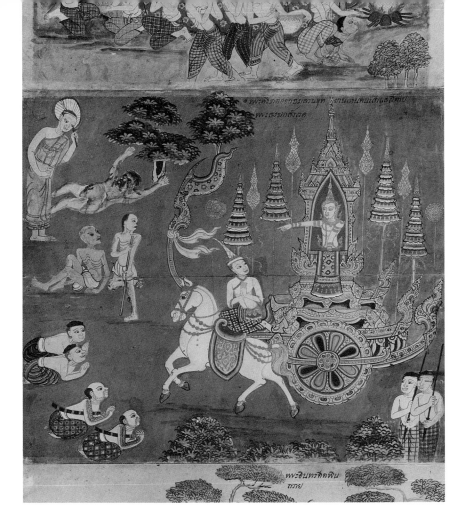

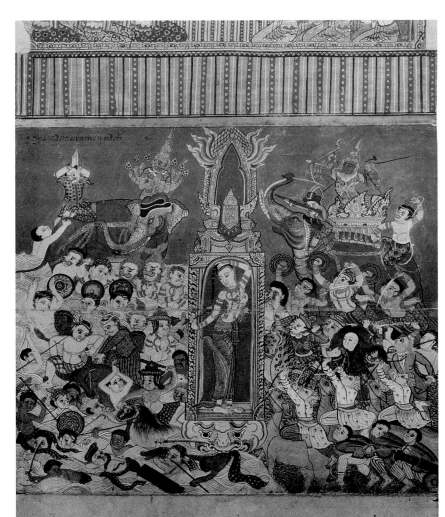

(b) The second life illustration presents the young Prince Siddhartha going on a pleasure drive arranged by his father, who, "reflecting that the prince's tender mind might be perturbed thereby,... forbade the appearance of afflicted common folk on the royal road" (R. Mitra, p. 80). The gods, however, desiring Siddhartha to abandon his princely life, caused the apparitions of an old man, a sick man, and a dead man to appear before the young noble. Some texts add a fourth encounter with a monk, whose tranquillity and serenity in the face of the inevitability of death and decay led Siddhartha to realize that he must abandon the princely life for that of an ascetic.

The Thai artist has illustrated all four encounters, although it is interesting that the sick man, shown here as a leper, is not mentioned in the inscription: "Siddhartha goes sightseeing on a conveyance, sees an old man, a dead man, and a monk, causing him to feel pity." The chariot in which the prince rides is a tour de force of decorative invention, and, as in the previous scene, the artist reveals his talent for close observation in such details as the way the monk's robe is worn and the tattoos on the arms of the two kneeling figures at the lower left.

(c) This scene illustrates the great departure. Sakyamuni rides away on his horse, Kanthaka, whose hooves are muffled by four deities. The groom, Chandaka, holds on to the rump of the horse, while Brahma flies just above, carrying the future monk's yellow robe and begging bowl. Leading the horse is the green-skinned Indra, while the evil, blue-skinned Mara, on the far right, makes a fruitless attempt to stop the departure.

(d) The last of the four life scenes depicts the attack and defeat of Mara's army. This illustration follows a popular compositional formula used in the wall paintings of Thai temples: Mara's army is shown attacking on the right; the personified Earth goddess stands at the center with the Buddha, in most cases, seated above her; on the left, Mara's army is washed away in the flood of water that flows from the goddess's hair (cf. no. 45). This particular illustration is unusual in that the Buddha is not represented as a human being but as a golden lotus-bud decoration placed in the otherwise empty pavilion above the Earth goddess.

It is toward this lotus bud that the soldiers on the right direct their charge. Mara, green-skinned and armed with an array of weapons held in his multiple hands, rides on an elephant. Included in his army are several Europeans, as well as three bow-wielding Muslims riding camels. On the opposite side, the army is shown being washed away, while the defeated Mara, who now appears riding on the elephant's neck, places two of his many hands in the gesture of adoration and holds lotus buds in the others.

—R. L. B.

Life of the Buddha
Eastern Tibet, 19th century
Opaque watercolors on cotton
34¼ × 149 in. (87 × 378.5 cm.)
Musée Guimet, Paris

Major events from the life of the
Buddha are depicted with profuse
detail in this busy work. A few
scenes that are not generally
included in such narrative scrolls
bear noting here. In the center of the
painting is an enthroned image of
Sakyamuni accompanied by his two
principal disciples, Sariputra and
Maudgalyayana. More interesting,
however, is the scene below the
elaborate throne that illustrates the
Buddha's conversion of Hariti, the
malevolent, child-devouring Mother
of Demons. While this story is found
in Indian Buddhist canonical lit-
erature and later became particu-
larly popular in China (see no. 61), it
is only rarely represented in the art
of other countries. The Tibetan
representation illustrated here fol-
lows a Chinese pictorial tradition
that dates at least to the Song period
(960–1279).

The Buddha hid Hariti's favorite
child under his alms-bowl in
order to teach her the anguish
she caused to human beings
when she devoured their chil-
dren. In return for her promise
to stop killing, Sakyamuni
allows Hariti a glimpse of the
child under the bowl, where-
upon she exhausts her powers in
a vain attempt to free him.
Finally, she agrees to obey the
Buddhist prohibitions and her
child is restored to her. *(Murray,
p. 256)*

16b

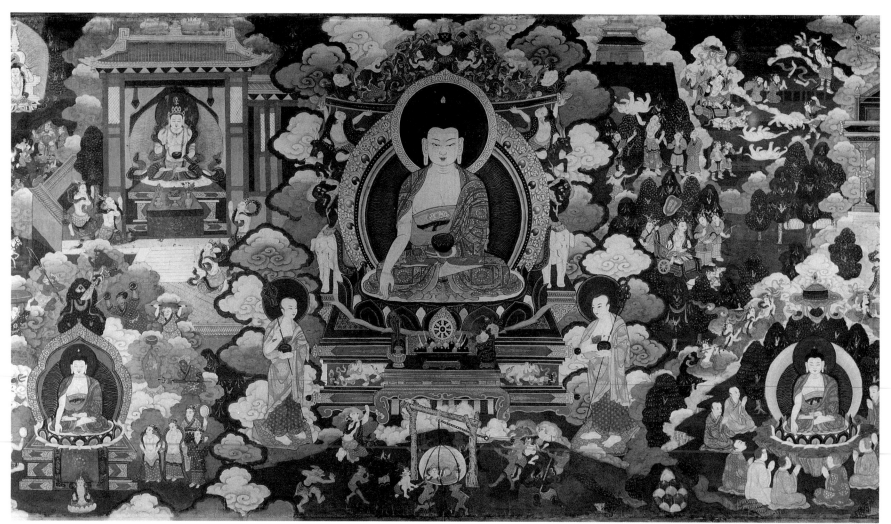

In the scroll, following the Chinese manner, a group of demons pull a rope from which a glass bowl containing Hariti's child is suspended. Hariti herself kneels and begs the Buddha's forgiveness.

The scenes of heaven and hell illustrated in segment (a) are also unusual. Seated in a pavilion beside blue and green rocks, a Buddha (either Sakyamuni or Amitabha) watches a heavenly dancer accompanied by several celestial musicians. This scene is reminiscent of the typical representation of paradise—especially the Western Paradise—in Chinese paintings. (See the essay in section four of the catalogue for further discussion of Amitabha Buddha and the Western Paradise.) Immediately below and slightly to the left is hell, where the damned, floundering in icy water or engulfed in flames, are confronted by angry deities.

Two other scenes show interesting idiosyncratic deviations: In the middle segment (b) immediately to the right of the central shrine, we see the young Siddhartha displaying his skill by lifting an elephant with his right hand. This feat is not described in any of the known texts but is characteristic of the behavior of heroes in Central Asian legends.

An amusing detail is added in the representation of the Nativity cycle in the upper right-hand corner of the third section of the scroll (c). Here, the newborn infant is actually shown jumping from one flower to the next as he takes the seven steps that announce his spiritual sovereignty.

The style of this scroll is typical of the province of Kham in eastern Tibet, where a lively tradition of narrative painting developed in the sixteenth century.

—P. P.

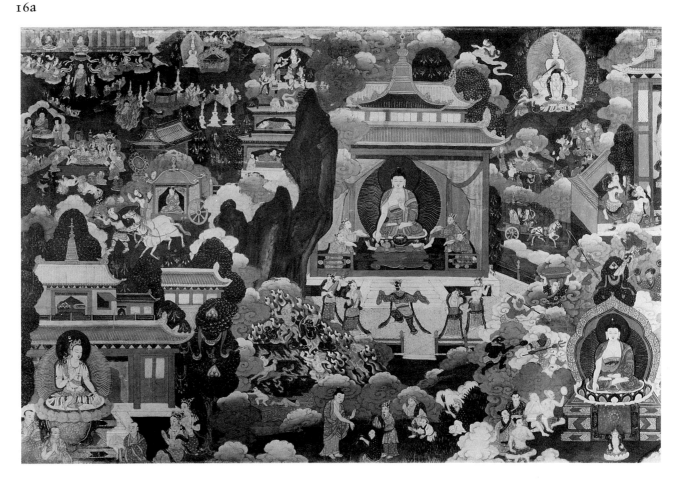

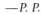16c

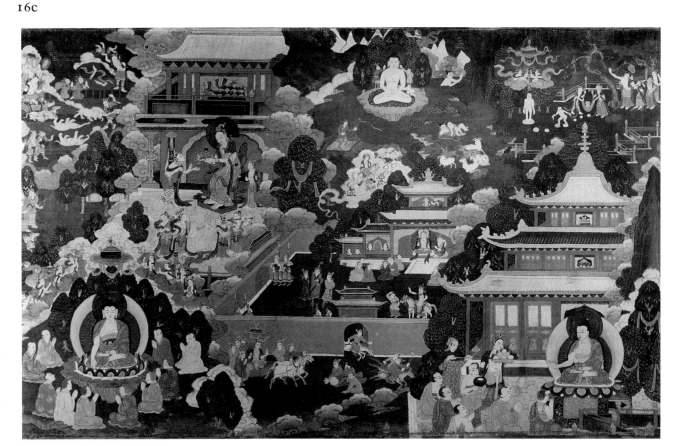

17

Katsushika Hokusai
(Japanese, 1760–1849)
The Illustrated Story of Sakyamuni's Life; Edo period, 1845
Six volumes of woodblock prints
Each page: 5 × 8⅛ in. (12.7 × 20.6 cm.)
Spencer Collection, The New York Public Library

Painted and printed versions of the Buddha's life were popular in nineteenth-century Japan. The six-volume narrative *Shaka Goichidaikai Zue (The Illustrated Story of Sakyamuni's Life)*, written in 1839 by Yamada Isai and illustrated by Hokusai, typifies the elaborate and idiosyncratic Buddhist art of the period. Chapter one of this text begins by noting that the story of Sakyamuni has been recounted in "numerous earlier books" and stipulates that this version is intended for the "instruction of women and children." The set was obviously popular, since two later editions were issued in 1845 and 1884.

The designs Hokusai produced for this text are stylistically similar to those he created for translations of Chinese literature during the first decades of the nineteenth century. The illustrations represent particularly dramatic episodes from the life of the Buddha, and they are presented in a great variety of formats—both vertical and horizontal double-page compositions and single-sheet designs. The figures are often presented in the dynamic style associated with Hokusai's portrayals of famous warriors, such as the heroes of the *Suikoden* (1807) or *Chushingura* (1808), rather than his realistic portrait style. Interestingly, some of the episodes wherein Sakyamuni displays the classical virtues of wisdom, benevolence, and bravery draw upon the poses and compositions that the artist used to illustrate Japanese mythological heroes in their battles with supernatural beings.

The first of the illustrated illuminations, *Sakyamuni Coming Down the Mountain* (a), is from a group of four that accompanies the preface. These initial illustrations are intended to introduce the reader to the basic cast of characters encountered in the text, among them Sakyamuni and his wife, Yasodhara. Each figure in this prefatory group is shown singly, without a landscape or architectural setting. Sakyamuni is depicted with his feet resting on lotuses, and he appears to float in a starry atmosphere. His hair is arranged in soft waves around a bald spot, and he is amply covered by the traditional priest's robe *(kesa)*, which is made of appliquéd patches. The jaunty mustache and whiskers are typical of Hokusai's portraits of foreign subjects (Hillier, pp. 45–46). The image is surrounded by a border in a cloud design, and a circular cartouche in the upper right bears a single character which may be read as "void" or "emptiness." In the lower left, a brief explanatory label reads:

"Image of Sakyamuni Nyorai, founder of the Buddhist faith."

In contrast to the four frontispiece illustrations, pages filled with crowded and active scenes dramatize the actual biographical episodes. Following a convention established in eighteenth-century ukiyo-e versions of Sakyamuni's life, Hokusai often combines several events within a single composition (cf. no. 25). This is the case in illustration (b), which treats the miraculous events associated with Sakyamuni's Birth: the seven steps, the lustration at the Lumbini gardens, and the first speech. Statuelike, the naked Sakyamuni stands on a large, lotus-shaped basin resembling that used in ceremonies involving bronze baby Buddha images *(tanjobutsu)* (see no. 26). Two mythical dragons bathe the divine child from above, and crowds of earthly and divine witnesses fill the right side of the composition. This audience is arranged cosmologically; the human figures are separated from the divine by layers of thick, billowing clouds. At the lowest level are a throng of patriarchs modeled on Hokusai's conventional foreigner type. Above the clouds are the Six Divine Kings and the Guardians of the Four Directions (four identical figures, each of which carries a different weapon and is oriented toward a different vantage point). Two diminutive bodhisattvas are shown seated in aureoles above the assembled deities. An explanatory label reads: "I alone am the most honored in the four cardinal spheres" (Baskett, p. 91). A second note below describes the scene as the Birth of Siddhartha.

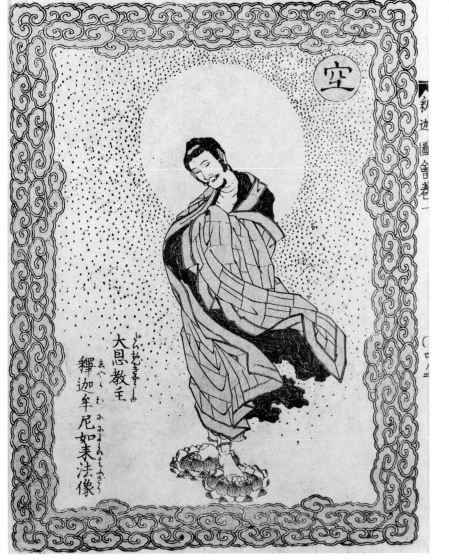

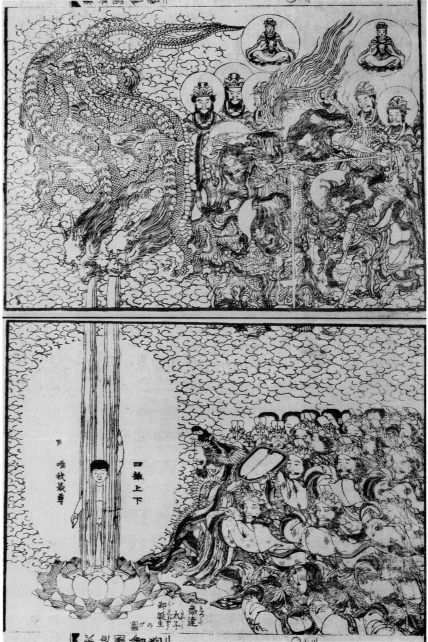

In a third illustration (c), the contrived theatricality of Hokusai's composition is readily apparent. A nine-footed ghost, described as having eight faces, hovers with one of its feet raised above and in front of the Buddha, "tempting" him. Although the subject is not described as such, it may symbolize the attack of Mara's army (Baskett, p. 92). In an unusual twist, Sakyamuni, seated in meditation, presents his back to the viewer. The repetitive designs that Hokusai employs in the figures of the Buddha and the ghost effectively emphasize their opposition. The explanatory note for this last illustration reads: "An eight-faced nine-legged ghost attempts to test Prince Siddhartha."

—A. G. P.

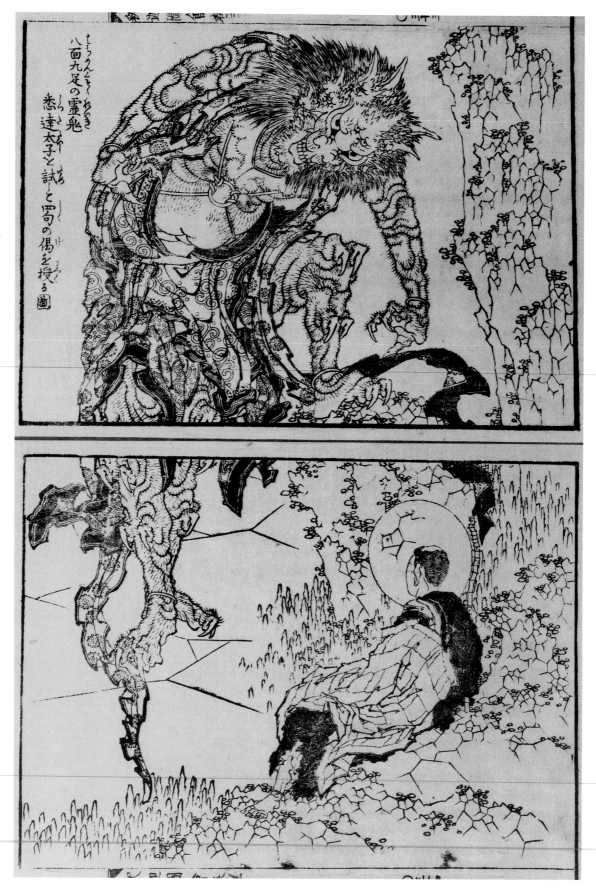

Individual Episodes from the Life of Buddha Sakyamuni

Entries no. 18 through 66 are arranged following the chronology of events in the Buddha's life.

The Conception
Pakistan (Ancient Gandhara),
2nd–3rd century
Gray schist
h: 10⅜ in. (26.4 cm.)
Asian Art Museum of San Francisco,
The Avery Brundage Collection

When the mighty and mindful one passed away from his abode in Tusita, taking on the form of an elephant of the colour of a snow-white boar,
Mindful, self-possessed and virtuous he descended into his mother's womb as she lay abed high up in the palace, fasting and clothed in pure raiment.
(Jones, vol. 2, p. 11)

Thus the dream of Maya is described in the *Mahavastu*, a text compiled shortly before the birth of Christ that contains a legendary biography of the Buddha. In this simple relief from Gandhara, the divine elephant is seen descending from the Tushita Heaven to enter Maya's womb as she sleeps. On the other side of the column, a female guard stands below a leafy canopy. A lamp above the recumbent Maya's legs and the disc of the full moon atop the canopy indicate that this is a night scene.
—*P. P.*

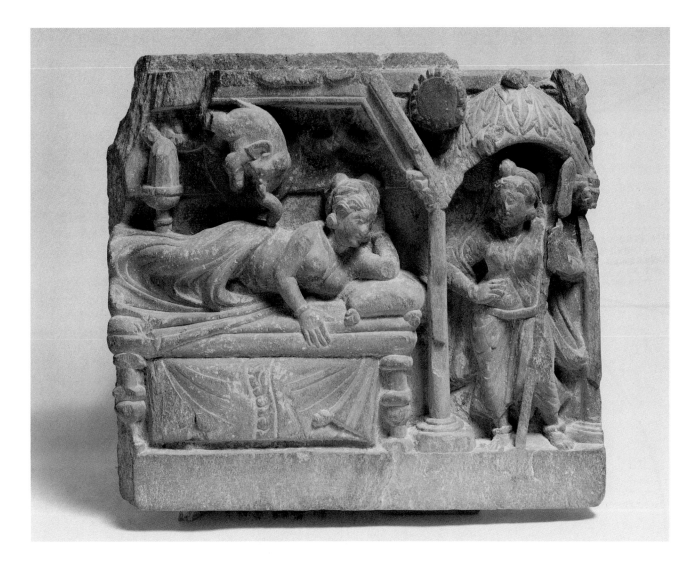

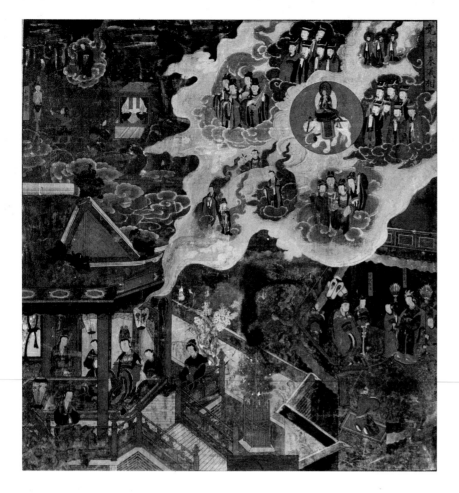

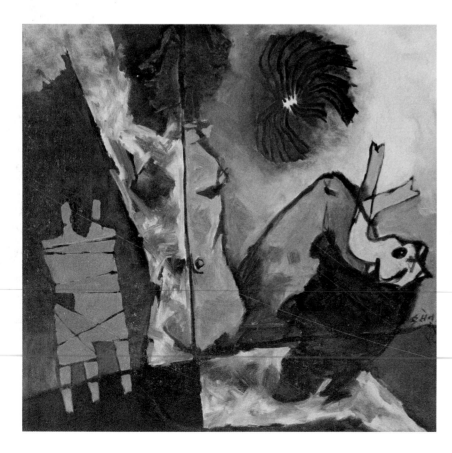

Maya's Dream and the Conception
Korea; Yi dynasty, 18th century
Ink and colors on cloth
45¼ × 41½ in. (115 × 105.3 cm.)
Baekyang-sa, Cholla-namdo Province, Lent by the Dongkuk University Museum, Seoul

The bold diagonal composition of this work emphasizes Maya and her attendants in the lower left; a white cloud is employed to link this scene to the assemblage in the upper right. The cloud-encompassed area represents the Tushita Heaven, where the bodhisattva, or future Buddha, rides a six-tusked white elephant surrounded by musicians and male figures. The latter wear eighteenth-century garments characteristic of a strongly Confucian age. Cartouches identify the smaller scene in the lower right as Suddhodhana and Maya asking the family priest to interpret Maya's dream. In the upper left, another cartouche describes pregnancy, and a female figure stands alone as if being instructed.

Compositional problems often arise when artists are required to illustrate more than one event in a story. The use of the diagonal in this particular work enables one to immediately identify the subject, while animating the narrative in much the same manner as the earliest Buddhist representations at Bharhut in India did, two thousand years before. This eighteenth-century painting, which forms a pair with no. 37, thus successfully continues a long tradition of Buddhist narrative works that achieve artistic quality while remaining within scriptural limits.

—R. E. F.

M. F. Husain (Indian, b. 1915)
Maya the Dream, 1972
Acrylic on canvas
51 × 51 in. (129.5 × 129.5 cm.)
Mr. and Mrs. Chester Herwitz
Family Collection

Like the print by Munakata (no. 131), this painting by Husain, one of the most distinguished artists of contemporary India, eschews traditional iconography in favor of a more individual and abstract expression. Using the motif of the elephant entering Maya, Husain has enriched the composition with other distinctly idiosyncratic symbolic images. For instance, Maya is depicted with a divided body, the right half being less developed than the left. The gray form in the painting's lower left-hand corner, which is reminiscent of Henry Moore's imagery, may represent a compressed symbol of humanity. The whirling mass in the upper right is a variation of a cosmic symbol that occasionally appears in Husain's works.

Despite a lack of formal training, Husain is a versatile artist who not only paints but also makes films and writes poetry. He has exhibited widely in India and abroad, and in 1968 he was awarded the Golden Bear at the Berlin Film Festival for his film *Through the Eyes of a Painter*.

—P. P.

21

*Stele with Sakyamuni and Scenes
from His Life*
China; Northern Wei dynasty (386–
535), early 6th century
Buff sandstone
h: 27¹⁵⁄₁₆ in. (71 cm.)
Nelson Gallery—Atkins Museum,
Kansas City, Missouri (Nelson Fund)

In this relief, the Buddha sits in a
shallow niche beneath a curious, on-
ion-shaped dome. His raised right
hand is webbed between the index
finger and the thumb, and his left
hand grasps the end of his garment
in a far more prominent fashion than
is typical for Indian Buddhas. The
disproportionately large left hand
and the two fingers extending
considerably beyond the niche are
highly unusual. Interestingly, the
Buddha's eyes are completely shut,
as if he is in a deep trance, but his
countenance remains serene. The
lower rim of the arch above
Sakyamuni ends in the forepaws of
two rather amusing dragons, and the
body of the arch itself is filled with
delicately carved floral patterns.

The figures surrounding Sakyamuni
are also rendered in extremely shal-
low relief; a row of donors along the
bottom of the stele appears unfin-
ished. On each side of Sakyamuni is
an ascetic displaying the gesture of
adoration and a crowned bodhi-
sattva holding a flower.

The two scenes portrayed in the up-
per corners, separated by a pair of
celestials playing musical instru-
ments, are particularly noteworthy.
The scene on the left depicts the
Birth of the Buddha in the typically
decorous Chinese manner, with the
infant's head being pulled by a god as
it emerges from Maya's left sleeve.
The Chinese, however, have tradi-
tionally shown the infant Buddha
emerging from Maya's right sleeve, a
device which has also been adopted
by the Japanese.

In the opposite corner, the infant
Buddha stands with his hands in the
gesture of adoration, perhaps sup-
ported by the same figure who held
him at the moment of his Birth. Very
likely this scene represents the Bud-
dha's seven steps, although he is nor-
mally not shown with his hands in
this position (cf. nos. 25–29).

Apart from its iconographic interest,
this stele is also aesthetically appeal-
ing and introduces us to a style of re-
lief sculpture in which the Northern
Wei artists excelled. This "curiously
linear and elongated style is charac-
teristic of a regional school centered
around Sian, Shensi province"
(Taggart et al., p. 29). Because of the
linear definition of the forms and
the shallowness of the relief, the fig-
ures appear particularly animated.
Students of Romanesque art will
find this style quite familiar. As Ben-
jamin Rowland has written: "The
approximate similarities of tech-
nique and purpose result in startling
approximation of the actual mate-
rial forms, even though the works of
art under consideration were created
in widely separated areas and cen-
turies removed in time" (Rowland,
1968, p. 52).

—P. P.

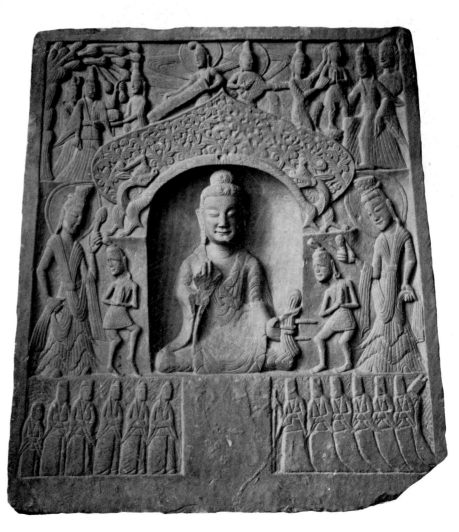

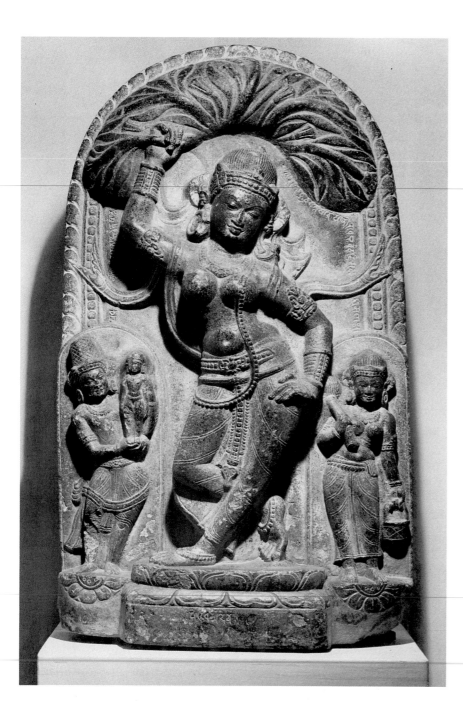

The Nativity
India, Bihar; 9th century
Gray schist
h: 23½ in. (59.7 cm.)
The Newark Museum

More elaborate than the Nepali version (no. 24) but less so than the Cambodian relief (no. 23), this representation shows the infant Siddhartha being received by Indra, the king of the gods. Wearing his miter, Indra holds the infant as if he were displaying a statue. In keeping with the usual Indian convention, Siddhartha appears as a fully grown figure simply reduced in scale, rather than as a child. On Maya's left is a nimbused female holding a fly whisk in her right hand and a bag in her left. The halo behind her head identifies her as a goddess rather than as Maya's sister Mahaprajapati, who is usually shown supporting Maya, as in the Cambodian relief (no. 23).

It is clear that the earlier narrative intent (cf. no. 1) is eschewed here for a more hieratic representation in which Maya appears as a goddess. This is evident not only from the fact that she is much larger than the other figures but also by the absence of the actual Birth and the substitution of a divine attendant for her sister.

—*P. P.*

The Nativity
Cambodia, 13th century
Stone
h: 30 in. (76.5 cm.)
National Museum, Bangkok

In this very clearly composed depiction of the Nativity, Maya, supported by her sister Mahaprajapati, is shown holding the branch of a tree. The baby Buddha, adorned with ornaments and a crown, springs from his mother's side and is received by a god whose multiple faces and four arms identify him as Brahma. Indian versions of the Birth usually depict Indra receiving the infant Buddha (see no. 22). The various Buddhist texts give different accounts of the gods in attendance at the Buddha's Birth; it is the *Lalitavistara* that mentions Brahma in addition to Indra (see the essay in this section of the catalogue). Standing behind Brahma on the Cambodian carving are three unidentified gods, who are probably intended to make, with Brahma, a group of four deities—several texts group the gods present at the Birth in fours.

It is interesting to note the hand and arm positions assumed by this baby Buddha. Although he holds his right hand in the gesture of reassurance with his left arm extended at his side—as is frequently found in Indian examples—it is easy to see how, with the extension of the index finger on each hand, the standard formula of the Nepali and East Asian baby Buddhas is achieved (cf. no. 29).

—*R. L. B.*

The Nativity
Nepal, 19th century
Gilt copper, inlaid with
semiprecious stones
h: 21⁷⁄₁₆ in. (54.5 cm.)
Musée Guimet, Paris

In this late gilded Nativity image
from Nepal, the familiar tree, now
encrusted with semiprecious stones,
has become stylized and more celes-
tial than earthly in character. Al-
though a millennium separates this
Birth scene from the earlier Indian
representation (no. 22), the persis-
tence of the iconographic tradition is
remarkable. In all probability, these
two examples were not intended as
parts of any narrative sequence, and
they may therefore indicate a minor
cult of the Nativity. If they were
used in annual celebrations of the
Buddha's Birth, they could in fact
represent the Indo-Nepali coun-
terpart of the East Asian cult of the
infant Buddha.

—*P. P.*

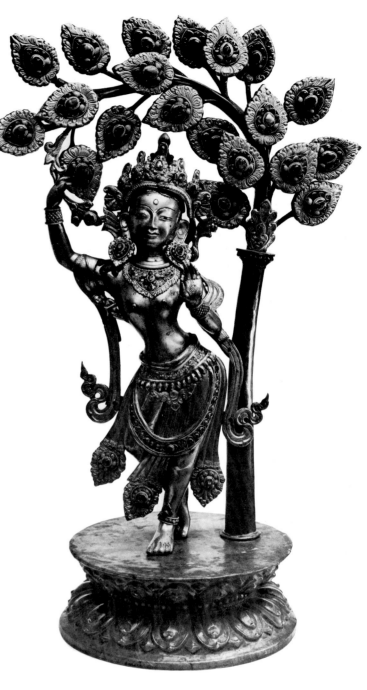

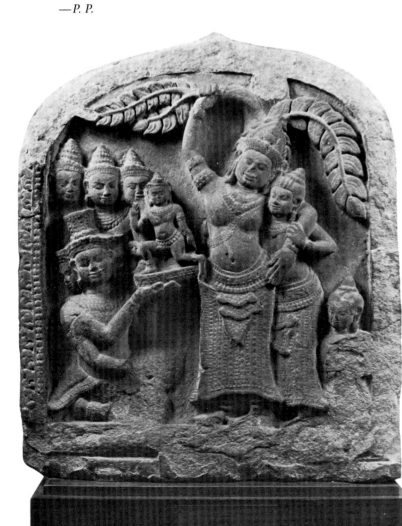

Nishimura Shigenaga
(Japanese, c. 1697–1756)
The First Bath of Sakyamuni;
Edo period, 18th century
Woodblock print, hand colored
11¹⁵/₁₆ × 5¼ in. (30.3 × 13.3 cm.)
Fogg Art Museum, Harvard University, Cambridge, Massachusetts,
Gift of Mrs. Henry Osborn Taylor

In this ukiyo-e print, Shigenaga combines scenes of Sakyamuni's Birth and the ritual bathing in the Lumbini garden. The infant Sakyamuni (Shaka in Japanese) stands on a lotus rising out of a pond and is showered by two *nagas* (serpents), portrayed here as fearsome dragons. Queen Maya and King Suddhodhana sit on either side of him, and four noble attendants kneel in front; all are attired in court dress.

It is interesting to note that in most Japanese prints illustrating the first bath of the infant Buddha, the Indian *nagas* are replaced by Chinese dragons. Both textual and artistic evidence indicate that this substitution had occurred in China as early as the Tang period (618–906) (Whitfield, pls. 31–32).

— *A. G. P.*

[Although the inscriptions on this print identify the scene as "the Birth and first bath," in point of fact only the latter event is depicted. Moreover, the strict symmetry of the composition, the hieratic representation of the baby Buddha in the center, and the scene of worship at the bottom clearly make this an icon rather than a narrative representation. In addition to the dragons, the costumes of the royal couple and the worshipers further emphasize how the occasion has been converted into a Japanese court scene; only the infant Buddha's loincloth announces his Indian origin. More important for us is the scene of worship at the bottom of the print where the devotees are seen performing the annual lustration ceremony of the baby Buddha, as is done every spring in Japanese temples even today.
— *P. P.*]

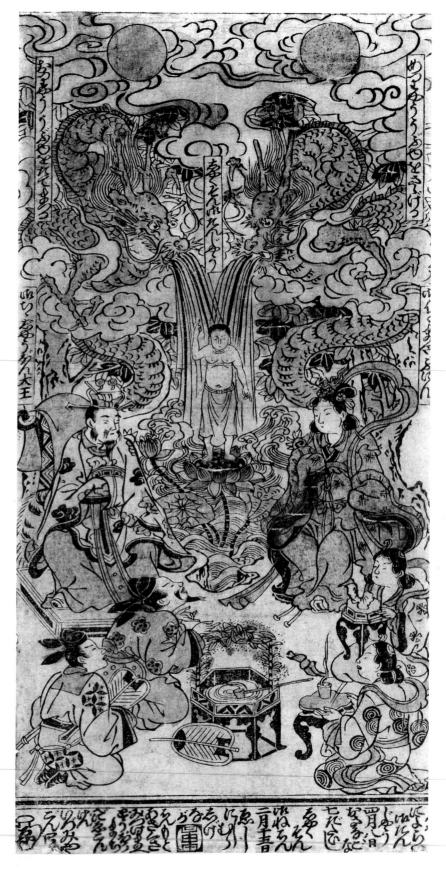

26

(a) *Sakyamuni as a Baby*
Japan; Nara period, 7th century
Bronze
h: 8³⁄₁₆ in. (20.8 cm.)
Private Collection

(b) *Sakyamuni as a Baby*
Japan; Nara period, 7th century
Bronze
h: 4½ in. (11.4 cm.)
Private Collection

The *Kako-genzai-inga-kyo (Sutra of Cause and Effect, Past and Present)*, which contains a biography of Sakyamuni, describes Siddhartha's Birth and lustration thus:

> The birth occurred on the eighth day of April. The newly-born Sakyamuni took seven steps unaided, raised his right arm and majestically intoned, "I alone am honored in heaven and on earth. This triple world is full of sufferings; I will be the savior from these sufferings." Seven lotus blossoms then appeared in the seven footprints he had made. Catvaro maharajikah (Four Heavenly Kings), Sakro devanam indrah (Taishakuten) [Indra, king of the gods] and Brahma-deva (Bonten) [the god Brahma] then appeared on either side of him, celebrating his birth, and the Two Dragon Kings showered pure water of two kinds, warm and cool, down from the sky over his body. The eight kings of beings played music, burned incense, scattered flowers, and let fall heavenly garments and jewelled necklaces. *(Asuka Historical Museum, p. 133)*

The two bronze images included here portray the infant Sakyamuni just after his miraculous Birth. In both sculptures, he stands facing the viewer with his right hand raised to the sky and his left pointing toward the ground. Several sutras describe Sakyamuni as assuming this stance at the moment when he first spoke, after taking his seven steps. Although an infant, he already displays some of the distinguishing signs of Buddhahood, among them the bump on the top of the head *(ushnisha)* and the snail-curl coiffure. (See the essay The Buddha Image in India in section three of the catalogue for a more complete description of these signs.) He wears only a loincloth.

The *tanjobutsu* (baby Buddha) figure is very popular in Japan, where on April 8 of each year it is used in a ceremony called Kambutsu. This ritual entails pouring water or tea over statues such as those illustrated. The origin of the ceremony is to be found in accounts from a number of sutras describing the dragon kings' lustration of the newborn Sakyamuni (Asuka Historical Museum, p. 131). The ceremony seems to have been practiced in Japan as early as the seventh century, and the usually small, ceremonial *tanjobutsu* figures have been found throughout Japan. Although a few of these were made of wood, most of the known images are of bronze—

clearly a more appropriate material for this usage. The Nara period (646–794) sculptures included in this exhibition may originally have been raised on lotus bases, but few *tanjobutsu* figures with a full pedestal survive.

—*A. G. P.*

[The use of a lotus base may be seen in the Korean and Chinese baby Buddha sculptures (nos. 27 and 28), as well as in the ukiyo-e print (no. 25). Interestingly, the ritual mentioned in this entry is shown being performed in the print.—*P. P.*]

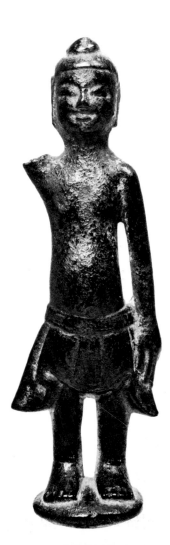

27

Infant Buddha
Korea; Unified Silla dynasty,
8th–9th century
Gilt bronze
h: 10⅝ in. (27 cm.)
Kwak Yong-dae, Seoul

Sculptures of the newborn Buddha are well known in East Asia, and the many remaining Korean examples indicate the considerable popularity of the image. As in most Korean sculptures of this type, Sakyamuni stands erect with his right arm extended above his head—a gesture signifying the moment after the taking of the seven giant steps that symbolize his conquest of the world. This triumphant pose, more regal than childlike, reflects the momentousness of the event. Often, infant Buddhas are shown with both arms at their sides, and these images, which more accurately portray a newborn child, signify the lustration of the baby prince. Some newborn Buddhas are represented nude, but more commonly the figures wear a simple garment around the waist that occasionally trails to the ankles. The unique infant Buddha illustrated here wears only flowing scarves, such as can be found on bodhisattva images of the same period. This unusual garb enhances the majestic calm expressed in the figure's face and body. The elaborate base is of a type often found among Korean Buddhist bronzes of the eighth and ninth centuries, and the figure is similar to the well-known version owned by the Todaiji in Nara that is believed to date from the year 752.

—R. E. F.

28

Infant Buddha
China; late Ming dynasty,
16th–17th century
Gilt bronze
h: 11¼ in. (28.5 cm.)
Paul F. Walter

Like the cult of the baby Krishna (a Hindu deity) in India, that of the infant Buddha appears to have once been popular throughout East Asia. It still plays an important part in Japanese Buddhist ritual, where images of the baby Buddha are washed and worshiped during annual festivals celebrating the Birth of Sakyamuni (see nos. 25 and 26). Fewer images of the infant Buddha have survived in China than in Japan, but examples such as this elaborate Ming dynasty (1368–1644) baby Buddha establish the existence of a Chinese cult. Although no precedent for this image is known in India or in other Buddhist countries, the fifth-century Chinese example in The Cleveland Museum of Art and numerous early Japanese statues indicate the antiquity of the cult. Very little is known, however, of its nature or origin in China.

In this statue, the infant Buddha, clad only in a sash, stands atop an open lotus. The flower's stem emerges from the cosmic ocean which is sheltered from our view by a balustrade. The plump and cherubic boy, whose features are clearly Chinese, points toward the earth with his right hand while pointing skyward with the index finger of his left hand. The arms appear to be reversed here; generally, the right hand is raised, with the left pointing downward (cf. nos. 25, 26, and 27).

Interestingly, the artist has added four animals around the stem of the lotus. These are the elephant, monkey, tortoise, and dragon (the East Asian counterpart of the *naga*, or serpent). All four animals play important roles in the *jataka* (previous-birth) stories concerning the Buddha; thus their presence is not inappropriate. These creatures have relevance for the secular life of the Chinese as well: The elephant is "the symbol of strength, sagacity, and prudence"; the monkey is said to "bestow health, protection, and success on mankind, if not directly, indirectly, by keeping away malicious spirits or goblins"; while, along with the unicorn and the phoenix, the tortoise and dragon constitute "the four spiritually endowed creatures" (see C. A. S. Williams, 1960, for a more detailed explanation of these symbols).

—P. P.

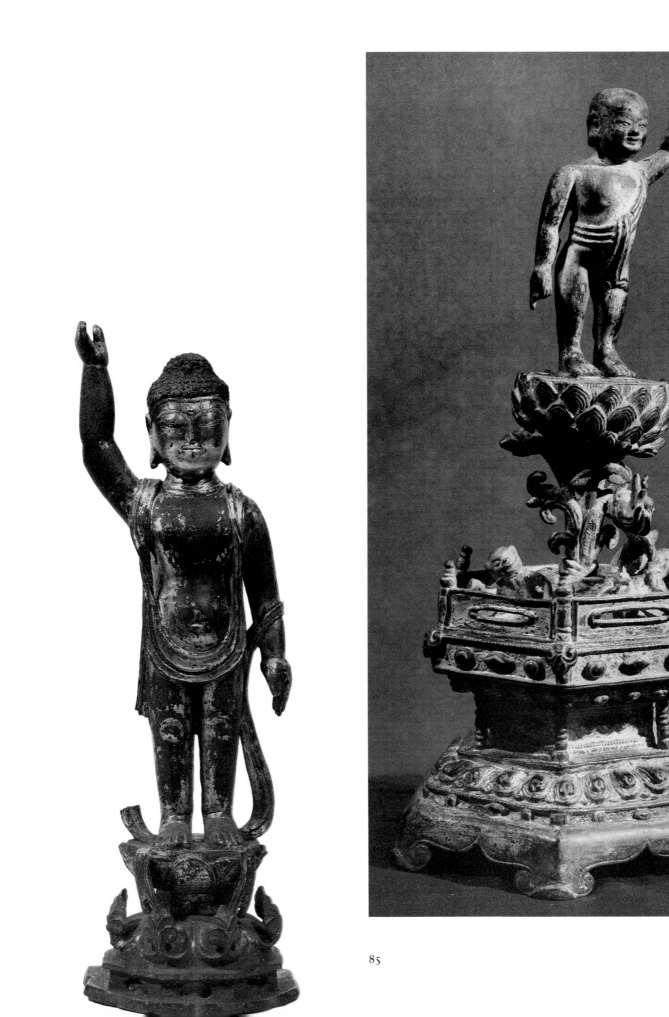

85

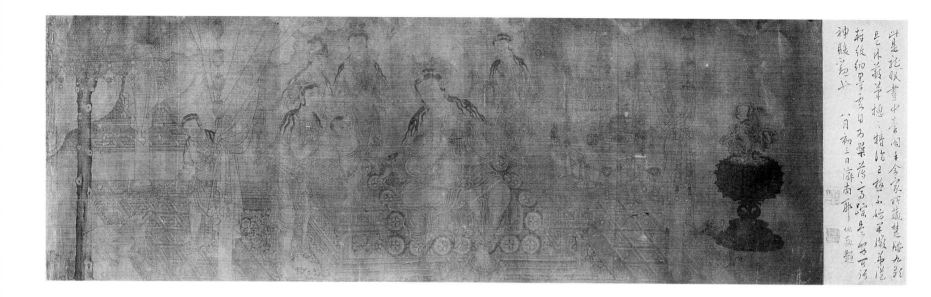

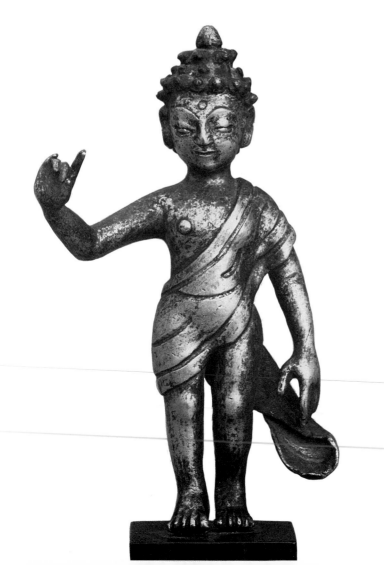

29

Infant Buddha
Nepal or Tibet, 16th century
Gilt copper with traces of
polychromy
h: 4 in. (10.2 cm.)
Ex Pan-Asian Collection, Property
R. H. Ellsworth Ltd.

This is a rare example of a
freestanding image of the infant
Buddha from Nepal or Tibet. No
independent cult of the baby Buddha
is known to have existed in either of
these countries, as it did in China
and Japan (see nos. 25, 26, and 28). It is
possible that the bronze was
originally part of a larger composi-
tion depicting the Birth scene and
thus served in a narrative context.
Alternatively, the image may have
been used in ceremonies associated
with the annual festival of the Bud-
dha's Birth.

The baby is clad as a monk, with a
piece of cloth thrown over his shoul-
der. His right hand is raised, with the
finger pointing to the sky as is usual
in Chinese and Japanese representa-
tions. Although his body and face
are childish, the addition of the *urna*
(a mole or dot between the eye-
brows) and the rendering of the hair
are features borrowed from the adult
Buddha. The right nipple is promi-
nently shown, and atop the
ushnisha (cranial bump), another
protuberance is placed that probably
symbolizes the flame of wisdom.

—*P. P.*

30

Wang Zhenpeng (Chinese, active 1280–1329)
Mahaprajapati Holding the Infant Buddha; Yuan dynasty, early 14th century
Handscroll
Ink on silk
12⁹⁄₁₆ × 37³⁄₁₆ in. (31.9 × 94.5 cm.)
Museum of Fine Arts, Boston—Chinese and Japanese Special Fund

This is one of a very few Chinese paintings that depict Siddhartha with Mahaprajapati, who was both his aunt and his stepmother. Appended to the handscroll is an extract from the *Prajnaparamita*, a philosophical text that has nothing to do with the life of the Buddha. The following excerpt from another text, the *Manorathapurani*, seems to more closely approximate this representation of the lavish environment Suddhodhana created for his son.

> Devoid of all foul things, sprinkled with fragrant water, strewn with flowers, perfumed with rare incenses burned in censers, and decorated with banners of colored silk, tasselled hangings, bejewelled pennants, garlands, and nets bedecked with pearls …indeed with all manner of precious things resplendent as the light of the sun, the moon and the stars… (Tomita, p. 13)

Within such an elaborate setting, Prince Siddhartha is cradled in the lap of his stepmother, who amuses her royal charge with a peach held in her left hand. Mahaprajapati's natural child, Nanda, stands nearby, attended by two nurses. As Nanda also seems to covet the peach his mother holds, the nurses may be interpreted as restraining, rather than supporting, the child. Two other nurses wait in the background, holding a peacock-feather fan and a bowl of flowers probably intended to distract the royal infant. At the left a boy feeds a lion, which, although perhaps intended as a diversion for Siddhartha, may also function as a symbol of the Buddha: "the precious lion that has come into the world" (Tomita, p. 13).

Barely legible on the lower part of the tree trunk at the extreme left of the scroll is the tiny signature of Wang Zhenpeng [Wang Chen-p'eng], who was known for his masterful rendering of architectural complexes using minute detail. The delicate linear style, with fine lines drawn in black ink, is called *baimiao*.

—G. K.

31

Siddhartha Goes to School
Pakistan (Ancient Gandhara),
2nd century
Gray schist
h: 12⅞ in. (32.5 cm.)
Victoria and Albert Museum

Young Siddhartha is shown here riding to school in a chariot drawn by two rams. The driver of the carriage appears to be walking by its side. Companions holding writing tablets and inkwells (?) accompany the prince, while a monklike figure stands reverentially behind him.

Only in reliefs from Gandhara do we encounter Siddhartha riding to school in a conveyance drawn by rams. This mode of transportation may have been common for the affluent children of the region. It is not, however, mentioned in any biography of the Buddha. This work was recovered from the Charsadda district in Pakistan, and it provides a fine example of the Greco-Roman style of relief sculpture favored by Gandhara artists in the early centuries of the Christian Era.

Despite the insistence on naturalistic representation, this relief and others like it from Gandhara represent the Buddha in his idealized, divine form rather than as a normal human child. He is clad in the garments of a monk, a *ushnisha* appears on his head, and he is even provided with a halo to indicate his divinity. Only his relatively small size betrays his adolescence. This again serves to emphasize the fact that the Buddha was depicted in art only after his divinity had become well established.

—P. P.

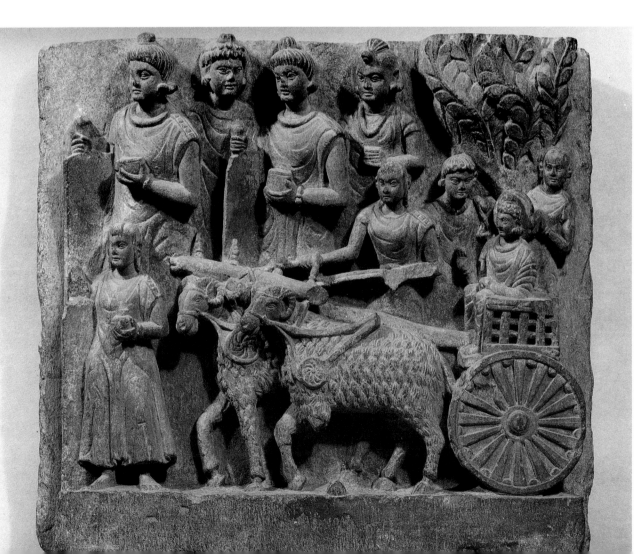

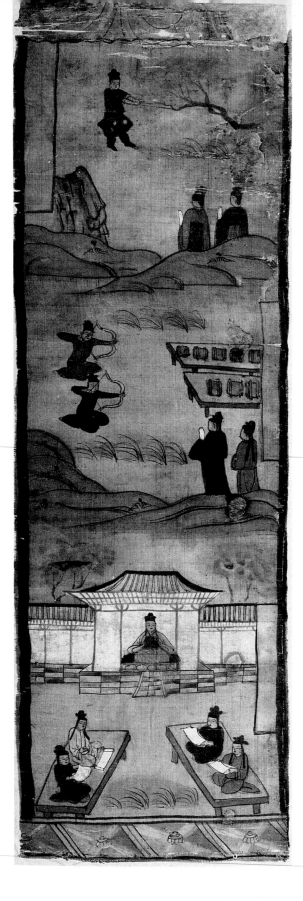

32

The Education of Siddhartha
China, Dunhuang Cave Temples;
9th century
Ink and colors on silk
24⅜ × 7⅝ in. (62 × 19.5 cm.)
Musée Guimet, Paris
(Reproduced in color)

This banner, along with another in the exhibition (no. 34), once flanked the central wall paintings in the caves at Dunhuang in Gansu. The ordering of scenes within a single banner suggests that a sequential order was also intended for their presentation as a group (Whitfield, p. 329). The incidents illustrated in the Guimet banners are also depicted on examples in the Stein Collection of the British Museum and in the National Museum, New Delhi (Whitfield, pp. 326–32).

Represented on this particular banner are three of the competitions in which Prince Siddhartha proved himself superior to all the other Sakya youths and a worthy husband for Yasodhara. In the uppermost scene, Siddhartha uproots a tree with his bare hands. The central scene portrays an archery contest, in which two figures are preparing to shoot at iron drums. The archer most distant from the target is undoubtedly the prince, who will thereby prove victorious over greater odds. As in the scene above it, two dignitaries view the match. The final scene illustrates a competition involving a knowledge of literature and mathematics. The official administering the examination sits in a pavilion, while the four competitors occupy two parallel benches set within the garden of the prince's palace. The figure clad in a yellow robe with his right hand raised, who sits nearest the examiner on the left side of the painting, is probably Prince Siddhartha. Within each vignette is a blank cartouche, a device often found in banners depicting well-known episodes from the life of the Buddha, which require no identification for the viewer.

—*J. B.*

[Although unprecedented in India, it is interesting that in keeping with the Chinese emphasis on the civil service examination, Sakyamuni engages in competition in the areas of literature and mathematics, which would be emphasized in administrative training.—*P. P.*]

33

Miracle below the Jambu Tree
India, Andhra Pradesh;
2nd–3rd century
White limestone
h: 15½ in. (39.4 cm.)
Los Angeles County Museum of Art,
Gift of the Ahmanson Foundation

The principal event depicted in this work is Siddhartha's trance below the *jambu* tree. Although in one version of this story the prince appears as a child, in another he is described as a young man. The latter representation characterizes this relief. Although the incident occurred long before the Enlightenment, the artist has added a halo behind the future Buddha's head to indicate his divinity. The turbaned male adoring Siddhartha is undoubtedly his father, while the female is his foster mother, Mahaprajapati. Although the two were present on this occasion, most texts do not state that they adored the prince.

The scene of Siddhartha's departure in search of enlightenment is illustrated above the *jambu*, separated from it by a railing. In this scene, the horse's back appears to be empty, but the four *yakshas* (nature deities) muffling its hooves are clearly visible.

The juxtaposition of the two events in the same relief is not accidental. According to Asvaghosha's *Buddhacharita*, it was while seated under the *jambu* tree that Siddhartha first pondered the wretched state of existence and then conversed with a monk who convinced him to renounce the world (Johnston, pp. 63–65). Thus, the placement of the departure immediately above the miracle of the *jambu* tree is perfectly appropriate.

Rendered in shallow relief in the delicate Amaravati style (see nos. 36 and 38), this fragment was once part of a casing stone for a stupa at Gummididurru in Andhra Pradesh.

—*P. P.*

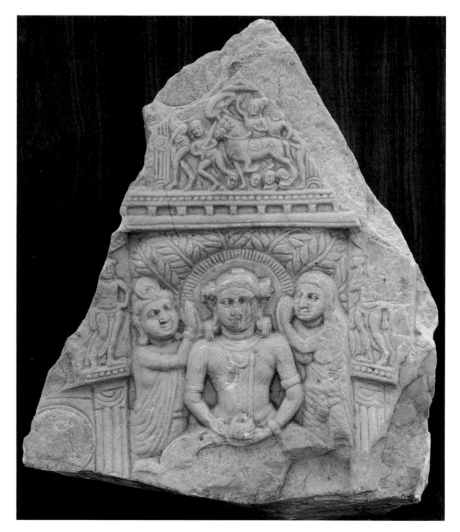

34

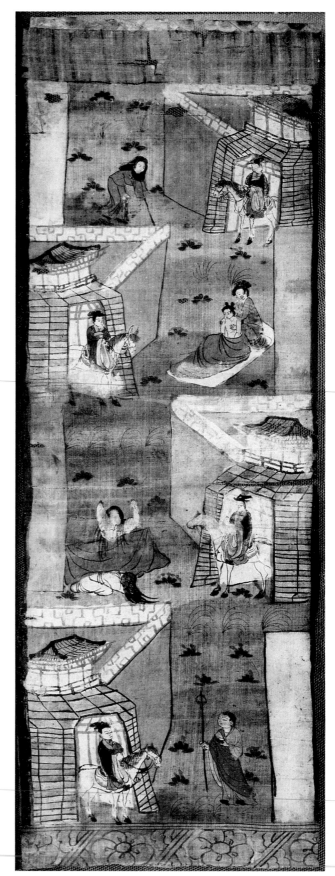

*The Four Encounters of
Prince Siddhartha*
China, Dunhuang Cave Temples;
9th century
Ink and colors on silk
22¹⁄₁₆ × 7½ in. (56 × 19 cm.)
Musée Guimet, Paris
(Reproduced in color)

This banner depicts the four
encounters that induced Siddhartha
to renounce his princely life and
search for enlightenment. The four
scenes are divided by the recurrent
image of the prince on horseback at
the palace gate; this image appears
four times, forming a zigzag pattern
as it moves back and forth down the
banner. Each of the four encounters
is thus flanked by the palace gate on
one side and a blank cartouche on
the other.

In the top scene, Prince Siddhartha
confronts an old man leaning on a
cane. Following this, he witnesses a
sick man lying on the ground, nude
to the waist, supported by a woman
seated on a white sheet behind him.
In the third scene, the prince ob-
serves a coffin lying on the ground
and two mourners lamenting beside
it. Finally, Siddhartha encounters a
monk carrying a bent staff in his
right hand and an alms bowl in the
palm of his left hand. The tranquil
appearance of this monk in a world
replete with pain and suffering
inspires Siddhartha to leave his fath-
er's palace and his family and seek
enlightenment.

—*J. B.*

Palace Scenes
Pakistan (Ancient Gandhara),
2nd century
Gray schist
h: 15½ in. (39.4 cm.)
Seattle Art Museum, Eugene Fuller
Memorial Collection

This sharply carved and finely fin-
ished relief shows two scenes of pal-
ace life. In the upper panel,
Siddhartha and his wife, Yasodhara,
watch the performance of a court
dancer accompanied by a group of
female musicians. In the lower com-
position, a tired Yasodhara stretches
out on her bed, while a maid reclines
on the floor. Four figures stand
watching behind the seated Sid-
dhartha, and a man approaches him
with a jug. It is not clear whether
this figure is an attendant or a god
(deva) or, for that matter, what the
significance of his jug might be. Per-
haps he is offering more wine to the
prince. Two Amazonian guards
stand below arches on either side of
this lower scene.

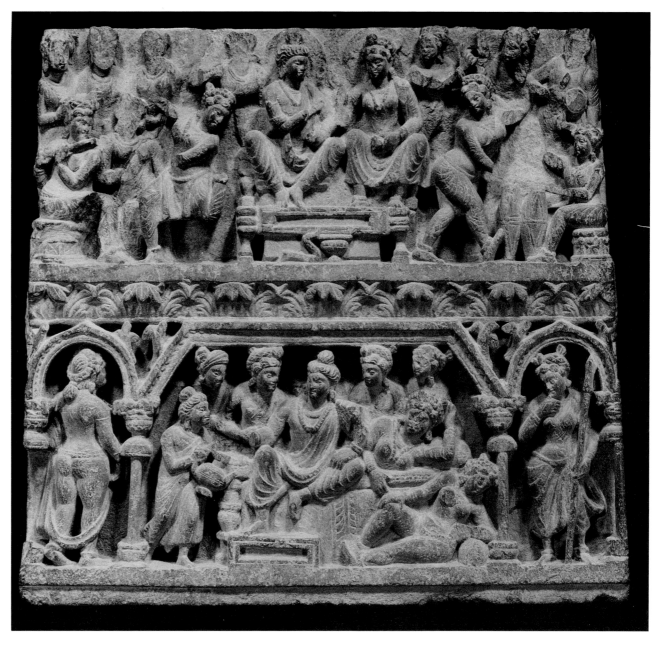

In the *Buddhacharita*, Asvaghosha
gives a vivid description of palace
life, which seems to have inspired
this Gandhara sculptor.
 Thus seated on his jeweled
 couch, surrounded by the fumes
 of sandalwood, the dancing
 women took their places round;
 then sounded forth their heav-
 enly (Gandharva) music.... And
 tho' the sounds filled all the pal-
 ace, they fell upon his ear
 unnoticed. At this time the
Deva of the Pure Abode, know-
 ing the prince's time was come,
 the destined time for quitting
 home, suddenly assumed a form
 and came to earth, to make the
 shapes of all the women
 unattractive, so that they might
 create disgust. *(Beal, 1968, p. 54)*

These two scenes probably represent
the events of the night prior to
Siddhartha's departure.
 —P. P.

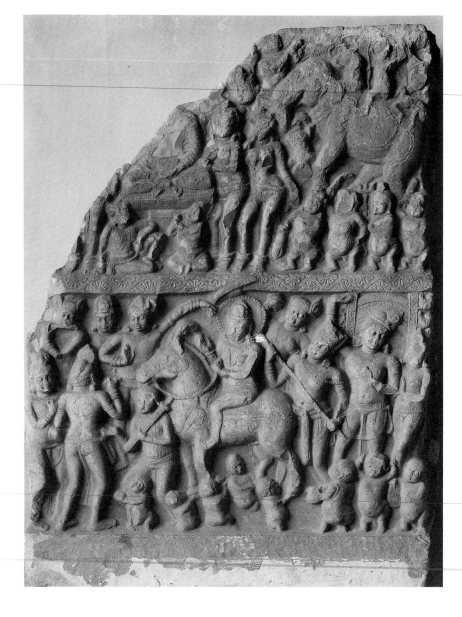

The Great Departure and Mara's Assault
India, Andhra Pradesh; 3rd century
White limestone
h: 57½ in. (146.1 cm.)
Lent by The Metropolitan Museum of Art, Fletcher Fund, 1928

The upper panel of this relief, which once served as an encasement for a stupa in Nagarjunakonda, depicts Mara's assault (cf. nos. 44–48). The preserved portion of this panel shows part of the Buddha, in addition to two of Mara's seductive daughters, four delightful dwarfs armed with assorted weapons, and Mara himself, riding a magnificent elephant that has been rendered with wonderful naturalism.

The lower half of the relief represents Siddhartha's great departure. Astride his favorite steed, Kanthaka, Siddhartha rides into the night in search of enlightenment, as the gods rejoice. His faithful groom, Chandaka, bearing his master's sword, walks just below the horse's head. Indra holds a parasol above Siddhartha's head, and the four *yakshas* (nature deities) raise the hooves of the horse in order to muffle their sound. Other *yakshas* and gods are shown playing various instruments.

Between the first century B.C. and the fourth century A.D., a magnificent school of Buddhist art flourished in the Guntur district of Andhra Pradesh. The principal sites of this activity were the cities of Amaravati and Nagarjunakonda. This is the region where Mahayana Buddhism may have originated. The sculptures and monuments of this school are distinguished by the use of a distinctive greenish white limestone. Although the reliefs of the Amaravati school are not as deeply carved as those of Gandhara, they are characterized by a sensuous elegance and a joie de vivre that seem entirely to contradict the Buddhist emphasis on renunciation (see also nos. 33 and 38).

—*P. P.*

The Great Departure
Korea; Yi dynasty, 18th century
Ink and colors on cloth
45 ¼ × 41 ½ in. (115 × 105.3 cm.)
Baekyang-sa, Cholla-namdo Province, Lent by the Dongkuk University Museum, Seoul
(Reproduced in color)

Swirling clouds are used in this painting to isolate several episodes involving Sakyamuni's departure from his father's palace. In the lower left-hand corner, sleeping figures can be identified in the cartouches as wives and attendants. The large empty chair indicates the absent prince. Sakyamuni is shown riding away in the upper right-hand corner, surrounded by heavenly deities. In the center, the kneeling groom Chandaka reports Siddhartha's departure to his worried family. Various gods appear in the lower right-hand corner, together with the riderless horse. Typical of Yi dynasty (1392–1910) paintings are the numerous male figures portrayed as either Confucian scholars or court administrators. A combination of clouds and architectural elements enliven this composition and facilitate the presentation of several different scenes within a single painting. One of the cartouches provides an eighteenth-century reign date. This attribution agrees with the style of the painting, which forms a pair with no. 19.

—*R. E. F.*

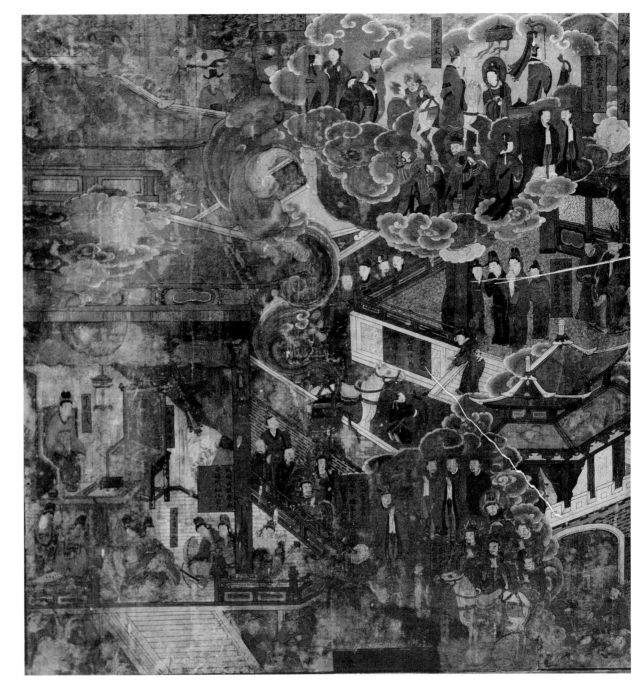

38

The Adoration of Siddhartha's Turban
India, Andhra Pradesh;
2nd–3rd century
White limestone
h: 27½ in. (70 cm.)
National Museum, New Delhi

Upon arriving at a hermitage after his flight from home, Siddhartha decided to send his groom back, along with his horse, clothing, and ornaments. The removal of his turban is described by Asvaghosha in his *Buddhacharita:*

> Having unsheathed it [his sword] with its blade dark blue as a blue lotus petal, he cut off his decorated headdress with the hair enclosed in it and tossed it with the muslin trailing from it into the air, as though tossing a goose into a lake. And the inhabitants of Heaven caught it reverently, as it was thrown, with the intention of worshipping it, and the divine hosts paid it due adoration in Heaven with celestial honors. *(Johnston, p. 89)*

In this wonderfully animated relief from Nagarjunakonda, the sculptor has captured and superbly rendered the unmitigated joy displayed by the gods as they dance exuberantly, carrying Siddhartha's turban in a basket. It is interesting to note that the gods also wear turbans and that no goddesses are included among the divine celebrants. This is a fine example of the sensuous and elegant Amaravati style of figural sculpture that was developed in Andhra Pradesh in the early centuries of the Christian Era in order to embellish large stupas (see also nos. 33 and 36).
—*P. P.*

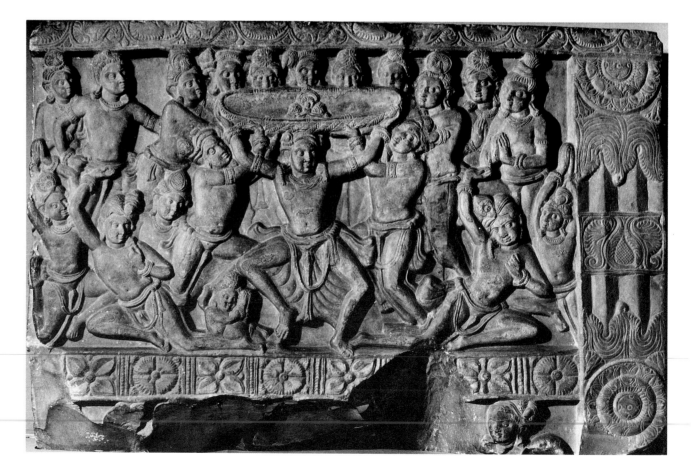

(a) *Emaciated Buddha*
 Pakistan (Ancient Gandhara),
 2nd–3rd century
 Gray schist
 h: 20½ in. (52 cm.)
 Bumper Collection

(b) *Emaciated Buddha*
 Pakistan (Ancient Gandhara),
 3rd century
 Gray schist
 h: 10¾ in. (27.3 cm.)
 Professor Samuel Eilenberg

Although the emaciation of Sakyamuni is occasionally represented in a narrative context in Tibet and Nepal (see no. 9 and 14), only the artists of ancient Gandhara, who were strong devotees of the artistic realism derived from the Hellenistic tradition, created an iconic type characterized by the two examples illustrated. With the exception of the Chan, or Zen, tradition in China and Japan (see nos. 42 and 43), almost no other school of Buddhist art represented the gaunt and ascetic Sakyamuni. There was a temple, however, dedicated to the emaciated Buddha in Bodhgaya.

While the larger sculpture (a) is more complete, an additional scene is carved along the base of the Eilenberg image (b), wherein a Buddha is shown preaching before a group of six monks with shaven heads. The exact identification of this scene is difficult. Sometimes the Buddha figure on such pedestals is identified with the Future Buddha, Maitreya (see the essay in section four of the catalogue for a discussion of Maitreya). It may also represent the First Sermon of the Buddha, although five ascetics and not six monks were present on that occasion. Both sculptures are more summarily modeled on the back than on the front, which indicates that they were originally placed in shallow niches and used as cult objects.

—*P. P.*

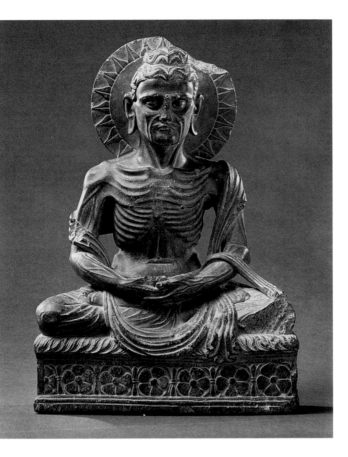

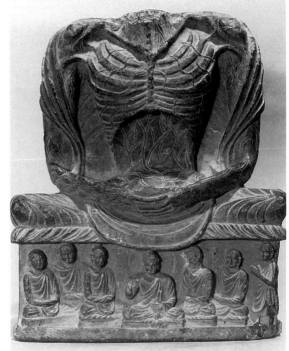

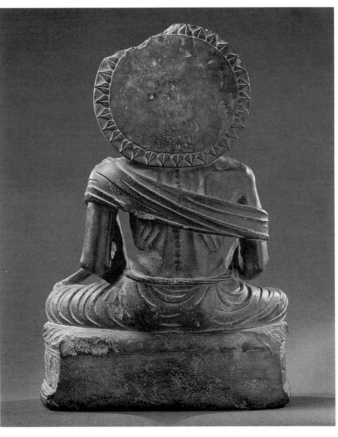

40

Sakyamuni Coming Down the Mountain
China; Song dynasty, dated 1244
Hanging scroll
Ink on paper
29½ × 12¾ in. (74.9 × 32.4 cm.)
The Cleveland Museum of Art, Purchase, John L. Severance Fund

> Since entering the mountain,
> too dried out and emaciated,
> Frosty cold over the snow,
> After having a twinkling of revelation with impassioned
> eyes
> Why then do you want to come
> back to the world?
> *(Ho et al., p. 83)*

The adepts of Chan, or Zen, Buddhism viewed enlightenment as a personal responsibility, a goal that could be achieved only through individual effort and solitary meditation. Therefore, although interpretations differ as to whether Sakyamuni achieved Enlightenment during his meditation or following his return to normal life, the theme of his return from the mountains, following a lengthy period of asceticism, was extremely important to Chan Buddhists and figured prominently in their paintings.

The characteristic use of a mountainous landscape in this genre may have had special significance for the Chinese who considered all mountains sacred. This belief was accepted by Daoists and Confucianists, as well as Buddhists. Given this particular association, Chan Buddhists may have believed that Sakyamuni attained Enlightenment during his retreat in the mountains, a unique interpretation that was unsupported by traditional canonical texts (Rogers, pp. 17–18).

This theme is commonly known by its Japanese name, *Shussan Shaka (Sakyamuni Coming Down the Mountain)* (cf. nos. 41 and 42). Typically, paintings of the descent depict a worn and emaciated Sakyamuni who proceeds slowly along with downcast eyes. Two major styles of painting were used to represent this occasion. The more orthodox tradition involved painting in color with a detailed rendering of the figure in an archaic linear style. Depictions of this sort place the figure of the Buddha within a full landscape setting. This style was popular during the Song dynasty (960–1279) and includes the famous painting by Liang Kai [Liang K'ai] (active early 13th century) in the Tokyo National Museum. The second type, popular during the thirteenth century, including the Yuan period (1280–1368), was executed exclusively in monochrome ink. It minimized landscape elements and rendered figures spontaneously in broad, wet brush strokes. The Cleveland Museum of Art example, which falls into the latter category, is one of the earliest extant monochrome ink paintings of *Shussan Shaka.* It is an anonymous work based on a style ascribed to Li Que [Li Ch'üeh], a follower of Liang Kai, and contains a colophon by Chijue Daochong [Ch'ih-chüeh Tao-ch'ung] (1170–1271).

41

(a) *Sakyamuni Coming Down the Mountain*
Japan; Kamakura period, c. 1300
Hanging scroll
Ink on paper
35¾ × 16½ in. (90.8 × 41.9 cm.)
Seattle Art Museum, Eugene Fuller Memorial Collection

(b) Chuan Shinko (Japanese, active mid-15th century)
Sakyamuni Coming Down the Mountain; Muromachi period, mid-15th century
Hanging scroll
Ink on paper
28³⁄₁₆ × 10⅞ in. (71.5 × 27.5 cm.)
Museum für Ostasiatische Kunst, Cologne

(c) Kano Yasunobu (Japanese, 1613–1685)
Sakyamuni Coming Down the Mountain; Edo period, 17th century
Hanging scroll
Ink and light colors on silk
39¼ × 15¾ in. (99.7 × 40 cm.)
Private Collection

He enters the mountains and returns from the mountains. In the East it flows rapidly, in the West it disappears. He has the bearing of a Phoenix and the manner of a Dragon. He is draped in silk, but emaciated to the bone. This is what he achieved in six years of asceticism: He became utterly confused...(!) *(Fontein and Hickman, p. 70)*

This poem by the Chinese monk Dongming Huiri [Tung-ming Hui-jih] (1272–1340) is inscribed on a painting of *Shussan Shaka (Sakyamuni Coming Down the Mountain)* that is now in the Chorakuji in Gumma Prefecture. It typifies the personalization of Sakyamuni's austerities, which Zen Buddhism stressed in order to set an example for a priest's or adept's own path to enlightenment *(satori).* The use of a mountainous setting is a convention that originated in China and was later adopted by the Japanese. No such environs are mentioned in the traditional canonical literature describing Sakyamuni's life.

In depictions of this subject, Sakyamuni frequently displays a halo or *mandorla,* the *urna,* and the *ushnisha,* yet his general appearance and demeanor clearly suggest a man, rather than a deity. This emphasis is apparently a peculiarity of Chinese and Japanese Buddhist art that is at variance with traditional versions of the Buddha's life. Some Japanese scholars interpret such portraits to mean that Buddha returned as a man, after his Enlightenment, in order to enlighten us all (Fontein and Hickman, pp. 69–70).

—*G. K.*

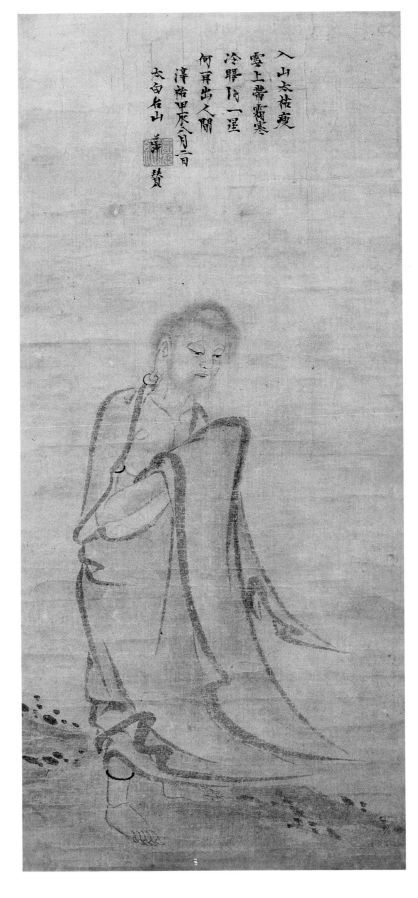

入山太枯瘦
雪上畳霜寒
冷眼片一星
何再出之間
淳祐甲辰八月三日
太白叟山　贊

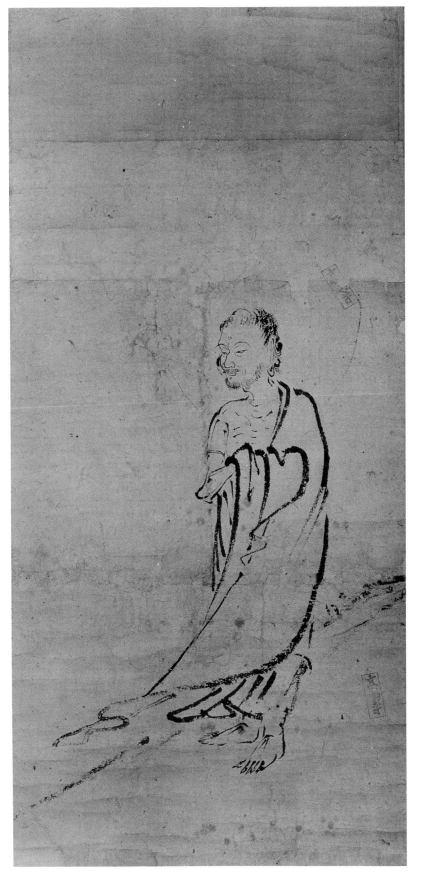

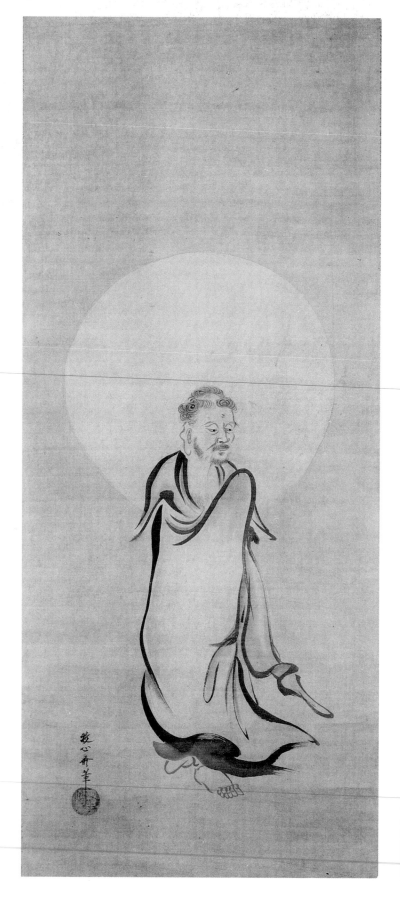

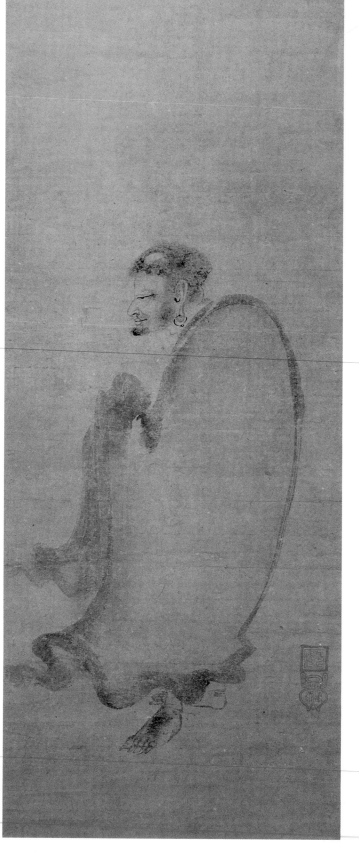

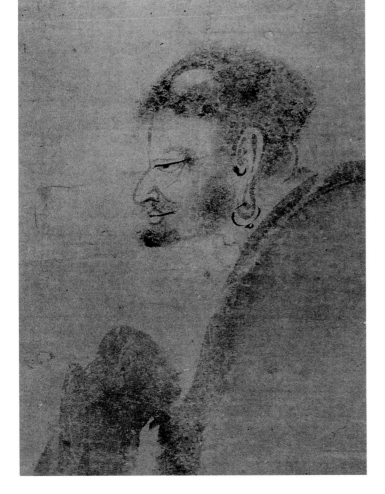

The figural style and iconography in all three paintings are uniformly Zen. Except for painting (c), which shows washes of light color, they are painted using monochrome ink in a style epitomizing the fresh and individual Zen approach to Buddhist themes. The Seattle scroll (a) is believed to have been a model for painting and is an early example of Kamakura period (1185–1333) adaptations of Chan Buddhist themes. It is one of a group of cartoons all bearing the seals of the Kozanji monastery, a Shingon sect temple in Kyoto that was noted throughout the thirteenth century for collecting Chinese iconographic drawings and training monk-painters to copy them for distribution to other esoteric temples. The Seattle image shows the distinctive stylistic technique and paper associated with the Kozanji atelier, and the artist has focused chiefly on a careful, finely brushed delineation of Sakyamuni's quiet and thoughtful expression.

Within the genre, we find other Zen-sect paintings, generally executed in monochrome ink, that employ a rough, abbreviated line, such as the Cologne scroll (b) by Chuan Shinko. This famous monk-painter lived over a hundred years later than the artist of the Seattle scroll and resided at the large Zen monastery of Kenchoji in Kamakura, at the time the center of Zen Buddhism in eastern Japan. Again Sakyamuni is shown as an isolated figure; the setting is not even suggested. He is depicted in profile as an Indian ascetic, and his emaciated body is almost entirely submerged in voluminous robes.

Scroll (c), the Edo period (1615–1868) version of Sakyamuni's descent, was painted by Kano Yasunobu. A member of the Kano School, Yasunobu worked in a variety of styles and painted a range of subjects. The Kano repertoire typically included Zen themes, of which this is an example, as well as traditional subjects. Originally the Yasunobu scroll was the central panel of a triptych, but the two outer paintings have been lost.

—A. G. P.

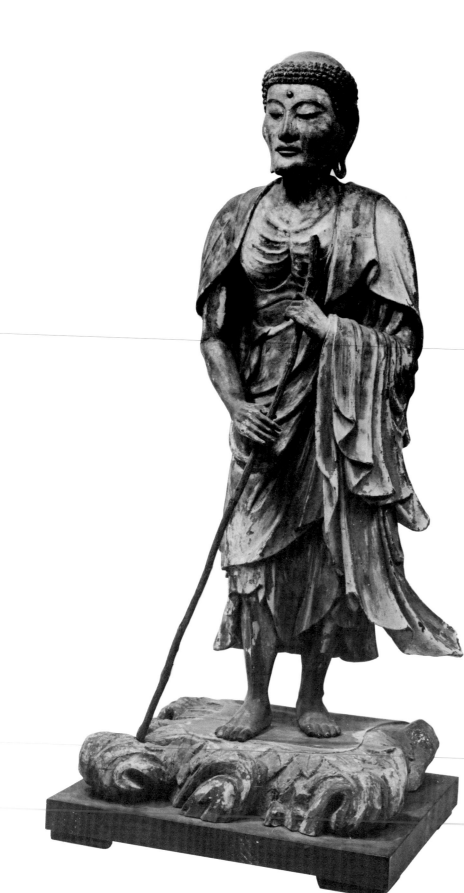

(a) *Sakyamuni Coming Down the Mountain*
Japan; Muromachi period,
15th century
Wood with polychromy and gold
h: 37⅞ in. (96.3 cm.)
Nara National Museum

(b) Sosai (Japanese, active
c. 1880–1890)
Sakyamuni Coming Down the Mountain; Meiji period,
19th century
Ivory
h: 9½ in. (24 cm.)
Museum of Art, Carnegie Institute, Pittsburgh; H. J. Heinz Collection

The theme of *Shussan Shaka (Sakyamuni Coming Down the Mountain)*, although common in painting, is an unusual subject for Japanese Buddhist sculptors. The carved wood figure from the Nara National Museum presents the emaciated Sakyamuni in a realistic manner. Clad in an elegant robe that falls in stylized folds, Sakyamuni faces the viewer while leaning on a staff. He stands with one foot placed in front of the other on a section of rock. On close inspection, one notes that the figure bends slightly forward, thereby making its presence more immediate. The Buddha's head more closely resembles a portrait than any idealized representation.

His face is full and broad, and only the gaunt cheekbones and emaciated arms and torso attest to his recent ascetic experience.

The ivory carving of Sakyamuni by Sosai is not merely a novelty but a tour de force of craftsmanship. Such objects demonstrate the persistence of realism as well as the popularity of the *Shussan Shaka* theme in the late nineteenth century. The popularity of Buddhism, as exemplified by the frequent occurrence of this theme, perhaps provoked the edict of 1868, issued by the Meiji regime (1868–1912), which made Shinto, as opposed to Buddhism, the official state religion of Japan. The state of meditative sensitivity evoked by this sculpture shows, however, that Buddhist craftsmen continued to be inspired by a living devotion to traditional Buddhist themes.

—A. G. P.

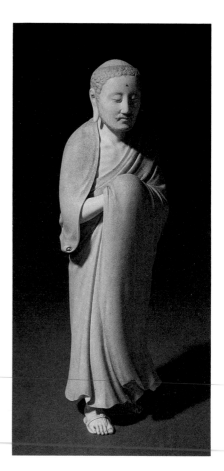

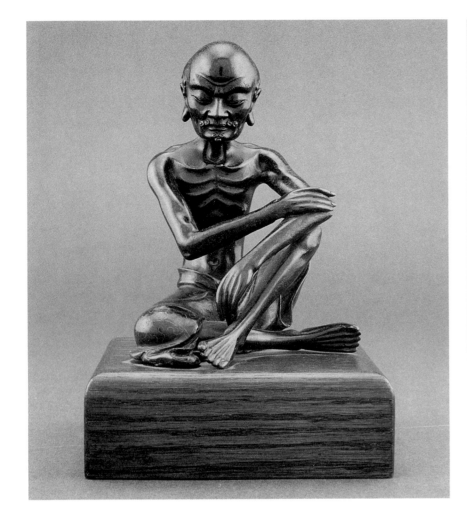
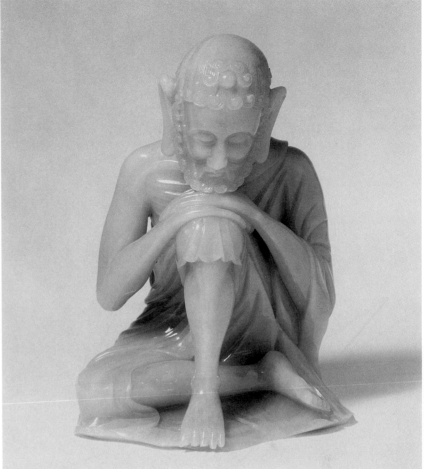

43

(a) *Ascetic Sakyamuni*
China; late Ming dynasty,
16th century
Bronze with silver inlay
h: 6 in. (15.2 cm.)
Mr. and Mrs. James W. Alsdorf,
Chicago

(b) *Ascetic Sakyamuni*
China; late Qing dynasty,
18th–19th century
Light green and lustrous jade
h: 10 in. (25.4 cm.)
Asian Art Museum of San Francisco, The Avery Brundage
Collection

These two sculptures represent a type of Buddha image that appears to have originated during the Yuan period (1280–1368) in China.

Conceptually this image is related to the Chan- or Zen-inspired paintings depicting the ascetic Sakyamuni descending from the mountains (see nos. 40 and 41). Although this theme in painting was common in both Japan and China, the sculptural form appears to have been more popular among the Chinese. The idea of representing the emaciated Buddha originated with the Gandhara artists in India (see no. 39), but the Yuan prototypes from which the images illustrated here evolved were probably the combined result of a Chan concern with asceticism and the Yuan artists' interest in naturalism.

In both of these sculptures, the artists have emphasized the skeletal body of Sakyamuni as he appeared during one of the lengthy meditations of the Enlightenment Cycle. The rib cage, the veins of the neck, and an arched back revealing the spinal column are prominent in both figures, and although they strike different postures, the sculptures convey a reflective mood. The Alsdorf figure (a) wears only a loincloth, while figure (b) is clad in an upper garment as well. The facial features of the two images are quite different: The bronze figure has a much more Chinese face, a few curling locks serving as a beard and mustache, and a bald head; the jade Buddha has more hair on both the face and head, and its features are more Indian than Chinese. Both sculptures, however, sit in naturalistic postures commonly assumed by Indians.

What is perhaps most interesting about these portrayals is that, unlike their Yuan forebears, they could be depicting Sakyamuni as an old man, although at the time of his Enlightenment he was barely forty years old. These representations may thus be intended to portray the Buddha as a sage pondering over the sufferings of life, rather than depicting the occasion of his emaciation due to fasting. It should also be pointed out that while Gandhara artists created a hieratic image showing the Buddha actually engaged in meditation, the Chinese artists have given us a much more realistic portrait in keeping with the stronger emphasis on the humanistic tradition in China.

—P. P.

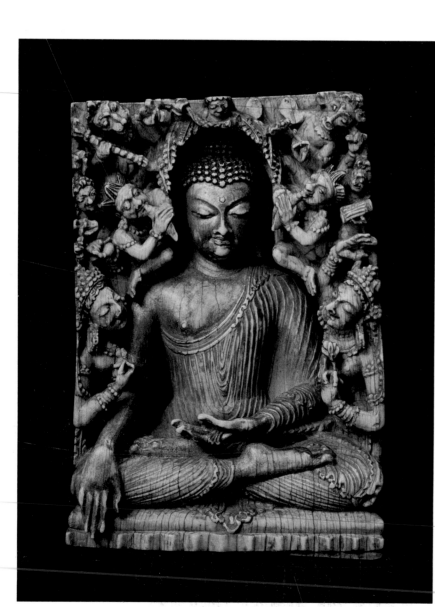

The Temptation of Mara
India, Kashmir; 8th century
Ivory with traces of polychromy
h: 5⁵⁄₁₆ in. (13.5 cm.)
The Cleveland Museum of Art, Purchase from the J. H. Wade Fund

In this beautiful ivory relief from Kashmir, Sakyamuni sits in meditation with downcast eyes. He remains calm and serene, although two of Mara's attendants blow conchs into his ears and a third beats a drum nearby. Simultaneously, several ferocious-looking demons attack him with weapons. Two handsome figures, each smiling and holding a flower, flank the meditating Sakyamuni. The male figure on the left of the relief may represent Mara, and the figure on the right, who appears to be female, may be one of his daughters. The position of Sakyamuni's right hand touching the earth in the gesture known as *bhumisparsamudra* indicates the moment of his Enlightenment and hence his victory over Mara.

This is one of a spectacular group of ivories that appear to have been the products of a single workshop, probably located in Kashmir. The date of their execution, however, is by no means certain. Almost all of these works depict scenes from Sakyamuni's life, and they were once painted and set into miniature wooden shrines. Although each work is conceived on a small scale, the carving is astonishingly deep and the figures appear almost as if they were modeled in the round.

—*P. P.*

The Enlightenment of Sakyamuni
Cambodia, 12th–13th century
Bronze
h: 15⁷⁄₁₆ in. (39.2 cm.)
The Cleveland Museum of Art, Purchase, Andrew R. and Martha Holden Jennings Fund

The scene depicted on this finial is the moment during the Buddha's Enlightenment when Mara made repeated but unsuccessful efforts to force Sakyamuni from his seat under the *bodhi* tree. One of the ploys Mara used was to have his three daughters, transformed into beautiful maidens, dance seductively before Sakyamuni. Having failed in this and all other attempts, Mara finally asked Sakyamuni who could bear witness that he was worthy of achieving Enlightenment. In his innumerable past lives, the Buddha had commemorated each of his countless donations or acts of merit by pouring libations of water on the ground; he therefore responded to Mara's challenge by touching the Earth with his right hand and calling her to be his witness.

On the finial, the Buddha is shown seated, with his right hand extended as if touching the earth. Below him appears a dancing female figure. While it would be usual in an Indian context to identify this female figure as one of Mara's daughters, in Southeast Asia she is frequently, as here, the personification of the Earth, identified by the act of wringing her hair. The purpose of this hair-twisting is explained in the *Pathamasambodhi*, a version of the life of the

Buddha known in Thailand, Laos, and Cambodia, where, in response to Sakyamuni's request for the Earth to bear witness,

the angel of the earth, unable to resist his invocation, sprang from the earth in the shape of a lovely woman with long flowing hair, and standing before, answered: "O Being more excellent than angels or men! it is true that when you performed your great works you ever poured water on my hair." And with these words she wrung her long hair, and a stream, a flood of waters gushed forth from it. Onwards against the host of Māra the mighty torrent rushed. His generals were overturned, his elephant swept away by the waters, his royal insignia destroyed, and his whole army fled in utter confusion, amid the roaring of a terrific earthquake and peals of thunder crashing through skies. (Alabaster, pp. 154–55)

Flanking the personified Earth on this finial are two of Mara's demons. The wavelike decoration behind the Earth goddess may be intended to represent the waters flowing from her hair, which Mara's attendants flee.

The theme of the personified Earth wringing her hair is a peculiarly Southeast Asian invention. It remains extremely popular in Thailand and Cambodia, where the goddess is often represented alone. This figure only began to appear in Buddhist art in the twelfth century, and its appearance on the Khmer finial is one of the earliest instances known.

—R. L. B.

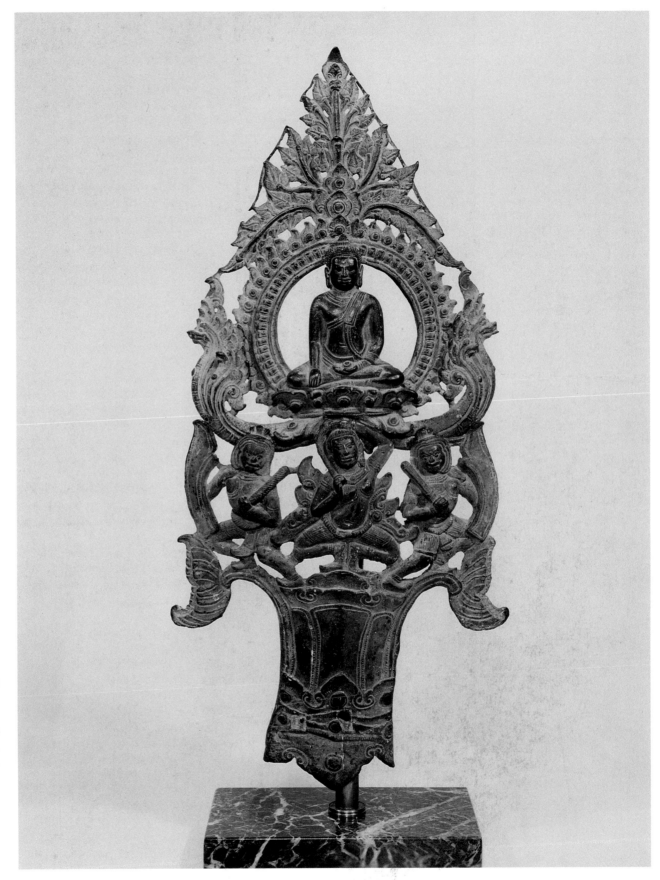

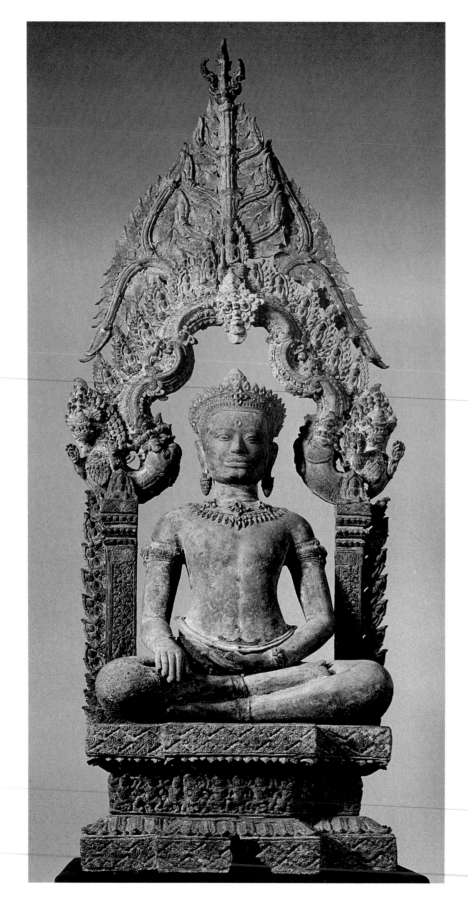

The Enlightenment of Sakyamuni
Thailand; Khmer style, late 12th–
early 13th century
Bronze
h: 70 in. (177.8 cm.)
Kimbell Art Museum, Fort Worth

While at first glance this large and impressive enthroned bronze Buddha may appear radically different from the small Cambodian finial (no. 45), both represent Sakyamuni's victory over Mara at Bodhgaya. In each sculpture, the Buddha sits under a stylized *bodhi* tree with his right hand in the earth-touching gesture and his left hand in his lap holding a sacred gem. (The precise meaning of this gem is unknown.) Demons from Mara's army are positioned below the Buddha on both bronzes.

Unlike the finial, however, the Kimbell bronze does not include the figure of the personified Earth. There is also a major difference in the dress of the two Buddhas. The Buddha on the finial wears a monastic robe with few ornaments, while the larger Buddha appears nude from the waist up and is wearing a crown, earrings, and other elaborate ornaments. (We assume, however, that the nude torso is a convention and that this Buddha would have been considered properly clothed.)

During a visit to Bodhgaya in the seventh century, the Chinese Buddhist pilgrim Xuan Zang [Hsuan Tsang] (c. 596–664), observed the practice of using removable jewelry or inlaid gems to bedeck images of the Buddha: "Not far to the west of the *Bodhi* tree is a large *vihara* [monastery] in which is a figure of Buddha made of *Teou-shih* (brass) ornamented with rare jewels" (Beal, 1906, p. 3). It was also around the seventh century that Indian sculptors began to represent jewelry directly in their works.

In twelfth- and thirteenth-century Cambodia, as well as areas of Thailand controlled by the Khmer, crowned and bejeweled Buddha images were extremely popular. During this period the Khmer kings were attempting to stress their close relationship to, if not their complete identification with, the Buddha. Thus, the crown and jewelry worn by Buddha images such as the Kimbell bronze are similar to those adorning the earthly kings represented in the relief sculptures created during the first half of the twelfth century at Angkor in Cambodia. The earliest crowned Buddha images in Southeast Asia occur at Phimai, a Khmer provincial capital located in what is now northeastern Thailand, where Tantric Buddhism was of great importance.

This sculpture is said to have been found in the province of Chaiyaphum in northeastern Thailand, and a recent study provides stylistic support for this provenance (Woodward, 1979, pp. 72–83). The bronze was probably made in Thailand during the period of heavy Khmer influence. A tradition of monumental bronze work existed in Cambodia, but a similar tradition existed independently in northeastern Thailand before Khmer influence. The combined influence of the two traditions must explain the remarkable technical achievement evidenced in this piece, which was cast in thirteen separate sections. One can imagine how magnificent the enthroned Buddha would have been when gilded, its crown and jewelry inlaid with brightly colored glass paste.

—*R. L. B.*

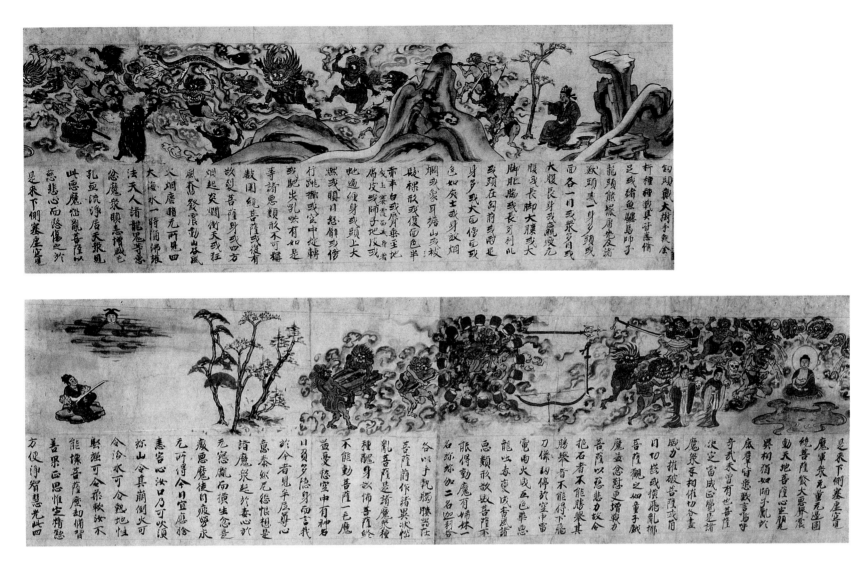

47

The Temptation of Sakyamuni
Japan; Kamakura period, first half of
the 13th century
Handscroll
Ink and polychromy on paper
$10^{7}/_{8} \times 61^{5}/_{8}$ in. (27.6 × 156.5 cm.)
Mrs. Jackson Burke
(Shown in Los Angeles only)

In a frenzy of color and brushwork,
the scene depicted here dramatically
illustrates Mara's assault on the
meditating Buddha. Mara sits in a
craggy landscape at the far right urg-
ing his army to attack. Brandishing
weapons of all types and sizes, a fi-
ery formation of frightening mon-
sters, demons, and dragons moves
toward Sakyamuni, who meditates
while seated on a grassy knoll
behind a pond. Some of the demons
and dragons are seen breathing
wind, fire, and smoke directly upon
the Buddha, and the accompanying
text indicates that the creatures' poi-
sonous breath has been rendered
harmless by a fragrant breeze. At-
tired in long robes and carrying
skulls, Mara's two daughters at-
tempt to challenge Sakyamuni;
skulls also appear in the fiery sky
above. The kneeling figure about to
draw a sword may be Mara himself.
Sakyamuni, clothed in a red robe,
does not display the earth-touching
gesture generally associated with
Mara's attack and his own impend-
ing Enlightenment. Rather, his
hands rest in his lap in the gesture of
meditation, thereby indicating that
he has yet to gain victory.

This scene is an illustration from a
scroll of the *Kako-genzai-inga-kyo
(Sutra of Cause and Effect, Past and
Present)*, a text which is thought to
have originated in India during the
third century. This sutra recounts
the story of one of the Buddha's past
incarnations and his life as Prince
Siddhartha up until his Enlighten-
ment. It was a popular biography of
Sakyamuni both in China and Japan.
—A. G. P.

[The absence of the *bodhi* tree
marks a significant deviation from
Indian depictions of the temptation
and Mara's assault. Furthermore,
Mara's daughters carry skulls when
according to Indian accounts they
are supposed to tempt the Master
with lascivious dances. These in-
novations indicate the development
of an independent East Asian tradi-
tion concerning the Buddha's life. It
is interesting to note, however, that
the artist has indicated the grass on
which the Buddha sits. According to
Indian biographies, after his bath in
the river Sakyamuni met a grass-
cutter and took some grass from him
to cover his seat below the *bodhi*
tree.—P.P.]

48

The Temptation of Sakyamuni
Nepal, dated 1561
Colors on cotton
42¾ × 29¾ in. (108.5 × 75.6 cm.)
Museum of Fine Arts, Boston.
Gift of John Goelet

In this busy and densely packed composition, an anonymous Nepali artist has vividly presented the tumultuousness and ferocity of Mara's assault. Below the central shrine in which the Buddha sits unperturbed, Mara's daughters dance lasciviously, attempting to distract him. Meanwhile, from his chariot in the lower left-hand corner, Mara shoots arrows of desire at the meditating Sakyamuni. The rest of the painting is filled with a legion of Mara's demons, including various Hindu deities. Attacking the Buddha ferociously from all sides, the demon horde hurls rocks and weapons and blows on horns. Some of the attackers wear masks, others have grinning faces on their bellies, and still others sport the heads and wings of birds.

As is usual in the Indic tradition, Sakyamuni does not sit directly below the tree but is instead enshrined within a temple. Moreover, he wears full monastic robes, as well as a diadem and jewelry. The central composition is, therefore, a recreation of the shrine and Buddha image at the Bodhgaya temple. The diadem and jewelry are emblematic of the Buddha's spiritual kingship, reflecting the ritualistic elements of royal consecration ceremonies practiced in Vajrayana Buddhism.

— P. P.

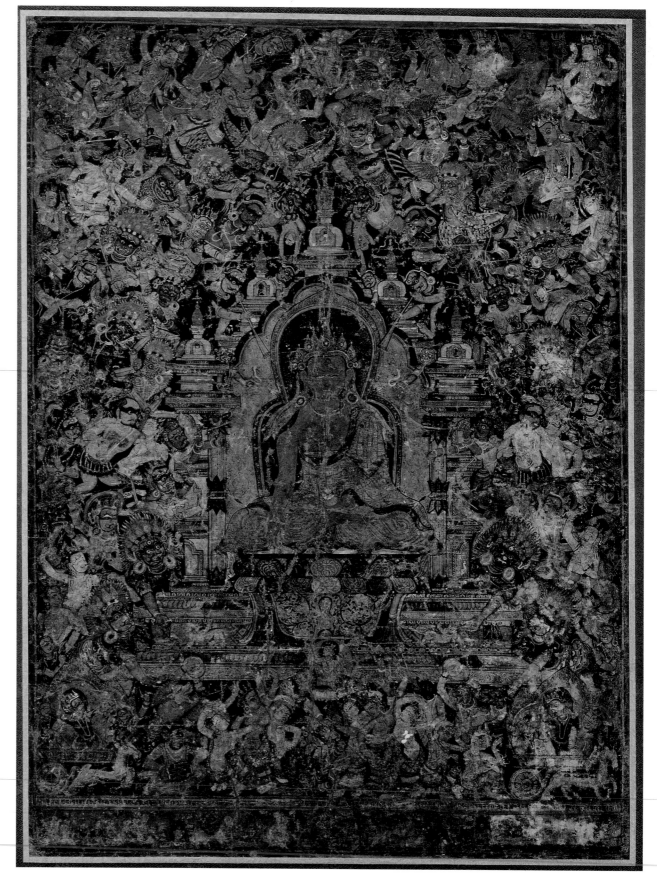

49

Sakyamuni under the Bodhi Tree
China; Ming dynasty, first half of
the 17th century
Hanging scroll
Ink and color on silk
50¾ × 24½ in. (128.9 × 62.2 cm.)
The Cleveland Museum of Art, Pur-
chase from the J. H. Wade Fund

Although this painting represents
the Buddha's Enlightenment under
the *bodhi* tree, both its iconography
and composition present novel fea-
tures. The Buddha's bald *ushnisha*
(cranial bump) and his long curling
hair are characteristic of Chinese
portrayals dating from the tenth cen-
tury onward; in keeping with the
Chan Buddhist tradition, he is
bearded.

Instead of portraying the usual
attack of Mara's monsters and drag-
ons upon the meditating Sakya-
muni, the artist has chosen to depict
this sequence in a rather unique
manner. The Buddha is shown
seated upon three demons, main-
taining his concentration despite
their efforts to divert him. The artist
has obviously interpreted the theme
of Mara's attack rather freely, as the
Buddha's posture and gestures are
not represented in the conventional
manner.

Stylistic precedents for this work
exist among Yuan dynasty (1280–
1368) paintings, but it has been
attributed to the first half of the sev-
enteenth century, based on composi-
tion, stylization of foliage, and the
modeling of trees and rocks. In addi-
tion, the brushwork, which jux-
taposes free brush strokes with
detailed, restrained lines and deco-
rative, pointillistic patterns, con-
forms to a seventeenth-century style
(Ho et al., p. 274, no. 210).
—*J. B.*

[Given the unusual variants in
iconography and topography men-
tioned above, it is possible that the
presence of the demons below
Sakyamuni may symbolize gen-
erally his conquest of the passions
and the senses.—*P. P.*]

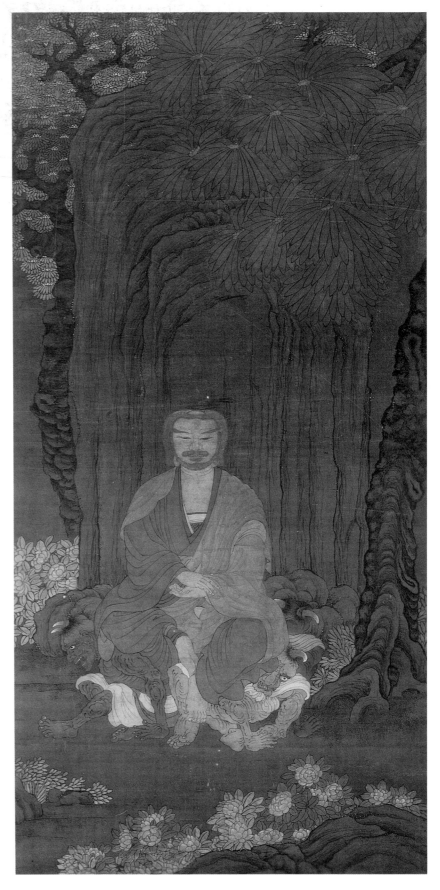

(a) *Buddha Sheltered by Muchalinda*
Cambodia, 12th century
Bronze
h: 28¾ in. (73 cm.)
The Asia Society, New York:
Mr. and Mrs. John D. Rockefeller
3rd Collection

(b) *Buddha Sheltered by Muchalinda*
Thailand, 12th century
Stone
h: 44 in. (112 cm.)
Chantharakhasem National
Museum, Ayutthaya, Thailand

Both of these sculptures portray the serpent king Muchalinda protecting the Buddha from a storm during the sixth week after the Enlightenment. While the Buddha sat cross-legged, enjoying the bliss of emancipation, a great cloud appeared out of season, rainy weather which lasted seven days, cold weather, storms, and darkness. And the Nāga (or Serpent) king Muchalinda came out from his abode, and seven times encircled the body of the Blessed One with his windings, and kept extending his large hood over the Blessed One's head, thinking to himself: "May no coldness [touch] the Blessed One! May no heat [touch] the Blessed One! May no vexation by gadflies and gnats, by storms and sunheat and reptiles [touch] the Blessed One!" *(Rhys Davids and Oldenberg, p. 80)*

As has often been pointed out, while the text specifically and logically says that the snake wrapped his coils around the Buddha, from the earliest depictions in second-century India, artists have almost always placed the Buddha on top of the coils, as if on a throne. This was obviously done to enable the Buddha's entire body to be seen.

Because of the complex system of associations that Khmer kings encouraged between themselves and the Muchalinda Buddha, this event in Sakyamuni's life had special significance in Cambodia and in Khmer influenced areas of Thailand. In form as well, the Khmer Muchalinda Buddha images display special features. For example, it was in the Khmer provincial capital of Phimai, located in present-day northeastern Thailand, that crowned Buddhas first appeared on the snake in the twelfth century. It was also the Khmer who popularized the form in which the *naga*'s coils increase in size upward from the bottom, as seen on the stone statue (b).

The difference in the form of the coils is the only significant formal difference between the two images. While there are minor differences in such things as decorative patterns of crowns and jewelry, and although one can note a somewhat softer expression on the face of the Buddha made in Thailand (typical, perhaps, of Khmer style art from Thailand), the two images show a remarkably consistent conception of the Buddha Muchalinda. The lacquer and gilt layer on the bronze icon (a) has recently been applied.

—*R. L. B.*

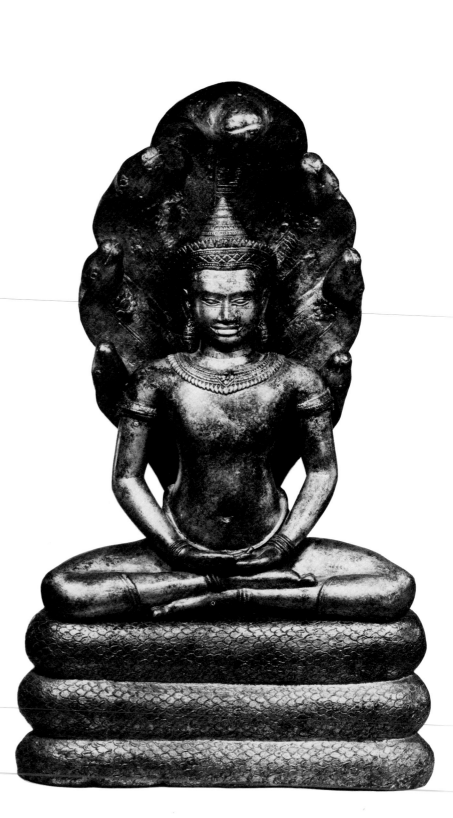

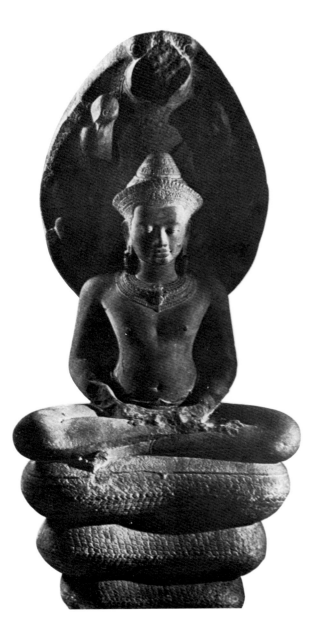

Buddha Preaching His First Sermon
India, Uttar Pradesh, Sarnath;
5th century
Sandstone
h: 30⅛ in. (76.5 cm.)
Indian Museum, Calcutta

This beautiful relief from Sarnath shows a serene and perfectly poised Buddha engaged in preaching his First Sermon. On either side of the relief stands a bodhisattva holding a fly whisk. The figure on the Buddha's left can be identified as the Mahayana deity Avalokitesvara by the lotus he grasps in his left hand. Both bodhisattvas are dressed as ascetics. The Buddha's hands display the gesture known as turning the Wheel of the Law. Below the Buddha's cushion, a wheel is shown flanked by two deer. The deer symbolize the Deer Park at Sarnath, where Buddha Sakyamuni delivered the First Sermon to the five ascetics who had abandoned him earlier during the Enlightenment Cycle. The ascetics are seated behind the deer with their hands clasped in the gesture of adoration.

Although not as well known as the famous fifth-century image preserved in the Sarnath Museum (Snellgrove, pl. 63, p. 99), this icon is a fine example of a type considered a hallmark of the Sarnath school of Buddhist art. While the contemporary sculptors of Mathura preferred a somewhat earthbound and naturalistically modeled figure for their Buddhas (see nos. 83 and 84), their colleagues in Sarnath created a much more ethereal and abstract figural form.

—*P. P.*

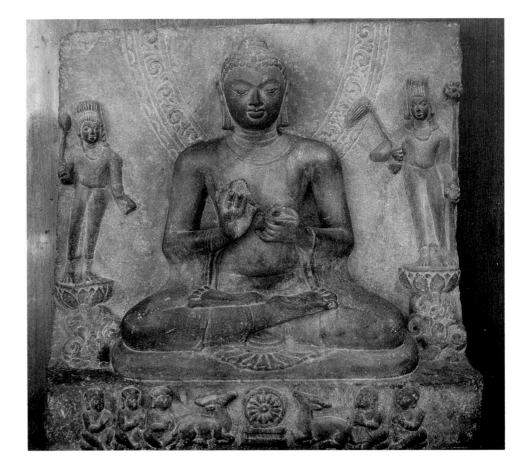

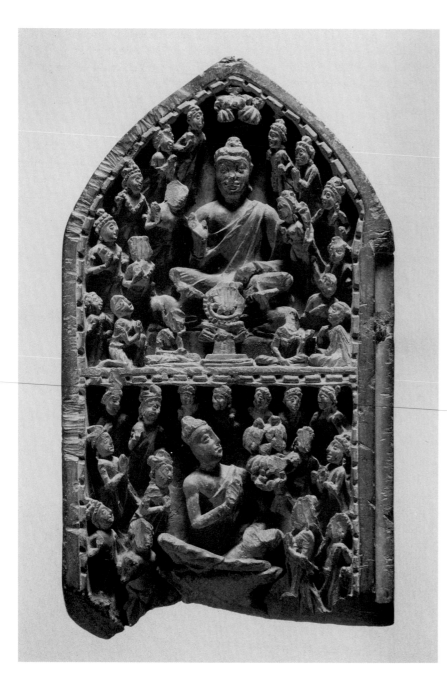

Part of a *Diptych with Preaching Buddhas*
Pakistan (Ancient Gandhara) or Kashmir, 6th century
Gray schist
h: 6¼ in. (15.9 cm.)
Professor Samuel Eilenberg

Two scenes from the life of the Buddha are depicted in this surviving half of what must once have been a diptych intended for use as a portable shrine. In the upper half of the relief, the Buddha is shown preaching before a large congregation. With his left hand, he touches a wheel placed in front of him upon a stand. This literal interpretation of the gesture of turning the Wheel of the Law is generally encountered in the art of Gandhara. The audience attending the Buddha's sermon consists of seated monks and a number of gods hovering in the atmosphere.

The identification of the lower composition is more baffling. Although there seems to be little doubt that here, too, a Buddha is seated in the midst of an assembly, it is unclear what distraction causes him to turn his head. There appears to be a cluster of flowers near this Buddha's left shoulder, tempting us to identify the scene as a reference to the legend of Dipankara Buddha and the brahmin Megha. According to this legend, as recounted in the *Mahavastu*, Megha had once thrown five lotuses at Dipankara and wiped the Buddha's feet with his own hair. Dipankara then predicted that Megha would be born in the future as Sakyamuni and emancipate others. "Having won final release you will give final release to others, as I do now," said Dipankara. "So will you set rolling the incomparable wheel of dharma" (Jones, vol. 1, p. 195). This is quite literally what the Buddha Sakyamuni does in the upper panel.

The exact provenance of this relief is uncertain. It may have been carved in Gandhara or in Kashmir, where similar small reliefs depicting scenes from the Buddha's life have emerged. The composition and the figures are also comparable to the well-known group of Kashmiri ivories, one fine example of which is included in this exhibition (no. 44).

—P. P.

53

(a) *The Sravasti Miracles*
Thailand, c. 8th century
Terracotta
h: 5½ in. (14 cm.)
Margot and Hans Ries

(b) *The Sravasti Miracles*
Thailand, c. 8th century
Terracotta
h: 5½ in. (14 cm.)
National Museum, Bangkok

The theme of the miracles the Buddha performed at Sravasti was extremely popular in the Dvaravati style art of Thailand, two examples of which are shown here. The Ries tablet (a) shows the Buddha seated in meditation on a central lotus throne and engaged in performing two miracles. The first miracle involves his producing multiple likenesses of himself, which fill the air. Only one text, the *Divyavadana*, describes this particular miracle:

On this [the lotus] the Buddha sat in *paryankasana* [a seated posture] creating before, behind, and on both sides [of him] a group of Buddhas reaching up to the Akanishtha Heaven. *(My translation)*

These multiple images are shown on the tablet in the form of five Buddha figures above the central Buddha: Two recline on either side of his head; above these recumbent figures are two standing Buddhas; and the fifth Buddha sits in meditation at the center top, just as Buddha Sakyamuni sits below. On each side of this uppermost Buddha are two figures kneeling in adoration. These are probably the Hindu gods Indra, on the left, and Brahma, on the right, who can be identified by a crown and matted hair, respectively. The *Divyavadana* specifies that Indra and Brahma were present during the Multiplication Miracle, as were King Prasenajit, a follower of the Buddha (seen here on the left of the main Buddha figure), and the heretical teacher Purana Kasyapa (who appears on the right).

Sakyamuni's magical display was directed against Kasyapa and his band of heretics, who had taunted him and suggested that he could not perform miracles equal to their own. Since Kasyapa and his followers were actually charlatans, they tried in several ways to prevent the Buddha from performing his miracles. For example, since the Buddha had predicted he would perform the miracles while seated under a mango tree, the heretics destroyed all the mango trees at Sravasti. The Buddha, therefore, had a mango seed planted that instantaneously grew into a mature tree. This is the second miracle depicted on the Ries votive tablet; the leaves and fruit of the tree appear at the top.

The second Dvaravati votive tablet (b) does not represent the Sravasti Miracles as unequivocally as the first; but the snake *(naga)* figure upholding the lotus on which the Buddha sits, the mango (?) tree over his head, and the two figures of the sun at the upper corners (a feature found only in Dvaravati representations of this event) suggest such an identification. The other figures on the tablet, however, are not multiple Buddha figures but rather bodhisattvas and other celestial beings.

Inscribed on the back of this tablet, as is often the case with Dvaravati votive tablets, is the standard Buddhist creed:

The conditions which arise
from a cause,
Of these the Tathagata has
stated the cause,
Also the way of suppressing
these same:
This is the teaching of the
Great Ascetic.
—*R. L. B.*

[The above creed is inscribed on various Buddhist images, and it often helps to differentiate Buddhist sculptures from those of other religions.—*P. P.*]

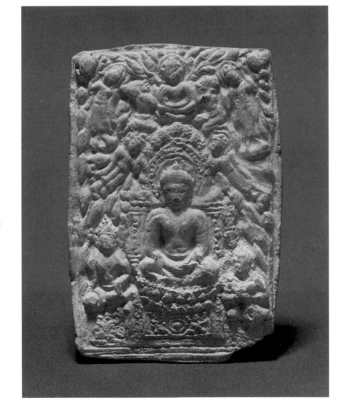

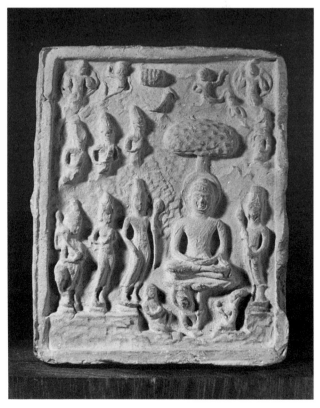

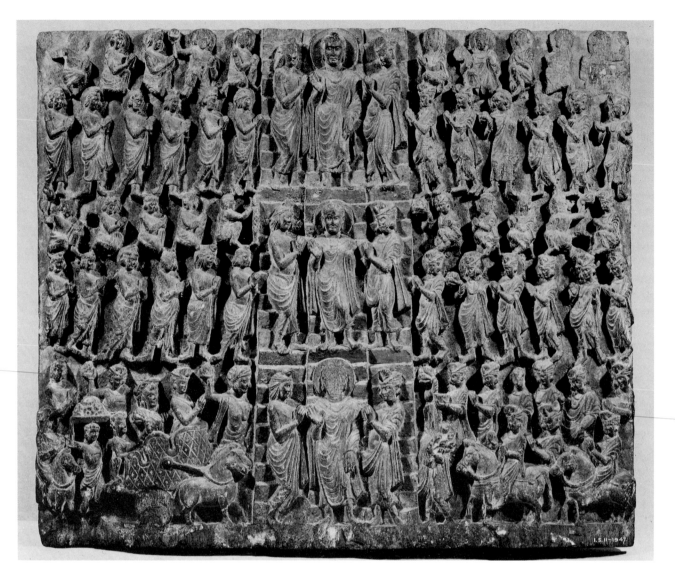

This well-organized relief from Gandhara represents the occasion with elegant clarity. The Buddha and the two gods are shown walking down three centrally placed ladders, and they are represented in three distinct stages of their descent. Six rows of divine and human devotees salute the Master from both sides of the relief. The gods are shown in the four upper rows (note the absence of goddesses, including the Buddha's mother), while the two lower rows are reserved for mortals. The figure shown in the chariot at the bottom left is very likely King Udayana who, according to some versions of the event, came to receive the Buddha carrying his sandalwood statue. Udayana's statue, however, is not included in this relief. It is also rather curious that while tradition mentions that the Buddha's disciples Sariputra and Maudgalyayana accompanied him to the Trayastrimsa Heaven, nothing is said about their descent, nor are they included in the various representations of the scene.

—P. P.

54

Descent from the Trayastrimsa Heaven
Pakistan (Ancient Gandhara),
3rd century
Gray schist
h: 19½ in. (49.5 cm.)
Victoria and Albert Museum

Soon after performing the Sravasti Miracles (no. 53), the Buddha decided to go to the Trayastrimsa Heaven to preach before the gods and his mother. It was on this occasion that King Udayana of Kausambi had a sandalwood image of the Bud-

dha made to serve as a symbol of the Master during his absence (see nos. 55 and 118). Buddha reached the heaven in three strides—reminiscent of the three strides of Vishnu described in Vedic mythology. He preached there for several months and returned to earth at a place called Sankisya. Tradition states that three ladders were used for the descent. The Buddha came down a central ladder made of jewels, while Brahma and Indra accompanied him on either side upon ladders made of gold and silver.

The Presentation of a Statue (?)
Pakistan (Ancient Gandhara),
2nd–3rd century
Gray schist
h: 11⅝ in. (29.53 cm.)
Professor Samuel Eilenberg

In the larger, lower panel of this relief, we see a Buddha holding in his right hand what appears to be the image of a monk with a shaven head. The placement of this small figure's feet upon a base clearly identifies it as a statue. Behind the Buddha stands Vajrapani, his guardian angel, and in front of him are two monks, one kneeling and the other standing. A turbaned figure appears in the background, behind the monks.

The exact identification of this scene is difficult. It is possible that it depicts the legend of King Udayana's image. During the period when the Buddha went to the Trayastrimsa Heaven to preach to his mother, Udayana became so distraught that he had a statue of the Buddha carved from sandalwood. Upon the Buddha's return to earth (no. 54), Udayana went to greet the Master and took his statue with him. In another Gandhara representation of this story, now in the collection of the Peshawar Museum, Udayana is shown holding a conventional statue of a seated Buddha. Here, however, the statue is represented as the rather animated figure of a monk.

Alexander Soper has discussed another version of this tale that seems particularly descriptive of the Eilenberg relief's iconography. In it, the image "dismounted just as if it had been a real Buddha, walked in the air while flowers rained from under its feet and rays of light were emitted; and so welcomed its double." Sakyamuni then prophesied to the image: "In the future you will work great feats for Buddhism. After my Nirvana, it is to you that my disciples will be entrusted" (1959a, pp. 259–60). It is possible that this scene and the Buddha's prophecy to the animated statue in his hand are intended to be illustrated by this work.

In the upper part of the relief, a bodhisattva holding a small pot is seated in meditation on a lotus within a shrine. On either side stand two divine attendants with offerings. This bodhisattva is generally identified as the Future Buddha, Maitreya. (See the essay in section four of the catalogue for further discussion of Maitreya.)

—P. P.

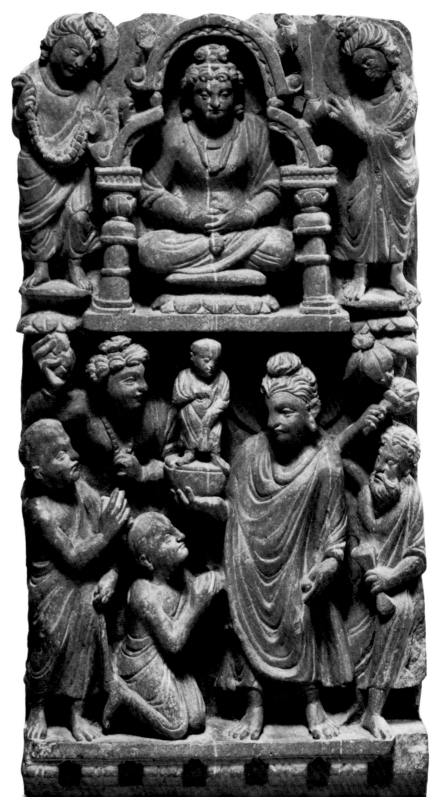

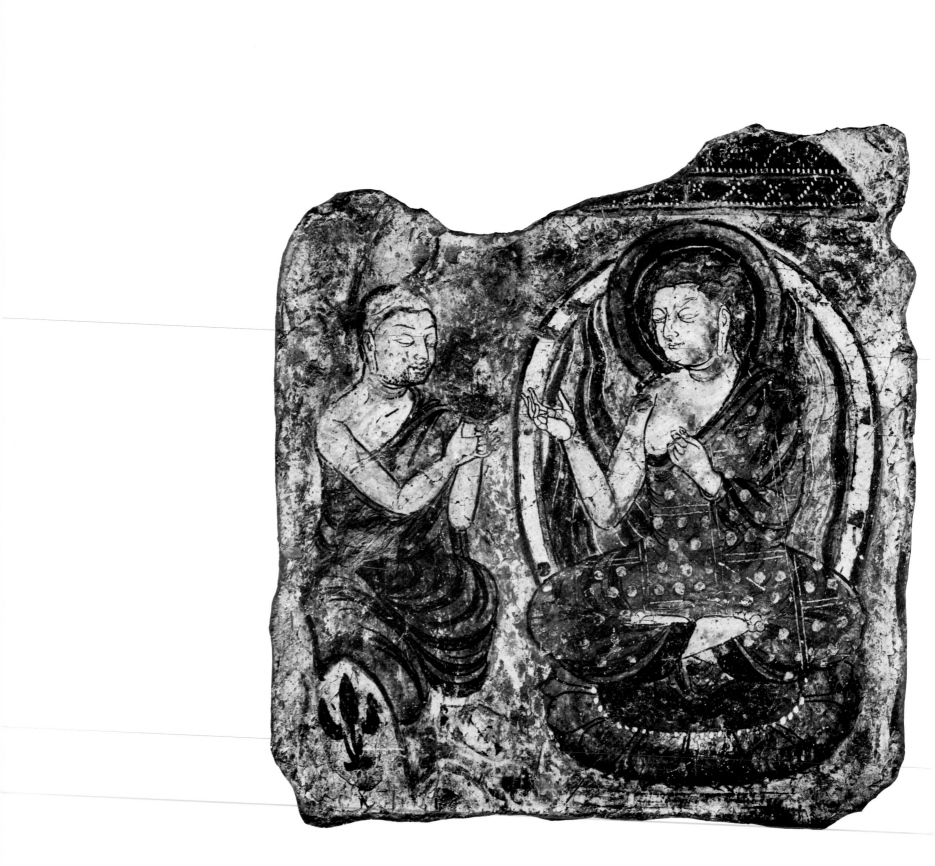

56

Buddha Sakyamuni and a Monk
China, Kumtura, Cave at the Bend;
8th century
Wall painting
18½ × 16½ in. (47 × 41.9 cm.)
Staatliche Museen Preussischer
Kulturbesitz, Museum für Indische
Kunst, Berlin

This mural fragment from Kumtura, once an important center of Buddhism along the Central Asian Silk Route, depicts Buddha Sakyamuni receiving an offering from a monk. Both figures are dressed in orange and red robes, and they have similar features. The monk, however, has stubble on his chin, perhaps indicating that he has recently been traveling. The Buddha is distinguished by his lotus seat, flaming nimbus, and halo. His spotted robe, divided into uneven rectangles, may represent a patchwork garment. This would conform to the ideal for a monk's attire, which was to be assembled from rags discarded by the householder. The canopy above the Buddha's head may indicate an umbrella or some sort of roof.

Although neither face betrays emotion, the two figures seem to interact through their expressive gestures and attitudes. The monk's humility is quite apparent from his disposition and bearing, while Sakyamuni's elegantly rendered right hand seems eager to receive the devotee's offering. Thus, even though the gestures are ritualized, the unknown artist has succeeded in infusing his subjects with subtle but recognizable feelings.

Because this fragment has been removed from its original context, it is not possible to precisely identify the charming scene it depicts. Such encounters between the Buddha and devoted monks, however, must have been a common occurrence during the Master's life.

—*P. P.*

57

The Gift of Anathapindada (?)
Pakistan (Ancient Gandhara),
2nd century
Gray schist with gilding
h: 9⅝ in. (24.4 cm.)
Professor Samuel Eilenberg
(Reproduced in color)

Observed by several monks and laypersons, a man wearing a turban offers a bowl filled with small square objects to the Buddha. A monk kneels below the turbaned figure, and an attendant holding a watering pot and a fly whisk stands immediately behind him, at the left of the relief.

This scene probably represents the occasion when Anathapindada, the richest merchant in Sravasti, offered the Jetavana park to the Buddha as a gift. Moreover, in order to build a monastery, Anathapindada is said to have given the Buddha enough coins to cover the entire park. The small, square objects in the bowl probably represent coins. In ancient India, the giving of a donation or a gift was sealed by the donor's pouring water into the hands of the donee; hence, the significance of the attendant with the watering pot. The gesture the Buddha makes with his right hand seems to express his surprise at the merchant's magnanimity. When completed, the Jetavana monastery was one of the largest in India, and it apparently remained a favorite retreat of the Buddha throughout his life.

Apart from its crisply defined forms, this relief is a fine example of the expressive style of narrative sculpture devised by the artists of Gandhara. Enough gold lingers on the surface of the relief to demonstrate that most such Gandhara sculptures were originally gilded. Note also the Buddha's mustache, a common feature in representations from Gandhara. The monk behind the Buddha has his right arm disposed in a manner seen in portraits of Roman officials.

—*P. P.* 115

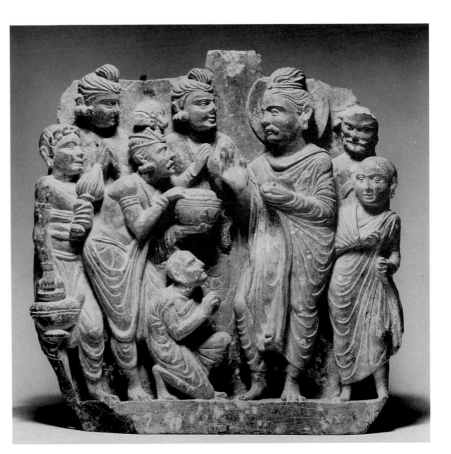

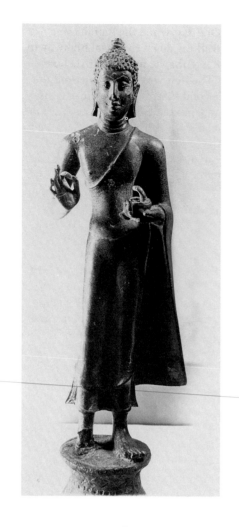

*Buddha Sakyamuni Preaching
before Indra*
India, Uttar Pradesh, Sarnath; c. 450
Beige sandstone
h: 18¼ in. (46.3 cm.)
Los Angeles County Museum of Art,
Los Angeles County Fund
(Shown in Chicago and Brooklyn
only)

According to Buddhists, the gods,
like mortals, are inferior beings who
need to be taught the way to enlight-
enment by a Buddha. This is why,
early in his career, Buddha Sakya-
muni went to the Trayastrimsa
Heaven to teach the Law to his
mother and the gods (no. 54). On
another occasion, while Sakyamuni
was staying in the Indrasala Caves in
Rajagriha, Sakra, or Indra, the king
of the gods, came down to earth to
hear him preach. This is the event
represented in this rare stele from
Sarnath. Although the subject was
popular in the narrative art of
Gandhara, it was seldom depicted in
the arts of other regions or periods,
either in India or elsewhere.

The greater part of the stele is oc-
cupied by the figure of the Buddha,
whose hands display the gesture of
turning the Wheel of the Law. Hov-
ering near Sakyamuni's right shoul-
der is a cherubic celestial holding a
flower in his right hand; the figure
on the other side of the relief is
broken off. Along the base, Indra,
wearing his characteristic tall
crown, seems to be engaged in con-
versation with two monks. Behind
Indra is his mount, an elephant,
rendered with lively naturalism.
The missing figure is the divine mu-
sician Panchasikha who supposedly
accompanied Indra on his visit.

—P. P.

to...Kassapa (saying), "Here you
see the Nāga, Kassapa; his fire
has been conquered by my fire."
*(Rhys Davids and Oldenberg,
p. 120)*
This victory so impressed Kasyapa
that he became a follower of the
Buddha.

The Buddha's presentation of the
snake to Kasyapa was a very popular
theme in Gandhara narrative reliefs,
some of which show the Buddha
holding the serpent in his bowl in a
manner very similar to that of this
Indonesian bronze (cf. Nagar, no. 11).
In later Indian paintings the scene
occurs occasionally, as in the exhib-
ited Pala manuscript cover (no. 7).
Individual icons of the Buddha hold-
ing a bowl containing a snake, how-
ever, appear to be unknown in India.
In Indonesia, there are several
bronze Buddhas that display the
teaching gesture and hold an empty
bowl (see Bernet Kempers, 1959,
pl. 97). Perhaps the snakes were at
times cast separately and placed
loosely in the bowls and, as a result,
are now lost.

—R. L. B.

*Buddha Holding His Alms Bowl
with Snake*
Indonesia, 9th century
Bronze
h: 7¹¹⁄₁₆ in. (19.5 cm.)
Professor Samuel Eilenberg

The Buddha is shown standing with
his right hand in the teaching ges-
ture *(vitarkamudra)* and his left
hand holding a bowl from which a
snake emerges. There are two epi-
sodes in Sakyamuni's life wherein
he overcame a snake and put it in his
alms bowl: In one instance, the Bud-
dha was asked by a king to rid a gar-
den of a frightening snake that was
terrorizing the people; the second
and more popular episode involves
Buddha's victory over a powerful
snake king who resided in the fire

temple at Uruvilva, where Kasyapa,
a famous Hindu teacher and ascetic,
worshiped. The Buddha asked
Kasyapa if he could spend the night
in the fire temple. Kasyapa agreed to
this but warned the Buddha of the
snake: "A savage Nāga (or Serpent)
king of great magical power, a dread-
fully venomous serpent; let him do
no harm to you" (Rhys Davids and
Oldenberg, p. 119). During the night,
the Buddha and the *naga* waged a
great battle in which both sent forth
flames.
 That night having elapsed, the
Blessed One [Buddha], leaving
intact the skin and hide and
flesh and ligaments and bones
and marrow of that Nāga, and
conquering the Nāga's fire by
his fire, threw him into his
alms-bowl, and showed him

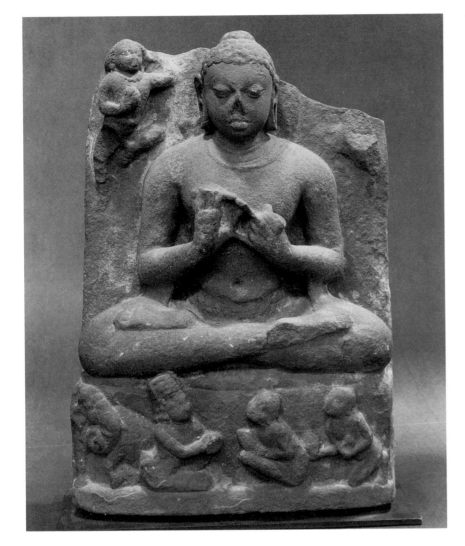

The Offering of Dust
Pakistan (Ancient Gandhara),
2nd century
Gray schist
h: 10 in. (25.4 cm.)
Julian Sherrier Collection, London

The charming event represented in this relief is unique to the art of Gandhara and is only occasionally depicted. The story itself does not occur in the usual Buddhist hagiographies, but it appears in the *Divyavadana*, a collection of didactic tales, or *avadanas*, associated with the Buddha. (See the essay in section four of the catalogue for further discussion of *avadana* tales.)

One day, while the Buddha was walking down the royal highway in Rajagriha, he met two little boys. "The first was named Jaya and the second Vijaya. They were playing and making houses with dust. At the sight of the Blessed One...Jaya said to himself, 'I will give him flour,' and he threw the contents of his hands full of dust into the bowl of the Blessed One; and, Vijaya, lifting his two joined hands, approved" (Foucher, 1905, vol. 1, pp. 518–19; translation by Sheila R. Canby).

The expression of such simple faith is the essence of the *avadanas*. At the end of each story, the Buddha usually predicts that the performer of a pious act will be born in the future as an arhat (a member of a class of enlightened teachers) or a Buddha. In this instance Buddha is said to have forecast that Jaya would be reborn in the future as the great Maurya emperor Asoka (c. 273–232 B.C.), who was considered by the Buddhists of his time to be their greatest royal supporter.

In the stele Jaya is shown as a plump little boy who strides forth and puts the dust in the Buddha's bowl. Standing on the ground behind the Buddha are Vajrapani, the Buddha's guardian angel, who is here dressed as a Roman, and a monk holding a bowl. Along the top, five divine beings—each provided with a halo, as is the Buddha—watch the incident. The relief is framed by a tree on one side and a column containing an image of a meditating Buddha on the other.

—P. P.

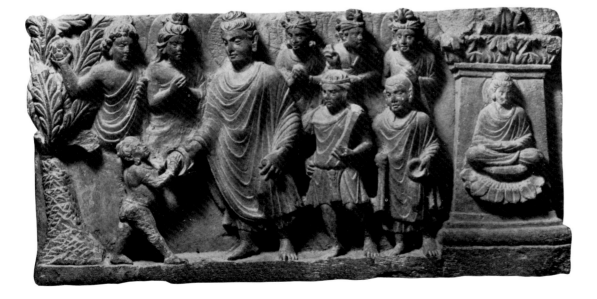

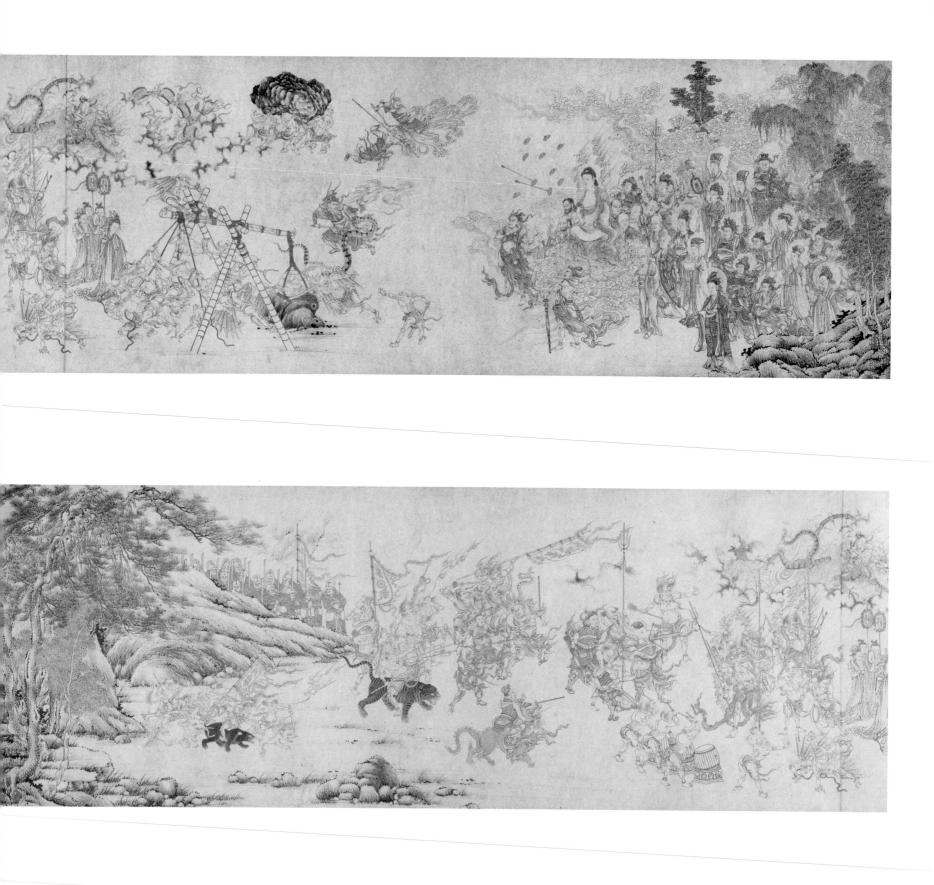

Wang Zhenpeng (Chinese, active
1280–1329)
The Conversion of Hariti
Handscroll
Ink on paper
12⅟₁₆ × 63¾ in. (31 × 162 cm.)
Indianapolis Museum of Art: Gift of
Mr. and Mrs. Eli Lilly

This handscroll attributed to the
painter Wang Zhenpeng [Wang
Chen-p'eng] portrays the demon-
mother Hariti at the moment of her
forced conversion to Buddhism (cf.
no. 16). According to the legend,
Hariti, herself the mother of five
hundred demon children, had vowed
to devour one human child a day. To
stop her, the Buddha imprisoned the
demon-mother's favorite child,
Pingala, in a glass alms bowl, so that
Hariti, in her grief, would learn
compassion for those whose off-
spring she killed. Before she re-
lented, however, the distraught
mother sent her army of demons to
extricate her child; following this
unsuccessful assault, Hariti con-
verted to Buddhism and Pingala was
returned. When she pointed out to
the Buddha that, deprived of her food
source, she and her children would
starve, Sakyamuni promised Hariti
that his monks would offer her a
daily pittance. Thereafter she
became a protectress of Buddhism
and a guardian of nunneries.

The iconographic representation of
the encounter between Sakyamuni
and Hariti is nearly unique to China,
and it derives from an account in the
Samyuktaratna-pitaka, which was
translated into Chinese during the
Northern Wei period (386–535). This
sutra details Hariti's exhaustive ef-
forts to free her imprisoned child,
and this aspect of the Hariti legend
came to be portrayed exclusively in
China (see Murray, pp. 253–67, for an
extensive discussion of this theme).
The earliest images of Hariti are
Gandhara stone sculptures that
depict her as a matronly figure with
children. Representations of this
sort were common throughout Asia
(Foucher, 1917b, pp. 271–91), and they
were described by Yijing [I-ching], a
Chinese pilgrim who traveled to In-
dia by sea between 671 and 685. In
China Hariti became a protectress of
women, as this passage by the Liang
period (502–557) author Zong Lin
[Tsung Lin] suggests: "The Goddess
with the Nine Sons was worshiped
with offerings of thin cakes in the
under storey of the Changshasi pa-
goda by the childless people of the
markets, often with miraculous
results" (Soper, 1959a, p. 228). The rise
of esoteric Buddhism in China dur-
ing the Tang dynasty (618–906) broad-
ened the mystical powers of Hariti
and increased interest in her wor-
ship. Images of Hariti with children
continued to be produced, and to
this theme, the Chinese artists
added her confrontation with
Sakyamuni. Hariti's powers were
elaborated upon by Chinese artists
who portrayed her demon army, per-
haps inspired by the theme of Mara's
attack (Murray, pp. 258–59).

There are several paintings of this
theme that originated in China in
the tenth century. The artist of this
particular painting, Wang Zhenpeng,
was a "boundary" painter (a painter
whose work was characterized by
careful delineation of architecture),
who also executed a few paintings of
landscapes and figures. His painting
represents the seated Hariti as rather
dispassionate compared to other
depictions. She is surrounded by
attendants, who watch while her
army of demons launches an assault
on the glass bowl in the center and
left of the composition.

—*J. B.*

[From China, the theme appears to
have traveled to Tibet, where it was
represented at least once (see no.
16).—*P. P.*]

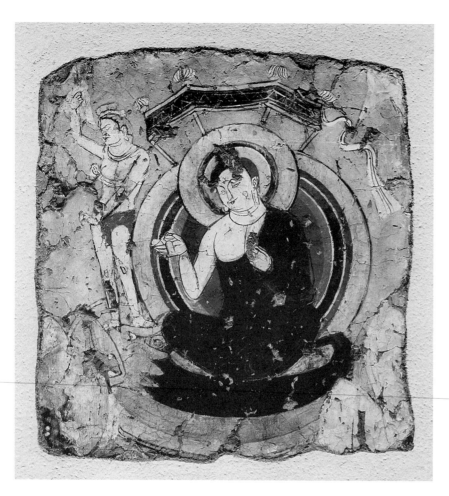

62

The Buddha on a Dragon Boat
China, Kizil, Cave of the Musicians;
600–650
Wall painting
13⅜ × 12⅛ in. (34 × 30.8 cm.)
Staatliche Museen Preussischer
Kulturbesitz, Museum für Indische
Kunst, Berlin

The Buddha on a Dragon Boat is
possibly a depiction of one of the last
miracles the Buddha performed
before he decided to end his earthly
life (Hartel et al., p. 122). While trav-
eling from Rajagriha to Vaisali, the
Buddha came to the Ganges near
Pataliputra. Unable to convince the
ferryman to take him across the
swollen river, the Buddha, making
use of his miraculous powers,
floated across on a "dragon boat."

Shaded by a canopy that indicates
his eminence, the Buddha tranquilly
gestures to his right. Above the drag-
on's head stands a small attendant
figure whose hands appear to be
holding an invisible pole, propelling
the craft through the water. Rocks
on either side suggest the nearby
shore.

The dragon has remained a constant
theme in popular Chinese
symbology. Since the late Zhou
dynasty (1027–256 B.C.), boats
adorned with dragons had been used
in a festival to commemorate the
tragic death of Chu Yuan (Ch'u
Yüan), a Chinese statesman who
drowned himself in the Mile River
in 295 B.C. (C. A. S. Williams, p. 138).
When this painting was executed at
Kizil, Central Asia was under Chi-
nese hegemony. This scene of the
Buddha on a dragon boat may be a
syncretic integration of an ancient
Chinese tradition with an episode
from the Buddha's life.

—G. K.

The Death of the Buddha
Pakistan (Ancient Gandhara),
3rd century
Gray schist
h: 21 in. (53 cm.)
Victoria and Albert Museum

In this expressive relief depicting the *Mahaparinirvana*, the Buddha lies on a bed resting his haloed head on his right hand. Shown meditating at the bottom of the work, his head partially covered by his robe, is the Buddha's last disciple, Subhadra. A few protruding locks of hair indicate that this recently admitted disciple has not yet shaved his head as befits a monk; his smiling and cherubic countenance also seem rather curious in the context. In contrast to Subhadra's cheerful expression, the grief of the distraught Vajrapani, the Buddha's guardian angel sitting to the right of the young disciple, seems all the more conspicuous. The monk with the staff standing near the Buddha's feet is possibly Mahakasyapa, one of the chief disciples, but the naked figure behind him is difficult to identify. Other grieving monks stand in the background, all expressing their feelings in a telling manner. Even the dryad within the leafy medallion in the upper right is unable to control herself and conceals her face in her garment.

Such graphic expressions of grief are not unusual in Gandhara art, where the influence of Hellenistic naturalism was strong. What is curious is that this naturalistic mode does not extend to the figure of Sakyamuni, who is stretched out in an unrealistic manner. Indeed, as in most such representations, the artist has simply placed a standing figure, complete with halo, on its side. In both later Indian and Southeast Asian depictions of this theme, realism is generally eschewed in favor of an idealized, formulaic representation, as seen in the image from Sri Lanka (no. 65). In China and Japan, the subject was popular in paintings that, as in Gandhara art, depict the anguish and distress of both the Buddha's attendants and various animals; this grief is contrasted with the Master's beatific serenity.

—P. P.

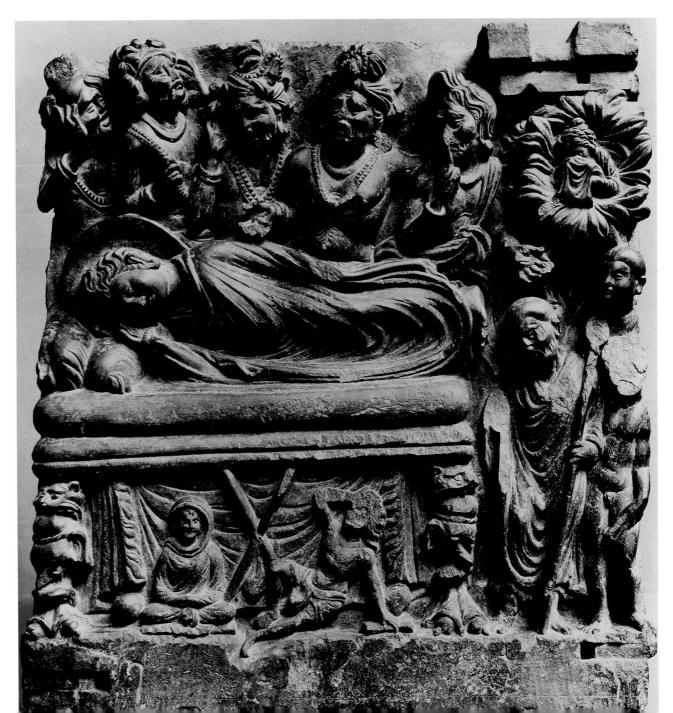

64

(a) *Nehan*
 Japan; Kamakura period,
 1185–1333
 Bronze
 4 × 14 in. (10.2 × 35.5 cm.)
 M. Maruoka Collection, Tokyo

(b) *Nehan*
 Japan; Nambokucho period,
 14th century
 Hanging scroll
 Ink, colors, and gold on silk
 58¼ × 57⅝ in. (148 × 146.4 cm.)
 Takashi Yanagi, Kyoto
 (Reproduced in color)

(c) Yokoyama Kazan
 (Japanese, 1784–1837)
 Nehan; Edo period, 19th century
 Hanging scroll
 Ink and color on paper
 52½ × 11⅜ in. (133.4 × 28.9 cm.)
 The Brooklyn Museum, Loan
 from Mr. and Mrs. Patrick J.
 Gilmartin

(d) Nakamichi Sadatoshi
 (Japanese, 19th century)
 Nehan; Edo period, 19th century
 Hanging scroll
 Opaque watercolors on paper
 66⁷⁄₁₆ × 47 in. (168.8 × 119.4 cm.)
 Shin'enKan Collection

In Japan, paintings of the *Nehan* (the Japanese equivalent of *Mahapari-nirvana*) were used as devotional icons and displayed in Buddhist temples during a special nirvana ceremony which took place on the fifteenth day of the second month of each year. This subject was most commonly represented in paintings, although sculptures, such as the Kamakura period example illustrated here, do exist.

Nehan paintings ostensibly depict *Butsu-Nehan* (the Death of Sakyamuni), but their essential focus is the portrayal of the grief and anguish of the Buddha's followers.

When the Blessed One died, of those of the brethren who were not yet free from the passions, some stretched out their arms and wept, and some fell headlong on the ground, rolling to and fro in anguish at the thought.... But those of the brethren who were free from the passions...bore their grief collected and composed. *(Moran, p. 122)*

The hanging scroll from the Yanagi collection is a spectacular Nambokucho period (1333–92) *Nehan* painting. Painted in bright mineral pigments and gold, it depicts Sakyamuni (Shaka in Japanese) lying on a bier in a grove of *sala* trees, surrounded by divine, human,

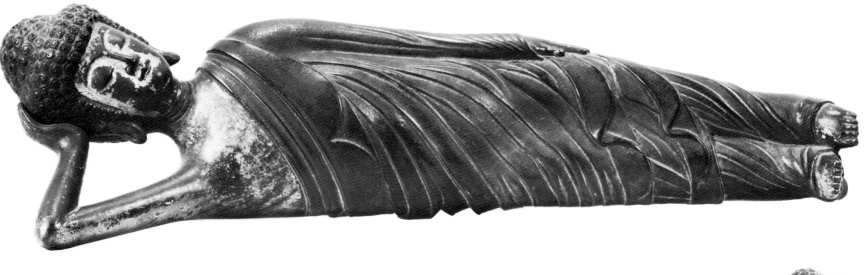

64a

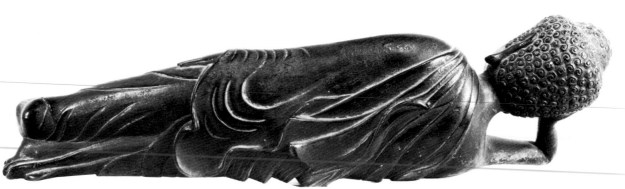

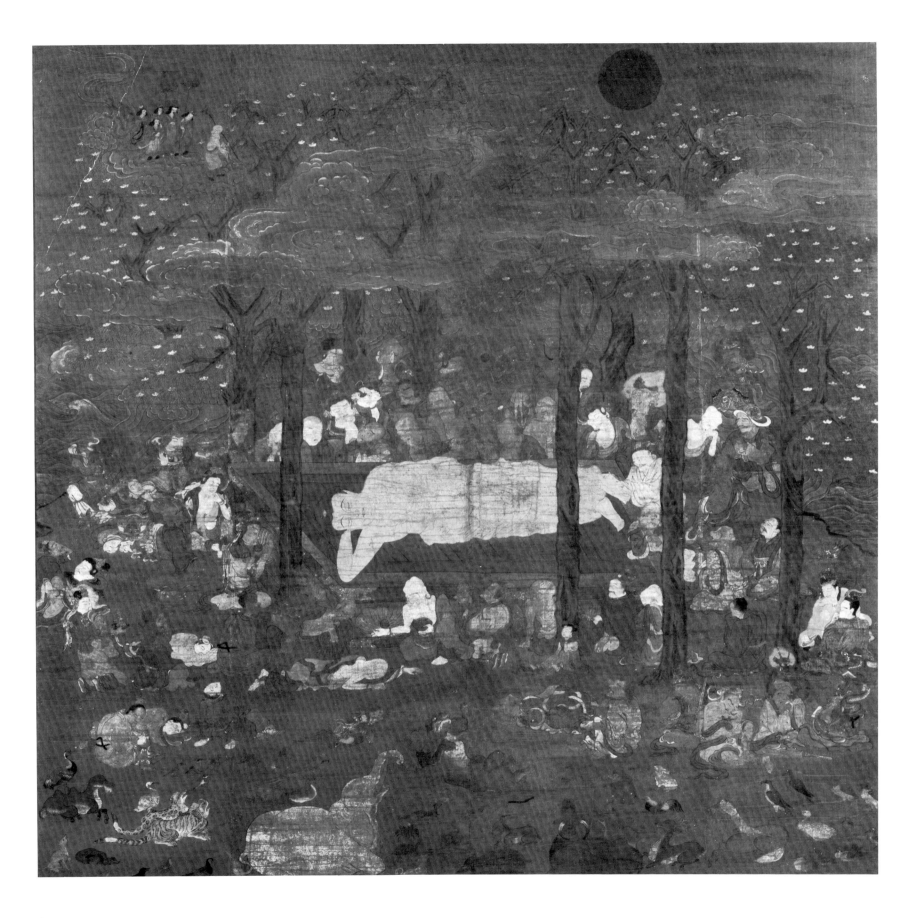

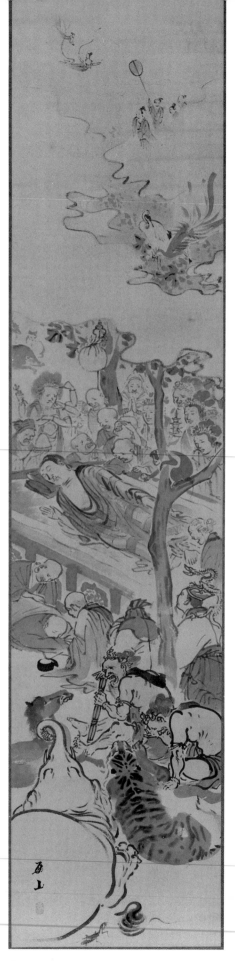

64c

and mythical mourners. The traditional composition is symmetrically arranged, with Sakyamuni reclining on his right side, most closely surrounded by heavenly devotees, such as bodhisattvas. His acolyte Ananda prostrates himself in front of the bier.

Although not described in early Buddhist texts, realistically rendered groups of mourning figures were prescribed by tradition, and by the fourteenth and fifteenth centuries their proliferation had become characteristic of the genre in Japan. The contrast between the attendants who display obvious emotion and those who view the scene with seeming detachment can be observed in the Yanagi painting and in numerous other Japanese versions of the scene as well. Such a pictorial contrast may not be unrelated to the ambiguous nature of the Japanese concept of nirvana, which can refer to enlightenment *(satori)* on the one hand and to the death and abandonment of the mortal body *(muyo-nehan)* on the other.

The presence of animals in such scenes is typically Japanese. In the earliest known Japanese *Nehan* painting, dated 1086 and housed at Kongobuji, Mt. Koya, only one animal appears; whereas in the Yanagi example, over twenty-five animals are present. In still later portrayals, a horde of animals is assembled.

The Edo period (1615–1868) variations on the *Mahaparinirvana* theme in painting provide an interesting contrast to earlier works. In the illustrated scroll by Yokoyama Kazan, a Kyoto artist of the Shijo School, the organization of the subject lacks the traditional axial composition. This is usually attributed to the influence of Western techniques for representing perspective, evidenced in the diagonal arrangement of the scene. The artist has calligraphically abbreviated the

mourners and reduced their number to a symbolic twenty figures and six animals. The pathos of the scene is immediately apparent, especially in the case of the monkey shown perched in the branches of the tree beside the Buddha. This small creature extends his paw with an offering of fruit to Sakyamuni, mistakenly assuming that the recumbent figure is only sleeping. In a feature typical of these scenes, the clouds above contain the Buddha's mother coming down to meet him, as well as a crane, peacock, and *sennin* (a deity)—traditional Japanese symbols of longevity. This group witnesses the scene and welcomes the Buddha to paradise. The placement of the artist's signature on the rump of the elephant in the left foreground adds a humorous touch. In the Edo period, it was common for artists to vary the *Nehan* theme in a personal manner.

The Nakamichi *Nehan* scroll, also from the Edo period, presents a more or less traditional *Nehan* composition. The numerous minutely detailed additions to the usual crowd of mourners distinguish it as a work influenced by the Kyoto artists of the Maruyama and Shijo schools. The peacocks and birds perched on the branches of the *sala* trees, as well as the carp, crayfish, squid, and other shellfish emerging from waves in the foreground, are a departure from the standard *Nehan* formula; they are shown weeping with their faces turned toward the Buddha. These figures are painted using the highly decorative style evolved by Maruyama Okyo (1733–1795). Typical of this style was an increased interest in sketches from life. The use of double lines to echo forms of clouds and trees, in contrast with the finely outlined figures of demigods and worshipers, is also reminiscent of Okyo.

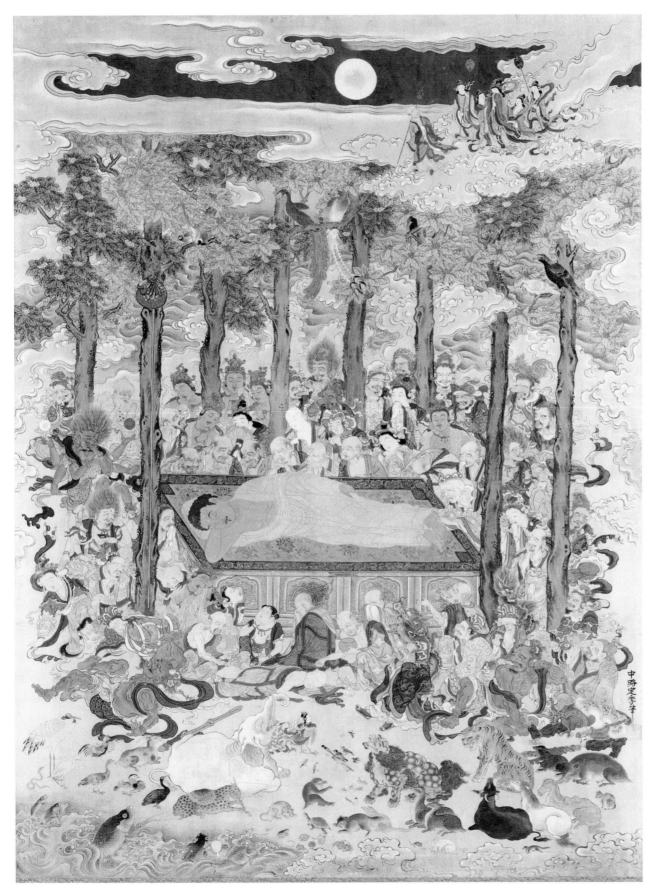

64d

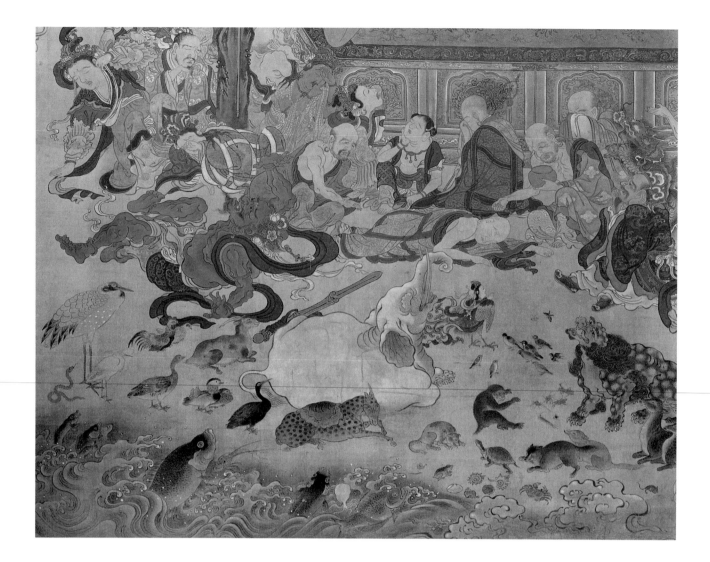

The artist, whose signature is written along the right border of the painting, is identified as Nakamichi Sadatoshi. The characters of his signature can be read in a number of ways, most probably Nakaji Sadatoshi or Nakaji Sadasue. Japanese artists' dictionaries reveal only one Edo period artist with this given name, Nakaji Sadatoshi, an artist known as a Kano School illustrator of the early 1700s. The characters are written differently, however, and Buddhist designs by this artist are not known. It is not at all unusual that the artist who created this beautiful and idiosyncratic painting cannot be found in the standard references. Artists of Buddhist paintings rarely signed their works, and, as a rule, anonymous temple craftsmen were employed to create such scenes. Paintings were only signed on a regular basis when traditional painters were commissioned to paint specific works.

—A. G. P.

65

Reclining Buddha
Sri Lanka, 17th–18th century
Wood with polychromy
11⅝ × 34½ in. (29.5 × 87.6 cm.)
Los Angeles County Museum of Art,
Purchased with Funds Provided by
Anna Bing Arnold
(Reproduced in color)

This Sinhalese Buddha lies
langorously on a decorated base,
supporting his head on the hand of
his bent right arm. His eyes are fully
open and his expression resembles
that typically seen on seated or
standing images. A beautifully deco-
rated backfoil appears behind the
figure.

Although this is a representation of
the *Mahaparinirvana*, the Buddha is
not shown with his eyes closed, as if
near death; on the contrary, his open
eyes and raised head make him
appear fully awake. There are several
possible reasons for such a repre-
sentation. When the Buddha became
ill before his Death, he lay down on a
couch but did not immediately die.
According to the *Mahaparinir-
vanasutra*, he carried on a long dia-
logue from his reclining position
with his disciple Ananda and other
monks. Following this, he went
through a series of meditations or
trances, also while recumbent. It
may be that this lengthy period
before the Buddha's Death is
depicted in this reclining image.

It should be mentioned that in
Southeast Asia such images are fre-
quently not interpreted as repre-
sentations of the Buddha's Death. In
this context, it is interesting to note
that the Sinhalese scholar, Senarat
Paranavitana, in describing the fam-
ous monumental twelfth-century
reclining Buddha image at Gal
Vihara in Polonnaruwa, comments:
"The recumbent image is not a
representation of the Parinirvāna
(the final passing away) of the Mas-
ter, but of the Buddha in the sleeping
attitude engaged in meditation"
(Paranavitana, p. 136).

Made of wood, a popular medium in
Sri Lanka, this beautiful Kandy
period (1592–1815) reclining Bud-
dha has retained much of its poly-
chromy. While the figure is ideal-
ized, the artist has used paint to
realistically depict the eyes, skin
color, and robe; and he has naturalis-
tically placed pillows to support the
Buddha at armpit and ankle.

—*R. L. B.*

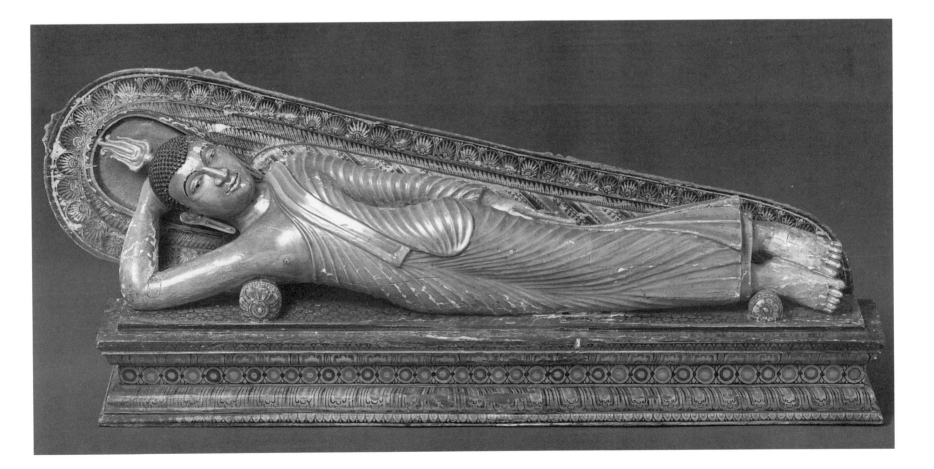

66

Shibata Zeshin (Japanese, 1807–
1891)
Nehan; Edo period, c. 1845
Hanging scroll
Ink and color on paper
54⅛ × 27¼ in. (137.5 × 69.2 cm.)
Honolulu Academy of Arts, The
James Edward and Mary Louise
O'Brien Collection, 1977

Nehan Mitate (a category of parody
involving the *Nehan* theme) became
popular in Japan during the Edo
period (1615–1868). In such paro-
dies, a figure or object was substi-
tuted for the recumbent Sakyamuni
and was intended to suggest an asso-
ciation familiar to the viewer. This
hanging scroll by the noted nine-
teenth-century artist Shibata Zeshin
is a charming example of the humor-
ous elements that enter into the
Nehan Mitate. In this scroll, a
daikon radish—a vegetable often
associated in China and Japan with
the frugality of monastic life—has
replaced the figure of Sakyamuni. It
is placed flat on a wood cutting
board surrounded by numerous
other types of vegetables and fruits.
There exist several earlier examples
of this specific type of *Nehan
Mitate*, and they are related to a vari-
ety of Buddhist texts. Such images,
commonly referred to as *Yasai
Nehan* (Vegetable *Nehan*) were
intended to interest the viewer in
"exploring the smallest details for
additional puns" (Link, no. 5).
<div align="right">—A. G. P.</div>

II SYMBOLS OF BUDDHA SAKYAMUNI

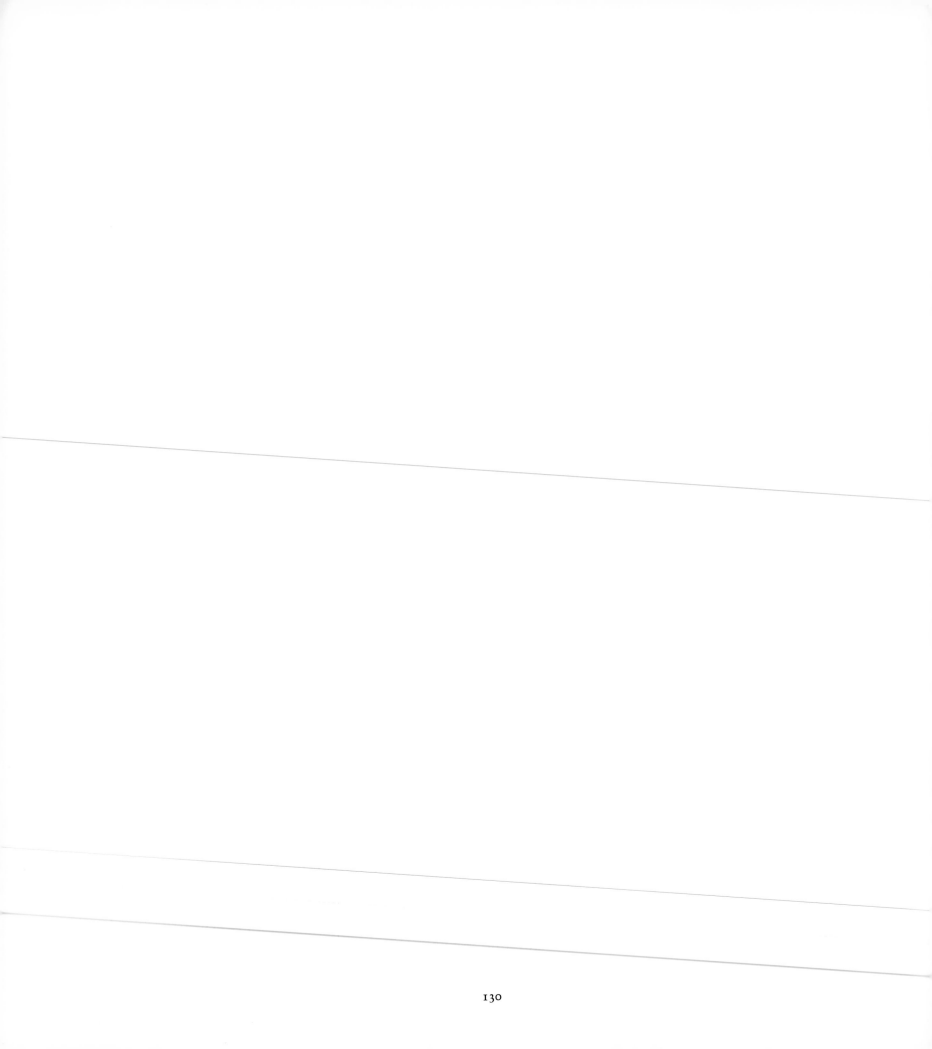

Introduction **U**NTIL AROUND THE TIME of the birth of Christ, Buddha Sakyamuni was generally represented by symbols, rather than by an image. Curiously, although Sakyamuni himself was represented by a symbol, there was no reluctance to portray him in his previous animal or anthropomorphic incarnations in narrative panels depicting *jatakas* (stories of the Buddha's previous lives). (See the essay in section four of the catalogue for further discussion of *jataka* tales.) By the time Buddhism spread beyond India (c. 2nd century), however, images of Buddha Sakyamuni had become a forceful presence, even though many of the early symbols continued to be venerated and remained popular artistic motifs. The reason for the early Buddhists' avoidance of anthropomorphic representations of Buddha Sakyamuni remains a mystery. Interestingly, early Christians also refrained from depicting Christ in his human form, preferring instead a variety of symbols.

The ancient Vedic religion, which was practiced in India from 1500 B.C. through the Buddha's lifetime, was primarily centered around sacrifices and did not incorporate image worship. There seems little doubt, however, that the use of images was prevalent in India even before the arrival of the Aryans from West Asia (c. 1500 B.C.) and the introduction of the Vedic religion. Certainly by the third or second century B.C., it had become customary to build temples enshrining images of nature deities, as well as deified human heroes. The use of the expression *bhagavata*, meaning "blessed" or "divine," to designate Sakyamuni also became prevalent by the second century B.C., as is evident from literature and inscriptions of the time. We have already referred to the strong Buddhist tradition

that maintained that an image of the Master was made by King Udayana of Kausambi during the Buddha's lifetime (nos. 54 and 55). Similar traditions are recorded in later Buddhist texts as well. An iconographic text, compiled probably as early as the seventh or eighth century, begins as follows:

> Buddha, the Holy One, was staying (then) in the Jetavana. When he had come back from the noble Tuṣita heaven after initiating his mother into the *dharma*, Sāriputra said to the worshipful One, "Oh Lord! When you go (elsewhere) or attain *parinirvāṇa* how will you be honored by the noble and respectful disciples (of yours)?" The Master replied, "Oh Sāriputra! When I go (elsewhere) or attain *parinirvāṇa*, my body (image) of *nyāgrodhaparimaṇḍala* type should be made; (i.e.) the full height of the figure should be equal to its width across the chest along the line of the arms fully outstretched."
> *(Banerjea, p. 1)*

Despite the insistence of the literary tradition, however, the artistic evidence conclusively demonstrates that in early Buddhist art, Buddha Sakyamuni was invariably represented by a symbol. This may have been due to the fact that Sakyamuni did not regard himself either as a divine personage or as the founder of a cult or religion. According to tradition, he was reluctant to preach following his Enlightenment, and the gods had to intervene in order to persuade him to share his spiritual experience with others. Early Buddhism did not place much emphasis on any form of ritual worship, whether congregational or individual, and the expression of a devotional attitude was probably limited to the circumambulation of the stupa and the lighting of lamps before or around it. Buddhist monks spent a good deal of time engaged in meditation in order to find their own salvation, and no need was felt for an image that one could communicate with directly or use as an intermediary. It must be remembered, however, that a cult of the bodily relics of the Buddha developed soon after his Death, and it is curious that while his mortal remains were enshrined and venerated, there should have been such reluctance to depict his image.

Artistic evidence indicates that by the second century B.C., significant changes were taking place in the Buddhist church. The relief sculptures surviving at Bharhut, Bodhgaya, and Sanchi clearly show that some form of adoration of the various symbols of the Buddha was proliferating. This change of attitude probably reflected a desire on the part of the Buddhist establishment to appeal to the growing lay congregation. There can be little doubt that the principal force behind the rapid expansion of the religion in the third and second centuries B.C. was the extraordinary patronage extended to Buddhism by the great Maurya emperor Asoka (c. 273–232 B.C.), who is rightly regarded by the Buddhists as their Constantine. Most surviving early Buddhist stone monuments seem to have sprung up all over India during the second century B.C. The relief sculptures decorating these stupas and their railings unequivocally served a didactic purpose. The message of Buddhism was made graphic and direct with vivid visual images.

Major Symbols THE MOST IMPORTANT of the early symbols were: the *bodhi* tree, below which Buddha Sakyamuni was enlightened at Bodhgaya; the stupa (nos. 68 and 69); the empty throne (nos. 70 and 71); the pillar (no. 70); the wheel (no. 72); and the footprint (no. 67). These symbols, along with others, continued to be employed with varying degrees of frequency even after the appearance of the Buddha image. The *bodhi* tree and the stupa remained essential

elements of Buddhist art and apart from signifying the faith itself, the latter became a specific symbol of the Master's Death. Significantly, while the word *stupa* literally means "a mound," its synonym *dharmadhatu* means "essence of religion."

Some of these symbols—the stupa, the pillar, the tree, the footprint, and the wheel—are shared by other Indian religious systems that antedate Buddhism. Stupas, for example, were traditionally raised over the remains of universal monarchs and thus served as memorials similar to grave-stones. The stupa, however, is also rich in cosmic symbolism (see no. 69), as are both the pillar and the tree. The cult of the cosmic pillar and tree that connect the heavens to the earth embodies important religious and cosmogonic concepts. This cult was prevalent in many ancient Asian and European civilizations and not simply confined to ancient India. Thus, within the context of Buddhism, the *sala* trees, which figure in the Birth and Death, and the *bodhi* tree from the Enlightenment cycle reflect the continuity of more ancient mythic traditions.

The veneration of the footprints of divinities, as well as of enlightened mortals, can also be traced to pre-Buddhist days. Not only do footprints symbolize the "presence" of a personage (devout Indians literally worship sandals worn by their gurus), they also carry a cosmic significance. A footprint implies a step, and in Vedic mythology the cosmic deity Vishnu strides forth with three steps to cover the universe. Similarly, the infant Buddha takes seven steps immediately after his Birth in order to symbolize his spiritual domination of the universe. As one text recounts:

> As soon as he was born he takes seven strides over the earth, surveys the regions of it and laughs a loud laugh…. As soon as he was born this was the thought that occurred to the supremely Eloquent One: "Is there anyone who is my equal in intelligence? Are there any who are irked by the course of recurrent birth as I am?" It is for this purpose, to have this doubt resolved, that the Kinsman of the Sun scans all the regions of the world.
> *(Jones, vol. 2, pp. 18–19)*

The wheel is yet another appropriate and ubiquitous symbol of both the Buddha himself and his teachings. Prior to acquiring this significance, the wheel, an ancient symbol like the others, represented the sun. The history of this symbol is preserved in the epithet "Kinsman of the Sun," which is used of the Buddha in the passage quoted above. In Thailand this association is made explicit by the placement of the sun god himself in front of the wheel (see no. 72). The Buddha's First Sermon in the Deer Park at Sarnath is specifically symbolized by the wheel, and the event is generally referred to as the turning of the Wheel of the Law *(dharmachakrapravartana)*. A wheel is frequently present in representations of this event, and in Gandhara, the Buddha is shown literally turning the wheel (no. 52). Occasionally, a *yaksha* (nature deity) is shown carrying three wheels (no. 1), presumably symbolizing the fact that the First Sermon consisted of the three fundamental precepts of Buddhism: the Four Noble Truths; the Eightfold Path; and the Middle Way.

Pratapaditya Pal

A Footprint of the Buddha
Pakistan (Ancient Gandhara),
2nd–3rd century
Gray schist
h: 22½ in. (57.2 cm.)
Mr. T. Kaku, Taiyo Ltd.,
Tokyo

This illustrated footprint of the Buddha is framed by a raised border decorated with a meandering vine and alternating rosettes. The sole is decorated with a large wheel and a lotus supporting an emblem that looks like a trident *(trisula)* but probably symbolizes the three jewels *(triratna):* Buddha, *dharma* (religion), and *sangha* (monastic order). This combined three-jewels motif is also repeated on the bottom of the big toe. The other toes are adorned with the swastika *(svastika),* another ancient Indian symbol of auspiciousness.

—*P. P.*

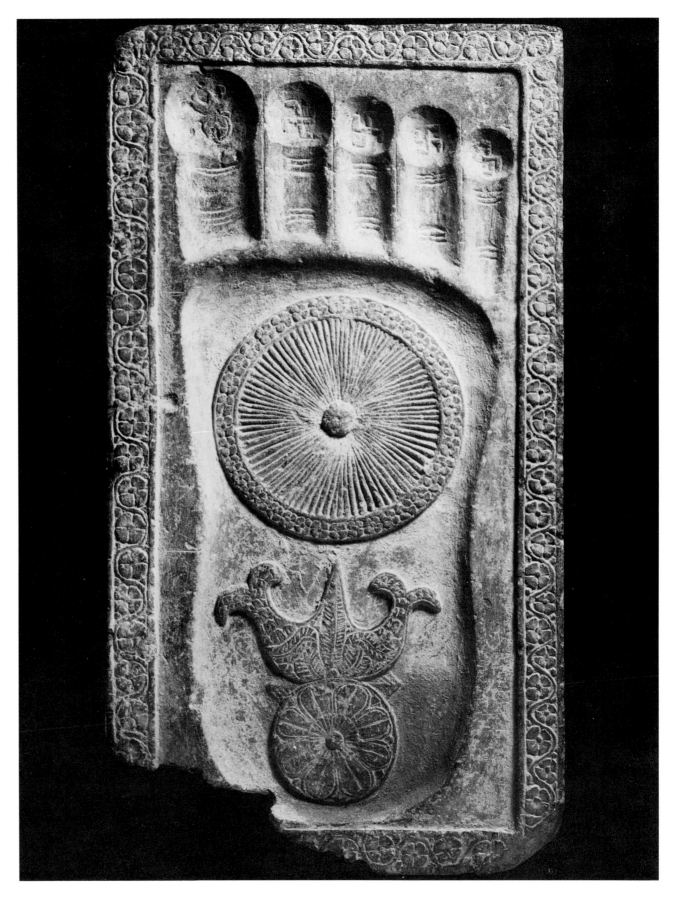

68

Stupa with Sakyamuni
Pakistan (Ancient Gandhara),
2nd–3rd century
Silver
h: 18 in. (45.7 cm.)
Doris Wiener Collection,
New York City

The front of the square base of this stupa is adorned with the figure of a seated Buddha in a shallow niche flanked by leaves and branches of the *bodhi* tree, symbolic of his Enlightenment. The surfaces of the remaining three sides are divided into three panels, and each is decorated with identical floral motifs. A column appears at each corner of the base, and a row of dentils underlines the upper molding on all four sides. The hemispherical section of the stupa, known as the egg *(anda)*, rises from a molded circular base above the square platform. This dome is surmounted by an entablature, known as the *harmika*, from which

a tall, tapering spire emanates, piercing five discs.

While the basic form of this stupa is not in itself unusual, the addition of the four freestanding columns is. These columns rise from four bases, each of which consists of a square and two circular sections, and their fluted shafts are decorated with spiraling bands of vines and foliage. The capital of each column features an inverted lotus supporting an erect lotus, which is surmounted in turn by a roaring lion. The lion capital is a well-known feature of Buddhist architecture and sculpture. These lions are no doubt symbolic of the Buddha himself, Sakyasimha (Lion of the Sakyas), whose sermons are often compared to a lion's roar. The fact that each animal faces one of the four directions reiterates the cosmic symbolism of the stupa. The tall shaft emerging from the dome certainly serves to symbolize a cosmic pillar, the cult of which probably antedated Buddhism.

—*P. P.*

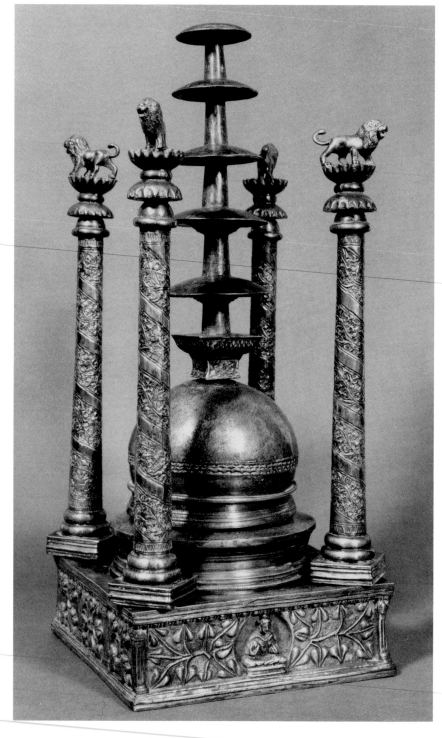

69

Stupa with Scenes from the Life of the Buddha
India, Bihar; 8th–9th century
Bronze
h: 16⅛ in. (41 cm.)
National Museum, New Delhi

This stupa once adorned an altar in the great monastic complex of Nalanda in Bihar. Between the fifth and the eleventh centuries, Nalanda was one of the leading centers of Buddhism in India and played a significant role in the spread of Buddhist ideas outside the country. During this period the university at Nalanda attracted students and monks from all the Buddhist countries in Asia.

Along with bronze images, stupas such as this one were dedicated as ex-votos in the various monastic establishments by pious donors. Richly embellished with scenes from the life of the Buddha, this stupa is composed of three major sections. Above the four legs is a square base divided into eight shallow niches with eight seated bodhisattvas guarding the eight directions. The middle section of the stupa is an octagon divided by means of narrow columns. Each panel in this section illustrates one of the Eight Great Miracles. Next, the hemispherical top section of the stupa rises from a lotus and supports an entablature from which springs an umbrella shaft piercing eight discs.

The divisions of the stupa clearly emphasize its cosmic significance. The square base represents the earth; the octagonal mid-section, the atmosphere; and the dome, the sky. In the use of this structure, the stupa follows the familiar tripartite division of the *linga*, an abstract symbol of the Hindu deity Siva. The *linga* usually consists of a square base, an octagonal shaft, and a circular top symbolizing the vault of the sky.

—P. P.

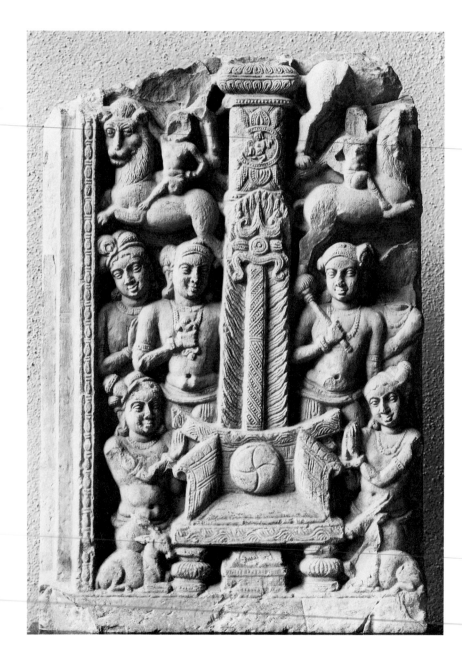

The Worship of the Fiery Pillar
India, Andhra Pradesh,
Nagarjunakonda; 2nd–3rd century
White limestone
h: 20½ in. (52.1 cm.)
Cincinnati Art Museum,
Anonymous Gift

This relief, once an encasement for a stupa, depicts a theme characteristic of the early Buddhist art from the Andhra Pradesh region—the representation of the Buddha as a fiery pillar.

Two deer and two devotees with hands joined in the gesture of adoration flank an empty chair or throne with a cushion placed against its back. In front of the throne is a footrest marked with the Buddha's footprints, and immediately behind the throne rises a flaming pillar decorated with various symbols. A narrow shaft adorned with a garland of beads and located in the middle of the pillar supports the combined motif of a circle or flower balancing the *triratna*. This same motif occurs on the sole of the footprint from Gandhara (no. 67). The flames terminate immediately above this device, but the pillar continues. The upper segment of the pillar is decorated with what appears to be a vertical bow or knot with a central medallion containing a lively dancing cherub. The cushion-shaped capital is adorned with lotus petals; as the upper part of the relief is broken, we do not know if this cushion once supported a finial.

Behind the throne and on either side of the pillar stand figures, two on each side. Since the figure immediately to the left of the pillar is Vajrapani, the thunderbolt bearer, who is shown grasping a thunderbolt with his right hand, presumably all four represent divine beings. In early Buddhist narrative reliefs, both from Gandhara and Andhra, Vajrapani is frequently depicted accompanying the Buddha as a guardian angel (nos. 55 and 60). The figure corresponding to Vajrapani on the right of the throne holds a fly whisk. Above are two cherubim or *putti (yakshas)* riding lions. Fragments of two additional riders can be recognized higher up (cf. the four lions on the four columns of the stupa, no. 68).

The exact significance of such scenes is yet to be satisfactorily explained. Although the chair is empty and the pillar is placed behind it, the presence of the footprints on the footstool (also observed in other examples from Amaravati) clearly implies that the flaming pillar is meant to represent the Buddha. The inclusion of the two deer has led some to consider this scene a representation of the First Sermon at Sarnath, which is more usually represented by the wheel. The pillar itself may represent the ancient cosmic pillar, while the flames may symbolize Agni, the Vedic fire god. The superimposition of some of the other motifs or symbols on the pillar, however, especially the dancing cherub, remains unexplained.

—*P. P.*

71

The Adoration of the Halo
India, Mathura; 2nd century
Sandstone
h: 13 in. (33 cm.)
Victoria and Albert Museum,
Presented by Dr. Turton

This small relief probably once adorned a stupa. It depicts a shrine with an empty throne or chair. The seat is draped with a carpet, and a cushion or a halo is placed against the back. Below the overhanging carpet is a wide stool or footrest. The shrine is supported by two columns with winged-lion capitals and is protected by a railing in front. Behind the throne appear two attendants holding fly whisks.

An empty throne, with or without a cushion, was commonly used in early Buddhist art to indicate the Buddha's presence. This is clear from the near contemporary relief from Andhra Pradesh (cf. no. 70), in which the addition of two footprints on the footrest makes the association between the Buddha and the vacant throne more explicit. The placement of the round object against the back of the throne would suggest that it is intended as a cushion. The scalloped design along the object's edge, however, makes it resemble the halo behind the Buddha's head seen in Mathura images of this period (no. 75). Furthermore, these images frequently show the Buddha flanked by two divine attendants bearing fly whisks. There are also some Gandhara reliefs from this period wherein the circular object on the throne seems to be a halo. In the case of this relief, however, it must be pointed out that logically one would expect a halo to be placed much higher, in the place where the Buddha's head would rest were he actually depicted as sitting on the throne.

The date of the relief indicates that the Buddha continued to be represented by symbols even while his images had already been fashioned in Mathura. This was also the case in Andhra Pradesh.

—P. P.

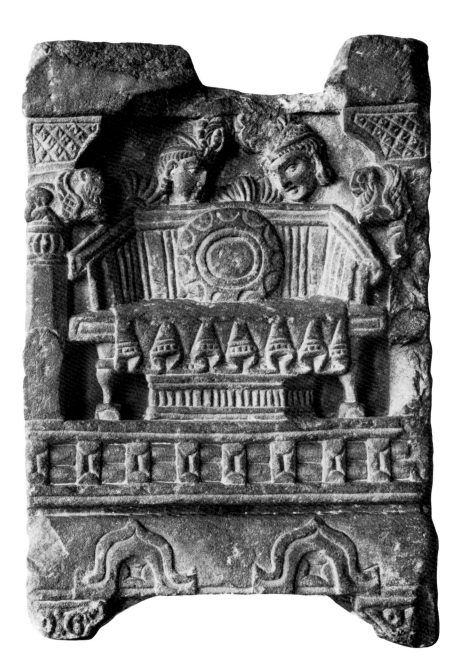

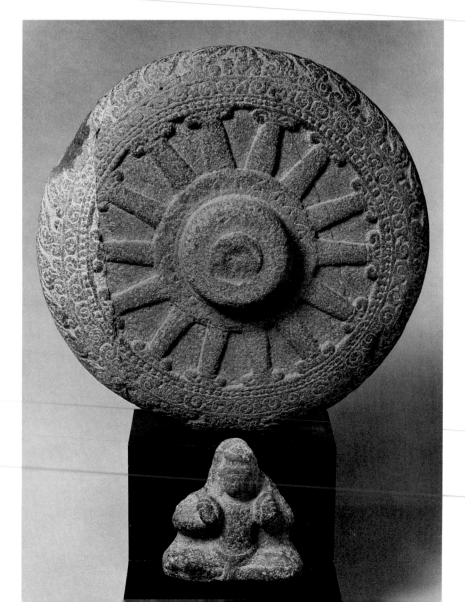

Wheel of the Law with Sun God
Thailand, 8th–9th century
Stone
diam. of wheel: 14 in. (35.6 cm.);
h. of sun god: 5¼ in. (13 cm.)
Los Angeles County Museum of Art,
Purchased with Funds Provided by
The Ahmanson Foundation, Mr. and
Mrs. Harry Lenart, and the Museum
Acquisition Fund

After Sakyamuni attained his Enlightenment at Bodhgaya, he walked to Sarnath, just outside of Banaras. There he first taught his newfound doctrine and "set the wheel of the Law in motion" (Krom, p. 129). The Buddha's First Sermon and the Law, or doctrine, he taught were symbolized by a wheel, since his teachings were considered analogous to the movement of the chariot wheels of the world sovereign (*chakravartin*) as he traverses his empire.

The wheel became one of the most prevalent Buddhist symbols; it was used both alone and in conjunction with an image of the Buddha. Frequently, in the latter instance, the Buddha was shown with his hands positioned in front of his body so that he seemed to grasp an invisible wheel in one hand, which he turned with the other hand (cf. no. 51). By itself, the wheel was often raised on a pillar—the earliest extant example being that set up by the Maurya emperor Asoka at Sarnath in the third century B.C.

This idea of the wheel on a pillar was adopted in Dvaravati in the seventh century. About forty Dvaravati wheels are known. All are made of stone, and they range in size from small ones, such as this example, to large ones over six feet in diameter. The illustrated example displays many of the typical features of the Dvaravati wheels, although it has several unusual characteristics that suggest it may be a later copy. Typical features include: the flamelike decoration on the wheel rim, which is also decorated with designs and pearl bands; spokes that resemble Ionic columns; and a projecting and undecorated hub.

Associated with this wheel is a small seated figure of the sun god Surya. The lotus stems he holds in his hands, the buds of which lie on his shoulders, permit this identification. The wheel was often used as a symbol of the sun, but it was only the Dvaravati who concretized this relationship by actually representing Surya in conjunction with the Buddhist wheel. There are two other wheels that involve Surya figures, but these figures are actually attached to the wheels as part of the relief. One of these wheels was, in fact, the model on which this small wheel and Surya figure were modeled (see Snellgrove, pl. 335).

—R. L. B.

73

Model of the Bodhgaya Temple
India, Bihar, Bodhgaya;
10th–11th century
Soapstone
h: 5⁵⁄₁₆ in. (13.5 cm.)
Museum of Fine Arts, Boston.
Gift of Benjamin Rowland, Jr.

Siddhartha attained Enlightenment *(Bodhi)* near the ancient town of Gaya, hence Buddhists came to refer to the site as Bodhgaya. Naturally, it became the most important center of pilgrimage for Buddhists, just as Banaras is for Hindus, Mecca for Muslims, and Jerusalem for Jews and Christians. In many countries, including Nepal, Tibet, and China, temples were built in imitation of the famous shrine at Bodhgaya. It was also customary for pilgrims visiting the site to pick up a small soapstone model of the temple, such as this example, and take it home as a cherished souvenir. Perhaps the model was then placed on a domestic altar for worship or presented to one's home monastery. This miniature shrine is richly carved with various images and symbols of Buddhism.

The earliest shrine at Bodhgaya must have been quite modest and very likely consisted of the tree itself, encircled by a plain wooden railing. Sometime in the second century B.C., the wooden railing was replaced by a more elaborate stone example, but the tree remained the focal point. A structural temple with an image of the Buddha was probably built no earlier than the second century A.D. By the year 400, when the Chinese pilgrim Fa Xian [Fa Hsien] visited the site, there were four temples, each dedicated to one of the four principal events of the Buddha's life. It is possible, however, that the temple Fa Xian describes was basically similar to this later model and simply contained four subsidiary shrines dedicated to the four principal events, which are represented in niches in this tiny example.

—*P. P.*

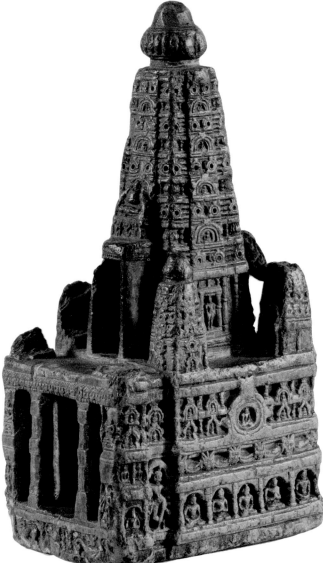

III IMAGES OF BUDDHA SAKYAMUNI

This form of yours, calm yet lovely, brilliant without dazzling,
Soft but mighty,—whom would it not entrance?
Whether one has seen it a hundred times, or beholds it for the first time,
Your form gives the same pleasure to the eye.

. .

Where else would these virtues of a Tathagata be well housed
Except in this form of yours, blazing with signs and marks?

(Conze et al., p. 191)

THE BUDDHA IMAGE IN INDIA

Introduction

A GLANCE AT THE IMAGES OF Sakyamuni included in this exhibition will make it abundantly clear that despite their great diversity, they are in many ways remarkably consistent. Whether created in Sri Lanka or Tibet, in Japan or in Java—no matter how pronounced the ethnic and stylistic differences—the image of a Buddha, idealized, impassive, serene, and otherworldly, is easily recognizable. This is precisely because—to paraphrase the sixth-century Indian poet Matricheta, whose verses are quoted here—it blazes with certain immutable signs and marks. All of these signs and marks were originally established in India by theologians and artists. The purpose of this essay is to briefly discuss such features and to explore the underlying concepts that distinguish the image of Buddha Sakyamuni.

Prior to delineating these characteristics, however, the original functions served by Buddha images should be briefly mentioned. It must be remembered that, although our tendency is to view Buddhist sculptures and paintings as isolated art objects, they initially served a variety of distinct purposes within different cultures. Many images were dedicated in temples and monasteries in an attempt to secure both material and spiritual well-being for the donor, his family, and his friends. Some dedicatory inscriptions on early Indian images indicate that the donor specifically sought nirvana. Mahayana Buddhists were generally less self-centered in their requests and often expressed the hope that all sentient beings might benefit from the presentation of an image. In China and Korea, donors often recorded the hope that they and their families would witness the appearance of the Future Buddha, Maitreya, or, failing that, be reborn in the heavens of Maitreya or Amitabha (two of the cosmic Buddhas discussed in section four of the catalogue).

Javanese inscriptions inform us that Buddha images and Buddhist temples were not only erected to protect land and property but also to aid monarchs in destroying their enemies. Images were also set up as memorials for the deceased or presented as a simple act of piety.

Large stone or bronze images were usually housed in temples and monasteries, where some of them served purely didactic purposes, and others were worshiped ritually. Smaller images, especially bronzes, adorned domestic or monastic altars, a practice that may still be observed in many Buddhist countries. Some large bronzes served as the personal images of wealthy Buddhists or royal patrons. The Chinese Maitreya included in the exhibition (no. 175) may have been one such sculpture; the Buddha image from Tibet in the collection of The Cleveland Museum of Art was certainly another (no. 114).

Worship of an image often involved bathing it either on a daily basis or during special ceremonial occasions, as is still done with baby Buddha images in Japan. Statues of Sakyamuni and of other Buddhist deities were also paraded through cities in processions celebrating important religious events. Buddhist paintings were also employed in a number of specific rituals. In various areas, painted images of Amitabha were necessary for the performance of special ceremonies aimed at prolonging life. Paintings representing Sakyamuni's descent from the mountains served as the focal point for ceremonies associated with the Enlightenment (nos. 40 and 41), and still other paintings were employed in yogic rituals associated with Vajrayana Buddhism.

Whatever the attitude of the earliest Buddhists, once the Buddha's divinity *(bhagavata)* was established, his image became the focal point of elaborate religious rituals. The significance of such practices may be gleaned from the following extracts taken from one of the many texts describing the coming of the Future Buddha, Maitreya. In this text, Maitreya addresses a congregation and explains that his audience is privileged to hear his teachings as a direct result of their having adored Buddha Sakyamuni.

> It is because you have worshipped Shakyamuni with parasols, banners, flags, perfumes, garlands, and unguents that you have arrived here to hear my teachings. It is because you have offered to the shrines of Shakyamuni unguents of sandalwood, or powdered saffron, that you have arrived here to hear my teaching.

Upon hearing these words, Indra, the king of the gods, declares:

> Raise therefore your thoughts in faith to Shakyamuni, the Conqueror! For then you shall see Maitreya, the perfect Buddha, the best of men! Whose soul could be so dark that it would not be lit up with a serene faith when he hears these wonderful things, so potent of future good! Those therefore who long for spiritual greatness, let them show respect to the true Dharma, let them be mindful of the religion of the Buddhas! *(Conze, 1959, pp. 240–42)*

Indian Images of the Buddha

ALTHOUGH TRADITION HAS IT THAT the first Buddha image was fashioned during Sakyamuni's lifetime at the insistence of King Udayana of Kausambi (see nos. 54 and 55), the exact date that artists began representing the Buddha in public

monuments is not known. As discussed in section two of the catalogue, symbols were used to represent Sakyamuni in early Buddhist art, but certainly by the first century, his image had made its appearance in both Gandhara and Mathura.

At Mathura, early images depicted the Buddha as a yogi (see no. 75), while at Gandhara he was represented more as a monk-teacher (see no. 74). In both image types, the figure was idealized, although in different ways. Gandhara artists modified Greco-Roman images of Apollo and deified Roman emperors with certain Indianized features (no. 76), while Mathura artists portrayed him as a yogi with an idealized body. Except for the fact that the Buddha's figure is larger than those of his attendants, in Mathura sculptures of the Kushan period (1st–3rd century) he remains an earthbound person with open eyes that seem to look squarely at the viewer. His head is neither clean shaven, like that of an ordinary monk, nor does he display the crown of curly locks typical of later images. Instead, his hair is gathered up in the spiral topknot characteristic of an ascetic yogi. In contemporary Gandhara images, on the other hand, he is given a full crown of luxuriant, wavy hair, which also covers the artificial bump on the top of his head. This bump, known in Sanskrit as a *ushnisha*, subsequently became a standard feature of all Buddha images, including those carved in Mathura after the third century.

It is curious that neither early Gandhara or Mathura images depict the Buddha's hair in the snail-shell curls that came to be one of the most prevalent and distinctive characteristics of Buddha images. This certainly indicates that at the time the first images of the Buddha were carved for public display, no strong literary or iconographic tradition had yet been codified. Indeed, the Mathura and Gandhara images are stylistically and conceptually so different that one must rule out the possibility of a central church or state authority issuing any edict or mandate regarding the appropriate form for the first image of the Buddha.

No specific iconographic description of the Buddha occurs in the early Pali literature compiled before the birth of Christ—the accounts in these texts being mostly hyperbolic and poetic—but there are a number of passages and verses that could easily have provided artists with the conceptual framework for creating the first image. Although one encounters the earliest images at Mathura and Gandhara, it seems reasonable to assume that the first sculpture depicting the Buddha would have been enshrined at Bodhgaya. The Enlightenment was certainly regarded as the most important event in the Buddha's life, as is clearly evident from the many subsequent representations (see for example nos. 9, 10, 11, 13, 14, 16, and 44–48). And it is certainly not fortuitous that the earliest images of the Buddha at Mathura consistently represent him seated under a *bodhi* tree. Moreover, there is a very curious passage in the early Pali text *Anagatavamsa*, where the Buddha states:

> Then, when the Dispensation of the Perfect Buddha is 5000 years old, the relics, not receiving reverence and honor, will go to places where they can receive them. As time goes on and on there will not be reverence and honor for them in every place. At the time when the Dispensation is falling into (oblivion), all the relics, coming from every place: from the abode of serpents and the deva-world and the Brahma-world, having gathered together in the space around the great Bo-tree, having made a Buddha-image, and having performed a 'miracle' like the twin-miracle, will teach Dhamma [religion]. *(Conze et al., p. 49)*

Whether or not there was an actual image of the Buddha placed under the *bodhi* tree, the early writers provided an excellent literary model for one, as evidenced in many Pali sources. For in-

stance, in the *Anguttara-Nikaya*, the brahmin Dona beheld the Buddha "sitting under a tree, comely, faith-inspiring, his sense-faculties and his mind peaceful, attained to the calm of uttermost control, restrained, tamed and guarded as to his sense-faculties" (Conze et al., p. 105). In the *Majjhima-Nikaya*, speaking of mindfulness, the Buddha says: "Herein, monks, a monk who has gone to a forest or the root of a tree or to an empty place, sits down cross-legged, holding his back erect, and arouses mindfulness in front of him. Mindful he breathes in, mindful he breathes out" (Conze et al., p. 56).

Clearly, these passages evoke the picture of a solitary yogi seated in meditation in a lonely place under a tree, an image that certainly antedated the Buddha. Similar passages can be selected from various Hindu texts as well, but we will limit ourselves to the well-known verses in the *Bhagavadgita*, the most important of all Hindu scriptures, where the ideal yogi is described with great precision.

> In a clean place establishing
> A steady seat for himself,
> That is neither too high nor too low,
> Covered with a cloth, a skin, and a kusa-grass,
>
> There fixing the thought-organ on a single object,
> Restraining the activity of his mind and senses,
> Sitting on the seat, let him practice
> Discipline unto self-purification.
>
> Even body, head, and neck
> Holding motionless, (keeping himself) steady,
> Gazing at the tip of his own nose,
> And not looking in any direction,
>
>
>
> Let him sit disciplined, absorbed in Me.
>
> As a lamp stationed in a windless place
> Flickers not, this image is recorded
> Of the disciplined man controlled in thought,
> Practicing discipline of the self.
>
> *(Edgerton, pp. 33–34)*

There can be little doubt that such descriptions of the ideal yogi provided artists with their model for the image of the Sage of the Sakyas, who was after all an enlightened or awakened yogi himself. A glance at sculptures of the seated Buddha—whether from Mathura (no. 75), Sarnath (no. 51), Sri Lanka (no. 80), or Burma (no. 99)—will make it clear that, stylistic variations and ethnic diversity notwithstanding, the image remained that of an elegantly serene, contemplative yogi engaged in solitary meditation with unflinching concentration.

At the same time, however, we notice several other features of the image that may appear initially puzzling. The Buddha's hands and feet are often marked with wheels (no. 78); the fingers of his hands are webbed (nos. 85 and 93); his earlobes are unnaturally elongated; his hair is shown in tiny curls that turn to the right *(dakshinavarta)*; a bump is added to his cranium; and in some

images (see for example nos. 77, 93, 104, and 107), a molelike dot appears between his eyebrows. Most of these signs are considered indicative of a superman *(mahapurusha)* or a universal monarch *(chakravartin)*, and they are shared both by gods and enlightened mortals, who are known as Buddhas or *Jinas*. According to tradition, Buddha Sakyamuni was endowed with the thirty-two major and eighty minor signs that had characterized the ancient concept of a *chakravartin*, a term which literally means "one who turns the wheel." Some of these features, such as the quality of the Buddha's teeth or voice, had no relevance for artists, but others did. Several texts, both in Pali and Sanskrit, provide us with lists of such signs. The following is a quotation from the *Mahavastu*.

> He has feet with level tread.
> He has designs of wheels on the soles of his feet.
> He has long toes and fingers.
> He can touch his knees with his hands when standing erect.
> His body is proportioned like the banyan tree.
> His hands and feet are net-like.
> His skin is the color of gold.
> His bust is consistently rounded.
> Between his eyebrows he has a hairy mole.
> His head is shaped like a royal turban.
> *(Jones, vol. 1, pp. 181–82)*

Similar descriptions occur in Hindu texts as well. For instance, the *Matsyapurana* tells us that the figure of a universal monarch is proportioned like the banyan tree. It goes on to explain that this means the height of the body should equal the length of the two arms when fully extended. We are also told that the arms should stretch down to the knees, the hands should be like palm leaves *(talahasta)*, the shoulders should be as broad as a lion's, the feet should be marked with the wheel and the fish, and the palms of the hands should bear the sign of the conch and the lotus.

Although these marks of excellence were canonically prescribed—perhaps even before the appearance of the Buddha image—they were not always consistently followed. Furthermore, some features which appear on images of the Buddha are not included on the list of major signs. A number of these can be explained symbolically, but others remain obscure. It is often difficult to determine whether an innovative characteristic was invented by an artist and subsequently explained in symbolic terms by a theologian or whether, conversely, the artist simply followed instructions.

It has already been pointed out that in early images from Mathura and Gandhara, the Buddha's hair is not shown in curls. And yet, by the end of the second or beginning of the third century, the snail-shell curls that turn to the right had become a consistent feature of most Indian Buddha images. (Chinese artists, however, continued to prefer the wavy hair observed in Gandhara representations, and in some instances, Southeast Asian artists depicted curls that turn toward the left.) This important iconographic feature is not included among the major signs. In the *Mahavastu*, we are told that Buddhas "keep their dark and glossy hair close cropped, although no razor ever cuts it" (Jones, vol. 1, p. 133). This account of course contradicts the fact that the Buddha himself supposedly cut his hair off upon his renunciation.

The mode of showing the hair arranged in small curls turning clockwise appears to have been an artistic borrowing. This type of coiffure occurs in earlier images of *Jinas* (the saints of the Jaina pantheon) at Mathura and, even more interesting, on members of the Malla tribe depicted in a relief at Sanchi that can be dated to the first century. It should be recalled at this point that like the Mallas, the Sakyas were a tribal people. In any event, it is rather curious that sometime in the second century, Mathura artists should have felt the need to change the Buddha's hairstyle, especially since their colleagues in Gandhara did not. The theological explanation offered later for the right-turning curls is that they are auspicious and the sign of a divine nature. Similarly, the navel of the superman turns to the right, one circumambulates a sacred object from left to right, and the circles around the mouth of a conch shell turn to the right.

The Buddha's elongated earlobes are another instance of a mark not included on the list but invariably seen in art. Why a superman should have such disproportionately large ears and such extended earlobes is not explained in any text known to us. Significantly, the ears are always pierced, and it is probable that Siddhartha wore large, heavy ear ornaments, as was the custom in his time. (Some tribal people continue this practice today.) These ornaments may have unnaturally extended his earlobes. It remains unclear, however, why Buddhist theologians did not evolve a symbolic explanation for this feature.

The three lines on the neck are also excluded from the traditional signs of greatness, although they are perceived as marks of beauty in most general iconographic texts. In describing the appearance of gods and kings, such texts suggest analogies with a variety of natural objects: Eyes are compared to lotuses (this comparison is always applicable to the Buddha); the nose is like the beak of a parrot in the case of male or the sesame flower in the case of a female; fingers resemble bean pods; and so forth. In a similar fashion, the neck is compared to a conch *(kambugriva)*, and the mouth of a conch shell is often surrounded by three circles. Thus, artists added three lines circumscribing the Buddha's neck.

Perhaps the two most curious marks are the *urna* and the *ushnisha*, both of which were traditionally major signs. Although translated by Jones, in the quotation from the *Mahavastu* given above, as a "hairy mole" and usually depicted in that fashion, the word *urna* means a tuft or circle of hair. Often the *urna* sits between the eyebrows or slightly higher, like the cosmetic beauty mark which Indian women add to their foreheads. Sometimes it is considered to be akin to the third eye—often referred to as the eye of wisdom—of the Hindu deity Siva, but it is not an eye at all. In East Asian paintings, it often becomes a source of light, especially in images of Amida Buddha. There is also no consistent pattern of inclusion of the *urna* on Buddha images. While it occurs frequently in early Mathura and Gandhara images, it seems to have gone out of fashion with the Gupta period (320–600) artists at Mathura and Sarnath. It is seen frequently in East Asian and Javanese images but rarely occurs in early images from Thailand and Cambodia. Rather, in Dvaravati images from ancient Thailand (no. 105), the eyebrows are joined in a continuous undulating line.

Why exactly a tuft of hair between the eyebrows should have become a mark of excellence is not explained anywhere, and even in the earliest Buddha images, a simple dot or mole is shown instead of a hairy curl. On the other hand, there is a common belief in some parts of India (certainly in Bengal) that joined eyebrows are a sign of a fortunate man. Evidently this is how the sculptors of Dvaravati understood the *urna*, for they were quite consistent in joining the eyebrows at the bridge of the nose.

The depiction of the *ushnisha* as a cranial bump is equally difficult to explain. The word literally means anything wrapped around the head, and normally the Sanskrit expression *ushnisha sirsham* or the Pali equivalent *unhisa-sisu hoti* would imply a turbaned head. Although at times the arrangement of an ascetic's long hair may look like a turban, neither a monk nor a yogi would wear such headgear. Certainly, prior to his renunciation, however, Siddhartha must have worn a turban, as was the custom in his day (see no. 38). If this mark of excellence was prescribed for the Buddha before the creation of his image at Mathura or Gandhara, then we must conclude that artists in both regions did not understand the term, as in fact we do not today. Neither the hairstyle of the Mathura Buddhas nor the bump apparent on those from Gandhara, Andhra, or for that matter Sri Lanka has anything to do with a turban, unless the *ushnisha* is meant to represent a bunch of hair around which a turban would be tied. According to tradition, however, Sakyamuni had cut off his topknot following the great departure. Even less plausible is Jones' translation of the term *ushnisha* in the passage quoted above: "His head is shaped like a royal turban." Even if this were accurate, the bump certainly would not contribute to approximating the shape of a turban. Whatever its original significance, the *ushnisha* subsequently came to be regarded as the source of wisdom and remained one of the most prominent iconographic features of the Buddha image.

As for the webbed hands and feet, neither was a consistently employed feature, and usually, the hands rather than the feet were represented as webbed. Webbed hands do not appear in Buddha images until the Gupta period. The word *jala* in the expression *jalahasta*—which is used of the Buddha's hands in the *Mahavastu* and other texts—means a net; the implication being that the Buddha will affect everyone, just as a net catches all manner of fish. This explanation, however, seems tendentious. On the other hand, the expression *talahasta*, as given in the *Matsyapurana*, makes more sense. The leaf of a palmyra, or fan palm *(tala)*, does spread out like a hand, and its prominent ribs are joined by leafy skin. Moreover, *talahasta* also implies large hands, and in some schools, such as those of South India (no. 86), the hands are often represented as disproportionately large. It has also been suggested that the idea of webbed hands and feet is borrowed from the duck or the goose which, because of its webbed feet, can swim through water effortlessly. Similarly, a Buddha goes through the phenomenal world *(samsara)* without being attached to it. A spiritually awakened person in India is often called *paramahamsa*, or the great goose. In fact, one text specifically compares the webbed feet of the Buddha to those of the wild goose. It is even more probable, however, that this feature was first dictated by utilitarian considerations. Since Buddha images were in great demand and frequently had to be carried long distances, artists may have felt it necessary to leave some of the stone between the fingers uncut in order to give them greater durability. In transporting images, the hands are usually the most vulnerable to damage, and fingers carved in the round would be particularly fragile.

By the Gupta period, all of the characteristics thus far described were codified in iconographic texts that were translated into the languages of the various countries to which Buddhism traveled. Along with analogical descriptions of specific features and parts of the body, very detailed and elaborate theories of proportion developed. Indeed, no image was considered worthy of worship unless it was made using the correct proportions. The suggested proportions of the body differed, however, sometimes significantly, in the various manuals. This inconsistency accounts in part for the differences we note among images from specific regions and periods. Certainly, the unusually elongated lower portion of Mathura Buddhas (no. 84), when compared with Sarnath or Nepali Buddhas (no. 107), must imply that the Mathura artists were following significantly different iconometric formulae.

Indeed, the existence of alternative canons of measure, even for so sacrosanct an image as that of the Buddha, is clearly apparent from a comparison of the few remaining Indian iconometric texts and the several traditions that are preserved in the Tibetan. There are also several pattern books from Nepal that contain iconometric drawings of the Buddha image, and these do not seem to follow a single canon of measure. Decades ago, in a signficant study of one such text that involved applying the prescribed measurements to images of the Buddha from various regions of India, the late Professor J. N. Banerjea demonstrated precisely the many deviations that had occurred from one tradition to another (see Banerjea). In a recent study of the Tibetan canons of iconometry, Kathleen Peterson has also demonstrated not only how the practice differed from the theory but how one theory differed from another.

> A comparison of several of the primary and secondary sources on which Tibetan iconometric theory is founded reveals that many of the differences that have been noticed in the work of contemporary craftsmen are the result of alternative canons of measure. Some of these alternatives are derived from differences in the original sources and others are the result of permissible variation in their interpretation by practicing craftsmen. Both cases, however, lead to the conclusion that the Tibetan iconometric tradition does possess a certain degree of flexibility and is not restricted to a single canon of measures. *(Peterson, p. 239)*

By and large these observations are true of all Buddhist countries, and variations in the canons of measure often accounted for the tremendous differences one notes among the Buddha images from various nations.

Local and historical preferences also account for significant variations in representations. Even though the texts described the ideals of the Buddha image with some degree of precision, the final product differed from age to age and region to region because of ethnic differences and aesthetic norms. Thus, a Chinese Buddha looks Chinese, just as an African Christ usually looks more like an African than a European. Ideals of human beauty were considerably different in the diverse civilizations and cultures and resulted in preferences for different body shapes. These ideals in turn varied from one region to another and within historical periods. The most dramatic comparison is offered by the images produced at Mathura and Gandhara in the second century (nos. 74 and 75) and slightly later in Andhra (no. 78). Or again, if we compare a Buddha created in China during the Eastern Wei period (no. 87) with others of the Sui (no. 88) and Tang periods (no. 97), it becomes clear that the variations are as much due to basic differences in aesthetic norms and physiological ideals as they are to the applications of different canons of measure.

Man has always made his god in his own image, but as we have seen, some of the iconographic traits of the Buddha image remained inviolable. These essential characteristics ensured the basic continuity of the tradition. Apart from the physical characteristics enumerated above, the most fundamental and unalterable feature of images is the Buddha's identity as a monk-yogi. He is always clothed in the traditional attire of a monk, which consists of three pieces of unsewn cloth *(trichivara)*. Sometimes he is crowned and bejeweled, but the monk's garments are almost invariable. Even though he might be represented as larger than life with his divinity announced by halos, aureoles, and a golden complexion, Buddha Sakyamuni was never portrayed with multiple limbs, as was the case with both Hindu and Buddhist gods in India. Despite his deification, he was never quite dehumanized. Like other Indian deities, however, he was nearly always represented as eternally youthful. The exception to this rule occurs in the East Asian Chan, or Zen, tradition where his human rather than his divine form was stressed (nos. 40 and 41).

The postures and gestures characteristic of the Buddha are simple and limited. He is either shown standing, walking, or seated (on most occasions in one of the yogic postures). The most common of the seated positions is that known as the lotus posture. In some instances, and only in his capacity as a teacher, the Buddha is shown seated on a throne or a chair with his legs pendant (nos. 158, 177, and 178), a posture that was undoubtedly borrowed from contemporary regal statues. In Sanskrit this posture is known as the *bhadrasana,* or auspicious posture. In scenes of the Buddha's Death (nos. 63, 64, and 65), the standing image was simply placed on its side, hence, the stiff and somewhat awkward appearance of such figures. When standing, the Buddha is sometimes shown in a strictly columnar posture (nos. 88 and 118), but more frequently his body was presented in *contrapposto.* In a type of image that was particularly popular in Thailand (no. 120), he definitely gives the impression of walking.

The gestures of the Buddha's hands were almost entirely limited to five, one of the most common being that of reassurance *(abhayamudra),* in which the right arm is raised to the chest level with the open palm of the hand facing the viewer (nos. 75, 76, and 77). If the right arm with the hand open is extended along the body, the gesture indicates the bestowing of a blessing or charity *(varadamudra)* (no. 107). In both of these instances the left hand holds the end of the Buddha's garment. The third gesture is known as the gesture of meditation *(dhyanamudra).* In this gesture both hands are placed, palms facing up, one upon the other, in the lap (nos. 80, 89, and 109). These three gestures are assumed by Hindu gods as well; the remaining two positions, however, are typically Buddhist. One of these, known as the earth-touching gesture *(bhumisparsamudra),* shows the right hand extended and touching the seat on which the Buddha meditates, the left hand being placed in his lap (nos. 44–46). This gesture is the most specific of the five and signifies the occasion of the Enlightenment. The fifth gesture is known as turning the Wheel of the Law *(dharmachakrapravartanamudra).* This is the most complicated of the five gestures and requires the use of both hands (no. 51). Raised to the level of the chest, the right hand forms, with the thumb and index finger touching each other, what is known as the teaching gesture *(vitarkamudra* or *vyakhyanamudra).* The left hand, forming the same gesture, is placed palm up, parallel to the ground and slightly below the right hand. Together, the two hands form a circle and symbolically suggest the rotation of a wheel. In some regions, such as Thailand, both hands display the teaching gesture and are raised to shoulder height. The basic gestures, however, remained those of reassurance, charity, meditation, touching the earth, and teaching. The only accessory the Buddha is ever shown carrying is his alms bowl.

Although the above discussion of the Buddha image is not exhaustive, it is hoped that it will help the reader to better appreciate the beautiful representations created by countless generations of talented artists wherever Buddhism flourished. As we admire these paintings and sculptures, we may easily come to understand their iconography and appreciate the technical skill involved in their creation. None of these external factors should make us forget the spiritual resources of the unknown and unsung artists who created these inspiring images of faith and hope for countless millions across one of the largest land masses on the face of the earth.

Pratapaditya Pal

THE BUDDHA IMAGE IN SRI LANKA
AND SOUTHEAST ASIA

IN SOME COUNTRIES of Southeast Asia the population of Buddha images far outnumbers the population of humans (Buribhand and Griswold, p. 3). Perhaps more Buddha images have been made in this area than anywhere else in Asia. The history of Buddhism and its art in Southeast Asia is extremely complex because the region is ethnically, linguistically, and culturally very diverse. The fortunes of Buddhism have varied given this diversity. Nevertheless, we may consider the art of Southeast Asia as a unit due to the shared predominance of Indian influence. In fact, Southeast Asian art can only be understood in terms of Indian art and thought.

As will be abundantly clear from an examination of the entries in this catalogue, however, a reliance on Indian models and ideas did not keep Southeast Asian artists from achieving the highest levels of artistic excellence and making some remarkable innovations. In this essay, particular attention will be paid to the connection between Indian and Southeast Asian art and to stylistic and iconographic developments. The reader should keep in mind, however, that each of the countries that make up present-day Southeast Asia—Burma, Thailand, Malaysia, Laos, Cambodia, Vietnam, and Indonesia—should ultimately be studied and understood in terms of its own individual artistic traditions, a task that cannot be undertaken within the scope of this catalogue.

The Buddha Image
in Sri Lanka

Before beginning a discussion of the Buddha image in Southeast Asia, it is helpful first to understand something about its history in Sri Lanka. This island country is located only seventy-five kilometers off the southern tip of India. As a result, Sinhalese and Indian history and art are closely related. At the same time, Sri Lanka has had close ties with Southeast Asia, particularly Burma and Thailand, with which it shares a tradition of Theravada Buddhism.

Buddhism is said to have been introduced to Sri Lanka, as well as Southeast Asia, by missionaries sent in the third century B.C. by the Indian king Asoka. Although few archaeological finds support such an early introduction of Buddhism to Southeast Asia, considerable evidence confirms its presence at this time in Sri Lanka. This evidence includes inscriptions paleographically dated to the third century B.C. that were found in natural caves used by the first Buddhist monks in Sri Lanka. Buddhism has thrived continuously on the island from its introduction up to the present, thus making the Sinhalese Buddhist tradition the longest-lived in Asia.

The initial appearance of Buddha images in Sri Lanka falls within the first period of Sinhalese Buddhist art, the Anuradhapura period (3rd century B.C.–10th century A.D.). A great deal of controversy, however, surrounds attempts to determine a more precise time frame. One group of scholars places the first appearance of standing and seated images in the second and third centuries, more or less contemporary with the creation and development of the Buddha image at Amaravati and Mathura in India. Furthermore, it is usually proposed that the Anuradhapura images developed from Indian models, primarily those from Amaravati (see for example Coomaraswamy, 1927, p. 161 and Rowland, 1971, p. 363). On the other hand, two Sinhalese scholars, D. T. Devendra and S. Gunasinghe, have suggested that the Anuradhapura Buddha icons were indigenous creations dating to the second century or earlier and were the source for the Amaravati style Buddha images (see Devendra, p. 31 and Gunasinghe, 1960). Another group of scholars, however, has argued rather persuasively that these dates are too early, and they have dated most of the images, particularly the seated examples, to the seventh century and later (see for example Barrett, pp. 46–47; Dohanian, pp. 79–106; and Boisselier, pp. 64, 115, and 125–26).

Whatever the date and source of the earliest Buddha images in Sri Lanka, once the initial standing and seated forms had appeared, the Sinhalese Buddha image came to be characterized by an almost unbelievable consistency and conservativeness in iconography. The variations of hand gestures and leg positions, as well as modes of wearing the robe, that we find in India and elsewhere in Asia are largely absent. No Sinhalese Buddha, for example, wears a robe covering both shoulders, nor is any seated in any posture except *paryankasana*. The hand gestures are restricted to those of reassurance *(abhayamudra)*, teaching *(vitarkamudra)*, and meditation *(dhyanamudra)*, the latter being used almost exclusively in seated images (see nos. 80, 89, and 101).

It is difficult to explain why the Sinhalese Buddha image was largely impervious to later influences and innovations, for Sinhalese history records constant and close interaction of both a secular and religious nature with India and Southeast Asia. There was also a period of substantial Mahayana influence on this largely Theravada Buddhist country, particularly from the seventh to the tenth century. Except for possibly introducing the colossal Buddha image (Dohanian, pp. 79–94), however, Mahayana Buddhism appears to have had little, if any, effect on the traditional forms of the Buddhist icon.

Nevertheless, within these rather narrow iconographic limits, Sinhalese artists managed to produce images of the greatest beauty and spiritual power. Typical of the seated figures are broad shoulders, a narrow waist, and legs that fold into a wide flat base (see nos. 89 and 101). The hands of Anuradhapura period examples are usually large and realistically modeled, a characteristic shared by some of the earliest Southeast Asian images (cf. no. 99). What is particularly distinctive about Sinhalese icons of all periods is the taut manner in which the torso is held upright, which, when combined with the raised head and unsmiling face, creates a majestic and powerful figure. This regal character distinguished Sinhalese images from Indian icons which by the fifth century tended to project a much more gentle and compassionate demeanor (see no. 84).

During the Polonnaruwa period (993–1235) many of the finest Buddha images were produced, including the famous colossal rock-cut statues of Gal Vihara. One of the rare later additions to Sinhalese Buddhist art, the reclining Buddha, was introduced at this time, and a tendency toward stylization also became apparent. The increasingly stylized treatment of the Buddha image, combined with an emphasis on magnificent decoration—particularly of the background—culminated in the handsome and colorful style of the Kandy period (1592–1815) Buddhas (nos. 65 and 125).

As we shall see, Sinhalese Buddhist art had some influence on the Southeast Asian Buddha image, particularly during the earliest stages of the latter's development. Considering Sri Lanka's close contact with Burma and Thailand from the eleventh to the fourteenth century, however—a period when the impact of Sinhalese Theravada Buddhism was decisive and Sinhalese artists were actually working in Southeast Asia—the influence, especially of a stylistic nature, was surprisingly slight. Nevertheless, the Buddha Sakyamuni images of Sri Lanka and of Theravada Southeast Asia share a common spiritual link that bridges any differences in style.

A Brief History of Buddhism in Southeast Asia

THE GREAT INDIAN EMPEROR ASOKA is said to have sent Buddhist missionaries in the third century B.C. to a land called Suvannabhumi, which is usually identified as a place in Southeast Asia—probably either Thaton in Burma or U Thong in Thailand. Although this early introduction is not improbable, it is not until almost six hundred years later that concrete evidence of Buddhism occurs in the region. It was only in the second and third centuries that Southeast Asia and India began to have significant interchange, our knowledge of which has come almost entirely from Chinese chronicles. By this time, however, at least a few small kingdoms in Southeast Asia had become to some extent Indianized, adopting, for example, the use of Sanskrit for inscriptions and names.

Evidence of Buddhism begins to occur in the fourth and fifth centuries with a few fragmentary inscriptions from Buddhist texts found in such places as Prome in Burma and Kedah in Malaysia and, as we shall see, with the limited appearance of Buddha images. Although there is no indication that Buddhism was popular at this time, it does seem to have reached a number of widely scattered areas within Southeast Asia. Evidence of the presence of Hinduism also exists from this period; it appears, however, that Buddhism was more important in introducing Indian culture to Southeast Asia.

From the sixth to the thirteenth century, Buddhism began to flourish in certain areas and functioned at times as a court or national religion. A general survey of Southeast Asia at this time produces the following picture. In Cambodia and Vietnam (ancient Champa), Buddhism was not as important as Hinduism during this period (with the exception of certain remarkable and highly innovative developments which occurred between the ninth and twelfth centuries and will be discussed later). Around 800 on the island of Java in present-day Indonesia, the Buddhist Sailendra dynasty (8th–9th century) built one of the greatest monuments of Buddhism, Barabudur. Although Buddhism continued to exist in Java after the dynasty's fall around 900 or earlier, it was never again as strong and ultimately became combined with Sivaism to produce a highly idiosyncratic religion. On the Indonesian island of Sumatra, as well as in neighboring Malaysia (across the Strait of Malacca) and in Peninsular Thailand, Buddhism was practiced concurrently with Hinduism by at least the fifth century. It became of major importance during the period from the seventh to the eleventh century under the rule of the maritime kingdom of Srivijaya. Finally, it was in Burma and Thailand that Buddhism had its most continuous success, flourishing almost without abatement from the moment of its earliest introduction.

The pattern that appears up until the thirteenth century, therefore, is one in which Buddhism and Hinduism were practiced side by side in most areas of Southeast Asia, with one or the other predominating depending on the particular time and place. This pattern is complicated if we take into consideration the various schools of Buddhism that were involved—Theravada, Mahayana, and Vajrayana. Theravada Buddhism was probably the school initially introduced into most areas of Southeast Asia, but inscriptions and the reports of visiting Chinese pilgrims have established the existence of Mahayana and Vajrayana (Tantric) Buddhism by the seventh century. In general, Mahayana Buddhism was more common in Cambodia, Champa, Indonesia, and Malaysia, while Theravada Buddhism predominated in Burma and Thailand.

It is difficult to say to what extent Buddhism was embraced by the people during the period from the sixth to the thirteenth century. While it is likely that Buddhism in Dvaravati (Thailand), Burma, and the Srivijaya Kingdom reached down in varying degrees to the common people, in Cambodia, Champa, and Java, Buddhism was probably more a religion of the ruling nobility. The radical innovations that took place in Buddhist philosophy and imagery under Jayavarman VII (r. 1181–1219?) in Cambodia (see no. 50) and Indravarman II (r. c. 875) in Champa, for example, must have relied in part on the ability of an elite to manipulate religious symbolism freely. Although we lack solid evidence, the religion of the common people was most likely a form of animism in which spirits were worshiped and propitiated. The belief in spirits, along with a faith in magic and prognostication, remains characteristic of the world view of most Southeast Asians even today.

Around the thirteenth century, a series of events occurred that produced the present religious geography of Southeast Asia. They included the introduction of a school of Sinhalese Theravada Buddhism to Burma and, a little later, to Thailand and Cambodia; the incursion of the Mongols into Burma, Cambodia, Champa, and Indonesia; the founding of the first Thai kingdom of Sukhothai; and the introduction of Islam into Malaysia and Indonesia. These events and others led to the eventual triumph of Theravada Buddhism throughout most of mainland Southeast Asia and the emergence of Islam in Indonesia and Malaysia. The nearly total eradication of Hinduism as a major religion occurred at the same time.

In the countries where Theravada Buddhism predominates today (Burma, Thailand, Laos, and un-

til recently Cambodia), the belief in spirits, ghosts, and magic—elements of the proposed indigenous religion mentioned above—exists comfortably with the doctrine of the Buddha. Moreover, there is nothing in the modern, popular Buddhism of Theravada Southeast Asia that could be considered out of step with the ancient Buddhism of India. The Buddha did not deny the existence of gods and spirits, nor did he reject magic, and he himself performed magical feats at Sravasti (see no. 53). The Buddha's position was simply that concentration on these concerns would distract one from, rather than help one toward, the goal of enlightenment and the final release from the chain of rebirth.

The flexibility and tolerance Buddhism tended to demonstrate toward other religions thus supposedly reflected the Buddha's own attitudes. The common people's ultimate acceptance of Buddhism must in part have been due to the religion's ability to tolerate and absorb indigenous beliefs. The use to which the Buddha image is often put in Southeast Asian contexts demonstrates the influence of these non-Buddhist beliefs. The almost universal Thai practice of wearing small Buddha images as amulets in order to gain everything from protection to sexual attraction is one example.

Introduction of the Buddha Image to Southeast Asia

THE OLDEST BUDDHA IMAGES in Southeast Asia have been attributed to the fourth century, with the fifth or even the sixth century being more likely. They do not appear to have been made locally, however, but were imported, probably from Sri Lanka or possibly from south India, perhaps by merchant sailors. Such images could have been introduced at any time after their manufacture, and the date they were made does not necessarily correspond to the time of their importation.

These early sculptures are of a uniform type. They are bronze, standing figures of the Buddha with both hands raised near the shoulders. The right hand displays either the gesture of reassurance or the teaching gesture, and the left hand usually holds the end of the robe, which is worn exposing the right shoulder. Buddha images of this type, which are usually quite large, are found scattered throughout Southeast Asia, including sites in Thailand, Vietnam, Sumatra, Java, and Celebes (see for example Snellgrove, pls. 110 and 119).

When we begin to look for the earliest locally made Buddha images in Southeast Asia, we encounter several surprises. To begin with, no indigenous images can be dated earlier than the fifth or perhaps even the sixth century. There is thus a gap of as much as two centuries between our evidence for the introduction of Buddhism and the origin of locally made images. Even more important is the discrepancy between the comparatively large amount of early evidence supporting the existence of Buddhism (in the form of inscriptions and Chinese reports) and the very few extant early Buddha images, either imported or made locally. This has led Jean Boisselier to suggest that "the dissemination of images and of the doctrine were two separate aspects of the spread of Buddhism overseas" (Snellgrove, p. 139). Boisselier's suggestion, however, seems highly unlikely. It is more probable that the discrepancy is the result of several factors, including the tendency of the Chinese Buddhist monks, on whom we must rely for most of our information on early Southeast Asia, to exaggerate the importance of Buddhism or at least to ignore other more important aspects of the culture. The lack of Buddha images may also indicate a purposeful selectivity on the part of local rulers. It may have been that the written word of the Buddhist texts attracted local rulers

because their own cultures were illiterate. Buddha images, even if they were introduced at this time, may not have initially appealed to them.

One would suppose that imported Buddha images in a number of styles from various areas of India and Sri Lanka would have been used initially by local artists to produce fairly accurate copies. The result would have been a series of workshops scattered over Southeast Asia and engaged in producing copies of Indian Buddha images of different styles. Surprisingly, this happened only rarely. Rather, when locally made Buddha images appear, they are highly individual in style and can be easily differentiated from their Indian prototypes. These early indigenous styles are limited in number, yet they sometimes cover a wide area.

One of these early indigenous styles is represented by a seated Buddha image from Burma included in the exhibition (see no. 99). This is one of a group of similar images that originated at about the same date but were found in widely different areas of mainland Southeast Asia, including Peninsular Thailand and Cambodia (where they were associated respectively with the ancient kingdoms of Funan and Chenla), as well as Burma. It appears, therefore, that an early and indigenous style of seated Buddha was developed somewhere in Southeast Asia (probably Peninsular Thailand) and spread quickly and widely. The ultimate South Asian source of this image was either south India or Sri Lanka (cf. no. 80). All of these seated Southeast Asian Buddhas represent Sakyamuni and are associated with Theravada Buddhism.

Development of the Buddha Image in Southeast Asia

AFTER THE QUITE SUDDEN, and in many ways yet unexplained, appearance of locally made Buddha images—images that on the whole show a rather remarkable homogeneity—Buddha figures begin to diversify and take on new, and specifically Southeast Asian, forms and meanings. It is not possible within the scope of this catalogue to discuss all the innovations of the Southeast Asian Buddha image. The presentation of a few of the most intriguing examples, however, will give the reader some idea of their nature and extent. For the sake of convenience, these innovations will be divided into categories of style and iconography. Such a division is appropriate within the context of Buddhist art because, as Coomaraswamy has stated: "For the Buddhist, iconography is art; that art by which he works. The iconography is at once the truth and the beauty of the work" (Coomaraswamy, 1977, p. 162). The form or style, on the other hand, is something extraneous to the function of the work. From this point of view, the Buddha image is like a book; its contents (iconography) are its most important aspect and must remain standardized, but its outward appearance, its size and cover (style), can vary endlessly.

It has already been stressed that each area of Southeast Asia quickly developed its own style of Buddha image, contrary to the reasonable expectation that various Indian styles would be faithfully copied in indigenous workshops. To be sure, there are a few scattered early images that may be copies (Griswold, pp. 37–73), but only in Java was an Indian style, that of the Nalanda school (9th–11th century) bronze images, the model for a large group of very close copies (see Bernet Kempers, 1933). Even here, however, there existed a contemporaneous Javanese style (see no. 157). Some of the indigenous Southeast Asian styles were highly innovative but had little lasting influence; others were extremely important and pervasive.

Two major styles developed in the area that is now Thailand. One was the Dvaravati style Buddha image described in entry no. 102. An Indian prototype for the Dvaravati Buddha can be found primarily in the Gupta style images of Sarnath. In almost every characteristic, however, there is a Dvaravati modification of the Indian original. The second stylistically innovative image from Thailand is the Sukhothai Buddha (see nos. 119 and 120). But here we are at a loss to find an Indian prototype or, in fact, any single model. The various possible sources for the style—Dvaravati, Khmer, Sinhalese, and Pala Indian images, as well as textual descriptions—are remarkable mainly for their inability to explain the form of the Sukhothai Buddha image. This style may be considered as novel as any developed in Asia.

The iconographic innovations observable in Southeast Asian Buddha images are numerous, but many are relatively minor deviations from Indian prototypes. For example, Indian images almost always represent the Buddha with his hands in separate gestures and usually held at different levels. The Dvaravati and later the Thai artists preferred to depict both of the Buddha's hands held at the same level and in the same gesture—either that of reassurance or teaching. It is possible that the double *mudra* was a creation of the Dvaravati, although it occurs as well in Sri Lanka, China, and Japan. The point being that such an iconographic innovation is a relatively slight departure from the Indian model.

A second Dvaravati image type, the depiction of the members of a Buddhist triad riding on a mythical animal (see no. 150), is almost certainly a Southeast Asian iconographic invention for which there appears to be no South Asian artistic prototype or textual source. It should be mentioned in this connection that the Dvaravati sculptures of Wheels of the Law (see no. 72), while Indian in concept, are also totally novel in their form, design, and construction; and, according to a theory first suggested by M. C. Subhadradis Diskul, these wheels may have once been attached to the Buddhist triads. If so, the wheels and triads may both reflect an indigenous worship of the sun. This theory, however, has yet to be fully substantiated.

With the founding of the Thai kingdom of Sukhothai in the thirteenth century, a new image, generally known as the "walking Buddha," became very popular (see no. 120). Sculptures of this type represent a fully modeled figure in a walking posture with one foot planted firmly on the ground and the heel of the other foot raised. The idea of depicting the Buddha in the act of walking was not in itself novel; it was, in fact, probably adopted from stone and stucco reliefs. Earlier relief representations of this theme occur in eastern India (Banerji, pl. 94b), as well as at Barabudur in Java, where one of the Buddha's heels is shown raised as in the Thai sculpture (Ministry of Information and Broadcasting, Government of India, p. 82, no. 7). The original contribution of the Sukhothai artists seems to lie in the creation of a three-dimensional image that conveys a greater sense of movement than its counterparts in relief. The freestanding walking Buddha is perhaps the most characteristic and familiar of all Thai images.

Another theme that attained special significance in areas of Southeast Asia was that of the Buddha protected by the serpent Muchalinda. Although not unknown in India and familiar in the art of Dvaravati, this episode became the focus of a special cult in thirteenth-century Cambodia. The event in Sakyamuni's life that inspired representations of the Buddha seated on the snake king Muchalinda is discussed in entry no. 50. This image, however, had additional meanings for the Khmer people. King Jayavarman VII (r. 1181–1219?) chose this image as the major form of the Buddha for worship. In choosing Buddhism as his religion, Jayavarman VII was breaking a

precedent. Although Hinduism and Buddhism had existed together in Cambodia and in most other areas of Southeast Asia before the fourteenth century, and although Jayavarman VII's father may have been a Buddhist, the religion of the Khmer kings had long been Hinduism. Furthermore, the *linga*, or phallic form of the Hindu god Siva, had been the palladium of the country. The kings identified themselves with Siva and the *linga* and were thus considered deities (Kulke, 1978).

In essence, Jayavarman VII replaced the Siva *linga* with the image of Buddha on the *naga*. He, in fact, went one step further in his own apotheosis and had what we assume are his own features carved on one Buddha image. The reasons why Jayavarman VII chose to stress the Muchalinda Buddha and the meanings he attached to the image seem to have been very complex, and our understanding of them remains speculative. We know that the snake was associated with healing, and perhaps because Jayavarman himself was lame, he emphasized healing, as indicated by his construction of hospitals throughout the kingdom. Furthermore, the Khmer economy relied on a very elaborate system of hydraulics and irrigation, and the snake may have been considered the spirit of the water. Whatever its exact meanings, the point remains that Jayavarman VII chose a relatively obscure form of the Buddha image and endowed it with a number of very consciously contrived associations.

The Life of the Buddha in the Art of Southeast Asia

THE NARRATIVE OF THE LIFE OF Sakyamuni was a popular topic for Southeast Asian artists. This fact may not be particularly apparent from the examples presented in this exhibition. The exhibited works tend to be iconic images for the simple reason that the vast majority of narrative scenes are found on relief sculptures and in murals in situ on architectural monuments.

Perhaps the best-known series of reliefs exists at Barabudur in Central Java. These sculptures depict Sakyamuni's life until his Enlightenment. The series is divided into 120 panels based on the *Lalitavistara*, a Mahayana text. The reliefs demonstrate a correspondence between text and visual image that is rarely found in India.

Another important relief series representing the Buddha's life appears on the Nanda temple, which was built around 1105 at Pagan in Burma. Here, 80 major sculptures relate the Buddha's life according to a Theravada text *Nidanakatha*. These 80 sculptures, however, comprise only a fraction of the over 1,500 relief sculptures in the Nanda temple, all of which deal with Buddha Sakyamuni. Included among these reliefs are 912 *jataka* scenes and 512 plaques depicting the demons who make up the army of Mara. The Nanda temple is only one of many important temples at Pagan that feature depictions of the Buddha's life and the *jataka* stories executed in a variety of media—including stone, ceramic tiles, terracotta, and painting. This focus on Sakyamuni at Pagan is well exemplified by the small and detailed dolomite sculpture included in the exhibition (see no. 10).

In addition to the reliefs, two unique Southeast Asian texts exist—one in Burmese and one in Thai—that detail the life of the Buddha. Some of the episodes in these texts are not found elsewhere, giving rise to peculiarly Southeast Asian representations.

While Sakyamuni's life was a popular topic in Southeast Asian art, perhaps even more popular were the *jatakas*, or tales of the Buddha's previous lives. The 912 *jataka* scenes in the Nanda temple have been mentioned above, and other examples are found throughout Southeast Asia. In Thailand, for example, there are eighth-century stucco and terracotta *jataka* reliefs at Chula Pathom Cedi in Nakhon Pathom (see Krairiksh, 1974), and approximately 100 engraved limestone plaques, dating to the fourteenth century, exist at Wat Si Chum in Sukhothai (Stratton and Scott, pp. 100–104).

One *jataka*, however, took on special importance in Southeast Asia and Sri Lanka. This is the *Vessantara Jataka*, the story of the Buddha's last incarnation before his Birth as Sakyamuni (see no. 135). This extremely long and complicated tale relates how Prince Vessantara, demonstrating the Buddhist virtue of charity, gave away all his possessions and finally even his own wife and children. In Thailand, Laos, and Cambodia, the public recitation of this *jataka*, which takes some fourteen hours, is the central event of the major Buddhist festival of the year. Furthermore, the *Vessantara Jataka* is the last in a series of *jatakas* that details the ten incarnations of the Buddha immediately prior to his Birth as Sakyamuni. This series, known as the *Dasajati*, is extremely popular in Burma, Thailand, Laos, and Cambodia. Each of the stories exemplifies one of the ten highest virtues or perfections *(paramitas)*. The *Vessantara Jataka* represents charity, while the third tale in the series, the *Sama Jataka*—depicted on the exhibited Thai banner (no. 134)—represents determination. These ten *jatakas*, and particularly the *Vessantara Jataka*, are depicted in modern paintings on the walls of thousands of Buddhist temples.

Conclusion

SOUTHEAST ASIAN AND SINHALESE BUDDHA images are characterized by their variety, diversity, and eclecticism. The innovations we have highlighted reveal no clear pattern and are the result of both misunderstanding and purposeful alteration of the Indian models. While we must often look to India for either artistic prototypes or textual sources, Southeast Asian and Sinhalese Buddha images almost inevitably display characteristics that are uniquely their own.

The history and prosperity of Buddhism varied radically within the various Southeast Asian countries and Sri Lanka. Unlike East Asia, both these regions had a significant tradition of Hinduism; one that continues today in the royal court of Thailand and in Bali in a highly modified form. There was a constant interplay between these two Indian religious traditions in early Southeast Asia. Nevertheless, we cannot think of Southeast Asian and Sinhalese art today without thinking of the Buddha image, for Buddhism did at one time penetrate virtually every area of these regions. The gentle and moral teachings of the Buddha have left their mark and are expressed in the sentiments of an inscription dated 761 from Dong Si Mahapot in Thailand:

> All Buddhas who have a royal heart full of compassion have established themselves in the world of sentient beings. These Buddhas, who like a full perfect moon, deliver the beings into purity. They understand the duty of giving; they experience suffering; they know, without exception, the Dharma; they have crossed to the other world. Let us bow our heads and pay respect to those Buddhas. *(Thiamthat; my translation, p. 58)*

Robert L. Brown

THE BUDDHA IMAGE IN CHINA

The Role of Buddhism in China

Despite its foreign origins, Buddhism had enormous influence on Chinese philosophy, art, and daily life. After its introduction to China during the Han dynasty (206 B.C.–220 A.D.), it gradually came to be accepted as an integral part of Chinese civilization, comparable in importance to Daoism and Confucianism. Initially, Buddhism seemed to the Chinese to be a variant form of Daoism that promised new methods for obtaining immortality. A tolerant and adaptable religion, it grew symbiotically with the other Chinese faiths and welcomed into its fold all those seeking its benign salvation. With its liberality and rather open ecclesiastical hierarchy, it adapted itself to local traditions and native beliefs and simultaneously acted as a vehicle for international cultural exchange. The new ideas, customs, and products introduced along with Buddhism enriched Chinese medicine, mathematics, and astronomy. Most importantly, the presence of Buddhism fostered a philosophical dialogue that catered to a variety of Chinese religious needs.

Under the aegis of Buddhism, new techniques and styles of architecture, sculpture, and painting were introduced to China from Central Asia, India, Iran, and even the Mediterranean. Tall multistoried pagodas were erected, inspired by the Indian *sikhara* (a type of towerlike edifice), and magnificent temples were constructed, some actually hewn out of rocky mountainsides, like those at Dunhuang, Yungang, and Longmen. These cave temples were modeled on the superb examples created in the Central Asian cities of Khotan, Kucha, and Kizil and ultimately the earlier Indian temples at Karli, Kanheri, and Ajanta. Images of Buddhas, bodhisattvas, and other deities of the Buddhist pantheon were

painted on temple walls and sculptured out of stone, clay, or bronze. These representations symbolized the Buddha, narrated his earthly life, and recounted his earlier lives as recorded in the *jatakas*. The enormous patronage of the arts occasioned by the construction of Buddhist temples encouraged the development of figurative painting and sculpture that culminated in the artistic achievements of the Tang dynasty (618–906).

The translation of Buddhist sutras from Pali and Sanskrit into Chinese expanded literary horizons with the introduction of novel forms of expression, new rhetorical devices, and lyrical examples of epic writing. Recent discoveries in the Dunhuang Caves have yielded ancient religious tracts, written in a vernacular style, that were the forerunners of the popular literature that developed into the Chinese novel and opera. Similarly new musical instruments and modes, as well as exotic forms of dance, were introduced to China in the cultural exchange that accompanied the influx of Buddhism.

The enthusiasm with which China embraced Buddhism during the Six Dynasties (265–581), Sui (581–618), and Tang (618–906) periods led to a movement to convert Korea and Japan. Buddhism was propagated through the intermediary of China rather than spreading directly from India; thus the unique character of Chinese civilization colored the Buddhist ideas and artistic styles that were introduced to these neighboring nations. As a result of this missionary effort, the tremendous cultural achievements of the Chinese were disseminated throughout East Asia.

The History of Buddhism in China

ONE OF THE MOST APPEALING legends explaining Buddhism's introduction to China is the tale of Emperor Ming of the Eastern Han dynasty (25–220). In the year 65, this emperor dreamed about a golden deity and subsequently dispatched emissaries to investigate this god and bring his cult back to China. The mission traveled to India and returned with Buddhist images and the Sanskrit *Sutra of Forty-two Sections*. A Buddhist monastery, the Baimasu (White Horse Monastery), was established in Luoyang to house these sacred treasures, and it still exists today. Two Indian monks Kasyapa-Matanga and Dharmaranya accompanied the returning Chinese and helped to translate the sacred text. Although the Han emperors were receptive to religious innovations, during this period Buddhism remained essentially a curiosity without any widespread popularity or influence.

After the fall of the Han Empire in 220 and the division of a once unified nation into contending states, China fell prey to barbarian invasions and rule by foreign dynasties. The depressing conditions wrought by political disunion and social unrest during the Three Kingdoms (221–265) and the Six Dynasties (265–581) periods resulted in a loss of confidence in the established Confucian order. The salvation and comforting afterlife promised by Buddhism, as well as its mysticism and spirituality, led to the popular acceptance of this foreign religion in every region of China. Mahayana Buddhism was a democratic faith offering salvation to anyone willing to adhere to its doctrine, and in the face of adversity, most Chinese found solace in this concept. In addition, the Buddhist renunciation of worldly ties appealed to intellectuals caught in the political turmoil and internecine strife of the times.

The Toba Tartars, who conquered north China and established the Northern Wei dynasty (386–535), favored Buddhists and recruited them, along with Daoists, for service in the governmental bureaucracy—opposing the traditional employment of Confucian scholars for such posts. During the fourth and fifth centuries the construction of Buddhist temples and monasteries flourished, culminating in the magnificent Yungang Cave temples cut from the mountainsides west of Dadung. Innumerable Indian and Central Asian monks came to China to teach the doctrine and to introduce new Buddhist sects. At the same time, Chinese Buddhists made pilgrimages to famous Buddhist sites in India and studied at the great centers of Buddhist learning such as Mathura, Sarnath, and Nalanda.

Many monks devoted their efforts to the difficult task of translating the sacred texts into Chinese. Among these canons, the *Saddharmapundarika (The Lotus of the True Law)* was widely acknowledged as the gospel of Mahayana Buddhism in China. It interpreted Buddhism as a religion of faith and maintained that, with the aid of bodhisattvas, salvation and rebirth in the Buddhist heavens were easily attainable. Faith in the Buddha, rather than knowledge, austerities, or good works, was all that was necessary. Brilliantly written, *The Lotus Sutra* was both suspenseful and dramatic. The poetic and visual imagery of its descriptive passages inspired artists to leave a magnificent record of them in sculpture and painting.

A number of the early Chinese pilgrims were outstanding men who, according to custom, kept diaries of their travels. These diaries are not only important for an understanding of the history of Chinese Buddhism; they are among the few extant early documents describing the life, customs, and architecture of India, Central Asia, and Southeast Asia. In 399, one of these pilgrims, the Chinese monk Fa Xian [Fa Hsien] (late 4th–early 5th century) traveled from Changan across Central Asia to India. He left an invaluable account of his wanderings through Chinese Turkestan, Afghanistan, and northwest India, and his observations serve today as a key source for the reconstruction of the history of these regions. He subsequently journeyed to Ceylon and Java before returning to China by sea. Fa Xian was succeeded by other great pilgrims such as Xuan Zhao [Hsuan Chao] (c. mid-7th century) and Xuan Zang [Hsuan Tsang] (c. 596–664), whose notes and diaries have also proved to be highly important historical documents.

During the Six Dynasties period Daoism, a native school of thought, was gradually evolving into a religion. Daoism and Buddhism initially had much to gain from each other. The early perception of Buddhism as a form of the indigenous Daoism had allowed the foreign religion to gain a secure foothold in China, while Daoists were able to borrow certain aspects of the institutional structure of Buddhism. A fundamental difference existed, however, in the Buddhist emphasis on asceticism and celibacy and the Daoist acceptance of sex, procreation, and longevity. Gradually during this period the early mutual tolerance turned to rivalry, and finally, a bitter hostility developed. As a result of this rupture, Buddhists occasionally fell subject to persecution, and their religion underwent severe restrictions under the Wei emperor Wu in 446 and the Northern Zhou emperor Wu from 574 to 577. Nevertheless Buddhism continued to flourish in the south, the ancient heartland of China, often enjoying fervent patronage, such as that exemplified by Emperor Wu of the Southern Liang dynasty (502–557). In 517, this emperor ordered one of the first monumental undertakings of Buddhist scholarship: the publication of the *Tripitaka,* a collection of all Buddhist scriptures.

Although Buddhism had originated in India, the Chinese selectively adopted and modified its tenets. Fundamental was the difference between the Indian conviction in the dominance of spirit over matter and the Chinese belief in a dualistic relationship. A rational and practical people, the Chinese could not accept the notion of transmigration of the soul or the Indian extremes of self-mortification and fasting.

The Sui and Tang periods saw the ultimate triumph of Buddhism in China. The unification of China was effected in 589, and with the ensuing prosperity, China expanded its borders in all directions. Its political dominance ultimately extended into Central Asia, Mongolia, and Annam. The secure and cosmopolitan Tang empire favored Buddhism and patronized the construction of temples and monasteries. Virtually all Buddhist sects flourished during the Tang period. The Paradise or Pure Land sects, however, were especially favored.

In the seventh and the first half of the eighth centuries, the Buddhist church was the recipient of unprecedented patronage from the royal court and from many devout and affluent Chinese who had prospered under benign Tang rule. This period witnessed the apogee of the art of wall painting, with leading painters receiving commissions to embellish temples and palaces with scenes of Buddhist paradises, Daoist deities, and Confucian sages. Buddhist sculptures were also created in enormous quantities, providing images for worship and didactic scenes explaining the faith. Unfortunately, most of these sculptures and almost all the bronzes have disappeared as a result of subsequent persecutions or neglect.

After the Rebellion of An Lushan in 755, the Tang dynasty declined and political and economic deterioration ensued. The cosmopolitanism and open tolerance for which the Tang dynasty was noted came to an end. The enormous wealth of the Buddhist monasteries and the deadly rivalry of the Daoists and Confucianists led to the proscription of all foreign religions in 845. The withdrawal of support and the destruction that followed broke the power of the Buddhist clergy and resulted in the obliteration of most of the great Buddhist monuments of architecture, painting, and sculpture.

A halcyon era for Buddhism and Buddhist art in China came to an end with the catastrophic Buddhist persecutions which commenced in 843 and continued to 845. Buddhist doctrines were now felt to conflict with traditional Chinese values of family, government, and ethics. Temples had accumulated vast wealth through solicitations that drained the secular economy and encouraged patterns of behavior at variance with conventional clan loyalties, ancestor worship, and propagation of the family. The universal ideology of Buddhism threatened the authority of the state and made the collection of taxes, as well as obligatory military and labor service, difficult to enforce. Buddhism came to be perceived as alien and oblivious to the hallowed customs of Chinese civilization, and its transcendental mysticism was dismissed by Confucian scholars as superstitious and irrational.

The advances in Chinese Buddhist thought, art, and doctrine that had matured during the Tang period were the culmination of centuries of development. All this disappeared with the destruction of temples, defrocking of monks, burning of libraries, and melting down of magnificent bronze statues. The Japanese monk Ennin (793–864) who visited China during this time lamented: "A document came on Imperial command saying that the bronze and iron Buddhas of the land were all to be smashed and weighed and handed over to the Salt and Iron Bureau"

(Reischauer, pp. 267–68). Persecutions continued throughout China, and Buddhism and indeed all other foreign religions were never to fully recover from this devastating blow. Only a few small bronze statuettes, some stone sculptures, and the remains of cave temples that escaped destruction due to the remoteness of their location or to chance survive to suggest the magnificent creations of early Buddhist art in China.

The eleventh and twelfth centuries saw the rise of the Neo-Confucianism of Zhu Xi [Chu Hsi] (1130–1200). Many of the transcendental and metaphysical ideas of Buddhism were adapted by the Neo-Confucianists, together with some Daoist concepts, to create an all-encompassing philosophy that traditional Confucianism had been unable to provide. Certain sects of Buddhism—the Chan during the Song (960–1279) and Yuan (1280–1368) periods and the Tantric schools—were to continue to play a part in the religious life of China during the later dynasties.

During the Song dynasty, Buddhism survived more as a great tradition than as a spiritual force, and only the Chan and Pure Land sects maintained large constituencies. The moral degeneration of the Buddhist clergy, the virtual end of Buddhism in India, and the rise of Neo-Confucianism combined to terminate the pervasive hold of Buddhism on the Chinese imagination.

There was, however, one last flowering of Buddhism with the growth of the Chan sect (Zen in Japanese). Chan Buddhism emphasized meditation and self-cultivation, believing that enlightenment could be attained through an intuitive flash of supreme cognition. Chan temples were built in remote and secluded locations with an atmosphere conducive to quiet meditation. The ideals espoused by this sect had much in common with ancient Daoist beliefs and had a profound influence on Chinese art, literature, and philosophy from the tenth to the thirteenth centuries. Chan derives from the Indian school of Dhyana Buddhism and began in China with the teachings of the legendary Bodhidharma, an Indian monk who came to China circa 470 or 475.

The alien dynasties of Liao (907–1125), Jin (1115–1234), and Yuan (1280–1368) favored Buddhism as the Toba Tartars had before them. They realized that it was capable of enhancing the art, literature, and philosophy of their own cultures. Furthermore, they saw in it a means to win the loyalty of the Chinese, who had in the past embraced Buddhism, and to counter the influence of the Confucianists. The ruling Mongols of the Yuan dynasty adopted Tantric Lamaism, a form of Buddhism, as the state religion, finding it perfectly suited to their temperament. Under official Yuan patronage, Lamaist temples were built, encyclopedic theological texts (tripitaka) were published (no. 146), and innumerable images of Tantric deities were produced (no. 162).

During the Ming dynasty (1368–1644) the Chan and Pure Land sects remained active despite movements to unify the various Buddhist schools. Similarly, attempts were made during this period to consolidate Buddhism, Confucianism, and Daoism (see no. 154). Towards the end of the Ming and subsequent Qing (1644–1912) dynasty, there was enormous growth in lay Buddhism. This popularization extended the beneficence of the Buddha to all levels of society, but it further sapped the Buddhist religion of its doctrinal fervor and creative vitality. The large number of Buddhist icons of little artistic merit produced during this time attests to the decline. Like other alien dynasties, the Manchu emperors of the Qing period embraced Buddhism and especially Lamaism, which they felt resembled their own shamanistic beliefs.

Central Asia and the Spread of Buddhism

BEFORE PROCEEDING TO DISCUSS the Buddha image in China, it is important to note the strategic role of Central Asia in the dissemination of Buddhism. In ancient times, Central Asia comprised the mountainous and desert regions above the Indian subcontinent that today belong to China and Russia. The ancient trade routes running across this area were the main arteries of communication between India and China. Along these roads and through the city states that served them, Buddhist monks traveled spreading the doctrine of the Buddha. People of every race and nationality, of every occupation and religion traversed these routes, which ran from Rome and Iran through Samarkand to Kashgar or northward from India through the Hindu Kush or Karakoram Mountains to Kashgar. From Kashgar there were two routes: a northern one to Kucha, Turfan, and Dunhuang; or, alternatively, a southern route through Khotan, Miran, Dunhuang, and finally Changan, the Chinese capital. During the first millennium of the Christian Era, these routes were destined to become major avenues for trade and for the exchange of ideas, technologies, arts, and religions—particularly Buddhism.

The ancient city-states of Chinese Central Asia were once flourishing centers located on the high Central Asian plateau along the foothills surrounding the Taklamakan Desert. They traded with and served caravans carrying the silks of China, the spices of India, and the gold and glass of the Roman East. This region was of the utmost strategic importance and became an area of contention between empires and powerful emerging states. Populated by once nomadic peoples of Hunnic, Turkic, Uighur, and other Central Asian stock, the culture of the region drew upon an amalgam of Classical, Sassano-Persian, Indian, and Chinese sources, reflecting the rise and decline of empires. Despite the eclectic nature of these influences, Central Asia developed a distinctive culture of its own.

About a century ago archaeologists from British India, Russia, Sweden, Germany, France, and Japan began to explore the ancient Buddhist sites around Kucha, Turfan, Khotan, and other cities that had been abandoned since the tenth century when the region was converted to Islam. Today museums in Berlin, London, Paris, Delhi, and Tokyo contain impressive collections of fresco fragments, sculptures, paintings, and manuscripts that were laboriously transported out of Chinese Turkestan, and a few of these pieces are included in this exhibition (see nos. 56, 62, 93, 94).

Many of the rulers of Central Asian city-states embraced Buddhism and became its fervent patrons. In their enthusiasm they built enormous complexes of cave temples that included colossal Buddha images—staggering in their monumentality—that were carved directly into mountainsides. Wealthy donors also commissioned colorful paintings that filled temple walls, votive banners, and sculptures representing Buddhist deities. This artistic activity occurred between the third and tenth century—a period in which Buddhism coexisted with other faiths in Central Asia. It ended with the Islamic conquest and its iconoclasm.

Chinese Images of the Buddha

BUDDHISM WAS INSTITUTIONALIZED IN CHINA during the Six Dynasties period as evidenced by the establishment of a clerical hierarchy, the construction of temples and monasteries, and the production of cult images. By this time, Indian representations of the Buddha had evolved from abstract symbols to a transcendental figurative form that was visually impressive. Hinayana Buddhism was introduced to China during the early centuries of the Christian Era, and the historical Buddha, Sakyamuni, was represented in Chinese sculpture and painting. At the same time, Mahayana Buddhism, which had developed in India in the centuries around the birth of Christ, was also brought to China where it gained a wide following. A belief in transcendental Buddhas of the present, past, and future in the form of Sakyamuni, Prabhutaratna, and Maitreya had evolved concomitantly. The acceptance of these Buddhas led to the concept of an infinite number of Buddhas who had existed and would continue to exist throughout time and were embodied in the iconographic theme of the Thousand Buddhas or the Ten Thousand Buddhas. All of these Buddhas were considered manifestations of one absolute Buddha whose nature transcends human perception.

The popularity of Buddhism led to the production of Buddha images, and the historical Buddha, Sakyamuni, was among the most frequently represented. Sakyamuni was felt to be accessible because he had had an earthly life, which was verified by the presence of holy monuments throughout India. Furthermore, he was regarded as the incarnate source of all knowledge.

According to legend, the first Buddha image ever created was that commissioned during the Buddha's lifetime by King Udayana of Kausambi in India (see nos. 54 and 55). Allegedly, a copy of this image was brought to Kucha in Central Asia by the Indian father of the Kuchean scholar Kumarajiva in 384. From Kucha the copy was taken to China where through the centuries it miraculously survived wars, fires, and natural disasters and served as a model for many wood and metal reproductions.

Udayana Buddhas were among the most widely worshiped representations of the Buddha Sakyamuni in China. Typically, Chinese Udayana images were standing sandalwood figures garbed in long robes, the folds of which were defined by repeated, arcate, stringlike lines symmetrically arranged. Although extremely patternized, this style probably originated in ancient Mathura and subsequently underwent full development in Central Asia. Udayana images are characterized by the presence of the major and minor attributes of a Buddha as detailed in Indian iconographic texts. The hands of these images assume the gestures of reassurance and charity. The monumental "Maitreya" sculpture dated 477 from The Metropolitan Museum of Art, New York (no. 175), and the diminutive fourteenth-century gilt bronze Sakyamuni from The Minneapolis Institute of Arts (no. 118) are both derived from this prototype.

The oldest datable Chinese Buddhist image with an identifiable iconography is a gilt bronze Buddha Sakyamuni cast in 338 (Lefebvre d'Argencé, no. 19, pp. 64–67), which is now in The Avery Brundage Collection of the Asian Art Museum of San Francisco (a similar meditating Sakyamuni image is included in the exhibition, see no. 79). The bronze is associated with the later Zhao dynasty (328–52), which ruled an area that overlaps parts of present-day Shansi and Henan provinces. This Buddha is shown seated on a dais with his legs crossed and his hands held facing inward in his lap in a variation of the gesture of meditation. The simple monk's robe covers both shoulders in the Gandhara style, and its pleats cascade down the front of the garment in perfect symmetry. Atop the Buddha's head is a *ushnisha*, a cranial protuberance symbolizing supernatural insight. Sakyamuni's expression is one of great calm. Although based on Indian and Central Asian prototypes, this image is Chinese in its abstract, linear quality; it lacks the sensuous plasticity of Indian sculpture and the rounder more natural forms characteristic of Gandhara. The emphasis on iconographic fidelity often took precedence over aesthetic considerations in early Chinese Buddha images.

By the late Six Dynasties period, foreign styles had been assimilated and a purely Chinese linear mode arose attuned to native artistic sensibilities. Many of the finest Buddhist images were created at this time, as exemplified by the sculptures and paintings in the Buddhist cave temples at Longmen. The Chinese genius for pictorial expression and rhythmic movement was articulated in images of the Buddha that were executed in an elongated linear style. The cascading drapery defined by flattened repetitive folds and the winglike projections of a serrated silhouette are characteristic of this fully sinicized style (see nos. 87 and 176).

It was also during the Six Dynasties period that Sakyamuni Buddha's uniqueness was undermined by the growing belief in the existence of his predecessors—Prabhutaratna, the Five Buddhas of the Past, and ultimately the Ten Thousand Buddhas. The Buddha Prabhutaratna is rarely seen in India but was popular during the late Six Dynasties period in China. He was either depicted as a single image or seated alongside Sakyamuni—a Buddha of the past welcoming the historic Buddha to his stupa in order to hear him recite *The Lotus Sutra* (see no. 141). Sakyamuni's dominant position was further eroded by the rise of the Paradise cults that promised rebirth in the Tushita Heaven of Maitreya or the Pure Land of Amitabha.

During the Northern Wei period (386–535) Maitreya, the Future Buddha, developed an enormous following. Devotees sought salvation through rebirth in the Tushita Heaven where Maitreya was waiting to become the next Buddha on earth. Alternatively, worshipers hoped to be reborn on earth at the same time Maitreya made his descent and thus benefit directly from his teachings. Both Hinayanists and Mahayanists were adherents of Maitreya, and his images can be traced back to the Gandhara school.

Although exceedingly rare in India, Amitabha Buddha was undoubtedly the most popularly worshiped Buddha in the history of China. As lord of the Western Paradise he expounded the law of cause and effect and openly welcomed newly deceased mortals who sought salvation under his benign guidance. For the Chinese, Amidism (worship of Amitabha) epitomized the Mahayana virtues of compassion and charity. The delights of rebirth in the Western Paradise (the Sukhavati Heaven) inspired some of the most ecstatic efforts made by Chinese artists. The wide dissemination of *The Lotus Sutra* in China was in part an attempt to redeem the status of Sakyamuni in the face of the ascendency of the Maitreya and Amitabha cults.

The Sui (581–618) and Tang (618–906) periods saw the ultimate triumph of Buddhism in China. Virtually all Buddhist sects flourished during the Tang period, but the Paradise and Pure Land sects of Amidism were especially favored, and this resulted in a shift in iconographic preferences. Images of Amitabha and the bodhisattva Guanyin (Avalokitesvara in Sanskrit) were ever present, and they were rendered in a style that reflected an increased interest in naturalism. The linear style of the late Six Dynasties period (265–581) was succeeded in the latter half of the sixth century by a return to sculptural volumes expressed in solid columnar forms that were not yet fully articulated. The succeeding Tang style demonstrates the culmination of centuries of artistic development in the creation of three-dimensional forms that suggest movement and are convincingly rendered in space (see nos. 97 and 177).

As mentioned earlier, the growth of the Chan sect represented a final resurgence of Buddhism in China. Although the sect had been introduced at an early date, it did not flourish until the Song period (960–1279). In its mature form, Chan Buddhism represented an anti-intellectual reaction to the elaborate ritual, written tracts, and complex theology that characterized other Buddhist sects. Its adherents sought a direct, simple, and personal route to enlightenment, and they stressed discipline, contemplation, and the dialogue between master and acolyte.

Chan found its profoundest expression in the medium of painting. With a few spontaneous brushstrokes, the Chan painter presented visual fragments that were to be completed in the viewer's mind. These paintings succinctly conveyed the process of sudden cognition essential to the Chan concept of enlightenment.

Buddha Sakyamuni attained a new importance with the growth of Chan Buddhism. The sect was fundamentally anti-iconic and rarely depicted the myriad deities of the Buddhist pantheon. In Sakyamuni, Chan Buddhists found an individual who, despite repeated failures and enormous personal effort, had ultimately achieved enlightenment. A genre of Chan painting evolved that focused specifically on the tribulations of the emaciated Sakyamuni in his efforts to attain enlightenment. The Song dynasty painting of *Sakyamuni Coming Down the Mountain* included in the exhibition depicts with pathos the gaunt and emaciated figure of the Buddha (see no. 40).

In addition to creating unique images, the Chinese often modified or elaborated the Indian sutras to better suit their sensibilities. At times they even invented their own parables to explain the Law. The popular Vimalakirti legend was reinterpreted, and Vimalakirti appears as a Chinese sage engaged in debate with the Bodhisattva of Wisdom, Manjusri (see no. 87). Similarly, Hariti, the demon ogress who was subdued by Sakyamuni, became a protectress of women and the guardian of children in China, while in Gandhara and Indian representations she personified fecundity and usually appeared accompanied by her divine husband Panchika (see no. 61).

The tributary relationships of the Chinese court with her neighbors inspired a host of paintings illustrating foreign ambassadors bringing exotic and precious gifts as tribute to the Chinese emperor. In a Buddhist version of this theme, Sakyamuni is depicted graciously receiving foreign emissaries who offer him tribute (no. 152). This incident does not occur in any Buddhist text and represents a uniquely Chinese invention.

From late Tang to Qing (1644–1912) times, many attempts were made to reconcile and consolidate Buddhism, Daoism, and Confucianism (Rogers, pp. 23–24). This idea was visually expressed

in portrayals of the three religious leaders, Sakyamuni, Laozi [Lao-tsŭ], and Confucius in a congenial group. An exhibited Ming dynasty painting illustrates this theme (no. 154).

The Chinese have always been a practical and rational people adept at accommodation and compromise. They honor Confucianism as an ethical system of government and family life, while enjoying the freedom and the escape into nature offered by Daoism. They also continue to worship the Buddhas and bodhisattvas, who promise salvation in this and the next world, and to study Buddhist sutras that lift the imagination into infinite realms of time and space. The deities of the Buddhist pantheon supplement ancient nature gods, ancestral spirits, Confucian sages, and Daoist immortals, enriching the spiritual life of all Chinese.

George Kuwayama

THE BUDDHA IMAGE IN KOREA

Introduction
BY THE TIME BUDDHISM was introduced to Korea from China in the fourth century, it had undergone lengthy development within India, as well as in China itself. Korea, however, never knew the early phases of the Indian Buddhist faith; it received instead a religion already complex and mature, divided into multiple schools and sects and tailored to the Chinese world view. The form of Buddhism that arrived in Korea was Mahayana as modified by the Chinese. It stressed the role of bodhisattvas and placed considerable emphasis upon the celestial realm. Consequently, the role of the historical Buddha, Sakyamuni, was overshadowed by the attraction of the resplendent paradise associated with Amitabha, one of the transcendental or cosmic Buddhas. Although Buddha Sakyamuni was no longer the central figure in this form of Buddhism, he never disappeared from the Buddhist pantheon, and throughout Korean history his image persisted, almost as a simple focus of the religion, which was expanded upon by other, more elaborate images.

The political scene at the time of Buddhism's introduction to Korea was characterized by emerging and warring kingdoms. A similar situation had aided the growth of Buddhism in China and was to be repeated among competing clans in Japan. In all three cases, Buddhism emerged on the side of the victors and thus benefited immediately from royal patronage. During the early centuries of the Christian Era, Korea was divided among three rival powers. In the north was the Koguryo Kingdom, which had close ties to northern China, as evidenced in its splendid tomb-wall paintings. These murals have Buddhist decorative themes, but they do not employ Buddha images; no Koguryo sculptures of the

Buddha from earlier than the sixth century are known. Ancient records, such as the thirteenth-century *Samguk Yusa*, point to the year 372 as the date of the first direct introduction of Buddhism into the Koguryo Kingdom, and they also indicate that Buddhist temples were completed by 375, with at least nine existing in the region of Pyongyang by 393. It would be safe, however, to assume that Buddhism had to wait until well into the fifth century before realizing any broad support, beginning, as it did, not as a popular movement but by imperial decree.

Paekche, the rival kingdom in the southwestern area of the country, was presumably introduced to Buddhism in 384. This introduction resulted from contacts with a different area of China, the southern kingdom of Eastern Chin. This orientation does much to explain the stylistic differences that occur between Paekche and Koguryo images. Paekche images, however, also generally exhibit more of what later came to be recognized as a distinct Korean style, while Koguryo images adhered more closely to Chinese prototypes.

The Silla Kingdom in the southeast of the Korean Peninsula was the last to embrace the Buddhist faith—officially in 527. Receiving influences from the other two kingdoms, especially Paekche, it ultimately conquered them both by 668 and established a unified Korea for the first time. The emergence of the Unified Silla Kingdom ended an era of territorial rivalry, and Korea was to know only unified dynasties until the twentieth century. Buddhism flourished throughout the Unified Silla period (668–935), and most of Korea's best-known images, such as those at the Sokkoram, a great stone monument erected in 751, originated during this epoch.

Two distinctive aspects of early Korean Buddhism deserve mention at this point. One was a political-religious movement; the other, the growth of a cult dedicated to Maitreya, the Future Buddha. Both of these developments had lost much of their popularity by the end of the Silla period, but they nevertheless left their mark upon the history of Korean Buddhism. The first of these features involved the close relationship that existed between the political unification of the Silla Kingdom and Buddhism. Following a pattern already established in China, the Silla king was considered to be a *chakravartin* (universal monarch) in the manner of the Indian Buddhist king Asoka (c. 273–232 B.C.). This Indian ruler became a model for later kings, who saw his conversion to Buddhism and his many pious deeds as worthy of emulation. In order to further link the destiny of the royal clan with the Buddhist faith, members of a Silla ruler's family were often named after various of Sakyamuni's relatives. The merging of the secular with the religious in the person of the ruler set the tone for subsequent developments in Silla history, where the goals of the state and Buddhism often coincided. Additional ties to the historical Buddha, included the belief that in Korea there were auspicious monuments connected with events in his life, such as a stone pedestal alleged to have been used by Kasyapa and Sakyamuni. Silla theologians also established a number of events paralleling those from Sakyamuni's life in India, such as the notion that the dragon protected Buddhism just as the serpent Muchalinda protected Sakyamuni at Bodhgaya (no. 50). These locally evolved legends and beliefs aided in establishing and glorifying Silla as the Land of the True Law, a Buddhist paradise, and hence a legitimate political entity.

Perhaps the most interesting link between the Silla Kingdom and the Buddhist faith, however, was a unique institution known as *hwarang*. This group was an outgrowth of pre-Silla organizations of Buddhist youths who served the state through their exemplary moral behavior, highly developed cultural achievements, and militant defense of the crown. The *hwarang* were an elite corps who supported the Silla monarchy very effectively between the sixth and eighth centuries.

According to the *Samguk Yusa,* in addition to vows of religious duty, each *hwarang* member was to keep secular commandments such as these given by the monk Wonkwang:

1. Serve the king with loyalty.
2. Honor your parents with filial piety.
3. Treat friends with sincerity.
4. Fight the enemy with bravery.
5. Kill living animals with discriminating mercy.

You should observe these commandments consistently, without the least neglect.

(Ilyon, p. 286)

The patron deity of the *hwarang* was the Future Buddha, Maitreya (known as Miruk in Korean). In early Korean Buddhism, Maitreya played a major role. (See the essay in section four of the catalogue for further discussion of Maitreya.) Indeed, the best-known Korean Buddhist image is the meditating Future Buddha portrayed as a bodhisattva with his right leg crossed over the pendant left leg and the fingers of his right hand touching his cheek (for a Chinese prototype see no. 87). The cult of Maitreya was also widespread in China, and would-be rulers frequently represented themselves as the Future Buddha in order to establish religious legitimacy for their political aspirations. Both the Paekche and Silla kingdoms saw widespread worship of Maitreya, and records such as the *Samguk Yusa* tell of brave soldiers *(hwarang)* who died serving the cause of the Future Buddha. General Kim Yusin, a *hwarang,* was in fact considered a personification of Maitreya.

The *hwarang* and the cult of Maitreya were not revolutionary in nature. Both functioned in support of the Silla ruler. The identification with Maitreya, the Future Buddha, gave the existing order an important link with the future and assured a continuing rule. It is also important to note that Maitreya was represented as a young prince, like the young prince Sakyamuni. This cult was part of the Madhyamika sect, and as such it precedes the broad acceptance of the Pure Land school (see the essay in section four of the catalogue for a discussion of the Pure Land school). The heavenly paradises of the latter became dominant by the late Silla period (9th–10th century), and by that time both the *hwarang* and the cult of Maitreya had lost their once-dominant positions. Very few images of the pensive Maitreya figure are known after the eighth century.

Although subject to the continued influence of Tang China (618–906), Silla Buddhism produced images of a distinctive Korean character, such as the Sokkoram Buddha and the meditating Maitreya, which have established the period from the seventh through the ninth century as the classical age of Korean Buddhist art. These accomplishments were carried to Japan, and they profoundly affected religious and artistic developments there, producing complex relationships that continue to occupy scholars today.

Buddhism maintained its dominant position throughout the Unified Silla epoch, despite the political unraveling that signaled the kingdom's decline. The subsequent Koryo period (918–1392) began under fervent Buddhist rule, and the Buddhist faith continued to enjoy prosperity as Korea's artistic and educational focus. Unfortunately, little Buddhist material remains from this period. By the early twelfth century, circumstances had changed, both within Korea and China, and, as a result, Buddhism began to lose its dominance over Korean culture. Initially, the enthusiasm for Buddhism had overshadowed native shamanistic practices; in time, however, these older, native beliefs began to reassert themselves, just as a renewed Hinduism in India and a revitalized Shinto in Japan diminished the strength of Buddhism in those countries. During the Koryo

period, Daoist beliefs, geomancy, and traditional shamanism infiltrated Buddhism to such an extent that it began to lose its identity. The flow of Buddhist inspiration from China lessened as Neo-Confucianism gained strength there, and the one Buddhist sect that did enjoy prosperity, the meditative Chan (Seon in Korean, Zen in Japanese), had less use for images. The culture now coming from China valued landscape painting, and the late Koryo artists followed the Chinese Song period (960–1279) masters in the development of this secular tradition.

With the succeeding Yi dynasty (1392–1910), this decline in the fortunes of Buddhism continued, accompanied by the rise of Confucianism. During the early Koryo period, the Buddhist monastic establishments had become enormously wealthy, mainly through landholdings, and the ensuing corruption and laxity provided the pro-Confucian Yi rulers with the evidence they sought. Imperial support ceased; some kings removed tax exemptions, forbidding repairs and the construction of new buildings, as well as destroying hundreds of temples and confiscating the lands of others (Reischauer and Fairbank, p. 434). Korean Buddhism never regained its former prominence. The shift from a Buddhist- to a Confucian-oriented culture, which was well under way by the fourteenth century, did not, however, herald the end of art and learning or, for that matter, the end of Buddhism. Korea was to develop its own alphabet, invent the first movable type, produce a vast body of literature, and create ceramics of the finest quality. Buddhism, although no longer the central focus of imperial attention, continued to exist, as it does today, on the popular level. The finest Buddhist art from the Yi dynasty belongs properly within the scope of folk art, a category characterized by enormous vigor and expressiveness. Korean folk art is only now being recognized as one of the most varied and rich of the world's folk art traditions, and extant Buddhist examples testify to the continued strength of the faith (nos. 123 and 126). The language changed over the course of five hundred years, but the message remained, and some of the Yi dynasty paintings and sculptures equal their more famous predecessors in capturing the essential spirit and meaning of Sakyamuni's message.

The Image of Sakyamuni in Sculpture

ALTHOUGH BUDDHISM HAD BEEN ACTIVE in Korea since the late fourth century, no Korean Buddha images remain today that can be positively dated earlier than the first half of the sixth century. By that time, Sakyamuni, Amitabha, and the well-known meditating bodhisattva usually labeled Maitreya had all appeared. Sixth-century images remain from each of the three kingdoms; most are bronze, but some small ones made of soapstone and a few larger examples carved from granite also exist. This production continued into the seventh century, although no positively identified Koguryo images can be dated later than 600. With the unification under Silla rule in 668, the three styles blended into a mature expression that culminated in the great stone masterpiece, the Sokkoram Buddha of the mid-eighth century.

Korean Buddha images are often difficult to differentiate, and a sculpture that appears to be Sakyamuni, according to the usual standards of pose, gesture, dress, and attributes, often carries an inscription designating it as Amitabha. It would appear that a single formula was used to create the image of the Buddha, and the label Sakyamuni or Amitabha was added later, according to the wishes of the donor. With the political unification and the rise of Pure Land Buddhism, images of Amitabha increased in number. There is no question, however, that images of Sakyamuni

remained important, despite the increased attraction of Pure Land sects. The single greatest Korean Buddhist monument, the Sokkoram group of 751, in all probability represents Sakyamuni at a time when the worship of Amitabha flourished.

Images of Sakyamuni retain basic qualities throughout Korean history. Most apparent among them is an expression of simple humility. The Korean version of Sakyamuni is usually represented with eyes downcast and a faint smile; he assumes a posture that makes him seem almost fragile. This youthful frailty and gentleness can be seen in early examples (nos. 90 and 91), as well as in a recent nineteenth-century figure (no. 126). The Korean Sakyamuni radiates a sense of inner power, strength, and gentleness, quite in keeping with the traditional interpretation of the historical figure. During periods dominated by esoteric worship, such as the late Silla, or when Amitabha's transcendent nature was emphasized, these traditional patterns were altered to reflect the new emphases but not completely changed. The resulting portrayal continued to embody some of the gentleness and simplicity, even though the image had become a transcendent being far removed from the historical Sakyamuni.

During the early years of Buddhism in Korea, Sakyamuni held a very special reality for believers. At this time, some preached that Korea had been the home of former Buddhas, while others believed it was the permanent abode of the Buddha and bodhisattvas (P. H. Lee, p. 10). The *Samguk Yusa* tells of a stone existing in Korea upon which Kasyapa and Sakyamuni used to sit together in meditation (Ilyon, p. 8). Old Silla kings were said to be of the *kshatriya*, or warrior, caste, as in the Indian system, and various Silla monks were believed to have performed miraculous feats recalling those in the legends of Sakyamuni. These miraculous events and circumstances were part of the initial enthusiasm for the newly imported religion, and they served to establish Sakyamuni's prominence during the early centuries of Korean Buddhism.

Early Korean images of Sakyamuni from the Three Kingdoms period (c. 1st century–668) embody the gentleness, simplicity, and naturalness mentioned above—traits that are often applied to the whole of Korean art. The small stone figure in the exhibition is especially representative of these qualities (see no. 90). In addition, this image reflects the Korean emphasis upon the face, with the rest of the figure being less carefully modeled. Three Kingdoms versions of Sakyamuni are usually shown with the right hand raised in the gesture of reassurance *(abhayamudra)* and, in the case of standing figures, the left hand simultaneously shown in the gesture of charity *(varadamudra)*. These traits are no doubt reflective of similar developments in Chinese sculpture that took place during the second half of the sixth century. The emergence of these characteristics in Korea can be seen when an early Three Kingdoms figure, dated 571 (see no. 165), is compared to the early seventh-century images (see nos. 90 and 91).

By the mid-seventh century, a number of Korean monks had returned from visits to China, bringing home the beliefs of various sects. The monk Uisang established the Avatamsaka sect early in the United Silla period; Chajang founded the Vinaya sect; and other branches, notably the Amitabha cult of the Pure Land school, enjoyed widespread popularity as well. Other Korean monks became active in spreading Buddhist beliefs to Japan, and some achieved prominence there. The primary effect of this cross-cultural activity on the portrayal of Sakyamuni can be readily seen. The images become more hieratic and fewer in number as the worship of Amitabha continues to grow in popularity. The iconography of the two figures, in fact, tended to merge to the point where they became virtually identical.

By the end of the Silla period in 935, all the various poses, postures, and materials found among sculptured Korean images of the Buddha were known. These types all ultimately derived from Chinese models. Some sculptures were carried to Japan to be copied by artists there, and distinctive Korean characteristics marked the style of nearly all of these exported images. Among standing images there continued to be a preference for the paired gestures that show the right hand raised in the gesture of reassurance and the left displaying the gesture of charity. The figures are fully robed, with both shoulders covered, and they have a distinctly hieratic appearance. This was especially appropriate for Amitabha, ruler of the Western Paradise, the most frequently depicted Buddha. Images seated in the lotus posture are likewise fully robed, often with one foot visible through the folds. A greater variety of hand gestures emerged, including the meditation gesture and the gesture of turning the Wheel of the Law. Late in the period, a gesture evolved that was reserved for Vairochana, in which the extended index finger of the left hand is grasped by the right (see no. 147). A number of variations on the two main gestures found among standing figures also continued to appear. The earth-touching gesture *(bhumisparsamudra)*, however, had become the most popular by the mid-eighth century. Representing Sakyamuni's moment of Enlightenment, it was seldom found among Korean images before 700, but with the dedication of the colossal stone Buddha at the Sokkoram in 751, it became dominant among seated figures. The appearance of this gesture in Korean representations corresponds with the period when Korean monks began to travel to India; these travelers may have seen the earth-touching gesture represented at Bodhgaya, the site of the Buddha Sakyamuni's Enlightenment and an important pilgrimage center. Despite the fact that this particular gesture was so closely bound to the story of Sakyamuni, most Korean images shown displaying *bhumisparsamudra* are identified as Amitabha, who was extremely popular at the time. The association of this particular pose with Amitabha may be unique to Korea. The entire Sokkoram monument itself has never been satisfactorily explained, and scholars differ as to the correct identification of the main image. It would appear that the label of Amitabha has little to do with the visual evidence. The earth-touching gesture, the presence of ten disciples, bodhisattvas, even the figure of Vimalakirti, the wise layman, all suggest Sakyamuni as the correct identification (Kim and Lee, pp. 69–73).

The other seated postures used in Silla images are usually associated with the Future Buddha, Maitreya. Best known is the pensive pose of Maitreya in the form of a bodhisattva described earlier. Although this posture originated in Gandhara, it has become closely associated with Korea. It is also found in Japan, no doubt the result of Korean influence. These images coincide with the popularity of the *hwarang* cult, and very few are found after the eighth century. The emergence of the earth-touching pose parallels the decline of this pensive, seated posture. Interestingly, in the Chinese version of the Maitreya image, the Future Buddha is shown as if seated upon a throne or chair, hence the popular designation of "European" posture (see no. 177). Few Korean images modeled on this Chinese formula are known (see no. 178).

Two other poses found in Silla images warrant notice. These occur among bronzes representing the infant Sakyamuni (no. 27). In one case, the baby Buddha's right hand is raised in a triumphant gesture; in the other, both arms hang down at his sides. Many such figures are known from Japan, and both countries paid homage to the earliest events in the life of Sakyamuni, his Birth and his first giant steps that conquered the world. The image of a pair of seated Buddhas shown in conversation, though rare, is also found among Silla works. It is copied directly from Chinese sources and seems to have had little popularity, despite the fact that the text from which it derives, *The Lotus Sutra*, was extremely well known.

All the images discussed above reflect, to some degree, Korean ethnic and regional characteristics, as well as aesthetic preferences, that set them apart from their Chinese sources. Most distinctive is the youthful, very human quality of the face. This is most apparent in early images, created before the rise in popularity of the hieratic, celestial Amitabha. With the advent of the Confucian Yi dynasty and the concomitant withdrawal of royal patronage from Buddhism, this human quality once again reasserts itself (see nos. 123 and 126). One can also point to the disproportionate size of the hands and the large head, which is often set almost directly upon the shoulders, as typically Korean features. Generally, the face and hands are given more extensive treatment than the rest of the image; this is especially true among stone sculptures.

During the long Silla dynasty, stone and bronze were the favored materials. Wood (no examples of which exist), clay, and lacquer, however, were also used. Whatever the medium, the characteristics of a Korean Buddha remain distinctive, and the simple humility of many of these images closely captures the spirit of the human Sakyamuni.

The Image of Sakyamuni in Painting

KOREAN BUDDHIST PAINTING has suffered far more than sculpture from the ravages of time. Many important examples of wall paintings were lost when temples were reduced in number during the anti-Buddhist campaigns of the Yi dynasty. In addition to the severe losses, in the West, many Korean paintings were often mistakenly assumed to be Chinese or Japanese, and only in recent times have scholars been able to correctly reattribute these mislabeled works. No Buddhist paintings remain from earlier than the Koryo period. Nearly all extant Koryo period paintings are currently in Japanese collections, mainly in Buddhist temples. Only in the past ten years have comprehensive publications, all in Japanese, been devoted to Korea's Buddhist paintings (see for example Kikutake and Yoshida). The beauty and richness of the one hundred fifty or so examples from Koryo ensure that interest in them will increase, and in Korea today, temples are still having the traditional Buddhist stories painted on their walls—evidence that the tradition is much stronger than the paucity of remaining works would suggest.

Among the rarest subjects of Korean Buddhist painting is Sakyamuni. If Silla examples remained, there would no doubt be more, but by Koryo times the world of Amitabha had largely assumed the primary position. Most of the extant works are various representations of Amitabha, depicted either preaching or enthroned in his paradise. Three Koryo Buddhas are known in American collections, and we are fortunate to have one of them in this exhibition (see no. 171). (The other two are in the collections of the Asian Art Museum of San Francisco and The Cleveland Museum of Art [see M. L. Williams]. The latter is the only one of the three that could represent Sakyamuni; the other two appear to be Amitabha.) In this painting, as in other examples, Amitabha is hieratic in pose and richly painted, with gold used on much of the decorative area. The gold was apparently always painted on, not applied in strips of gold leaf *(kirikane)* as was done in Japan (Kikutake and Yoshida, p. iii).

One tantalizing glimpse of what must have been a widespread painting tradition can be gained from looking at the pair of eighteenth-century paintings in this exhibition (see nos. 19 and 37).

These rare works illustrate scenes from the life of the Buddha: his conception and his departure from his father's palace. These incidents and the continuous narrative manner of composition indicate an older tradition, from which no examples remain. As mentioned earlier, such scenes continue to be painted upon temples today, but their traditional placement on exterior walls does not ensure a long life. It is difficult to determine the extent to which the life of Sakyamuni was portrayed in Korean art. Koryo period texts refer primarily to miraculous events, scenes of paradise, bodhisattvas, and related figures; they do not make reference to the story of Sakyamuni's life or relate stories of his past lives (jatakas). The popularity of the image of the newborn Buddha during Silla times might suggest at least some interest in literature dealing with Sakyamuni's life. As noted before, however, East Asian Buddhism is primarily the culmination of developed Mahayana beliefs, and the celestial realms occupy far more of the devotee's attention than do the comparatively mundane events of Sakyamuni's life.

One other type of Buddhist painting does remain from early times. During the Koryo period, numerous illustrations of Buddhist sutras were painted, often in gold pigment upon a rich blue background. These are similar to the wall paintings in complexity, usually involving many episodes taken primarily from two sources: *The Lotus Sutra* and the *Avatamsaka* (see no. 147). In their richness, these paintings are similar to medieval European illuminated manuscripts, to which they are related, at least in time of execution and size. They are all that remain to suggest the spectacular display of elaborate wall paintings that originally appeared behind the sculptural images in Buddhist temples.

Just as Sakyamuni was not the primary subject of Buddhist sculpture, he remained a secondary image in painting. Nevertheless, in both cases his image continues to be found, and with the shift from royal to popular patronage of Buddhism, his portrayal in folk art came to capture the traditional spirit and simplicity of the individual in a manner distinctively Buddhist and recognizably Korean.

Robert E. Fisher

THE BUDDHA IMAGE IN JAPAN

A Brief History of Buddhism in Japan

BUDDHIST THOUGHT AND RITUAL began to be absorbed into Japanese culture during the sixth century with the presentation of Korean Buddhist images to the Japanese imperial court. The first real flowering of Buddhist art in Japan, however, occurred in the Nara period (646–794) and was spurred by the missionary efforts of Chinese and Korean monks.

The Chinese Buddhist doctrines introduced to Japan were those of the Mahayana tradition, the so-called Northern Buddhism with its "Three Treasures-Buddha, the Law (Dharma) and the monastic orders (Sangha)" (de Bary, 1958, vol. 1, p. 92). This Chinese tradition was mature, highly developed, and fragmented into various sects and schools. Obviously, the first Japanese converts would have been hard pressed to instantly master or to fully appreciate the intricate arguments—evolved over a period of nearly a thousand years—that had come to differentiate the various Chinese and Indian Buddhist sects. Instead, the Japanese emphasized those aspects of the new religion that seemed to resemble or to enhance both their own beliefs and the structure of court life—aspects that were embodied in bronze images of the Buddha imported from China or Korea. The enormous and ornate Buddhist temples and monasteries built at Nara testify to the Japanese court's enthusiastic patronage of the new religion.

During the early years of Buddhism in Japan, the *Sutra of Cause and Effect, Past and Present (Kako-genzai-inga-kyo)*, the *Sutra of the Golden Light (Konkomyo saisho o-kyo)*, and the *Flower Wreath Sutra (Kegon-kyo)* were particularly influential. The most popular

text, however, was *The Lotus Sutra (Hokke-kyo).* All of these scriptures—known to the Japanese in their Chinese versions—were to some extent concerned with the life of Sakyamuni (Shaka in Japanese), the historical Buddha. Nevertheless, it must be remembered that Mahayana Buddhism had developed an elaborate pantheon of Buddhas *(Butsu)* and bodhisattvas *(bosatsu)* by this time.

Fundamental to the Chinese sacred teachings introduced to Nara period Japan was the distinction between exoteric and esoteric schools of Buddhism. The former school espoused conservative Mahayana doctrines, also known as "revealed" teachings. Following these doctrines, which included sutras concerned with the exemplary life of the historical Buddha, Sakyamuni, all men were supposed to be able to live in a manner that would ensure their attainment of nirvana upon death. Esoteric, or "hidden," teachings, on the other hand, relied on rituals known only by initiates. These practices included meditation on particular images of the Buddha and the performance of carefully prescribed and elaborate rites. The adherents of esoteric sects believed that through such rituals they could attain nirvana on earth. The promise of an earthly nirvana extended the appeal of esoteric schools, and, thus, they were not necessarily restricted to an elite group of adherents. Esoteric Buddhism in fact came to predominate over other sects during the next several centuries.

In the twelfth century, however, the Pure Land school (Jodo-shu) became influential in Japan. This school taught that salvation could not be gained by works or prayers but only through the mercy of Amida Buddha (Amitabha in Sanskrit). Although Pure Land Buddhism had long been known in China, certain Japanese sects went so far as to claim that the ritual invocation of Amida's name "Namu Amida Butsu" (a practice called *Nembutsu*) was sufficient to gain admittance to the Western Paradise. This idea had a tremendous appeal for both the noble laity and the common people in the late Heian (897–1185) and medieval periods.

The increased interest in the Pure Land school resulted in a vast outpouring of works of art relating to Amida (nos. 172–74), whose promise of an easily attained salvation came to be preferred to the rigorous requisites of the principal esoteric sects. Pure Land paintings—such as *Amida Crossing the Mountains* (no. 174) or *Amida Raigo with Twenty-five Bodhisattvas* (no. 173)— depict graceful and otherworldly figures who evoke an aura of perfection and flawlessness. Executed in rich colors and embellished with cut gold-leaf, these symmetrically arranged paintings focus on the central figure of Amida, whose perfection they are clearly intended to emphasize. Especially popular were portrayals of Amida's descent from the Western Paradise, which were called *Raigo.* Several interesting ritual practices also evolved surrounding the cult of Amida. For example, sculptures were draped with braid, or alternatively, strings were painted descending from Amida's eyes in *Raigo* paintings; a dying adherent of the Pure Land school would be presented with one of these images and instructed to grasp the strings so that he could be lifted into the next world.

This focus upon Amida did not mean that traditional subjects of Buddhist study were ignored. During the medieval period, the Tendai monk Nichiren (1222–1282) still preached the primacy of *The Lotus Sutra* and advised his followers to chant its verses as opposed to practicing the *Nembutsu:*

> If you desire to attain Buddhahood immediately, lay down the banner of pride…and trust yourselves to the unique Truth…When you fall into an abyss and someone has lowered a rope to pull you out, should you hesitate to grasp the rope because you doubt the power of the helper? Has not Buddha declared, "I alone am the protector and saviour"?…This is

the rope! One who hesitates to seize it, and will not utter the Sacred Truth, will never be able to climb the precipice of Bodhi.... Devote yourself wholeheartedly to the "Adoration to the Lotus of the Perfect Truth", and utter it yourself as well as admonish others to do the same. Such is your task in this human life. *(de Bary, 1958, vol. 1, pp. 216–17)*

The successful introduction of Zen Buddhism to Japan took place during the Kamakura period (1185–1333). Although there had been numerous prior attempts to import the teachings of the Chinese Chan school, Zen, its Japanese equivalent, did not gain popularity until the twelfth and thirteenth centuries. Zen teaching, as introduced from Song (960–1279) China, was based upon the premise that Buddhahood could be found within each human being. Meditation or concentration was viewed as the means to attain this self-realization, and this emphasis was expressed in phrases such as "the mind itself is Buddha" or "outside of the mind there is no Buddha." By the twelfth century, Chan was the only variant of Buddhism still influential in China, and this fact doubtlessly assisted the growth of Zen sects in Japan. Despite its emphasis on meditation, Zen was by no means consistently associated with a rejection of traditional scriptures. The Zen priest Dogen (1200–1253) preached that "To discard the sutras of the Buddha...is to reject the mind of the Buddha" and in his later life came to prefer original Indian accounts of Sakyamuni's life as scriptural subjects of study (de Bary, 1958, vol. 1, p. 249). Eisai (1141–1215), another pioneering Zen priest—who visited China and ultimately founded the Rinzai sect in Japan—followed Chan models and rejected dependence on scripture as symptomatic of an intellectualization that detracted from the development of moral character. Nonetheless, this monk's writings demonstrate wide knowledge of the traditional texts:

> Great indeed is Mind! Of necessity we give such a name to it, yet there are many others: the Highest Vehicle, the First Principle, the Trust of Inner Wisdom, the One Reality, the Peerless Bodhi, the Way to Enlightenment as taught in the Lankavatara Sutra, the Treasury of the Vision of Truth, and Insight of Nirvana. All texts in the Three Vehicles of Buddhism and in the eight treasuries of Scripture, as well as all the doctrines of the four schools and five denominations of Zen are contained in it. Shakya, the Greatest of all teachers, transmitted this truth of the Mind to the golden-haired monk [Kashyapa], calling it a special transmission not contained in the scriptures. *(de Bary, 1958, vol. 1, pp. 236–37)*

The Zen tradition retained its vitality for centuries, and it would be impossible to try and trace or fully describe here the range of Zen teachings in the Kamakura (1185–1333), Nambokucho (1333–92), Muromachi (1392–1568), and Momoyama (1568–1615) periods. The discourse between Zen masters remained a principal feature of Japanese intellectual life even in the Edo period (1615–1868), during which time much of the Zen ink painting we know today was created.

The great Edo-period painter Hakuin (1686–1769) inherited the mantle of the Rinzai Zen sect, and his writings are extensive and well published. As late as the eighteenth century, this priest continued to wrestle with problems that would have been familiar to the earliest Japanese Buddhist converts:

> I had heard that the Lotus Sutra was the king of all sutras, respected even by the ghosts and the gods...Thereupon, I picked up the Lotus Sutra and in secret started reading it, only to discover that is was filled with parables, with the exception of the sections on the doctrines...If this sutra had any influence, I thought, the Chinese classics and the books of all the other schools must be equally effective; there was no particular reason why this sutra should be esteemed so highly. The great hopes I had had were completely dashed.

This disappointment occurred when I was sixteen years old. *(de Bary, 1972, p. 383)*

The Japanese Buddha Image

AS MENTIONED EARLIER, Korean Buddha images were presented to the Japanese court in the sixth century, although Buddhist art did not really begin to flourish in Japan until the seventh century. The early development of Japanese Buddhist art coincided with and was influenced by the evolution of late Sui (581–618) and early Tang period (618–906) art in China. Although Chinese paintings of this date are rare today, the style remains evident in certain wall paintings found in the caves at Dunhuang in Gansu Province. Until the middle of the present century, Japanese examples of this shared tradition could be seen in the murals at Horyuji in Nara. This temple was largely destroyed by fire in 1949, but fortunately, it is well documented in photographs.

Buddhist art in Japan was created for both devotional and instructional purposes, and it was not usually intended to produce a detached aesthetic experience. In 806, following his return from a period of study in China, the monk Kukai (774–835) wrote a *Memorial Presenting the List of Newly Imported Sutras.* In this work, he clearly delineated the aims of Buddhist art:

> Mistakes will be made in the effort to point at the truth, for there is no clearly defined method of teaching, but even when art does not excite admiration by its unusual quality, it is a treasure which protects the country and benefits the people.

> In truth, the esoteric doctrines are so profound as to defy their enunciation in writing. With the help of painting, however, their obscurities may be understood. The various attitudes and mudras of the holy images all have their source in Buddha's love, and one may attain Buddhahood at sight of them. Thus the secrets of the sutras and commentaries can be depicted in art, and the essential truths of the esoteric. *(de Bary, 1958, vol. 1, pp. 137–38)*

The Lotus Sutra and other Mahayana doctrines that emphasize the historical Buddha were first brought to Japan during the sixth century. The early sculptures, therefore, generally portrayed Sakyamuni. The Buddha image as an object of adoration was intended to communicate compassion, detachment, peace, and joy, and consequently, rich ornamentation was not considered important. Durability, on the other hand, was highly valued in such images, despite the fact that almost no stone sculpture is known from early Japan. Japanese Buddhists did, however, import bronze images from Tang dynasty (618–906) China, and this practice became even more common during the Chinese Song (960–1279) and Yuan dynasties (1280–1368).

Early Japanese temples were usually centered around a pagoda that contained a relic of the historical Buddha or around the Golden Hall *(Kondo)* that symbolized the residence of Sakyamuni. The idea that he who ruled over an immeasurable world must be of a corresponding dimension contributed to the early popularity of Buddha images of immense size *(Daibutsu).* (Two colossal bronze images—the Buddha Mahavairochana made in 752 and installed in the Todaiji in Nara [this work has been restored numerous times] and the seated Amida Buddha of 1252 housed in the Kotokuin Temple in Kamakura—may still be seen today.) The central hall of a traditional Mahayana temple often contained a sculpture of the revered Buddha that filled the entire space. Alternatively, a monumental altar was used to occupy this area. In contrast, the temples of eso-

teric pagodas were intended to represent the Womb World or Diamond World—two of the subjects of esoteric mandalas (*mandara* in Japanese). Esoteric sects placed emphasis on the entire pantheon of Buddhas and bodhisattvas, as opposed to focusing on Sakyamuni. Consequently, they often filled their temples' halls with a host of small statues representing the heavenly horde. Similarly, esoteric-sect paintings were characterized by incredible complexity and often depicted paradise scenes and diagrams that were crowded with as many as thirteen thousand Buddhas.

A constant awareness of past conventions was evidenced in Japanese images of Sakyamuni. As in all Japanese Buddhist art, composition, form, and technique were copied. This copying process was intended to provide the means to augment the public's understanding of sacred texts and to disseminate the religion. The practice ultimately led to a proliferation of images for use in elaborate rituals pertaining to Sakyamuni.

Among these celebrations was the annual commemoration of Sakyamuni's Birth on the eighth of April. This event continues to be celebrated in Japan today and is designated a national holiday. The Kambutsu (Meeting of the Buddha's Baptism) ceremony involves setting a bronze image of the infant Sakyamuni in a basin and bathing it with water or tea. This procedure commemorates the lustration of the baby in the grove of Lumbini. Various Indian texts, which were eventually translated into Japanese, describe the infant Buddha being bathed by streams of water emanating from the *naga* kings Nanda and Upananda. According to de Visser, the *Sutra on the Meritorious Action of Bathing the Buddha's Image* was translated into Japanese on two different occasions during the eighth century. De Visser describes one of the translations as follows:

> [The translator] explains the way of washing his images, on behalf of the kings, princes, ministers, queens and royal concubines, devas and nagas, men and demons, and calls it the most excelling of all offerings. He prescribes precious incense, rubbed on a pure stone, and how the altar, square or round, large or small according to the circumstances, must be erected on a pure spot. After having washed the image on the altar, the worshipper with two fingers must drip the water with which it has been washed, called Kichijo-sui,..."Water of Felicity", on the top of his own head, and then he must shed it on a pure ground, not to be trodden by feet. Thereupon he must wipe the image with a thin and soft towel, burn all kinds of incense around it, and put it on its original place. If virtuous men perform this rite, felicity, health and long life shall be granted to the great mass of men and devas on account of the purity of the Buddha's images. *(de Visser, 1935, vol. 1, p. 49)*

This ceremony had antecedents in India where Sakyamuni's Birth was celebrated by a procession carrying Buddha images through the streets. In China, a ritual washing of an image by the emperor was practiced as early as the fifth century (de Visser, 1935, vol. 1, p. 51). The Japanese ritual was first celebrated in the seventh century, and two bronze images from this period are included in the exhibition (see no. 26). These small figures *(tanjobutsu)* assume a characteristic stance with the right arm held high above the head and the hand pointed to the sky; the left arm is lowered and the left hand indicates the earth. Several texts describe the infant Buddha as standing in this manner at the moment of his first speech and subsequent to his taking of the seven steps. Three Nara temples, the Horyuji, Daianji, and Todaiji, supposedly used baby Buddha images as early as the eighth century, and the Kambutsu ceremony was performed in the imperial palace at Kyoto for the first time in 840. Early ceremonies involved bathing the image in various types of perfumed water, but by the Edo period (1615–1868), the bronze baby Buddhas were washed with sweet tea. Every Buddhist temple, with the possible exception of those of the

Jodo-Shinshu sect, would have celebrated this holy day, and each would have venerated one or more such statues. Statues used in this ceremony are known from all periods, and the episode is also represented in several Edo period printed versions of Sakyamuni's life (no. 25).

Other events in the Buddha's life have also been celebrated and continue to be observed in Japan. Sakyamuni's return from the austerities of the Enlightenment Cycle is marked each November. In art, this theme is known as *Shussan Shaka (Sakyamuni Coming Down the Mountain)*. Portrayals of Sakyamuni's return were especially important to adherents of Zen Buddhism (see no. 41). Early Japanese versions of this theme were greatly reliant on contemporary Chinese prototypes. The choice of a mountainous locale and the typical depiction of Sakyamuni as a monk are characteristic of tenth- and eleventh-century Chinese *Shussan Shaka* paintings and of the Japanese works modeled after them. The Zen emphasis on self-realization through meditation had its pictorial counterpart in the concentration on the single figure of Sakyamuni. Bearded, his hair long, his body emaciated and bent forward, Sakyamuni appears physically weakened by his arduous austerities. The only indication of his Enlightenment is an aureole or physical attributes such as the *ushnisha* and *urna*. Interestingly, the Japanese sometimes represent the *ushnisha* as a bald spot rather than a cranial protuberance (see nos. 41 and 155). The depiction of the solitary Buddha in an asymmetrical composition executed in monochrome ink with irregular brushstrokes was clearly opposed to the typically symmetrical and minutely detailed esoteric-sect paintings of crowded pantheons.

February fifteenth is the date of the annual Japanese celebration of the *Mahaparinirvana (Nehan* in Japanese). Each year, paintings and sculptures representing this event are displayed in temples. *Nehan* paintings were particularly popular in Japan, although early examples are now quite rare. The oldest extant version is a large hanging scroll executed in colors on silk and dated 1086 that is currently housed in the Kongobuji, Koya-san, Wakayama Prefecture. This painting is typical of the Heian period and shows the recumbent Buddha surrounded by various bodhisattvas, the Guardian Kings, the Ten Great Disciples, and other devotees. The inclusion of animal mourners ultimately became characteristic of the *Nehan* genre, and the number of beasts depicted increased over the years to the point where paintings became crowded with them.

By the Edo period, Zen meditation and the proliferation of Buddhist subject matters led to interpretations of texts that were frequently more personalized. This is apparent in the late *Nehan* paintings included in the exhibition (see nos. 64c and 64d). The nineteenth-century paintings by Yokoyama Kazan and Nakamichi Sadatoshi clearly bear the stamp of the artists' individual visions. Nakamichi has added additional figures to the traditional crowd of mourners, and we can observe weeping crustaceans and fish actually shedding tears in the foreground of his painting. Yokoyama Kazan has arranged his *Mahaparinirvana* scene on a wide horizontal plane, a choice which may reflect the influence of Western perspective. The history of the *Nehan* theme exemplifies the distinctly Japanese ability to humanize the portrayal of Sakyamuni. This tendency found its ultimate expression in humor. The placement of the artist's signature on the elephant's rump in the Kazan *Nehan* is a case in point. Parodies *(mitate)* of this theme also developed, such as the painting included in the exhibition wherein a radish is substituted for the recumbent Sakyamuni and assorted other vegetables assume the roles of mourners (see no. 66). In later times, the *Nehan* format was emulated in secular paintings. In the *Basho Nehan*, the poet Basho (1644–1695), who originated the *haikai* short verse form, was depicted lying on a bier surrounded by disciples and characters drawn from his poetry. During the Edo period the *Nehan* formula became particularly popular as a format for memorial portraits, and by this time, over forty different

mitate forms had evolved. Even the well-known ukiyo-e memorial portraits of Kabuki actors shown in their favorite roles and surrounded by stage props can be traced to traditional *Nehan* compositions.

Sakyamuni was also worshiped by the Japanese as one of the Buddhas of the Four Directions who surround Mahavairochana. These Buddhas are arranged in a cosmic diagram *(mandara)* which may be represented in paintings or in the placement of statues on an altar. Images of this type were used to assist the adherent or priests in activities connected with mourning rites.

In an annual ceremony called Butsumyo-e, the names of thirteen thousand Buddhas, including Sakyamuni, were invoked accompanied by prayers of repentance. The thirteen-divinity scroll from the Hammer Collection included in the exhibition is typical of the paintings which were used in this ceremony (see no. 148). This scroll is important not only because it differentiates each Buddha by means of posture or hand gestures but also because it presents the Buddhas in a vertical progression that implies a definite hierarchy. Interestingly, the identity of the bodhisattvas flanking each Buddha and the order of the Buddhas themselves do not conform to any canon.

Sakyamuni is also represented as a member of various trinities. He appears as an attendant flanking Vairochana in a trinity venerated by the Tendai sect. Similarly, he is one figure in the Trinity of Light, an icon linked to ceremonies of thanksgiving and repentance, such as the Bon festival which is celebrated in July of each year.

The earliest sculptural images of Sakyamuni from Japan were inspired by Chinese models or Korean copies of Chinese works. This is often apparent in the treatment of costume or the modeling of the face. With the development of indigenous Japanese styles, we note that differences between images are not primarily regional in nature; rather, a master carver and his atelier or followers would develop a style prescribed by the tenets of the particular sect with which they were associated. Although certain subjects were usually executed in a style common to a particular period, the iconography of an image could be influenced by the specific requirements and beliefs of the sect for which it was produced.

Of course, the idea of a priestly workshop in which like images were turned out in numbers for the education of devotees did not originate in Japan. In describing his studies in China, Kukai, founder of the True Words or Mantrayana sect of esoteric Buddhism recalled:

> The abbot informed me that the Esoteric scriptures are so abstruse that their meanings cannot be conveyed except through art. For this reason he ordered the court artist Li Chen and then about a dozen other painters to execute ten scrolls of the Womb and Diamond Mandalas, and assembled more than twenty scribes to make copies of the Diamond and other important esoteric scriptures. He also ordered the bronzesmith Chao Wu to cast fifteen ritual implements. *(de Bary, 1958, vol. 1, p. 141)*

The Buddha image in the Seiryoji in Kyoto is a significant example of the workshop phenomenon in Japan. In 986, Chonen, a priest of the Todaiji in Nara, had a Song dynasty Chinese sculptor copy a sandalwood image of a standing Sakyamuni in cherrywood. Chonen brought this image back to Japan, and imitations began to be made in the Heian period (794–1185), becoming widespread by the Kamakura period (1185–1333). Sculptures of this sort became known as Seiryoji type Sakyamuni images. Their principal characteristics are the ropelike pattern of the hair, which may

ultimately be derived from Gandhara sculptures, and the wave pattern of the drapery folds covering portions of the thighs and the stomach. Many examples of this image type are known throughout Japan, and we can see its influence in the bronze *Nehan* from the Maruoka collection included in the exhibition (see no. 64a).

From the time Buddhism first reached Japan, it was intended that Buddha images would be differentiated by their distinguishing attributes, as described in sutras. It is, nonetheless, often difficult to identify the particular Buddha depicted in a Japanese work of art. The reasons for this confusion include: missing iconographic details; attributes that are shared by two or more deities; the effacement of inscriptions identifying the figures; and the fact that early Japanese converts to Buddhism may have interpreted Buddhist texts differently than their Chinese or Korean teachers did. A Buddha image may hold certain objects or display specific gestures that are based on a principle derived from, but not readily apparent in a text. In several medieval versions of the *Kako-genzai-inga-kyo* sutra scrolls, for example, the Buddha is represented during the attack of Mara's army. Sakyamuni, wearing red robes, sits in a meditative attitude with his hands in the gesture of meditation. In front of him is a stylized vulture-shaped pond (see no. 47). All of these features, however, are conventional indicators of Amida Buddha. This idiosyncratic use of attributes and episodes traditionally restricted to a certain Buddha can be observed in many works of art.

From the earliest times, sculptures of Sakyamuni could usually be identified by the gesture of reassurance indicated by his right hand and the gesture of charity displayed by his left. By the Kamakura period, however, Amida was also represented with his right hand in the gesture of reassurance. As a result, images of Amida and Sakyamuni can frequently only be differentiated by their context.

Sakyamuni was represented in many ways, reflecting the variety of doctrines and scriptural sources known to the Japanese. He was often portrayed as a teacher in monk's robes and shown either standing or seated. In narrative scenes depicting the Buddha preaching, especially representations of episodes from *The Lotus Sutra*, Sakyamuni often appears taller than the other figures or in some way dominates the painting. With the exception of Zen images or those emphasizing Sakyamuni's human qualities, Japanese paintings characteristically show Sakyamuni among other figures. He is usually depicted in the center of a group or as the focal point of a circle of devotees. Furthermore, the Buddha may be shown wearing royal robes, a crown, and jewels; representations of this type symbolize the moment of supreme Enlightenment. Buddha Sakyamuni is also frequently shown preaching in one of the various Buddhist heavens.

Despite encroaching formalism in later centuries, Buddhist art in Japan maintained a humane focus. Japanese artists, particularly those of the Zen sects, created a realistic portrayal of Buddha Sakyamuni, as opposed to the representation of idealized forms that was the rule in most of Asia. This realism was not, to be sure, what we now think of as photographic similitude, and Japanese practice did not entail working from live models. Rather, the Buddhist artists of Japan attempted to convey the nervous energy, the detail, the inner personality that gives life to an image. The Zen sect with its emphasis on the individual and on idiosyncratic analysis brought the gods back from heaven to earth. Similarly, the previously mentioned introduction of humor to the *Nehan* composition indicates the characteristically Japanese desire to perceive the Buddha and Buddhist subjects in human terms. Only a people of great inventiveness could have carried such ancient themes to such individualized and varied lengths.

Amy G. Poster 190

*Buddha Sakyamuni and
Companions*
Pakistan (Ancient Gandhara), 83 (?)
Gray schist
h: 24½ in. (62 cm.)
Claude de Marteau Collection,
Brussels

Apart from being one of the finest extant Gandhara reliefs, this sculpture contains a dated inscription of great significance to the history of Buddhist art. The inscription states that the image was dedicated in the year five by Buddhananda, who was learned in the three *pitakas* (scriptures) and wished to honor his deceased parents (see: Harle; Fussman). Nothing further is known about Buddhananda. It is generally believed, however, that the year cited refers to the Kanishka era, although there is disagreement among scholars as to when that era began. While there is strong reason to believe that the Kanishka era is the same as the Saka era, which commenced in the year 78, some are of the opinion that it began in the first half of the second century. Thus, this image must have been dedicated sometime between the years 83 and 150. The earlier date would make it the oldest extant dated relief depicting the Buddha from the ancient Gandhara region.

In the relief, the Buddha is shown seated on a flower that looks more like an artichoke than a lotus. The gesture he makes with his hands held against his chest is generally interpreted as symbolic of teaching, although it seems to be depicted rather tentatively here when compared to the more articulated representations observed in later sculptures (cf. nos. 51 and 59). The leafy, flowering branches above project considerably to form a canopy over the Buddha's head.

The standing figures on either side of the Buddha represent bodhisattvas. The figure on the left is probably Maitreya, while the one on the right may be identified as Avalokitesvara by the effigy of a seated Buddha that appears in the crest of his turban. Behind this pair, two more divine figures lean towards the Buddha in adoration, their bodies projecting three dimensionally from the background. The crowned figure on the right holds a thunderbolt and is certainly Indra,

the king of the gods, while the ascetic figure represents Brahma.

This work is similar to the near-contemporary relief from Mathura (see no. 75), with the following exceptions: The gestures made by the Buddha are different in each representation; there are two additional attendants in the Gandhara relief; and while the Mathura relief definitely depicts the *bodhi* tree, the tree in the Gandhara relief has not been positively identified. The Mathura relief certainly represents the Buddha's Enlightenment at Bodhgaya, although the addition of

the two bodhisattva figures gives this historic occasion a transcendental import. The exact identification of the scene illustrated in the Gandhara relief, however, is yet to be determined.

Buddhananda's relief may represent an occasion in heaven rather than on earth. The tree above the Buddha, with garlands emerging from the clusters of leaves, seems more celestial than terrestrial. Moreover, Brahma, Indra, and the two bodhisattvas constitute a divine rather than a mortal audience. Since the Buddha is engaged in delivering a sermon, it is possible that the relief depicts the occasion when the Buddha went to the Trayastrimsa Heaven to preach to his mother, or it may be simply an instance of his preaching before a divine assembly.
—*P. P.*

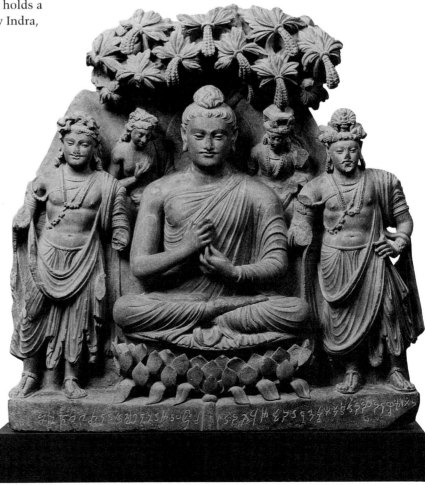

75

Buddha Sakyamuni
India, Uttar Pradesh; c. 100
Reddish sandstone
h: 14 in. (35.5 cm.)
Mr. and Mrs. James W. Alsdorf,
Chicago

This relief is a typical example of the earliest type of Kushan period (1st–3rd century) triad from Mathura that incorporates an image of Buddha Sakyamuni. The Buddha assumes the yogic posture, seated on a throne supported by three heraldic lions. His left hand is placed on his left knee, and his right hand is raised to shoulder level, displaying the gesture of reassurance. The presence of an upper garment is indicated by parallel lines carved over his left shoulder and arm. Otherwise the body appears naked. The Buddha's hair is gathered at the top of his head in a spiral cone *(kaparda)*. Behind his head is a circular halo with a scalloped edge; some identify this scalloped motif as an abstract representation of a serpent's hood.

On either side of the Buddha and slightly behind him stand two bodhisattvas in princely attire. Holding fly whisks in their right hands, they fan the Master as one would an enthroned monarch. Leaves and branches of the *bodhi* tree are carved on both sides of the nimbus and on the back of the stele as well. Superimposed on the leaves at the top front of the relief are two flying angels adoring the Buddha.

The presence of the *bodhi* tree indicates that the occasion represented is Sakyamuni's Enlightenment. It is also clear that the earth-touching gesture usually associated with this event (see nos. 9–11) was a later invention. The throne and the presence of bodhisattvas and angels indicate that this is not merely a depiction of a historical event. Rather, Buddha Sakyamuni has become exalted and appears here as a transcendental and cosmic figure.

Although only three lions are depicted on the throne, one must assume the presence of another at the back facing the fourth direction. The directional significance of the lions (which continues the iconographic tradition of four lions supporting the wheel seen in the Sarnath capital of the Emperor Asoka, the symbol of India [see also no. 68]); the dual role of the *bodhi* tree, which functions both as a historic tree and the cosmic tree of life and knowledge; and the inclusion of the bodhisattvas and angels are very specific traits serving to emphasize the Buddha's transcendental nature.

—P. P.

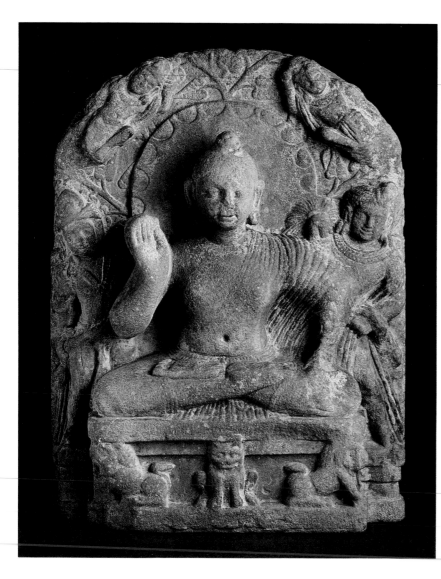

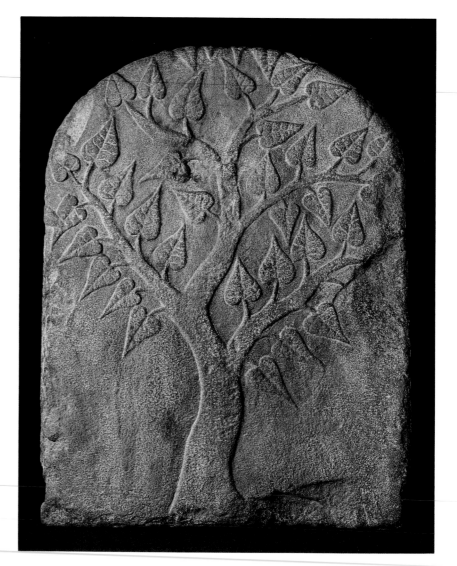

76

Buddha Sakyamuni
Pakistan or Afghanistan (Ancient
Gandhara), 2nd century
Bronze with green patina
h: 6⅝ in. (17 cm.)
M. Nitta Collection, Tokyo
(Shown in Los Angeles only)

Although the exact provenance of
this extraordinary bronze is not
known, it remains one of the earliest
and most distinctive Buddha images
to emerge from the region of ancient
Gandhara. A hybrid style of art, syn-
thesizing Indian, Iranian, and Hel-
lenistic elements, flourished in this
area during the early centuries of the
Christian Era.

The relationship between Gandhara
Buddha images and those of the Ro-
man Apollo has often been pointed
out, but few images so clearly reflect
the connection as this one. Despite
its Indian features, it was quite evi-
dently modeled on a Classical Ro-
man sculpture. The bronze remains
as close to late Roman Republican
portraits as possible, given the
iconographic variations demanded
by the new subject. Except for the
typically Indian posture and arrange-
ment of the hair (although not its
handling), this figure could well
have passed as an idealized portrait
of a deified Roman emperor. The
youthful face and spoked halo in
particular evoke images of Apollo
more vividly than most other
Gandhara Buddhas.

The Buddha sits majestically with
his legs crossed. The soles of his feet
are marked with lotuses. His left
hand holds the end of his upper gar-
ment, which wraps his body with re-
markably naturalistic folds. Despite
the volume of the garments, one is
aware of the subtle modeling of the
flesh underneath. The slim elegance
of the torso is echoed in the raised
right hand with its elongated and
gracefully proportioned fingers. The
face is a perfect oval dominated by
deep-set, open eyes and a prominent
mustache.

—P. P.

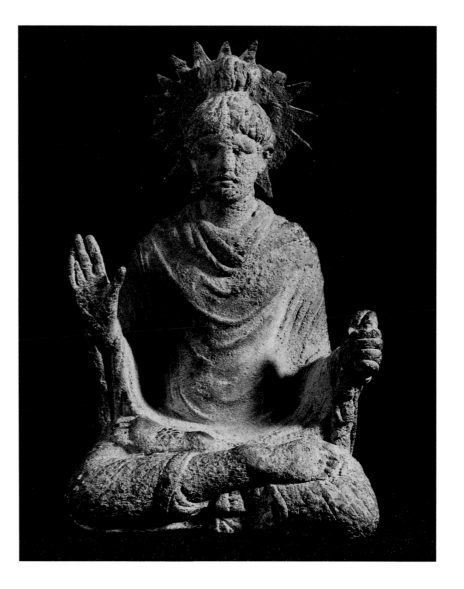

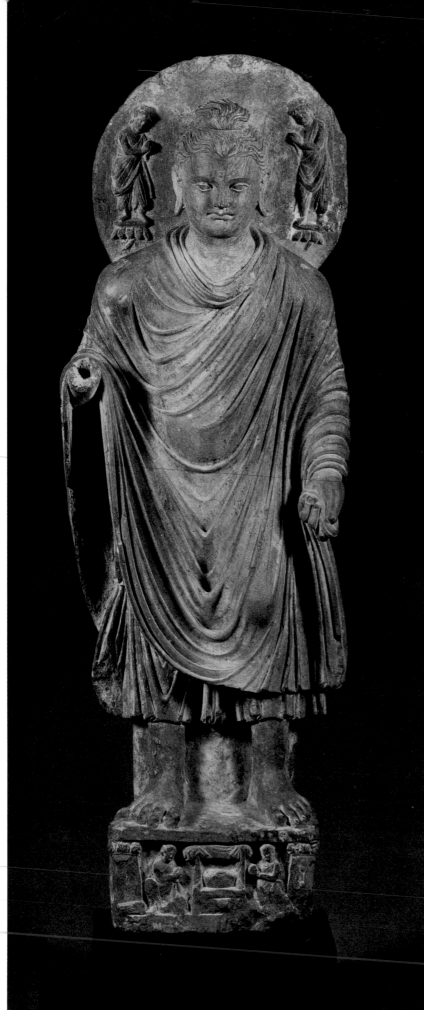

77

Buddha Sakyamuni
Pakistan (Ancient Gandhara),
2nd–3rd century
Gray schist
h: 33 in. (83.8 cm.)
Mr. and Mrs. Willard G. Clark

This is an impressive example of the type of standing Buddha image that was popular in the Gandhara region. Clad in monk's robes, the Buddha stands upon a small base that displays a scene of worship carved in a shallow niche between two columns. The sense of volume conveyed in the delineation of the Buddha's garment is characteristic of Gandhara sculptures. Both the folds of the clothing and the body underneath are modeled with a greater sense of naturalism than can be seen in images from either Mathura or the Amaravati region (cf. nos. 75 and 78). The earlobes are not as extended as they usually are. The stylized, wavy hair, covering both the head and the cranial bump, is slick and smooth. Although now broken, the Buddha's right hand would have displayed the gesture of reassurance; his left hand holds the end of his garment.

The addition of two divine figures on the halo makes this image unusual; in most Gandhara images, the halo is a plain disc. Both divinities stand on lotuses and bend toward the Buddha with hands joined in adoration. The figure on the right appears to wear a crown and may represent Indra, the king of the gods; the other would then be Brahma. The exact function of the hole between the Buddha's feet is not clear.

—*P. P.*

78

Buddha Sakyamuni
India, Andhra Pradesh; 3rd century
Green marble
h: 26 in. (66 cm.)
The Brooklyn Museum,
Anonymous Loan

Although missing the head and right hand, this work remains a rare example of an Amaravati region seated Buddha image sculpted in the round. Most freestanding images of the Amaravati school show the Buddha standing. Moreover, rather than being a generalized image, this particular example symbolizes the Buddha's First Sermon, thereby relating the sculpture specifically to the life cycle. Stylistically, it is comparable to the type of Sinhalese Buddha image in which the folds of the robe are clearly indicated (no. 80). Aesthetically, however, this figure is much more solidly proportioned with heavy feet and hands; it conforms readily to Coomaraswamy's characterization of such early Buddhas from Andhra Pradesh and Sri Lanka as "primitive."

The left hand of the Buddha is placed, palm up, on his lap; the broken right hand must once have displayed the gesture of reassurance, as we have seen in the early Mathura Buddha (no. 75). The garments are strongly defined and add to the ponderous mass of the form. The throne on which the Buddha sits is divided into three shallow panels by simple columns. The central panel contains two seated gazelles that must symbolize the First Sermon in the Deer Park at Sarnath. On each of the two side panels, a couchant but naturalistically delineated lion is carved with its head turned toward the central panel. The lion is, of course, emblematic of sovereignty and of

Sakyamuni himself. One wonders, however, if, in placing the lions and the deer together, the artist did not also intend to signify the tranquil atmosphere of a hermitage where the two kinds of animals could coexist in harmony. Double entendres of this sort are not unusual in Indian art and literature.

—P. P.

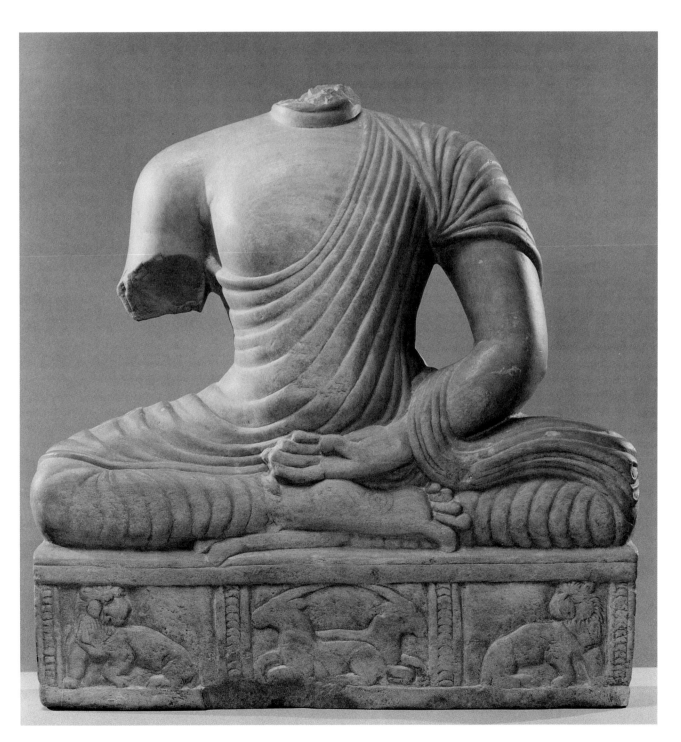

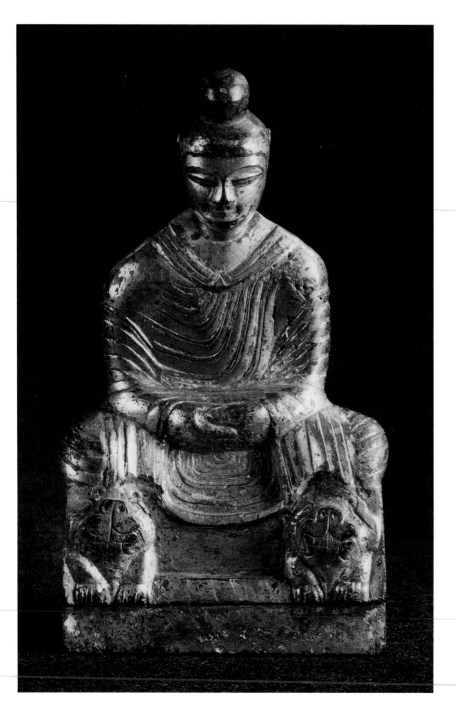

Meditating Buddha on Lion Throne
China; Six Dynasties, 4th century
Gilt bronze
h: 6¹/₁₆ in. (15.3 cm.)
M. Nitta Collection, Tokyo
(Shown in Los Angeles only)

Among the most popular representations of the Buddha during the early Six Dynasties period (265–581) of Chinese Buddhism were images showing Sakyamuni seated in the lotus position with his hands placed in his lap in the gesture of meditation. In sculpture, Sakyamuni appears seated on a lion throne, signifying his royal birth, as well as being emblematic of the Sakya clan. He is clad, however, in a monk's robe, indicating his renunciation of worldly pursuits. In such early representations, the Buddha's hair is characteristically short and the *ushnisha* appears as a pronounced topknot on his head; both of these features were strongly influenced by Indian representations.

The style of the clothing is based on Gandhara (nos. 76 and 77) and Central Asian prototypes, and the sense of bulky mass apparent in the treatment of the figure is characteristic of Indian sculptural traditions. The cascading pleats asymmetrically descending from the left shoulder and the twist in the scarf at the neck are derivative of Mathura-Gandhara images, knowledge of which was transmitted to China through Central Asia in models such as those discovered at Khotan. Otherwise, the iconography of this image is typical of a group of small seated Buddhas dating from the fourth and fifth centuries (Munsterberg, 1967, pls. 1 and 2; Matsubara, pls. 3–8).

Despite its diminutive size, the figure is powerfully modeled. The sculptural form suggests ponderous volume, while the delicate rendering of the face expressively conveys the serene and calm image of the meditating Buddha.

—J. B.

Buddha Sakyamuni
Sri Lanka, c. 5th century
Stone
h: 20¾ in. (52.7 cm.)
Anonymous

In the style of nearly all Sinhalese Buddha images, this example sits with one leg placed on top of the other *(paryankasana)* and both hands held in the lap in the gesture of meditation. The robe worn to expose the right shoulder, the upright body, low *ushnisha*, and forward-directed gaze (there appears to have been some recutting of the eyes) are also characteristic of images from Sri Lanka.

There are, however, several unusual features in this work, some of which point toward a fairly early date. It is interesting, for example, that the Buddha is not carved in the round but is essentially depicted in relief. The figure sits against a throne back that is only indicated by the upturned ends of the horizontal crossbar, carved on both the front and back of the stone slab. A blanket with corner tassles appears to be folded over the crossbar on the back of the relief. Behind the Buddha's head is a simple, unadorned halo. The form of the crossbar and the halo are reminiscent of those seen on second- to fourth-century relief carvings from Amaravati and Nagarjunakonda in India. This resemblance provides a clue to the date of the Sinhalese Buddha.

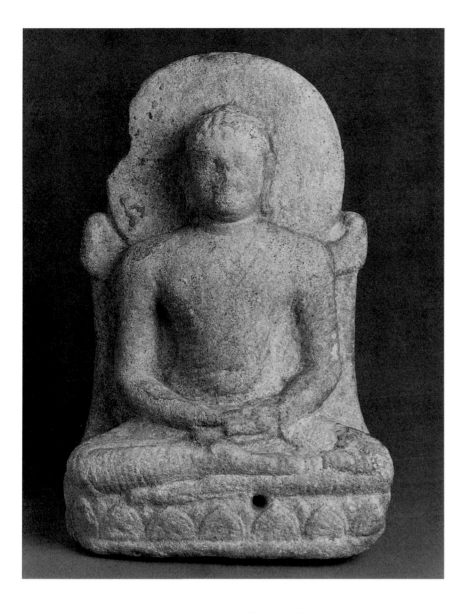

This relief, however, was not conceived for the same purpose as those from the two sites in Andhra. The Indian stone reliefs, often illustrating scenes from the Buddha's life, were used as casing slabs to face stupas and thus were usually carved on only one side. The practice of facing stupas with stone reliefs was not popular in Sri Lanka, where stupas were usually left plain. This Sinhalese Buddha relief is carved on both sides and thus was intended to be seen from both front and back in the same manner as the more common three-dimensional Sinhalese Buddha images (no. 89).

Yet other unusual characteristics of this Buddha are its proportions and modeling. The shoulders and expanse of the folded legs are somewhat narrower than is common among Sinhalese images, while the figure is fuller and the modeling softer, two features suggesting the possible influence of fifth-century Gupta art from north India.
—R. L. B.

81

Part of a *Portable Shrine with Buddha*
China, Karakhocho; c. 5th century
Wood
h: 14¼ in. (36.2 cm.)
Lent by The Metropolitan Museum of Art, Fletcher Fund, 1929

This small sculpture of the Buddha was once fitted with two wooden doors and served as a portable shrine for either a traveling monk or a family. It is said to have come from Karakhocho (Khocho) in Central Asia, but its origin is uncertain. Although it has been attributed to the Tang period (618–906) (Priest, p. 38), its style has much in common with sculptures dated to the fifth century. An earlier attribution is supported by stylistic analogies to: statues from Kizil, Khotan, and other Central Asian sites; the large, bronze standing Buddha, dated 477, in the collection of The Metropolitan Museum of Art, New York (no. 175); and Yungang sculptures of the first period, exemplified by Cave xx.

The svelte body revealed through closely clinging drapery derives from Gupta models. The "string" drapery lines, the Y-shaped folds at the shoulders, and the zigzagging fold edges below the arms, however, are Central Asian stylizations of Gandhara modes. The patterned curls of the Buddha's hair also originated in images from Gandhara, but the facial type is Central Asian. Both of the Buddha's hands are now missing, but the right hand probably displayed the gesture of reassurance. The *mandorla* and halo behind the Buddha are simplified into a dense field of radiating lines.

—*J. B.*

82

Head of the Buddha
India, Uttar Pradesh; 5th century
Red sandstone
h: 12 in. (30.5 cm.)
Los Angeles County Museum of Art, from the Nasli and Alice Heeramaneck Collection, Museum Associates Purchase
(Shown in Chicago only)

This life-size head was once part of a standing image of the Buddha from Mathura comparable to the one illustrated in no. 84. Characteristic of Mathura images, the face is full and fleshy. Slightly swollen cheeks and a prominent chin make the face appear puffed up. The subtle modeling of the half-shut eyes and the full, sensuous lips are noteworthy. The precisely articulated curls of the hair turn emphatically to the right, as is prescribed in the iconographic texts. The cranial bump is prominent, and the earlobes are elongated, but the *urna*, or dot, between the eyebrows is missing, as is characteristic of Gupta period (320–600) Buddhas from Mathura.

—*P. P.*

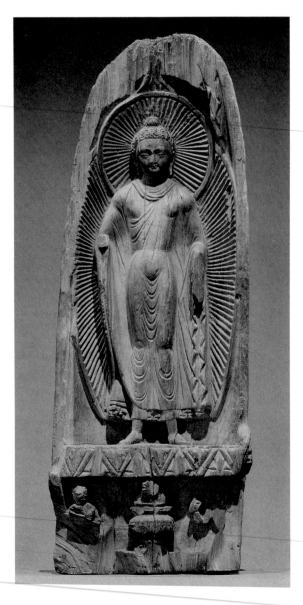

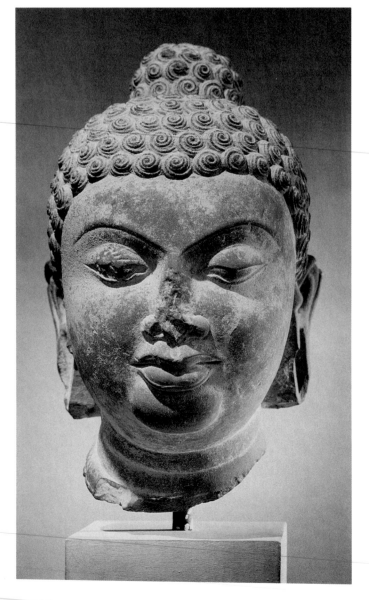

Buddha Sakyamuni
India, Uttar Pradesh; 5th century
Red sandstone
h: 32¼ in. (82 cm.)
The Cleveland Museum of Art, Purchase, Leonard C. Hanna Jr. Bequest
(Shown in Chicago only)

Although considerably damaged, this work remains a rare example of a freestanding sculpture from Mathura depicting the preaching Buddha. The original appearance of the head and face can be imagined by comparing this figure with other contemporary Mathura Buddhas included in the exhibition (see nos. 82 and 84). The hands were obviously poised in front of the chest performing the gesture of turning the Wheel of the Law. The Buddha is seated in the classical yogic posture on a cushion, but his feet and calves are raised somewhat unusually. The delicate edge of his upper garment falls below his legs in the shape of a garland. Two heraldic, rampant lions once adorned the sides of the throne, and the Buddha's halo was richly decorated with aquatic, vegetal, and geometric motifs.

When intact, the image probably looked much like the better-preserved stele from Sarnath (no. 51). It is unlikely, however, that this figure would have been accompanied by two bodhisattvas. Despite its condition, it is an unusually fine sculpture in which the artist has very deftly expressed the equipoise and serenity of a yogi in harmony with himself and his surroundings.

—P. P.

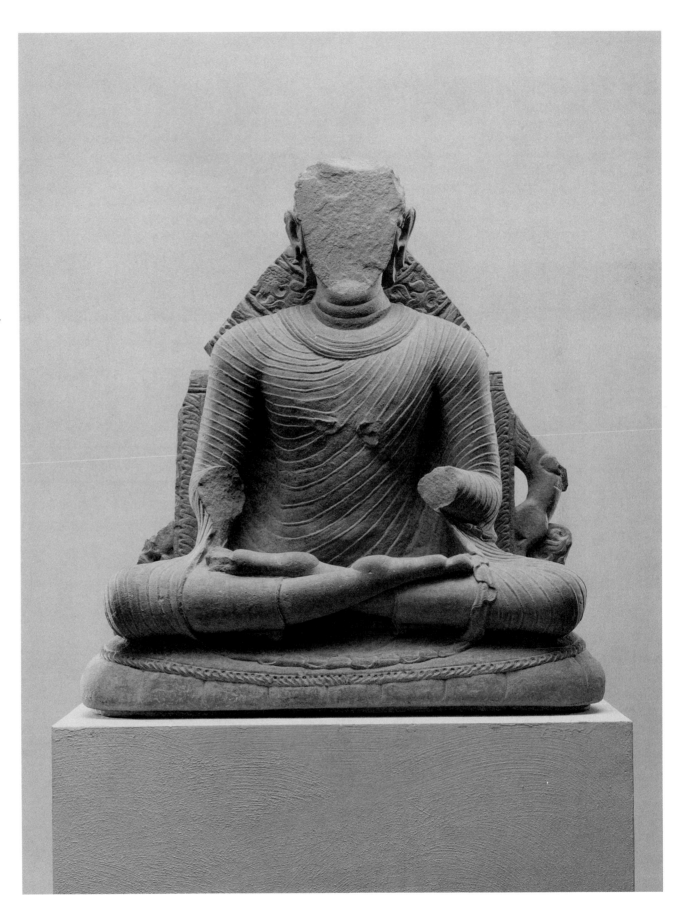

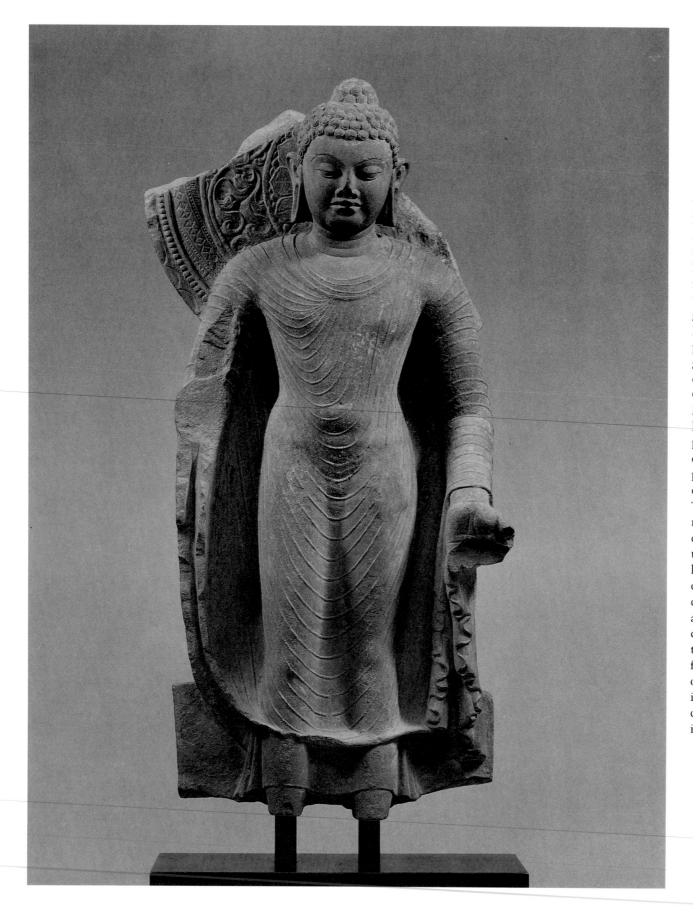

Buddha Sakyamuni
India, Uttar Pradesh; c. 500
Red sandstone
h: 33⅝ in. (85.4 cm.)
Lent by The Metropolitan Museum
of Art, Purchase, 1979, Enid A.
Haupt, Gift
(Shown in Los Angeles and Brooklyn
only)

This is an example of the classic
Buddha-image type developed in
Mathura during the Gupta period
(320–600). Most surviving Mathura
Buddha images represent a standing
figure, often well over life-size. As is
typical of these images, the upper
garment in this sculpture is articu-
lated with uniformly undulating
parallel lines reminiscent of a topo-
graphical map. This stylistic con-
cept was originated by the artists of
Gandhara (see nos. 76 and 77); the
Mathura adaptation, however, was
less naturalistic than the Gandhara
prototype. The unnatural elongation
of the legs, which are quite dis-
proportionate to the torso, is also
characteristic of Mathura Buddhas.
The right hand of such images is al-
most always broken, but it is appar-
ent that in this sculpture it formed
the gesture of reassurance. The left
hand characteristically holds the
end of the upper garment. A richly
carved halo decorated with vegetal
and geometric motifs in concentric
circles—which may be seen even in
this damaged example—always
frames the head. The scalloped edge
of the halo, a characteristic surviv-
ing from the Kushan period (1st–3rd
century), is a hallmark of Mathura
images (see no. 75).

—*P. P.*

Buddha Sakyamuni
North India, 6th century
Brass with traces of polychromy
h: 15½ in. (39.4 cm.)
Los Angeles County Museum of Art,
Gift of the Michael J. Connell
Foundation

This golden image elegantly combines the stylistic traits of Buddha images from Mathura with those of Sarnath. These two cities were important artistic centers in Gupta India (320–600), and they have given us some of the finest Buddha images ever created in stone. Despite their prodigious lithic output, however, neither Mathura nor Sarnath produced any known Gupta period bronze Buddhas.

The treatment of this Buddha's garment, with its prominently indicated folds, follows the Mathura mode. However, in its essential characteristics—the garment's transparency, the slim elegance of the body, and the facial features—the figure is more typical of Sarnath than Mathura. The traces of pigment on the face and particularly the indigo on the hair may indicate that this bronze was once preserved in a Tibetan monastery. After the destruction of monasteries in India in the twelfth century, many Indian bronzes found refuge in Tibetan and Nepali monasteries. Whatever its exact provenance, this sculpture remains one of the finest realizations of the ideal image of the Buddha created by the artists of Gupta India. Characteristic of the images of this period, no *urna* is delineated between the eyebrows, and the webbing of the fingers of the right hand is prominently indicated.

—*P. P.*

Buddha Sakyamuni
India, Tamilnadu; 5th–6th century
Bronze
h: 16 in. (40.6 cm.)
M. Nitta Collection, Tokyo

This is a fine example of a typical bronze Buddha from Tamilnadu, formerly an important Buddhist center on the southeastern seacoast of India. Buddhapad and Nagapattinam are two of the principal sites in this region where metal images have been discovered in large numbers. Bronzes from the Tamilnadu area were carried across the ocean to Southeast Asia and Sri Lanka. As a result, there was a lively exchange of religious and artistic ideas between these regions.

Although derived from earlier Amaravati style Buddha images (no. 78), the form here is less ponderous and weighty. The greater transparency of the drapery and the more linear definition of the outline probably reflect the influence of the Gupta style of northern India. However, the wide, square shoulders, the disproportionately large feet and hands, and the manner in which the drapery is thrown over the left arm reflect the continuance of earlier local traits. The shape of the head and the physiognomy are also characteristically Dravidian and distinctly regional.

—*P. P.*

Buddha Sakyamuni with Companions
China; Eastern Wei dynasty,
dated 536
Buff-gray limestone
h: 40¾ in. (103.5 cm.)
Museum Rietberg Zurich
(Von der Heydt Collection)

A long inscription on the back of this impressive stele informs us that it was dedicated in the year 536 by members of the Feng family, probably in Hopei Province in northeastern China (see Brinker and Fisher, p. 134). Sometime during the first quarter of the present century, it was acquired by Baron Von der Heydt, whose collection now forms part of the Museum Rietberg in Zurich.

Buddha Sakyamuni is represented sitting in a posture reflective of majestic grandeur with his right hand raised in the gesture of reassurance and his left in that of charity. His body is enveloped in robes, the hems of which form a beautiful cascading design across the throne. He is flanked by two monks, two adoring bodhisattvas, and two ferocious-looking guardians. The scowling monk above the Buddha's right shoulder may represent the elderly disciple Kasyapa, while the counterpart above his left shoulder is very likely Ananda, another disciple. The throne is supported by two menacing, stylized lions, and a dragon and a devotee embellish the remaining portion of the canopy above. When complete, this canopy would probably have been surmounted by intertwining dragons, a variety of other auspicious symbols, and perhaps flying celestials.

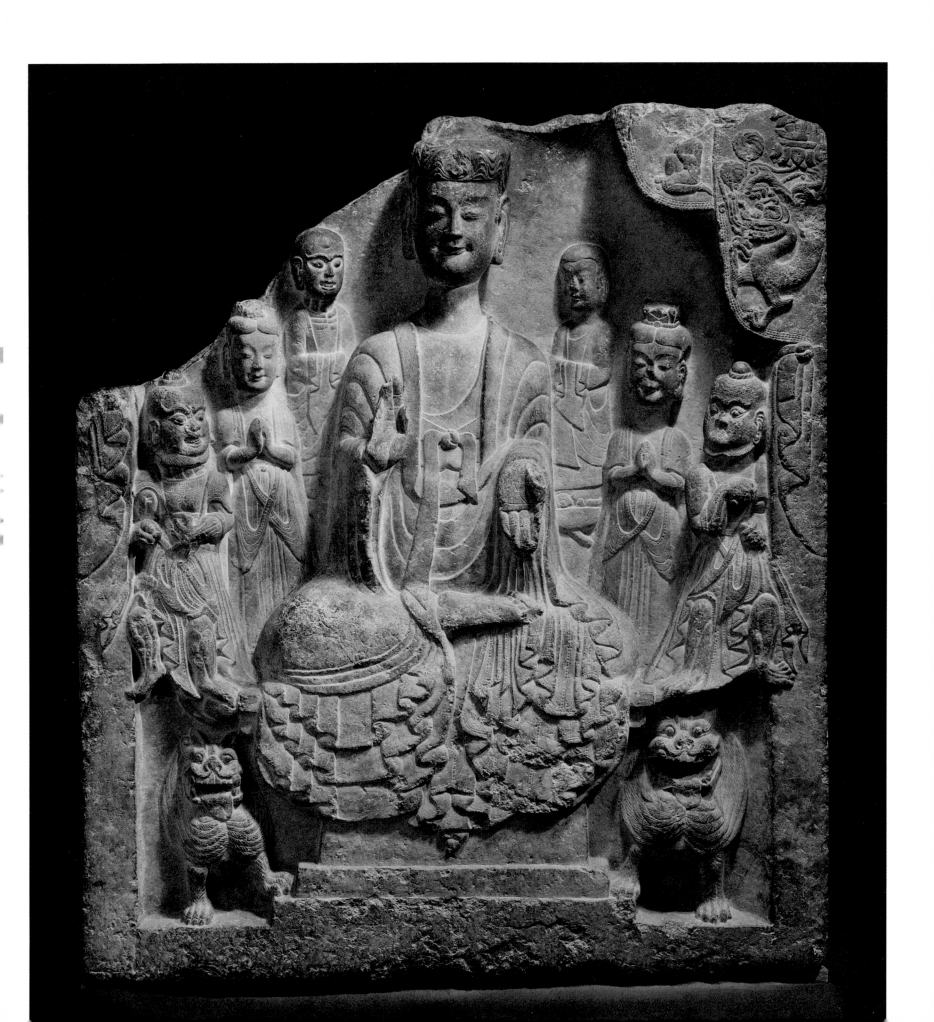

Two narrow panels on the sides of the relief depict landscapes with figures (a) and flowers (b). The hills in (a) are adorned with animals and trees. Above these sits a pensive figure with his left leg placed across his right and his head resting on his left hand. In front of him stands a dignified person dressed as an official. Although the pensive figure has been identified as Siddhartha, he may also represent the Future Buddha, Maitreya. (This image type originated in Gandhara and became fashionable in East Asia, particularly in Korea, where it was specifically employed to depict Maitreya.) This latter identification seems even more probable given the invocation of Maitreya in the dedicatory inscription. The most prominent motif above the mountainscape in panel (b) is the lotus flower, although a figure may have originally been seated at the apex.

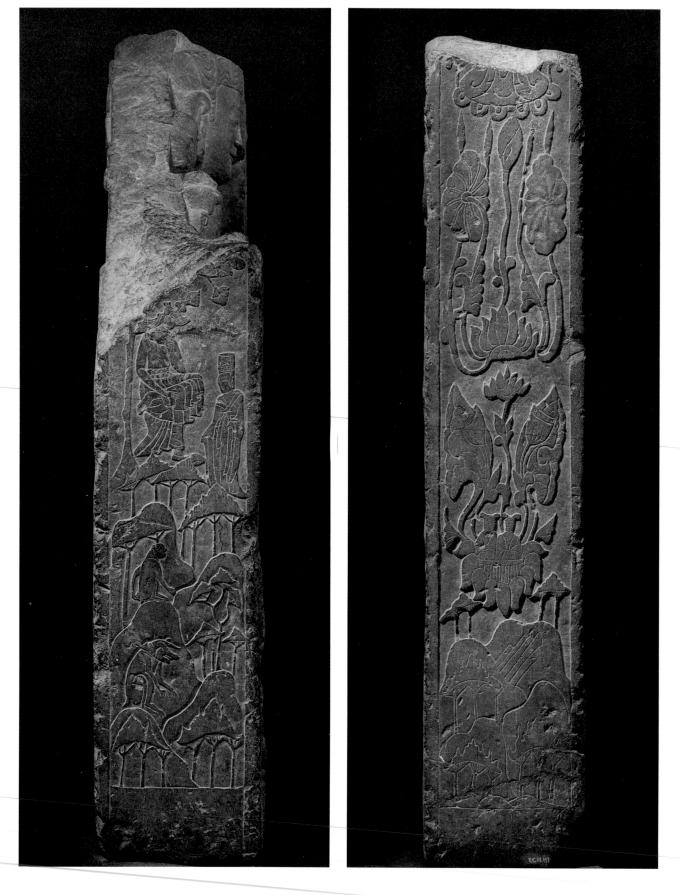

The greater portion of the back of the stele is taken up by the dedicatory inscription. Along the top, however, portrayed in shallow relief, is a theme especially popular in China during the fifth and sixth centuries that is rarely encountered in the other Buddhist traditions. The meditative figure in the middle, resembling a mummy below a pavilion, may be a monk. The figure seated on a platform holding a fly whisk in his left hand probably represents Vimalakirti, the hero of the text known as the *Vimalakirti-nirdesa*. Vimalakirti was a prosperous householder who held a debate or dialogue concerning the Buddhist faith with Manjusri, the Bodhisattva of Wisdom, whose figure would have been placed on the other side of the panel. The story of the conversion of a patriarchal householder appealed especially to the Confucian heritage of the Chinese.

The schematic arrangement of the figures on the front of the stele is offset not only by the two dramatic guardian figures and the amusingly animated lions but also by the busy treatment of the Buddha's garments. With his smiling countenance, the Buddha is a serenely elegant figure. As has been pointed out: "The milder, more softly curved treatment of the folds of the robes shows distinctive features of the Eastern Wei style as opposed to the harder, more sharply cut style of the Northern Wei" (Brinker and Fischer, p. 132).

—P. P.

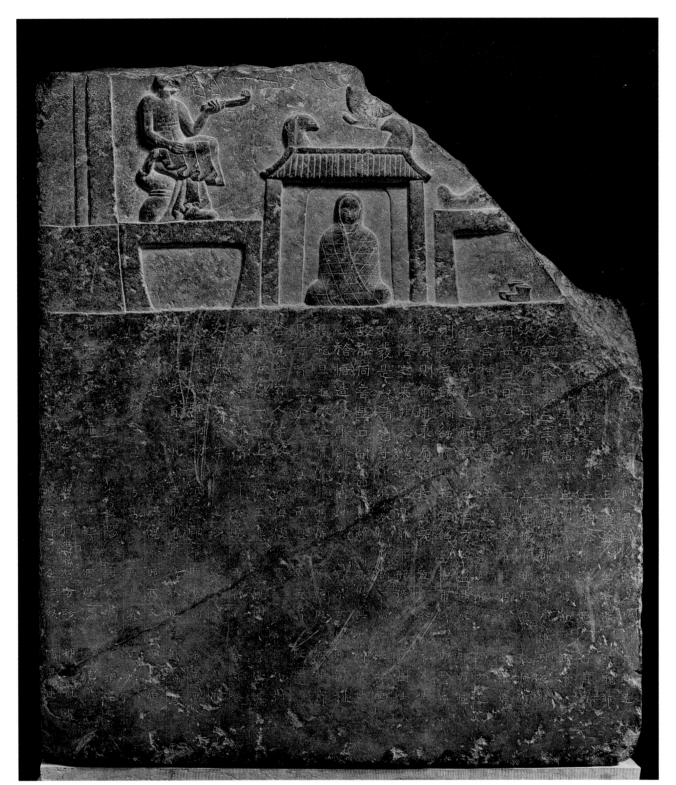

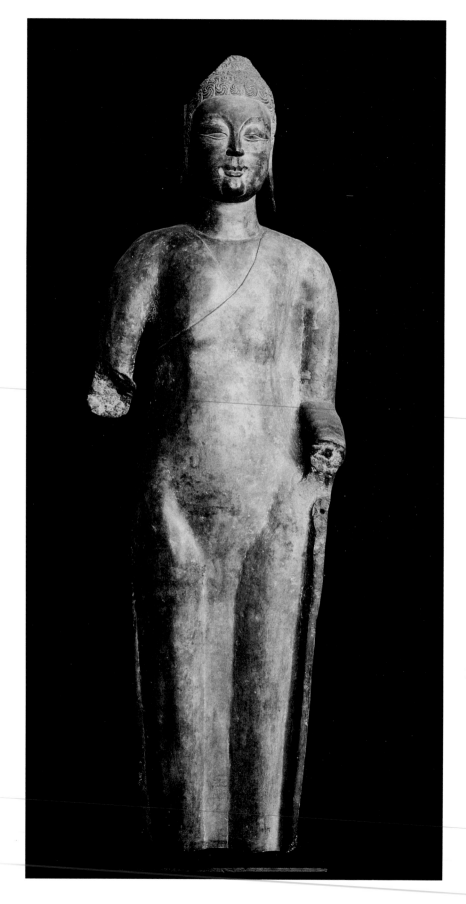

Buddha Sakyamuni
China, Sui dynasty (581–618)
Limestone
h: 50¼ in. (127.6 cm.)
Seattle Art Museum, Eugene Fuller
Memorial Collection

This limestone Buddha stands
pillarlike, erect, and frontal. The
sculpture's subtle outline and
smooth, cylindrical form are in
keeping with the Sui style. The art
of the Sui dynasty (581–618) em-
bodied the final stages of the North-
ern Zhou (557–89) and Northern
Qi (550–89) stylistic traditions,
which in turn marked a transition
between the linear style of late
Northern Wei (386–535) and the
naturalism characteristic of the
Tang period (618–906).

Indian Gupta styles of the fifth cen-
tury (see no. 3) began to influence
Chinese sculpture during the Sui
period, and the Seattle Buddha
appears to be a Chinese adaptation
of the Gupta Sarnath style. This is
apparent in the diaphanous, sheath-
like robe, devoid of folds, that clings
to the Buddha's body. The spheroidal
head attached to a cylindrical neck
displays the austerity and abstrac-
tion characteristic of Sui sculpture.
The bold simplicity of the body con-
veys a sense of power and some of
the heroic grandeur often found in
the period's early sculpture. The
swell of the chest and abdomen and
the slight protrusion of the knees,
however, indicate an incipient inter-
est in anatomy that is a harbinger of
the intense fascination with natural-
ism that characterizes Tang sculp-
ture after 640.

—*G. K.*

Buddha Sakyamuni
Sri Lanka, 6th–7th century
Stone
h: 29½ in. (74.9 cm.)
Anonymous

Although this Buddha image is
weathered and much of its detail is
now lost, it produces an impression
of power and nobility that is typical
of the best Anuradhapura period (3rd
century B.C.–10th century A.D.)
icons. Its stately presence is due
largely to the way in which the body
is held. The torso and head are kept
absolutely upright. At the same
time, the chest is expanded and the
back is slightly concave, adding a
sense of taut strength and impend-
ing animation that keeps the figure
from appearing rigid.

This posture is a very accurate repre-
sentation of the yogic posture in
which Sakyamuni or any Buddhist
monk would typically sit in medita-
tion. The legs are folded one on top
of the other, and the hands are held
in the lap. The expanse of the chest
and dilation of the diaphragm indi-
cate the yogic practice of breath
control.

As previously mentioned, the rather
abraded condition of the stone in
this image has destroyed many
carved details. Such weathering is
common on Sinhalese stone sculp-
ture, as much of it has been exposed
for long periods to the heavy mon-
soon rains. One interesting detail
that remains is the edge of the robe
that runs directly down the center of
the Buddha's back. It appears as if
the Buddha has thrown the end of
his robe over his left shoulder, allow-
ing it to fall freely down his back.
This characteristic corresponds pre-
cisely to the way the robe is repre-
sented on standing Buddhas of the
period.

The hair, which is formed in the shape of a cap, without any indication of the usual curls, is also interesting. While this treatment of the hair is extremely rare, it does occur on one well-known Buddha image from Mankuwar in India that dates to 429. It occurs, as well, on several images in the *vatadage* (temple) at Polonnaruwa in Sri Lanka that date to around the twelfth century. This style of hair has not been satisfactorily explained; it has been suggested, however, that it represents either an actual cap or is merely an unfinished section of these sculptures. Perhaps the simplest and most obvious explanation is that it depicts the Buddha immediately after the cutting of his hair. In so doing, it reflects the universal practice of monks who shave their heads and not the mythical version of Siddhartha cutting his hair after the great departure (see no. 38).

—*R. L. B.*

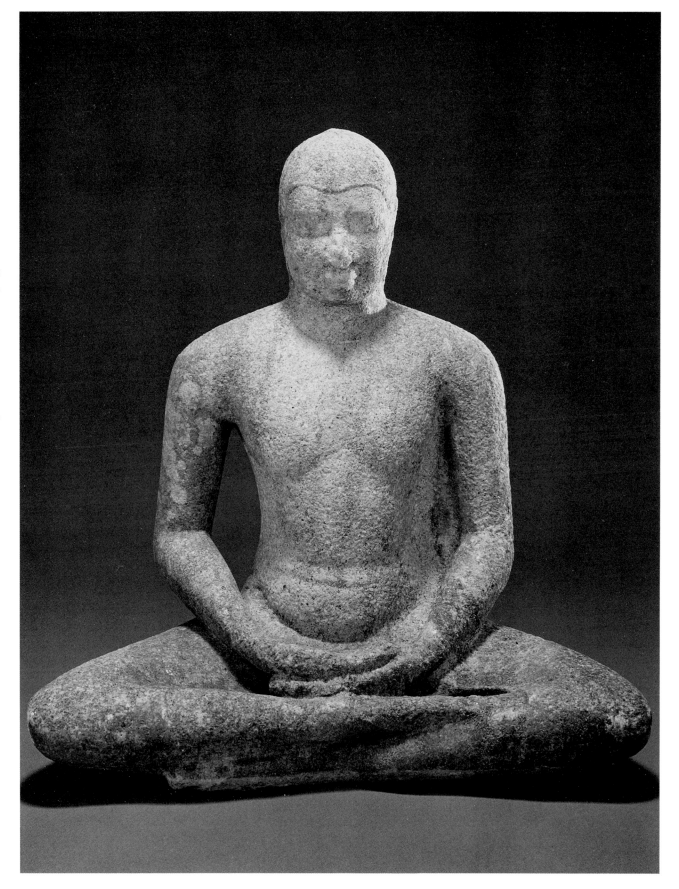

90

Buddha Sakyamuni
Korea; Three Kingdoms period,
7th century
Stone
h: 4¾ in. (12.1 cm.)
Private Collection, Tokyo

This small stone sculpture was crea-
ted during the Three Kingdoms
period (c. 1st century–668), a forma-
tive stage in the development of Ko-
rean Buddhist art. The serene face
and the voluminous drapery, which
nearly covers the entire figure, are
similar in style to features observed
on the few other small stone images
that have been found in the Paekche
region in southwestern Korea. Un-
like the others, however, the hands
of this example rest palms up upon
its crossed legs. This gesture of
meditation is usually rendered dif-
ferently in comparable early Korean
figures. Instead of showing the
palms facing up, other examples fol-
low the earliest Chinese models and
depict the hands held against the
abdomen with the palms facing the
body (see no. 79). The gesture seen
here is the orthodox version of
dhyanamudra, which is found
among images from India. This
arrangement of the hands, along
with the gentle expression, overly
large head, and expressive calm,
marks this as one of the finest of the
early Sakyamuni images from Korea.

—R. E. F.

91

Buddha Sakyamuni
Korea; Three Kingdoms period,
7th century
Gilt bronze
h: 10⁷⁄₁₆ in. (26.5 cm.)
M. Nitta Collection, Tokyo
(Shown in Los Angeles only)

Early Korean versions of the Buddha
image are highly derivative of other
traditions, particularly those of
northern and southern China. In
fact, most early Korean representa-
tions agree so closely with their
sources that at times it is difficult to
determine any differences. This su-
perb bronze, although derived from
Chinese prototypes, displays native
Korean features, as well as tradi-
tional Chinese elements associated
with portrayals of Sakyamuni. The
handling of the robe, gestures of the
hands, and smooth treatment of the
head are all typical of Chinese im-
ages of the sixth and early seventh
centuries. Specifically Korean traits
are the youthful face, overly large
head and hands, and the sturdiness
of the figure.

There remains considerable stylistic
variety among Korean images attrib-
uted to the Three Kingdoms period
(c. 1st century–668). Due to chance
finds and the infrequent appearance
of inscriptions, it hasn't been possi-
ble to group these works by regional
styles. This standing figure, how-
ever, has much in common with
known Paekche works from south-
western Korea, including a late
sixth-century seated soapstone im-
age (Kim and Lee, fig. 37). Several
similar images are known, and
together they may represent a sixth-
to seventh-century style that was ul-
timately absorbed by the Silla King-
dom in the late seventh century. As
mentioned above, this image reflects
many traits of a Korean type at the
earliest stage of its development.
Some of these Korean features were
borrowed by Japan, where many
Hakuho era (646–710) images were
based upon this type of Korean
model. The illustrated example
clearly indicates how close the
styles of Korea and Japan had
become by the seventh century and
thus how much the Japanese had
been influenced by Korean Buddhist
art.

—R. E. F.

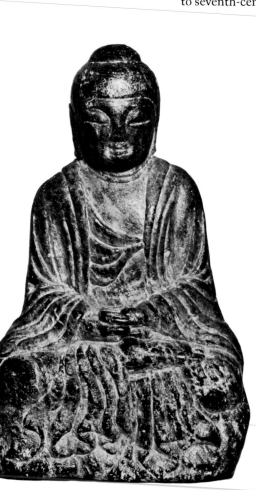

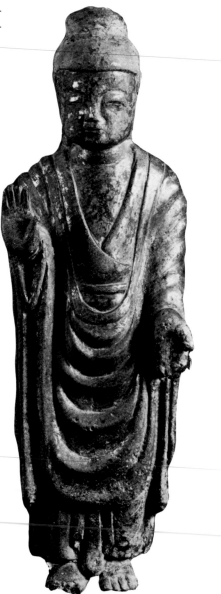

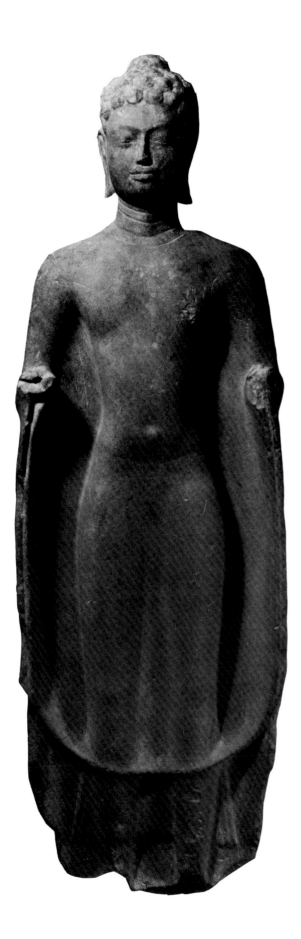

92

Buddha Sakyamuni
Cambodia, 7th century
Stone
h: 38 in. (96.5 cm.)
Private Collection

This fine example of an early
Cambodian Buddha is distinguished
by a slim, long body that is subtly
modeled in simplified volumes.
Both hands were once raised to
elbow height, but as they are now
missing, it is difficult to be certain
about their original gestures. It is
probable that the right hand would
have assumed the gesture of teach-
ing *(vitarkamudra)*; interestingly,
this hand was attached to the sculp-
ture with a metal pin, a practice fre-
quently observed in Dvaravati im-
ages from ancient Thailand.

Even a cursory comparison with the
Rockefeller Dvaravati Buddha (no.
102a) will reveal how closely related
the two Buddhas are in certain
respects. The treatment of the form
of the body and the depiction of the
drapery are strikingly similar. In
fact, if the head of the Cambodian
Buddha were missing, it is likely
that one would attribute it to
Dvaravati in Thailand.

The characteristics of the head and
the facial expressions of the two
sculptures are, however, quite dif-
ferent. The expression of the
Cambodian Buddha displays a much
more human quality than the
Dvaravati image. A sweetly and re-
alistically rendered countenance,
such as that characterizing the
Cambodian Buddha, is rarely found
in Dvaravati art; it is shared, how-
ever, by the relatively small group of
pre-Angkorian (before 802) Cambo-
dian Buddha images. This group of
Buddha images also shares with the
illustrated image such specific
stylistic and iconographic traits as
large hair curls, a low cranial bump,
small narrow eyes with inscribed
irises, the absence of the *urna*, and a
smile formed by the upturned cor-
ners of the upper lip. As mentioned
in the essay on the Buddha image in
Sri Lanka and Southeast Asia, most
of these traits are representative of a
style of image that appeared around
the sixth century in widely sepa-
rated areas of mainland Southeast
Asia. These various relationships
underscore an important point,
already established in this cata-
logue: that early indigenous South-
east Asian Buddha images have
much more in common with each
other than they do with any Indian
prototypes.

—R. L. B.

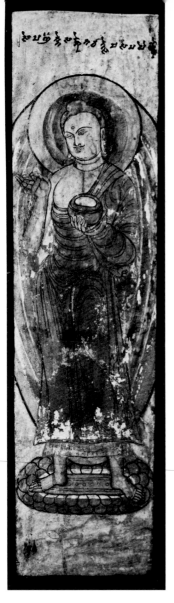

93

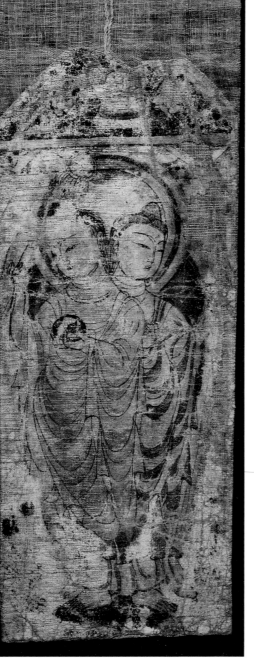

94

93

Sanketava (Tocharian ? active 7th century)
Buddha Sakyamuni; China, Kizil, Cave above the Cave of the Coffered Ceiling; 7th century
Painting on wood
18⅞ × 3¹⁵⁄₁₆ in. (48 × 10 cm.)
Staatliche Museen Preussischer Kulturbesitz, Museum für Indische Kunst, Berlin

This painting of a standing Buddha is one of several painted wooden panels that were made by pilgrims as votive offerings. These paintings were found in the caves at Kizil in the Xinjiang Autonomous Region (Hartel et al., p. 107, no. 39), and they share a number of stylistic and iconographic traits (Bhattacharya, nos. 11–18).

The illustrated figure possesses many of the characteristic attributes of the Buddha and ultimately derives from Gandhara images. Sakyamuni holds a monk's alms bowl in his left hand, and webbing appears between the fingers of his right hand—one of the thirty-two auspicious signs of a *chakravartin* (universal monarch). His right palm, facing outward, is held in the teaching gesture *(vitarkamudra)*. The double-lined folds of the drapery, which also appear on other panel paintings from Kizil, are a stylization of the string-fold drapery seen in Gandhara sculptures.

The Buddha stands on a lotus pedestal before a *mandorla* that surrounds his entire body; a nimbus encircles his head. This double *mandorla* is a common feature in early Buddhist art from East Asia and may have been inspired by the colossal aureoled figures associated with solar deities that have been found in Central Asian cave temples (S. E. Lee, 1982, p. 33).

An inscription in Tocharian, written across the top, reads, "This Buddha was painted by the hands of Sanketava" (Hartel et al., p. 107, no. 39).
—*J. B.*

[Sanketava may have been a Tocharian monk. Many examples of Central Asian paintings are signed by artists who were also monks.—*P. P.*]

Double Image of the Buddha
China, Khocho; 7th–8th century
Painting on ramie
20½ × 7½ in. (52 × 19 cm.)
Staatliche Museen Preussischer
Kulturbesitz, Museum für Indische
Kunst, Berlin

The subject of this temple banner is a miracle performed by the Buddha in honor of two pious but impoverished pilgrims. As recounted by Xuan Zang [Hsuan Tsang] (c. 596–664), the famous Chinese monk, both pilgrims desired a painting of the Buddha. After paying the artist, however, they were dismayed to learn that their money was only sufficient to commission a single painting. At this point, the compassionate Buddha interceded and doubled his own image within the painting.

Painted on ramie, a fibrous textile, one Buddha is shown standing slightly behind the other, although they share a common pair of feet. They are surrounded by a single *mandorla*, or aureole, and nimbus. The figure on the left holds an alms bowl to his chest, raises his right arm, and looks down toward a woman worshiping at his feet; this Uighurian woman is barely discernable in the badly deteriorated portion of the painting. Folds in the Buddha's garments are emphasized by brown symmetrical shading, a stylization reminiscent of Western chiaroscuro that is especially apparent in the right-hand figure.

In Eastern Turkestan, under the influence of the Chinese emperor Taizong [T'ai-tsung] (r. 616–49), a great number of such temple banners were produced in monastery workshops. It was believed that when a banner was purchased as an offering and inscribed with an appropriate dedication, the donor or his relatives would be blessed with wealth and longevity and be assured of entry into paradise.

—G. K.

Sakyamuni
Japan; Early Nara period,
late 7th century
Bronze with traces of gilding
h: 8⅜ in. (21.3 cm.)
Nelson Gallery—Atkins Museum,
Kansas City, Missouri (Nelson Fund)

Reflecting the influence of Mahayana Buddhism, which was first introduced to Japan in the sixth century, images of Sakyamuni and Bhaishajyaguru, the Healing Buddha, were among the first to appear in Japanese Buddhist sculpture. Most of this early sculpture was bronze, which accounts for the large number of surviving images. In addi-

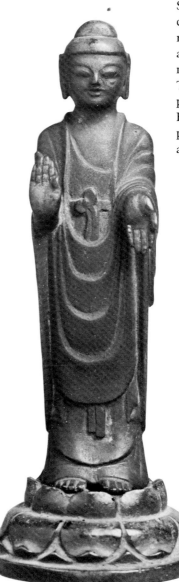

tion to single figures and cast plaques, clay images and paintings of scenes from the Buddha's life were also created during the Nara period (646–794), although few survive. To a certain extent, this late seventh-century image of Sakyamuni reflects Tang dynasty (618–906) iconographic concerns that had been introduced to Japan from Silla dynasty (668–935) Korea. Sculptured images such as the Kansas City Buddha are not, however, entirely dependent on Korean and Chinese Buddhist art, but represent instead a period of technical experimentation in Buddhist sculpture when bronze casting met with the need for monumental images and new techniques were created. Although the illustrated image of Sakyamuni has traditionally been considered a Nara period bronze, the rendering of the drapery and the appearance of Sakyamuni's feet beneath his robe suggest a later dating. This slender standing Buddha displays a gesture signifying exposition. His youthful face and rigid, frontal pose combine to create an expressive and idealized image.

—A. G. P.

96

Head of the Buddha
Java, 7th–8th century
Terracotta
h: 9 in. (22.9 cm.)
Paul F. Walter

This beautiful relief shows the head of the Buddha surrounded by a simple circular band and rich vegetal decoration. The band is similar to the three-dimensional halos seen on Central Javanese period (778–930) bronze images (cf. no. 157). A Central Javanese period date for the Walter relief is supported as well by the style of the Buddha's face. A puzzle arises, however, in that the material used—terracotta—is very rare in Central Javanese art, being almost exclusively limited to the Eastern Javanese period (10th–16th century).

This head is said to have been found in the remains of a brick temple at a site on the edge of the Dieng Plateau. The early date (8th century) of the well-known stone Dieng temples, coupled with the popularity of brick temples with terracotta decoration in Gupta India (320–600)—which one might expect to be reflected in early Javanese art—could suggest the existence of early brick temples with terracotta decorations in Java.

The arrangement of the hair on this Buddha is also quite unusual. The curls themselves are very large and three dimensional, but the cranial bump is unusually low. Particularly surprising is the striated band that adorns the forehead at the hairline. A similar striated band, representing strands of hair, frequently occurs on both Indian and Southeast Asian bodhisattva images. In the case of the Buddha, however, it has no functional significance.

It is difficult, without comparative material, to determine either the exact date or significance of this interesting small head. We can only speculate that it may have originally been part of a Buddha image that adorned a brick and terracotta temple. Both in terms of style and material used, it introduces us to a distinctive type of Javanese Buddha image.

—*R. L. B.*

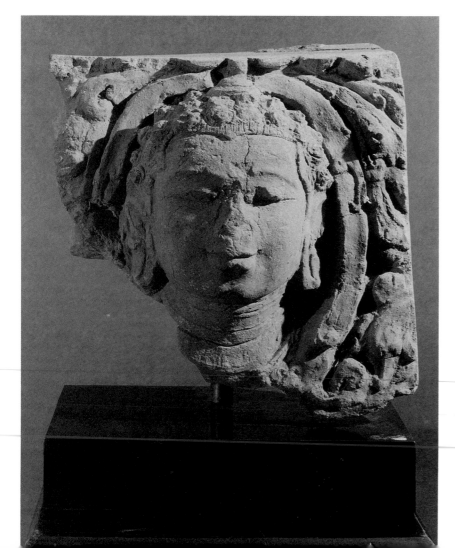

Buddha Sakyamuni
China, Tang dynasty (618–906)
White marble with traces of
polychromy
h: 30 in. (76.2 cm.)
Henry and Ruth Trubner Collection,
on Loan to Los Angeles County
Museum of Art

In this classic Tang dynasty image, the Buddha sits in the yogic posture atop an octagonal pedestal covered with a cloth. His right hand, now missing, was once attached to the arm with a dowel. The left hand rests on his left thigh. The Buddha's head and the rather large cranial bump are covered with swirls of hair rather than the small curls that are more characteristic of Indian images. These pinwheel-like swirls may simply be an affectation, or they may represent radiating light. The *urna*, which often appears on the Buddha's forehead, is absent in this sculpture.

The octagonal base of the pedestal is decorated with large, highly stylized lotus petals. The shaft, also in the shape of an octagon, is left plain. There is little doubt that the base represents the eight directions and symbolizes the celestial Mount Meru, the cosmic pillar or axis. These associations make it clear that Buddha Sakyamuni is presented here as a cosmic being. Although the missing right hand would have assumed the gesture of reassurance, Chinese images of this type symbolize the preaching Buddha, as is clear from the contemporary plaque (no. 167).

The date of this sculpture can be precisely determined by comparing it with a similar example in the collection of The Brooklyn Museum that was dedicated in the year 717. Stylistically, it also resembles The Art Institute of Chicago's inscribed Maitreya (no. 177). Both sculptures are fine examples of a style, developed in Tang dynasty China, that has been characterized as "international." This style was certainly much more naturalistic than earlier Chinese styles, which emphasized more austere and linear formal elements. Perhaps in light of the increased cosmopolitanism of the period, Tang sculptors became more aware of the importance of modeled form in sculpture and as a result, Buddha images of the period are much more sensuously modeled than their predecessors.

—*P. P.*

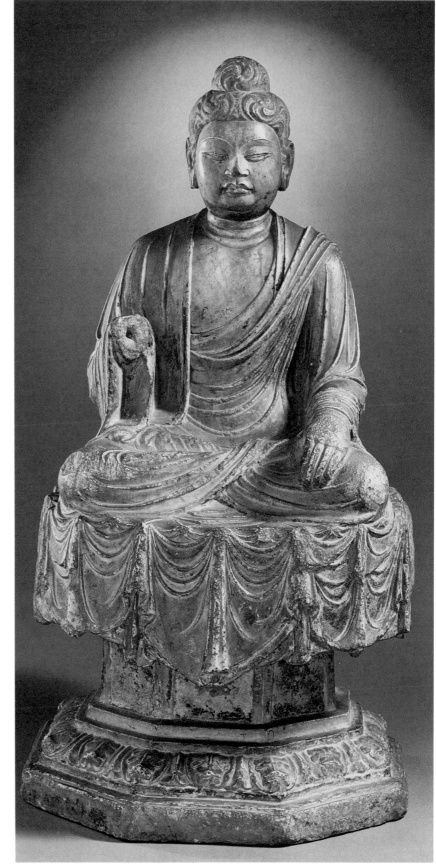

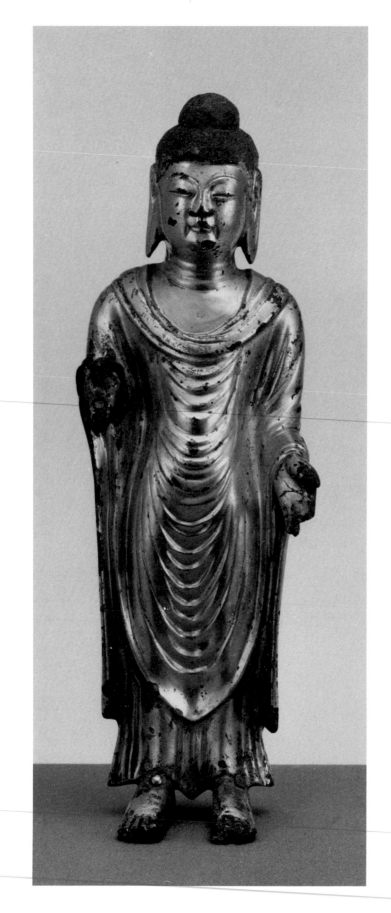

Buddha Sakyamuni
Korea; Unified Silla dynasty,
8th century
Gilt bronze
h: 8⅛ in. (20.6 cm.)
Seoul National Museum, Kim Don-
won Collection

Even without its pedestal, this richly
gilded image projects an aura of regal
confidence appropriate to the Uni-
fied Silla dynasty (668–935), an
epoch during which some of Korea's
finest Buddhist art was created. Stat-
ues of this quality were produced
throughout East Asia during the
eighth century—Buddhism's great-
est moment in East Asia in terms of
broad popularity and vigorous artis-
tic production.

In its hand gestures—a popular vari-
ation of the teaching gesture
(vitarkamudra) in which the thumb
touches either the second or third
finger—and its overly large head,
this image is typically Korean. The
drapery falls down the front of the
image in rhythmic folds, ending in a
graceful point that reflects the curve
across the chest and corresponds to
the soft lines about the arms.
Cascading drapery folds of this sort
are a variation of those used on the
Udayana image type. The Udayana
image was supposedly the first ever
made of Sakyamuni; according to
legend, it was created during his life-
time (see nos. 118 and 175). Copies
were supposedly made from this ini-
tial sculpture, which were observed
by Chinese pilgrims, such as Fa Xian
[Fa Hsien] in 400 and Xuan Zang
[Hsuan Tsang] in 664. A wooden im-
age of this type, datable to the tenth
century, exists in Japan at Seiryoji in
Kyoto. Once the Udayana formula
was established, countless versions
were produced. Here the prescrip-
tion is handled with grace and ele-
gance, resulting in a superb version
of the earliest known and most
auspicious representation of the
Buddha Sakyamuni.

Buddha Sakyamuni
Burma, 7th–8th century
Limestone
h: 16 in. (41 cm.)
Denison University Gallery

This is perhaps the earliest South-
east Asian Buddha image in the exhi-
bition. It is thought to be from
Burma and is made of a type of lime-
stone found near old Prome (see Bai-
ley), an area associated with the
ancient Pyu Kingdom (c. 5th–9th
century). The Buddha sits with one
leg on top of the other and holds his
large, carefully modeled hands in his
lap in the gesture of meditation. His
absolutely smooth robe covers one
shoulder, its hems signified by sim-
ple incisions. The statue has open
staring eyes and large broad lips; the
corners of the upper lip turn slightly
upward, producing a rather peculiar
smile. The hair is arranged in large
flat curls, and there is little em-
phasis on the cranial bump.

This description identifies the image
as one of a group of stone Buddhas
that have been found in various loca-
tions in mainland Southeast Asia,
including Peninsular Thailand
(Chaiya and Sathing Pra districts)
and Cambodia (see, for example,
Krairiksh, n.d., pls. 17 and 19; and
Snellgrove, pl. 117). Only in its base
does the Denison University Buddha
differ significantly from others in
this group. The Denison sculpture
has a plain round pedestal, while the
others have the so-called double lo-
tus carved on the base. It is likely,
however, that either the Denison
Buddha's base was left unfinished or
that, at one time, it was painted with
the lotus design.

—*R. E. F.*

The source for this early indigenous Southeast Asian style of Buddha image must be, as mentioned in the essay on this region, either south India or Sri Lanka. A comparison of the Denison statue with the three Anuradhapura period (3rd century B.C.–10th century A.D.) images from Sri Lanka (nos. 80, 89, and 101) reveals a number of similarities, including the position of the legs and hands, the frontal stare, the low cranial bump, and the large modeled hands. If the Anuradhapura style images are not the sources for the Southeast Asian type represented by the Denison Buddha, both the Sinhalese and Southeast Asian examples must have developed from a mutual Indian prototype.

—R. L. B.

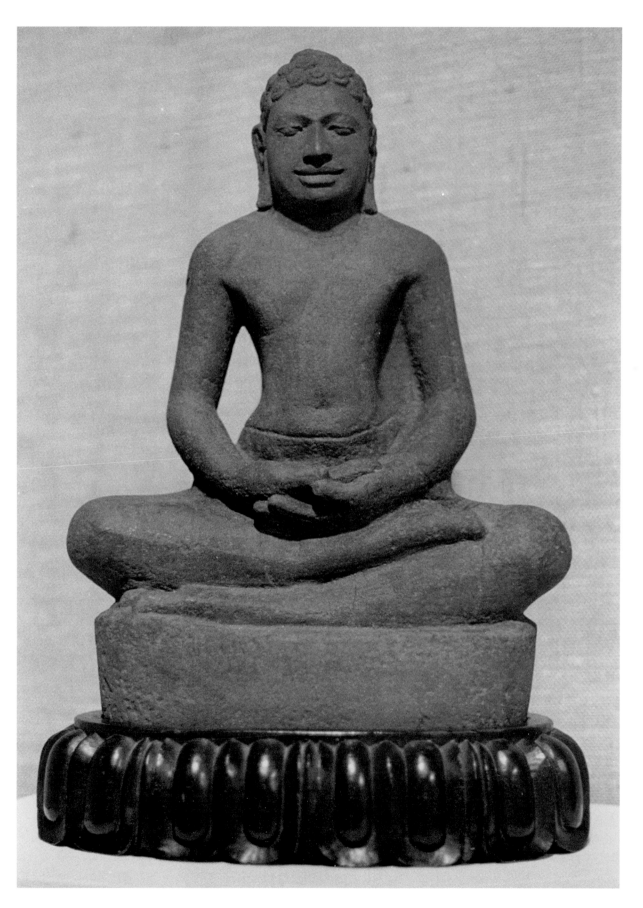

Buddha Sakyamuni
Thailand, 8th century
Terracotta
h: 17¾ in. (45 cm.)
National Museum, Bangkok

This terracotta Dvaravati style Buddha is one of a number of almost identical images, apparently made from the same mold, that were found at U Thong in central Thailand. Each of these images is iconographically unusual in that the left arm and leg are placed on top of the right. This may have been an intentional deviation, or it may possibly have been due to the failure of the artist to allow for the reversal of the image that occurs when a mold is used. The left leg placed over the right may be seen in other Buddha images from Dvaravati and elsewhere in Asia (see Pal, 1983). The left hand covering the right, however, is much more unusual and suggests that in this case the reversal was probably due to the use of the mold. The flat, triangular shape of the lap is also probably the result of using a mold, which the artist, for technical reasons, would wish to keep as shallow as possible to avoid any great extension in depth. Interestingly, this characteristic became a stylistic feature, used at times by Dvaravati artists when casting bronze images.

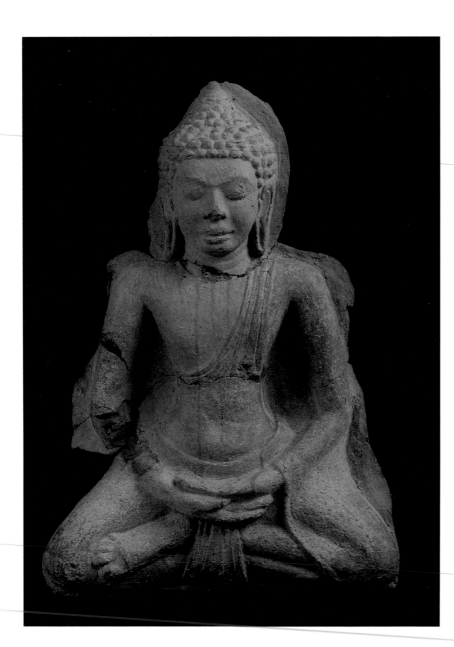

These U Thong terracotta Buddhas were found in the ruins of a monastery *(vihara)*. Unfortunately, the building was too badly destroyed to be able to determine the original location of the Buddha images. It is likely, however, that they were placed in niches on the outside of the brick structure. In Dvaravati, where Theravada Buddhism predominated, these meditating Buddhas would represent Sakyamuni at Bodhgaya during his Enlightenment. One may well imagine the Buddhas set in niches decorated with the *bodhi* tree painted on plaster or modeled in stucco relief. The Buddha images themselves were almost certainly painted, as some retain traces of polychromy. The image of Buddha Sakyamuni seated in meditation would have been highly appropriate for the decoration of a monastery where monks resided and practiced meditation as they worked toward their own enlightenment.

—*R. L. B.*

101

Buddha Sakyamuni
Sri Lanka, 8th century
Bronze
h: 11 in. (28 cm.)
Los Angeles County Museum of Art,
Purchased with Funds Provided by
Alice Heeramaneck and Museum
Acquisition Fund

This bronze Buddha image, like the two stone images from Sri Lanka (nos. 80 and 89), sits in meditation; it also shares their erect posture and forward stare. In dating the bronze image, however, we are on much more solid ground than in dating the earlier stone examples, as the form of the drapery folds and other details of the robe indicate an eighth-century date.

Most Sinhalese bronzes of this period are fairly small. This image is among the larger examples, and it is an icon that has long been worshiped, as indicated by the recutting around the eyes and the front area of the hair. Such reworking is necessitated by the practice of rubbing images during worship. The seventh-century Chinese pilgrim Yijing [I-ching] has left us an invaluable discussion of the way in which the Buddha image was worshiped in India, which is applicable to Sinhalese practice as well. Customarily, the image was placed in a basin while perfumed water was poured over it. The scent is prepared as follows:
> take any perfume-tree, such as
> sandal-wood or aloes-wood, and
> grind it with water on a flat
> stone until it becomes muddy,
> then anoint the image with it
> and next wash it with water.
> After having been washed, it is
> wiped with a clean white cloth.

Yijing further states that:
> in individual apartments...of a
> monastery, priests bathe an im-
> age every day so carefully that
> no ceremony is omitted.
> (I-tsing, p. 149).

The daily bathing of an image with scented water would eventually wear away its features, but metal images underwent an additional and even more abrasive process. Yijing recommended that in order to keep them shiny, such images should be polished regularly with ash or brick powder (I-tsing, p. 150).

The long use of this Sinhalese image and the reverence in which it was held are also indicated by two features that were added at a later date. One of these details is the hooklike *urna* attached to the hairline at the center of the forehead. While Sinhalese Buddhas do not usually have *urnas*, this particular hook form appears frequently on Buddhas from the south Indian site of Naga-pattinam, showing a connection between the Sinhalese image and south India. The bronze may have been owned by a south Indian Buddhist living in Sri Lanka. The second added feature is the large lyrelike symbol placed on the top of the Buddha's head (cf. no. 65). It was common practice in Sri Lanka to update images with such attachments, which represent a flame and thus Buddha's fiery energy *(tejas)*.

These later additions to the bronze Buddha do not detract from the image's original grandeur, which is accentuated by the extremely broad shoulders, narrow waist, and elongated torso. Although the bronze is much smaller than the earlier stone images, it expresses the monumental and majestic quality that is observable in Sinhalese Buddhas regardless of their size.

—R. L. B.

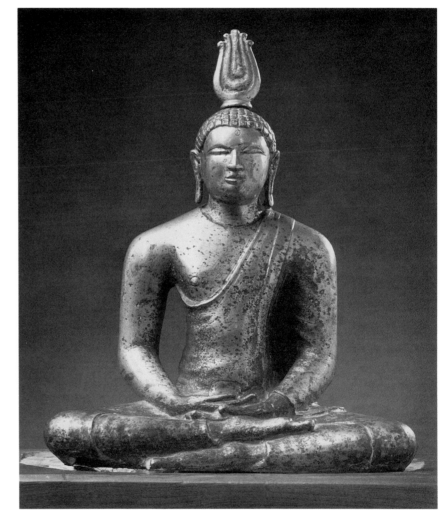

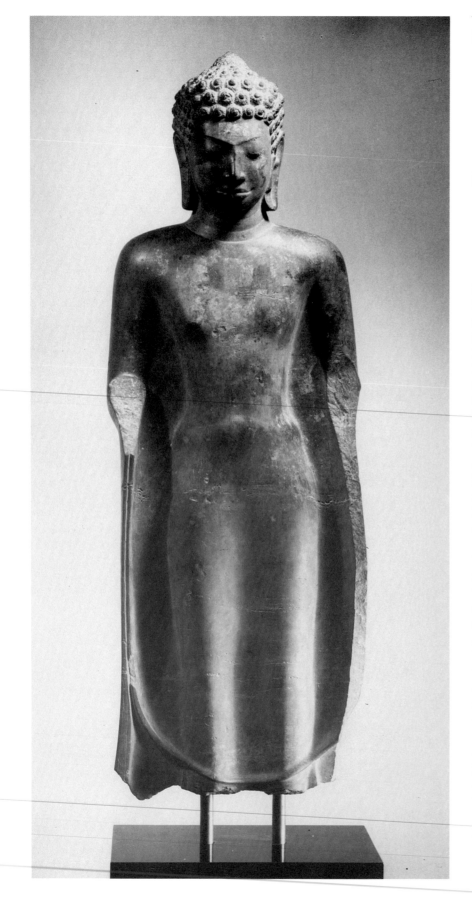

(a) *Buddha Sakyamuni*
Thailand, 8th century
Gray limestone with traces of gilding
h: 36½ in. (92.7 cm.)
The Asia Society, New York:
Mr. and Mrs. John D. Rockefeller 3rd Collection

(b) *Buddha Sakyamuni*
Thailand, 8th century
Bronze
h: 20½ in. (52.1 cm.)
Mr. and Mrs. James W. Alsdorf, Chicago

Dvaravati was the name of a city or kingdom that we know from Chinese references and from three small inscribed medals found at Nakhon Pathom and U Thong in Thailand. Except for its name, almost nothing is known about this kingdom. Traditionally, however, a style of art has been assigned to Dvaravati that was created in much of what is now Thailand during the period from the sixth to the eleventh centuries. The Buddha image was the great achievement of this style, and two particularly lovely, although quite different, examples are illustrated here.

The Rockefeller Buddha (a) displays many of the identifying characteristics of the Dvaravati style. The smooth robe is worn over both shoulders and wrapped tightly against the elongated and sexless body. The entire body is inscribed within a rectangle formed by the arms and robe; its width is determined by the breadth of the shoulders. Unlike most Indian Buddhas, the body is rigidly frontal. The facial features, such as joined eyebrows, prominent eyes, high cheekbones, flat nose, and large, broad lips, are usually thought to reflect the characteristics of the indigenous Mon population. The curls of the hair are large and flat.

The most important Dvaravati Buddha images are made of stone, and some standing images are over nine feet tall. Unfortunately, almost all standing stone Buddhas now lack forearms and hands, due both to the fragility of the projecting arms and to the practice of carving the arms separately and attaching them with a mortise-and-tenon system. The loss of the hands on the Rockefeller image makes it difficult to identify what aspect of Buddha's life is being represented. Judging from the position of the breaks and from the gestures of analogous bronze images, it is probable that the hands would have been held in the double teaching gesture *(vitarkamudra)*. This combination of hand positions is unknown in India but was very popular in Dvaravati. It is not known what the double *vitarkamudra* signified in the Dvaravati period, although it later came to refer to the Descent from the Trayastrimsa Heaven.

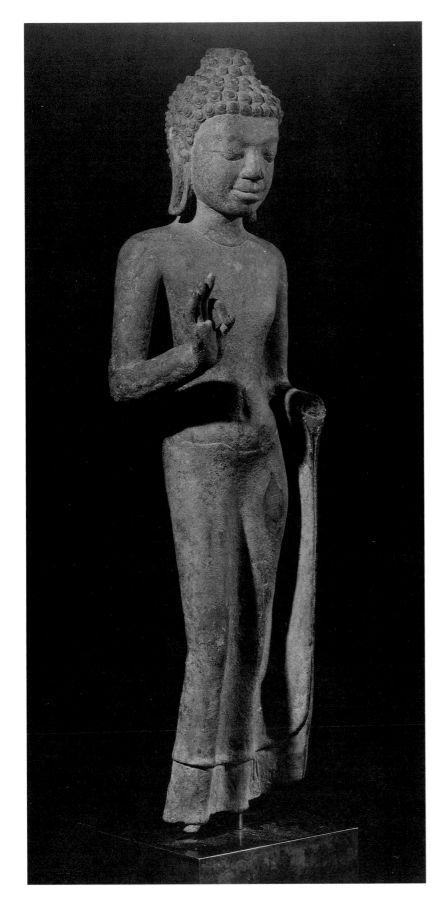

While many Dvaravati period bronze Buddha images are small and of indifferent quality, the large bronze Alsdorf Buddha (b) represents a major commission and is the work of a master sculptor. The Alsdorf Buddha wears his robe under his right arm, unlike the stone Buddha (a), whose robe covers both shoulders. Their hand gestures are also different. The bronze figure holds his right hand in a teaching gesture; the hand of his somewhat lowered left arm would have held a section of his robe. In contrast, the stone Buddha would have held both forearms at right angles to the body and, as mentioned above, would probably have performed the double *vitarka-mudra.* Furthermore, the bronze Buddha stands in a gentle flexion *(tribhanga),* as compared to the rigid and unbending posture of the stone image.

It is interesting that the characteristics associated with the Alsdorf Buddha are found in Dvaravati art almost exclusively in bronze images that have a single shoulder covered. Bronze images with both shoulders draped rarely show the combination of hand gestures or the bend of the hips seen in the Alsdorf sculpture. Those examples with one shoulder covered that do display the twist of the hips tend to be awkward, with either the wrong hip raised or one hip abnormally swollen. The artist who created this bronze image, however, subtly and accurately represented the Buddha with his weight placed on his left leg, his left hip raised, and his freed right leg slightly bent.

While the bronze Buddha image does reveal a certain degree of anatomical accuracy, it does not share the extreme concern for realism seen in the Si Thep Buddha (no. 103). The two images possess many of the same characteristics—hand gestures (although these are conjectural), method of wearing the robe, bend of the body, even the lack of any indication of the edge of the robe under the right arm—but the Dvaravati artist has interpreted them using a much more abstract and traditional canon of beauty.

—*R. L. B.*

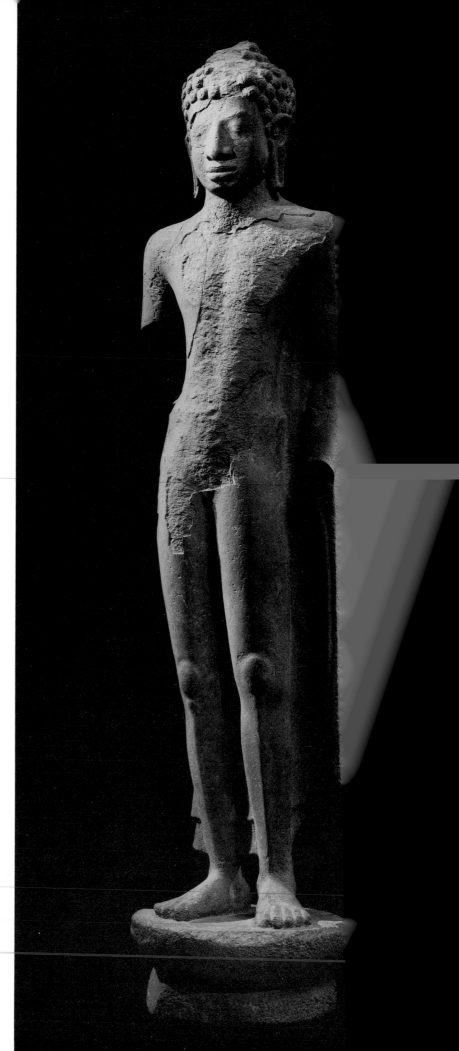

Buddha Sakyamuni
Thailand, Si Thep; 8th century
Stone
h: 77¹⁵⁄₁₆ in. (198 cm.)
Jean-Michel Beurdeley Collection,
Paris

Although influenced in some ways
by the Dvaravati school, the
contemporaneous Si Thep school in
northeastern Thailand produced a
unique style of sculpture. This Bud-
dha is not only an outstanding exam-
ple of the Si Thep style but is one of
the great masterpieces of Southeast
Asian sculpture. As a representation
of Buddha Sakyamuni, it is remark-
able for its many unusual character-
istics and its great beauty.

The image is carved completely in
the round; the back is fully modeled,
and the feet are cut free from the
stone. In India, stone icons were al-
most always carved in relief, and al-
though a tendency toward three-
dimensional standing figures existed
in Southeast Asia, images of this
type usually relied upon stone sup-
ports or enlarged legs to sustain their
weight. Only at Si Thep were images
completely cut free from the stone.
As a result, it is possible to place the
Beurdeley Buddha in this school of
sculpture, which in turn allows a
number of the image's other charac-
teristics to be explained.

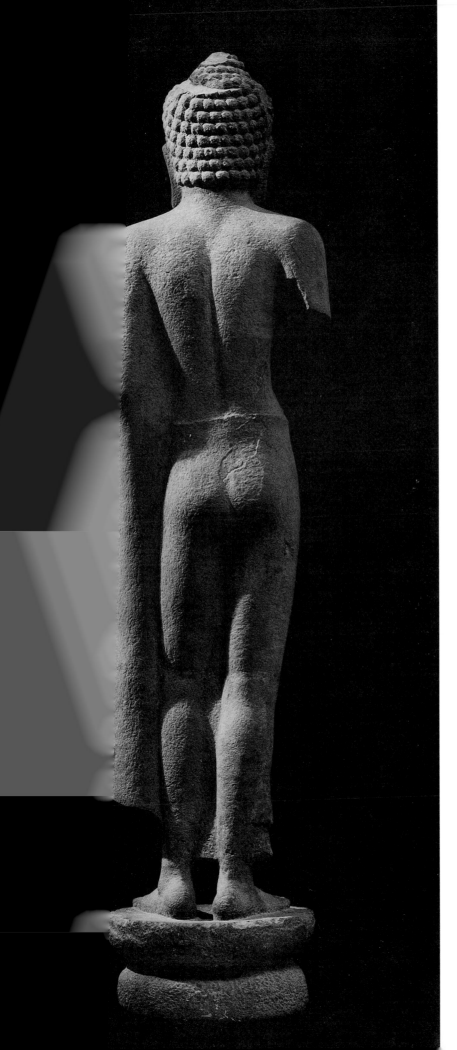

At Si Thep, life-size images of Hindu deities, especially of Vishnu, were carved in the round without stone supports—a procedure that can only be termed a flagrant disregard for the friability of stone. These Hindu deities were portrayed with a few ornaments and a short loincloth *(sampot)* but were otherwise almost naked. They were modeled with an unusual degree of realism (see Czuma, figs. 12, 14, and 15). It is into this series of sculptures that the Beurdeley Buddha fits. The careful modeling of the figure's back and buttocks, so appropriate to a Hindu deity, lends a sensuality to the Buddha that is out of keeping with the concept of the ascetic Sakyamuni. Furthermore, the Buddha appears naked from the waist up: Even the edge of the robe, which passes under the right arm, is not indicated on the back, as if the sculptor were unwilling to mar the beauty of the nude torso (cf. no. 102b).

The way in which the Buddha wears the robe, combined with the placement of his arms, is also unusual. While the right arm is now broken, it would have been held in either the gesture of reassurance or of teaching; the hand of the lowered left arm would have grasped a section of the robe. This combination of arm positions (right arm raised and left arm lowered) and hand gestures (right hand engaged in a specific gesture and left hand holding the robe) is almost unknown in India; and, although it occurs in Dvaravati, it is rare in Southeast Asia.

There is Dvaravati influence apparent in this Si Thep Buddha, specifically in the facial features (cf. no. 102a). This should not surprise us, however, as we know, based on the type of Wheel of the Law (see no. 72) found at Si Thep, that Dvaravati Buddhism existed there in the seventh century. Nevertheless, the sensuality and realism of this Buddha mark it as a unique achievement.

—R. L. B.

Buddha Sakyamuni
India, Bihar; 8th century
Copper alloy
h: 16¼ in. (41 cm.)
Ravi Kumar

This handsome Buddha is a direct descendant of the sixth-century north Indian figure illustrated in no. 85. Age has obliterated many of the linear striations that once indicated the folds of this Buddha's garments. The gilding, too, has disappeared, leaving the surface with a mellow rust-brown hue. The eyes of this image, like those of the sixth-century sculpture, remain half-shut, but the nose has gained considerably in prominence. The mouth is still characterized by a thick and sensuous lower lip, but it is somewhat smaller. The empty irises of the Buddha's eyes were probably originally inlaid with silver. An *urna* is prominently marked between the eyebrows. (As mentioned earlier, the *urna* is generally not represented in Gupta period (320–600) Buddhas from Sarnath and Mathura, but it became a consistent feature of images from Bihar beginning in the seventh century.)

Similar bronzes have been found both at Nalanda and Kurkihar, two important Buddhist centers in Bihar during the rule of the Pala dynasty (8th–11th century). Stylistically, the figure is closely related to those embellishing the bronze stupa from Nalanda (no. 69).

—*P. P.*

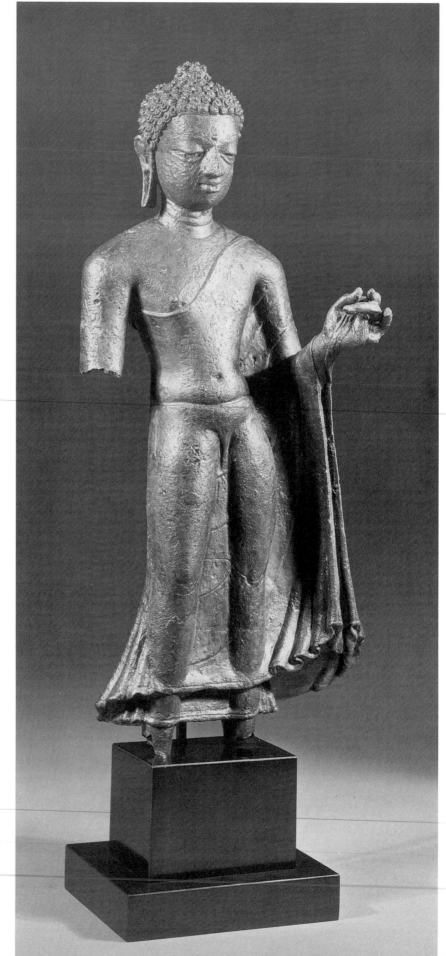

105

Buddha Sakyamuni
Thailand, 8th–9th century
Bronze
h: 5¼ in. (13.4 cm.)
Los Angeles County Museum of Art,
Gift of Michael Phillips

This is a fine example of a seated
Dvaravati bronze Buddha image. It
has, however, several unusual fea-
tures, one of which is a mustache.
On the Indian subcontinent, it was
only in Gandhara that the Buddha
was depicted with a mustache, a fea-
ture out of keeping with monastic
rules. These rules state that a monk
must retain a razor as one of his few
worldly belongings, so that he may
shave his beard and hair. The
Gandhara example with a mustache
quickly spread to Central Asia and
from there to China and Japan. The
mustache in Southeast Asian repre-
sentations of the Buddha, however,
may have developed independently,
with the most likely source being
contemporary Hindu sculpture. The
form the mustache often took in
Dvaravati Buddha images, where it
is quite rare, and in Khmer exam-
ples, where it is more frequently
found, was an elaboration of the up-
per lip border (cf. no. 99). It is this
form that appears on the Los An-
geles Buddha.

The broad mouth, flat nose, widely
set eyes, and connected eyebrows on
this small bronze are features typi-
cal of Dvaravati period (6th–11th

century) images. The mustache, the
piercing gaze produced by the in-
cised irises, the flaring nostrils, and
taut mouth, however, create an un-
usually powerful expression.

Another interesting characteristic of
this bronze image is the way in
which the legs are folded so that the
right foot does not lie on top of the
left calf, as is usually seen in this
seated posture. Instead, it is placed
in front of the shin and twisted in an
anatomically impossible position so
as to expose the sole. This leg posi-
tion is not uncommon among Dva-
ravati images, and it is surprisingly
similar to the crossed-ankle posture
of the early Amaravati style images
(cf. no. 78). At U Thong in Thailand,
a small stucco fragment of a Buddha
seated in the crossed-ankle position
on a *naga* has been found that
appears to relate to the early
Amaravati style. Therefore, we
probably see in this later bronze a
holdover from the early Indian form
of the seated Buddha.

—R. L. B.

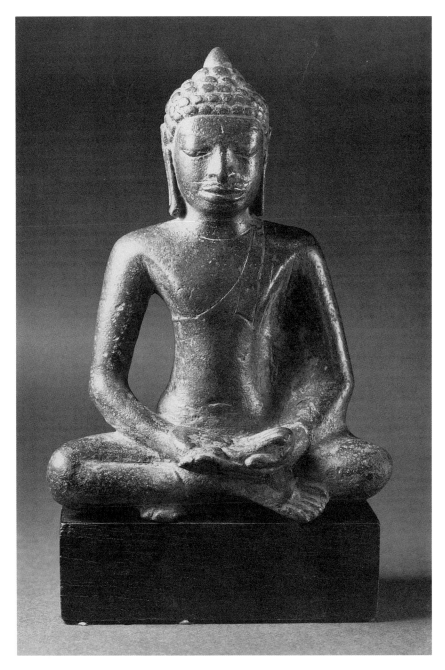

106

Buddha Sakyamuni
Cambodia, 8th–9th century
Gold
h: 3⁷⁄₁₆ in. (8.1 cm.)
Ex Pan-Asian Collection, Property
R. H. Ellsworth Ltd.

Gold is a substance for which Southeast Asia was famous in ancient times, a fact exemplified by many geographical place names. One need only think of the Golden Khersonese celebrated in Ptolemaic geography or of Suvannabhumi (Land of Gold) mentioned in early Indian texts. Many modern place names continue this tradition, such as U Thong (Cradle of Gold) in central Thailand, a city where some of the earliest Indian-related art in Southeast Asia has been found.

The reports of Chinese visitors substantiate the fact that gold was used extensively throughout the kingdoms of Southeast Asia, especially at the royal courts. It is recorded, for example, that in 446 the Chinese removed 100,000 pounds of gold from the sacked Cham capital, near modern Hué in Vietnam. It is reasonable to assume that the Chinese melted down most gold objects before transporting them, a practice repeated throughout the history of mainland Southeast Asia. This custom and the continued value of gold have combined to reduce drastically the number of gold objects surviving today.

The small gold repoussé plaque illustrated here, which depicts a Buddha seated on a lotus, may have been spared because it was once buried as part of the foundation deposit of a Buddhist stupa or a monastery. A number of similar repoussé plaques, in both gold and silver, have been excavated in Cambodia and Thailand. Once buried, such plaques were never intended to be seen again, their function being to protect the monument and assure its efficacious operation.

—R. L. B.

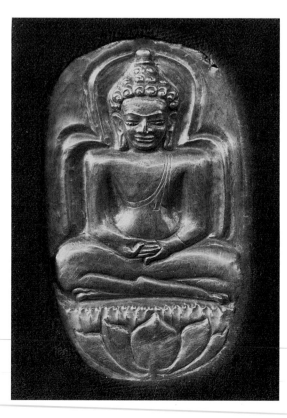

107

Buddha Sakyamuni with Two Bodhisattvas
Nepal, c. 800
Black chlorite
h: 25 in. (63.5 cm.)
Private Collection

Buddha Sakyamuni is represented here flanked by two bodhisattvas in a type of stele that was very popular in Nepal. Each figure is provided with an oval halo, fringed with a flame motif that also embellishes the edge of the stele. All three figures extend their right arms along their sides; their right hands display the gesture of charity. The figure dressed as an ascetic on the left holds a rosary and vase that identify him as the bodhisattva Maitreya. The crowned figure on the other side is very likely the bodhisattva Avalokitesvara. The Buddha himself employs his left hand to gather up the end of his garment with an elegant sweep.

The style of this Buddha image, as well as the idea of a triad formed with a pair of bodhisattvas, was obviously derived from images created at Sarnath in India (no. 51). While both attendant figures are depicted as ascetics in Sarnath, here they are clearly distinguished. It may be recalled that Maitreya and Avalokitesvara accompany the Buddha in earlier Gandhara reliefs as well (no. 74). One feature encountered in the Nepali triad that is not observed in those from Sarnath is the clear indication of the divine tuft of hair between the eyebrows. Depicted as a circle, this *urna* appears on the forehead of each of the three figures.

A close stylistic parallel of this Buddha figure may be seen in a near-contemporary bronze from Bihar (no. 104). The differences between the two sculptures, however, are also noteworthy. The folds of the enveloping garment are treated somewhat differently in each image, as is the manner in which the end of the robe is held; furthermore, the nose in the Nepali Buddha is less prominent than that of the Bihar figure.

—P. P.

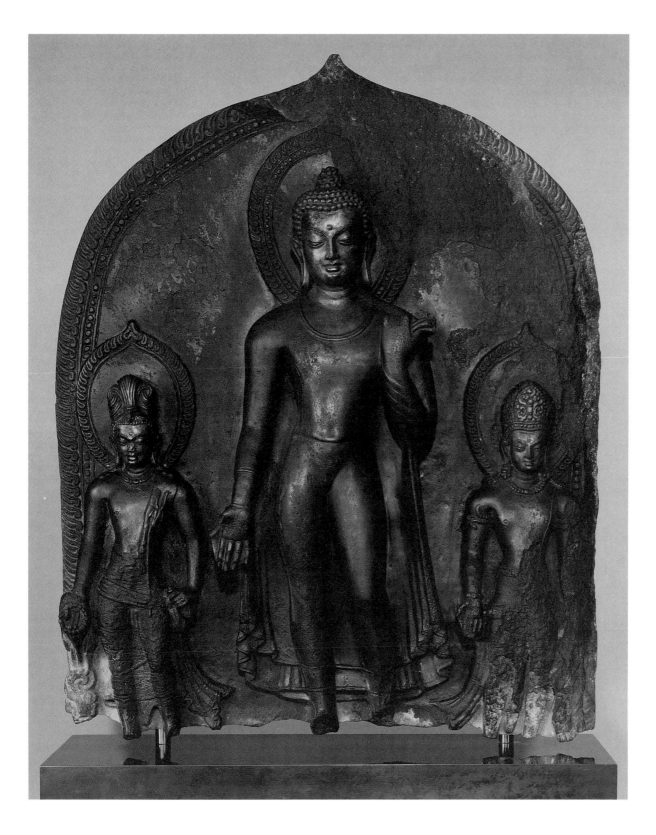

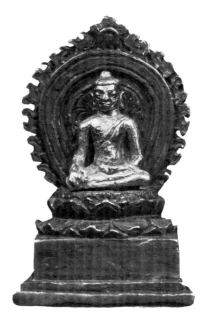

108

Buddha Sakyamuni
Java, 8th–9th century
Gold and silver
h: 2⅞ in. (7.3 cm.)
Mr. and Mrs. James W. Alsdorf,
Chicago

Unlike the few examples from mainland Southeast Asia (see no. 106), a fairly large number of ancient gold and silver images from Java are extant. These vary in size and quality. Miniature Buddha images, such as this one, were popular during the Central Javanese period (778–930). Such small images must have belonged to individuals, either laymen or monks, and were used for personal worship.

Extremely simple and sometimes almost crude in their details, these small images are nonetheless often very appealing. The figure of the Buddha in this instance has been cast in gold, while the base and the aureole are silver. The summary treatment of the details are compensated for by the intrinsic luster of the two precious metals. Typical of these tiny figures are the overly large nipple of the exposed right breast and the lack of curling hair.

—R. L. B.

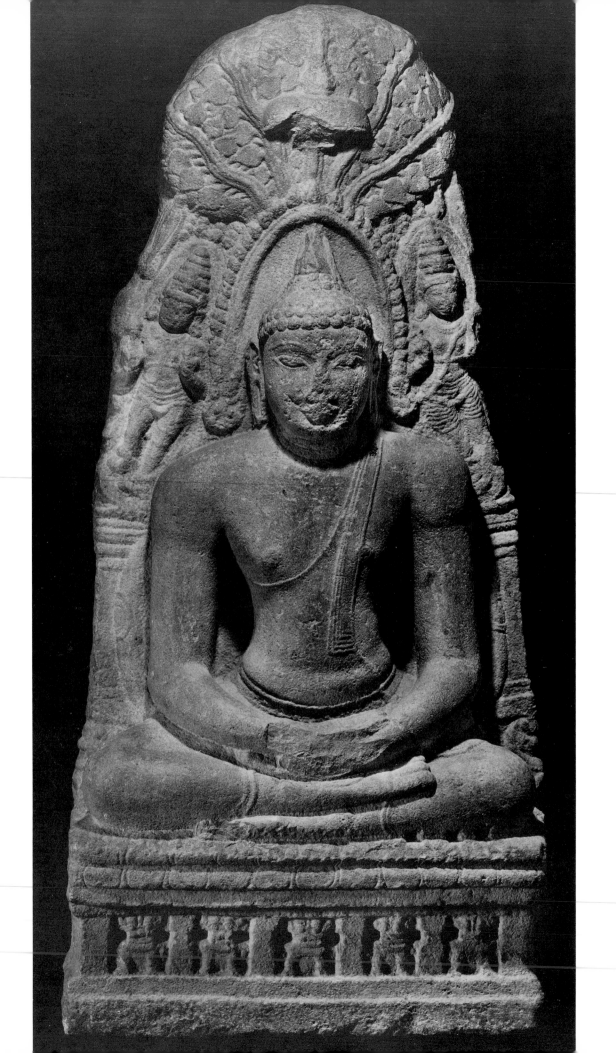

Buddha under the Bodhi Tree
India, Tamilnadu; 9th century
Granite
h: 71 in. (180.3 cm.)
The Brooklyn Museum, Lent by
Miss Alice Boney
(Shown in Brooklyn only)

This impressively large image of the
Buddha from Nagapattinam in
Tamilnadu, along with the Thai
head (no. 122), will give the viewer
some idea of the colossal images
that remain in situ in most coun-
tries where Buddhism prevailed. The
inclination to raise monumental im-
ages—often several hundred feet
high—in an attempt to awe the wor-
shiper was particularly strong
among Buddhists. Followers of no
other religion, except that of ancient
Egypt, have made such immense im-
ages of their gods in such profusion.

Nagapattinam in Tamilnadu
remained an important center of
Buddhism longer than any other site
in south India. Being situated on the
southeastern seacoast, it was a
significant trading center and main-
tained close relationships with both
Sri Lanka and Southeast Asia. As
was the case at Nalanda in Bihar,

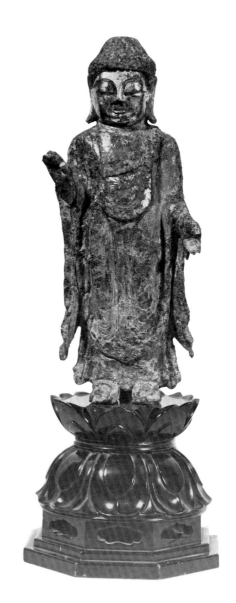

there were monasteries and hostels at Nagapattinam for the foreign monks who visited regularly.

In this sculpture, the Buddha sits on a throne supported by a row of five lions. The *bodhi* tree above his head and his meditative posture are clearly intended to represent the Enlightenment at Bodhgaya. At the same time, the addition of a parasol and hanging garlands make the tree a celestial symbol of life or knowledge *(kalpavriksha)* and, by extension, represent the Buddha as a transcendental figure. The addition of a flame at the top of the Buddha's cranial bump is an iconographic feature characteristic of Nagapattinam. This protuberance, like the *ushnisha* itself, symbolizes knowledge or wisdom. On either side of the Buddha's oval halo, which is framed by a row of stylized flames, is a bodhisattva wearing the conical crown typical of south India.

— *P. P.*

110

Buddha Sakyamuni
Korea; Unified Silla dynasty,
9th–10th century
Gilt bronze
h: 11 in. (27.9 cm.)
Kim Dong-hyun, Seoul

This image of the Buddha, although eroded in parts, retains most of the original gilding on its face. It is noteworthy because it differs so markedly from earlier Korean Buddha images. Absent is the characteristic gentleness and youthfulness; instead, one is faced with an image of awesome power, heavy in its proportions and mysterious and introspective in its mood. The overly large head, so typical of Korean images, communicates a forbidding presence with none of the inviting warmth one usually finds. The same type of image is well known in ninth-century Japanese Buddhist art, and in both countries it owes its origin to the popularity of esoteric Buddhism with its mysterious and complex ceremonies. The evolution of this image type has been accurately described by Sherman Lee:

> We must bear in mind that it is a hieratic art, produced in the service of a faith and strictly regulated by that faith. It is physically forbidding, and its image types do not accord with present-day ideals of beauty. At the same time, they are awesome, perhaps the most awesome images created in East Asia, just as the Byzantine images may well be the most awesome created in Medieval Europe. *(S. E. Lee, 1982, p. 290)*

— *R. E. F.*

227

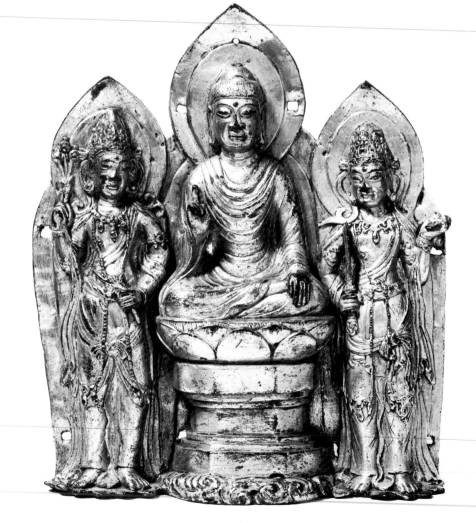

Buddha Sakyamuni with Bodhisattvas
China, Song dynasty (960–1279)
Gilt bronze
h: 8⅝ in. (21.9 cm.)
Asian Art Museum of San Francisco, The Avery Brundage Collection
(Reproduced in color)

This attractive gilt-bronze triad is one of the few extant examples of early Chinese repoussé, a technique of embossed relief frequently employed in Buddhist altar plaques. The Buddha is shown on a high lotus pedestal flanked by two bodhisattvas. The bodhisattva on the left, who holds a spray of flowers, may be Avalokitesvara, while the book and sword identify the other attendant as Manjusri. The gesture of the Buddha's right hand signifies that he is engaged in teaching. Noteworthy is the additional low mound at the base of the Buddha's *ushnisha* (cranial bump). This became a characteristic feature of Chinese Buddha images during the Liao (907–1125) and Song (960–1279) dynasties and is generally regarded as a symbol of luminosity.

Compared to the Buddha, who is characterized by a certain rigidity and hieratic grandeur, these bodhisattvas seem to swagger elegantly. This divergence is further emphasized by the contrast between the Buddha's simple and austere attire and the elaborate garments and ornaments worn by his attendants. Although the style of the figures continues the naturalism of the Tang period (618–906), the tendency to cover the body with swirling scarves and garments was a characteristic of Song sculpture. —*J. B.*

[The additional mound emphasizing the Buddha's luminosity may be a Chinese counterpart of the additional flame that began to be added to the cranial bump in other areas during this period (cf. nos. 109 and 115).—*P. P.*]

Buddha as Avatar of Vishnu
India, Uttar Pradesh; 10th century
Sandstone
h: 35 in. (88.9 cm.)
Collection of The Santa Barbara Museum of Art, Gift of Mrs. K. W. Tremaine

Sometime around the fifth century, Buddha Sakyamuni was admitted into the Hindu pantheon as an avatar, or incarnation, of the god Vishnu. The followers of Vishnu, known as Vaishnavas, believed that whenever the world was filled with evil, the god assumed a suitable form and descended to earth to save his devotees. Although, theoretically, the avatars were many, Vaishnava theologians developed a list of ten significant avatars that included both historical and mythical figures. The three historical personages included were: Rama, the hero of the epic *Ramayana*; Balarama, an ancient hero of the Vrishni tribe; and Buddha Sakyamuni, who became the ninth avatar of Vishnu.

The avatars were usually represented as a group in small reliefs attached to Vaishnava temples. It is probable, however, that entire temples were occasionally devoted to the ten, as is indicated by this handsome representation. This image's companion avatars are of equally impressive size, and it seems likely that they were worshiped in a large temple dedicated to the group (Davidson, 1968, pp. 46–47). The sculpture represents a rare example of a medieval Buddha image from Uttar Pradesh.

—*P. P.*

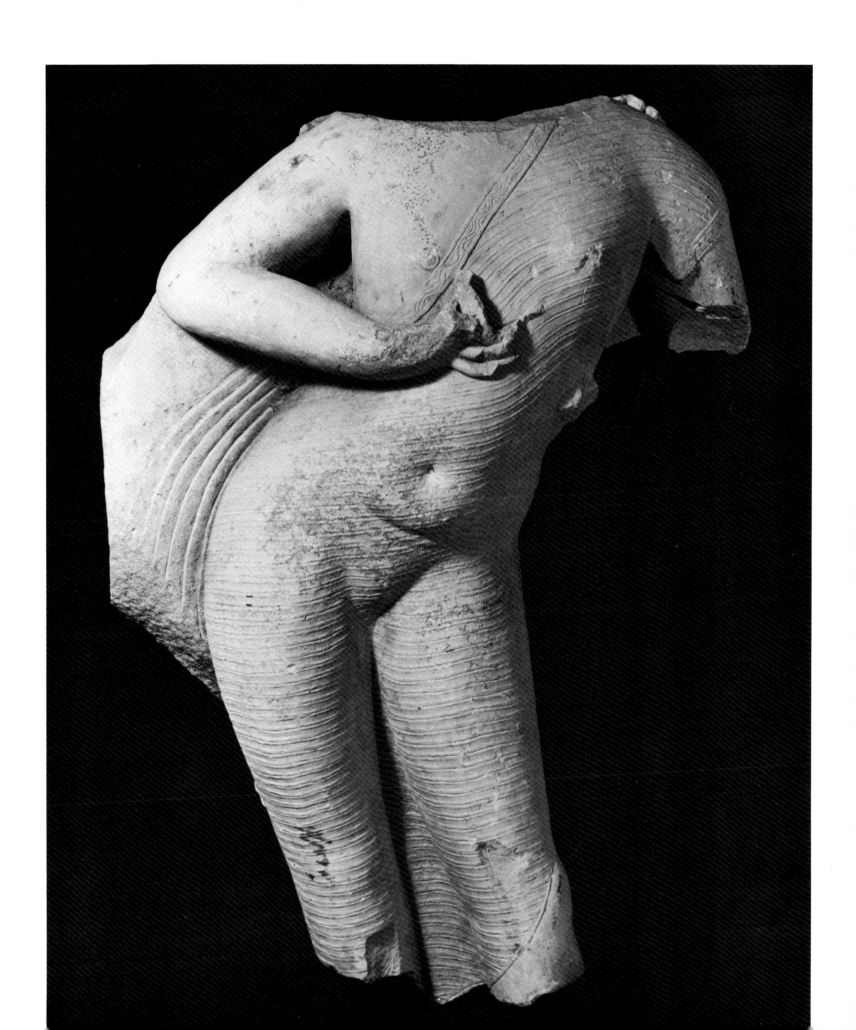

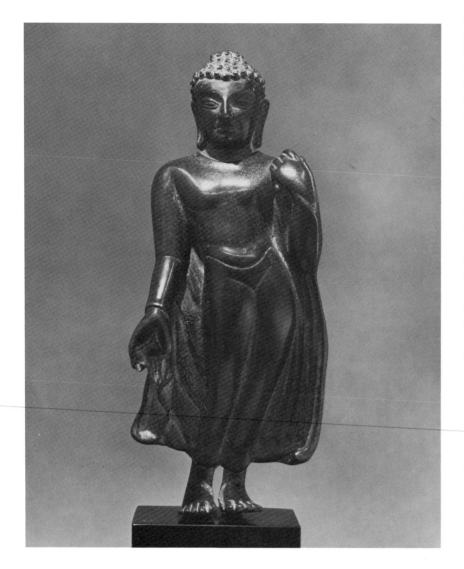

Buddha Sakyamuni
Western Tibet or Kashmir, c. 1000
Brass with silver inlay
h: 38⅝ in. (98.1 cm.)
The Cleveland Museum of Art, Purchase, John L. Severance Fund

Surrounded by a flame nimbus, parts of which are now broken, this representation of Buddha Sakyamuni stands gracefully on a lotus atop a simple molded base. A slim and elegant figure, he strikes the classic *tribhanga* (triple-bent) posture and raises his right hand in the gesture of reassurance while holding the end of his garment in his left hand. The troughlike delineation of the Buddha's robe not only emphasizes the outline of the body, but also creates a greater sense of volume. This volumetric quality is further accentuated by the rippling and fluid folds of the garment and the subtle modeling of the pectoral and abdominal muscles. Even though the legs are long and columnar, the figure's smooth flesh seems to pulsate with life beneath his clinging garments.

113

Buddha Sakyamuni
Celebes (?), c. 9th–10th century
Bronze
h: 8¾ in. (22.2 cm.)
Ex Pan-Asian Collection, Property R. H. Ellsworth Ltd.

This intriguing bronze Buddha is reported to have come from Celebes, one of the islands of the Indonesian Archipelago. While there are very few extant Buddhist objects from Celebes, one of the earliest Buddha images in Southeast Asia—an imported icon, probably from south India or Sri Lanka—was found there.

This early image dates to circa the fourth or fifth century and indicates that Buddhism may have been introduced to Celebes fairly early.

The Ellsworth Buddha appears to be a local and probably provincial Southeast Asian product, as it shows a number of apparent misunderstandings of what must have been an Indian model. The Indian prototype was clearly a type of Buddha that had been developed in the fifth and sixth centuries in the rock-cut caves at Ajanta, Ellora, and Kanheri. This prototype characteristically wears a robe over both shoulders, holds its right arm and hand extended in the gesture of charity, and lifts its left hand to the shoulder, holding a section of the robe. Typical also of these Indian images is a rather pronounced sway of the hips *(tribhanga)* and a short stocky body.

Although many of these characteristics are readily apparent in the Ellsworth bronze, it also displays a number of features that are clearly non-Indian in nature. The lowered right hand, which in Indian images would have been open in the gesture of charity, here displays an inverted form of the teaching gesture *(vitarkamudra)*; interestingly, this form of the gesture occurs in Chinese art. The stylized drapery folds in the sections of the robe on either side of the body are also non-Indian. In their random and unnatural patterns, these folds clearly show a misunderstanding of the model; particularly in the fall of drapery below the right hand, they reveal the artist's unfamiliarity with the way in which a monk's robe is worn. As has frequently been pointed out, the Buddha image in Asia is usually characterized by a remarkably accurate depiction of the monastic robe. This is not surprising because the artists were in daily contact with monks, often being, or having once been, monks themselves. Therefore, the artist of the Ellsworth bronze may not have been a Buddhist or have lived in an area where Buddhism was widespread. It is possible that he created the image for a visiting Buddhist merchant. A Celebesian origin for this image would, therefore, not be unreasonable.

Still other indications of a copyist could be pointed out, such as the unnatural angle of the legs that produces the pronounced sway of the image. The overall result, nonetheless, is a surprisingly appealing and unique image of the Buddha Sakyamuni.

—*R. L. B.*

The incised inscription on the base of the sculpture informs us that this image once belonged to Lha-tsun Nagaraja. *Lha-tsun* was the title assumed by the kings of Guge (an ancient kingdom in what is now southwestern Tibet). Nagaraja was one of the sons of King Yeshe-o (c. 1000), who was largely responsible for the revival of Buddhism in Tibet. Indeed, so pious a king was Yeshe-o that he ultimately abdicated and donned the monastic robes along with his sons Nagaraja and Devaraja. It is very likely, therefore, that this outstanding image once graced the private chapel of Prince Nagaraja.

While Nagaraja may have been the owner of the image, it is not clear whether he commissioned it himself or whether it was an earlier sculpture to which the inscription was later added. It is also difficult to determine whether the image was cast in Guge by a sculptor from Kashmir or from Chamba in Himachal Pradesh or whether it was imported from those regions. During this period, artists working in Kashmir and Chamba created some of the most monumental metal sculptures produced in the Indian subcontinent. Whether made in India or in Guge, there seems to be no doubt that this image was the creation of a master sculptor. It is not only the finest and the largest brass image to have emerged from the monasteries of Tibet but is also one of the most beautiful Buddhas of the Indic tradition.

—*P. P.*

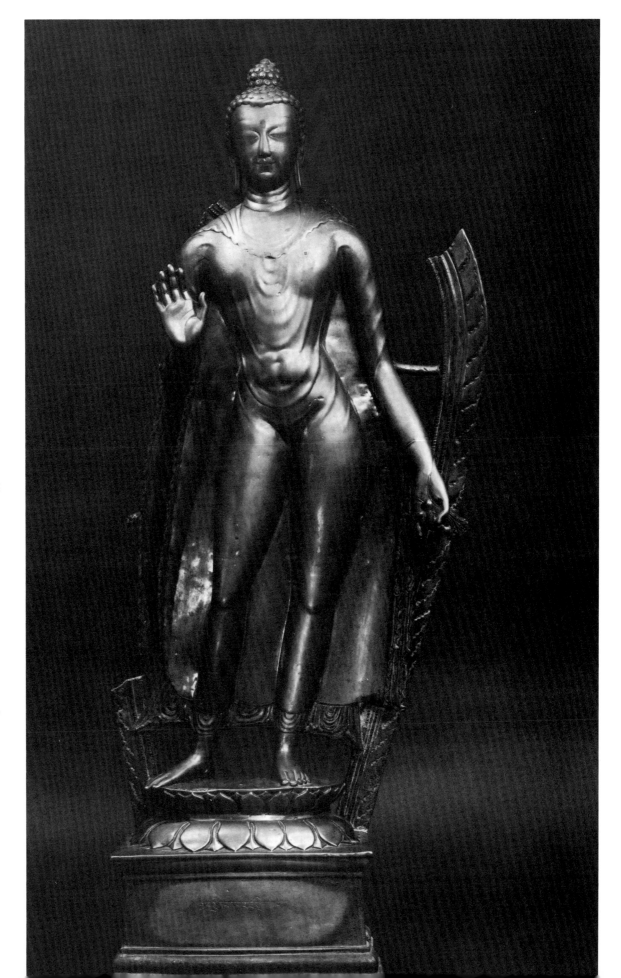

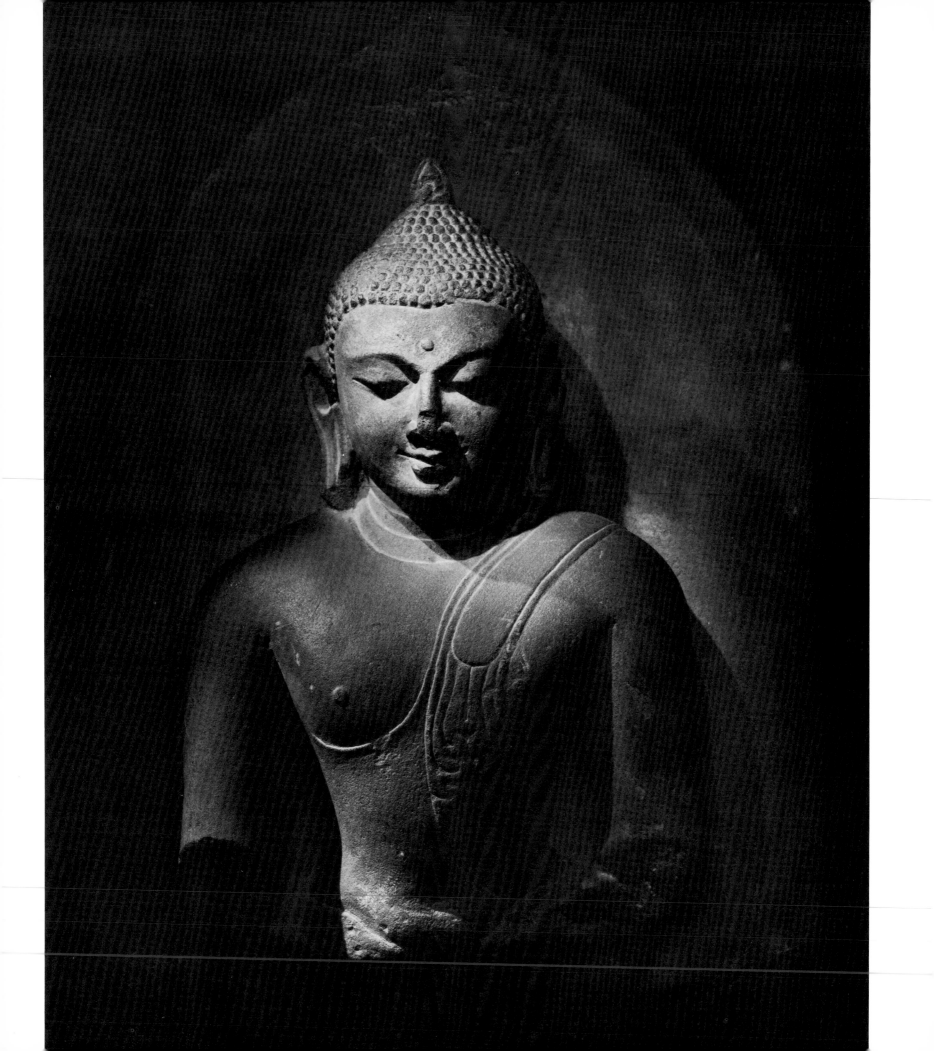

115

Buddha Sakyamuni
Burma, 11th century
Stone
h: 20⅞ in. (53 cm.)
Jean-Michel Beurdeley Collection,
Paris

When complete, this Buddha would have sat with his right hand extended in the earth-touching gesture, just as the central Buddha does on the small plaque illustrated in no. 10. Like the figure on the plaque, this Buddha may have come from the Pagan area of Upper Burma, where Theravada Buddhism predominated, beginning with the reign of the great king Aniruddha (r. c. 1044–77). Aniruddha, who was converted to Theravada Buddhism by a Mon monk, chose to represent the seated Buddha almost exclusively displaying the earth-touching gesture, which signaled the victory over Mara. This preference reflects the high regard in which the famous earth-touching Buddha icon in the Mahabodhi temple at Bodhgaya was held. Aniruddha may also have favored this posture as a reflection of his own conquests, both temporal— he was the first king to unify Burma—and spiritual—he was the monarch who converted Pagan and, by extension, all of later Burma to Theravada Buddhism. The kings of Pagan themselves expected, judging from their inscriptions, to be reborn as Buddhas in the future.

The style of Pagan Buddha images closely follows that of Pala period (8th–11th century) images of eastern India (cf. nos. 5 and 6). This connection would be expected, in part due to the close geographical proximity of Pagan to Bengal and Bihar. The Buddhists of eastern In-

dia, however, unlike the Theravada Buddhists of Pagan, were followers of the Mahayana and Tantric traditions. Nevertheless, Bodhgaya and its images were sacred to all Buddhist sects, and the styles of art that were developed in Bihar and Bengal and were seen at Bodhgaya were the most influential styles throughout Southeast Asia during this period.

The Beurdeley Buddha may have been carved during Aniruddha's reign, as it retains the softness of the facial features associated with images of this period. Typical of the Pagan style is the small flame atop the Buddha's *ushnisha*, the presence of an *urna*, and the stylization of the flap of cloth over the left shoulder, which comprises the hem of the robe, ending in fishtail folds and overlaid by a folded shawl.

—R. L. B.

116

Votive Tablet with Sakyamuni Buddha
Found in Thailand,
c. 11th–15th century (?)
Lead with lacquer and gold leaf
h: 7⅞ in. (20 cm.)
National Museum, Bangkok

This Buddha sits displaying the earth-touching gesture inside a trefoil arch. The tower *(sikhara)* atop the arch is modeled on that of the Mahabodhi temple at Bodhgaya, where the Buddha attained Enlightenment (see no. 73). Thus, this Buddha image is perhaps a replica of the famous *Sakyasimha (Lion of the Sakyas)*, the major icon in the Mahabodhi temple. Although the Buddha on the votive tablet appears to be seated in front of the temple, we must interpret this as an artistic convention for representing the image as inside the sanctum. Surrounding the arch and the central Buddha are numerous stupas of various sizes, which seem to be floating in air. This, too, is a representational convention, however, and these votive stupas signify those that were placed on the ground around the Mahabodhi temple. The section at the bottom of the tablet is now

broken, but it would have held the Buddhist credo.

Votive tablets were extremely popular in India and Southeast Asia. Originally, such small plaques were probably manufactured at major sites associated with events in the Buddha's life and then taken home by visiting pilgrims. Frequently, clay votive tablets were made from molds, and one can assume they were produced by monks who gained merit through manufacturing them.

This lead votive tablet was made from a mold and was found with other examples made from the same mold in the eastern stupa of Wat Phra Si Sanpet in Ayutthaya, Thailand. It is, however, purely of the Indian Pala style (8th–11th century). As similar tablets have been found at sites in Burma, it appears likely that monks brought molds from Bodhgaya to Southeast Asia. While the molds may date to around the eleventh century, the actual tablets could have been made at any time thereafter. This particular example may have been made as late as the fifteenth century, when the stupa in which it was found was constructed.

—R. L. B.

A Buddha
Cambodia, 13th century
Bronze
h: 6½ in. (16.5 cm.)
Ex Pan-Asian Collection, Property
R. H. Ellsworth Ltd.

This small bronze image, made striking by a brilliant azure patina, depicts the Buddha seated with his right hand extended in the earth-touching gesture. While the iconography of the figure follows the usual conventions, the expression of the face does not. Rather than the serene, gentle smile that we have come to expect of the Buddha, we see here a scowling frown and an almost demonic expression. It is impossible to determine if the artist intended to deviate from convention in creating this formidable countenance. The individual elements that make up the expression, however, are typical of the period. The representation of the eyebrows as a wide, undulating band, which tapers at the ends and appears almost like a flying bird, became standard in twelfth- and thirteenth-century Cambodian bronzes. The half-closed eyes and broad, double-outlined mouth are also standard features in bronzes of this period. Whether intended or not, the expression on this arresting face adds enormous power to the image.

—*R. L. B.*

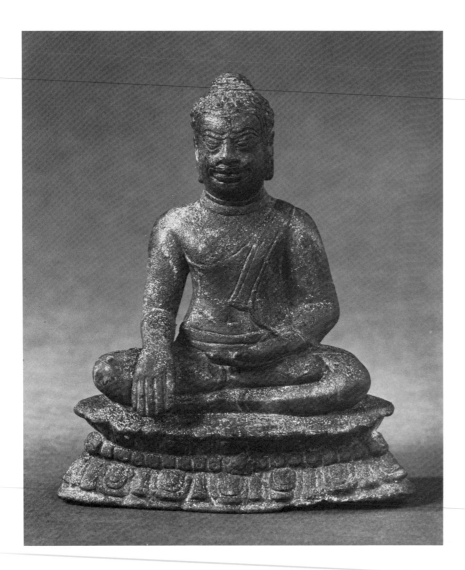

118

Buddha Sakyamuni
China; Yuan dynasty, 14th century
Gilt bronze
h: 6 in. (15.2 cm.)
The Minneapolis Institute of Arts,
The Searle Fund

This is a small version of the famous Udayana image type that was one of the most venerated representations of the Buddha Sakyamuni in China. There are various versions of the Udayana legend, and they have been studied by Alexander Soper with his characteristic thoroughness (see Soper, 1959a, pp. 259–64). Briefly, however, the tale may be recounted as follows: When Buddha Sakyamuni proceeded to the Trayastrimsa Heaven to preach to the gods and his mother (see nos. 54 and 55), King Udayana of Kausambi became so disconsolate that he had a sandalwood statue of the Master made. According to some accounts, he actually sent one of the Buddha's disciples to the Trayastrimsa Heaven to create an exact likeness.

An image alleged to be a copy of this famous statue was apparently brought from India to the Central Asian kingdom of Kucha by the Indian father of the famous Kuchean scholar and translator Kumarajiva in 384. From there, it was taken to China, where it remained one of the most powerful of all Buddha images, as evidenced by the following extract from a fourteenth-century inscription: "All year round offerings made to the 'auspicious sandalwood image' would never stop coming, from nobles and high officials, to the womenfolk of the common class" (Lee and Ho, no. 8). A copy made in 986 was taken to Japan where it became the principal image of the Seiryoji in Kyoto. Furthermore, the Japanese found the image so charismatic that they convinced themselves it was the original copy brought directly from Kucha.

The Chinese version of the Udayana image, as exemplified by this diminutive figure and by the colossal Buddha in the collection of The Metropolitan Museum of Art, New York (no. 175), is a stylistic synthesis of elements from sculptures created at Mathura in India and Khotan in Central Asia. The schematic and orderly delineation of the drapery folds is clearly an archaized version of the striations seen in Mathura Buddhas (cf. nos. 83 and 84). The treatment in which the bottom edge of the garment ends above the ankles, as Soper has pointed out, is related to a style observed in Buddha images recovered from the ruins of monasteries at Rawak in Khotan.

Whatever its origin, the original image from Kucha remained a model for countless later copies made in Tibet, as well as China. This gilt bronze of the Yuan period (1280–1368) is a particularly handsome and interesting example. It has been suggested that the facial features, soft expression, and high cranial bump, reflect the distinct influence of images from Nepal. This is not surprising, considering that the leading master of Buddhist art in Yuan China was Aniko, a gifted young Nepali artist brought to the imperial court during the rule of Kublai Khan (r. c. 1259–94) by the Sakyapa monks of Tibet. Subsequently, Aniko and his principal Chinese disciple established a distinct school of Buddhist iconography in China.

—*P. P.*

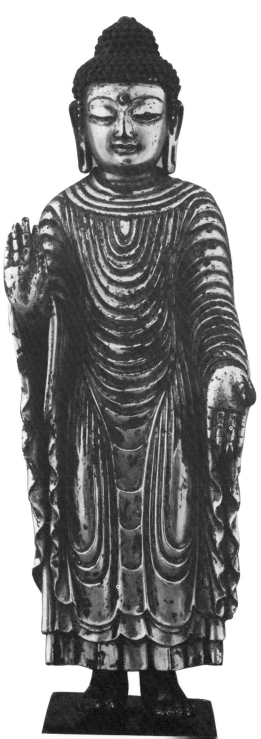

235

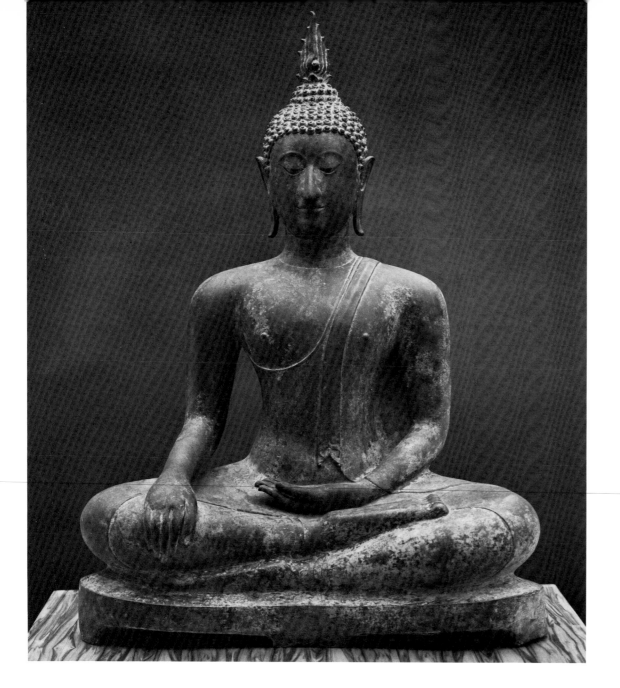

Individual facial features are also stylized and curvilinear, producing the haughty yet gentle expression typical of Sukhothai Buddha images. A supernatural anatomy, with such obvious supramundane features as the cranial bump, is characteristic of Buddha images, but the more-than-human nature of the Buddha is also expressed by the Asian artists' lack of interest in anatomical realism. The Sukhothai artists of the thirteenth and fourteenth centuries perhaps pushed to the limit this lack of concern with a realistic portrayal of the body.

One major source for the abstract form of the Sukhothai Buddha is literary description. As mentioned in the essay on the Buddha image in India, Pali canonical literature includes lists of anatomical marks characteristic of the Buddha. Indian artists largely ignored such lists, choosing to represent only a few of the thirty-two major and eighty minor bodily marks described in the texts. The Sukhothai artists, however, felt these marks were of particular importance, and they depicted even such infrequently seen characteristics of the Buddha as projecting heels, flat feet, and pointed ears.

The Thai artists also looked for inspiration in the conventional similes that occur in Sanskrit poetry. These similes describe the ideal physical form of heroes and gods. Whereas Indian artists accepted such descriptions as literary devices, the Sukhothai artists attempted to reproduce them. Similes describing a head like an egg, a nose like a parrot's beak, a chin like a mango stone, and arms as smooth and rounded as the trunk of a young elephant were made concrete. The genius of the master Sukhothai artist was in the ability to translate these metaphorical ideas and other diverse influences into original works of manifest spirituality.

—R. L. B.

119

Buddha Sakyamuni
Thailand, 14th century
Bronze
h: 29 in. (73.7 cm.)
Ex Pan-Asian Collection, Property
R. H. Ellsworth Ltd.

This impressive bronze Sukhothai style (13th–14th century) image presents an extremely abstract conception of the Buddha. The body and face lack articulation of the muscles and joints, and rounded, rather geometrical forms make up the head and sections of the body.

Buddha Sakyamuni
Thailand, 14th century
Bronze
h: 10¼ in. (26 cm.)
Mr. and Mrs. Harry Lenart
Collection

The Sukhothai artists invented the bronze, three-dimensional image of the Buddha shown walking with one heel raised. In India, the Buddha was frequently represented in scenes that specifically called for him to walk, such as the Descent from the Trayastrimsa Heaven on a ladder (cf. no. 54); despite this, Indian artists do not appear to have represented the Buddha in the process of taking an actual stride with his foot leaving the ground. He is depicted instead as a standing figure with both legs straight and feet planted flatly on the ground. Movement may be implied in some Indian relief carving, however, through such conventions as the direction in which the Buddha's feet are pointed and the position of his head.

The lack of a walking Buddha in Indian art is all the more surprising when we consider how important walking was to the Buddha and to Buddhist monks. During the great departure, signifying his abandonment of princely life, Sakyamuni dismounted from his horse Kanthaka and never again rode on an animal or used any form of conveyance. This is in keeping with the ideal of the Buddhist monk as a peripatetic mendicant, and Buddhist texts describe the Buddha as constantly wandering by foot from city to city in India in the course of his teaching.

Some explanation for the failure of Indian artists to represent a "walking" image may be found in the description of the first of the characteristic thirty-two major marks of the Buddha: "He hath feet with level tread." This is further explained as "evenly placing his foot upon earth, evenly drawing it up, evenly touching earth with the entire surface of the foot" (Rhys Davids and Rhys Davids, pp. 137 and 139). Literally following this description would result in an awkward and unnatural movement, and this perhaps dissuaded Indian artists from attempting a plastic rendition.

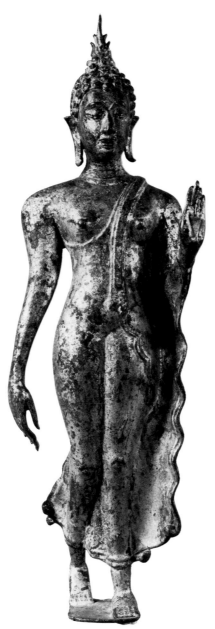

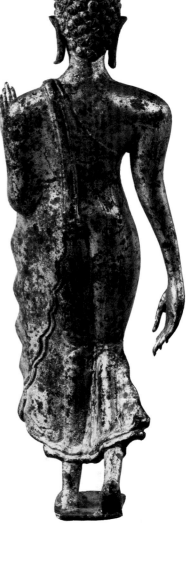

When Sukhothai artists created the walking Buddha as a freestanding icon, they must at times have intended it to represent the Descent from the Trayastrimsa Heaven, as Sukhothai period reliefs often represent this scene. It is likely, however, that the walking Buddha was also understood in a more general way as representing Sakyamuni's spiritual conquest of the world. It was during the Sukhothai period (13th–14th century) that the footprint of the Buddha (cf. no. 67) became especially popular, and there is a bronze Sukhothai image in the National Museum in Bangkok that shows a walking Buddha leaving his footprint behind. Thus, like his secular counterpart, the universal conqueror *(chakravartin)*, who marks his domain with the tracks of his chariot wheels, the walking Buddha has left his footprint across the Thai landscape as a symbol of his spiritual conquest.

—*R. L. B.*

121

Meditating Buddha
Korea; Yi dynasty, 16th century
Ink, color, and gold on silk
54½ × 26½ in. (138.5 × 67.3 cm.)
The Denver Art Museum

Surrounded by a flaming aureole and resplendent in his colorful robe, the Buddha is seated in the traditional meditative *(dhyana)* posture. Above him is a canopy decorated with banners, and below are the decorative lotus petals of his throne. Nearly half of the composition is devoted to an elaborate three-part pedestal with traditional roof tiles along the top and bottom tiers, in addition to hanging lanterns and numerous colorful surface decorations. Two muscular guardians occupy the center tier, and a pair of small children are placed at its sides. In the lower part of the pedestal a circle encloses a radiant palace, which sits atop a mountain.

Both the style and subject matter of this painting are unusual in later Korean art. Beginning with the Yi dynasty (1392–1910), Buddhism no longer enjoyed royal patronage, and most Buddhist paintings of this time lack the technical polish and fine brushwork usually found in examples done during the preceding Koryo period (918–1392) when Buddhism was the state religion. This work, however, exhibits some of this earlier quality in its accomplished brush technique, rich details, and the use of fine materials, such as gold pigment.

Even more remarkable than its style, however, is the painting's subject. Painted images of Sakyamuni are extremely rare in Korean art, as Amitabha came to dominate the pantheon. Several aspects of this work, however, suggest that it may be a portrayal of the historical Buddha, one of the very few known. All seated Korean Buddha images wear the prescribed patchwork robe, but in this instance the usual elaborate gold-painted roundels are absent (cf. no. 171). Instead, the humble patchwork garment is emphasized by bold outlines. The gesture of meditation *(dhyanamudra)* is also rare within the context of known Korean paintings of Buddhas. Typically, one finds the right hand raised in the gesture of reassurance *(abhayamudra),* although occasionally both hands are held in the teaching gesture *(vitarkamudra).* The likelihood of this being Sakyamuni is also indicated by the presence of the palace in the circle at the bottom of the pedestal. This represents Mount Meru, the cosmic pillar and the location chosen by Sakyamuni during a prior birth as the site of his final earthly life. As such, the cosmic mountain is associated with Sakyamuni and not with the celestial Amitabha. This painting is similar to contemporary Ming period (1368–1644) versions from China, and its fine technical quality may be the result of Chinese influence. By this time, Korean painting had shifted away from Buddhist subjects, and examples of this quality are seldom found. —*R. E. F.*

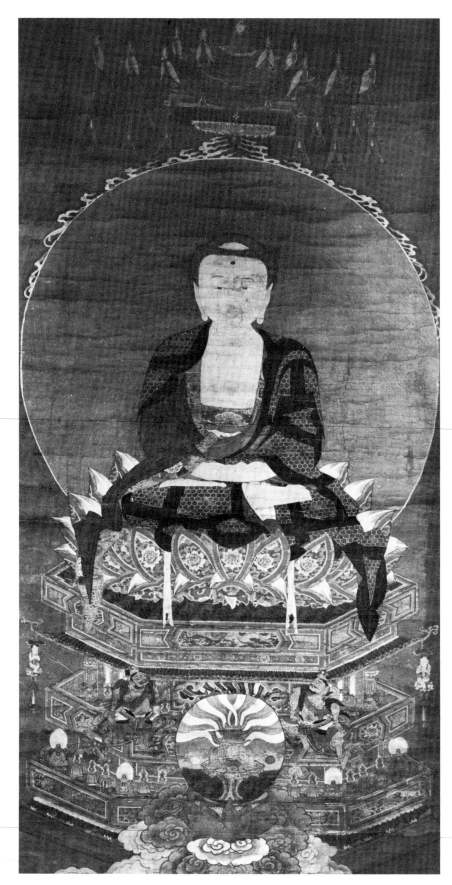

Head of the Buddha
Thailand, 17th century
Sandstone
h: 36 in. (91.4 cm.)
Los Angeles County Museum of Art,
Purchased with Funds Provided by
The Ahmanson Foundation, Mr. and
Mrs. Harry Lenart, and the Museum
Acquisition Fund

This monumental head once belonged to a larger-than-life-size image of the Buddha. It has already been mentioned that even in the earliest depictions, the Buddha was usually represented as larger than his companions. This practice was true of both reliefs and icons and was an obvious attempt to stress the Buddha's superiority. In addition, colossal images were set up in most countries where Buddhism predominated in order to awe the viewer with the Buddha's cosmic presence.

In Thailand, over-life-size images are known from the Dvaravati period (6th–11th century), but it was only after the foundation of the Thai capital at Ayutthaya in 1350 that colossal Buddha images became particularly popular. This Ayutthayan head, carved from solid stone, may have sat on the shoulders of a seated image of Sakyamuni, the body of which would have been made of brick and plaster. The entire figure would have been around fifteen feet high, not including a pedestal. It is also probable that the entire image would have been gilded, so that it would impart the impression of an enormous gold figure. Even by itself, this somewhat damaged head gives the viewer a sense of the grandeur such colossal images conveyed, and continue to convey, to their worshipers.

We are fortunate to have a description of Ayutthaya and its splendors, written by Joost Schouten, a Dutch traveler who visited Thailand in the seventeenth century. It is entirely possible that Schouten's travels brought him face to face with the Buddha whose head we see here. He recorded that the Thais

have every where great and little Temples and Cloysters for the service of their Gods; and the dwellings of their Priests. These Edifices are builded of Wood and Stone very Artificial and sumptuous, with gilded Towers and Pyramids; each of the Temples and Cloysters being filled with an incredible number of Idols, of divers materials and greatness, gilded adorned and beautified very rich and admirable; some of the Idol are four six, eight, and ten fathoms long; amongst the rest there is one of an unimaginable greatness, being one hundred and twenty foot high. *(Manley, p. 140)*

—*R. L. B.*

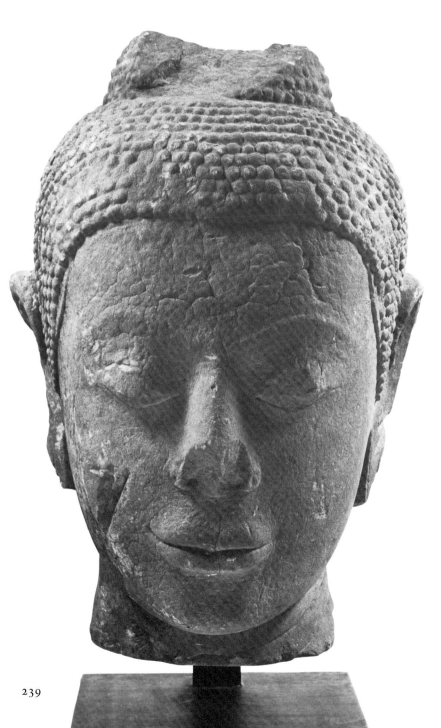

Buddha Sakyamuni
Korea; Yi dynasty, 17th–18th century
Stone with traces of polychromy
h: 7½ in. (19 cm.)
Mr. and Mrs. Robert Wm. Moore
Collection, Los Angeles

This small stone image exemplifies the Korean folk art tradition. It captures the humble and human qualities of Sakyamuni in its simple, almost primitive carving, and it has little in common with the refined elegance of the earlier gilt bronzes. Areas of the robe and body are reduced to simple planes, and the traditional cranial bump is merged with the head, thereby losing its distinctiveness. The curled hair is crudely carved, and the added indication of radiance, which is represented in earlier images as a glowing jewel at the base of the *ushnisha*, appears here as a simple lozenge form.

The use of the earth-touching gesture *(bhumisparsamudra)* with the right hand reaching over the knee became established in Korea by the mid-eighth century. This hand position had been represented on the famous Sokkoram Buddha of 751, which, by virtue of its size and imperial patronage, became a model for subsequent seated images. In India this particular gesture was associated with Sakyamuni's Enlightenment, but in Korea it appeared in representations of various Buddhas, including Amitabha. Its popularity was greater in Korea than in either China or Japan, and its widespread appearance came about at the same time that Korean monks began making pilgrimages to India. Perhaps during their travels these monks saw the great Buddha image at Bodhgaya and returned to Korea filled with enthusiasm for this seated pose and the earth-touching gesture.

—R. E. F.

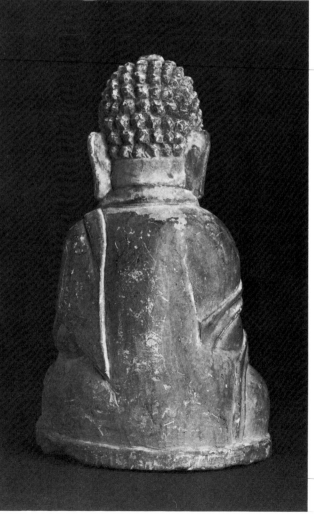

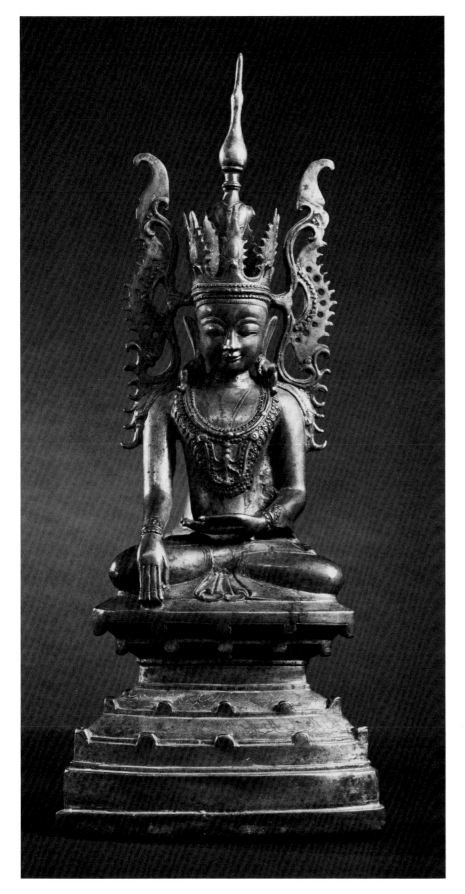

Buddha Sakyamuni
Burma, 18th century
Brass
h: 17¾ in. (45.1 cm.)
Ex Pan-Asian Collection, Property
R. H. Ellsworth Ltd.

The idea of a crowned and bejeweled
Buddha is not unusual in the con-
texts of Mahayana and esoteric Bud-
dhism. In predominantly Theravada
Burma, however, beginning around
the fourteenth century, the crowned
Buddha assumed a particularly inter-
esting form and meaning. These
Burmese crowned Buddha images,
like the Ellsworth bronze illustrated
here, are characteristically portrayed
as seated with their right hands held
in the earth-touching gesture. Over
his monastic robe, the Buddha wears
an extremely elaborate necklace
that covers his entire chest. In addi-
tion to the crown, a tall projection
appears on his head, which is an
elaboration of the lotus bud finial on
top of the cranial bump. Perhaps the
most original feature, and one that
adds greatly to the appeal of such im-
ages, is the openwork decoration on
each side of the head that represents
an ornate form of the projecting rib-
bons of the crown.

These Buddha images depict
Sakyamuni at a time when he trans-
formed himself into a universal
monarch in order to convert an
earthly king, Jambupati. Initially,
King Jambupati's pride and ambition
led him to refuse to listen to the
Buddha's teaching and caused him
to threaten to attack the realm of a
fellow king who was a follower of
the Buddha. In order to humble
Jambupati, the Buddha caused him-
self to be crowned and seated on a
beautiful throne in a great palace.
When Jambupati was brought before
the enthroned Buddha, he was over-
come; realizing his own insignifi-
cance, he converted to Buddhism.

The story of Jambupati does not
occur in the Buddhist literature of
India and Sri Lanka but only in that
of the Theravada Buddhist countries
of Southeast Asia—Burma, Thai-
land, Laos, and Cambodia. It has
been suggested that the story was
created in order to explain the exis-
tence of crowned Buddha images to a
Theravada Buddhist following, for
the Theravada Buddhists worshiped
almost exclusively the historical
Buddha, Sakyamuni, who by
convention should always be
dressed as a monk (Fickle, pp. 85–
119).

—*R. L. B.*

[It may be noted that in Indian
cosmology, one of the seven islands
into which the world is divided is re-
ferred to as Jambudvipa or the Island
of Jambu. India is said to be a part of
this island. Also relevant is the Bud-
dhist story of Sakyamuni's trance
under the *jambu*, or rose apple, tree
(no. 33).—*P. P.*]

125

Buddha
Sri Lanka, 18th century
Ivory with polychromy
h: 13¾ in. (34.9 cm.)
Los Angeles County Museum of Art,
Purchased with Funds Provided by
the Julian C. Wright Bequest

The landing of the Portuguese in Sri Lanka in 1505 began a long period of political and religious instability on the island. The Portuguese were followed by the Dutch and, finally, by the British. During this era of European colonization, periodic persecution of Buddhists occurred with an accompanying deterioration of the Buddhist monastic order *(sangha).* As a result, the Sinhalese had to request in 1753 that a delegation of monks from Thailand be sent to Sri Lanka to renew the proper line of ordination. The Thais could perform this task with a sense of reciprocity, as they had received their own ordination line from the Sinhalese in the thirteenth century.

Buddhist art in Sri Lanka became decadent during this late period, paralleling the general decline of Buddhism. This was particularly true in the areas of Sri Lanka controlled by the Europeans. The kingdom of Kandy, however, which was relatively isolated and located among hills at the center of the island, retained its independence some two centuries longer than the other Sinhalese kingdoms and was not conquered by the British until 1815. It was at Kandy that Buddhist art continued to be produced and evolved into an individual style.

This handsome painted ivory Buddha image is an excellent example of the Kandy style, which may be most readily identified by the delicate wavy pattern covering the robe. The characteristics of the Sinhalese Buddha seen in the three earlier seated images (nos. 80, 89, and 101)—the extremely erect stance, serious expression, and regal bearing— remain, but they have become stylized. The interest in decorative pattern is also very apparent, particularly in the right hand, which displays the teaching gesture *(vitarkamudra).* The fingers of this hand are twisted into an anatomically impossible position, so that the auspicious patterning of the palm will be shown to advantage.

—*R. L. B.*

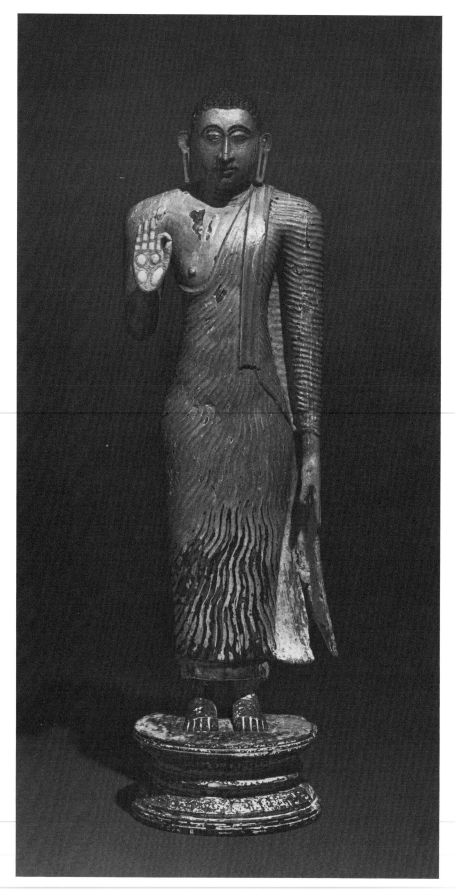

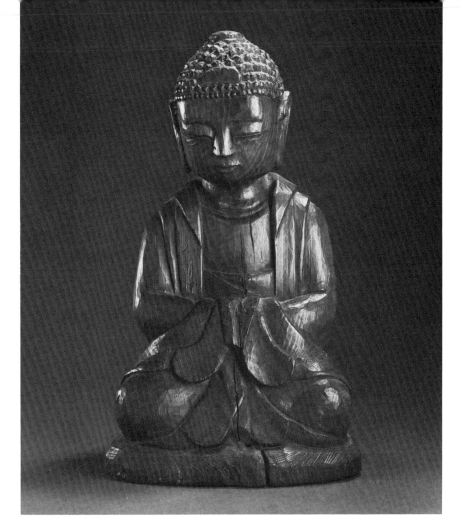

Meditating Buddha
Korea; Yi dynasty, 19th century
Polished wood
h: 13¹³⁄₁₆ in. (35 cm.)
Mr. and Mrs. Robert Wm. Moore
Collection, Los Angeles

Wood was a popular medium for the creation of Buddha images, but few examples remain because of the many threats this material is subject to. Due to the shift to Confucianism, which occurred in Korea at the beginning of the Yi dynasty (1392–1910), Buddhism no longer enjoyed the royal patronage that had characterized earlier epochs. Although Buddhist paintings and sculpture continued to be produced, they now fell into the general category of folk art. The simplicity and directness of these folk images often captured the humility and innocence of the historical Sakyamuni more effectively than the more hieratic and elaborate images of prior eras. In this late version, the downcast gaze, simple kneeling pose, and childlike expression are reflective of Sakyamuni in ways that were not explored during the periods of Buddhism's greatest popularity. No longer remote and regal, Buddha once again assumes a simple and earthly form.

—R. E. F.

(a) *Crowned and Jeweled Buddha
Sakyamuni*
Thailand, 19th century
Gold
h: 9⅞ in. (25 cm.)
National Museum, Bangkok

(b) *Buddha Sakyamuni*
Thailand, 19th century
Rock crystal, gold, and enamel
h: 7¼ in. (18.5 cm.)
National Museum, Bangkok

Both of these small Buddha images were made in the period after the Thai capital was moved to its present location of Bangkok in 1782. The Bangkok period, known in Thai as the Ratanakosin (Jewel of Indra) period, extends up to the present. The art of this age has been characterized by great diversity, and many stylistic and iconographic innovations have been initiated by the devout Buddhist kings of the Cakri dynasty (1782–present). The general trend, however, has been an emphasis on decoration and a concomitant decline of concern for the figure. These tendencies have frequently resulted in rather uninspired images of the Buddha.

The interest in decoration is well represented by these two images. In each example, the artist has placed the Buddha figure on a high base covered with lovely patterns and in the case of the crystal Buddha (b), inset with enamel. The Bangkok period artists' penchant for decoration is probably most obviously revealed by the crowned Buddha (a) whose body has all but disappeared under an encrustation of decorative patterns. This type of Thai Buddha, like the Burmese crowned Buddhas, is related to the story of Jambupati (see no. 124).

The crystal Buddha (b) wears the familiar monastic dress and in its simplicity and translucence provides a pleasant contrast to its elaborate pedestal. The use of crystal and other semiprecious stones for carving Buddha images occurred in all areas of Asia, although relatively few examples are extant, due to their fragility and the value of the material, which can be reused for other purposes.

Buddha images made of semiprecious stones seem to have had a special significance during the Bangkok period. The most venerated icon in Thailand today is the famous Emerald Buddha, installed in the Wat Phra Keo (Temple of the Emerald Buddha) in Bangkok. This image, which is about 75 centimeters high, is not made of emerald but of jade or perhaps jasper. The great reverence felt for this icon contributes to the present appeal of images made from semiprecious stones.

—*R. L. B.*

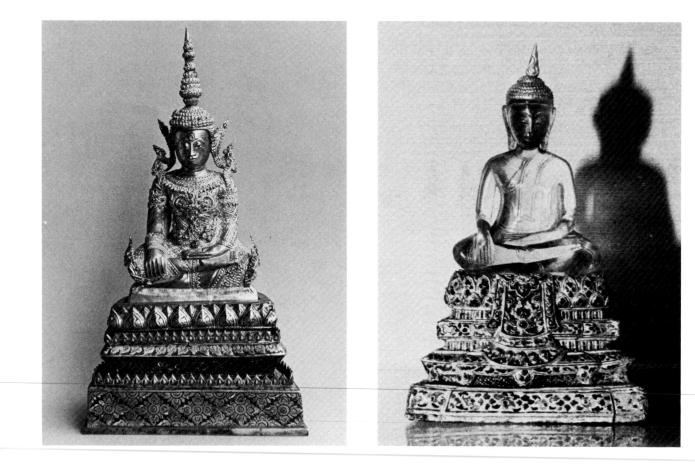

Thomas Daniell (English, 1749–1840)
Two Drawings of Buddha Images,
1789–90
Pencil and ink wash on paper
a) 6½ × 8⅝ in. (16.5 × 22 cm.)
b) 10⅛ × 7½ in. (25.7 × 19 cm.)
Paul F. Walter

Thomas Daniell is a well-known name in the history of British art produced in India. Daniell and his nephew William visited India together between 1786 and 1794, and they have left a vast number of sketches, drawings, prints, and paintings documenting their travels. Especially fascinating for historians of art and architecture are the Daniells' remarkably accurate renderings of ancient monuments.

The two drawings included here were probably done during a trip across northern India in 1789 and 1790. Traveling north up the Ganges River from Calcutta, Daniell and his nephew visited Banaras in November 1789 and Bodhgaya in March of the following year. The profile of the Buddha's head (a) may have been sketched at Sarnath, as the style of the face suggests that the model originated there. The treatment of the head shows how perceptive an observer Thomas was, for he did not draw curls at the back—following the practice of the Indian sculptors, who left this area bare. The separate sketches show that the Buddha's curls clearly intrigued the artist. It is noteworthy that these curls turn in the reverse of the usual clockwise direction. This may not have been an error on Daniell's part, however, as sculptures representing the Buddha's curls turning toward the left did occur.

The second drawing (b) represents an image of the Buddha's Enlightenment, and it may have been based upon the sculpture that was enshrined in the main temple at Bodhgaya. Characteristically, Daniell has meticulously delineated all the salient details, including the thunderbolt emblem near the Buddha's right foot. He has even noted the subtle differences between the two bodhisattvas flanking Sakyamuni. All three figures, however, are much more naturalistically rendered than the abstracted human figural type typically employed by Indian artists to depict the Buddha. Especially striking are the muscular arms, clearly reflecting Daniell's European training, and even the lion on the base seems to be taken directly from the British royal insignia.

—*P. P.*

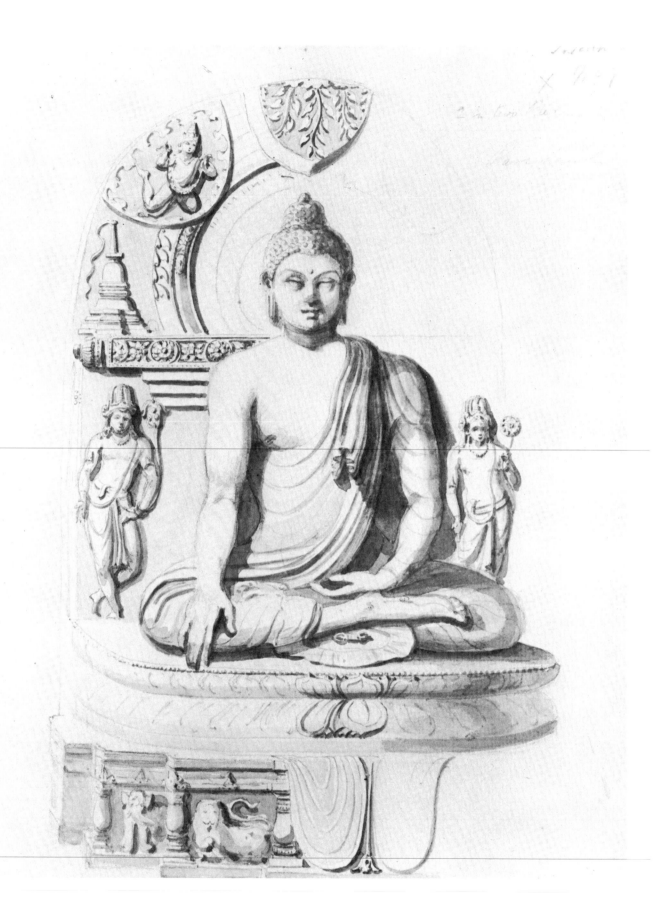

129

Paul Gauguin (French, 1848–1903)
Te Atua (The Gods), 1891–93
Woodcut
8 × 13¾ in. (20.3 × 34.9 cm.)
The Art Institute of Chicago, Joseph Brooks Fair Collection

European artists and writers working in the second half of the nineteenth century showed considerable interest in Asian art and religion. Their concern was part of a general trend of discovery and reevaluation of non-Western cultures. During this period ethnologists published studies of African, Oceanic, Pre-Columbian, South Asian, and Southeast Asian peoples. These scholars frequently returned from their research trips with art objects which they deposited in Europe's newly formed ethnological museums, often making such material available to Western artists for the first time. In the great Paris Exposition of 1889, a good deal of space was devoted to this "primitive" art, and both Odilon Redon and Paul Gauguin were impressed and inspired by these displays.

The Southeast Asian art included in the Exposition so influenced Gauguin that he decided to apply for a position with the French government in Tonkin (present-day North Vietnam). This would not have been his first visit to Asia, however, as he had traveled to India as a youth in the merchant marine. The inspiration Gauguin hoped to derive from living in Southeast Asia is expressed in one of his letters:

> All of the Far East, the great philosophy written in letters of gold in all their art, all that is worth studying and I think I will be reinvigorated out there. The West is rotten today and any Hercules can, like any Antaeus, draw new strength from the ground in that part of the world. *(Teilhet-Fisk, p. 10)*

It is clear from this excerpt that Gauguin perceived the Far East as one essentially undifferentiated artistic and philosophical area. He considered European civilization bankrupt and looked to Asia as an uncontaminated source for artistic and spiritual revitalization.

Gauguin did not receive the Southeast Asian post he sought, and this disappointment eventually led to his well-known move to Tahiti. The woodblock *Te Atua* was carved in France after Gauguin's first stay in Tahiti, and it combines Polynesian and Asian symbolism. In the print, the Buddha sits in a yogic posture at the center; he holds his right hand in his lap while assuming the earth-touching gesture with his left. The immediate artistic source for this Buddha image appears to be a relief scene depicting the assault of Mara that is found at Barabudur in Java. The artist took photographs of this particular relief with him to Tahiti.

Gauguin has changed the Javanese model considerably, however, most obviously in the addition of the long hair. This may have been an attempt to give the image an androgynous character in conformity with Gauguin's conception of the androgyne as a symbol of divinity (Teilhet-Fisk, pp. 50 and 52–53).

The two gods to the left of the Buddha are Hina, the Tahitian goddess of the moon, and Tefatu, the god of the earth. The standing idol on the right is also a representation of Hina. This grouping of Polynesian and Buddhist gods is intended to suggest their syncretic and interchangeable nature. Following the theosophical philosophy of the time, Gauguin believed all religions could be combined to express one ultimate truth. Gauguin's woodcut was intended to illustrate his autobiography *Noa Noa*.

—*R. L. B.*

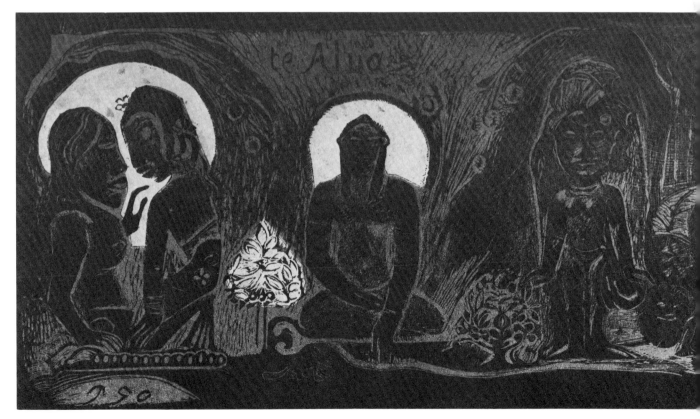

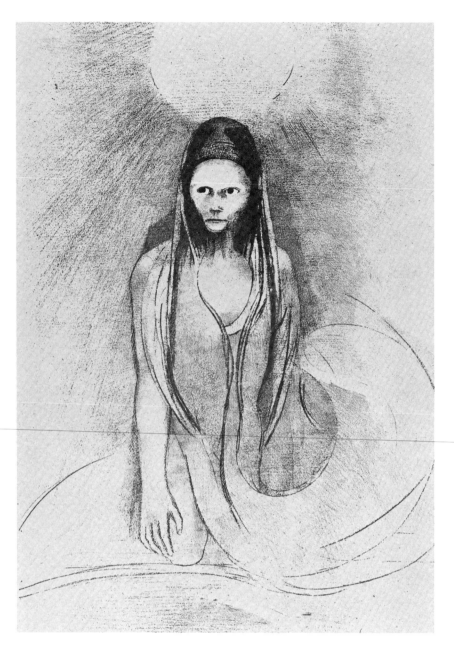

ening into an azure tint, twist symmetrically around a protuberance at the top of his head. His arms, of great length, fall straight down his sides. His two hands, with open palms, rest evenly on his thighs. *(Flaubert, p. 104)*

In the course of the book, the Buddha recounts his life and in so doing brings all the listening gods to a low bow.

Having vanquished the demon, I passed twelve years nourishing myself exclusively on perfumes;—and as I had acquired the five virtues, the five faculties, the ten forces, the eighteen substances, and penetrated into the four spheres of the invisible world, the Intelligence was mine, and I became the Buddha! *(Flaubert, p. 107)*

Unlike Gauguin's Buddha, Redon's does not follow any specific Asian model. Instead, he has imaginatively used Flaubert's description, interpreting the vibrating circle as a sun and making the protuberance on the Buddha's head resemble a round hat. The artist deviated considerably from the description, however, in showing the figure kneeling and wearing a veil and robe. While the images in the two prints vary considerably, both Gauguin and Redon shared a vision of the Buddha that, although not historically accurate, inspired remarkable works of art.

—*R. L. B.*

130

Odilon Redon (French, 1840–1916)
L'Intelligence fut à moi! Je devins le Bouddha (The Intelligence Was Mine! I Became the Buddha), 1896
(1933 edition)
Lithograph
12⅟₁₆ × 8½ in. (31.3 × 21.6 cm.)
Los Angeles County Museum of Art, Gift of Mr. and Mrs. David Gensburg

Like the Gauguin woodcut (no. 129), this lithograph by Odilon Redon was used as an illustration for a literary work, in this case Gustave Flaubert's popular *La Tentation de Saint Antoine (The Temptation of Saint Antony)*. The title of the print is taken directly from Flaubert's text, which also inspired much of the imagery. The Buddha is described as:

A naked man...,seated in the middle of the sand with his legs crossed. A large circle vibrates, suspended behind him. The little curls of his black hair, deep-

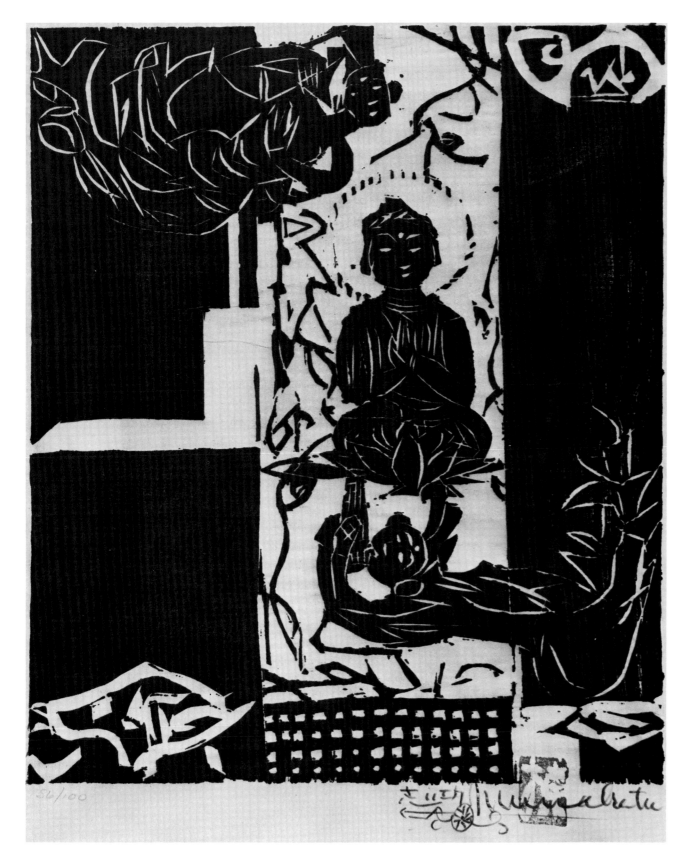

56/100

Munakata Shiko
(Japanese, 1903–1975)
Shaka Nyorai and Attendants,
20th century
Woodblock print
13⅞ × 11½ in. (35.2 × 29.2 cm.)
Los Angeles County Museum of Art,
Gift of Mr. and Mrs. Assa Drori

[Munakata] is perhaps the most widely acclaimed of Japan's modern print masters and has been designated by his government as a Living National Treasure. His works compare to medieval Buddhist folk prints with strong black and white forms produced by a single woodcut. (Kuwayama, p. 48)

Many of Munakata's prints are devoted to traditional Buddhist subjects and are noted for their simplicity and spontaneity. In this regard, they seem to have reflected Munakata's own character, which Hugo Munsterberg has affectionately described as "reminding me of those mad Zen fools Kanzan and Jittoku who laughed in the same manner and behaved in a strange and eccentric way, oblivious of convention and etiquette" (1972, p. 4).

Although Munakata's Buddhist prints are often compared to medieval Japanese woodblock prints, they are remarkable less for their meticulously worked and complex designs than for their spontaneous, intuitive style, which is more in keeping with the work of Zen painters. Indeed, the prints convey the feeling of brushwork.

In the Los Angeles print, two joyous heavenly musicians *(gandharvas)* float in front of the seated figure of Sakyamuni (Shaka Nyorai). The subject is readily apparent, and Munakata's figures have an association with Japanese folk images comparable to the carvings of the priest-sculptor Enku (1635–1695).
—A. G. P.

250

IV TRANSCENDENTAL AND COSMIC BUDDHAS

The conduct of the Exalted One is transcendental, his root of virtue is transcendental. The Seer's walking, standing, sitting and lying down are transcendental.

The Sugata's body, which brings about the destruction of the fetters of existence, is also transcendental. Of this, my friends, there should be no doubt. (Jones, vol. 1, p. 132)

There is no distinction between any of the Buddhas in physical beauty, moral habit, concentration, wisdom, freedom, cognition and insight of freedom, the four confidences, the ten powers of a Tathagata, the six special cognitions, the fourteen cognitions of Buddhas, the eighteen Buddha-dhammas [Buddha-religions], in a word in all the dhammas of Buddhas, for all Buddhas are exactly the same as regards Buddha-dhammas. (Conze et al., pp. 109–110)

TRANSCENDENTAL AND COSMIC BUDDHAS

THE TWO PASSAGES quoted above are from the *Mahavastu* and the *Milindapanha*, or *The Questions of King Menander*, respectively. The latter is a unique Buddhist philosophical text that was written in the form of a dialogue between the monk Nagasena and King Menander, an Indo-Greek monarch who ruled Bactria and parts of northwest India in the first century B.C. These quotations indicate the belief that there are innumerable Buddhas and assert that there is no distinction, either physical or psychological, between one Buddha and another. This profound change in the concept of the Buddha had taken place before the time of Menander.

The early proponents of the transcendental nature of the Buddha were known as Mahasamghikas (Great Assemblists). As a group, the Mahasamghikas were more democratic than the Theravadins (Elders). This latter group believed that only a monk could hope to attain enlightenment and consequently paid little attention to the layman. The Mahasamghikas had a more liberal outlook concerning the lay follower and also a fundamentally different concept of the Buddha. They declared that the Buddha was not merely a historical figure but a supramundane *(lokattara)* being: perfect, immeasurable, and omniscient. They also asserted that the Buddha's length of life is unlimited due to his accumulated past merits. The theory that the Buddha had had past lives in which he accumulated merit was obviously influenced by the belief in the doctrines of karma and rebirth, which are as fundamental to Buddhism as they are to other Indian religious systems. Thus, the Mahasamghikas claimed that before becoming a Buddha, Sakyamuni passed through numerous previous existences in a wide variety of forms, both human and

animal. The accounts of these previous lives were known as *avadanas.* Although the Theravadins did not accept the idea of a supramundane or divine Buddha, they too believed in the theories of karma and rebirth and introduced stories about the previous lives of the Buddha known as *jatakas.*

Structurally there is little or no difference between an *avadana* and a *jataka.* Both are simple folk-tales, some of which were current before the time of the Buddha, while others were probably invented by pious Buddhists. In each type of story, the Buddha is invariably virtuous, performing a noble act as a result of which he is born on a higher plane of existence in his next life. It must be stressed, however, that these stories by no means constitute a chronological sequence.

In one *avadana,* we are told that the Buddha Sakyamuni was born as the brahmin Sumedha during the period when an earlier Buddha named Dipankara appeared on earth. Determined to attain merit and thus become a Buddha in the future, Sumedha spread his long hair on the ground so that Dipankara Buddha's step would be cushioned. In view of this act of piety, Dipankara Buddha predicted that Sumedha would be born as Buddha Sakyamuni. Altruism and self-sacrifice are two of the most important virtues exalted in the *avadanas* and *jatakas.* This emphasis on altruism, along with universal compassion, became the focal point of the bodhisattva ideal of Mahayana Buddhism.

Belief in the transcendental nature of the Buddha was of fundamental importance not only for the religion but also for Buddhist art, as it cleared the way for the introduction of the image of the Buddha. The Buddha was no longer considered merely a historical figure; he had become a spiritual principle. His body or image was not that of an ordinary human; instead, like the stupa, it had evolved into a symbol of the religion itself (cf. nos. 68 and 69). Thus, even the earliest images of the Buddha from Mathura and Gandhara represent an idealized divine being and not merely the historical Sakyamuni (see nos. 74 and 75). Significantly, even within the context of naturalistic life scenes from Gandhara, the Buddha is consistently portrayed as a larger-than-life figure. The Mahasamghikas tell us that even in the womb, the Buddha sat cross-legged and preached to the gods, and he issued out of the womb through the right side of Maya's body without piercing it. Similarly, the Buddha took seven steps immediately following his Birth in order to announce his cosmic nature; the sage Asita noticed the thirty-two signs of a superman *(mahapurusha)* on the infant; and Sakyamuni ultimately achieved Enlightenment below the tree of knowledge *(bodhidruma),* which is also the cosmic pillar. Later in life, Buddha Sakyamuni performed various miracles that emphasized his supernatural powers. Among these, the Multiplication Miracle at Sravasti and the Descent from the Trayastrimsa Heaven by a ladder have definite cosmic connotations (nos. 53 and 54).

Paralleling the concept of the Buddha Sakyamuni's innumerable previous existences as a bodhisattva, it was believed that many other Buddhas had existed in the past (see no. 137). They had appeared during various cycles and in various worlds to preach the same religion. The Mahayana Buddhists expanded this concept even further, and Buddhas became as numerous as the grains of sand on the banks of the Ganges. These Buddhas were represented both in painting and sculpture in certain significant numeric groups—five, nine, thirty-five, or a thousand being among the most common. The group of thirty-five, for example, constituted the Buddhas of Confessions of Sins. These Buddhas were invoked by monks who gathered periodically to confess their sins in public and repent. Among these past Buddhas, the most particularized in art were

Dipankara, whom we have already mentioned, and Prabhutaratna, who suddenly made his appearance in a text called the *Saddharmapundarika (The Lotus of the True Law)*, a Mahayana work that was especially popular in China. Hence, Prabhutaratna appears predominantly in Chinese Buddhist art (no. 141) and less frequently in Korean representations (no. 142).

While there were countless Buddhas of the past, Sakyamuni is the only Buddha of the present age. Furthermore, only one Buddha of the future is named in texts, although we may assume that the cycle of the appearance of Buddhas on earth will be repeated endlessly. The Future Buddha is Maitreya, who presently awaits his turn in the Tushita Heaven. As he is the potential Buddha, he is portrayed both as a bodhisattva and as a Buddha in artistic representations. Although Maitreya images are found in all Buddhist countries, and he was accepted by all Buddhist sects, his cult appears to have thrived especially in China and Korea. Throughout the history of Chinese Buddhism, Maitreya's appearance was regarded as much more imminent than it was in India or elsewhere. The Maitreya cult was particularly popular during the Northern Wei dynasty (386–535), when it was hoped that "Maitreya would make use of that dynasty to pacify and unify the world" (Ch'en, p. 178).

Indeed, the peculiar development of the Maitreya cult in China, both among orthodox Buddhist and heretical sects, comprises a fascinating chapter of popular Buddhism in that country. It is also an instructive story of the manner in which Buddhism was accepted at a popular level in different locales. Apart from satisfying the general desire for the immediate appearance of the Future Buddha, the Maitreya cult often served as the focal point for both heretical religious sectarianism and dissenting political movements that frequently took a violent turn. From time to time, self-proclaimed Chinese political leaders declared themselves to be the Future Buddha and made abortive attempts to usurp power. The Hopei area in northeastern China seems to have been a particularly fertile breeding ground for the heretical and militant Maitreya cult. The consistent refrain of the Maitreya sectarians appears to have been the assertion that "Sakyamuni Buddha has declined, Maitreya Buddha shall rule the world." A parallel development occurred in Korea where the Maitreya cult was closely associated with a group known as the *hwarang* (see the essay on the Buddha image in Korea in section three of the catalogue).

Another Buddha who was venerated by all Buddhist sects was Bhaishajyaguru, the Healing Buddha. In reality, however, Bhaishajyaguru was simply a manifestation of Buddha Sakyamuni himself in his role as the Supreme Physician (see no. 145). According to tradition, the Buddha was remarkably healthy, and even at the age of seventy-nine, he is said to have swum across a river, thereby surprising his weaker disciples. It may also interest modern nutritionists to know that the Buddha was a concerned dietician who stressed proper health care. It was for the maintenance of good health that he proscribed the taking of evening meals by monks.

> I, monks, do not eat a meal at night. Not eating a meal at night, I, monks, am aware of good health and of being without illness and of buoyancy and strength and living in comfort. Come, do you too, monks, not eat a meal at night. *(Birnbaum, p. 4)*

In a recent and thorough study of the concept of the Healing Buddha, Raoul Birnbaum pointed out that healing is discussed from three points of view in Buddhist texts: "(1) The cure of disease through healing agents (herbs and foods), surgery, and other physical means; (2) spiritual causes and cures of diseases; and (3) the healing process as a metaphor for spiritual growth, with the Buddha named as Supreme Physician and the Buddhist teachings termed the King of Medicines"

(Birnbaum, p. 3). It may be recalled that confrontations with a sick man and a corpse were among the encounters with human suffering that initially led young Siddhartha to renounce the world and seek the means to escape the cycle of rebirth.

Although several Sanskrit texts were composed about the concept of the Healing Buddha and bodhisattvas, images of Bhaishajyaguru are rare on the Indian subcontinent. His complexion is usually described as the color of lapis lazuli, and it is therefore possible that some of the dark-complexioned Buddhas depicted in the caves at Ajanta in west central India may represent Bhaishajyaguru. The distinctive emblem of this Healing Buddha is the myrobalan, which he holds in his right hand. The yellow myrobalan, *Terminalia chebula* (*haritaki* in Sanskrit), is an astringent fruit that is highly regarded for its medicinal properties in Indian pharmacology. It is also an essential element in many religious and social rituals.

The cult of the Healing Buddha flourished especially in China, Japan, and Tibet. The popularity of the cult in China is evident from both the number of related texts translated into Chinese and the large quantity of copies of the *Bhaishajyagurusutra* found in Chinese Central Asia, especially at Dunhuang in Gansu. The cult appears to have gained a special popularity in China after the translation of this sutra by Xuan Zang [Hsuan Tsang] (c. 596–664), the famous Chinese pilgrim and scholar who visited India in the first half of the seventh century. Painted and sculptured representations of Bhaishajyaguru from China are also abundant.

Less than a century after Xuan Zang's return from India, the most impressive temple ever dedicated to Bhaishajyaguru was built in Japan. The Yakushiji in Nara was constructed in the year 730, and its Golden Hall contains what may be the largest bronze image of the Healing Buddha. Ever since that time, Bhaishajyaguru (Yakushi in Japanese) has remained a popular Buddha in Japan, along with Sakyamuni and Amitabha (see no. 148).

Bhaishajyaguru also continues to be a popular figure in Tibet, perhaps due to the great interest in medicine and healing among the Tibetans. The cult may have entered Tibet from Central Asia, or it may have come directly from the Kashmir-Gandhara region where it originated. The earliest Tibetan *thankas* depicting Bhaishajyaguru, however, do not date earlier than the fifteenth century (no. 149).

The last group of transcendental Buddhas that requires explanation is the pentad of Mahayana and Vajrayana Buddhism. The five Buddhas comprising this group are: Amitabha (Infinite Light), Akshobhya (Imperturbable), Amoghasiddhi (Infallible Success), Ratnasambhava (Jewel Born), and Vairochana (Resplendent). Vairochana also means "The Son of Virochana" which is a synonym for the sun. All these names are actually nothing more than epithets applicable to Buddha Sakyamuni himself. Three of the Buddhas—Amitabha, Akshobhya, and Vairochana—appeared early in Mahayana Buddhism and remained the focal point of individual cults. In Vajrayana Buddhism, each of these five figures is regarded as the head of a family of deities and is often represented on the crown of a deity who belongs to his particular family.

The earliest of the five Buddhas to appear was Amitabha, whose independent cult gave rise to what is known as the Pure Land school of Buddhism in China, Korea, and Japan. Also known as Amitayus (Infinite Life) and as Amida in Japan, Amitabha has remained as important as Sakyamuni in East Asia.

It seems probable that like the concept of Bhaishajyaguru, the cult of Amitabha originated in Gandhara in northwestern India (present-day Pakistan). Around the time of the birth of Christ, Gandhara was a very cosmopolitan region where Bactrian Greeks, Roman traders, Iranians, Scythians, Parthians, and various other Central Asian peoples commingled with the native population. It is possible that the cult of Amitabha developed in this syncretic cultural milieu and absorbed elements from Zoroastrianism, as well as cults of solar and luminous deities.

The most important aspect of the Amitabha/Amitayus cult was its emphasis on the concept of the Western Paradise. It was believed that devotion to Amitabha/Amitayus would lead not to nirvana but to a permanent residency in the Sukhavati (Land of Bliss, Happy Land, or Pure Land). In texts such as the *Sukhavativyuha*, the prospect of being reborn in the Pure Land was presented with seductive imagery in unabashedly utopian terms. As the Buddha himself tells Ananda:

> This world Sukhavati, Ananda, which is the world system of the Lord Amitabha, is rich and prosperous, comfortable, fertile, delightful and crowded with many Gods and men. And in this world system, Ananda, there are no hells, no animals, no ghosts, no Asuras [non-gods], and none of the inauspicious places of rebirth. And in this our world no jewels make their appearance like those which exist in the world system Sukhavati. *(Muller, p. 33)*

In the Sukhavati, one can gratify one's physical desires, enjoy perpetual spring in delightful surroundings, live in sumptuous palaces, and in short indulge in all those luxuries that the average person merely dreams of. It is not difficult to see why such a goal would be far more desirable to the ordinary man than nirvana with its emphasis on emptiness. Besides, in this form of Buddhism, all one needed was faith in Amitabha and his spiritual son, the bodhisattva Avalokitesvara, and salvation was assured.

In the *Sukhavativyuha* the Buddha Sakyamuni assures his disciple Ananda that Amitabha himself will descend with his retinue at the time of a devotee's death to personally escort him to Sukhavati, if only the devotee thinks of Amitabha and prays to him (see no. 174). So intense is the power of faith in Amitabha that even the mere mention of his name is considered sufficient to gain entry into the Pure Land. This is the origin of the Sino-Japanese practice of chanting the *Nembutsu*, which requires the devotee to continually repeat the formula "obeisance to Amitabha Buddha" ("Namu Amida Butsu" in Japanese) over a period of ninety days.

Indeed, how pervasive the Pure Land cult had become in China by the Tang period (618–906) can be gauged by comparing dedicatory inscriptions at the rich Buddhist site of Longmen. Between the years 495 and 575, fifty inscriptions were dedicated to Sakyamuni and nine to Amitayus. During the Sui (581–618) and the Tang periods, however, Sakyamuni was the object of eleven inscriptions while one hundred twenty-five were dedicated to Amitabha/Amitayus. Most of the inscriptions conclude with the pious wish that the donor may be reborn in the Pure Land or be present when the Future Buddha Maitreya appears in the world. From China, Pure Land Buddhism first spread to Korea and then to Japan, where it continued to flourish and inspired some of the finest examples of Japanese Buddhist paintings. Although all five Buddhas, as well as Sakyamuni and Maitreya, have their paradises, none is as well known as that of Amitabha.

In Vajrayana Buddhism, especially in the more advanced level of Yogatantra, all five Buddhas play an important role in various consecration rituals involving mandalas. In addition, one or the

other of the five may preside over a specific mandala. For instance, in Japan the Vajradhatu Mandala (Mandala of the Diamond Essence) is of particular importance, and it is presided over by Vairochana, or Dainichi as he is called in Japan. (Vairochana may also have been intended in the representation of the Supreme Buddha in the great stone mandala at Barabudur in Java and is certainly the most important figure in the iconographic scheme of the murals of Alchi in Ladakh in northern India.)

It should be remembered that, by and large, the Buddhas of the pentad are simply different emanations of the Buddha Essence or the Cosmic Buddha. This is affirmed by the fact that they symbolize the four cardinal directions and the center of the universe, as well as representing the five basic elements (earth, water, fire, air, and ether). When a Vajrayana priest sits down to perform a Yogatantra ritual, he wears a crown embellished with images of the five Buddhas, thereby identifying himself with the cosmic principle. Tantric Buddhism, in the higher stages of practice, lays particular emphasis on the reintegration of the adept with the Ultimate Consciousness, or the Manifest Complete Buddha. According to Vajrayana Buddhist theories, even Buddha Sakyamuni had to go through five special stages of *abhisambodhi* (revelation-enlightenment) involving five different initiations in order to become a Manifest Complete Buddha. In each of these stages of enlightenment, he became homologized with one of the five Buddhas. Only thereafter was he successful in eliminating the "subtlest observations of the knowable and attained the union beyond learning" (Lessing and Wayman, p. 39).

Perhaps the most significant innovation of the Buddhism of faith was the assertion that all beings are potential Buddhas. For example, we are told that "the body of the Perfect Buddha irradiates everything, [and therefore] at all times have all living beings the Germ of Buddhahood in them" (Conze et al., p. 181). The later mystical teachers of Buddhism, many of whom lived between the seventh and eleventh centuries, lamented the fact that most sentient beings were unaware of their potential Buddha nature and were much too involved with meaningless rituals and weighty scriptures. As one such mystic called Saraha (7th century?) pointedly remarked:

All these pandits expound the treatises,
But the Buddha who resides within
The body is not known.

.

"This is myself and this is another."
Be free of this bond which encompasses you about,
And your own self is thereby released.
Do not err in this matter of self and other.
Everything is Buddha without exception.
Here is that immaculate and final stage
Where thought is pure in its true nature.
(Conze et al., pp. 233–38)

Pratapaditya Pal

Entries no. 132 through 179 are arranged in groups as follows:

132–35	*Jataka* Tales
136–39	Multiple Buddhas and Buddhas of the Past
140–47	Buddha Sakyamuni's Transcendental Manifestations
148–49	The Healing Buddha
150–55	Idiosyncratic Representations
156–74	The Transcendental and Cosmic Buddhas of Mahayana and Vajrayana Buddhism
175–79	The Future Buddha, Maitreya

132

Buddha Sakyamuni with Jataka Scenes
Tibet, 1573–1619
Opaque watercolors on cotton
26½ × 18 in. (67.3 × 45.7 cm.)
Zimmerman Collection

Several hundred *jatakas*, or stories of the Buddha Sakyamuni's previous lives, are known to exist (see Cowell). Each of these tales recounts one of Sakyamuni's numerous births as a bodhisattva, his performance of a good deed, and his subsequent rebirth on a higher level. Not only was the Buddha previously incarnated as a human, he was also reborn at various times as an animal, bird, or aquatic creature. *Jatakas* were represented in reliefs at Bharhut in India as early as the second century B.C. and remained a popular subject, especially in the murals and paintings on cloth that were executed in the monasteries of most Buddhist countries. Both of these forms of art are easily destroyed in tropical countries, however, and as a general rule only later examples have survived.

This *thanka* represents the earliest extant example of a type of *jataka*

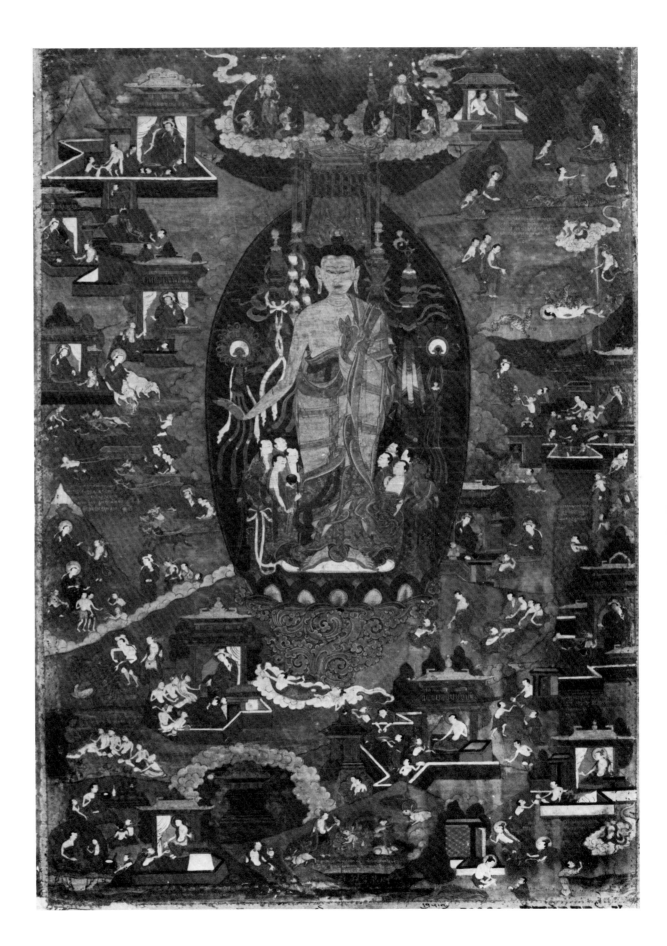

painting that was very popular in Tibet. A Chinese inscription at the bottom of the painting indicates that the series belonged to the Ming emperor Wanli [Wan-li] who ruled from 1573 until 1619. As is usual in *thankas* of this type, the *jataka* tales are represented in a landscape setting arranged around the commanding central figure of Sakyamuni. In this particular example, Sakyamuni stands on a lotus, surrounded by various banners and symbols, and appears gigantic when compared to the bodhisattvas and monks who huddle near his legs.

Space will not permit an identification of all the *jatakas* that are represented in this *thanka*; we will therefore confine ourselves to a description of two of the most poignant stories. The well-known tale of the hungry tiger, which is included in both *jataka* and *avadana* texts, appears in the upper right-hand corner. This story relates that in a previous life the bodhisattva happened upon a hungry tigress who was considering eating her own cubs. In order to save the cubs, the bodhisattva offered himself as a meal for the tigress.

The other *jataka* involves Sakyamuni's self-sacrifice during a prior incarnation as a hare; it is represented at the bottom center of the painting. Some versions of this story state that the hare lived in the woods with an ascetic. One day when the ascetic had no food, the hare told him to light a fire and plunged into it so that the ascetic could consume him. In a more elaborate version of the same *jataka*, the hare is said to have lived with a jackal and an ape. One day the god Indra, in the guise of a brahmin, came to test the three and demand food. Unlike the jackal and the ape, who had spare food to offer, the hare had nothing, so he piously jumped into the fire, asking Indra to eat his roasted flesh.

—*P. P.*

133

Buddha Sakyamuni with Jataka Tales
Tibet, c. 1700
Opaque watercolors on cotton
25⅝ × 16⅝ in. (65.2 × 42.2 cm.)
Mr. and Mrs. John Gilmore Ford
(Reproduced in color)

Jataka and *avadana* tales formed part of Buddha Sakyamuni's discourses, and he would often recite them during his sermons to illustrate a particular point. As a result, Tibetan representations of *jataka* tales frequently show Buddha Sakyamuni seated centrally and preaching to a group of monks and lay disciples, as is the case in this example.

This style of painting was prevalent in eastern Tibet, especially in the province of Kham. The various tales are subtly divided by architectural or natural motifs, but they nevertheless seem to telescope into each other, ignoring both spatial and temporal constraints. Although some of the motifs may have been derived from the Chinese tradition, the overall conceptualization of such paintings was distinctly Tibetan.

The representation of two giant fish at the bottom of the *thanka* is so cryptic that it is difficult to identify the tale, especially since there are several *jatakas* involving fish. It may, however, represent the occasion when the bodhisattva, incarnated as a fish, preferred death to being separated from his mate.

A second tale, involving a snake, appears along the right side of the painting. In this *jataka*, a brahmin is said to have put his bag under a bush while he went to drink some water. Attracted by the food in the bag, a snake entered it unbeknown to the brahmin, who gathered up his belongings and continued on his way to Banaras. Upon his arrival there, he met the bodhisattva who was engaged in preaching. Through his clairvoyance, the bodhisattva divined the snake's presence and instructed the brahmin to beat his bag with a stick. The brahmin was thus saved from a dreadful fate.

The well-known *Valahassa Jataka* is represented along the top of the *thanka*. In this tale, the bodhisattva was born as a winged horse endowed with supernatural powers. From the Himalayas, the horse traveled to Sri Lanka, which was then inhabited by demonesses who routinely seduced and devoured shipwrecked merchants. On one occasion, five hundred merchants were shipwrecked on the island and would have been eaten but for their leader, who realized the nature of their plight. Half his men agreed to leave with him, but they had no conveyance. In his incarnation as the winged horse, the bodhisattva offered his services and flew the men back to their homes. The flight of the winged horse with his passengers is isolated in a golden circle at the top center of the painting.

—*P. P.*

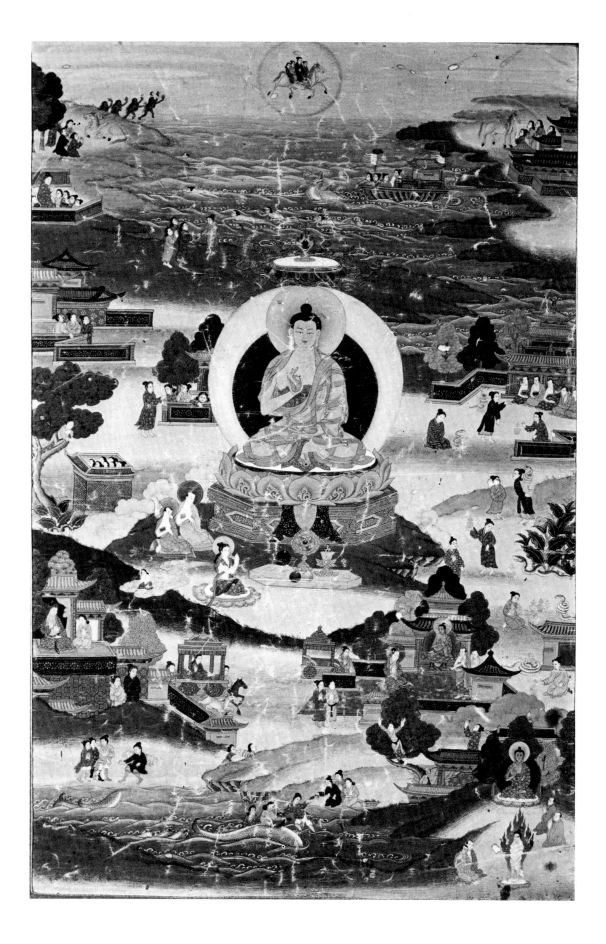

134

Buddha Sakyamuni and the Sama
Jataka
Thailand, 19th century
Opaque watercolors on silk
114½ × 37⅛ in. (290.8 × 94.2 cm.)
Margot and Hans Ries, on Loan to
Los Angeles County Museum of Art

This banner is divided into two
parts. In the upper section, the Bud-
dha Sakyamuni is shown standing
between two monks; in the lower
segment, a *jataka* tale is illustrated.
The attendant monks in the upper
section may be identified as the Bud-
dha's two principal disciples,
Maudgalyayana and Sariputra. This
triad, composed of the Buddha
flanked by his two disciples, became
popular in the Theravada Buddhist
countries of Thailand, Cambodia,
and Burma. In areas where Maha-
yana Buddhism prevailed, the Bud-
dha was more commonly repre-
sented as attended by a pair of bodhi-
sattvas. Two beautifully rendered
gods carrying lotus buds are shown
coming to worship the Buddha in
the upper corners of this section.

The *Sama Jataka* is depicted in the
lower section of the banner. A long
and rambling story, it recounts the
Buddha's previous birth as Sama, the
son of two blind forest ascetics.
Sama was a devoted son on whom
his parents were totally dependent.
Living quietly in the forest, Sama
and his parents were friends of all
the wild animals. It was the boy's
habit to go to the river with a group
of deer to bathe and fetch water in a
jug for his parents. On one of these
excursions he was mortally
wounded by a poisoned arrow shot
by a hunter, the king of Banaras. The
king, thinking the boy was perhaps a
god or a *naga*, hoped to wound him
and thereby discover his identity.
Through the intercession of a god,
Sama regained his life, and his par-
ents miraculously recovered their
eyesight. The king, of course, was
converted to Buddhist principles
and after many virtuous acts, went
to heaven.

On the banner the king is shown to
the right, balanced on one leg after
letting fly the arrow. Sama, who
appears on the left among the deer,
spills his jug of water as the arrow
hits him. Sama and the king are
rendered in the standard style for
representing heroes and villains in
Thai painting. Three figures appear
above the hunting scene, dressed in
the leafy skirts of forest ascetics.
This group may represent Sama,
who has just been restored to life,
greeting his parents. The empty
building on the right is their
hermitage.

The banner was commissioned,
according to the inscription at the
bottom, in order to gain merit for a
woman named Bon.

—*R. L. B.*

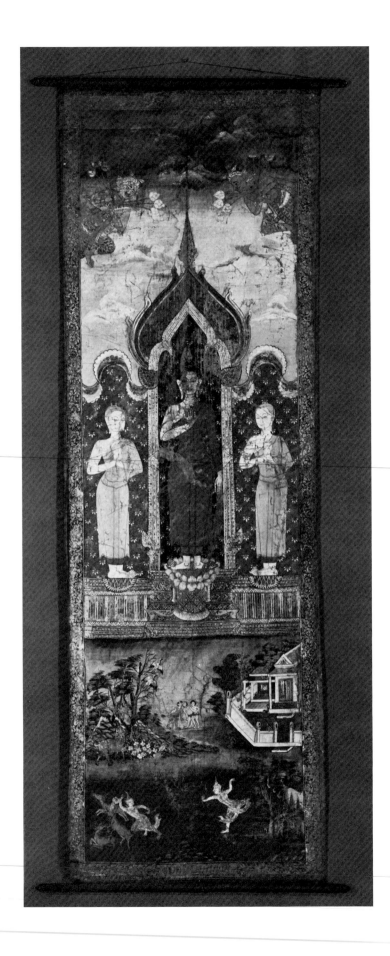

The Vessantara Jataka
Thailand, dated 1776
Ink, gold, and opaque watercolors on paper
Each folio: 20⅜ × 9¼ in.
(51.8 × 23.5 cm.)
Staatliche Museen Preussischer Kulturbesitz, Museum für Indische Kunst, Berlin

These two scenes are included in the same manuscript as the scenes of Sakyamuni's life that are illustrated in entry no. 15. A long section of this manuscript is devoted to depicting the *Vessantara Jataka*, the final previous-birth story of the Buddha Sakyamuni. In this tale, the future Buddha is born as Prince Vessantara, who symbolizes generosity, the highest of the ten perfections or virtues. Vessantara's selfless giving is tested repeatedly. He accedes without hesitation to requests ranging from the initial petition of a group of brahmins seeking his kingdom's rain-making elephant to the final solicitation of a disguised god for his wife. Having proven his perfect generosity, Vessantara ultimately has all that he has given away—including his family, wealth, and kingdom— restored to him by the gods.

The artist of the Berlin manuscript has used the depiction of a stylized river to divide the pages in half horizontally. With a few exceptions, the scenes are arranged chronologically, starting at the right and reading to the left along the lower horizontal section and returning, from left to right, along the upper section. The initial gift of the elephant is represented in the upper right-hand corner of (a). Seated on the white elephant's back, Vessantara pours water into the hands of four brahmin suppliants, a gesture that is traditionally used to finalize a donation or agreement.

According to the legend, Vessantara's fellow countrymen, angered by the loss of their elephant, demanded his expulsion from the kingdom. Vessantara decided, therefore, to go into the forest and become an ascetic. He is shown departing in an elaborate chariot, accompanied by his wife, Maddi, and their two children, in the lower right-hand corner below the scene with the elephant. In the same scene, Vessantara pours water into the hands of another brahmin and thereby agrees to give this petitioner his chariot. Reduced to continuing their journey on foot, Vessantara and Maddi are shown on the left, each carrying one of their children.

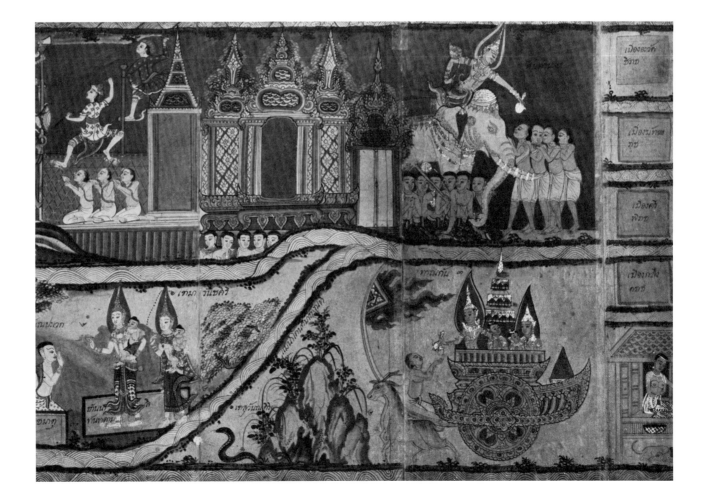

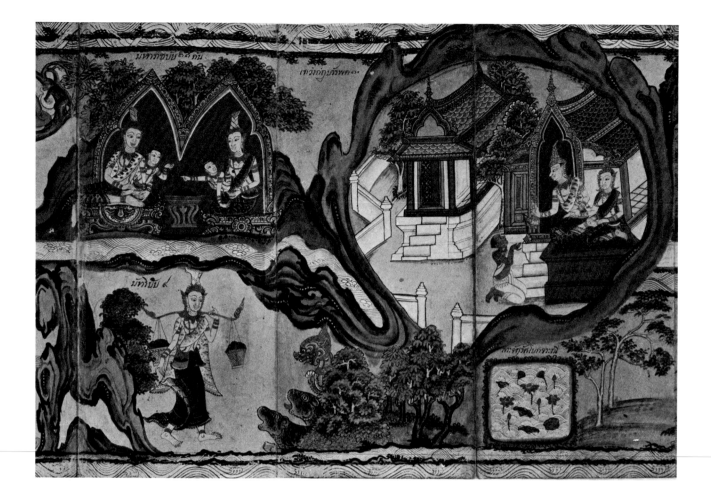

After arriving in the forest, Vessantara and his family begin to live as ascetics. In the second selection of scenes from this *jataka* (b), Maddi is depicted in the lower left returning to the hermitage carrying the roots and fruit she has gathered in the jungle. This scene initiates one of the most important and popular portions of the story. The returning Maddi is about to learn that during her absence Vessantara has given away her beloved children to the cruel brahmin Jujaka. The textual versions of the *jataka* linger on the descriptions of the sorrow Maddi feels at the loss of her children. Gods assume the form of wild animals and compassionately attempt to bar Maddi's way so that she will not return in time to see her children being taken away. In our illustration, the gods are depicted as two tigers and a *singha* (a mythical lionlike animal).

Represented within a circular space formed by mountains on the right side of scene (b), Vessantara accedes to the final request. He gives Maddi, as his ultimate gift, to a brahmin who is actually the god Indra in disguise. Vessantara holds Maddi by the hand and, at the same time, pours water into the hands of the kneeling god.

When he had fulfilled all the requests and proven himself unparalleled in his generosity, the gods returned Vessantara's family to him. The reunion is depicted in the upper left-hand corner with the couple and their children seated in their forest hermitage.

—*R. L. B.*

A Luminous Buddha
Nepal, 10th century
Gilt copper
h: 6⅜ in. (16.2 cm.)
Mr. and Mrs. James W. Alsdorf,
Chicago
(Reproduced in color)

Surrounded by an oval aureole decorated with bold flame motifs and tiny pearls, a Buddha stands elegantly on a lotus. Typically, his right hand displays the gesture of reassurance, and his left hand holds the end of his garment. The depiction of two additional flames attached to his shoulders and a fiery nimbus behind his head, however, is quite unusual. The flames are, in fact, so graphically delineated that the Buddha's entire head seems to be afire.

To my knowledge, no other Buddha image from Nepal or, for that matter, from the Indian subcontinent depicts the effulgence of a Buddha with such telling effect. Only in some Gandhara images of the Kushan period (1st–3rd century) are flames attached to the shoulders of a Buddha, while in later representations, it became customary to add a small flame, symbolizing wisdom or yogic heat, above the cranial bump. In the art of Gandhara, the flaming shoulders are associated with either the Dipankara Buddha or the Sravasti Miracles. In neither instance, however, is the head surrounded by a mass of flames. It has been suggested that the idea of adding flames in Gandhara Buddha images may have had some connection with Iranian royal cults and their concepts of fire and light. At the same time, it can be postulated that images of a flaming Buddha may be related in some way to Agni, the Vedic god of fire.

The cult of Dipankara has remained popular in Nepal, but most known representations of this Buddha date from the late period, and they do not depict flames emanating from his shoulders. Nevertheless, this particular image may have been inspired by the Gandhara tradition. There are one or two other instances of Gandhara influence in Nepali Buddhist art, such as the practice of depicting the emaciated Buddha (see no. 9 and 14). Thus, this image may well represent Dipankara Buddha, following the Gandhara model.

—*P. P.*

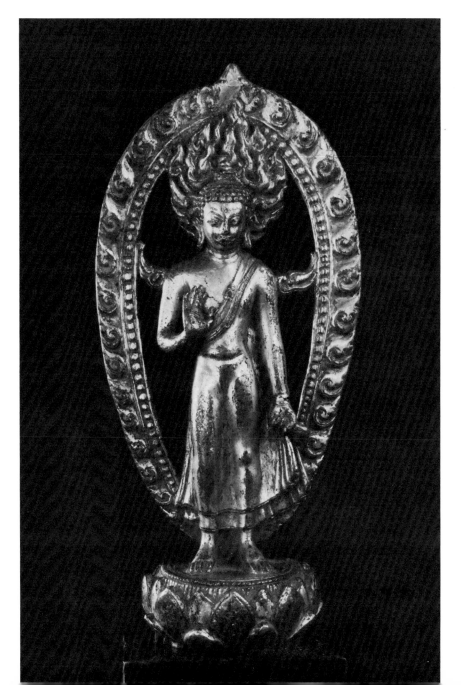

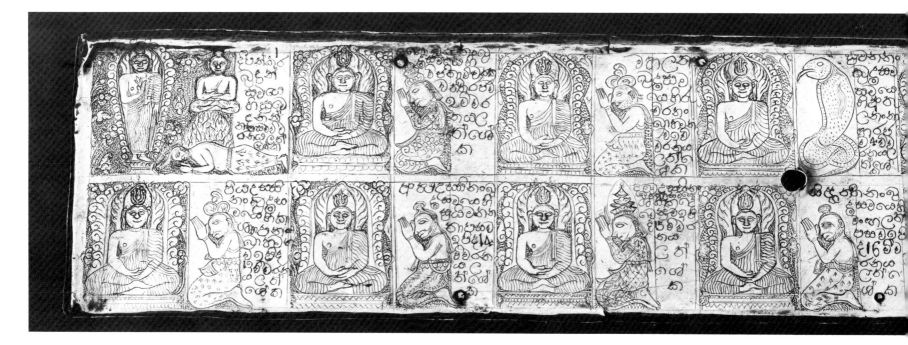

137

Pair of Manuscript Covers
Sri Lanka, Kandy; late 18th or early
19th century
Silver
Each cover: 2¾ × 24 in. (7 × 60.9 cm.)
Los Angeles County Museum of Art,
Herbert Cole Bequest

A detailed account of the rich
iconography of these two manu-
script covers is beyond the scope of
this catalogue. They demonstrate
the uniqueness of Buddhist iconog-
raphy in Sri Lanka; the representa-
tion of the Buddha's seven weeks of
meditation following his Enlighten-
ment is especially significant in this
context. This seven-week period is
ritually reenacted by Sinhalese
monks in an annual fast known as
sat satiya (seven weeks).

The catalogue entry given below
was prepared by Professor Siri
Gunasinghe who has kindly trans-
lated all of the inscriptions. As they
are perfectly adequate for the identi-
fication of the illustrated themes, it
seemed redundant to write a sepa-
rate entry.

—P. P.

Cover a—The Twenty-four
Prophecies

Very early in the evolution of Bud-
dhism, a mythology concerning the
periodic appearance of Buddhas
became popular. Evidence of this
belief can already be seen at Sanchi
in India. Twenty-four Buddhas pre-
vious to the present Buddha
Sakyamuni were named, as well as a
Future Buddha, Maitreya. According
to this belief, Buddha Sakyamuni
met each of these Buddhas of the
past during twenty-four of his pre-
vious births as a bodhisattva.
Sakyamuni's destiny as the future
Buddha was announced at each of
these meetings. The theme of the
Twenty-four Prophecies is one of the
most popular motifs of Sinhalese
Buddhist art, particularly of the late
medieval times.

Beginning at the left side of the up-
per register, the inscriptions
translate:
1. During the time of Buddha
 Dipankara, as the ascetic named
 Sumedha, he [Buddha Sakya-
 muni] received the prophecy
 [that he would become a Buddha
 after so many aeons].
2. During the time of Buddha
 Kondanna, as the universal mon-
 arch *(chakravartin)* Vijitavi, he
 received the second prophecy.
3. During the time of Buddha
 Mangala, as the brahmin named
 Rucira, he received the third
 prophecy.
4. During the time of Buddha
 Sumana, as the *naga* king named
 Atula, he received the fourth
 prophecy.
5. During the time of Buddha
 Revata, as the brahmin named
 Atideva, he received the fifth
 prophecy.
6. During the time of Buddha
 Sobhita, as the brahmin named
 Sujata, he received the sixth
 prophecy.
7. During the time of Buddha
 Anomadassi, born as a *yaksha*
 chief, he received the seventh
 prophecy.
8. During the time of Buddha
 Paduma, born as a king of lions,
 he received the eighth prophecy.
9. During the time of Buddha
 Narada, born as the ascetic
 named Uggra, he received the
 ninth prophecy.
10. During the time of Buddha
 Piyumatura, born as the ascetic
 named Jatila, he received the
 tenth prophecy.
11. During the time of Buddha
 Sumedha, born as a youth named
 Uttara, he received the eleventh
 prophecy.
12. During the time of Buddha
 Sujata, born as a universal mon-
 arch possessing the seven jewels,
 he received the twelfth prophecy.

Beginning at the left side of the
lower register, the inscriptions
translate:
13. During the time of Buddha
 Piyadassi, born as the brahmin
 named Kasyapa, he received the
 thirteenth prophecy.
14. During the time of Buddha
 Atthadassi, born as the ascetic
 named Susima, he received the
 fourteenth prophecy.
15. During the time of Buddha
 Dhammadassi, born as Sakra,
 the lord of gods, he received the
 fifteenth prophecy.

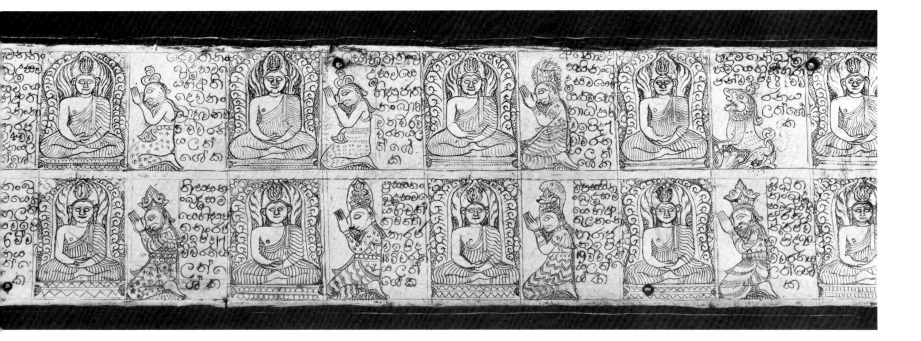

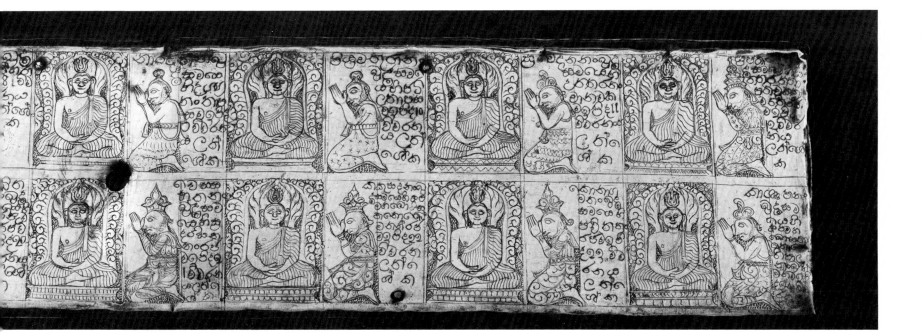

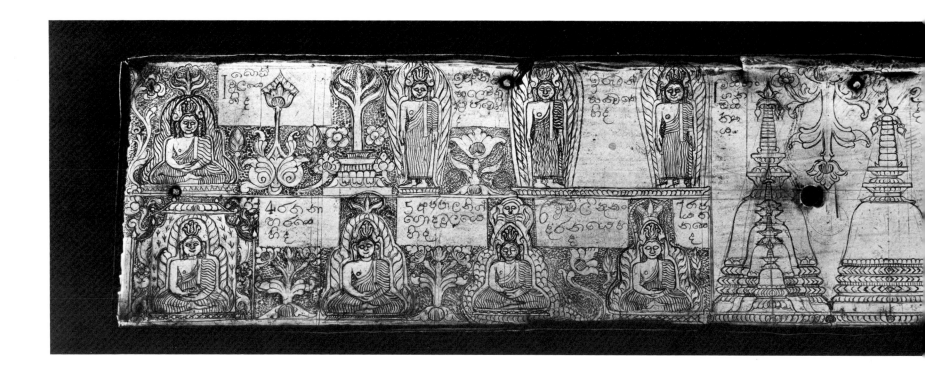

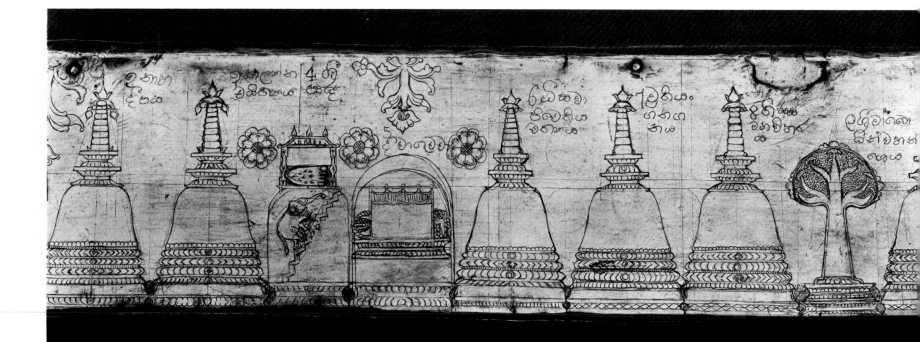

16. During the time of Buddha Siddartta, born as the ascetic Mangala, he received the sixteenth prophecy.

17. During the time of Buddha Tissa, born as the king named Sujata, he received the seventeenth prophecy.

18. During the time of Buddha Phussa, born as a universal *naga* monarch [no such universal monarch is named in the literature], he received the eighteenth prophecy.

19. During the time of Buddha Vipassi, born as the *naga* king named Atula, he received the nineteenth prophecy.

20. During the time of Buddha Sikhi, born as the king named Arindava, he received the twentieth prophecy.

21. During the time of Buddha Vessabhu, born as the king named Sudarisana, he received the twenty-first prophecy.

22. During the time of Buddha Kakusada, our great bodhisattva, born as the king named Khema, he received the twenty-second prophecy.

23. During the time of Buddha Konagama, born as the king named Parvata, he received the twenty-third prophecy.

24. During the time of Buddha Kasyapa, our great bodhisattva, born as the brahmin named Jotipala, he received the twenty-fourth prophecy.

Cover b—The Cycle of Seven Weeks

Approximately one-third of the left-hand side of the upper and lower registers on this cover are devoted to the seven weeks immediately following Sakyamuni's Enlightenment. This seven-week cycle was a popular motif with medieval artists in Sri Lanka.

Beginning at the left side of the upper register, the inscriptions translate:

1. At the foot of the *bodhi* [tree] and
2. [At the] offering of the unblinking gaze and
3. On the jeweled promenade and

Beginning at the left side of the lower register, the inscriptions translate:

4. In the jeweled chamber and
5. At the foot of the Ajapala banyan tree and
6. On the coils of the *naga* called Muchalinda and
7. At the foot of the tree named Rajayatana

Beginning with the stupas on the right-hand side of the cover and reading from the left, the sixteen principal Sinhalese pilgrimage centers are illustrated. These scenes are numbered with Arabic numerals, and numbers four and five are particularly interesting. Number four represents Mount Samantakuta, also known as Adam's Peak, on top of which the Buddha's footprint can be seen. The fifth stupa represents Divaguha, a cave in which the Buddha purportedly rested on one of his visits to Sri Lanka.

—S. G.

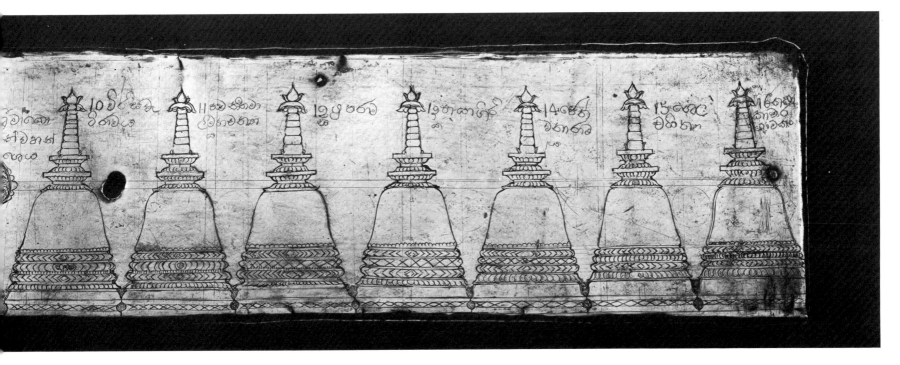

138

Book Cover with Buddhas
Tibet, 14th century
Wood with polychromy
10½ × 28⅛ in. (26.7 × 71.9 cm.)
Mr. and Mrs. John Gilmore Ford

Forty-four Buddhas, identical except for their gestures, are represented in four registers on this book cover. Attired in red garments and characterized by a yellow complexion, each Buddha sits upon a lotus in the yogic posture. The lotuses are painted alternately in red and blue. Behind each Buddha is a green cushion with a scroll design, two triangular gold segments that project like wings, a red aureole, and a white nimbus. The exact identification of this group of forty-four Buddhas is difficult to determine, especially without recourse to the iconographic scheme of the missing second cover. The repetition of the Buddhas and their identical complexions make it likely that the figures symbolize the theme of the Thousand Buddhas (cf. no. 139).

The gestures that the various Buddhas assume are: touching the earth, turning the Wheel of the Law, teaching, charity, meditation, reassurance, and the wisdom fist *(bodhyangi).* This latter gesture is usually associated with the transcendental Buddha Mahavairochana (see no. 159). Only one Buddha, the second from the left in the bottom row, forms the gesture of reassurance with his right hand stretched out as if bestowing blessings and his left hand held against his chest. This form of the gesture of reassurance is usually unique to representations of Sakyamuni and is used specifically in depictions of the Taming of the Mad Elephant Nalagiri (nos. 5 and 6).

This resplendent cover from fourteenth-century Tibet will give the viewer some idea of the impression conveyed by the myriad Buddhas depicted on the walls of the caves at Ajanta in India and at Dunhuang in China, among other sites. The repetition of the Buddha image was considered to increase its worth and earn greater merit for the devotee.

—*P. P.*

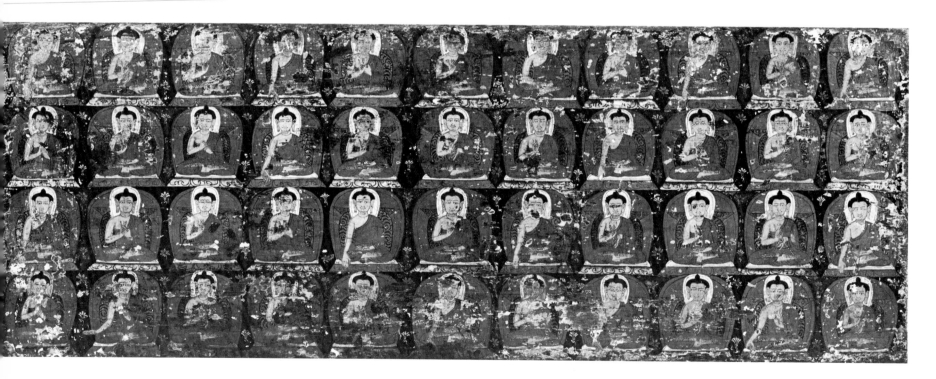

139

Myriad or Multiple Buddhas
Burma, 17th century
Ivory
h: 25½ in. (65 cm.)
Paul F. Walter

Carved around this elephant's tusk
are six bands of Buddha images. Each
figure sits cross-legged with its right
hand extended to touch the earth, a
posture that indicates the Buddha's
victory over Mara at Bodhgaya. The
concept of multiple Buddhas has
several interpretations within the
context of Sakyamuni's life. We have
already discussed the miracle the
Buddha performed at Sravasti
whereby he multiplied himself up to
the heavens (see no. 53). A second
popular manifestation of the mul-
tiple-Buddha theme was that of the
Thousand Buddhas. A Mahayana
text states:

> Through the Buddha's might
> the Four Great Kings in this
> great trichiliocosm, and the
> other gods up to the gods of the
> Pure Abode, scattered heavenly
> sandalwood powder and came
> to where the Lord was. They
> reverently saluted the Lord's
> feet with their heads and stood
> on one side. Thereupon through
> Buddha's might the minds of all
> these deities were impressed by
> (the sight of) a thousand Bud-
> dhas in the act of teaching the
> Dharma. *(Conze, 1975, pp.*
> *305–6)*

Representations of the Thousand
Buddhas, who are usually shown
lined up in rows, occur in paintings
and sculpture throughout Asia.

Most pertinent to the Theravada
context in which the Burmese tusk
was made, however, is the belief that
in the creation of a Buddha image
great merit accrues to the patron.
The amount of merit is increased by
the sheer number of Buddha images
produced. Carved elephant tusks
such as this one were set in match-
ing pairs in bronze stands on mon-
astery altars in Burma and Thailand.
—R. L. B.

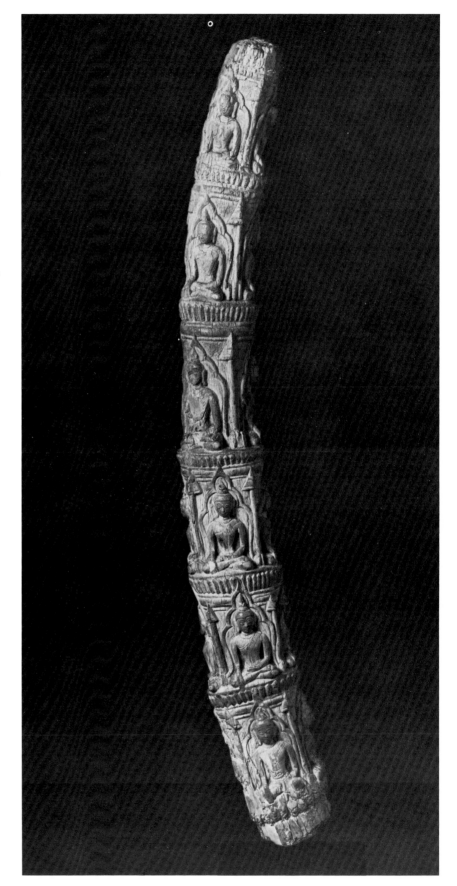

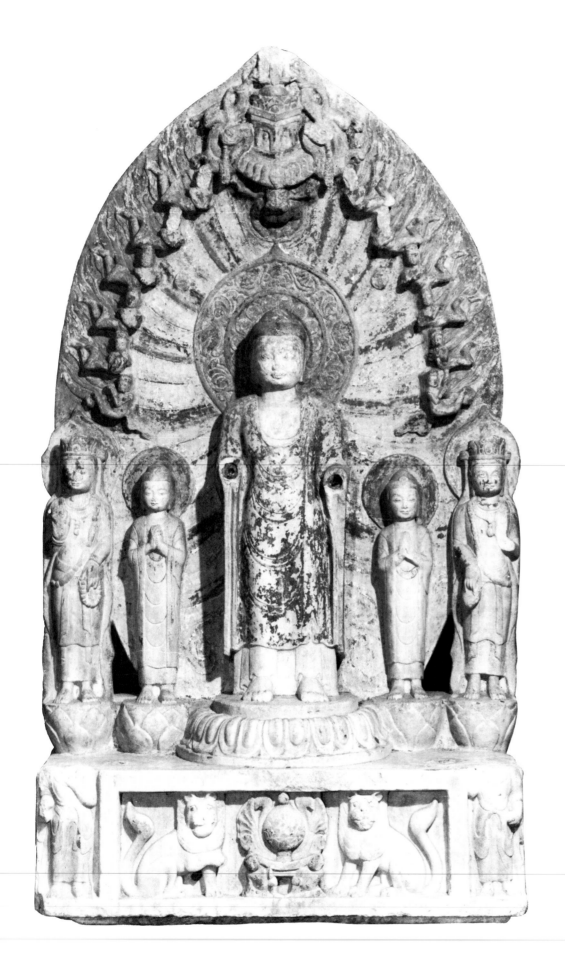

Stele with Buddha and Attendants
China, Northern Qi dynasty
(550–89)
White marble with polychromy
h: 52¾ in. (133 cm.)
From a Private English Collection,
Presently on Loan to the Victoria
and Albert Museum

This impressive stele still has much
of its original polychromy intact and
traces of green, red, and black pig-
ment, as well as some gilding, can be
seen. It is richly carved on both
sides, as was often the case with
Chinese reliefs of this period. Al-
though the representation is hi-
eratic, the scene depicted in the
front relates to the well-known *Lo-
tus Sutra*, which played a significant
role in Chinese Buddhist art (see no.
141).

Sakyamuni is shown standing on a
lotus pedestal and although his
hands are now missing, they appear
to have been held in the gestures of
reassurance and charity that were
associated with the preaching of *The
Lotus Sutra* in Chinese art. The Bud-
dha is flanked by monks, possibly
the disciples Ananda and Kasyapa,
both of whom display the gesture of
adoration. Standing by each monk is
a bodhisattva. The one on the left,
holding a rosary, may be Avalo-
kitesvara; the one on the right,
Mahasthamaprapta. These two
bodhisattvas are found paired in
sculptural representations in the
Buddhist caves of Yungang (Row-
land, 1937, p. 106), and they figure
prominently in *The Lotus Sutra* (Da-
vidson, 1954, p. 29). The decoration
of the stupa described in *The Lotus
Sutra* is depicted here on the
mandorla behind the figures, which
is filled with *apsaras* (flying
celestials), their gowns and scarves
sweeping upward.

On the back of the relief is a Buddha seated in the "European" posture within a niche formed by *bodhi* trees. This Buddha is flanked by two monks who hold their hands in the gesture of adoration.

In its iconography and style, this stele resembles a type which, based on dated examples, appears to have been common in China from the late 550s to the year 570 (Siren, 1940, p. 488). These stelae, some of which portray both Sakyamuni and Maitreya, suggest the rise in influence of the Paradise cults in China during this time (Davidson, 1954, pp. 58–61). They may also establish a precedent for identifying this figure as Maitreya. There are thirty-five Buddhas seated in the meditative posture carved in individual niches above this central Buddha. This group may represent the thirty-five Buddhas of Confessions of Sins, invoked by those who had committed sins and wished to repent (Soothill, p. 60). They may also represent the Thousand Buddhas, seen in similar niches at the Buddhist caves at Yungang (Mizuno and Nagahiro, 1954, vol. 13 [plates], Cave 19, pls. 1–63).

The base on the back and sides of the stele is carved with representations of eight Spirit Kings. These Spirit Kings appear on the bases of several Northern Qi (550–89) stelae and may also be seen in the caves of Xiangtanshen. Their original prototype may have been a series of demon deities painted by an Indian at Shaolinsi in the early sixth century. Shaolinsi is located in Henan province near Longmen, where these Spirit Kings first appear in Chinese sculpture. Alternatively, these deities may have originated with an Indian concept that first traveled to

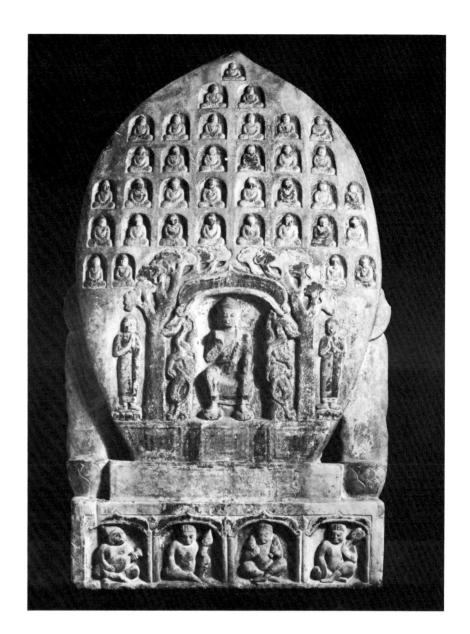

Southeast Asia and then to China. In Java, nature dieties of a similar sort were placed around the foundations of buildings (Bunker, pp. 33–36).

In China, these deities were conceived of as a group of ten. Although their iconography and low placement ultimately derived from Indian Buddhist art, indigenous elements were added, such as the introduction of the Dragon Spirit and the use of native costumes. The Spirit Kings appear to have been developed by the Chinese as additional guardians of Buddhism and to have waned in

significance at the end of Sui dynasty (581–618) or the beginning of the Tang dynasty (618–906) (Bunker, ibid). Six of the eight Spirit Kings shown on this stele can be identified: the Dragon Spirit, who wears a serpent around his neck; the Elephant and Monkey Spirits, seen in their respective animal manifestations; the Wind Spirit, represented with windswept hair and holding his wind bag; the Fire Spirit, identified by flames; and the Fish Spirit, who wears a fish around his neck.

—*J. B.*

Stele with Sakyamuni and Prabhutaratna
China; early Sui dynasty, dated 595
Pale buff marble with traces of pigment and gilding
h: 33 in. (83.8 cm.)
Asian Art Museum of San Francisco, The Avery Brundage Collection

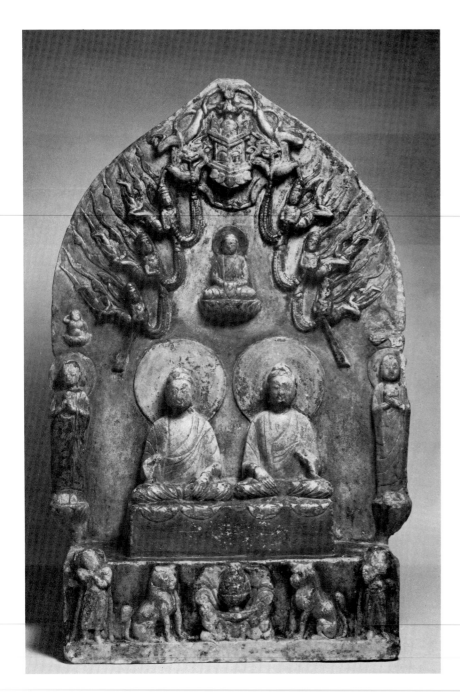

Two inscriptions on the back of this impressive stele inform us that it was originally dedicated in the year 595 and then rededicated in 1520. The large group of original donors, whose names are listed, "respectfully had an image of the Buddhas made primarily for [the salvation of] the emperor, and secondly [for the salvation of] monks, parents, and all sentient ordinary souls" (Lefebvre d'Argencé and Turner, p. 152).

Three Buddhas and two deified monks are depicted on this stele. The two principal Buddhas are similar, but their hand gestures are reversed. The monks, holding bowls, stand columnlike on lotuses at each side of the relief. Between and above the two Buddhas appears a third, seated upon a lotus with his hands placed in the gesture of meditation beneath his garments. This third figure is no doubt Amitabha, the lord of the Western Paradise. The two principal Buddhas are certainly Sakyamuni and Prabhutaratna. Two cherubic figures, one of which is now missing, originally appeared above the heads of the monks and may have been intended to represent two unclad newborn souls. Celestial beings with garlands and two dragons supporting a Chinese-style stupa are arranged symmetrically around the figure of Amitabha to form a canopy over all three Buddhas. The incense burner at the bottom of the stele is flanked by two heraldic lions and two guardians.

There seems little doubt that the scene represented here with such formal dignity is the appearance of a stupa in the sky, which is described in the *Saddharmapundarika (The Lotus of the True Law).* This particular text played a distinctive role in Chinese Buddhism (see Davidson, 1954, for a thorough study of *The Lotus Sutra* in Chinese Buddhist art).

Sakyamuni explains to the assemblage that this apparition is the stupa containing relics of the extinct Buddha Prabhutaratna who had vowed to appear wherever the *Lotus* was presented. The scene is developed with an imagery recalling the vision of St. John the Divine. Buddhas from all the universe appear, and within this kaleidoscopic brilliance Sakyamuni rises to the stupa. Using a finger as a key, he opens the door to reveal the extinct Buddha, who says "Excellent, excellent, Lord Sakyamuni." The two Buddhas then sit side by side in the stupa. *(Davidson, 1954, p. 5.)*

This theme was especially popular in China during the Tang dynasty (618–906) and is frequently depicted in the Yungang Caves. A rare Korean representation of the theme is included in the exhibition (no. 142). Elaborating on the popularity of the theme in China, Davidson writes:

It is fair to assume that the interest in the apparition of Prabhutaratna depended on magical connotations at least as much as on the philosophical and dramatic value. The event is even more wondrous than the raising of Lazarus, whose life was resurrected within his corporeal form, for Prabhutaratna had been *extinct* for eons. Yet the words of Sakyamuni preaching the *Lotus* were enough to make him manifest, although he had long ago reached his nirvana....It is not surprising that the Buddhist craftsmen depicted the event so as to glorify his Lord and impress His power on both believer and skeptic. *(Davidson, 1954, p. 15)*

—P. P.

142

Sakyamuni and Prabhutaratna
Korea; Unified Silla dynasty,
9th century
Bronze
h: 2⅜ in. (6 cm.)
Seoul National Museum

In this small bronze, we see two figures seated side by side, assuming identical postures. Their left hands rest upon their knees, and their right hands are raised in the gesture of reassurance. The bodies of the two Buddhas are fully covered by robes, and their heads are placed almost directly upon their shoulders. The figures represent Buddha Sakyamuni and Prabhutaratna, a Buddha of the distant past. This meeting of the two Buddhas is based upon an episode from *The Lotus Sutra* and has particular value in reminding the devotee of the timeless nature of Buddhist Law. By recalling a former Buddha, Sakyamuni is affirming the unchanging truth of the faith. In all versions of this theme, the two fig-

ures are rendered as identical; they are seated with one hand raised, indicating dialogue. Often they are portrayed inside the stupa that, according to *The Lotus Sutra*, appeared in the sky carrying Prabhutaratna. Although *The Lotus Sutra* was enormously popular in Korea, artistic representations of the meeting of the two Buddhas occurred much more frequently in China. This is a very rare Korean example that is based upon Chinese prototypes (see no. 141).

—*R. E. F.*

143

Two Buddhas in Conversation
Nepal, 15th century
Opaque watercolors on cotton
22¾ × 17¾ in. (57.8 × 45.1 cm.)
George P. Bickford

As is the case with the better-known Chinese representations of Sakyamuni and Prabhutaratna (see no. 141), two Buddhas are shown engaged in conversation in this rare Nepali painting. The figure on the left can be easily identified as Nagarjuna by the appearance of the multi-hooded serpent *(naga)* behind him. A great dialectician and the founder of the Madhyamika school of philosophy, Nagarjuna was perhaps the most important figure in the history of Buddhism after the Buddha Sakyamuni.

Although information about his life is scanty, he is presumed to have been born to a brahmin family in Berar in present-day Andhra Pradesh and to have lived during the first century of the Christian Era. He spent most of his life in northern India and in the Nagarjunakonda region, which was then the most important center of Buddhism in the south. Nagarjuna is also considered to be the author of the *Prajnaparamita (Perfection of Wisdom)*, which is the most important of all Mahayana texts; it expounds the doctrine of *sunyata*, or emptiness.

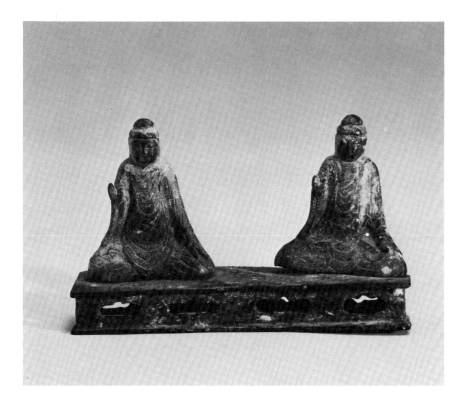

Legend has it that Nagarjuna was born under an *arjuna* tree and received esoteric knowledge from the serpents. It was believed that Sakyamuni first taught the new doctrine of *sunyata* in heaven; it was then transferred to the serpents in their underwater kingdom, and from the serpents the doctrine was communicated to Nagarjuna. These legends clearly explain why Nagarjuna is distinguished by a serpent in artistic representations. Because he had achieved *bodhi*, he is also shown as a Buddha.

The exact identification of Nagarjuna's companion Buddha is, however, a little more difficult to determine. The gestures of this second Buddha's hands indicate that he is the one expounding the doctrine. That the text of the *Prajnaparamita* is being preached is evident from the placement of a manuscript on a stand in the center of the painting. It may also be noted that all offerings are placed before this second figure, rather than Nagarjuna. Thus, it seems probable that the figure represents Sakyamuni himself, even though he did not transmit the doctrine directly to Nagarjuna. It is also possible, however, that the figure represents Aryadeva, Nagarjuna's premier disciple, as there was a Tibetan tradition in which the two were depicted together.

In any event, the painting demonstrates the common practice of representing eminent Buddhists, such as Nagarjuna, as Buddhas. It must be pointed out that no image of Nagarjuna has yet come to light in India nor, for that matter, in any Buddhist country other than Nepal and Tibet. The other figures in this unique Nepali painting are gods, *mahasiddhas* (a class of teacher in esoteric Buddhism), and monks.

—*P. P.*

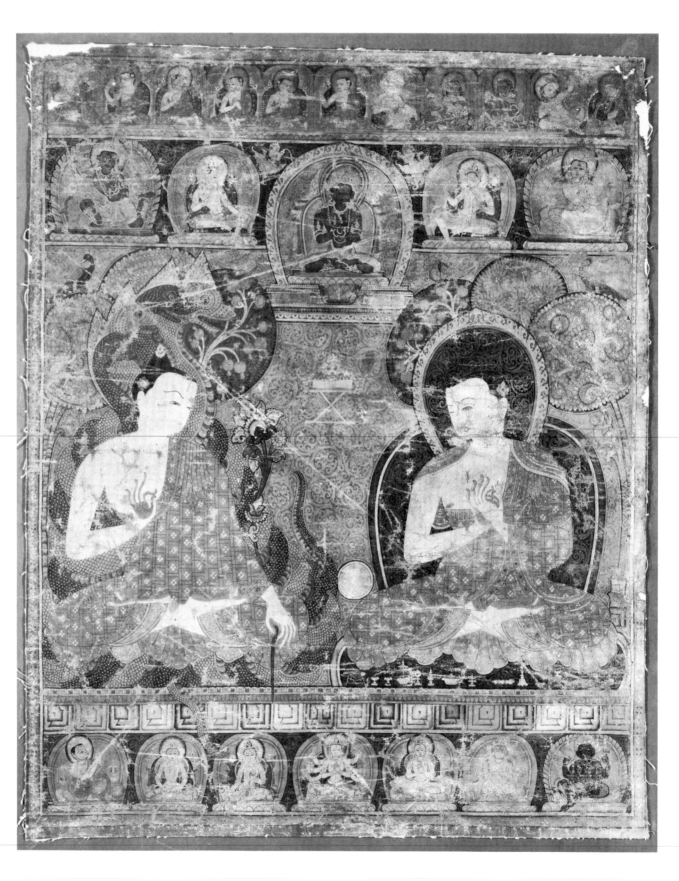

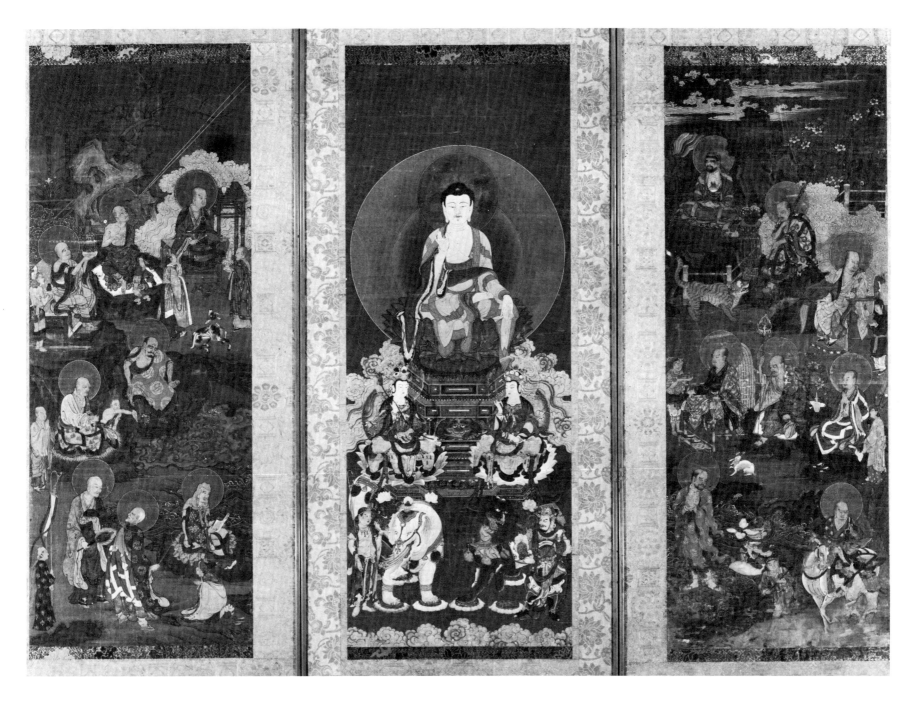

144

Sakyamuni, Manjusri, and
Samantabhadra with Sixteen
Arhats
Japan; Muromachi period, first half
of 15th century
Hanging scrolls
Ink, colors, and gold on silk
Each panel: 39¼ × 15¼ in.
(99.5 × 39.0 cm.)

John W. Gruber
(Reproduced in color)

The five hundred arhats (lohan in
Chinese, rakan in Japanese) are
described in The Lotus Sutra as
disciples of Sakyamuni who at-
tended his sermons at Vulture Peak
and acted as the principal dissemi-
nators of his teachings after the
Mahaparinirvana. The arhats—of-
ten grouped in literary and artistic
representations as eight, sixteen, or
five hundred—were enlightened
mortals who had declined Buddha-
hood in order to assist other practi-
tioners of the faith to achieve
enlightenment. Furthermore, by
means of their supernatural powers,
this group of enlightened teachers
also set examples of correct
behavior.

In the central panel of this magnificent triptych, Sakyamuni (Shaka in Japanese) sits preaching, attended by the bodhisattvas Manjusri (Monju in Japanese) and Samantabhadra (Fugen in Japanese). These bodhisattvas are represented astride the animals they customarily ride—the lion and elephant respectively. Two side panels frame this triad, each of which depicts eight arhats. The arhats, shown with green halos, are dressed as monks in beautifully brocaded robes. They appear either seated or standing in a three-quarters view and are accompanied by acolytes and worshipers who present offerings.

Since there is no dedicatory inscription and the arhats are not separately labeled, we do not have any completely accurate way of identifying this triptych as a ritual or devotional object created for a particular Buddhist sect. It has been suggested, however, that the triptych was probably made for a Zen temple (Kokka, p. 42). The special arrangement of this triad with Sakyamuni and the sixteen arhats would seem most appropriate to adherents of Zen or to esoteric Buddhists of the Muromachi period (1392–1568).

The bodhisattva Samantabhadra, like the five hundred arhats, appears in *The Lotus Sutra*, where he is encouraged by Sakyamuni to continue preaching (Hurvitz, p. 333). Painted icons depicting Sakyamuni surrounded by Manjusri and Samantabhadra have been common in China since the Tang dynasty (618–906). This triad may also be derived from another sutra, the *Avatamsaka* (Ho et al., no. 7).

Paintings of Arhat's were popular in Song dynasty (960–1279) China, where the theme was a favorite of the Chan Buddhist sects. The spread of Chan Buddhism to Japan in the thirteenth century (where such teachings became known as Zen Buddhism) made the arhats a favored subject of devotional painting in that country (Rosenfield and ten Grotenhuis, pp. 46–49). Arhats were frequently painted individually or in sets ranging from eight to one hundred. In this example, the figures are identified by individual attributes. Each of the arhats was supposed to have conquered evil by virtue of some miraculous feat, and that act is symbolized by a unique detail. On the right-hand panel, the arhat Bhadra tames a tiger in the upper right-hand corner, while Nakula rides a horse, accompanied by an attendant at the lower right. At the center of the left-hand panel, the arhat Kalika subdues a poisonous dragon with a precious pearl, and in the lower right-hand corner of the same panel, Panchika sits with his head covered, reading a sutra.

The middle panel of this spectacular triptych was once considered to be older than the side panels. Erroneously, the style of presenting the Buddha and bodhisattvas in the central panel was thought to be closer to the Northern Song (960–1126) style, while the less schematized arhats were linked to the Southern Song (1127–1279) tradition. Scholars now generally agree that the entire composition is based on twelfth-century Southern Song prototypes, which were known in Japan from the end of the twelfth century onward.

—A. G. P.

Sakyamuni Meditating and Preaching
Japan; Heian period, c. 11th–12th century
Handscroll
Gold and silver ink on indigo-dyed paper
10¾ × 10⅝ in. (27.3 × 26.9 cm.)
Collection of Philip Hofer

Throughout the Japanese medieval period, but especially during the twelfth century, the production of richly ornamented holy texts was common. *The Lotus Sutra*, for example, was known in many versions. This sutra contains Sakyamuni's sermons extolling the virtues of piety, compassion, and service that are central to Mahayana Buddhism. For those who believed in it or preached its doctrines, *The Lotus Sutra* was considered a means to achieve blessing. As a result, copies of this holy text were commissioned by pious courtiers and other laymen who wished to ensure the fate of a deceased relative or obtain personal merit by donating them to temples.

Celebrated calligraphers and professional illustrators were commissioned to prepare versions of *The Lotus Sutra.* A wide variety of formats was used, ranging from wall paintings to miniature illuminated handscrolls and decorated fans. On this richly treated frontispiece from a *Lotus Sutra* handscroll, the subjects of four chapters are illustrated in an abbreviated form, using gold and silver ink on indigo-dyed paper. The scenes are literal representations of chapters sixteen through nineteen, which glorify virtue, charity, and renunciation. The texts of these chapters were probably originally intended to follow this frontispiece, but there are no labels on the frontispiece, and the painting is now separated from the text.

The four episodes are lavishly presented in a crowded format, characterized by few extraneous details and little or no landscape setting. At the top center, the parable of the practitioner meditating in a cave (the *Funbetsu kudokuhon,* chapter 17) is shown. To the left near the top, a priest recites the scripture to a gathering of laity (the *Hosshi kudokuhon,* chapter 19). Below this scene, Sakyamuni compares himself to a good physician preaching to his sons who have consumed poisonous medicines, and he asserts that they will be miraculously cured after their faith is restored (the *Nyorai juryohon,* chapter 16). On the right, the figure of Sakyamuni preaching *The Lotus Sutra* (the *Zuiki kudokuhon,* chapter 18) dominates the page. This preaching scene is clearly meant to be emphasized, and the Buddha is shown on a larger scale than the worshipers, a convention common in Buddhist paintings prior to the Kamakura period (1185– 1333).

—A. G. P.

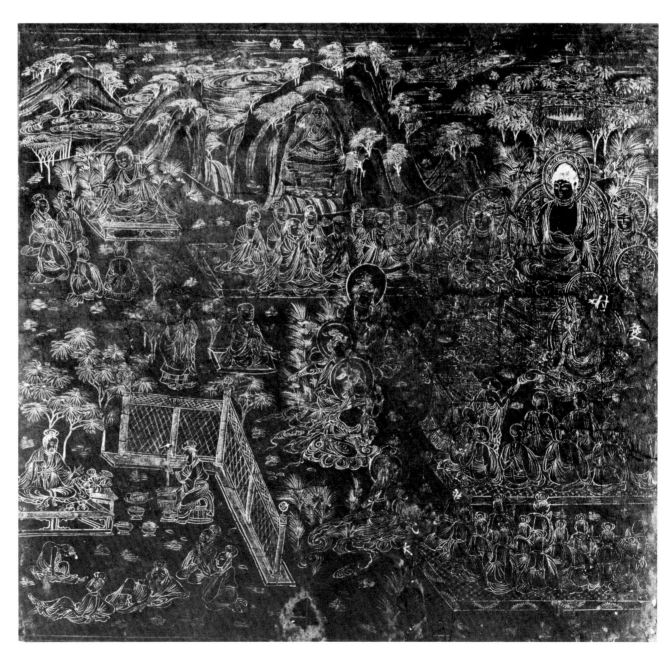

146

Sakyamuni Preaching to an Assembly
China; Yuan dynasty, first half of the 14th century
Woodblock print
11¾ × 4¾ in. (29.9 × 12.1 cm.)
Los Angeles County Museum of Art, Far Eastern Art Council Funds

This frontispiece to volume 486 of the *Jisha Tripitaka* illustrates a seated Sakyamuni preaching to an assemblage of deities. His hands display the gesture of turning the Wheel of the Law. Facing the Buddha and sheltered by a jeweled parasol is a seated female deity who displays the gesture of reassurance with her right hand. These attributes, together with the third eye on her forehead, suggest that she is Sitatapatra Aparajita, a cosmic form of the goddess Tara. Surrounding these two central figures are various bodhisattvas, arhats, guardian kings, and other deities.

The monumental task of translating Buddhist texts from Pali and Sanskrit into Chinese had been pursued continuously since the time of the initial introduction of Buddhism to China. Following the catastrophic persecutions in 845, the Song emperor Taizu [T'ai-tsu] (r. 960–75) endeavored to revitalize interest in Buddhism and sent monks to India to collect additional sacred Buddhist texts for translation into Chinese. The first of these theological compilations, called *Tripitaka (Three Baskets)*, was made around 970, and this manuscript was supposed to have been written in gold and silver characters. In 972 the carving of some 130,000 blocks was begun preparatory to issuing a printed edition of the entire Chinese *Tripitaka;* a task that was completed in 983 (Loehr, 1968, pp. 13–15).

Many different collections of the *Tripitaka* were printed during the succeeding centuries. One of these, the Jisha edition, is extant and is currently stored in two monastic libraries in Xi'an, Shaanxi. Isolated volumes are also found in various foreign collections. The edition was printed at the Jisha monastery over a period of 132 years (1231–1363). A gap of 41 years occurred in the printing process, however, due to a fire that broke out in 1258; printing was resumed in 1299 under Mongol domination.

The style of the illustration shown here reflects strong Tibetan influences, evident in the figures, facial expressions, and iconography. This is not surprising since Tibet was subject to the power of the Yuan Mongols who discovered in Tibetan Lamaism a religion well suited to their temperament and customs.

—*G. K.*

147

Illustrated Frontispiece to the Avatamsaka Sutra
Korea; Koryo dynasty, first half of the 14th century
Gold on blue paper
19½ × 8⅞ in. (49.5 × 22.5 cm.)
Seoul National Museum, Lee Hong-kun Collection

The sutra known as the *Avatamsaka* was transmitted from China to Korea in the seventh century by the famous monk Uisang. The copying of such sutras was considered an auspicious act and a means to gain merit, and the decorative illustrations in these holy texts were often rendered in gold and silver to indicate their importance. The *Avatamsaka* is one of the most complex Buddhist treatises, and illustrations such as this usually contain a range of subjects; this scene includes the Buddha Vairochana on the far right, as well as depictions of the various levels of existence and the Buddhist hells. The transcendental or cosmic Buddhas have replaced Sakyamuni as the focus of this work, as befitting the later stages of Buddhist development. The juxtaposing of heavenly and earthly scenes (note the lounging scholar in the foreground) serve to link the often esoteric message of the Buddhism of this time to the daily world of the believer. The use of blue and gold materials communicates a richness appropriate to the often elaborate practices of esoteric cults.

The scenes portrayed here are taken from a portion of the *Avatamsaka* that is known as the *Gandavyuha.* This portion of the sutra recounts the continuing travels of one Sudhana in his search for enlightenment. This young boy is pictured kneeling in a posture of devotion in front of various figures, each of whom adds to his growing knowledge of the way of the bodhisattva and directs him to the next teacher he should visit. The many episodes represent Sudhana's accumulation of wisdom and loosely parallel the searching that Sakyamuni underwent prior to his Enlightenment. The various bodhisattvas of the Mahayana pantheon are included in the *Gandavyuha,* and the stories often feature the elaborate settings and events of this northern style of Buddhism.

The richly decorative style and pictorial conventions of this frontispiece probably derive from Song period (960–1279) Chinese models of the thirteenth century. Judging from extant thirteenth- and fourteenth-century examples, this type of painting was extremely popular in Korea, and some scholars believe that it may actually be of Korean origin (Rosenfield, p. 71).

Illustrated sutras were less in demand during the Confucian-dominated Yi dynasty (1392–1910), but similar pictorial arrangements can be found in Buddhist wall paintings as late as the eighteenth and nineteenth centuries.

—*R. E. F.*

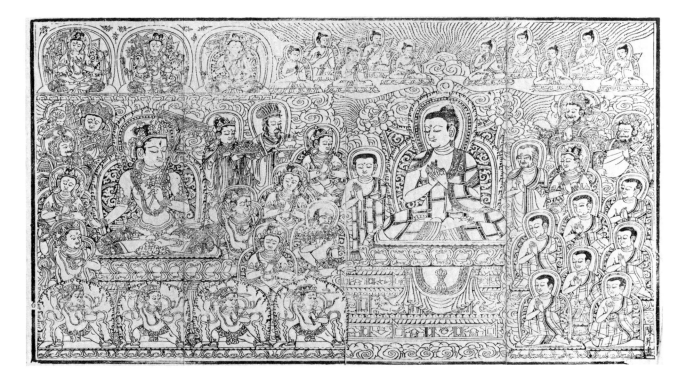

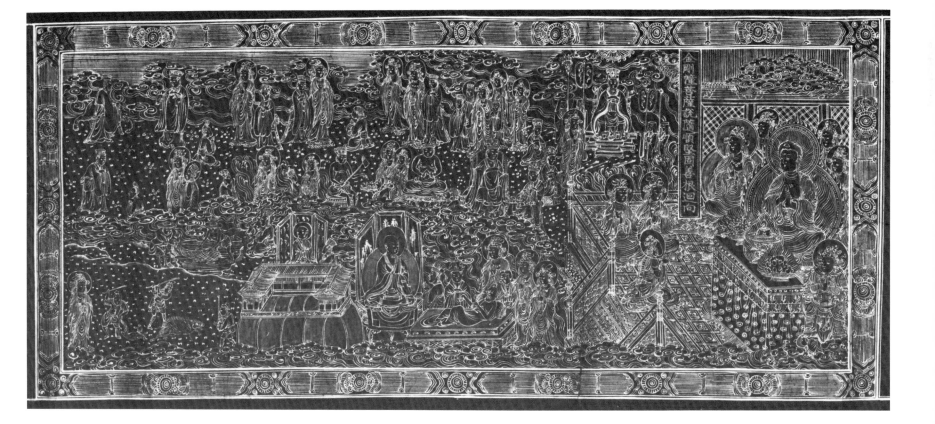

281

148

The Thirteen Buddhist Deities
Japan; Kamakura period,
14th century
Hanging scroll
Ink, colors, and gold on silk
42¼ × 15¾ in. (107.3 × 40 cm.)
Marion Hammer Gallery, Lugano,
Switzerland

The mandala (a schematic representation of the universe) was known in early times in Japan from the theme of the Thousand Buddhas seen, for example, at Dunhuang in China. Although the early esoteric teachers placed great emphasis on the painting of "Diamond-World" and "Womb-World" mandalas, other mandala forms were not popular in Japan until the Kamakura (1185–1333), Nambokucho (1333–92), and Muromachi periods (1392–1568), when they appeared in numerous paintings. As in *Raigo* paintings (see no. 173 for further discussion of this genre), even the most hieratic Japanese presentations of Buddhist deities, such as the traditional Mandala of the Thirteen Buddhist Divinities, show great variation in color, arrangement, and style.

Images in mandala format of the Ten Divine Kings or the Thirteen Buddhist Divinities were worshiped during the seven-week period of mourning following a death. This mandala is composed of six Buddhas, arranged in ascending order, with Amida (Amitabha in Sanskrit) at the lowest register in the center. Amida is invariably shown in this position as the first to meet the deceased in paradise. In this case, his companion is Fudo, the immovable guardian, who appears in the lower right. Above Amida are Shaka, Miroku, Yakushi, Ashuku, and Dainichi. The six Buddhas are traditionally accompanied by seven bodhisattvas, as shown in the key provided below (cf. P. & D. Colnaghi & Co., p. 35):

Left

Ashuku (Akshobhya),
Buddha of the East

Kokuzo (Akasagarbha),
Bodhisattva of the Sky
and the Void

Seishi (Mahasthamaprapta),
Attendant of Amida

Monju (Manjusri)

Jizo (Kshitigarbha)

Center

Yakushi (Bhaishajyaguru),
Healing Buddha

Shaka (Sakyamuni)

Amida (Amitabha)

Right

Buddha Dainichi (Vairochana)

Miroku Nyorai (Maitreya),
The Future Buddha

Kannon (Avalokitesvara)

Fugen (Samantabhadra)

Fudo (Achalanatha)

—A. G. P.

[This kind of painting can be viewed as an interesting iconographic document because it identifies the various Buddhas with inscriptions and thus helps us to resolve some of the confusion that has arisen regarding their hand gestures. For instance, Amida holds his right hand in the teaching gesture; Shaka displays the same gesture, using both hands. Yakushi also indicates the teaching gesture with his right hand, holding a small pot in his left (cf. no. 149). Ashuku, however, does not engage in his usual earth-touching gesture (see no. 164). The wisdom-fist gesture displayed by Dainichi is common in Japan, but is less frequently encountered elsewhere (see no. 159).—P. P.]

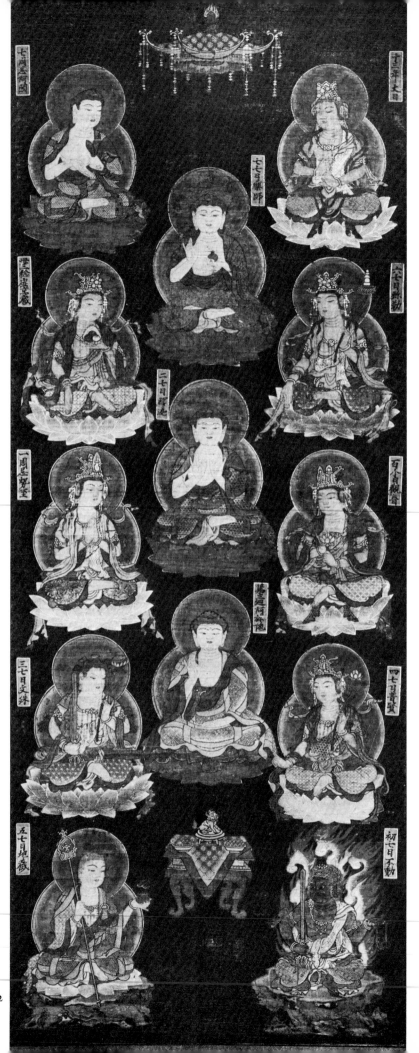

282

149

The Healing Buddha
Tibet, Guge; 15th century
Opaque watercolors on cloth
31¾ × 24¼ in. (80.6 × 61.6 cm.)
Los Angeles County Museum of Art,
from the Nasli and Alice
Heeramaneck Collection, Museum
Associates Purchase

The central figure in this painting represents Bhaishajyaguru, the Healing Buddha. Even in the early Pali canon, Buddha Sakyamuni had come to be regarded as the Supreme Physician, both literally and metaphorically (see no. 145). In his excellent book on the concept of the Healing Buddha, Birnbaum states:

> His healing methods were twofold: healing through teaching and psychic or 'miraculous' healing. The Buddha taught patients according to the severity of the disease. Those with fatal diseases received lessons on impermanence, while those who could be cured were taught to meditate on the "seven limbs of enlightenment." *(Birnbaum, p. 10)*

Characteristic of the Healing Buddha, the central figure in this painting holds a bowl in his left hand and the medicinal myrobalan fruit in his right. He is accompanied by the bodhisattvas Suryavairochana and Chandravairochana. Immediately above his head is the figure of Sakyamuni, clearly establishing a homology between the two. This relationship is further emphasized by the inclusion of scenes from Sakyamuni's life against the base of the throne. Also represented on the throne are Amitayus, the Buddha of Infinite Life, and the goddess Ushnishavijaya, both of whom are worshiped by Buddhists to promote longevity. Interestingly, thirty-five other Buddha figures in four rows have been added in the upper section of the painting. These are the thirty-five Buddhas of Confessions of Sins.

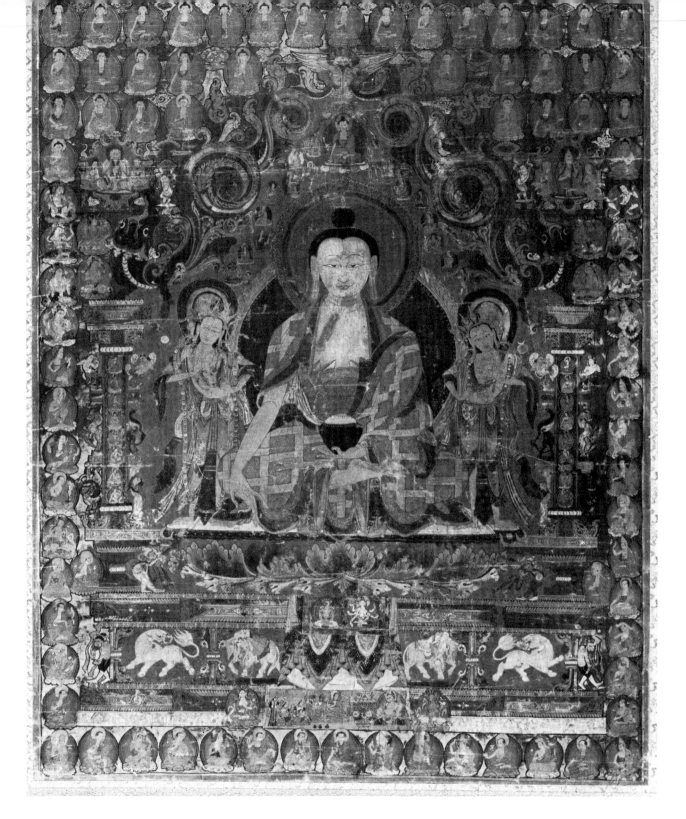

Among other figures represented in this iconographically rich picture are the eighteen arhats around Bhaishajyaguru's nimbus and the various gods, monks, and other Buddhas who surround the throne. Although Bhaishajyaguru is generally said to have a complexion the color of lapis lazuli, here he and his two bodhisattvas are represented as golden skinned.

The cult of Bhaishajyaguru flourished both in China and Japan. Although there is scant evidence that it existed in India, the cult seems to have had some currency in western Tibet. This *thanka* is a fine example of a distinctive style of painting that developed in the ancient kingdom of Guge in western Tibet.

—*P. P.*

150

Buddha and Companions Riding on a Mythical Animal
Thailand, c. 8th century
Stone
h: 17 in. (43.2 cm.)
Mr. and Mrs. Lawrence R. Phillips

This relief represents one of the most distinctive and enigmatic of all Buddha images from Thailand. The Buddha and two attendants are shown riding on a mythical animal. Although the Buddha's hands are broken, we can conjecture, based on similar reliefs, that they would have been held in either a teaching gesture *(vitarkamudra)* or in a gesture representing the holding of an object *(katakahastamudra)*. This latter gesture is somewhat unusual for

Buddha images. All triads of this type come from present-day Thailand (with the exception of one that was found just across the border in Cambodia), and all are clearly associated with Dvaravati culture (6th–11th century).

The meaning of these reliefs has not yet been explained. The creature's outspread wings indicate that the Buddha is being carried through the air. As in this example, a scalloped edge or pattern is occasionally used behind the figures in triads of this type to represent the sky or heavens. Unfortunately, the texts have failed thus far to suggest an episode in the

Buddha's life wherein he was transported through the air by a birdlike animal. Several scholars have suggested that the reliefs could represent the Buddha's ascent to or Descent from the Trayastrimsa Heaven. The texts, however, are rather explicit in their description of these events, particularly the Buddha's descent down a ladder of jewels (see no. 54).

Yet another barrier to identification is the lack of consistency among the various reliefs. Many triads clearly differentiate the two attendants. As in this example, the attendant on the Buddha's left often wears a short *dhoti* and a crownlike headdress, while the figure on his right wears a long *dhoti* and a chignon of matted hair, characteristics that could identify the gods Indra and Brahma respectively. On other reliefs, however, the two attendants appear almost identical, and in still other examples there are no attendants at all. Representations of the flying creature also exhibit considerable variation. There are instances when this beast has a human face and a birdlike nose and thus can almost certainly be identified as a *garuda*. The creature in the Phillips relief, however, is an odd mix of a *kala* (demon) face, combined with a *garuda*'s beak and wings, and the mane of the lion or of yet another mythical creature the *makara* (a mythical crocodile-like animal).

It is clear that the Dvaravati created a new form of Buddha icon in these reliefs—one based on a mistake, a purposeful reinterpretation, or perhaps a completely new conception reflecting local beliefs. Until new evidence is uncovered, these reliefs remain a mystery.

—R. L. B.

151

Boundary Marker with Reliefs of the Buddha
Thailand, 12th–13th century
Stone
h: 29⅛ in. (74 cm.)
National Museum, Bangkok

This extremely interesting carved stone block is probably a Buddhist boundary marker or *sima* (boundary). Such markers are placed around an area, usually an ordination hall, to designate it as a sacred or consecrated space for use in certain ceremonies performed by monks. The *simas* are placed either alone or in pairs at the four corners of the space and at the center of each of the four sides. These markers take two basic forms: they are either flat and slablike or, as in this example, square with a tapering top.

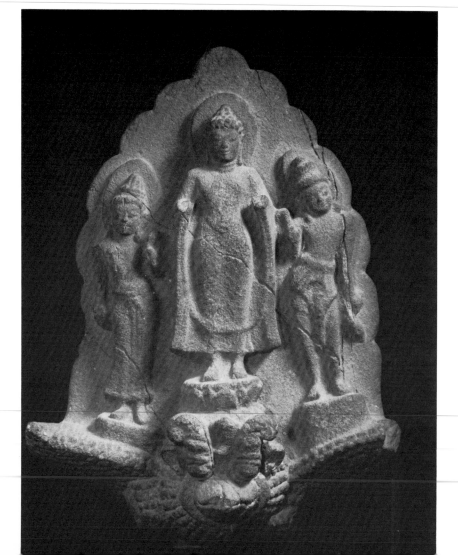

The reliefs on this marker stress two themes commonly seen in Buddhist art, the lotus and the serpent king Muchalinda. These themes, however, are presented in unusual ways. The Buddha Muchalinda theme, which has already been discussed (see no. 50), appears on three sides of the marker. It is interesting, however, that the birth of Brahma, a Hindu subject, is represented on the fourth side (a). At the bottom of this very worn side, the Hindu god Vishnu reclines on the cosmic snake, Sesha. Coming out of Vishnu's navel is a lotus stem that divides into seven stalks. Six of these stalks rise to the same height and form blossoms holding figures, only four of which are fully carved. The seventh stalk continues above the others with Brahma sitting on the lotus blossom. To the right of Brahma is a circle containing a figure; we can assume that a similar figure would once have appeared on the opposite side. These small figures represent the sun god Surya and the moon god Chandra. Brahma, Surya, and Chandra, along with the six figures represented below them, form a group of nine deities that was popular in Khmer style art. These gods relate to the nine planets *(navagraha)* and the directional guardians *(dikpala)*. The entire scene, which is similar to one depicted in a relief at Angkor Wat in Cambodia, represents Vishnu recreating the universe.

Although we cannot specifically determine the relationship that the artist intended between this Hindu scene and the Buddhist scenes, he was clearly making a comparison between Vishnu reclining on the cosmic snake and Buddha seated on Muchalinda. The important role of the lotuses, observed in the Vishnu scene, is also stressed in the other three panels. On side (b), for example, the Muchalinda Buddha, like Brahma in the Hindu scene, sits on a lotus upheld by a long stem. Further-

more a four-armed female figure, probably the goddess Tara, holds lotus buds as attributes, while the kneeling figure directly above her holds a lotus bud as if in an offering to the Buddha. A small seated Buddha appears to the right of the Muchalinda Buddha; below this small image is a male figure, probably Vajrapani, dancing on a corpse. The presence of Vajrapani and Tara indicates the influence of Tantric Buddhism.

Side (c) is organized somewhat similarly to side (b). Buddha Muchalinda, flanked by two figures, is raised on a lotus stalk under which other figures are placed. This lower register has a seated *yaksha*-like male in the center with a kneeling devotee presenting a lotus on each side of him. Standing Buddhas, with their hands held in identical gestures, accompany the elevated Muchalinda Buddha. The last side (d) features the Buddha Muchalinda with two flying divinities, and the theme of the lotus is stressed again in the array of stalks that appear on either side of the Buddha.

These four reliefs, with their unusual focus on the lotus and their combination of Hindu and Buddhist themes, perhaps represent regional developments and indicate the complexity and originality of Buddhism at this time under Cambodian influence.

—*R. L. B.*

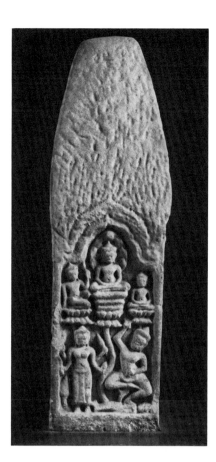
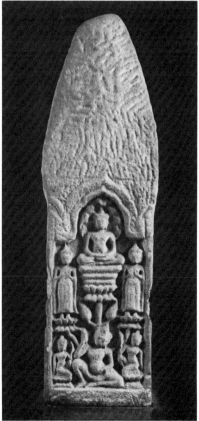
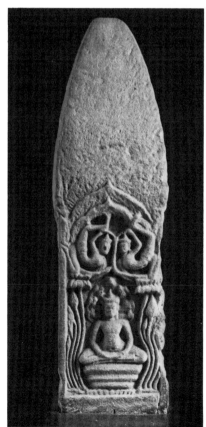

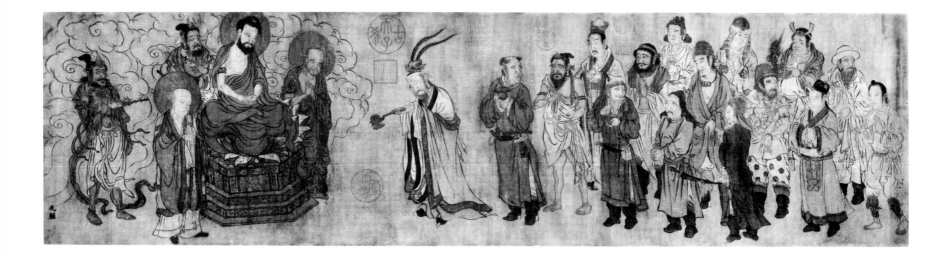

152

Foreign Dignitaries Worshiping the
Buddha
China; Northern Song dynasty,
12th century
Handscroll
Ink and color on silk
11¼ × 40¾ in. (28.6 × 103.5 cm.)
The Cleveland Museum of Art, Gift
of Mr. and Mrs. Severance A.
Millikin
(Reproduced in color)

This interesting painted handscroll
does not illuminate a passage from
any sutra; instead it portrays an
imaginary scene wherein the Bud-
dha receives a host of barbarian roy-
alty. In its choice of subject matter,
this painting resembles the frequent
Tang period (618–906) depictions of
the Chinese emperor accepting trib-
ute from foreign emissaries. As is
the case with several other Buddhist
themes represented in this exhibi-
tion (see nos. 40, 61, and 154), this
subject was completely invented by
the Chinese. Iconographic precedent

for the composition may be found,
however, in the tale of the sixteen
monarchs who came from all over
the world to attend the debate
between Vimalakirti and the
bodhisattva Manjusri (Chapin, p.
134). (See entry no. 87 for further
discussion of this debate.)

Buddha Sakyamuni is shown seated
on a lotus throne with his hands
placed in the gesture of meditation;
he is flanked by his disciples
Kasyapa and Ananda and attended
by two guardians. The Buddha is
approached by a procession of fig-
ures displaying a remarkable variety
of racial types and styles of dress.
Particularly interesting is the third
figure from the left, who wears a
loincloth and a plain upper garment
and must represent an Indian as-
cetic. The fine linear execution of
the robes and the sensitive rendering
of facial expressions make this an
exemplary work in the tradition of
Tang (618–906) and Song period
(960–1279) Chinese figure painting.

This handscroll bears the name of
Zhao Guangfu [Chao Kuang-fu],
who was a member of the Academy
of Painting during the reign of the
first Song emperor, Taizu [T'ai-tsu]
(r. 960–75). This artist excelled in
depicting figures, horses, and espe-
cially Buddhist and Daoist subjects.
Although the signature is regarded
as spurious, the painting does reflect
the tradition of Zhao Guangfu, and
the style of the brushwork indicates
a twelfth-century date. It is a
marvelous painting accompanied by
two colophons, one by Zhao Mengfu
[Chao Meng-fu] (1254–1322) and the
other by Guo Bi [Kuo Pi] (1280–
1335), two distinguished artists of
the Yuan dynasty (1280–1368).
Twenty-one seals also appear on the
work, including those of Emperor
Qianlong [Ch'ien-lung] (r. 1736–95)
and Jiajing [Chia-ch'ing] (r. 1796–
1820).

—J. B.

[The presence of the many colo-
phons and seals indicates that this
painting was highly valued. It is also
interesting to note that even Zhao
Mengfu, presumably the first owner
of the work, did not know the paint-
er's identity, for he writes in his
colophon: "Nor should it make any
difference whether the painter is
ancient or modern" (Ho et al.,
p. 60).—P. P.]

153

A Transcendental Buddha
China, Shande (Henan); Yuan
dynasty, 13th–14th century
Qingbai ware, porcelain with milky,
off-white glaze
h: 10½ in. (26.7 cm.)
Courtesy of the Royal Ontario
Museum, Toronto

This ceramic Yuan period (1280–1368) Buddha with its characteristic blue-tinged white glaze is an important example of *qingbai* porcelain, as well as being an early prototype for the famous *blanc-de-chine* figurines from Dehua and other kilns. During Yuan times, porcelain figures representing Buddhist deities were produced in substantial numbers at *qingbai* kilns in Jiangsu Province. These images were usually freely modeled with jewelry and appurtenances, which were mold-made and applied later. Several pieces were inscribed with dates from the Yuan period thereby providing a solid basis for their attribution (Riddell, pp. 76–77, fig. 51).

This seated figure is simply dressed in a Buddhist mantle, or *sanghati*, with its legs crossed in the classic yogic posture. The hands form an uncommon gesture, which may be a variation on the gesture of turning the Wheel of the Law or even a free adaptation of the *vajrahumkara-mudra*, a gesture employed in Vajrayana Buddhist iconography. The subtle grace and benign amiability of the smiling countenance make this an appealing example of Yuan ceramic sculpture.

—*G. K.*

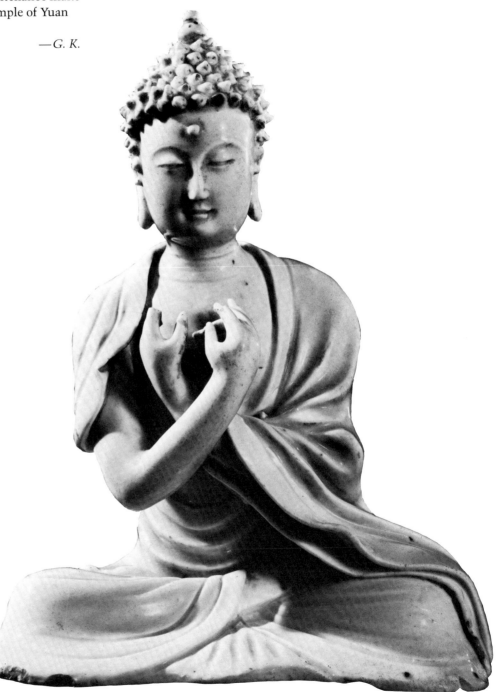

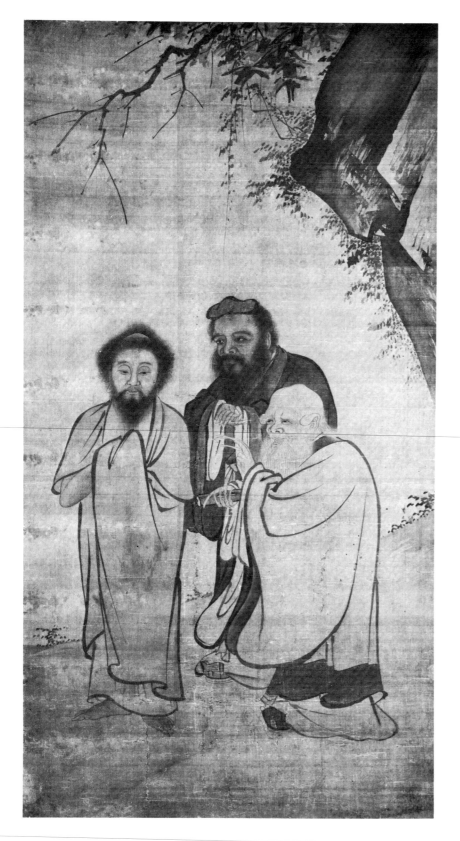

Confucius, Sakyamuni, and Laozi
China; Ming dynasty, late 15th–
early 16th century
Hanging scroll
Ink and color on silk
57⅝ × 29 in. (146.4 × 73.7 cm.)
Nelson Gallery—Atkins Museum,
Kansas City (Given in Memory of
John B. Trevor [1878–1956] by His
Son, Bronson Trevor)

The three figures in this hanging
scroll are generally identified as:
Confucius (551–478 B.C.), the
founder of Confucianism; Buddha
Sakyamuni; and Laozi [Lao-tzǔ] (7th
century B.C.), the apocryphal founder
of Daoism. Significantly, these reli-
gious leaders were not contempo-
raries, and of course they never actu-
ally met one another. This intriguing
composition showing the three
together is a distinct Chinese contri-
bution to Buddhist art.

Iconographically, this theme is also
referred to as "the three laughers,"
"the three tasters of vinegar," "the
three patriarchs," or "the three
teachings," and it was popular in
both China and fifteenth- and six-
teenth-century Japan. In China, it
appeared as a subject in paintings as
early as the ninth century (see Rog-
ers). In the colophon of this particu-
lar painting, the nineteenth-century
collector Kong Guangtao [K'ung
Kuang-t'ao] attributes it to the artist
Ma Yuan [Ma Yüan] (active c. 1190–
1230) (Ho et al., pp. 158–59, no.
135). Ancient catalogue descriptions
of now-lost Ma Yuan renderings of
this theme, however, state that
Confucius was shown paying hom-
age to a seated Buddha with Laozi
placed to the side.

The original idea of a confluence of
the three high religions reflects the
syncretic tendencies of the Song
period (960–1279). But the belief
gained popularity in China with Lin
Zhaoen [Lin Chao-en] (1517–1598),
who espoused the essential oneness
of the three doctrines. The fun-
damental basis of his doctrine was
the incorporation of Daoist and Bud-
dhist beliefs into Confucianism.
Lin's writings and philosophies were
profoundly influenced by those of
the early-Ming Confucian philos-
opher, Wang Shouren [Wang Shou-
jen], also known as Wang Yangming
[Wang Yang-ming] (1475–1529), who
had questioned certain Confucian
theories and explored the beliefs of
Daoism.

It has been suggested that the com-
position of the Nelson Gallery paint-
ing demonstrates Lin's belief in the
superiority of Confucius. Sakya-
muni, however, is the only figure of
the three to be presented in full
view. Furthermore, Laozi and
Confucius display somewhat def-
erential attitudes toward him. The
portrayal of Buddha Sakyamuni is
deeply indebted to a painting by
Liang Kai [Liang K'ai] (active early
13th century), *Sakyamuni Buddha
Leaving His Mountain Retreat*, and
to the Song tradition of depicting the
Buddha with a finely curling beard
and hair and a small bald spot. Laozi,
depicted with a long white beard and
eyebrows and dramatic, elongated
fingernails, holds a scroll; this repre-
sentation of the Daoist leader is
iconographically derivative of Zhang
Lu's [Chang Lu] (c. 1464–1538)
painting *Laozi Riding on a Water
Buffalo*.

Although unsigned, this work can
be dated to the late fifteenth- or early
sixteenth-century Zhe School by vir-
tue of its brushwork, particularly
the treatment of rocks and foliage.
The Zhe School, based on the Ma
Yuan–Xia Guei tradition of the
Southern Song Academy, is noted for
an angular, moist treatment of fo-
liage such as can be seen in the
rough wet execution of the rocks
and foliage in the upper right-hand
corner of this painting. The
calligraphic drapery strokes and lin-
ear treatment of the facial features
give each of these figures a
commanding presence.

—J. B.

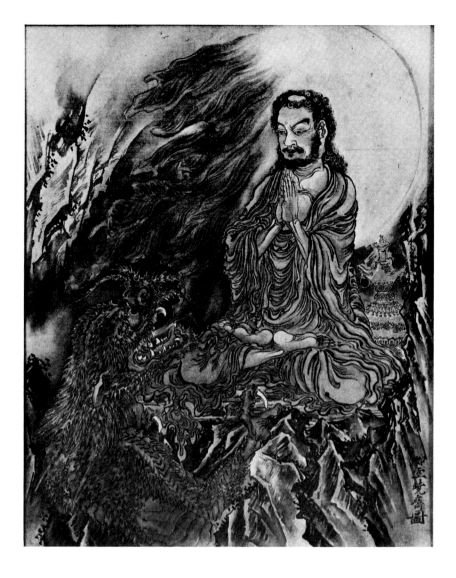

Kawanabe Gyosai
(Japanese, 1831–1889)
Sakyamuni and the Dragon;
Meiji period, late 19th century
Ink, colors, and gold on silk
14½ × 11 in. (36.8 × 28.0 cm.)
Lent by The Metropolitan Museum
of Art, Charles Stewart Smith
Collection, Gift of Mrs. Charles
Stewart Smith, Charles Stewart
Smith, Jr., and Howard Caswell
Smith, in Memory of Charles Stewart Smith, 1914

In this album leaf, Sakyamuni is shown seated in a meditative posture on a rock, where he is confronted by a fire-breathing dragon rising from the sea. Although the textual source for the scene is not identified, the painting may portray the conversion of the dragon king's daughter to Buddhahood, which is described in the Devadatta chapter of *The Lotus Sutra* (Hurvitz, p. 200).

Frequently recounted in classical Japanese poetry beginning in the Heian period (794–1185), the Devadatta chapter also became a standard source of pictorial themes. As a result, depictions of the dragon king's daughter rising out of the sea to offer a precious jewel to Sakyamuni are common.

Sakyamuni is portrayed here with a rough bearded face, and he exhibits many of the sacred marks of the Buddha, such as the aureole, the *ushnisha*, long earlobes, *urna*, and a variation on the snail-curl coiffure. The drapery folds of his robe are depicted with an almost arbitrary patterning that imparts an immediacy to the representation not unlike that of a realistic figure sketch.

This page is one of a large set of Meiji period (1868–1912) paintings, many by Gyosai, that are now in the collection of The Metropolitan Museum of Art, New York. This is the only Buddhist subject in the group, and for this particular painting, the artist has assumed a name with appropriately Buddhist overtones: "Nyoku Gyosai zu," or "picture by voidlike Gyosai."

—*A. G. P.*

[The subject of this painting could possibly be related to Zen Buddhism and may symbolize Sakyamuni's metamorphosis following his descent from the mountains (cf. nos. 40 and 41). Interestingly, Sakyamuni appears bearded here, as he does in many Zen paintings. The use of the mountains and the dragon could be taken further to represent Chan Buddhist borrowings of Daoist ideas. The dragon, symbol of the *yang* principle, is "not to be governed or restrained," but is used as a metaphor "for the benefits of meeting with noble men" (Rogers, p. 17). Significantly, the dragon in this painting seems to be greeted by Sakyamuni.—*P. P.*]

156

A Preaching Buddha (Vairochana?)
India, Kashmir; 8th century
Brass with silver inlay and black
paint
h: 16 in. (40.6 cm.)
Los Angeles County Museum of Art,
from the Nasli and Alice
Heeramaneck Collection, Museum
Associates Purchase

Portrayed as a monk-teacher, this
Buddha sits on a throne supported
by several creatures. His upper gar-
ment *(sanghati)*, indicated by rip-
pling, schematic folds, is draped
diagonally across his body, leaving
his right arm and shoulder free. The
hands with their slim and delicate
fingers display the gesture of turn-
ing the Wheel of the Law.

While the figure conforms to the
conventional type of preaching Bud-
dha (see nos. 51 and 74), it is distin-
guished here by an elaborate throne.
In the front, the throne is supported
by a central *yaksha*, who is flanked
on each side by a winged griffin and
a lion. In the back, the plain central
upright is decorated with pierced
scrollwork, while two columns with
pot bases and foliage capitals are
added at the corners. The idea of
yakshas supporting a divine struc-
ture or a throne is fairly old in India.
As regal emblems, however, both the
lions and the griffins were probably
introduced from neighboring Iran.
This particular configuration of mo-
tifs was typical of Kashmiri sculp-
tures, as was the practice of inlaying
a Buddha's eyes with silver.

Given the time period in which this
beautiful bronze was created, its
Buddha may represent either Sakya-
muni or Vairochana, one of the tran-
scendental Buddhas of the Vajrayana
pentad.

—*P. P.*

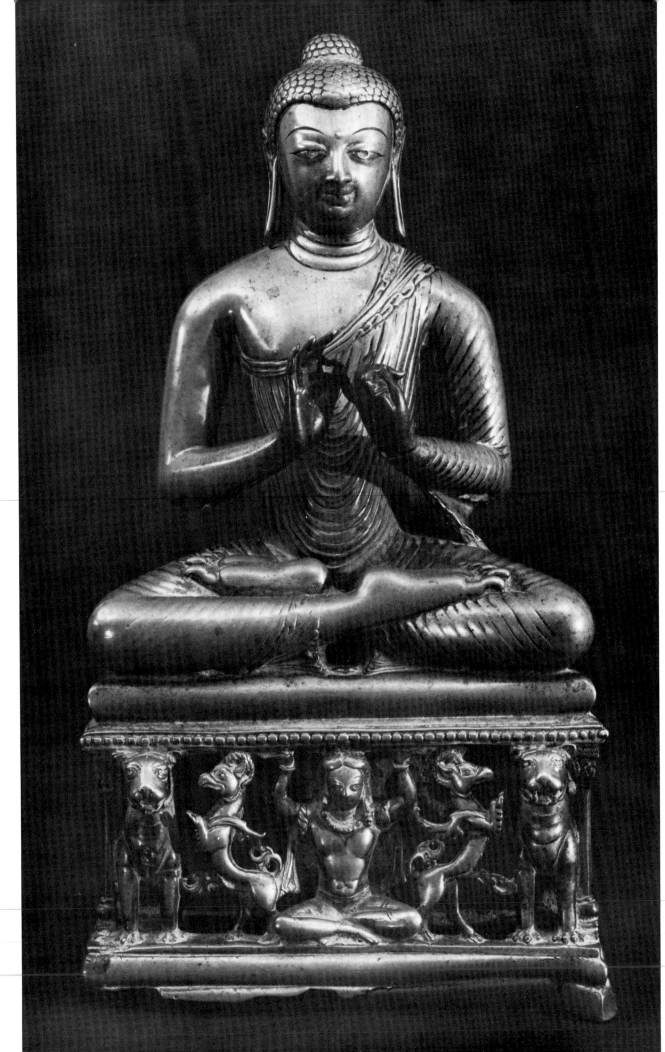

A Transcendental Buddha
Java, 8th–9th century
Bronze
h: 7½ in. (19 cm.)
Professor Samuel Eilenberg

Seated on a lotus, this Buddha performs a teaching gesture *(vitarkamudra)* with his right hand, a gesture commonly made by Sakyamuni in Southeast Asian representations (cf. no. 102b). In eighth- and ninth-century Central Java, however, Buddha images frequently did not represent Sakyamuni but rather one of the five transcendental Buddhas of Vajrayana Buddhism. These Buddhas are, however, depicted in the same postures and shown performing the same gestures as the historical Buddha. Unless there are specific indications, such as a wheel or deer, it is frequently difficult to make a positive identification of a particular Buddha image.

The transcendental Buddhas are differentiated from one another by their hand gestures. In the case of Buddhas, such as this one, who perform the *vitarkamudra*, however, a complication arises. While a teaching gesture is associated with the Buddha Vairochana, it is usually not *vitarkamudra* that is depicted but rather the wheel-turning gesture *(dharmachakrapravartanamudra)* (cf. no. 156). More rarely, Vairochana images display the wisdom fist *(bodhyangi)* (cf. no. 159). Buddhas displaying both the *vitarkamudra* and *dharmachakrapravarta-namudra* occur together on such monuments as Barabudur in Central Java, and scholars are unsure whether both versions indicate Vairochana or whether two different Buddhas are intended. It has been suggested that *vitarkamudra* may

indicate Samantabhadra rather than Vairochana or that it may differentiate Vairochana from another form of this deity, Mahavairochana.

In style this image closely follows that of the well-known Buddha images found at Barabudur and particularly at Candi Sewu in Central Java. Two basic styles of Buddha image emerged during the Central Javanese period (c. 778–930). One style is associated with bronze icons and one with stone images. The bronze-style images tend to follow the Pala style bronzes from eastern India. The style associated with the stone images, on the other hand, is a more indigenous creation. While the Indian-related bronze style rarely occurs in stone, the indigenous Javanese style of the stone images was sometimes produced in bronze, and the Eilenberg image is an excellent example of that practice.

—R. L. B.

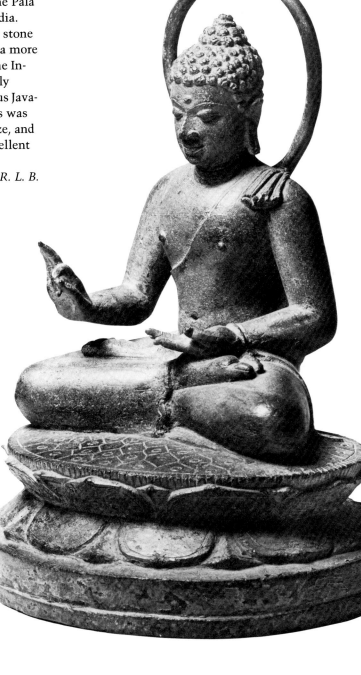

158

(a) *Preaching Buddha*
Java, 9th century
Bronze
h: 4½ in. (11.5 cm.)
Staatliche Museen Preussischer
Kulturbesitz, Museum für
Indische Kunst, Berlin

(b) *Preaching Buddha*
Java, 9th century
Bronze
h: 5¾ in. (14.6 cm.)
Professor Samuel Eilenberg

Both of these bronze images depict the Buddha seated on a throne performing the gesture of turning the Wheel of the Law. The form of this gesture varies somewhat from the Indian model (cf. no. 156). The seated posture with both legs pendant, however, differs radically from the cross-legged position of the Indian and Southeast Asian Buddha images seen thus far in this catalogue. This particular position is often referred to today as the European posture, presumably because of the Western predilection for sitting this way. Known in Sanskrit as *pralambapadasana* (sitting posture with the legs hanging down), this position was used in Indian Buddha images only slightly later than the cross-legged position, having been introduced at Amaravati or Nagarjunakonda in about the third century. Although it was used in India at various times and places, it never became as widespread as the cross-legged posture. In Southeast Asia, however, it was particularly popular in Dvaravati and in pre-Angkorian Cambodia at about the same time that these two Javanese bronzes were created.

The pendant-legged posture does not identify any particular Buddha in Indian and Southeast Asian art, although it became associated with the Future Buddha Maitreya in Chinese art (see no. 177). In Java, there are examples of the Buddha image seated with his legs pendant and performing the wheel-turning gesture that incorporate a wheel and deer, thus referring specifically to Sakyamuni's First Sermon. The same gesture and posture are also used on the colossal stone Buddha at Candi Mendut that must be identified as the transcendental Buddha Vairochana because of the iconography of the temple in which it is located. The two small bronze images illustrated here, however, lack any indication of their identities; they may represent Sakyamuni, Vairochana, or perhaps even Maitreya.

Although both bronze images display similar iconography and were created at about the same time, it is interesting to note how different they are in style. The figure and throne in the Berlin example (a) are much more angular than those in the Eilenberg image (b), which is characterized by rounded forms. Particularly appealing features of this latter bronze are the rearing lions shown supporting the throne. While similar lions appear in Javanese art of this period, this artist has produced creatures that are intriguing in their stylization and exuberance.

—*R. L. B.*

159

Mahavairochana
Java, 9th century
Silver and bronze
h: 4 in. (10.2 cm.)
Professor Samuel Eilenberg

This small silver Buddha sits with his legs crossed on a lotus that is placed on an ornate throne. He holds his hands in the gesture known as the wisdom fist *(bodhyangi)*, in which the index finger of the left hand is held by the right hand. This hand position symbolizes the union of "wisdom" and "means," a Tantric Buddhist concept, and is characteristic of the Buddha Mahavairochana (cf. no. 148). While this gesture is rarely encountered in Southeast Asia, where it is almost exclusively confined to Central Javanese art of the eighth and ninth centuries, it became very popular in East Asia, particularly Japan.

The Buddha wears the familiar monastic robe with the right shoulder exposed, although the Central Javanese artist has added two ribbons that fall over the legs and onto the lotus. These ribbons appear to be the ends of the cloth belt that held up the undercloth *(antaravasaka)*. One would assume that such an innovation would reflect the actual style in which Javanese monks wore their robes.

The throne on which the Buddha sits is very elaborate. A foliate *makara* (a mythical crocodile-like animal) head projects from the throne back on either side of the Buddha's shoulders. Along the sides of the throne are other foliate designs, which are usually considered to represent light or flames. This design has a very long and complicated development in Asia, and here it is reminiscent of the typical Chinese cloud motif.

On the base below the Buddha, there is a roundel set within a square and filled with a somewhat unusual form of the foliate design we have already seen. Two vertical pearl bands flank the central square. The source for this uncommon decoration, specifically the idea of a roundel filled with ornamental motifs, may be Chinese textiles. It has been demonstrated that similar roundels modeled after Chinese textile patterns were used to decorate eighth-century Javanese temples (Woodward, 1977, pp. 233–43). The appropriateness of the roundel placed on the base below the Buddha image, however, lies in its suggestion of a wheel *(chakra)*, which in addition to symbolizing Sakyamuni's First Sermon was also the specific symbol of Mahavairochana.

—*R. L. B.*

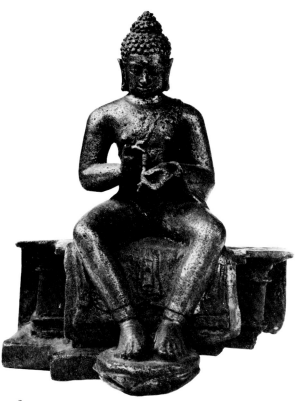

158a

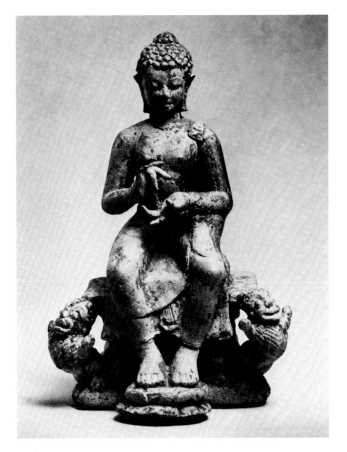

158b

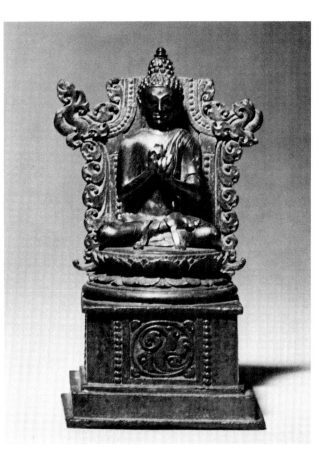

159

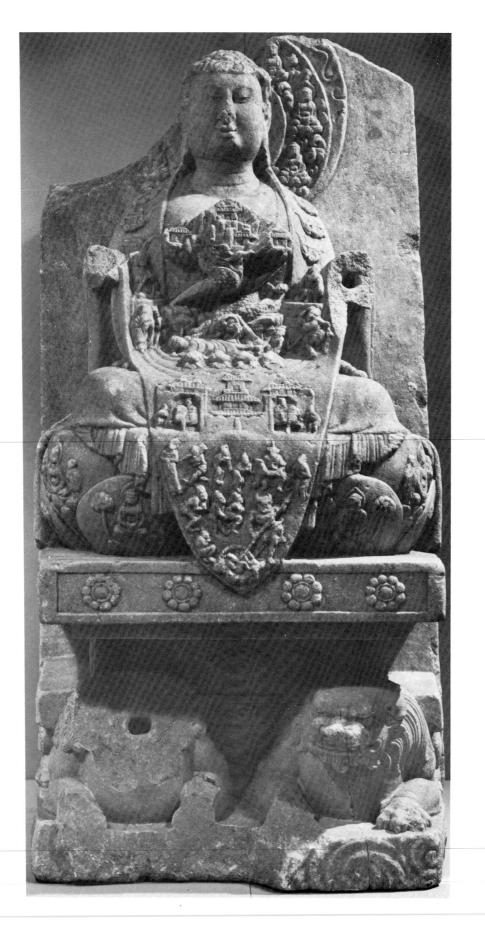

Cosmic Buddha
China, Yizhou area; Liao dynasty
(907–1125)
Pale cream, coarse-grained marble
h: 39⅛ in. (99.4 cm.)
Asian Art Museum of San Francisco,
The Avery Brundage Collection

This dramatic cosmic Buddha is related to images of Vairochana from Khotan in Central Asia (J. Williams, 1973, pp. 117–24). In examples from Khotan, however, the robe covering the Buddha is usually illustrated with symbols, whereas this image bears a mantle containing representations of heaven and hell, Mount Sumeru, and scenes from the life of Buddha Sakyamuni. In the portrayal of this figure and in similar Chinese examples, including those from Dunhuang, the artists have demonstrated greater freedom in interpreting the concept of a universal deity than that seen in the Khotan examples. One scholar has identified two related Chinese sculptures as representations of the Buddha Vairochana; he states that "with these images, the Buddha's body itself becomes the stage upon which the spiritual drama unfolds" (Munsterberg, 1967, p. 34).

The Tushita Heaven, supported by a dragon, appears within the triangular area at the top of the Buddha's mantle. This celestial realm contains Chinese-style buildings and rocklike projections that represent Mount Sumeru, the cosmic mountain. At the base of the supporting dragon, Buddha Sakyamuni's Death is represented with ten figures depicted in various attitudes reflecting lamentation. Below the Buddha's waistline is a large Chinese tower flanked by gates and city walls. The great departure of Prince Siddhartha, mounted upon his horse and ready to leave his father's palace, is depicted in both the left and the right gateway. At the bottom of this pictorial mantle is a scene in hell,

with demons torturing the damned and the underworld deity Yama brandishing a spear.

This Buddha is seated on a lotus pedestal supported by a square throne held by two large lions. The lotus pedestal is two layered; the lower level is adorned with images of Sakyamuni meditating under the *bodhi* tree, and the Buddhist trinity (Prabhutaratna, Sakyamuni, and Maitreya) is depicted on the upper layer. Images of the Buddha Sakyamuni seated in a meditative posture also appear on the halo of this image, while temples resting on clouds are represented on the shoulders of the robe. The heavy and ponderous treatment of this figure suggests an exaggeration of the Tang style and thus a later date (Soper, 1966b, pp. 103–12; for a similar example of a Liao dynasty Buddha, although not a cosmic one, see Siren, 1925, vol. 4, pl. 584).

—J. B.

[Images such as this may have been used in Yogatantra rituals. Yogatantra asserts that in his previous life, Sakyamuni became the Buddha Vairochana, after he had undergone certain initiations and five forms of contemplation. "Having become a Buddha, he performed the four kinds of marvel. He proceeded to the summit of Mt. Sumeru and pronounced the Yoga Tantras. Thereupon, he was known in the world of men as the son of King Suddhodhana, and displayed the method of the twelve acts" (Lessing and Wayman, p. 29).—P. P.]

Triad with Ratnasambhava
Java, 8th–9th century
Bronze
h: 4½ in. (11.5 cm.)
Professor Samuel Eilenberg

The transcendental Buddha Ratnasambhava, identified by the gesture of charity, is shown here flanked by two bodhisattvas. The bodhisattva on the left is Manjusri, who can be identified by the book he holds on top of a lotus. The bodhisattva on the other side of the Buddha is too fragmentary to be identified. Although all three figures are about the same size, the Buddha's preeminence is indicated by his central position and the slightly higher back frame behind him. Originally, this frame would have been topped by an umbrella, like the one that appears over Manjusri. Buddhist triads of this type were popular during the eighth and ninth centuries in Central Java and are products of Mahayana Buddhism.

—R. L. B.

[Other interpretations of the triad may be possible. Because of the absence of the jewel, a distinctive attribute of Ratnasambhava, and the inclusion of Manjusri, the central figure may represent Sakyamuni.—P. P.]

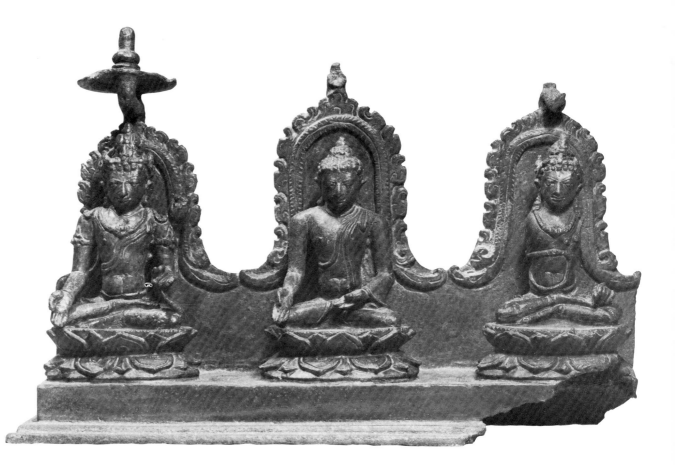

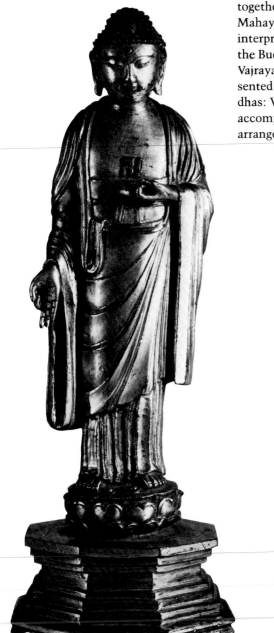

162

Buddha Ratnasambhava
China; Yuan dynasty, 13th century
Gilt bronze
h: 10¾ in. (27.4 cm.)
M. Nitta Collection, Tokyo

This sculpture portrays Ratnasambhava (Jewel Born), one of the five transcendental Buddhas of Vajrayana Buddhism. With the arrival in China of the Indian monks Subhakarasimha, Vajrabodhi, and Amoghavajra in the eighth century, Vajrayana Buddhism received new impetus. The developments of the esoteric schools of Vajrayana, together with Hinayana and Mahayana, completed the major interpretations of the teachings of the Buddha. The Tantric cosmos of Vajrayana was symbolically represented by five transcendental Buddhas: Vairochana in the center accompanied by four others arranged directionally.

This Ratnasambhava image bears many of the traditional features of a Buddha, but there are certain iconographical elements that make it an unusually interesting example. The high-waisted Chinese skirt is tied with a sash below Ratnasambhava's chest, which is emblazoned with a Buddhist swastika. The presence of the swastika may reflect Tibetan Lamaist influences, since by the eleventh century, iconographic elements—including the swastika—taken from Bon, the native Tibetan religion, had been incorporated into the Buddhism practiced in that country. The hand positions observed in this image are typical of Ratnasambhava. The right hand displays the gesture of charity, and the left hand placed across the chest may have held the wish-fulfilling jewel *(chintamani)*. This gesture of the hand, with the thumb and index finger forming a circle, signifies esoteric power.

The mound of light positioned in front of the cranial bump is an iconographic feature that first appeared in the Song dynasty (960–1279); but the portly body, the wide bared chest, and the free-flowing robe that hangs loosely over the shoulders have not yet been codified in the rigid stylization of the Ming period (1368–1644). All of these factors suggest a Yuan period (1280–1368) attribution. The Yuan court's espousal of Tantric Buddhism and the Tantric iconography of this Buddha are consonant with such a date.
—*G. K.*

[The swastika—from the Sanskrit word *svasti* (auspicious)—is an ancient Indian symbol, used ubiquitously by Hindus, Buddhists (see no. 67), and Jains. Rarely, however, is it depicted on the chest of a Buddha. The Bonpos (practitioners of the native Tibetan religion) employ the swastika as a distinctive mark of their deities. Significantly, Tibetan monks were very influential in the Yuan court of China.—*P. P.*]

163

The Buddha Ratnasambhava
Central Tibet, Kadampa monastery;
13th century
Opaque watercolors on cloth
36¼ × 26⅞ in. (92.1 × 68.3 cm.)
Los Angeles County Museum of Art, from the Nasli and Alice Heeramaneck Collection, Museum Associates Purchase
(Shown in Chicago and Brooklyn only)

The yellow-complexioned central figure in this painting is Ratnasambhava (Jewel Born), one of the Buddhas of the Vajrayana pentad. Seated upon a multicolored lotus, the Buddha is bedecked with jewelry and tiaras. His right hand assumes the gesture of charity, and the left rests in his lap. The horse, Ratnasambhava's symbol, is represented twice on the pedestal of his throne, and part of a mantle or carpet, decorated with four birds, overhangs this pedestal. Each of the five Vajrayana Buddhas has a directional significance, and the birds on the mantle may symbolize the south, which is associated with Ratnasambhava. This symbolic use of birds may have been borrowed from Chinese cosmology.

Eight bodhisattvas surround Ratnasambhava. The white bodhisattva on his left holding a white lotus may be identified with Avalokitesvara. The yellow bodhisattva on the other side, who appears to hold a stupa in his right hand, is probably the Future Buddha, Maitreya. Canopies formed of clusters of stylized leaves appear behind the nimbi of Ratnasambhava and the four seated bodhisattvas represented along the top of the painting. Multicolored lotus petals form a border for the entire painting and enclose the nimbus of Ratnasambhava as well.

It would appear that the *thanka* represents a Mandala of the Eight Bodhisattvas. The cult of this mandala originated in India during

the early days of Mahayana Buddhism, and it was particularly popular in Central Asia and Tibet. The Eight Bodhisattvas, representing the eight directions, were worshiped in a mandala largely by those seeking mundane favors or protection from disease, famine, and war. Mandalas of the Eight Bodhisattvas are also found in wall paintings in several Tibetan monasteries, thus attesting to the cult's wide popularity. The only Indian region where the cult was strong, however, was Bihar, during the Pala period (8th–11th century) (Pal, 1972–73). The style of this painting is directly derived from the Pala style.

There are a few iconographic peculiarities of this representation that should be pointed out. Ratnasambhava is depicted here as a bodhisattva rather than a Buddha. He is not attired in the garments of a monk but wears a *dhoti* as would a bodhisattva. Moreover, he has a full crown of matted hair arranged in a tall chignon, as opposed to a Buddha's closely cropped curly hair. Unusual as these iconographic deviations may seem, they would be considered appropriate for the regally attired Buddha images used in certain esoteric rituals of Vajrayana Buddhism.

—*P. P.*

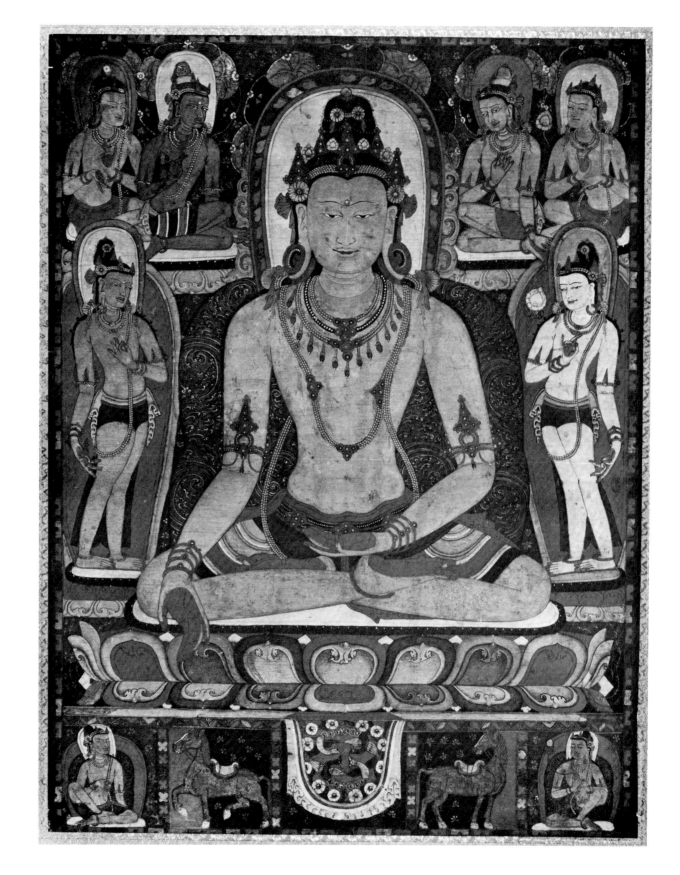

164

Buddha Akshobhya in a Shrine
Western Himalayas, 11th century
Brass
h: 10 in. (25.4 cm.)
Vajra Arts

In this sculpture, a Buddha sits in meditation on a lotus within a shrine supported by four heraldic lions. His right hand, stretched out in front of him, displays the earth-touching gesture normally asso-ciated with Sakyamuni's Enlightenment. In a Vajrayana context, however, this gesture is also characteristic of Akshobhya (Imperturbable), one of the five transcendental Buddhas. Given the time when this shrine was produced, its Buddha was probably intended to represent Akshobhya and not Sakyamuni.

The most distinctive features of this Buddha are large open eyes, made more expressive by the use of silver inlay. Even more curious are the masklike faces with extended eyes that decorate the upper corners of the columns. Such faces occur frequently in the art of the Western Himalayas, although they are not usually this exaggerated. The shrine is surmounted by a stupa placed on an open lotus and encircled by a snake.

—*P. P.*

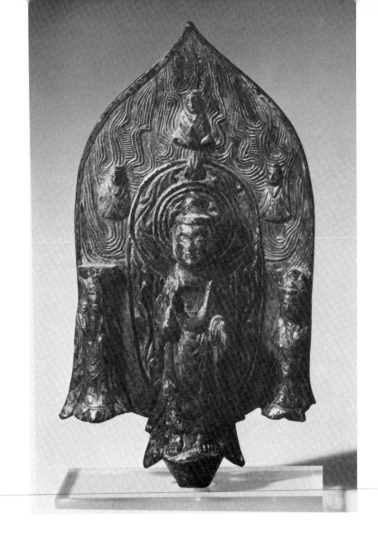

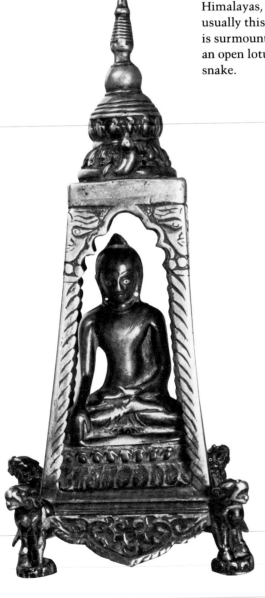

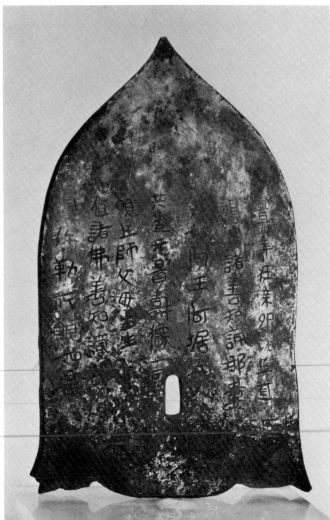

Buddha with Bodhisattvas
Korea; Koguryo dynasty, dated 571
Gilt bronze
h: 6⅛ in. (15.5 cm.)
Kim Dong-hyun, Seoul

This small triad is one of the few remaining Three Kingdoms period (c. 1st century–668) examples of Buddhist art from the Koguryo Kingdom in northern Korea. The inscription on the back of the aureole is dated to 571 and identifies the Buddha as Amitabha:

> In the fourth year of Kyong-(?), the year of Sinmyo, monk To (?) and four other people made a Buddha statue of Eternal Life [Amitabha] with the desire that the deceased teacher and parents be always with the Buddha and all of us meet the Maitreya and live together afterward to see the Buddha preach the law.
> *(Kim and Lee, p. 329)*

This triad closely follows the example of northern Chinese works, particularly the Northern Qi style of the late sixth century. The central figure, which was cast separately from the aureole, exhibits the gesture of reassurance with its right hand. The left hand displays a popular variation of the gesture of charity, wherein only two fingers are extended. The cranial bump is present, but the hair is shown without curls. The overly large head is set almost directly upon the shoulders. The square cavity in the chest appears to be from the original casting and probably once contained a relic or prayer. The aureole surrounding the central figure consists of flame and lotus flower designs with three small seated Buddhas shown near the top and one larger bodhisattva placed on each side. The three seated Buddhas—common among sixth- and seventh-century Chinese images and also found in Korea from the late sixth and early seventh century—may indicate that this is actually an image of Sakyamuni. According to Jonathan Best, these figures may represent the three men who attained Buddhahood in this era *(kalpa)* and be intended to form a group with Sakyamuni, who is the fourth or last Buddha (Best, pp. 89–108). Once an image was made, it was not unusual for a dedication to be added later to suit the wishes of the donor. This practice explains the existence of sculptures carrying labels that are not in complete agreement with the iconography of the image.

—R. E. F.

A Preaching Buddha
Japan; Early Nara period, late 7th century
Bronze with traces of gilt
h: 9⁷⁄₁₆ in. (24 cm.)
Marion Hammer Collection

This bronze figure of a preaching Buddha is a moving example of the sensitive and elegant style that developed in Japan in the second half of the seventh century. The Early Nara period (646–710), often designated the Hakuho period, ushered in

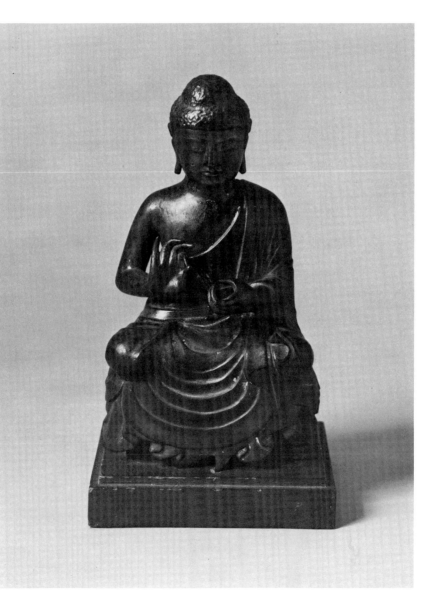

a new age in the history of Japanese bronze casting—as evidenced by this exquisitely modeled image. This age also witnessed a new interpretation of the Buddha image in Japan. Noma Seiroku has pointed out that, instead of expressing the desire to "mold this world according to Buddhist ideals," the Hakuho Buddha's face exhibits the impulse to leave the world and "escape to an unblemished land beyond" (Noma, 1966, pp. 35–36). It has been asserted that the greater tenderness and compassion expressed in the countenances of Hakuho Buddhas may reflect a desire on the part of the populace to alleviate the sufferings and anguish caused by civil wars.

The face of this Buddha is both boyish and highly introspective without being remote or unapproachable. Despite the idealization of the form and the rhythmic and elegant stylization of the robes, the figure possesses a human quality that is often a characteristic of Hakuho bronzes. The hands appear disproportionately large, and yet they are so gracefully and sensitively rendered that they immediately capture the viewer's attention. Together with the simplified lines of the garments' folds, the expressive gestures make this a lively and friendly figure without detracting from its noble dignity.

The exact identification of such Japanese Buddhas is difficult to determine when they are removed from their context. Japanese scholars tend to identify all such figures as Amida; an identification with Buddha Sakyamuni, however, cannot be ruled out.

—P. P.

*Amitabha Buddha Preaching to an
Assembly*
China, Tang dynasty (618–906)
Gilt bronze
h: 3⅝ in. (9.3 cm.)
M. Nitta Collection, Tokyo

This handsome gilt-bronze plaque
portrays Amitabha Buddha preach-
ing to his disciples in the Pure Land
Paradise. The Buddha's hands do not
assume the teaching gesture usually
associated with such scenes in In-
dian iconography. Instead his right
hand displays the gesture of reassur-
ance, which was commonly used in

China to represent the preaching
Buddha (Davidson, 1954, p. 5). The
attendant disciples hold their hands
in the gesture of adoration. The Bud-
dha is shown seated on a two-lay-
ered lotus throne with his legs
crossed and his eyes closed in medi-
tation. Beneath the throne appears
an incense burner shaped like the
chintamani jewel associated with
several Buddhist deities; it is flanked
by two lions. Considered felicitous
symbols, lions were often repre-
sented near the bottom of Buddhist
assemblages. Above the group is a
Chinese style canopy with stylized
clouds projecting from its sides. The
canopy and the *apsaras* (flying
celestials) above it suggest the Para-
dise of the Buddha Amitabha, who
became a popular subject in Chinese

art during the Tang dynasty (618–
906) and who was represented more
frequently than the historical Bud-
dha Sakyamuni.

By the time of the Tang dynasty,
Buddhist sculpture had become
more naturalistic. This increased
naturalism is apparent in the treat-
ment of the figure and drapery and in
a more sophisticated organization of
space. A Tang dynasty plaque that
provides interesting grounds for
comparison is currently in the
collection of the Fogg Art Museum,
Harvard University (Munsterberg,
1967, pl. 120).

—J. B.

167

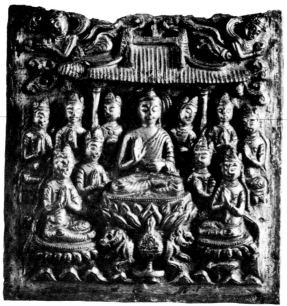

168

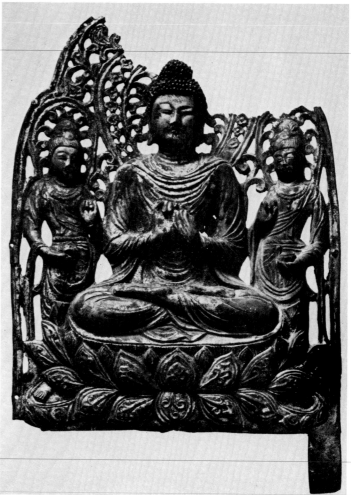

Amitabha Triad
Korea; Unified Silla dynasty,
8th century
Gilt bronze
h: 7 1/16 in. (17.9 cm.)
Kyongju National Museum

Since the concept of Amitabha, the ruler of the Western Paradise, was developed by Chinese Buddhists, it is logical to expect that early Korean representations of the Buddha would follow the Chinese style. And this gilt-bronze plaque, probably once part of a wooden shrine, is Chinese in nearly all respects. It closely follows Tang period (618–906) examples in the treatment of the robe, the teaching gesture indicated by the central figure, and the swaying posture *(tribhanga)* of the two bodhisattvas. The openwork aureole and double-lotus throne also closely adhere to Chinese models. Similar repoussé copper plaques were well known in eighth-century Japan, indicating the widespread occurrence of this image type—one of the most popular in East Asia. In both Korea and Japan, the ensuing centuries saw a more native style evolve that ultimately replaced this essentially imported type. Subsequent Amitabha triads, however, can usually trace their origin to the Chinese source.

This plaque is one of a group excavated from Anap-chi Pond, in Kyongju in southeast Korea. This man-made lake was constructed, according to the circa twelfth-century text *Samguk Sagi*, by King Munmu of Silla in 674 (National Museum of Korea, p. 162). It was later abandoned and is known primarily from Yi dynasty (1392–1910) records. Excavations in 1975–76 disclosed over fifteen thousand objects and evidence of five nearby pavilions. These Buddhist materials are thought to date from the seventh to the tenth century.

In this triad, Amitabha has been created with richness of effect, but the figure itself remains the long-established version of Sakyamuni, which has been translated into the role of ruler of the Western Paradise.

—*R. E. F.*

Amitabha Buddha
Korea; Unified Silla dynasty,
8th–9th century
Gilt bronze
h: 8 7/16 in. (21.4 cm.)
Musée Guimet, Paris

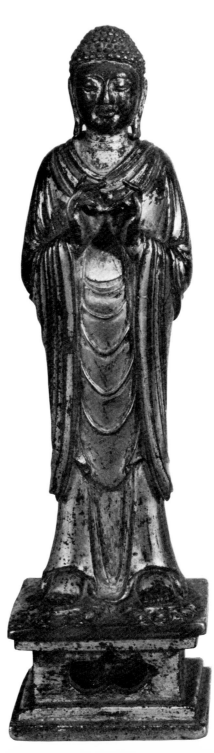

This late Silla image of Amitabha Buddha retains the Chinese stylistic features that dominated many earlier Korean images. Here both shoulders are covered, and the vertical lines of the sleeves frame a series of drapery folds on the center of the Buddha's robe that evoke the smooth ripples of a shallow stream. The head is covered by snail-shell curls, and the face is a blend of traditional Chinese imagery and Korean ethnic features. There are several other interesting characteristics which make this an unusual image. Noteworthy is the fact that the Buddha stands on two lotuses rather than one. This representation was quite common in Chinese images during the seventh and eighth centuries. The tall, slim figure of the Buddha illustrates a style seen in earlier Korean images and also found in seventh-century Japanese figures, such as the example included in the exhibition (no. 95).

Most distinctive, however, are the hand gestures made by this Buddha. By the end of the Unified Silla period (668–935), the Koreans had developed a particular gesture for Amitabha that signified his welcoming the deceased to paradise. This gesture consisted of touching the second finger to the thumb; a Japanese version of the same gesture involved the joining of the index finger and thumb. In nearly all examples, however, the hands are held apart, with one placed near the chest and the other arm extended below the waist (cf. nos. 170 and 171). In this instance, the hands are held symmetrically in front of the chest, and the thumbs touch the third finger, forming the gesture of good for-

tune *(srimudra).* This gesture is not unknown in Korea, but the placement of both hands together at the chest is uncommon; this example may, in fact, be unique. The illustrated gesture is related to the traditional turning of the Wheel of the Law, and it is similar to that made by Sakyamuni in a Japanese painting (see no. 148). It also resembles the double teaching gesture that was popular in Thailand and Cambodia, although the Korean image's hands are held higher and closer to the chest. The delicacy of the gesture's delineation in the illustrated image is typically Korean, but the placement of the hands probably represents a local variation that failed to gain popularity and hence was not repeated.

—R. E. F.

[Since this gesture is specifically given to Sakyamuni in a later Japanese painting (cf. no. 148), an identification of this figure as the Buddha Sakyamuni, rather than Amitabha, cannot be ruled out.—P. P.]

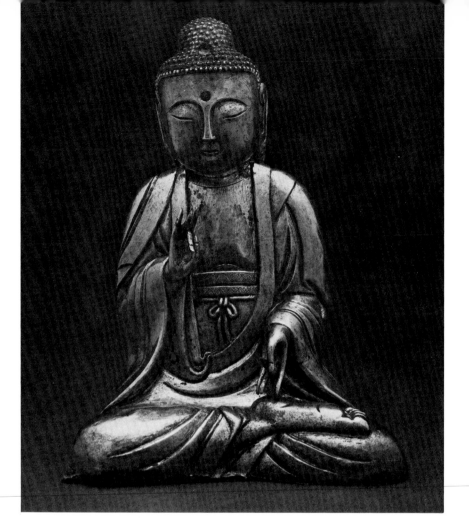

Amitabha Buddha
Korea; Koryo dynasty,
13th–14th century
Gilt repoussé silver
h: 7½ in. (19 cm.)
Mr. and Mrs. Robert Wm. Moore
Collection, Los Angeles

This unusually well-preserved image of Amitabha Buddha is typical of the fully developed style of the Koryo period (918–1392). The Koryo dynasty actively patronized the Buddhist faith. During this time images were created not only in the traditional stone and bronze but in a number of other materials that had begun to appear in the late Silla period (668–935), when the conventional media were joined by lacquer, clay, and iron. This remarkable image appears to be made of silver covered with gold. Its lightness and malleability are not qualities that encourage longevity, and few such images remain. The two hands form the gesture most commonly employed on Korean Amitabha images—the thumb joins the second finger in a variation of the teaching gesture. Also typically Korean is the overly large head that rests almost directly upon the shoulders and the sense of gentleness, almost fragility, that marks the developed Korean formula for Buddha images.

—R. E. F.

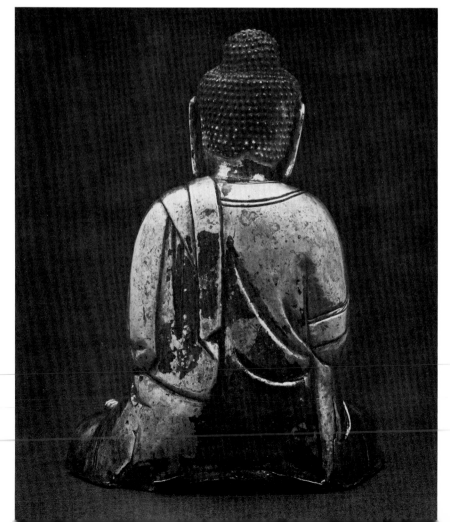

171

Amitabha Buddha
Korea; Koryo dynasty, 14th century
Ink, color, and gold on silk
38¾ × 16½ in. (98.5 × 41.9 cm.)
The Asia Society, New York:
Mr. and Mrs. John D. Rockefeller
3rd Collection
(Reproduced in color)

Two types of paintings of the Buddha exist from the Koryo period (918–1392). The Buddha is either shown seated atop an elaborate lotus throne or standing upon a lotus base. Usually, various other figures are represented in attendance—bodhisattvas, arhats, monks, guardians, and musicians; this is especially true of the grand displays that characterize heavenly scenes. When portrayed alone, the Buddha is usually depicted standing. The illustrated painting agrees in style with other such Koryo images, all of which may be found today in Japanese collections.

This hieratic image is completely surrounded by a nimbus, and the head is emphasized by a circular halo. The chest is exposed, but the rest of the figure is covered by two bright red garments, which are accentuated by medallions featuring phoenix and lotus designs painted in gold. Supporting the figure are a pair of delicately painted lotus flowers. The hand gestures are those commonly found among Amitabha images, especially Japanese versions.

In some respects, however, this image differs from known Koryo representations of Amitabha. In Korea, the Buddha is usually shown in a three-quarters view not frontally as here, and the gestures of the hands are reversed, so that the left hand is raised. Frequently, the teaching gesture *(vitarkamudra)* shown here is limited to the upper hand, and the other is shown with the palm open in the gesture of charity *(varadamudra)*. Furthermore, Koryo images usually exhibit a variation of the teaching gesture wherein the second finger touches the thumb (see no. 170), rather than the index finger, as in this painting. The linear painting style and frontal pose, although not unknown in Koryo examples, link this image to Japanese Amitabhas of the Kamakura (1185–1333) and Nambokucho (1333–92) periods and demonstrate the close relationship that existed between the Buddhist cultures of Korea and Japan.

—*R. E. F.*

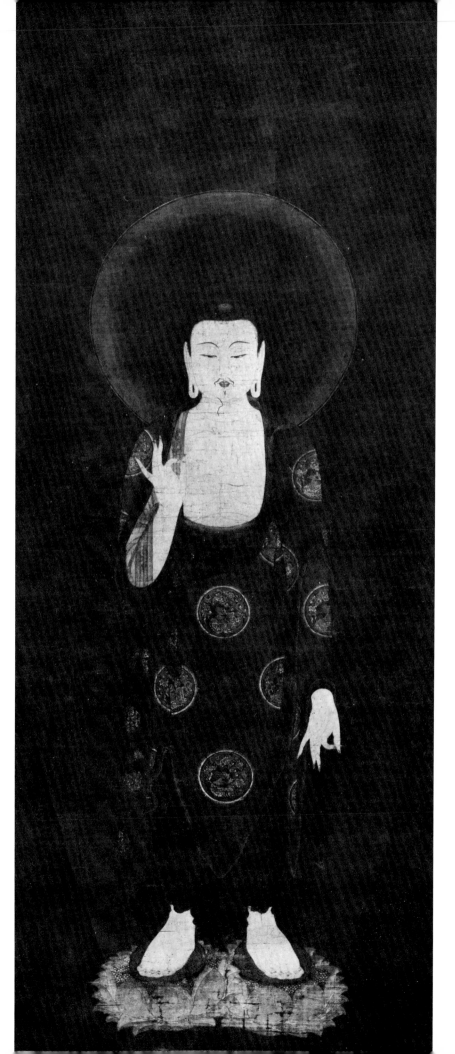

172

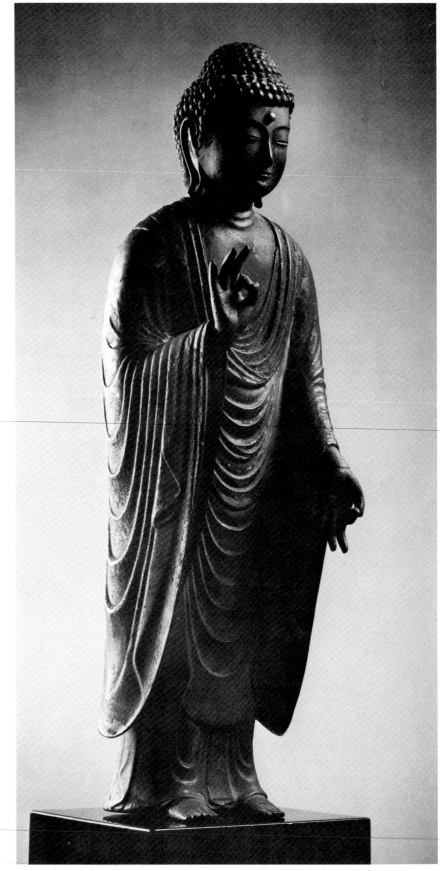

(a) *Amida Nyorai*
Japan; Kamakura period,
13th century
Bronze with carved wooden
hands
h: 18¾ in. (47.6 cm.)
Los Angeles County Museum of
Art, William T. Sesnon, Jr.,
Bequest

(b) Koei (Unkei IX) (Japanese, active
15th century)
Amida Nyorai; Muromachi
period, 1472
Wood with traces of polychromy
h: 21 in. (53.5 cm.)
Property R. H. Ellsworth Ltd.

Adherents of the Pure Land sect
(Jodo in Japanese) believed that
merely by reciting the name of
Amida (Amitabha in Sanskrit), one
could enter into the Western Para-
dise. This became a very popular
form of Buddhist worship in Japan
after the late Heian period (897–
1185) and particularly during the
Kamakura period (1185–1333).

Amida was portrayed in both seated
and standing poses. The standing
bronze figure of Amida Nyorai illus-
trated here (a) appears in a classic
pose that combines Heian idealism
with Kamakura realism. Statues like
this one were probably modeled
after a renowned bronze Amida
dated 1254 at Zenkoji in Nagano.
Such images also recall the central
figures of Amida frequently repre-
sented in *Raigo (Welcoming
Descent)* paintings. (See no. 173 for
further discussion of the *Raigo*
genre.)

Kaikei and Unkei were two broth-
ers, both master sculptors and
believers in Amidism, who lived in
the late twelfth and early thirteenth
centuries. Each developed a particu-
lar sculptural style that was subse-
quently emulated by generations of
artists. Kaikei's style was the softer
and more ideal of the two and was
calculated to emphasize the benign
and compassionate qualities of
Amida—the Los Angeles bronze ob-
viously belongs to this tradition.

The second image of Amida (b) is carved in wood. Although its hands are now lost, this seated figure would probably have maintained the same hand gestures seen in the Los Angeles bronze, which symbolize the Buddha's welcoming a devotee into one of the nine degrees of birth in paradise. This sculpture probably once rested on a lotus pedestal that has since been lost. The image is signed by Koei, who was the ninth generation in a direct line of followers of the twelfth-century sculptor Unkei, Kaikei's brother. Unkei was one of the most important sculptors in Nara and the leader of the Kei School, which was responsible for the development of a dynamic realism in Japanese Buddhist sculpture. No other pieces by Koei are recorded (Uehara, p. 92), and thus this image is an especially important document of the work of the late Kei School. The sculpture is beautifully proportioned with a benevolent face and rounded volumes countered by deeply carved drapery. The carving of the drapery is somewhat shallower than that of earlier Kei School works, and it is generally more rigid and stylized.

When the piece was dismantled for restoration, an inscription was found on the interior of the back of the head.

Carved by Unkei IX on the 8th day of the 8th month, 4th year of Bunmei [1472] at Daisanji of Yoshu, at Matsuyama Shikoku. Carved by Koei, *daiyu hogen* [an honorary rank] of the Shichijo Bussho workshop. *(Translation by Keita Itoh)*

The Shichijo Bussho was founded by the artist Jocho (d. 1057), who carved the masterpiece of Heian sculpture, an Amida image for the Phoenix Hall of Byodoin. The survival of his workshop into the fifteenth century demonstrates the continued appeal of this current in Buddhist sculpture. The rank of *hogen*, literally "eye of the law," originated as a title given to Buddhist priests but came to be awarded to artists associated with Buddhist monasteries and later to artists belonging to workshops specializing in religious sculpture. This system originated in the late Heian period during Jocho's lifetime.

—A. G. P.

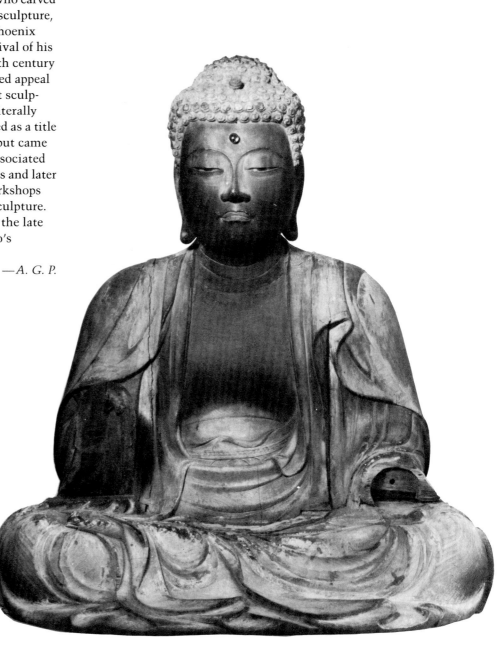

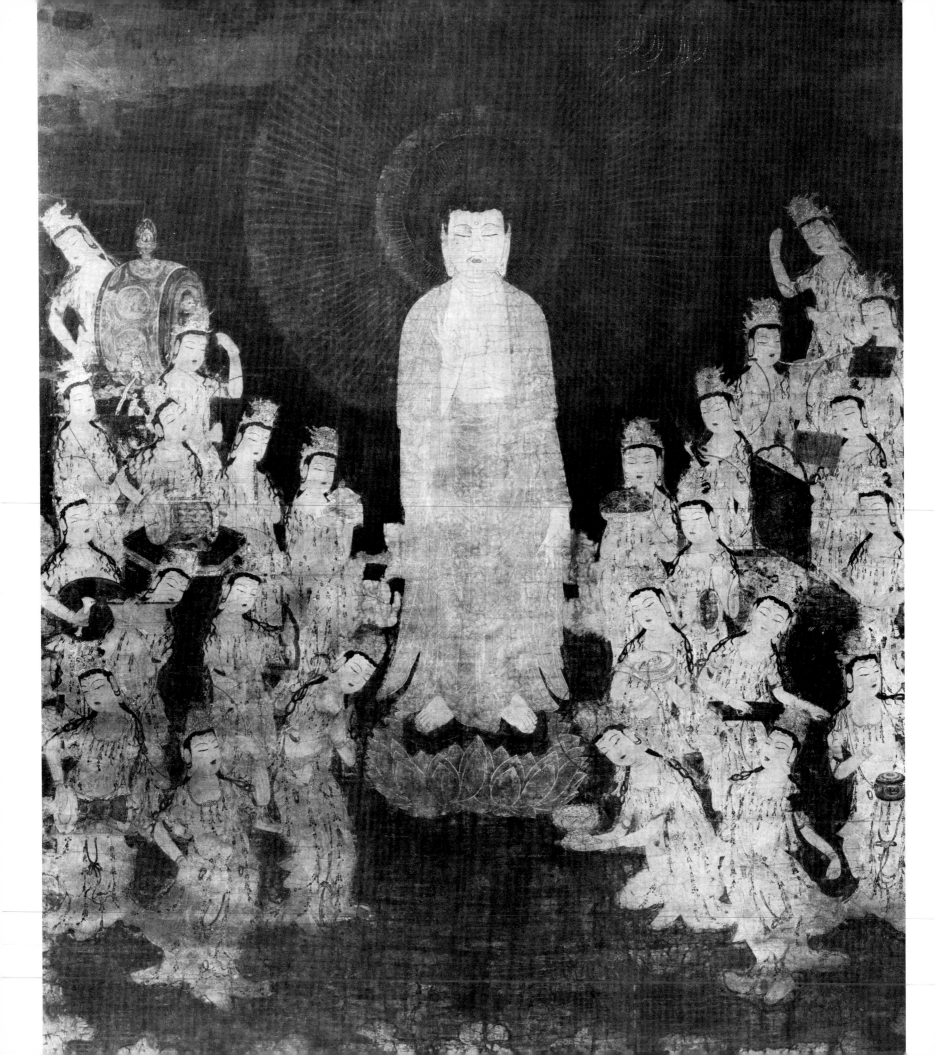

*Amida Raigo with Twenty-five
Bodhisattvas*
Japan; Kamakura period, early 14th
century
Hanging scroll
Ink, colors, and gold on silk
65 × 55½ in. (165 × 140 cm.), exclusive of mounting
Property R. H. Ellsworth Ltd.

How much more, then, does he who for many years has controlled his mind and piled up the merits of the *Nembutsu,* find great joy in his heart when he comes to die! The great vow of Amida Nyorai is such that he comes with twenty-five Bodhisattvas and the host of a hundred thousand monks. In the western skies purple clouds will be floating, flowers will rain down and strange perfumes will fill the air in all directions. The sound of music is continually heard and golden rays of light stream forth. In brilliant rays which dazzle the eyes, he (Amida) will appear. *(Okazaki, p. 102)*

The above is a quotation from the *Ojo Yoshu,* a work by the tenth-century Japanese monk Genshin (942–1017). This monk was apparently the first Japanese to promote the painting of *Raigo* scenes—paintings that represent the welcoming descent of Amida (Amitabha in Sanskrit) from the Tushita Heaven. Genshin's interest in this subject was largely responsible for its popularity in painting. His oeuvre also encouraged the dissemination of Pure Land Buddhism throughout Japan in the medieval period.

In this radiant *Raigo* painting, the central standing figure of Amida is encircled by twenty-five bodhisattvas (*bosatsu* in Japanese), who are depicted as a host of heavenly musicians. The golden bodhisattvas play musical instruments and assume animated poses. Although each is rendered with extreme attention to detail, the effect of their massed array is to focus attention back on the oversized Buddha figure.

This monumental scroll was formerly housed in the Kiyotakiyama Sogan-in of Jochiji in the Awa Tokushima Prefecture of Shikoku. Records of its restoration and remounting are documented on the reverse side with inscriptions dated 1688 and 1854. From the seventeenth century on, the Takeuchi family was responsible for maintenance of the painting. The first donation for restoration was given by seven members of this family as recorded in the 1688 inscription. The money was paid to Jitsuyo Shina Jonin, a priest from the Sorensha temple.

In the ninth month of Kaei 7 (1854), Takeuchi Shinosuke, a member of the twentieth generation of the Takeuchi family, inscribed the names of the heads of the preceding generations on the reverse of this painting. This was done to assure that his forebears, at least since Kamakura times (1185–1333), would secure a place in heaven. He also listed his first son and his first grandson to assure the future of their families. Interestingly, this latter inscription refers to the painting as depicting fifty-five *bosatsu.*

The mention of fifty-five *bosatsu* in the 1854 inscription may be an indication that there were originally additional bodhisattvas shown accompanying the central figure of Amida; possibly they were depicted on side panels that are now missing. *Raigo* triptychs are not uncommon, and although twenty-five is the number of bodhisattvas prescribed to accompany the descending Amida, the earliest paintings of this type usually depict fewer attendant figures. Over time, numerous variations in *Raigo* portrayal developed. These included variations in Amida's posture. He is sometimes seated in earlier works and sometimes shown standing in later ones. Different types of descent also evolved, such as the swift descent *(Haya-Raigo)* or the return trip *(Kaeri-Raigo),* which depicts Amida returning to Paradise with the deceased person who is about to be reborn. Different groupings of attendants accompanying the descent were also devised, among them: the Sixteen Arhats, the Twelve Bodhisattvas, the Fifteen Bodhisattvas, and the Forty-nine Manifestations. Thus, although there is no other known example of Amida descending with fifty-five attendants, such a portrayal would be entirely probable.

The closest stylistic parallel to this painting is the triptych of the same subject and period in the Jogon-in temple, Shiga Prefecture (Okazaki, pl. 95–75), but there were numerous variations on the subject during the Kamakura and Muromachi (1392–1568) periods.

—A. G. P.

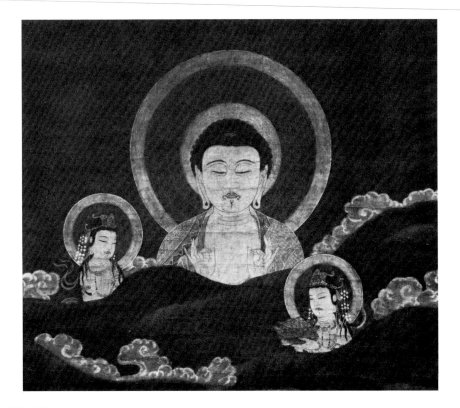

173 (detail of back)

奉開眼

頓以此功徳
平等施一切
同発菩提心
往生安楽国

三尊山越来迎図
恵信僧都之筆

阿波国
興禅寺浄現
瞿所持

天保十二年丑歳
十二月十五日

174

Amida Crossing the Mountains
Japan; Muromachi period,
15th century
Hanging scroll
Ink, colors, and gold on silk
23¾ × 26¼ in. (60.3 × 66.7 cm.)
Mr. and Mrs. James W. Alsdorf, Chicago
(Shown in Chicago and Brooklyn only)

This hanging scroll depicts Amida (Amitabha in Sanskrit) rising from behind a distant mountain. His attendant bodhisattvas, Seishi (Mahasthamaprapta) and Kannon (Avalokitesvara), are shown in front of the mountain, indicating that they have already crossed over and are now approaching the believer to welcome him into the next world. As is usual in devotional scrolls representing the *Yamagoe* or *Yamagoshi Raigo* (both *yamagoe* and *yamagoshi* mean "to cross a mountain"), the three main figures are painted in brilliant gold, here articulated with *kirikane* (gold leaf) brocade decoration on their garments. Such paintings were used by the *Nijugozammai* (Twenty-five Meditation) religious society; and they were customarily brought to the bedside of dying believers, who were instructed to grasp the threads depicted as emanating from Amida's hands to ensure direct contact with this Buddha and birth into the Western Paradise.

The *Yamagoe Raigo* is said to have originated with the Heian priest Genshin (942–1017), who, as legend recounts, had a vision of Amida rising from behind Mount Hiei. However, at the time the Pure Land cult first gained popularity, Tang China (618–906) may have been the ultimate source for the scene. In China the subject was depicted simply as a triad composed of Amida and his two attendant bodhisattvas. The Japanese have traditionally associated this *Raigo* type with the contemplation of the setting sun or of the full moon rising behind the mountains.

The oldest extant *Yamagoe Raigo* paintings date from the middle of the Kamakura period, or around the thirteenth century, when a standard iconography was developed. The subject continued to be popular into the Muromachi period (1392–1568).
—*A. G. P.*

308

Buddha Maitreya (?)
China; Northern Wei dynasty,
dated 477
Gilt bronze
h: 55¼ in. (140.3 cm.)
Lent by The Metropolitan Museum
of Art, Kennedy Fund, 1926
(Shown in Los Angeles only)

According to the inscription on its
base, this monumental bronze figure
depicts Maitreya and was made in
477 for the great empress dowager
and all living beings on earth. The
authenticity of the inscription has
been questioned by some scholars,
but if it is genuine, the figure must
be identified as the Future Buddha,
Maitreya; otherwise it could just as
well depict Sakyamuni. Whether or
not the great empress dowager com-
missioned this figure in 477, its
monumentality and its quality cer-
tainly indicate that it would be
appropriate as a regal benefaction.

The prototype for such figures is
supposed to have been the famous
Indian image reportedly created dur-
ing Buddha Sakyamuni's lifetime at
the behest of King Udayana of
Kausambi (see no. 118). The ob-
servations of the seventh-century
Chinese pilgrim Xuan Zang [Hsuan
Tsang] are pertinent here: "The
princes of various countries have
used their power to carry off this
statue [King Udayana's image], but
although men have tried, not all the
number could move it. They there-
fore worship copies of it, and they
pretend that the likeness is a true
one" (Soper, 1959a, p. 262). The so-
called Udayana statues found in
China, including this example, are
actually based on models created in
Gandhara centuries after King
Udayana was to have had his image
made.

Apart from its impressive size, the
most striking feature of this image is
its air of benevolence and expansive-
ness. Not only is the Buddha's
amiability evident in his smiling
countenance; his arms seem to
openly welcome the devotee. The
hand gestures are not as ritualized as
they usually are in Buddha images;
they seem rather to have been fro-
zen, snapshotlike, just as the Bud-
dha was about to stretch out his
arms in an all-embracing gesture of
compassion. The animated and
expressive hands are even more
striking when compared to the for-
malized gestures seen in other im-
ages (cf. nos. 87 and 176).

—P. P.

Future Buddha Maitreya
China; Northern Wei dynasty, c. 530
Gilt bronze
h: 23 in. (58.4 cm.)
The Toledo Museum of Art; Gift of
Florence Scott Libbey

During the strongly Buddhist Northern Wei dynasty (386–535), many of the greatest Chinese Buddhist sculptures were produced. A wealth of cave monuments and individual sculptures, some inscribed with dates from the fifth and sixth centuries, survive from this period.

The style of this sixth-century Toledo Maitreya differs radically from

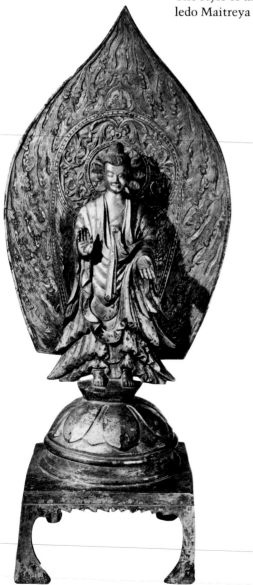

images created during the previous century, as the Central Asian and Indian elements apparent in comparable fifth-century works had become sinicized by this time. The purely Chinese tradition of noncorporeal linear expression in sculpture was fully developed in carvings from the Longmen Caves, which are contemporary with this sculpture (Mizuno and Nagahiro, 1941, pl. 40, p. 6).

This standing Maitreya is rendered in a mature Wei style characterized by simple, sharp lines and considerable attention to decorative detail. The emphasis is on the drapery, which is represented with flattened linear folds, winglike projections, and an abstract, less sensual style that conceals the human form beneath the cascading material. The figure itself stands on a lotus base and is dressed in a monk's robe. Maitreya's right hand is raised in the gesture of reassurance, and the left assumes that of charity. Typical of Chinese Wei figures, the fingers of the hands are rigid and unbent. Maitreya stands in front of a leaf-shaped *mandorla,* which is decorated with lotus and honeysuckle flowers and flames.

The inscription on the base reads: "A statue of Guanshiyin made (or caused to be made) by Lo Siyong. Fifteenth day, third month, second year of Wu P'ing (571)" (The Toledo Museum of Art, p. 70). This inscription was probably added upon the death of the person who received or commissioned the sculpture. Stylistically it can be dated to circa 530 in view of its close similarity to the Buddha dated 536 in the collection of The University Museum, University of Pennsylvania, Philadelphia (The Asia Society, pl. 27, p. 75). It is interesting to note that although Maitreya is characterized in the inscription as Guanyin (Avalokitesvara in Sanskrit), he is portrayed as a Buddha.

—*G. K.*

Future Buddha Maitreya
China; Tang dynasty, dated 705
Gray limestone
h: 32½ in. (82.6 cm.)
The Art Institute of Chicago, Gift of
Miss Alice Getty
(Shown in Chicago and Brooklyn only)

The inscription on the base of this sculpture informs us that in the year 705, this Maitreya and two bodhisattvas were dedicated by a pious Buddhist for the benefit of seventy generations of deceased ancestors. The two bodhisattva images mentioned must have been separate sculptures.

The Future Buddha, Maitreya, is shown seated imperiously on a high pedestal with both legs extended and his feet supported by lotuses. This particular posture, commonly designated "the European posture," is known in Sanskrit either as *pralambapadasana* (with extended legs) or as *bhadrasana* (auspicious posture). Sometime around the second or third century, this posture was adopted by Indian artists for use in images of the Buddha, probably inspired by royal portraits such as the monumental statue of the Kushan emperor Hurishka (2nd century), now in the Government Museum at Mathura. In China and Korea, however, the posture appears to have been rather exclusively employed for images of the Future Buddha, Maitreya, perhaps preaching in his celestial abode. In India, when the Buddha is depicted seated in this posture, his hands generally display the gesture of turning the Wheel of the Law, whereas in China, as in this example, the right hand is either held in the gesture of reassurance or in that of teaching. The left hand rests somewhat stiffly on the knee. Maitreya's head is set off here by a halo in the form of a lotus, and the nimbus is embellished with a bold, comma-shaped flame design, symbolizing his radiance.

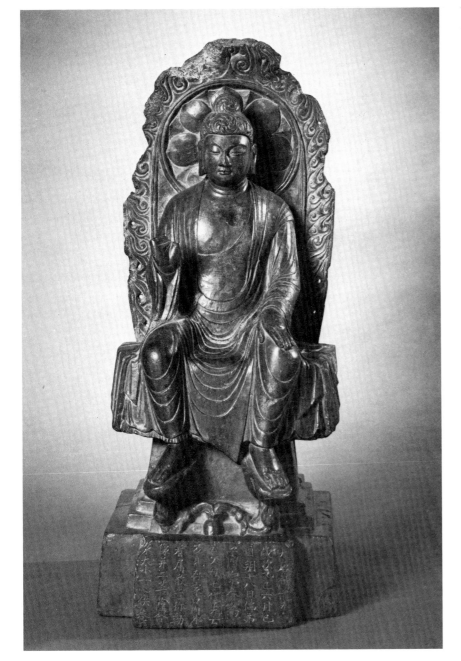

178

Buddha Maitreya
Korea; Unified Silla dynasty,
8th century
Gilt bronze
h: 5⁵⁄₁₆ in. (13.5 cm.)
Kyongju National Museum

Both in style and iconography, this small bronze figure of the Future Buddha, Maitreya, is closely related to the more impressive stone image from China (no. 177). Although not as popular and distinctive as another type of Korean Maitreya image in which he is shown as a pensive bodhisattva (see no. 87 for a Chinese prototype of this pensive Maitreya type), this variety was also well known. Few representations of this particular type have survived, however, making the Kyongju bronze a rare example.

The strong resemblance of this sculpture to Chinese models once again illustrates the close ties that existed between Unified Silla period (668–935) Korea and Tang (618–906) China. The cult of Maitreya was widespread in both countries, and undoubtedly, both types of Maitreya images were borrowed by the Koreans from China. The Koreans seem to have had a particular fascination for representing the Future Buddha as a regal though pensive figure, rather than as a monk.

—R. E. F.

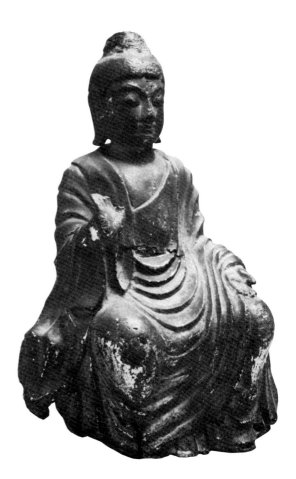

The popularity of the Maitreya cult in China, as mentioned in the introduction to this section, is evident not only from the large number of images dedicated to him but also from the variety of his forms. Even in the small selection of Maitreya images represented here, three distinct types may be seen (cf. nos. 175 and 176).

—P. P.

Future Buddha Maitreya
Central Tibet, c. 1750
Silk and gold brocade appliqué with couching and silk embroidery
134 × 76 in. (340 × 193 cm.)
Mr. and Mrs. John Gilmore Ford

The inscription at the bottom of this impressive and monumental appliqué *thanka* provides us with the following information:

> These sacred images are created skillfully out of the rainbow-like silken cloth—beautiful and bright.
>
> May the spiritual merits of the endeavor result in the long life of Kalsang Gyatsho, the reincarnation of Avalokitesvara, the universal protector.
>
> May he set in motion the Wheel of Dharma.
>
> May he watch all sentient beings with compassion.
>
> May I, abbot Jamyang Dondrub, who commissioned this banner, remain free from any immediate misfortunes. May I ultimately hear the teachings directly from the great Maitreya and thus partake in the glorious doctrine of Mahayana.
>
> May Zabyang Khilpa, the monastery of the precious order, continuously progress in the study of the sutras and in the practice of the three precepts (morality, meditation, and wisdom).
>
> May all be blessed. *(Translation by Lobsang Lhalungpha)*

Kalsang Gyatsho (1708–1757) for whom this *thanka* was dedicated was the Seventh Dalai Lama. At present, neither the abbot Jamyang Dondrub nor the monastery he refers to can be positively identified.

Given the wish of the pious Buddhist abbot that he might live to hear the Future Buddha preach his doctrine, it is appropriate that

Maitreya is represented as a Buddha and is shown engaged in teaching. The stems Maitreya holds support flowers; atop the right-hand flower is a watering pot; and on the left, a wheel. A stupa is represented in front of this Buddha's hair, and below his lotus-seat, a bowl with offerings appears, flanked by two antelopes. A second pair of antelopes roam at the left and the landscape is enriched by rocky escarpments and a pond with geese. The three figures depicted at the bottom of the *thanka* are: on the left, a guardian deity who stands upon a tiger skin; in the center, Kubera, the god of wealth; and on the right, the donor of the appliqué, Jamyang Dondrub. The two monks in the clouds are Ngorchen Kunga Zangpo (1382–1456) and Muechen Konchog Gyaltshan (1388–1469). Both were celebrated teachers of the Sakyapa order in Tibet.

—*P. P.*

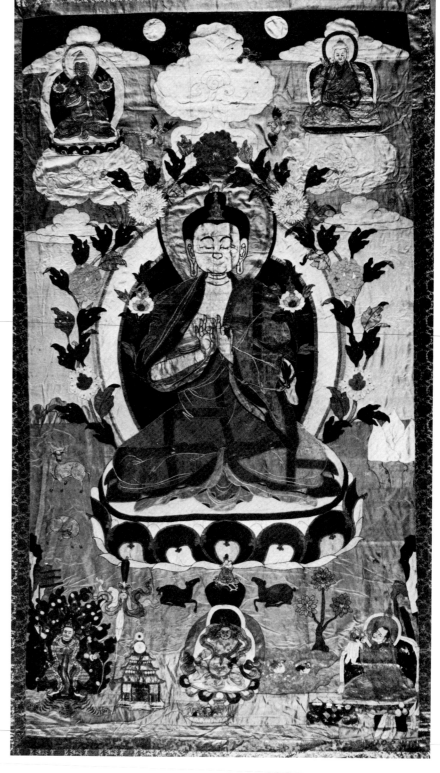

Ajātaśatru

Akanishṭha

Amarāvatī

Amitābha

Amitāyus

Anāgatavaṁśa

Ānanda

Anāthapiṇḍada

aṇḍa

Aṅguttara-Nikāya

antaravāsaka

Arāḍa Kālāma

Āryadeva

*Ashṭasāhasrikā
 Prajñāpāramitā*

Aśoka

Aśvaghosha

aśvattha

ātman

avadāna

Avalokiteśvara

Avataṁsaka

Balarāma

bhadrāsana

Bhagavadgītā

bhūmisparśamudrā

Brahmā

Buddhānanda

chintāmaṇi

dakshiṇāvarta

Devarāja

dharmadhātū

dhyāna

dikpāla

Divyavadāna

Dvāravatī

Gaṇḍavyūha

garuḍa

Hāritī

harmikā

Hīnayāna

Indraśāla

jālahasta

Jambudvīpa

jātaka

kambugrīva

Kaṇṭhaka

Kānyakubja

Kāśī

Kāśyapa

kaṭakahasta

Kauśāmbī

Kumārajīva

Kuśīnagara

Mahābodhi

Mahākāśyapa

Mahāparinirvāṇa

Mahāprajāpatī

mahāpurusha

Mahāsāṁghika

Mahāsiddha

Mahāvastu

Mahāyāna

Majjhima-Nikāya

Mañjuśrī

Māra

Matṛicheta

Matsyapurāṇa

Maudgalyāyana

Māyā

Milindapañha

mudrā

nāga

Nāgārjuna

Nāgasena

Nidānakathā

Pāla

Pañchaśikha

Pañchika

paryaṅkāsana

piṭaka

pralambapādāsana

Purāṇa Kāśyapa

Rāhula

Rājagṛiha

Rāma

Rāmapāla

Rāmāyaṇa

Saddharmapuṇḍarīka

Śailendra

Śakra

Śākya

Śākyamuni

Śākyasiṁha

śāla

Śāma Jātaka

saṅghāti

Śaṅkisya

Sāriputra

Śesha

Siddhārtha

śikhara

Sitātapatra Aparājitā

Śiva

Śrāvastī

śrīmudrā

stūpa

Subhākarasiṁha

Śuddhodhana

Sujātā

Sukhāvatī

Sukhāvatīvyūha

śunyatā

Sūrya

sūtra

tālahasta

Tārā

Tathāgata

Theravāda

Trayastriṁśa

triśūla

ūrṇā

ushṇīsha

ushṇīsha śīrsham

Ushṇīshavijayā

Vaiśāli

Vajradhātū Maṇḍala

vajrahuṁkāra

Vajrapāṇi

vajrāsana

Vajrayāna

Valāhassa Jātaka

vihāra

Vimalakīrtinirdeśa

Vishṇu

vyākhyāṇamudrā

Yaśodharā

BIBLIOGRAPHY

Ackerman, H. C. 1975. *Narrative Stone Reliefs from Gandhara in the Victoria and Albert Museum in London.* Rome: Istituto Italiano per il Medio ed Estremo Oriente.

Aiyappan, A., and P. R. Srinivasan. 1960. *Story of Buddhism with Special Reference to South India.* Madras: Government of Madras.

Alabaster, H. [1871] 1971. *The Wheel of the Law.* London: Trübner & Co. Reprint. Taipei: Ch'eng Wen Publishing Company.

An, K. H. 1977. "Silla Buddhism and the Protection of the Fatherland." *Korea Journal.* vol. 17, no. 4, pp. 27–29.

Arnold, E. 1971. *The Light of Asia.* Wheaton, Ill.: The Theosophical Publishing House.

The Asia Society. 1970. *Masterpieces of Asian Art in American Collections II.* exh. cat. New York: Asia House Gallery.

Asian Art Museum, San Francisco. 1979. *5,000 Years of Korean Art.* exh. cat. San Francisco: Asian Art Museum.

Asuka Historical Museum. 1978. *Ancient Statues of the Infant Buddha.* Nara: Asuka Historical Museum.

Baekeland, F. 1980. *Imperial Japan: The Art of the Meiji Era (1868–1912).* Ithaca: Herbert F. Johnson Museum of Art, Cornell University.

Bailey, J. T. 1981. Personal letter to Robert L. Brown, 1 August.

Banerjea, J. N. 1933. "Pratimā-lakṣaṇam." *Journal of the Department of Letters* (Calcutta: University of Calcutta). vol. 22, pp. 1–84.

Banerji, R. D. 1933. *Eastern School of Mediaeval Sculpture.* Delhi: Manager of Publications.

Bapat, P. V., ed. 1959. *2,500 Years of Buddhism.* New Delhi: The Publications Division, Government of India.

Barrett, D. 1954. "The Late School of Amarāvatī and Its Influences." *Art and Letters.* vol. 28, pp. 41–53.

Baskett, M. W. 1980. *Footprints of the Buddha.* Philadelphia: Philadelphia Museum of Art.

Beal, S., trans. 1906. *Buddhist Records of the Western World.* 2 vols. London: Trübner & Co., Ltd.

Beal, S. 1968. *The Fo-sho-hing Tsan-king: A Life of Buddha.* Delhi: Motilal Banarsidas.

Bernet Kempers, A. J. 1933. *The Bronzes of Nalanda and Hindu-Javanese Art.* Leiden: E. J. Brill.

Bernet Kempers, A. J. 1959. *Ancient Indonesian Art.* Cambridge, Mass.: Harvard University Press.

Best, J. 1980. "The Sosan Triad: An Early Korean Buddhist Relief Sculpture from Paekche." *Archives of Asian Art.* vol. 33, pp. 89–108.

Bhattacharya, C. 1977. *Art of Central Asia.* Delhi: Agam Prakashan.

Birnbaum, R. 1979. *The Healing Buddha.* Boulder: Shambhala.

Boisselier, J. 1979. *Ceylon.* Geneva: Nagel Publishers.

Brinker, H. 1973. "Shussan Shaka in Sung and Yüan Painting." *Ars Orientalis.* vol. 9, pp. 21–40.

Brinker, H., and E. Fischer. 1980. *Treasures from the Rietberg*

Museum. New York: The Asia Society.

Bunker, E. C. 1964. "The Spirit Kings in Sixth Century Chinese Buddhist Sculpture." *Archives of the Chinese Art Society of America.* vol. 18, pp. 33–36.

Buribhand, L. B., and A. B. Griswold. 1972. *Thai Images of the Buddha.* 4th ed. Bangkok: The Fine Arts Department.

Burlingame, E. W. 1969. *Buddhist Legends.* 3 vols. London: Luzac & Company.

Chapin, H. B. 1971. "A Long Roll of Buddhist Images." Rev. A. C. Soper. *Artibus Asiae.* vol. 33½, part 4, pp. 75–142.

Ch'en, K. 1972. *Buddhism in China.* Princeton: Princeton University Press.

Cohen, J. L. 1969. *Buddha.* New York: Delacorte Press.

Cone, M., and R. F. Gombrich. 1977. *The Perfect Generosity of Prince Vessantara.* Oxford: Oxford University Press.

Conze, E. 1959. *Buddhist Scriptures.* Harmondsworth: Penguin Books.

Conze, E., trans. 1975. *The Large Sutra of Perfect Wisdom.* Berkeley and Los Angeles: University of California Press.

Conze, E. et al. 1964. *Buddhist Texts through the Ages.* New York: Harper & Row.

Cook, F. H. 1977. *Hua-Yen Buddhism: The Jewel Net of Indra.* University Park, Pa.: The Pennsylvania State University Press.

Coomaraswamy, A. K. 1927. *History of Indian and Indonesian Art.* New York: Karl W. Hiersemann.

Coomaraswamy, A. K. 1935. *Elements of Buddhist Iconography.* Cambridge, Mass.: Harvard University Press.

Coomaraswamy, A. K. 1964. *Buddha and the Gospel of Buddhism.* New York: Harper & Row.

Coomaraswamy, A. K. 1977. "The Nature of Buddhist Art." In *Coomaraswamy, I: Selected Papers. Traditional Art and Symbolism*, ed. R. Lipsey. Princeton: Princeton University Press.

Coomaraswamy, A. K., and I. B. Horner. 1948. *The Living Thoughts of Gotama the Buddha.* London: Cassell.

Coomaraswamy, A. K., and Sr. Nivedita. 1967. *Myths of the Hindus and Buddhists.* New York: Dover Publications.

Couling, S. 1964. *The Encyclopaedia Sinica.* Shanghai: Kelley and Walsh.

Cowell, E. B., ed. [1895–1913] 1969. *The Jataka, or Stories of the Buddha's Former Births.* Reprint. 3 vols. London: Luzac.

Cummings, M. 1982. *The Lives of the Buddha in the Art and Literature of Asia.* Ann Arbor: Center for South and Southeast Asian Studies, University of Michigan.

Czuma, S. 1980. "Mon-Dvāravatī Buddha." *The Bulletin of the Cleveland Museum of Art.* vol. 67, no. 7, September, pp. 228–39.

Davidson, J. L. 1954. *The Lotus Sutra in Chinese Art.* New Haven: Yale University Press.

Davidson, J. L. 1968. *Art of the Indian Subcontinent from Los Angeles Collections.* Los Angeles: UCLA Art Gallery.

Davidson, J. L., and N. Douglas. 1980. *The Enlightened Ones.* exh. cat. Beverly Hills: Kreitman Publishing, Inc.

de Bary, W. T. 1958. *Sources of Japanese Tradition.* 2 vols. New York and London: Columbia University Press.

de Bary, W. T., ed. 1972. *The Buddhist Tradition in India, China and Japan.* New York: Vintage Books.

Devendra, D. T. 1957. *The Buddha Image and Ceylon.* Colombo, Sri Lanka: K. V. G. De Silva & Sons.

Dohanian, D. K. 1977. *The Mahāyāna Buddhist Sculpture of Ceylon.* New York and London: Garland Publishing, Inc.

Drub, G. 1981. *Bridging the Sutras and Tantras.* Trans. G. H. Mullin. Ithaca, N.Y.: Gabriel/Snow Lion.

Edgerton, F., trans. 1964. *The Bhagavad Gita.* New York: Harper & Row.

Edwards, R. 1968. "Ue Gukei—Fourteenth-century Ink-painter." *Ars Orientalis.* vol. 7, pp. 169–78.

Ettinghausen, R. 1955. "An Illuminated Manuscript of Ḥāfiz-i Abrū in Istanbul." *Kunst des Orients.* vol. 2, pp. 30–44.

Fickle, D. H. 1974. "Crowned Buddha Images in Southeast Asia." In *Art and Archeology in Thailand.* Bangkok: Fine Arts Department.

Flaubert, G. 1904. *The Temptation of St. Antony or a Revelation of the Soul.* Trans. M. W. Dunne. Akron: St. Dunstan Society.

Fontein, J., and M. L. Hickman. 1970. *Zen Painting and Calligraphy.* Boston: Museum of Fine Arts.

Forrer, M. et al. 1982. *Hokusai and His School.* Leiden: Society for Japanese Arts and Crafts.

Foucaux, P. E. 1884. *Lalita Vistara.* Paris: Annales du Musée Guimet.

Foucher, A. 1905, 1917a, 1922, 1951. *L'Art Greco-Bouddhique du Gandhara.* 2 vols. Paris: Imprimerie Nationale.

Foucher, A. 1917b. *The Beginnings of Buddhist Art.* Trans. L. A. Thomas and F. W. Thomas. Paris: Paul Guethner; London: Humphrey Milford.

Foucher, A. 1949. *La Vie du Bouddha.* Paris: Payot.

Fozdar, J. 1973. *The God of Buddha.* New York: Asia Publishing House.

France-Asie. 1959. "Présence du Bouddhisme." *France-Asie.* vol. 16, nos. 153–57, February–June.

Fujimoto, R. et al., trans. 1965. *Jeodo Wasan: The Hymns on the Pure Land.* Kyoto: Ryukoku Translation Center, Ryukoku University.

Fussman, G. 1974. "Buddha de l'An 5." *Bulletin de l'École Française d'Extrême-Orient.* vol. 61, pp. 54–58.

Gardiner, K. H. J. 1969. *The Early History of Korea.* Honolulu: University of Hawaii Press.

Gray, B. 1978. *The World History of Rashīd al-Dīn.* London: Faber & Faber.

Griswold, A. B. 1966. "Imported Images and the Nature of Copying in the Art of Siam." In *Essays Offered to G. H. Luce*, ed. Ba Shin et al. vol. 2. Ascona: Artibus Asiae.

Grousset, R. 1971. *In the Footsteps of the Buddha.* New York: Grossman Publishers.

Gunasinghe, S. 1957. "Ceylon and the Buddha Image in the Round." *Artibus Asiae.* vol. 19, pp. 251–58.

Gunasinghe, S. 1960. "A Sinhalese Contribution to the Development of the Buddha Image." *Ceylon Journal of Historical and Social Studies.* vol. 3, pp. 59–71.

Gunasinghe, S. 1978. *An Album of Buddhist Paintings from Sri Lanka.* Colombo, Sri Lanka: National Museums of Sri Lanka.

Hackin, J. et al. 1963. *Asiatic Mythology.* London: George C. Harrap & Co.

Harle, J. C. 1974. "A Hitherto Unknown Dated Sculpture from Gandhara: A Preliminary Report." In *South Asian Archeology 1973*, ed. J. E. van Lohuizen-de Leeuw and J. M. M. Ubaghs. Leiden: E. J. Brill.

Hartel, H. et al. 1982. *Along the Ancient Silk Routes*. exh. cat. New York: The Metropolitan Museum of Art.

Herold, A. F. 1954. *The Life of Buddha*. Trans. P. C. Blum. Tokyo: Charles E. Tuttle Co.

Hillier, J. 1978. *Hokusai Paintings, Drawings and Woodcuts*. New York: E. P. Dutton.

Ho, W. K. 1966. "Three Seated Stone Buddhas." *Bulletin of the Cleveland Museum of Art*. vol. 53, April, pp. 84–102.

Ho, W. K. et al. 1980. *Eight Dynasties of Chinese Painting: The Collections of the Nelson Gallery— Atkins Museum, Kansas City, and The Cleveland Museum of Art*. exh. cat. The Cleveland Museum of Art.

Hobbs, R. 1977. *Odilon Redon*. Boston: New York Graphic Society.

Hurvitz, L. 1976. *Scripture of the Lotus Blossom of the Fine Dharma (The Lotus Sutra)*. New York: Columbia University Press.

Hwang, S. Y. 1979. *The Arts of Korea: Buddhist Art*. Seoul: Dong Hwa Publishing Co.

I-tsing. [1896] 1966. *A Record of the Buddhist Religion as Practiced in India and the Malay Archipelago A. D. 671–695*. Trans. J. Takakusu. Reprint. Delhi: Munshiram Manoharlal.

Ilyon. 1972. *Samguk Yusa: Legends and History of the Three Kingdoms of Ancient Korea*. Trans. Tae-hung Ha and G. K. Mintz. Seoul: Yonsei University Press.

Inada, K., and N. Jacobson. 1983. *Buddhism and American Thinkers*. Albany: State University of New York Press.

Irwin, J. 1981. "The Mystery of the (Future) Buddha's First Words." *Annali del'Istituto di Napoli*. vol. 41, pp. 623–53.

Jan, Y. H. 1964. "Hui Ch'ao an [sic] his works." *Indo-Asian Culture*. vol. 21, July, pp. 177–90.

Japan Art Center. 1980. *Zaigai Nihon no Shiho (Japanese Art: Selection from Western Collections)*. Tokyo: Japan Art Center.

Jayakar, P. 1982. *The Buddha*. Bombay: Vakils, Feffer & Simons Ltd.

Johnston, E. H. 1972. *The Buddha Carita or Acts of the Buddha*. New Delhi: Oriental Books Reprint Corp.

Jones, J. J. 1973. *The Mahavastu*. 3 vols. London: The Pali Text Society.

Kalupahana, D. J., and I. Kalupahana. 1982. *The Way of Siddhartha: A Life of the Buddha*. Boulder and London: Shambhala.

Kikutake, J., and H. Yoshida. 1981. *Koryo Buddhist Painting* (in Japanese with English summaries). Tokyo: Asahi Shinbunsha Publishing Co.

Kim, C., and W. Y. Kim. 1966. *The Arts of Korea*. London: Thames & Hudson.

Kim, C., and L. K. Lee. 1974. *Arts of Korea*. Tokyo: Kodansha International.

Kim, C. et al. 1964. *The Art of Burma, Korea, Tibet*. New York: Crown Publishers.

Kim, H. J. 1949. *Buddhism and Korean Culture*. New Delhi: The International Academy of Indian Culture.

Kjersgaard, E., ed. 1970. *Buddha's Veje*. Stockholm: National-museet.

Ko, I. C. 1981. "Wonhyo and the Foundation of Korean Buddhism." *Korea Journal*. vol. 21, no. 8, pp. 4–13.

Kokka. 1933. "Shaka Nyorai Juroku Rakan, Zukai." *Kokka*. no. 507, February, p. 42.

Krairiksh, P. n.d. *Art in Peninsular Thailand Prior to the Fourteenth Century A.D.* Bangkok: The Fine Arts Department.

Krairiksh, P. 1974. *Buddhist Folk Tales Depicted at Chula Pathon Cedi*. Bangkok: n.p.

Kramrisch, S. 1983. "Emblems of the Universal Being." In *Exploring India's Sacred Art*, ed. B. S. Miller. Philadelphia: University of Pennsylvania Press.

Krom, N. J. 1974. *The Life of Buddha*. Varanasi: Bhartiya Publishing House.

Kulke, H. 1978. *The Devarāja Cult*. Trans. I. W. Mabbett. Ithaca: Cornell University.

Kuno, T. 1965. "Buddha at Birth." *Kobijutsu*. vol. 10, pp. 23–34.

Kuwayama, G. 1972. *Contemporary Japanese Prints*. exh. cat. Los Angeles County Museum of Art.

Kyotaro, N., and E. Sano. 1982. *The Great Age of Japanese Buddhist Sculpture: A.D. 600–1300*. Fort Worth: Kimbell Art Museum.

Kyoto National Museum. 1981. *Special Exhibition of the Arts of Zen Buddhism*. exh. cat. Kyoto National Museum.

Lal, P., trans. 1970. *The Dhammapada*. New York: Farrar, Straus & Giroux.

Lee, J. 1981. "Sixth Century Buddhist Art." *Korean Culture*. vol. 2, no. 2, June, pp. 28–35.

Lee, P. H., trans. 1969. *Lives of Eminent Korean Monks, (The Haedong Kosung Chon)*. Cambridge, Mass.: Harvard University Press.

Lee, S. E. 1951. "Japanese Monochrome Painting at Seattle." *Artibus Asiae*. vol. 14, pp. 43–61.

Lee, S. E. 1982. *A History of Far Eastern Art.* 4th ed. New Jersey: Prentice-Hall, Inc.; New York: Harry N. Abrams, Inc.

Lee, S. E., and W. K. Ho. 1968. *Chinese Art under the Mongols: The Yüan Dynasty (1279–1368).* exh. cat. Cleveland Museum of Art.

Lefebvre d'Argencé, R.-Y., and D. Turner, eds. 1974. *Chinese, Korean and Japanese Sculpture in the Avery Brundage Collection.* San Francisco: Asian Art Museum.

Lessing, F. D., and A. Wayman. 1978. *Introduction to the Buddhist Tantric Systems.* Delhi: Motilal Banarsidas.

Ling, T. 1973. *The Buddha.* New York: Charles Scribner's Sons.

Link, H. A. 1979. *The Art of Shibata Zeshin: The Mr. and Mrs. James E. O'Brien Collection at the Honolulu Academy of Arts.* Honolulu: The Honolulu Academy of Arts.

Loehr, M. 1961. *Buddhist Thought and Imagery.* Cambridge, Mass.: Harvard University Press.

Loehr, M. 1968. *Chinese Landscape Woodcuts.* Cambridge, Mass.: Harvard University Press, Belknap Press.

Loehr, M. 1980. *The Great Painters of China.* New York: Harper & Row.

van Lohuizen-de Leeuw, J. E. 1981. "New Evidence with Regard to the Origin of the Buddha Image." In *South Asian Archeology 1979*, ed. H. Hartel. Berlin: Dietrich Reimer Verlag.

Ludowyk, E. F. C. 1958. *The Footprint of the Buddha.* London: George Allen & Unwin Ltd.

Lyons, I., and H. Ingholt. 1957. *Gandharan Art in Pakistan.* New York: Pantheon Books.

McCune, E. 1962. *The Arts of Korea.* Tokyo and Rutland, Vt.: C. E. Tuttle Co.

Manley, R., trans. [1671] 1969. *A True Description of the Mighty Kingdoms of Japan and Siam.* Written originally in Dutch by Francis Caron and Joost Schouten. Reprint. London: Charlermnit Historical Archives Series.

March, B. 1929. "New Chinese Sculptures." *Bulletin of the Detroit Institute of Arts.* vol. 11, pp. 20–25.

Matsubara, S. 1966. *Chinese Buddhist Sculpture.* Tokyo: Yoshikawa Kōbunkan.

Matsushita, T. 1974. *Ink Painting.* Trans. M. Colcutt. Art of Japan, no. 7. New York: John Weatherhill, Inc.

Meech-Pekarik, J. 1977. "Disguised Scripts and Hidden Poems in an Illustrated Heian Sutra: Ashide and Uta-e in the Heike Nogyo." *Archives of Asian Art.* vol. 31, pp. 53–78.

Ministry of Information and Broadcasting, Government of India. *The Way of the Buddha.* n.d. Delhi: Publications Division, Ministry of Information and Broadcasting, Government of India.

Mitra, D. 1971. *Buddhist Monuments.* Calcutta: Sahitya Samsad.

Mitra, R., trans. 1881–86. *The Lalita-Vistara, or Memoirs of the Early Life of S'ākya Siñha.* Bibliotheca Indica. Calcutta: Asiatic Society of Bengal.

Mizuno, K. 1982. *Buddhist Sutras: Origin, Development, Transmission.* Trans. M. Takanashi et al. Tokyo: Kosei Publishing Company.

Mizuno, S., and T. Nagahiro. 1941. *Kanan Rakuyō Ryomon Sekkutsu No Kenkyū (A Study of the Buddhist Cave Temples at Lung-Men, Honan).* Tokyo: The Zavho Press.

Mizuno, S., and T. Nagahiro. 1954. *Unkō Sekkutsu (Yun-Kang: The Buddhist Cave-Temples of the Fifth Century A.D. in North China).* 16 vols. Kyoto: Jimbunkagaku Kenkyusho.

Moran, S. 1974. "The Death of the Buddha, A Painting at Koyosan." *Artibus Asiae.* vol. 36, parts 1–2, pp. 97–146.

Muller, F. M. 1883. *Sacred Books of the East.* Delhi: Motilal Banarsidas.

Munsterberg, H. 1967. *Chinese Buddhist Bronzes.* Rutland, Vt.: C. E. Tuttle Co.

Munsterberg, H. 1972. "Shiko Munakata, A Personal Memoir." *Newsletter on Contemporary Japanese Prints.* vol. 2, pp. 3–8.

Murase, M. 1975. *Japanese Art: Selections from the Mary and Jackson Burke Collection.* New York: The Metropolitan Museum of Art.

Murray, J. K. 1981–82. "Representations of Hāritī, the Mother of Demons and the Theme of 'Raising the Alms-Bowl' in Chinese Painting." *Artibus Asiae.* vol. 43, no. 4, pp. 253–67.

Nagar, S. D. 1981. *Gandhāran Sculpture.* Columbia, Mo.: The Curators of the University of Missouri.

National Museum of Korea. 1980. *Special Exhibition of Artefacts Excavated at Anap-chi Pond.* exh. cat. Seoul: National Museum of Korea.

Noma, S. 1966. *The Arts of Japan: Ancient and Medieval.* vol. 1. Tokyo and Palo Alto: Kodansha.

Okazaki, J. 1977. *Pure Land Buddhist Painting.* Trans. E. ten Grotenhuis. Tokyo: Kodansha International Ltd. and Shibundo.

P. & D. Colnaghi & Co. and S. Day. 1981. *1,000 Years of Art in Japan.* London: Colnaghi Oriental.

Pal, P. 1972–73. "A Note on the Mandala of the Eight Bodhisattvas." *Archives of Asian Art.* vol. 26, pp. 17–73.

Pal, P. 1974, vol. 1; 1978, vol. 2. *The Arts of Nepal.* Leiden: E. J. Brill.

Pal, P. 1975. *Bronzes of Kashmir.* Graz, Austria: Akademische Druk.

Pal, P. 1982a. "Cosmic Visions and Buddhist Images." *Art International.* vol. 25, nos. 1–2, pp. 8–39.

Pal, P. 1982b. *A Buddhist Paradise: The Murals of Alchi.* Basel: Ravi Kumar.

Pal, P. 1983. *Art of Tibet in the Los Angeles County Museum of Art.* Los Angeles: Los Angeles County Museum of Art and University of California Press.

Paranavita, S. 1971. *Art of the Ancient Sinhalese.* Colombo, Sri Lanka: Lake House Investments, Ltd., Publishers.

Parimoo, R. 1982. *Life of Buddha in Indian Sculpture.* New Delhi: Kanak Publications.

Peterson, K. W. 1980. "Sources of Variation in Tibetan Canons of Iconometry." In Aris M. and A. S. S. Kyi, *Tibetan Studies in Honour of Hugh Richardson.* Oxford: Aris and Phillips.

Poppe, N. 1967. *The Twelve Deeds of Buddha.* Wiesbaden: Otto Harrassowitz.

Priest, A. 1944. *Chinese Sculpture in The Metropolitan Museum of Art.* New York: The Metropolitan Museum of Art.

Pye, M. 1979. *The Buddha.* Dallas: Duckworth.

Ramachandran, T. N. 1965. *The Nagapattinam and Other Buddhist Bronzes in the Madras Museum.* Madras: Government of Madras.

Reischaeur, E. O. 1955. *Ennin's Travels in T'ang China.* New York: Ronald Press Company.

Reischauer, E. O., and J. K. Fairbank. 1958 and 1960. *East Asia and the Great Tradition.* vol. 1. Boston: Houghton Mifflin Co.

Rhys Davids, T. W., and H. Oldenberg, trans. [1801] 1968. "The Mahāvagga." In *Vinaya Texts*, vol. 1. Sacred Books of the East, ed. F. Max Müller, vol. 13. Reprint. Delhi: Motilal Banarsidas.

Rhys Davids, T. W., and C. A. F. Rhys Davids, trans. 1921. *Dialogues of the Buddha.* part 3. Sacred Books of the Buddhists, ed. T. W. Rhys Davids, vol. 4. London: Humphrey Milford.

Riddell, S. 1979. *Dated Chinese Antiquities 600–1650.* London: Faber & Faber.

Rogers, H. 1983. "The Reluctant Messiah: Sakyamuni Emerging from the Mountains." *Sophia International Review.* vol. 5, pp. 16–33.

Rosenfield, J. M., ed. 1979. *Song of the Brush: Japanese Paintings from the Sanso Collection.* Seattle: Seattle Art Museum.

Rosenfield, J. M., and E. ten Grotenhuis. 1979. *Journey of the Three Jewels: Japanese Buddhist Paintings from Western Collections.* New York: The Asia Society.

Rosenfield, J. M. et al. 1973. *The Courtly Tradition in Japanese Art and Literature: Selections from the Hofer and Hyde Collections.* Cambridge, Mass.: Fogg Art Museum, Harvard University.

Rowland, B. 1968. *The Evolution of the Buddha Image.* New York: The Asia Society.

Rowland, B. 1971. *The Art and Architecture of India; Buddhist, Hindu, Jain.* Harmondsworth: Penguin Books Ltd.

Rowland, B., Jr. 1937. "Notes on the Dated Statues of the Northern Wei Dynasty and the Beginnings of Buddhist Sculpture in China." *Art Bulletin.* vol. 19, no. 1, pp. 92–107.

Sarkar, H. B. 1972. *Corpus of the Inscriptions of Java.* 2 vols. Calcutta: Firma K. L. Mukhopadhyay.

Saunders, E. D. 1960. *Mudra: A Study of Symbolic Gestures in Japanese Buddhist Sculpture.* Bollingen Series, no. 58. New York: Pantheon Books.

Schumann, H. W. 1973. *Buddhism: An Outline of Its Teachings and*

Schools. Trans. Georg Fenerstein. London: Rider.

Seckel, D. 1957. *Buddhistische Kunst Ostasiens.* Stuttgart: W. Kohlhammer.

Seckel, D. 1964. *The Art of Buddhism.* London: Methuen.

Sharma, R. C. 1972. "Pre-Kanishka Buddhist Iconography at Mathura." In *The Archeological Congress and Seminar Papers.* Nagpur: Nagpur University.

Siren, O. 1925. *Chinese Sculpture from the Fifth to Fourteenth Century.* 4 vols. London: Ernest Benn, Ltd.

Siren, O. 1940. "Chinese Marble Sculptures of the Transition Period." *Bulletin of the Museum of Far Eastern Antiquities.* no. 12, p. 488.

Snellgrove, D. L., ed. 1978. *The Image of the Buddha.* Tokyo and Paris: Kodansha and UNESCO.

Soothill, W. E. 1930. *The Lotus of the Wonderful Law.* Oxford: The Clarendon Press.

Soothill, W. E., and L. Hodous. 1937. *A Dictionary of Chinese Buddhist Themes.* London: Kegan Paul, Trench, Trübner & Co., Ltd.

Soper, A. C. 1959a. *Literary Evidence for Early Buddhist Art in China.* Ascona: Artibus Asiae.

Soper, A. C. 1959b. "A T'ang Parinirvāna Stele." *Artibus Asiae.* vol. 22, pp. 159–69.

Soper, A. C. 1966a. *Chinese, Korean and Japanese Bronzes; a Catalogue of the Auriti Collection.* Rome: Istituto Italiano per il Medio ed Estremo Oriente.

Soper, A. C. 1966b. "Chinese Sculptures." *Apollo.* vol. 84, no. 54, August, pp. 103–12.

Soper, A. C. 1969. "Some Late Chinese Bronze Images (Eighth to Fourteenth Centuries) in the Avery Brundage Collection, M. H. de

Young Museum, San Francisco." *Artibus Asiae*. vol. 31, no. 1, pp. 32–54.

Stoesz, W. 1978. "The Buddha as Teacher." *Journal of the American Academy of Religion*. vol. 46, p. 139ff.

Stratton, C., and M. McNair Scott. 1981. *The Art of Sukhothai, Thailand's Golden Age*. Kuala Lumpur: Oxford University Press.

Stryk, L., ed. 1968. *World of the Buddha*. New York: Grove Press.

Taggart, R. E. et al. 1973. *Handbook of the Collections*. Vol. 2, *Art of the Orient*. Kansas City: Nelson Gallery of Art, Atkins Museum.

Tanaka, I. 1972. *Japanese Ink Painting: Shubun to Sesshu*. Trans. B. Darling. Tokyo: Weatherhill/Heibonsha.

Tanaka, I. et al. 1959. *E Inga Kyo, Nihon Emakimono Zenshu*. vol. 16. Tokyo: Kadokawa Pub. Co.

Teilhet-Fisk, J. 1983. *Paradise Reviewed: An Interpretation of Gauguin's Polynesian Symbolism*. Ann Arbor: UMI Research Press.

Thiamthat, B. 1969. "Archeological Report of the Old City of Phra Rot, Dong Si Mahaphot, A Si Mahaphot, C. Phrachinburi" (in Thai). *Silpakon*. vol. 13, no. 1, pp. 48–59.

Thomas, E. J. 1960. *The Life of Buddha as Legend and History*. London: Routledge & Kegan Paul Ltd.

Tokiwa, D. 1913. "Daizōkyō Chōinkō." *Tetsugaku Zasshi*. vol. 28, pp. 382–83.

The Toledo Museum of Art. 1960. *Museum News*. vol. 3, no. 3, summer, p. 70.

Tomita, K. 1944. "Two Chinese Paintings Depicting the Infant Buddha and Mahaprajapati." *Bulletin of the Museum of Fine Arts*. vol. 42, pp. 13–20.

Tsunoda, R. et al., eds. 1958. *Sources of the Japanese Tradition*. New York: Columbia University Press.

Uehara, S. 1974. *Nihon no Bijutsu, no. 7: Muromachi Chokoku*. Tokyo: Shibundo.

Varley, H. P. 1977. "Ashikaga Yoshimitsu and the World of Kitayama: Social Change and Shogunal Patronage in Early Muromachi Japan." In *Japan in the Muromachi Age*, ed. J. W. Hall and T. Takeshi. Berkeley and Los Angeles: University of California Press.

Visser, M. W. de. 1923. *The Arhats in China and Japan*. Berlin: Oesterheld & Co.

Visser, M. W. de. 1935. *Ancient Buddhism in Japan*. Leiden: E. J. Brill.

Warren, H. C., trans. [1896] 1922. *Buddhism in Translations: Passages Selected from the Buddhist Sacred Books*. Harvard Oriental Series, vol. 8. Cambridge, Mass.: Harvard University Press.

Wasson, G. G. 1982. "The Last Meal of the Buddha, with Memorandum by Walpola Ruhūla and Epilogue by Wendy Doniger O'Flaherty." *Journal of the American Oriental Society*. vol. 102, no. 4, pp. 591–603.

Watson, W. 1957–59. "The Earliest Buddhist Images of Korea." *Transactions of the Oriental Ceramic Society*. vol. 31, pp. 83–92.

Wayman, A. 1957. "Contributions Regarding the Thirty-two Characteristics of the Great Person." *Liebenthal Festschrift, Sino-Indian Studies*. vol. 5, nos. 3–4, May, pp. 234–60.

Whitfield, R. 1982. *The Art of Central Asia: The Stein Collection in the British Museum*. Vol. 1, *Paintings from Dunhuang*. Tokyo: Kodansha International.

Williams, C. A. S. 1960. *Encyclopedia of Chinese Symbolism and Art Motives*. New York: Julian Press.

Williams, J. 1973. "The Iconography of Khotanese Painting." *East and West* (Rome: Istituto Italiano per il Medio ed Estremo Oriente). n. s., vol. 23, nos. 1–2, March–June, pp. 109–54.

Williams, J. 1975. "Sārnāth Gupta Steles of the Buddha's Life." *Ars Orientalis*. vol. 10, pp. 171–92.

Williams, M. L. 1982. "Korean Art in the Cleveland Museum of Art." *Korean Culture*. vol. 3, no. 4, pp. 4–17.

Woodward, H. W., Jr. 1977. "A Chinese Silk Depicted at Candi Sèwu." In *Economic Exchange and Social Interaction in Southeast Asia: Perspectives from Prehistory, History, and Ethnography*, ed. K. L. Hutterer. Michigan Papers on South and Southeast Asia, no. 13. Ann Arbor: Center for South and Southeast Asian Studies, University of Michigan.

Woodward, H. W., Jr. 1979. "The Bāyon-Period Buddha Image in the Kimbell Art Museum." *Archives of Asian Art*. vol. 32, pp. 72–83.

Woodward, H. W., Jr. 1981. "Burmese Sculpture and Indian Painting." In *Chhavi-2: Rai Krishnadasa Felicitation Volume*. Banaras: Bharat Kala Bhavan.

Wray, E. et al. 1979. *Ten Lives of the Buddha: Siamese Temple Paintings and Jataka Tales*. New York and Tokyo: John Weatherhill, Inc.

Zurcher, E. 1972. *The Buddhist Conquest of China*. Leiden: E. J. Brill.

INDEX

Note: Numerals in italics indicate illustrations.

Abhayamudra. See Reassurance, gesture of

Abhisambodhi, 258

Achalanatha, *282*

Agni, *138*, 265

Ajanta, 45, 165, 230, 270

Ajatasatru, 44

Akasagarbha, *282*

Akshobhya, 256, *282*

Alchi murals, 258

Alms bowl, 72, 116, *116, 118,* 119, 153, 210

al-Tabari: *Chronicle,* 64

Amaravati region, 92, *138*; examples of style, *89, 94, 195*; influence of, 156, 196, 202, 223

Amida Buddha, 184; images of, *186, 282, 304,* 304–5, *305, 306, 307, 308*; indicators of, 150, 190. *See also* Amitabha

Amidism, 172

Amitabha, 19, 256–57; in China, 172; Chinese images, *274, 300*; heaven of, 145, 175; in Korea, 175, 178–80, 181, 238, 240; Korean images, *298, 299, 300, 301, 301, 302, 303*; in life-prolonging ceremonies, 146. *See also* Amida Buddha

Amitayus. *See* Amitabha

Amoghasiddhi, 256

Amoghavajra, 296

Amulets: Buddha images as, 159

Anagatavamsa, 147

Ananda, 44, 127, 257; in images, *123, 124, 202, 272, 286*

Anathapindada, 44, 115, *115*

Andhra Pradesh: art of, 92, 94, 139, 152, 195; works, *89, 92, 94, 138, 195*

Anguttara-Nikaya, 148

Aniko, 235

Anuradhapura period, 156, 206

Apollo images, 193

Arada Kalama, 42

Arhats, *277,* 277–78, 307

Arnold, Sir Edwin, 16

Aryadeva, 276

Ashtasahasrika Prajnaparamita, 52

Ashuku. *See* Akshobhya

Asita, 41, *63, 67, 68, 69,* 254

Asoka, 117, 132, 140, 157, 176

Asvaghosha, 40, 42 89, 91, 94

Auspicious posture, 153, *310, 311*

Avadanas, 117, 254, 260

Avalokitesvara, 257, 312; images of, *59, 109, 173, 191,* 224, 228, 257, 272, *282, 296, 308*

Avatamsaka, 18, 182, 278, 280, *281*

Avatamsaka sect, 179

Ayutthaya: works from, *233, 239*

Baby Buddha: cults, 19, 70, 81, 84; images, 74, 80, *81, 83, 83,* 84, *85, 86, 180*; bathing of images, 82, 83, 146, 187–88

Baimasu (White Horse Monastery), 166

Baimiao, 87

Balarama, 228

Banaras, 43

Banerjea, J. N., 152

Bangkok: images at, 45, 244

Bangkok period, 244

Barabudur images, 20, 52, 158, 161, 162, 247, 291

Basho, 188

Basho Nehan, 188

Bathing of images, 82, 83, 146, 187, 217

Best, Jonathan, 299

Bhadra, *277,* 278

Bhadrasana, 153, *310, 311*

Bhagavadgita, 148

Bhagavata, 131

Bhaishajyaguru. *See* Healing Buddha

Bhaishajyagurusutra, 256

Bhallika, 62

Bharhut reliefs, *51, 78,* 132, 259

Bhumisparsamudra. See Earth-touching gesture

Bihar: works, 47, 52, 56, 57, 58, 59, 137, *141, 222*; parallels, 224, 233

Bimbisara, 44

Birnbaum, Raoul, 255–56, 283

Birth of the Buddha, 39, 40, 47, 52, 254; ceremonies, 84, 86, 187; representations: Cambodian, 80, *81*; Chinese, 51, 56, 57, *79*; Gandhara, *53, 55*; Indian, 56, 57, 80; Japanese, 51, *83*; Nepali, *60, 61, 68, 69, 81*; Persian, 64, *65*; Thai, 70, 70–71; Tibetan, 63, 66, 67

Bodhgaya, 42, 43, 47, 132, 141; temple, *63, 66, 67, 95, 106, 141*

Bodhidharma, 18, 169

Bodhisattvas: *Raigo* portrayals, 307

Bodhi tree, 133, 147, 192, 254

Bodhyangi, 270, 282, 291, 292, 293

Boisselier, Jean, 159

Bon festival, 189

Bon religion, 296

Brahma, 20, 41, 43, 83; representations, 53, *54*, 60, 70, 80, *81*, 111, *112*, 191, *284, 285*

Buddhacharita, 40, 42, 89, 94

Buddhananda, 191

Buddhas of Confessions of Sins, 254, 273, *283*

Buddhas of the Four Directions, 189

Buddhist creed, 111

Burma, 156, 158–59, 262; Buddha images, 214, *215*, 232, 233, 241, 271; narrative scenes, 52, 62, 162

Butsumyo-e ceremony, 189

Butsu-Nehan. See under Death of the Buddha: representations, Japanese

Cakri dynasty, 244

Cambodia, 20, 150, 262, 285, 292; Muchalinda cult, 19, 108, 161; religion in, 20, 158, 162; works, 80, *81*, 102–3, *103, 108*, 209, 214, 224, 234

Celebes images, 159, 230

Central Asia, 51, 52, 165, 167, 170, 171, 196, 198

Chajang, 179

Chakravartin, 140, 149, 176, 237

Champa, 158

Chan Buddhism, 18–19, 96, 99, 169, 173, 178, 185, 278; style of images, 41, *95*, 101, *107*, 152

Chandaka, 42, 66, *67, 68, 69*, 70–71, *71, 92, 93*

Chandra, *285*

Chandravairochana, *283*

Charity, gesture of, 153, 171, 179, 180, 190

Chenla, 160

Cherubs, 138, 274, *274*

China: Buddha images, *196, 198, 203–6, 210, 211, 228, 235, 272, 272–73, 280, 281, 286, 287, 288, 293–94, 294*; Buddhism in, 18–19, 96, 165–69; cults, 18, 19, 84, 255, 256, 257, 273, 283, 311; influenced Japan, 82, 183, 185, 188, 189, 308; influenced Java, 292; influenced Korea, 20, 177, 208, 238, 275, 299, 301, 311; influenced Tibet, 260; life scenes, 19, 51, 56, 79, 84, *85, 86, 87, 88, 90*, 96, 97, *101, 107, 114, 115, 118, 119, 120, 121*; Maitreya images, *309, 310, 311*

Chintamani, 296, 300

Chonen, 189

Chuan Shinko, 96, *98–99, 99*

Chunda the smith, 45

Complexion: of Sakyamuni, 149, 152; Bhaishajyaguru, 283; Ratnasambhava, 296

Conception of the Buddha, 66, 67, *77, 77, 78*, 182

Conch shell, 150

Confucianism, 166–69, 173–74, 178, 181, 243, 288

Confucius, *288*

Coomaraswamy, A. K., 39, 160, 195

Cosmic pillar, 133, 138, 238, 254

Cranial bump. *See Ushnisha*

Crowned and jeweled images, 104, *104, 106, 106, 108, 108–9*, 152, 190, 241, *241, 244, 244*

Daianji, 187

Daibutsu, 186

Dainichi. *See* Vairochana

Daisanji, 305

Dalai Lama, Seventh, 312

Daniell, Thomas: drawings by, *245–46*

Daoism, 19, 165, 167–69, 173–74, 178, 288, 289

Death of the Buddha, 19, 39, 44–45, 47, 52, 64, 133; representations: Burmese, *62*; Chinese, 19, *294*; Gandhara, 55, *121*; Indian, 56; Japanese (Nehan), *122–26, 128*, 188–90; Nepali, 60, 61, 68, 69; Persian, 64, *65*; Sinhalese, *127*; Tibetan, 63, 66, 67

Deer: as symbols, 109, 138, 195

Deer Park. *See* First Sermon

Descent from the Trayastrimsa Heaven, 48, 112, 218, 237, 254; representations of, 57, 58, 61, 62, 63, 66, 67, 112

Devadatta, 44, 49

Devaraja cult, 20

Devendra, D. T., 156

Dhammapada Commentary, 48

Dharmachakrapravartanamudra. See Turning the Wheel of the Law

Dharmadhatu, 133

Dharmaranya, 166

Dhyana Buddhism, 169

Dhyanamudra. See Meditation, gesture of

Diamond-World Mandala, 187, 189, 282

Dipankara Buddha, 68, 69, 110, 254, 265

Divyavadana, 111, 117

Dogen, 185

Dona, 148

Dongming Huiri, 96

Donors of images, 145

Dragon, 82, 84, 120, 176, 289

Dunhuang Cave temples, 165–66; works from, *88, 90, 186, 270, 282, 294*

Dvaravati Kingdom, 158, 218; iconographic features, 19, 150, 161, 216, 223, 239, 292; influence of, 209, 220; style of, 20, 161, 218; triads, 161, 284; wheels, 140, 161; works, 111, *111*, 223

Earlobes, elongated, 148, 150

Earth, personification of, 102–3, *103*

Earth-touching gesture, 52, 102, 153, 180, 241

Eastern Chin Kingdom, 176

Eastern Wei dynasty: stele, 202, *203–5*

Edo period, 124, 185, 187, 188; works, *75–76, 82, 96, 98, 99,* 122, *124, 125–26*

Education of Siddhartha, 41, 68, 69, 87, 88, *88*

Eight Bodhisattvas, Mandala of, 296–97, *297*

Eightfold Path, 44, 133

Eight Great Miracles, 47–49, 52, 57, *57,* 60, *60,* 61, *61,* 62, *62, 137. See also individual miracles*

Elephant: Siddhartha lifts, 73; as symbol, 84. *See also* Conception of the Buddha; Taming of the Mad Elephant Nalagiri

Emaciated Sakyamuni, 19, 42, 95, 101, 173, 188; representations, 59, *59, 61, 61,* 68, 69, *96, 97, 100, 101*

Emerald Buddha, 244

Empty throne, 133, *138, 139*

Enku, 249

Enlightenment: as goal, 159, 169

Enlightenment of Sakyamuni, 39, 42, 43, 47, 52, 254; representations: Cambodian, 102, *103;* Chinese, 96, 101; Gandhara, *54;* Indian, *56, 57, 58,* 102, 240; Japanese, 188, 190; Nepali, *61,* 68, 69; Thai, *104;* Tibetan, *63,* 67, *67*

Ennin, 168

Esoteric Buddhism, 179, 184, 187, 189

Ettinghausen, Richard, 64

Eyebrows, 150, 234

Fa Xian, 141, 167, 214

Feet: marks on, *135,* 149, *193;* webbed, 151

Fire temple, Uruvilva, 59, 116

First Sermon, 39, 43, 47; representations, *54, 56, 57, 61, 62, 63,* 66, 67, *109,* 138, 195; symbols of, 133, 138, 140, 195

Flame, 217, 227, 265

Flower Wreath Sutra, 183

Footprint of the Buddha, 133, *135,* 138, *138,* 139, 237, 269

Four encounters, 41, 56–57, *57,* 66, 67, 70, 71, *70–71,* 90, *90*

Four Heavenly Kings, 83

Four Noble Truths, 133

Fudo, *282*

Fugen. *See* Samantabhadra

Funan, 160

Future Buddha, Maitreya, 146, 257, 266; cult of, 171, 172, 177, 255, 311; heaven of, 145, 172, 257; images of: Chinese, 146, 171, 180, 204, 273, 292, 294, *295,* 309, *310, 310,* 311; Gandhara, *95,* 113, *191;* Japanese, *282;* Korean, 177, 178, 180, *311;* Nepali, 224, *225;* Tibetan, 296, *312*

Gal Vihara: image at, 45, 127, 157

Gandavyuha: illustration, 280, *281*

Gandhara, 119, 172, 173, 257, 265; Buddha images, *136, 147, 191, 193, 194;* emaciated Sakyamuni, 19, 42, 61, *95,* 101; Footprint of Buddha, *135;* iconographic features, 115, *139,* 147, 150, 194, 223; influence on China, 56, 172, 196, 198, 204, 309; influence on other countries, 189, 200, 265; life scenes, 52, *53–55,* 64, 77, *87,* 91, *95,* 110, *110, 112, 113, 115,* 116, *117;* style of, 20, 87, 147, *193,* 254

Gauguin, Paul: woodcut, 247

Gautama clan, 40

Gaya. *See* Bodhgaya

Genshin, 307, 308

Gestures, 153, 291. *See also individual gestures*

Golden Hall, 186

Good fortune, gesture of, 301–2, *301*

Great departure, 42, *53–54,* 66, 67, *68,* 69, *70–71,* 92, 182, 294

Great Stupa (Sanchi), 20

Greco-Roman style: Gandhara use of, 87, 147

Guanyin. *See* Avalokitesvara

Guardian Kings, 188

Guardians of the Four Directions, 76

Guge Kingdom, 231, 283

Gunasinghe, Siri, 156, 266

Guo Bi, 286

Gupta period, 201, 212; iconographic features, 150, 151, 198, 201; influence of, 161, 197, 198, 201, 206; style, 20, 56, 57

Hafiz-i Abru, 64

Hair: cutting of, *59, 63,* 67, 68, 69, 149; significance of arrangement of, 147, 148, 149–50, 207, 213

Hakuho period: images, 208, 299

Hakuin, 185

Halo, 96, 152; Adoration of, *139;* in infant Buddha images, *87, 89;* in *Shussan Shaka* scenes, 96, 188

Hands: large, 151, 157; marked, 148, 149; webbed, 148, 151, *210*

Han dynasty: and Buddhism, 165, 166

Hariti: conversion of, 72, 72–73, *118,* 119; role of, 173

Healing Buddha, 255–56, 283; images, 211, 256, 282, 283

Heian period, 184, 289, 304, 305; works, 188, 189, 278–79, *279*

Hinayana Buddhism, 171, 172, 296

Hinduism, 158, 162, 178, 221, 285

Horyuji, 186, 187

Husain, M. F.: painting by, 78

Hwarang, 177, 180, 255

Iconography, 151, 160–161, 171, 172

Iconometric canons, 151–52

India, 18, 144–53, 173, 310; ascetic images, 19, 42; influence of, 62, 160, 167, 197, 215, 230; life scenes themes, 52, 116; walking Buddha, 161, 237. *See also* Amaravati region; Andhra Pradesh; Bihar; Gupta period; Kashmir; Mathura; Nagapattinam; Sanchi; Sarnath; Tamilnadu; Uttar Pradesh

Indonesia, 158; bronze, *116*

Indra, 146, 260; at Birth of the Buddha, 41, *53, 54, 55, 60, 80, 83, 191*; and other life events, 59, 70–71, 92, 111, 112, 116, *117*; other representations, 194, 284

Indrasala Caves, 116

Indravarman II, 158

Infant Buddha. *See* Baby Buddha

Iran. *See* Persia

Islam, 158

Jambudvipa (Island of Jambu), 241

Jambupati, 241, 244

Jambu tree, 41, *89*, 241

Jami al-Tavarikh, 64

Jamyang Dondrub, 312, *312*

Japan, 186–90, 292, 301; Amida images, 304, *304–5*, 306, 307, 308; baby Buddha images, *83, 85*, 146; Buddhism in, 166, 179, 183–86; cults, 18, 19, 84, 184, 256, 257, 258, 283, 304; Korean ties, 20, 188, 208, 303; mandala, *282*; *Nehan* scenes, *122–26*; Sakyamuni images, 42, *211*, 249, 277–79, *277, 279, 289*, 299; *Shussan Shaka* scenes, *97–100*; other life scenes, 19, 51, 79, *105*

Jataka tales, 48, 131, 162–63, 166, 254, 259–64, *259, 261, 262, 263*

Java, 145, 150, 159, 160, 273; Buddhism in, 158; Central Javanese period style, 225, 291, 292, 295; works, *212, 225, 291, 292, 293, 295*. *See also* Barabudur images

Jaya, 117

Jayavarman VII, 19, 158, 161–62

Jetavana monastery, 48, 115

Jeweled images. *See* Crowned and jeweled images

Jin dynasty: and Buddhism, 169

Jisha Tripitaka, 280

Jizo, *282*

Jochiji, 307

Jocho, 305

Jodo-Shinshu sect, 188

Jodo-shu. *See* Pure Land Buddhism

Kadampa *thankas*, 63, 297

Kaikei, 304–5; work by, *305*

Kako-genzai-inga-kyo, 83, 105, *105*, 183, 190

Kalika, 277, 278

Kalsang Gyatsho, 312

Kamakura period, 185, 304; Amida images, 190, *304, 306, 307, 308*; other works, 97–99, *99, 105, 122, 282, 304, 306, 307, 308*

Kambutsu ceremony, 83, 187

Kandy Kingdom, 242

Kandy period: images, *127*, 242, 266–69

Kanheri cave temples, 165, 230

Kanishka era, 191

Kannon. *See* Avalokitesvara

Kano School, 99, 126

Kano Yasunobu: scroll, 96, 98, 99

Kanthaka, 42, *53–54*, 63, 66, 67, 68, 70–71, *70–71, 89*, 92

Kaparda, 192

Kapilavastu, 40, 44, 54

Karakhocho, *194, 198, 210*

Karli, 165

Karma, 253, 254

Kashmir: works, *102, 110, 110*, 230–31, *231*, 290

Kasyapa, 59, 111, 116, 176, 179, 185, 202, 272, 286

Kasyapa-Matanga, 166

Katsushika Hokusai: woodblock prints, 74–76, *75–76*

Kawanabe Gyosai, 288; album leaf, *289*

Kei School, 304

Kenchoji, 99

Khmer, 104, 108, 161–62, 223, 285; work, *104*

Khocho. *See* Karakhocho

Khotan, 170; works of as prototypes, 165, *196*, 198, *235*, 294

Kim Yusin, 177

Kizil: 165; works, *120*, 198, *210*

Kobo Daishi, 57

Koei (Unkei IX), 304, 305; work by, *305*

Koguryo Kingdom, 175–76, 178; images, *175–76, 178*, 298, 299

Kokuzo, *282*

Kong Guangtao, 288

Kongobuji, 188

Korea, 145, 175–82, 243; Amitabha images, *300, 301, 302, 302, 303*; Chinese influence, 20, 166, 311; cults, 18, 19, 176–77, 179, 255, 311; folk art, 178, *240, 243*; influence on Japan, 20, 183, 189, 303; life scenes, 78, 84, *85, 93*; Maitreya images, 204, 311; murals, 52; Sakyamuni images, 208, *208, 214*, 227, 238, *240, 243*, 275, 298, 299

Koryo period, 177–78; works, 181, 238, 280, *281, 302, 303*

Kosala Kingdom, 45, 48

Kotokuin temple, 186

Kozanji monastery, 99

Kshitigarbha, *282*

Kubera, *312*

Kucha, 165, 170, 171, 235

Kukai, 186, 189

Kumarajiva, 171, 235

Kurkihar, 222

Kushan period: art of, 147, *192,* 265

Kusinagara, 45, 47

Lalitavistara, 80, 162

Lamaism, 169, 280, 296

Lankavatara Sutra, 185

Laozi, 173, *288*

Lee, Sherman, 227

Liang Kai, 96, *288*

Liang period, 119, 167

Liao dynasty, 169; images, 228, *294, 295*

Licchavis, 48

Life-prolonging ceremonies, 146

Linga, 137, 162

Lin Zhaoen, *288*

Lions: significance of, 136, 192, 196, 300

Li Que, 96

Longmen Cave temples, 165, 172, 257

Lotus of the True Law. See Lotus Sutra

Lotus posture, 153

Lotus Sutra, 18, 167, 172, 181, 184, 186, 255, 274, 275, 289; scenes from, *182, 190, 272, 272, 274, 275, 277–79, 279*

Lumbini (goddess), 40, *53*

Lumbini, grove of, 40, 47

Lustration, 19, 41, *56,* 74, *75–76, 82, 83, 83, 85,* 187

Madhyamika sect, 177, 275

Magadha Empire, 45, 48

Magic, 159

Mahabodhi temple, *63,* 233

Mahaparinirvana. See Death of the Buddha

Mahaparinirvanasutra, 45, 127

Mahaprajapati, 40, 41, 44, 53, 80, *81, 86, 87,* 89

Mahapurusha: signs of, 149, 254

Mahasamghikas, 253, 254

Mahasthamaprapta, 272, *272,* 282, 308

Mahavairochana, 186, 189, 270, 291, 292, 293

Mahavastu, 77, 110, 149, 151, 253

Mahayana Buddhism, 92, 145, 262, 295; in China, 166, 171, 172; ideals of, 256, 278; in Japan, 184, 186, 187, 211; in Korea, 175; multiple Buddhas theme, 254, 271; pentad, 256; in Southeast Asia, 158; in Sri Lanka, 156

Maitreya. *See* Future Buddha, Maitreya

Majjhima-Nikaya, 148

Majma' al-Tavarikh, 64, *65*

Malaysia, 157–58

Malla tribe, 45, 150

Mandala of the Eight Bodhisattvas, 296–97, *297*

Mandalas, 187, 189, 258, 282, *282, 297*

Mango tree miracle, 48, 111

Manifest Complete Buddha, 258

Manjusri, 20, 173, 205, 228, *228, 277, 277–78,* 282, 286, 295

Mankuwar: Buddha image, 92

Manorathapurani, 87

Mantrayana sect, 189

Mara: temptation of Sakyamuni, 43, 62; representations, 60, *63,* 68, *70–71, 92, 102–7,* 162

Marriage of Siddhartha, 68, 69

Martial arts: Siddhartha learns, 41, *66, 67*

Maruyama Okyo, 125

Maruyama School, 124

Mathura, 109, 147, 150, 152, 254; influence of, 167, 191, 192, 201; works, *139, 192, 199, 200*

Matricheta: poetry of, 144

Matsyapurana, 151

Maudgalyayana, 68, 69, 72, *72–73, 112, 262*

Maya, 40, 41, *82;* Sakyamuni preaches to, 48, 61. *See also* Birth of the Buddha; Conception of the Buddha

Ma Yuan, *288*

Meditation: Chan and Zen emphasis on, 96, 169, 185, 188; of monks, 132; Sakyamuni's, 41–43, 101, 127. *See also* Emaciated Sakyamuni

Meditation, gesture of, *105,* 153, *156,* 180, 208, 238

Megha: legend of, 110

Meiji period: paintings, 289

Menander, 253

Middle Way, doctrine of, 44, 133

Milindapanha, 253

Mindfulness, 148

Ming dynasty, 169, 238, 296; works, 84, *85, 101, 107, 288*

Miracles. *See* Eight Great Miracles

Miroku. *See* Future Buddha, Maitreya

Miruk. *See* Future Buddha, Maitreya

Mongols, 64, 169, 280

Monju. *See* Manjusri

Monkey: as symbol, 84

Monkey Giving an Offering of Honey to the Buddha, 48, 57, *58, 60, 61, 62, 63,* 66, 67

Mon people, 218

Mount Meru, 213, 238

Mount Sumeru, 294, 295

Muchalinda, 43, *59, 60, 62,* 108, *108–9, 284–85, 285;* Cambodian cult of, 19, 161–62

Multiple Buddhas, 171, 172, 187, 189, 254, 266, *266–72,* 270, 271, 273, 282

Multiplication Miracle, 48, 56, 60, *60,* 66, 67, 111, *111,* 254

Munakata Shiko: woodblock, *249*

Munsterberg, Hugo, 249

Muromachi period: works, 96, *98–99, 99, 100,* 277, *277–78,* 282, 304, 307, *308*

Mustache, use of, 223

Muyo-nehan, 124

Myriad Buddhas. *See* Multiple Buddhas

Myrobalan, 256, *283*

Nagapattinam: images, 202, 217, 226

Nagaraja, 231

Nagarjuna, 52, 275, 276, 276

Nagarjunakonda, 92, 275; reliefs, *92, 94, 138*

Nagasena, 253

Nairanjana River, 43

Nakamichi Sadatoshi: *Nehan* paintings, 122, 124, 126, *125–26,* 188

Nakula, 277, 278

Nalanda: as learning center, 137, 167; works of, *137,* 160, 222

Nambokucho period: works, 122, *123, 124,* 282, 303

Nanda, 44, *86,* 87

Nanda temple, 162

Nara period, 183–84, 299; works, *83, 211, 299*

Nativity. *See* Birth of the Buddha

Navel, 150

Nehan. See under Death of the Buddha

Nehan Mitate, 128, 188

Nembutsu, 184, 257, 307

Neo-Confucianism, 169, 178

Nepal, 20, 235, 265; Buddha images, *225, 235, 265, 275, 276;* narrative and life scenes, 52, *60, 61, 68, 69, 81, 86, 95, 106;* pattern books, *152;* themes, 42, 47

Newars: metal casting, 61, *61*

Nichiren, 184–85

Nidanakatha, 162

Nijugozammai religious society, 308

Nirvana, 44, 124, 145, 184

Nishimura Shigenaga: woodblock print, *82*

Noma Seiroku, 299

Northern Qi dynasty: stelae, *272, 272–73;* style, 206, 299

Northern Wei dynasty, 119, 166, 167, 172, 255; style, 56, 79, 205, 206; works, 79, *310, 311*

Northern Zhou dynasty, 167, 206

Ojo Yoshu, 307

Paekche: images, 176, 208

Pagan, 162, 233

Pakistan. *See* Gandhara

Palace scenes, 66, 67, *68, 69, 91, 91*

Pala period: influence of, 62, 233, 291; works of, *59,* 116, 222

Panchika, 73, 277, 278

Paradise scenes: Japanese, 187

Paradise sects, 168, 172, 273

Paramahamsa, 151

Paranavitana, Senarat, 127

Paris Exhibition of 1889, 247

Paryankasana, 156, 197

Pataliputra, 120

Pathamasambodhi, 102

Pattern books, 152

Pava, 45

Persia: influence of, 290; works, 20, 64, *65*

Peterson, Kathleen, 152

Phimai: crowned images, 104, 108

Pilgrimage sites, 47–48, 62, 141, 269

Pillar, 133, 138, *138*

Pingala, 119

Polonnaruwa: images, 45, 127, 157, 207

Postures, 153, 180, 189, 292

Prabhutaratna, 171, 172, 255, 274, *274, 275, 275,* 294, 295

Prajnaparamita, 59, 60, 87, 275, 276; covers, 52, *59, 60*

Pralambapadasana, 292, 310, *311*

Prasenajit, 111, *111*

Purana Kasyapa, 111

Pure Land Buddhism: in China, 168, 169, 172, 257; Korean, 177, 179; in Japan, 184, 257, 304, 307

Pyu Kingdom, 214

Qingbai porcelain, 287, *287*

Qing dynasty: Buddhism, 169, 173; work, *101*

Questions of King Menander, 253

Rahula, 41, 44

Raigo paintings, 184, 304, 306, 307, 308, *308*

Rajagriha, 44, 48, 49, 116, 117

Rama, 228

Rashid ad-Din: *World History*, 64

Ratanakosin period, 244

Ratnasambhava, 256, *295*, 296, *296–97*, *297*

Reassurance, gesture of, 80, 153, 171, 190, 270; in China, 300, 310; in Korea, 179, 180, 238; other countries, 156, 159, 161, 190

Rebirth, doctrine of, 253–54

Redon, Odilon: lithograph, *248*

Relics of the Buddha, cult of, 132

Resurrection of Sakyamuni, 20, 64

Rinzai Zen sect, 185

Rowland, Benjamin, 79

Rukh, Shah, 64

Rumminidevi, 40

Saddharmapundarika. See *Lotus Sutra*

Sailendra dynasty, 20, 158

Saka era, 191

Sakra. *See* Indra

Sakya tribe, 40

Sakyamuni Coming Down the Mountain. See *Shussan Shaka*

Sakyasimha: epithet, 40, 136; icon, 233

Sala tree, 40, 45, 47, *122*, *123*

Sama Jataka, 262, *262*

Samantabhadra, 277, *277–78*, *282*, 291

Samguk Sagi, 301

Samguk Yusa, 176, 177, 179

Samsara, 151

Samyuktaratna-pitaka, 119

Sanchi, 20, 132, 150, 266

Sanketava: painting by, *210*

Sankisya, 48, 112

Saraha, 258

Sariputra, *68*, *69*, *72–73*, 112, 262

Sarnath, 43, 47, 54, 62, 140, 150, 167; influence of, 56, 57, 161, 206, 224; works, 52, 56, *56*, 109, *109*, 116, *117*. *See also* First Sermon

Schouten, Joost, 239

Seiryoji; images, 189, 214, 235

Seishi. *See* Mahasthamaprapta

Seon sect, 178

Sermons, 20, 61, 110, *110*, 277. *See also* First Sermon

Serpents: in life scenes, *56*, *59*, *82*, 116, *116*; replaced by dragon, 82. *See also* Muchalinda

Sesa, *285*

Seven steps, 41, 133, 254; representations: Chinese, *57*, 79; Japanese, 74, *75–76*, 83, *83*, 187; Korean, 84, *85*, 181; Nepali, *60*, *68*; Tibetan, *66*, *67*, 72, *72–73*, *73*

Shaka Goichidaikai Zue, 74, *75–76*

Shibata Zeshin: scroll by, *128*

Shichijo Bussho workshop, 305

Shijo School: scroll, *124*

Shinto, 100, 178

Shussan Shaka (Sakyamuni Coming Down the Mountain): theme, 42–43, 96, 188; works, 74, *75*, *97–100*

Signs, 148–51, 236, 237, 254

Silla dynasty, 176–79, 180–81, 208, 211, 302, 311; works, 84, *85*, *214*, *275*, *300*, *301*, *311*

Silla Kingdom, 176–79. *See also* Silla dynasty

Sitatapatra Aparajita, 280

Si Thep, 220–21; Buddha image, 219, *220*, *221*

Siva, *60*, 137, 162

Sivaism, 20, 158

Six Divine Kings, 76

Six Dynasties period, 166, 167, 171; images, 172–73, 196, *196*

Sokkoram, 176, 178, 179, 180, 240

Song dynasty, 97, 169, 173, 280, 288, 296; influence on Japan, 185, 186, 189; on Tibet, 72; Northern Song, 278, *286*; Southern Song style, 278; works, 97, *228*, *278*, *286*

Soper, Alexander, 21, 113, 235

Sorensha temple, 307

Sosai: ivory carving, *100*

Southeast Asia, 157–63, 202, 209, 215

Southern Song Academy, 288

Spirit Kings, 272, 273

Sravasti, 44, 48. *See also* Sravasti Miracles

Sravasti Miracles, 48, 111; representations, *57*, 61, 62, 63, *111*. *See also* Multiplication Miracle

Srivijaya Kingdom, 158

Sri Lanka, 156–57, 207, 242, 266; influence of, 20, 160, 195, 202, 215; style, 19, 20, 121, 127; works, *127*, *196*, *197*, 206–7, *207*, *217*, *242*, 266

Srimudra gesture, 301–2

Stupa, 20, 133, 136, *136*, 137, *137*, 197

Subhadra, *55*, *61*, 121

Subhadris Diskul, M. C., 161

Subhakarasimha, 296

Suddhodhana, 40, 41, 44, *78*, 87, 89

Sui dynasty, 166, 168, 172, 186, 206, 273; works, 206, *274*

Sujata, 43, *59*, 63, *68*, *69*

Sukhavati Heaven, 172, 257

Sukhavativyuha, 257

Sukhothai period: works, 158, 161, 237

Sumatra, 158, 159

Sumedha, 254

Sunyata, 275, 276

Surya, 140, *285*

Suryavairochana, *283*

Sutra of Cause and Effect, Past and Present, 83, 105, *105*, 183

Sutra of Forty-two Sections, 166

Sutra of the Golden Light, 183

Sutra on the Meritorious Action of Bathing the Buddha's Image, 187

Suvannabhumi, 157

Swastika, 135, *135*, 296, *296*

Symbols, 131–41, *135–41*

Taizong, 210

Taizu, 280, 286

Takeuchi family, 307

Takeuchi Shinosuke, 307

Tamilnadu: Buddha images, *202*, *226*

Taming of the Mad Elephant Nalagiri, 49, 57, *58*, *60–63*, *66*, *67*, 270

Tang dynasty: Buddhism in, 166, 168, 172, 257; influence of, 177, 186, 211, 286, 311; style, 173, 206, 228, 295, 300; themes, 82, 273, 274, 278, 308; works, *52*, *56*, *57*, *213*, 300, *310–11*, *311*

Tanjobutsu, 74, 83, 187. *See also* Baby Buddha

Tantric Buddhism, 104, 158, 169, 258, 285, 296

Tapussa, 62

Tara, *57*, 280, 285

Teaching gesture, 153; in China, 230, 311; Dvaravati art, 19, 161, 218; inverted, 230; in Korea, 109, 238, 302, 303; other countries, 116, 156, 159, 230; and Vairochana, 291

Temple banners, 210

Temple of the Emerald Buddha, 244

Temptation of Sakyamuni. *See under* Mara

Tendai sect, 184, 189

Ten Divine Kings, 282

Ten Great Disciples, 188

Ten Thousand Buddhas, *171*, *172*

Thailand, 19, 20, 52, 150, 153, 156, 159, 160, 161; *jatakas*, 162–63, *262*, *262*; life scenes, *51*, 70, *70–71*, *104*, *108*, *109*, *111*; religion in, 157, 158, 163; Sakyamuni images, *214*, *216*, *218*, *219*, *223*, *233*, *236*, *237*, *239*, *244*, *262*, *284*; walking Buddha images, 19, 153, 161, *237*, *237*; wheel and sun god, 133, 140, *140*. *See also* Dvaravati Kingdom

Theravada Buddhism, 156, 157, 158, 160, 162, 233, 241, 262, 271

Theravadins, 253–54

Thirteen Buddhist Divinities, 282, *282*

Thirteen Thousand Buddhas, 187, 189

Thousand Buddhas, 171, 254, 270, 271, 273, 282

Three Kingdoms period, 166, 179; works, 208, *208*, *298*, *299*

Tibet: Healing Buddha in, 256, 283, *283*; iconometric tradition, 152; influence of, 20, 280, 296; *jataka thankas*, *259*, *259–60*, *261*; life scenes, *47*, *51*, *52*, *62*, *63*, *66*, *72–73*, *86*, *95*, *119*; Maitreya *thanka*, *312*; multiple Buddhas, *270*; Ratnasambhava image, *296–97*, *297*; Sakyamuni images, *230–31*, *235*

Toba Tartars, 166

Todaiji, 85, 186, 187, 189

Topkapu Saray Library, Istanbul, 64

Tortoise: as symbol, 84

Trayastrimsa Heaven, 48, 61, 112, 113, 119. *See also* Descent from the Trayastrimsa Heaven

Tribhanga posture, 219, 230, 300, 301

Trichivara, 152

Trinity of Light, 189

Tripitaka, 167, 169, 280

Triratna, 135, 138

True Words sect, 189

Turban: adoration of Siddhartha's, 94, *94*

Turning the Wheel of the Law, 110, 153, 180, 291, 292, 310

Tushita Heaven, 77, 78, 172, 255, 294, 307

Twenty-five Meditation religious society, 308

Twenty-four Prophecies, 266, *266–69*, *269*

Two Dragon Kings, *83*

Udayana, King of Kausambi, 44; and Buddha image, *112*, *113*, 132, 146, 214; Udayana image type, 171, 214, 235, 309

Uisang, 179

Ukiyo-e works, 74, *82*, 189

Unified Silla dynasty. *See* Silla dynasty

Unkei, 304–5

Unkei IX, 304, 305; work by, *305*

Urna: as sign, 149, 150; use of, 86, 96, 188, 198, 201, 217, 222, 225

Uruvilva: fire temple, 59, 116

Ushnisha, 147, 149, 150–51, 226, 228; in baby Buddha images, 83, 86, 87; Chinese use of, 107, 172, 228; in *Shussan Shaka* works, 96, 188

Ushnishavijaya, *283*

U Thong, 157, 216, 218, 223

Uttar Pradesh: works, *109*, *116*, *117*, *192*, *199*, *200*, *228*, *229*

Vairochana, 189, 256, 258, 295, 296; gesture of, 180, 291; images of, 280, *281*, *282*, 290, 292, 294

Vaisali, 44, 48

Vaishnavas, 228

Vajjian State, 45

Vajrabodhi, 296

Vajradatu Mandala (Mandala of the Diamond Essence), 257–58

Vajrapani, *53–54, 113, 117, 121, 138,* 285

Vajrasana, 61

Vajrasana temple, 61, 63

Vajrayana Buddhism, 60, 146, 296; ceremonies, 58, 59, 106; pentad, 58, 59, 256, 257–58, 291, 296

Valahassa Jataka, 260, *260*

Vanaspati (Lord of the Forest), 19

Varadamudra. See Charity, gesture of Vedic religion, 131

Vessantara Jataka, 70, *70–71,* 163, *263–64, 263–64*

Vietnam, 158, 159

Vijaya, 117

Vimalakirti, 173, 180, 205, 286

Vimalakirtinirdesa, 205

Vinaya sect, 179

Vishnu, 20, 60, 133, 221, 228, *285*

Vitarkamudra. See Teaching gesture

Votive tablets, 233

Vrishni tribe, 228

Vulture Peak: sermon at, 277

Walking Buddha, 19, *59,* 153, 161, 237, *237*

Wang Shouren (Wang Yangming), 288

Wang Zhenpeng: handscrolls by, *86, 87, 119*

Wanli, Ming emperor, 260

Wat Phra Keo, 244

Wat Phra Si Sanpet, 233

Wat Si Chum, 163

Webbed hands and feet, 148, 151, *201, 210*

Wei dynasty. *See* Eastern Wei dynasty; Northern Wei dynasty

Western Himalayas: sculpture, *298*

Western Paradise, 73, 257

Wheel: as symbol, 54, 57, 109, 140, *140;* marks on hands and feet, *135,* 149. *See also* Turning the Wheel of the Law

White Horse Monastery, 166

Wisdom fist, 270, 282, 291, *292, 293*

Womb-World Mandala, 187, 189, 282

Wonkwang, 177

Xia Guei tradition, 288

Xuan Zang, 48, 104, 167, 211, 214, 256, 309

Xuan Zhao, 167

Yakshas, 42, *54, 71, 89, 92,* 133, 290, *290*

Yakushi. *See* Healing Buddha

Yakushiji, 256

Yama, *294, 295*

Yamada Isai, 74

Yasai Nehan, 128

Yasodhara, 41, *68, 69, 88, 91*

Yeshe-o, Tibetan king, 231

Yi dynasty, 178, 181; works, *78, 93, 238, 240, 243*

Yijing, 119, 217

Yogatantra, 257, 295

Yogi: Buddha as, 147–48, 152, 153; ideal, 148

Yogic posture, 153

Yogic rituals, 146

Yokoyama Kazan: scroll by, 122, 124, *124,* 188

Yuan dynasty, 96, 101, 107, 169, 186, 235; works, *86, 87, 235,* 280, *281, 287,* 296

Yungang Cave temples, 165, 167, 272, 273, 274

Zen Buddhism, 18, 96, 99, 185, 188, 289; and arhat theme, 278; emaciated Sakyamuni theme in, 42, 95, 99, *97–99,* 101, 188; and realism in images, 18, 152, 190

Zenkoji, 304

Zhang Lu, 288

Zhao dynasty, 172

Zhao Guangfu, 286

Zhao Mengfu, 286

Zhe School, 288

Zhou dynasty, 120

Zhu Xi, 169

Zong Lin, 119

Zoroastrianism, 257

Photo Credits

Unless otherwise noted, all photographs are courtesy of the lender. The numbers given below correspond to the catalogue entry numbers.

© American Academy of Benares: 69

Arkins, Joseph: 172b

© Asian Art Museum of San Francisco: 111

© Denver Art Museum: 121

Echelmeyer, Rick: 166

Fogg Art Museum, Harvard University: 145

© Foto Wettstein & Kauf, Museum Rietberg, Zurich: 87

Helga Photo Studio: 109, 173

© de Marteau, Claude: 74

© Museum of Fine Arts, Boston: 48

© National Museum, New Delhi: 38

Nelson, Otto E.: 2, 10, 11 (color), 41c, 47, 50a, 52, 57, 57 (color), 102a, 132, 148, 157, 158b, 159, 171, 171 (color)

© W. R. Nelson Trust: 21, 95, 154

Pollitzer, Eric: 28, 96, 128a, 128b

La Reunion des musées nationaux: 16, 24, 32, 24, 169

Reynolds, Larry: cover

Rheinisches Bildarchiv: 41b

© Royal Ontario Museum: 153

Wallace, Robert: 61

Wilson, Ellen Page: 68